JAN 1 3 2014

ext order

coupon for 15% off your next volo.com order!

Nolo.com/customer-support/productregistration

On Nolo.com you'll also find:

Books & Software

Nolo publishes hundreds of great books and software programs for consumers and business owners. Order a copy, or download an ebook version instantly, at Nolo.com.

Online Legal Documents

You can quickly and easily make a will or living trust, form an LLC or corporation, apply for a trademark or provisional patent, or make hundreds of other forms—online.

Free Legal Information

Thousands of articles answer common questions about everyday legal issues including wills, bankruptcy, small business formation, divorce, patents, employment, and much more.

Plain-English Legal Dictionary

Stumped by jargon? Look it up in America's most up-to-date source for definitions of legal terms, free at nolo.com.

Lawyer Directory

Nolo's consumer-friendly lawyer directory provides in-depth profiles of lawyers all over America. You'll find all the information you need to choose the right lawyer.

DIMO11

Brief Contents

PART ONE Programming Resources and Constraints

- 1 A Framework for Programming Strategies 1
- 2 Program and Audience Research 39
- 3 Domestic and International Syndication 84

PART TWO Broadcast Television Strategies

- 4 Prime-Time Network Entertainment Programming 122
- 5 Non-Prime-Time Network Television Programming 163
- 6 Television Station Programming Strategies 189
- 7 Public Television Programming 220

PART THREE Cable, Satellite, and Online Strategies

- 8 Cable, Wireless, Satellite, and Telephone Program Distribution 246
- 9 Basic and Premium Subscription Programming 280
- 10 Online Video and Audio Programming 314

PART FOUR Radio Programming

- 11 Music Radio Programming 338
- 12 Information Radio Programming 379

Abbreviations and Acronyms 409

Glossary 412

Annotated Bibliography 437

Internet Media Sites 445

About the Contributing Authors 447

Index to Program Titles 450

General Index 455

Detailed Contents

Preface xi

PART ONE

Programming Resources and Constraints

CHAPTER 1 A Framework for Programming Strategies 1

by Susan Tyler Eastman and Douglas A. Ferguson

What Is Programming? 2

The Lure of Lore 8

Structural Considerations 9

The Elements of Programming 13

A Model of Programming 20

External Influences on Programmers 24

What Lies Ahead 36

Sources 37

Notes 38

CHAPTER 2 ■ Program and Audience Research 39

by Douglas A. Ferguson, Timathy P. Meyer, and Susan Tyler Eastman

Decision-Making Information for Programmers 40

Program Testing 42

Qualitative Audience Research 44

Ratings Services 47

Ratings Terminology and Measurement Computations 53

Television Market Reports and Other Programming Aids 59

Radio Reports 64

Cable Ratings 68

Online Research Services 71

Ratings Limitations 74

Future Challenges 81

Sources 83

Notes 83

CHAPTER 3 Domestic and International Syndication 84

by John von Soosten

The Syndication Chain 85

Program Acquisition 92

Ratings Consultation 98

The Decision Process 104

Calculating Revenue Potential 107

Payment 111

Cable and Syndication 115

The International Marketplace 116

What Lies Ahead for Syndication 119

Sources 121

Notes 121

PART TWO

Broadcast Television Strategies

CHAPTER 4 ■ Prime-Time Network Entertainment Programming 122

by William J. Adams and Susan Tyler Eastman

The Scandals 123

Vertical Integration 124

Audience Targeting 128

Prime-Time Ratings 135

Prime-Time Scheduling Practices 139

Program Renewal 142

New Program Selection 146

Promotion's Role 152

Changing Format Emphases 153

Network Decision Making 158

The Risks and Rewards Ahead 160

Sources 161

Notes 162

CHAPTER 5 Non-Prime-Time Network Television Programming 163

by Robert V. Bellamy, Jr. and James R. Walker

Non-Prime-Time Dayparts 164

Scheduling Strategies 166

Sports 168

Daytime Soap Operas and Game Shows 171

Weekday News and Information 174

Weekend News and Information 180

Children's Programming 180

Talk Shows 184

Late-Night Weekend Entertainment 185

The Effects of Consolidation 187

Sources 188

Notes 188

CHAPTER 6 Television Station Programming Strategies 189 by Robert B. Affe

Sources of Television Programs 190

Network Programming for Affiliates 192

News and Local Programming 197

Syndicated Programming 199

Station Dayparts 203

Station Promotion 214

What Lies Ahead for Stations 215

Sources 218

Notes 218

CHAPTER 7 ■ Public Television Programming 220

by John W. Fuller and Douglas A. Ferguson

Program Philosophy 221

The Network Model 222

PBS Responsibilities 226

Types of Station Licensees 227

Program Production 232

Syndicated and Local Programming 235

Scheduling Strategies 238

National Promotion 240

Audience Ratings 240

Developments Ahead 244

Sources 245

Notes 245

PART THREE

Cable, Satellite, and Online Strategies

CHAPTER 8 ■ Cable, Wireless, Satellite, and Telephone Program Distribution 246

by Susan Tyler Eastman and Michael O. Wirth

The Multichannel Distributors 247

Selection Strategies 251

Technical Parameters 252

Legal Requirements 259

Economic Considerations 262

Marketing Factors 266

Scheduling Strategies 267

Evaluation Strategies 268

Promotion Strategies 270

Local Origination on Cable 270

Community Access on Cable 273

What Lies Ahead 277

Sources 278

Notes 279

CHAPTER 9 ■ Basic and Premium Subscription Programming 280

by Douglas A. Ferguson and Susan Tyler Eastman

Competing Program Services 281

The Nonbroadcast World 282

Selection Strategies 287

Scheduling Strategies 296

Evaluation 300

The Channels 303

Subscription Network Promotion 309

Audio Services 310

Directions for the Future 311

Sources 313

Notes 313

CHAPTER 10 Online Video and Audio Programming 314

by Douglas A. Ferguson

Convergence 316

The Online World 317

A Conceptual Framework 322

The Content Providers 324

Strategic Considerations 326

Specific Approaches 328

Online Measurement 330

Impact on the Mainstream Media 332

What Lies Ahead 335

Sources 336

Notes 336

PART FOUR

Radio Programming

CHAPTER 11 Music Radio Programming 338

by Gregory D. Newton

A Little History 339

Choosing a Format 344

Step-by-Step Selection Process 351

Implementation 354

The Music 357

Marketing and Promotion 363

News and Other Nonentertainment Programming 367

Station Personalities 369

Network and Syndicated Programming 369

What's Coming for Radio? 376

Sources 377

Notes 378

CHAPTER 12 Information Radio Programming 379

by Robert F. Potter

Information Versus Entertainment Radio 380

The Rise of Information Radio 385

Information Programming Formats 389

All-News Formats 390

Talk Formats 393
The Content Infrastructure 399
On-Air Talk Techniques 400
Information Formats on Public Radio 402
What Lies Ahead 406
Sources 407
Notes 408

Abbreviations and Acronyms 409

Glossary 412

Annotated Bibliography 437

Internet Media Sites 445

About the Contributing Authors 447

Index to Program Titles 450

General Index 455

Preface

his book about media programming deals with the emerging as well as the established mass communication media. Although it happily encompasses such developments as blogs, podcasts, Wi-Fi, iPhones, and mashups, it is primarily about *programs*—entertainment and informational television and radio coming to viewers as preproduced units of content.

The authors focus on how programs (units of content) are selected (or not selected), how the programs are arranged in schedules or menus of various kinds, how the programs are evaluated by the industry, and how they are promoted to audiences and advertisers. We are concerned with the limits on options arising from technology, financing, regulations, policies, and marketing needs. One central theme is that how content is paid for determines much of its structure and availability. Another is how the mass orientation and rigid content of traditional broadcasting has reacted to pressure from the emerging online and mobile media. The more personalized and flexible approach of this emerging media is being adopted and adapted by conventional television and radio as fast as is economically practical.

Still other themes are that the once-clear distinctions between networks, syndicators, and cable companies are dissolving, and that the big media conglomerates are now co-opting and commercializing online and mobile program content. At the same time, the persistent patterns of daily work and living continue to influence the availability

and arrangement of most media enterta ment content, and the realities of economics always overshadow all aspects of media programming.

The specifics in each chapter have been reorganized and updated with an eye on 2012. Since the sequence of the chapters in this book has stood the test of time, and since limiting the number of chapters to 12 has been convenient for both semesters and quarters, these aspects remain the same as in the previous edition, always recognizing that the media model is shifting rapidly underneath the surface. Some chapters have new sections that reflect greater breadth of content. For example, Chapter 8 now covers programming by satellite and telephone systems as well as cable systems; Chapter 11 covers satellite and online radio as well as traditional terrestrial radio.

Part One continues to provide a general introduction to the strategies of programming, the goals and processes of program and audience research, and the functions of domestic and foreign syndication. Part Two focuses on broadcast television from the perspectives of nationwide networks (during and outside of prime time), commercial stations, and public broadcasting. Part Three looks at programming in the newer media of cable, cells, and satellites; premium and on-demand cable and satellite networks; and the online video world. Part Four is about various kinds of radio, separated into chapters on music and information programming.

Two indexes are provided: one covering all program titles mentioned in the book and one

detailing the contents so that virtually any topic can be located. In addition, a glossary of media terms and a list of abbreviations and acronyms are provided for the convenience of readers, along with an annotated bibliography of recently published books and articles and a list of useful internet sites. The publisher and the editors of this book maintain a website at www.media-programming.com, where updates, links to recent articles and other related websites about programming, and flashcards and crossword puzzles for practicing glossary terms are posted. The site can also be reached by searching from www.wadsworth.com.

Change is the electronic media's most enduring characteristic, and the contents of this book have most value when they not only describe and interpret the present but also predict the patterns of the future. The next media revolution is already upon us, and we make educated assessments of likely changes in the nearer future. The impacts of media consolidation and digitalization are increasingly working their ways into viewers' homes and will remain the dominant forces operating to change programming strategies and practices in the coming decade. At the same time, the slow growth in the numbers of U.S. viewers and listeners has made serving diverse audiences—such as the fast-growing Hispanic and Latino audiences—more important and has simultaneously increased the financial significance of foreign distribution of American-made programs.

Moreover, the once-rigid barriers between domestic and foreign programming are dissolving. The impact has been more foreign-made programs in American homes competing for U.S. viewers. Concomitantly, the rise of local media industries in many countries that once imported most of their programs from America has forced the U.S. media into various kinds of international competition and cooperation—ranging from distribution price wars to co-ventures to mergers with program providers and distributors in other countries. The era of world media conglomerates has come, and the population of the United States is changing. Thus this edition includes more non-English domestic as well as international content.

Eight major changes related to programming guided the revisions for this edition:

- The networks' shift from multiplatform marketing to a multiplatform programming strategy. This refers to the major networks' reconception of the internet, PDAs, and cell phones as outlets for specially-created forms of their programs (the "third screens"), rather than merely as vehicles for premarketing existing on-air shows.
- The assimilation of diverse broadcast, cable, online, and syndicated interests within a giant parent corporation. This has led to conflicting goals within corporations in which programming decisions sometimes advantage its ownedsegments and sometimes disadvantage them to maximize overall profits.
- Incorporation of changing network configurations. WB and UPN have merged into The CW; Univision was sold; CBS and Viacom subdivided; Sirius and XM merged; NBC now controls all of MSNBC. Meanwhile, the major networks seek partners in the converging cell phone and internet businesses.
- Proliferation of streaming television and radio on the internet. In less than a handful of years, timid experiments exploded into thousands of program sites offering conventional and other television series and movies online, as well as radio.
- Expansion of mobile phones, PDAs, and handheld music players into real-time programming media. The rise of iPhones, the rapid spread of iPods that play video, personal communication assistants like BlackBerrys and Palm Pilots, Play-Station 3 game machines, and other portable digital media hold the potential for wholly new modes of distribution for the content that has traditionally been called television and radio.
- Growth of new kinds of programs. The rise of You Tube, MySpace, podcasting, v-blogging, and mashups (merged and altered video, sound, and data) are generating new kinds of media programming by both amateurs and professionals.

- Full parity with broadcast ratings for cable networks and Hispanic stations. Programs playing on TNT, USA, and other large cable networks can have ratings that equal those of any broadcast network over a season. Univision has become the fifth-largest television network, and in many markets, it beats competitors in visibility and ratings (and advertising sales). In a policy shift, Comcast, Time Warner Cable, and other cable operators now market packages of "family-friendly" channels. Meanwhile, the debate about unbundling cable continues.
- End of the classic era in network news. Three events—the death of Peter Jennings, resignation of Dan Rather, and move of Ted Koppel to cable—signaled the close of the classic evening newscast hosted by a single prestigious male anchor. New experiments with women anchors and new daytime teams are occurring. At the same time, we are also seeing the rise of pay-for-play for product placement in news, a startling development.

We continue to update the website, add to the graphs and tables as practical, and expand the glossary to reflect the latest trade jargon and practices. For new teachers, the online *Instructor's Manual* contains a sample syllabus, a list of teaching resources, and summaries, video resources, assignments, discussion topics, and test questions for each chapter of the text. The *Manual* is available online at *www.communication.wadsworth. com/eastman8*. Click on the Instructor's Resources tab to access and download the manual.

The two editors/authors updated this edition, but we want to reiterate our very great appreciation to our contributing authors—William J. Adams of Kansas State University; Robert B. Affe of Indiana University; Robert V. Bellamy, Jr. of Duquesne University; John W. Fuller of PBS; Timothy P. Meyer of the University of Wisconsin-Green Bay; Gregory D. Newton of Ohio University; Robert F. Potter of Indiana University; John von Soosten

of XM Satellite Radio; James R. Walker of Saint Xavier University; and Michael O. Wirth of the University of Denver. Of course, many other individuals contributed to earlier editions of this book, and much of what they had to say remains part of the present book.

In addition, among the many boxed inserts inside the chapters, discerning readers will find short blogs authored by other professional colleagues. We were delighted that these colleagues contributed original essays, and we warmly thank them for participating: James Angelini of University of Delaware; Timothy B. Bedwell, independent producer; Dom Caristi of Ball State University; Frank J. Chorba of Washburn University; George L. Daniels of the University of Alabama; Edward Fink of California State University at Fullerton; Deborah Goh of Indiana University; Lindsay E. Pack of Frostburg State University; Patrick Parsons of the Pennsylvania State University; Elizabeth Perse of the University of Delaware; Nancy Schwartz of Indiana University; and Daan van Vuuren, professor and retired director of Research for SABC, South Africa.

We also want to express our gratitude to our reviewers: David R. Nelson at the University of Colorado at Colorado Springs, James Overman at the California State University, Northr dge, and Jong G. Kang of Illinois State University. They were especially helpful for spotting dated material and drawing attention to new trends, and they were very practical about suggesting current examples to include in this new edition. We warmly thank our publisher Michael Rosenberg, our editor Karen Judd, our upbeat copy editor Michelle Gaudreau, and our efficient project manager, Swapnil Vaidya for their efforts on behalf of this edition.

Finally, we thank all of you for using and valuing this book, and we dedicate this edition, along with all the others, to Lewis Klein and to the memory of Sydney Head, without both of whom this book would never have gotten started so long, long ago.

Susan Tyler Eastman Douglas A. Ferguson

1

A Framework for Programming Strategies

Susan Tyler Eastman and Douglas A. Ferguson

Chapter Outline

What Is Programming?

The Process of Programming Programming Is Like Food How Programming Is Unique What Does the Audience Want?

The Lure of Lore

Structural Considerations

Sources of Programs
The Uniqueness of Scheduling
The Need for Promotion

The Elements of **Programming**

Compatibility
Habit Formation
Control of Audience Flow
Conservation of Program
Resources
Breadth of Appeal

A Model of Programming

Selection Scheduling Promotion Evaluation

External Influences on Programmers

Technological Influences Economic Influences Ownership Influences Regulatory Influences Ethical Influences

What Lies Ahead

Sources

Notes

n the media world, programming is the software that gives the hardware a reason for existing. Both are necessary for the system to work, but without programming no broadcast or wired services would exist. Programmers sincerely believe that "content is king."

What Is Programming?

Programming can refer to an outcome or a process. Programming can describe either a group of programs on a radio station, television channel, cell phone, MP3 player, PDA (personal digital assistant), or website, as in "I really enjoy the programming on that new channel"—or the act of choosing and scheduling programs on a broadcast station, a subscription channel, the web, or a portable device, as in "My job is programming; I choose and schedule most of the shows for this channel." The processes of selecting, scheduling, promoting, and evaluating programs define the work of a programmer; these processes are the subject of this book. Regardless of the position title in the industry, the person's job will be to choose the programs that target the desired audience, design a schedule for them, make sure they are effectively marketed, and monitor the outcome—a job description that applies to both the established media and the emerging commercial media. If a channel has weak programming, then the outcome may seem more important than the process. Such a channel needs new programming, in the most tangible sense, because owners typically seek large audiences for a channel's advertisers. The new shows the programmer chooses must appeal to more viewers (or listeners, in the case of radio, or users, in the case of websites) than did the old shows.

Two things about the industry's technology have changed programming a great deal. First is digitalization of home reception, which is displacing analog broadcasting almost entirely. Digital technology has changed how programs are created, distributed, and received, but the industry remains in flux because the eventual technology will soon go beyond merely digital to some form of high-definition television (HDTV) and

high-definition radio (HD radio). To date, only a small portion of television and radio programming reaches homes in HD, but the change is coming (see Chapters 8, 9, and 11).

Second is that some viewers and listeners now do much of their own media programming by recording and time-shifting using digital video recorders (DVRs), making television more like the internet. YouTube and MySpace, for example, are entirely programmed by their users, as are conventional iPods and other MP3 players, although commercial vidcasts are sneaking into these devices. Bloggers and podcasters sometimes find their words broadcast as part of radio programs—in just the same way that amateur videos and vlogs can end up on America's Funniest Home Videos and the like.

Nonetheless, despite all the exciting new portable media and self-programmable websites, only a trickle of time and money is directed to the content of the emerging media. At least 90 percent of viewing time, industry innovation, advertising expenditures, and subscription money still goes to the traditional television media. Sound, however, has become more diverse. Self-programmed music has taken a big bite out of the time once devoted to radio. (But did you know that the average iPod user is in his or her mid or late 30s? All those healthy runners and walkers who once gave up radio to use portable taped music have now tossed away bulky tape in favor of self-selected music stored on tiny players.) Still, there are at least two radios for every person living in the United States (although as few as two for every 1,000 citizens in some other countries).

Although distribution of programming is a lot less important than one might believe (because so much of it is the same content), programmers need to understand the different ways of getting content to the consumer because they involve limits and options. The basic distinction is wired versus broadcast. Wired communication takes place over a coaxial or fiber-optic cable, which usually comes from a cable company or a telephone company. Broadcast signals are typically transmitted over the air from radio (AM and FM and digital audio) and television stations (digital and HDTV), but most people get their broadcast signals as

retransmissions by cable or satellite companies. While direct broadcast satellite (DBS) operators transmit programs from geostationary orbiting transmitters to small receiving dishes, cable operators run wires right to houses and other locations.

Program-like content is also distributed over the internet in streaming audio and video to the threequarters of Americans who have online access. Being online is not necessarily being wired nowadays. as more and more public places, businesses, and homes adopt wireless (Wi-Fi) connections. In fact, just as sound has gone portable and handheld, so television has become battery-operated using lightweight flat screens connected to cable or satellite via Wi-Fi. Such technologies are quickly altering viewing behavior because audience members can carry them anywhere. Thus, portable versus fixed media have become important distinctions. From the point of view of audience members, it's all television (video) or radio (audio), but the precise means of distribution tells insiders a great deal about the constraining economics of a program service.

The Process of Programming

Programming is both a skill and an art. The primary goal in programming advertiser-supported media is to maximize the size of an audience targeted by advertisers. The only way to accomplish this goal is to satisfy the needs and wants of that audience. Although present-day technology permits viewers themselves to choose programs from a variety of sources (such as broadcast stations, cable/satellite channels, digital disks, videotape, and videoon-demand) and have more-or-less instant access to hundreds of digital and HD channels on cable and satellite, oddly enough, most people prefer to let someone else do the programming chore. Viewers tend to choose channels, but expect someone else to have filled those channels in an expert way.

In the case of mass-appeal channels, such as the major television networks and larger cable networks and internet services, programmers go after as many viewers as possible. Most advertisers assume that the demographic characteristics they want will be well represented in the total audience. But to cover all bases, many big media companies have expanded their brands into groups of channels, such as the 11 channels of ESPN, the 5 channels of MTV, the 10 channels of HBO/Cinemax, and so on. In the case of specialty cable and internet channels (called niche networks) such as the History Channel, Black Entertainment Television, Comedy Central, and Tennis (or Pet or Car or Shopping) channels, the programmer may be more interested in pleasing a particular audience subgroup than in expanding audience size outside the targeted group. Of course, the larger the size of that target audience, the easier it is to make money. Very narrowly targeted channels cannot survive long, even on the internet, unless they are subscription services and enough people are willing to pay to get the service.

All programmers must deal with certain limitations, most of them economic. Program resources are scarce. Good shows cost a lot of money. Unfortunately, bad shows are also expensive (except on YouTube). Good or bad, the four largest broadcast networks combined (ABC, CBS, FOX, NBC) spend more than \$15 billion annually on programs and rights to events, but audiences are scarce in terms of time and money. Viewers, listeners, and users are available to consume media of any kind for only so many hours per day, and less and less of that viewing goes to the Big Four networks. In the case of television programming for which viewers pay a fee, there is a limit to how much they will spend before they start complaining to Congress about subscription fees.

The following figure (see 1.1) illustrates the not-always-happy relationship between television viewers and television program services as a tug of war, and similar images might be envisioned for other media. The cartoon suggests that as audiences adopt new technologies, programmers must respond with new strategies for enticing and holding those audiences. Similarly, changing economic, regulatory, and social conditions usually result in acrimonious tensions between the sources of programs and their viewers, listeners, and users.

A step-by-step procedure for the process of programming would go something like this. First, choose programs that seem to meet the needs and wants of an audience. Second, organize those

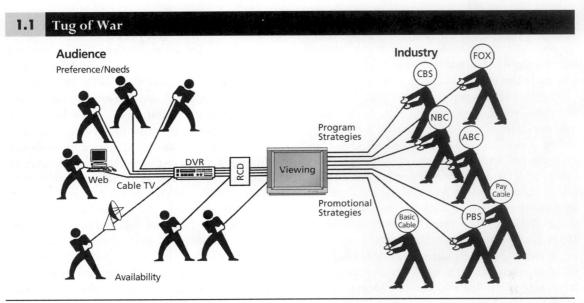

Art: Milt Hamburger

programs into a coherent schedule that flows from one program into the next. Third, market the programs to the appropriate audience. Finally, evaluate the results and make necessary adjustments. This is the basic recipe for cooking the perfect program schedule (see 1.2).

Programming Is Like Food

At its basic level, programming represents individual shows (programs) that people choose. The restaurant metaphor provides a useful basis for understanding program choice. TV Guide is your menu. The channels are the restaurants. The shows are the food. Although it is true in economic terms that programming is a public good and restaurant food is a private good, the distinction is lost on consumers, who presumably view both as discretionary choices.

When people think about food, a seemingly endless combination of choices is available, but foods all come from a few groups: meat, grains, vegetables, dairy, and fruit. Similarly, programs originate in a few types or genres. The prime examples are situation comedies (sitcoms), dramas, news, talk, music, reality, sports, and movies.

Quality or quantity or convenience—which does one want? If people want good food without much wait, they can expect to pay more. If they want fast food at a low cost, they can expect lower

1.2 Recipe for Successful Production

- 1. Target a demographically desirable audience.
- 2. Choose appropriate programs for that audience.
- **3.** Evaluate reasonable costs for program types and time slots.
- Evaluate the competition to determine a scheduling strategy.
- **5.** Make sure a program fits in with neighboring programs.
- **6.** Employ talented performers whom the public likes.
- **7.** Hire producers/directors/writers with a record of success.
- 8. Deal with currently popular subject matter.
- 9. Emulate comparable high-rated programs.

What Is Quality?

henever the word quality is attached to programming, viewers think they know what that means. Do they? Quality often connotes strong production values (lavish sets, famous performers, riveting scriptwriting, technical achievement) and critical acclaim. Those who fight to save quality programs often see some substantial social value in such shows. So why is quality lacking in most television shows? Is it money, or could it be that the masses want circuses instead of high culture? Perhaps quality signifies only that a group of viewers finds some subjective value that is independent of objective criteria. If we cannot garee on what constitutes quality, does it really exist? Maybe those who use the phrase "quality television" really mean to say "programs that we really like."

Programmers are well advised to be careful with the word quality as long as so little consensus exists about what it is. It might be better to strive toward shows that are popular (or critically acclaimed) by external standards, rather than programs that have intrinsic quality.

quality. It is the same with programming. Program producers can deliver high quality if audiences are willing to wait for those special events or if viewers are willing to bear the cost (see 1.3). For the most part, broadcast programming follows the fast food analogy: plenty of food, low cost, but not a wide selection, and certainly not the quality you might desire. To paraphrase one of NBC's acclaimed programmers, Brandon Tartikoff, most television is a very good hamburger, but it's not truffles.\(^1\) One might claim that the internet consists of billions of White Castles surrounding a few cheeseburgers and truffles.

Eating food requires no special skills, and neither does the consumption of media programming. Unlike books, which require reading skills, consuming radio and television requires no intelligence at all. This may explain the snobbish disdain of some critics for entertainment and much of the information distributed over the electronic media.

Like the food in some restaurants, broadcast programming is continuously available from various sources. Just as restaurants may be national, regional, or local, the distributors of media programs operate on three different levels. The network buys or produces programs to distribute over its affiliated stations and to promote online (see Chapters 4, 5, and 12). Program syndicators buy or produce shows to sell directly to stations or cable networks (see Chapters 3, 6, 8, and 9). Finally, each local station produces a few programs to meet the unique needs of its audience (see Chapters 6, 7, and 12). Menus change when the audience doesn't like the food (see Chapters 2, 10, and 11).

Thus, the stations, cable/satellite systems, and online services are the restaurants, and the networks and studios are the wholesale suppliers. Rerun programs are the leftovers. With the exception of DVD rentals and sales, the normal mode of distribution is home delivery. How much gets eaten off the plate determines how a show is rated.

Such an analogy, of course, can go only so far. Food is a necessity; entertainment probably is not. Food is a duplicable commodity; programs have unique identities. French fries can be copied much more easily than *House* or *Grey's Anatomy*. Furthermore, reruns of hit programs have enormous monetary value as domestic and foreign resale items and as extensions of the on-air program via video shorts for cells and online replay.

How Programming Is Unique

If Irving Berlin was correct when he wrote that there's no business like show business, then what makes a programming product unique? How are programs different from other products that corporations make for the public?

Certainly, ease of delivery is key. What other product can be simultaneously delivered to nearly every consumer? Even so, barriers to entry still limit budding suppliers. In theory, anyone can conceive an idea and sell it to a cable channel or a broadcast network or put it online, but the big distributors (cable and broadcast networks through their systems and stations) continue to exert a large measure of control over which programs

run. Nonetheless, it is possible for some programmers to start small and build national audiences. Oprah Winfrey started at a small station doing a local talk show before achieving national television prominence and creating her own production company (see 6.8 for more on Oprah). Beginning with a website is a likely path for many future entrepreneurs.

Reaching a national audience is becoming somewhat less difficult. Satellite dishes and Wi-Fi are proliferating, and a growing number of program suppliers are looking for additional program providers. Video rentals and sales offer another avenue for program suppliers, and the internet's ability to stream audio and video programming—looking and sounding both the same and different from traditional programs—improves continuously.

Broadcast programming is also unique because there is no apparent direct cost to consumers for the most popular shows. Although cable and satellite programmers siphon away some of the most desired programs, the big broadcast networks are able to provide very popular comedy and drama programs, along with top sporting events and live news coverage, seemingly absolutely free to the audience. Advertisers pay for the programs in exchange for having their commercials presented to the audience. Although the high cost of advertising is passed along to consumers, the advertiser's ability to market products to huge audiences actually decreases the per-item cost of many products because of economies of scale. It usually costs more for producers to market products to a small number of people.

Why should radio or television programmers care how "free" the programs are to the receivers? In the case of broadcast programming, the low cost to viewers generates audiences large enough to sell to advertisers. Contrary to popular belief, broadcasters are not in the business of creating programs; they are in the business of creating audiences that advertisers want to reach. Even in the case of cable/satellite channels and online sites, advertiser support is very important to programmers because costs are seldom borne entirely by subscriber or user fees.

Programming is a unique product in that it is used to lure the attention of consumers so that advertisers can show those consumers commercial messages that help sell other products. Programmers work only indirectly for the audience; *the primary customer is the advertiser*, without whom there would be few programs to see or hear.

What Does the Audience Want?

The most important part of programming is understanding the audience. What appeals to viewers or listeners or online users? Quite simply, audiences want to be entertained, and they want to be informed. Speaking very generally, these two elements comprise the whole of programming content (see 1.4).

The demand for entertainment encompasses a mixture of comedy and drama. Narrative stories represent the norm. These stories have a beginning, a middle, and an end occurring within each episode (and ends that occur for entire serials such as Lost and 24, and for telenovelas). Characters have goals resulting from a desire. Along the way, they encounter some form of conflict. In a comedy program, the conflict is a humorous situation resolved in a way that causes the audience to laugh. Sitcoms usually appear in half-hour episodes. In a drama, the conflict results from a counterforce, often "the bad guys." Most dramas last an hour. occasionally longer. By the turn of this century, the reality format (Survivor and Fear Factor) had resurfaced on a wave of game shows (Who Wants to Be a Millionaire?), which was soon overtaken by other types of reality programs (Dancing with the Stars and American Idol) and one more hit game show (Deal or No Deal). Comedies, which had real staying power for decades, were consistently taking a beating in the ratings in the first decade of the 2000s, leading some critics to wonder whether viewers find serial dramas and reality shows especially addicting.

Comedies and dramas are composed of various ingredients that appeal to most audiences: engaging dialogue, attractive characters, romantic themes, nostalgia, suspense, and high emotion, to name a few. The audiences for both entertainment genres are also interested in seeing or hearing something novel, even if it is an old idea with a new twist (see 1.5). Reality shows, on the other hand, create

1.4 Uncovering the Mystery

erely asking television audiences what they want is difficult. Many times viewers do not know what they want until they see it, and a short while later they tire of it and crave scmething new. Programmers must become accustomed to dealing with fickle audiences. The only refuge is to uncover the mystery of how the audience makes choices about what to watch.

The process whereby audience members make choices is seldom clear, but researchers use three basic approaches to predict those choices. One way looks at the uses and gratifications of media consumption. This approach frequently substitutes the self-reported attitudes of viewers for more concrete information on their actual behaviors. A second way uses additional predictors of choice, such as market size, program length, awareness, cable/DVD/satellite penetration, and audience availability. Research findings in this area are

equally unsatisfying or unusable because really strong predictors, such as when the audience is available, are not usually controlled by the programmers (or the viewers).

The most promising way to predict choice seems to be to study the actual content of programs, but the industry has sponsored very little generalizable research. What element in a television or radio program is most important? Some say it is the likeability of the main characters. Others point to the compelling nature of the story or the format. Little research has been done in this area, perhaps because using structural predictors is easier than using content variables. In any case, studying programming as a serious topic is not easy. The networks and other program suppliers focus on the ratings and on testing ideas and p lots (see Chapter 2), but programming seems to remain one big gamble where instinct is more important than science.

1.5 A Programming Myth

he late Sydney W. Head was a frequent contributor to earlier editions of this textbook, and he had this to say about programming:

A popular fallacy holds that innumerable workable new program ideas and countless usable new scripts by embryonic writers await discovery and that only the perversity or shortsightedness of program executives keeps this treasure trove of new material off the air. But television executives hesitate to risk huge production costs on untried talents and untested ideas. Even when willing, the results rarely differ much because mass entertainment remains the goal. A national talent pool, even in a country the size of the United States (and even for superficial, imitative programming), is not infinitely large. It takes a certain unusual gift to create programs capable of holding the attention of millions of people hour by hour, day by day, week after week.

a "human spectacle" that is every bit as scripted, primarily through postproduction editing, as programs with a preproduction script.

Information programming is also driven by novelty and entertainment value. Viewers want fresh stories that promise something new. Critics can complain about the trivialization of information, but network and syndicated news and information programming with an entertainment approach (infotainment) attracts big audiences. Consider, for example, the long-time success of 60 Minutes, 20/20, and The Today Show. These programs mix popular topics with more serious information. In their newscasts, local stations also necessarily pay close attention to the lighter side of community events, partly because there are fewer opportunities for hard news than on the national level and partly because "positive" stories appeal strongly to viewers. The trend has reached the point that younger audiences get much of their news from shows that actually mock the news (for example, The Daily Show with Ion Stewart).

Looking at the types of programs demanded by audiences is one way to learn what people want, although it is not a perfect method. Some people say they want just comedy, for example, but some sitcoms have "serious" episodes that address social issues, while some dramas venture into comedy. Adding to the general misinformation about programming is the fact that viewers and listeners believe they are programming experts merely because they watch or listen. Most people who tune to a broadcast program feel that they could do a better job of choosing the shows and selecting the time slots. If that were really true, of course, there would be no need for a book on how to be a programmer. Programming skills can be learned, but the art is a bit more difficult than it seems to many people.

The Lure of Lore

Everyone watches television, so nearly everyone professes to understand what programs ought to be like. Yet merely having preferences does not qualify a viewer—or a programmer—to make accurate decisions or judgments about program strategy. Because television viewing is so easy, the audience feels confident that putting shows on is really simple. Just make good programs and schedule them when they do not conflict with other good shows. Never make any bad shows. What could be easier?

The professionals who work at the major broadcast and cable networks, along with their counterparts at the individual stations in each city, sometimes take a similarly simplistic stand. Always do this. Never do that. Give the people what they want. Or as Dick Block of the National Association of Television Program Executives (NATPE) preached, "Find out what works, what doesn't work."

Out of this no-brainer philosophy has grown a garden of "rules" that the wisdom of experience has nurtured. Call it folklore or just lore, many programmers believe that achieving success in television programming is a matter of avoiding common mistakes. Unfortunately, programming is much more complicated. But it is useful

to examine some of the lore that has grown up around programming. Certainly some of it may be good advice. Like most lore, however, the student of programming should be suspicious of universal truths.

First, there is the matter of *dead genres*. A genre is a type of program, such as a western or a sitcom. At various times in the history of programming, common wisdom has declared each genre dead. Family sitcoms were dead in 1982, they said—until *Cosby* went on the air. Game shows were dead, they said—until *Who Wants to Be a Millionaire?* came along. Reality shows such as *America's Funniest Home Videos* were very popular in the early 1990s, and then they were dead—until they came back a decade later in the form of *Survivor*.

Second, program lore holds that there is a formula approach to building a successful show. For example, take a grizzled veteran in an action profession and pair that character with a young person to create dual appeal—something for both older and younger viewers. Or hire a big-name star from the world of movies, music, or sports. The problem with such recipes is that they lead to bland television. Moreover, fans can name plenty of programs fitting these formulas that got quickly canceled—far more than shows that lasted on network television.

Third, program lore preaches that certain formats always fail. Anything with chimps. Sciencefiction drama has never spawned a major network hit, not even Star Trek (although X-Files came close, and NBC has tackled suspense-filled fantasy). Never bank on satire. The list goes on... The internet has become the home for thousands of experiments in program content most of these amateur, short-lived, and attracting few repeat viewers in many cases, but attracting millions to the big successes. A few commercial sites, such as those produced by Comedy Central and some other professional producers, generate huge audiences for a time, but not for the many daily hours that characterize conventional television viewing. So far, only a handful of experimental online programs have given rise to new types of television programs for large audiences, but more may lie ahead.

This chapter—indeed, the rest of this book—outlines what practitioners and scholars generally agree are the *real* fundamentals of programming. These are the building blocks that programmers construct with, whatever the medium, and they go well beyond the lore described above. Competence in the field comes from understanding the sources of programs, the factors impacting audience size, and the influences of technology, economics, ownership, and regulation on programming strategies and practices. Beyond them lies artistry—or magic.

Structural Considerations

Programming can be seen as largely a matter of choosing materials and building a schedule. These two processes—followed by promotion and evaluation—are the essence of what a programmer does on a day-to-day basis. Choosing programs depends on circumstances that are closely linked to the source of the programming. Similarly, scheduling is greatly influenced by whether the type of channel that will carry it is broadcast, cable, cell, or online.

Sources of Programs

Three basic program sources exist for television and radio: network programs, syndicated programs, and local programs. These compartments, however, are by no means watertight. Produced shows sometimes develop into hybrid blends of local production and syndication. Network entertainment programs "go into syndication" to cable channels or broadcast stations after their initial plays on the national network. Networks produce short segments of programs suited to the small screens of online and cell reception. Network suppliers sometimes produce movies made especially for television (made-for-TV movies). Pay-television suppliers may produce made-for-pay movies and entertainment specials by taping live performances on location at concerts, at nightclubs, and in theaters. Live sports events crop up on both cable and broadcast network services and also as syndicated local/regional productions.

Network Programs

The national, full-service, interconnected network is broadcasting's way of pooling resources to generate information programming. Newspapers shared news and features by means of news agencies and syndicates long before broadcasting began, but broadcasting introduced the elements of instantaneous national distribution and simultaneous programming. The seven national commercial television networks (ABC, CBS, CW, FOX, ION, MNTV, and NBC), the public noncommercial network (PBS), and the three large Spanish-language networks (Telemundo-TEL, TeleFutura-TFA, and Univision-UNI) supply broadcast programs by making or purchasing them. About 250 or so cable program networks deliver the bulk of satellite and cable systems' content. The internet is more varied, drawing on both conventional television and radio content as well as on the commercial and amateur sources in vidcasts, podcasts, blogs, vlogs, and so on.

Aside from news and news-related publicaffairs materials, the broadcast networks buy most of their programs from studios (all but one of which are owned by the parent corporation of one of the broadcast networks) and occasionally from the very few remaining independent production firms. The tortuous route from program idea to finished, on-the-air network series is described in Chapters 4 and 5. Each year, network programmers sift through thousands of initial proposals, shepherding them through successive levels of screening, ending up in the fall with a couple of handfuls of new programs for each network's new schedule. Outside authors write the scripts, and the networks' production houses do the rest of the creative work.

Cable networks differ in major respects from broadcast television networks. In technical delivery, they are similar: in both cases a central head-quarters (the network) assembles programs and distributes them nationwide, using orbiting satellites to reach affiliated stations (CNN Headline News, for example, goes straight to some stations), thousands of cable systems, or millions of individual homes via DBS. But the financial and working relationships between broadcasting

affiliates and their networks and between cable affiliates and their networks differ fundamentally. In addition to retransmitting broadcast stations, local cable systems supply hundreds of channels of satellite-distributed programming and must deal with hundreds of networks. The traditionally symbiotic relationship between each broadcast network and its 200 or so affiliates does not exist in the cable field. Most programmers who work for cable networks also have far less input into the creative aspects of programming than do their broadcast counterparts.

The great bulk of cable network programming comes from the same sources as broadcast programming—distributors of feature films and syndicated programs—and, indeed, much of cable content has been old network programming, although this is rapidly changing as cable networks spend more for recent off-network hits and increase their own production enterprises. At the same time, the multiplication of digital splinter channels (called virtual channels) has greatly increased the difficulty of the programmer's task of attracting a large audience for any one channel.

Network programmers for public broadcasting face still another situation. Originally designed as an alternative to the commercial system, Public Broadcasting Service (PBS) programming comes ready-made from the larger member stations specializing in production for the network, from small independent producers, and from foreign sources, notably the British Broadcasting Corporation (BBC), which now has its own satellite channel. The programming is selected, scheduled, and distributed by PBS, but no programs are produced by the network itself (although PBS now has its own satellite channels that compete with its affiliates; see Chapter 7). Foreign sources are especially useful because they can supply more elaborate productions than PBS can generally afford to commission domestically, costing PBS about one-tenth of what a similar program would if produced in the United States. Coproduction, sharing production costs by broadcasting organizations in different countries, accounts for an increasingly large proportion of national noncommercial programming and is being widely copied by the commercial studios and producers (see Chapters 3 and 7).

The Spanish-language networks draw much of their serial programming from Mexico's Televisa, a producer of movies and telenovelas (popular soap-opera-like serials with a definite ending after some months and usually with a moral or educational point). Univision, the fifth-largest television network in the country, also produces several long-running programs, including the blockbuster *Sabado Gigante*. Telemundo, TeleFutura, and Univision also produce newscasts and carry live and taped sports, especially soccer and tennis matches originating outside the United States.

The traditional radio networks once offered by ABC, CBS, and NBC no longer qualify as full-service networks. Those that have not been sold now resemble syndicators, supplying features and program inserts such as newscasts (see Chapters 11 and 12). Conversely, some radio program syndicators supply stations via satellite with complete schedules of ready-to-air music in various established formats, much like the TV networks supply schedules of programs, except that the stations now pay the radio networks for the content. Formerly, the radio networks paid the stations to air the commercials (called compensation), but that system is disintegrating.

Syndicated Programs

Local broadcast programmers come into their own when they select syndicated programs for their individual stations. They draw upon the following sources:

• Off-network series. Programs that have reverted to their copyright owners after the network that first aired them has used up its contractual number of plays (increasingly, the networks demand a share of ownership rights in many of their shows). These programs used to go directly to stations, but nowadays such cable networks as TNT, USA, and A&E gobble up many of the best off-network dramas while TBS and the newer broadcast networks—ION and MNTV—take many of the popular sitcoms to rerun.

- First-run syndicated series and specials. Programs packaged independently by producers and marketed directly to individual stations rather than being first seen as network shows (for example, *Entertainment Tonight*, *Oprah*, and *Wheel of Fortune*).
- Feature films. Movies made originally for theatrical exhibition, although this category has diminished because so many movies go to such cable networks as HBO, Showtime, and pay HD channels.

Of all the program types, the feature film is the most in demand because of its popularity on so many different delivery systems.

The term window-borrowed from the world of space flight where it refers to the limited timespace openings when conditions are just right for launching rockets—has been applied to the release sequence by which feature films reach their various markets. First, of course, comes the traditional window of theatrical release-films are either simultaneously released in several thousand theaters throughout the country or put out in stages of "limited release." Next in the usual order of priority come releases through the windows of DVD and pay-per-view cable, then regular pay cable, then broadcast networks, and finally general broadcast and cable syndication. Prices for licenses (and rentals) decrease at each stage of release as products age and lose their timeliness. However, studios sporadically experiment with different release cycles for specialized movies to see what makes more profit.

Local Production

Local programs are those shows produced "inhouse," usually by professionals but sometimes homemade by amateurs who find distribution on public access cable and online channels (see Chapters 8 and 10). As Chapters 6 and 12 on station programming will show, local newscasts play an important role in television and radio station strategies (but even newscasts, though locally produced, often contain a great deal of syndicated material as inserts). Aside from news, however,

locally produced material plays only a minor role as a program source. It is true that all-news, all-talk, and all-sports radio stations depend almost entirely on local production, but those formats cost so much to run and have such a specialized appeal that they remain relatively few in number and exist only in the larger markets. Stations simply find syndicated material cheaper to obtain and easier to sell to advertisers. Localism is more worshipped than practiced.

The Uniqueness of Scheduling

Of all the programmer's basic skills, perhaps scheduling comes closest to qualifying as a unique radio and television specialty. Scheduling a station, cable system, or network is a singularly difficult process, and nothing comparable occurs online as yet. Even with hundreds of competing channels, the availability of the web, and the proliferation of remote controls and digital video recorders, the audience for one show normally influences adjacent programs. The influence can be to build up adjacent program audiences or to drag them down.

Effective scheduling requires understanding one's own and one's competitors' coverage patterns, market, and audience demographics. Most broadcast stations in a market compete directly for viewers and advertising dollars, but some viewers are more desirable than others, and programmers at stations without a network affiliation or with only a poor affiliation are disadvantaged compared with those programmers who deliver the most popular network programs.

Cable system programmers have different problems. They have to weigh the claims of competing services for specific channel locations. Broadcast television stations, for example, would much prefer channels on cable systems that invoke their overthe-air channel numbers (a Channel 2 wants to be 2 on basic cable and 102 or 202 on digital cable, there being no necessary relationship between a station's own assigned broadcast number and the number it occupies on cable). Being repositioned (moved to a higher analog channel number) used to be a very contentious issue between stations PART ONE

and cable until the FCC mandated that broadcasters get the same digital and analog cable channel numbers that they used for their over-the-air channels, if requested—although those very high up usually prefer to come down.

This FCC decision, combined with widespread adoption of digital cable, has pretty much made channel positions a nonissue. When a station or cable network multiplexes, one channel number is the primary, and the others get decimal places, as in 2, 2.1, 2.2, and so on. Nonetheless, if positions are vacant, cable operators prefer to give the choicest positions—the lowest in a group because they are easiest to remember—to the most popular (or most lucrative) services, whether they are broadcast or cable-only. Cable operators especially favor the cable channels owned all or in part by their parent corporations.

The Need for Promotion

The broadcast and cable networks forgo billions of dollars in advertising revenue in order to promote their programs on their own air, interrupting programs with clusters of promos and cluttering the bottom of the screen with animated program reminders. Such promotion is essential for interesting viewers in new programs and new episodes of continuing programs, and for retaining audiences by making them feel satisfied with the program array. In addition, millions are spent on paid program advertising appearing in guides and other media, and on marketing endeavors in cooperation with such retailers as Kmart or McDonald's. Stations also cosponsor concerts and sporting events to attract audiences to television and radio programs.

At the same time, having a presence in the online world has become a necessity for all 10 broadcast networks. First PBS and then the five biggest commercial networks—ABC, CBS, FOX, NBC, and UNI—developed huge multimedia sites on the World Wide Web, and the major studios and most cable networks followed suit. Television and radio enthusiasts can now point-and-click their way through myriad home pages designed by the networks, their affiliates, the studios, the major cable channels, fan clubs,

and even the program stars themselves. Unlike most blog and podcast sites, these are sophisticated promotional sites created to capture attention, generate buzz, and feed the fans' yearning for closer contact with programs and their stars. Commercial interests sponsor most of these sites. Not to be outdone, this textbook itself has a section within www.wadsworth.com.

Traditionally, programming and promotion generally were considered separate spheres at networks, stations, and services, and the process of promotion is still often classified as "marketing" in the cable industry. Nonetheless, the greatest of network programmers are as much known for the brilliance of their promotional strategies as for their program scheduling. NBC's Sylvester Weaver, for example, came up with the "spectacular," a kind of one-time-only program that would be virtually self-promoting because of its high visibility and uniqueness.

Nonetheless, a great deal of airtime had to be devoted to telling the audience that a spectacular (nowadays called a special) was coming soon and that it was worth watching. Fred Silverman, another giant in network programming history, understood that how programs were promoted was as important as how they were scheduled. The allocation of immensely valuable airtime to program promotion each year on every network and station is clear evidence that the industry is convinced of the truism that the best program without promotion has no audience. If the audience doesn't know what day, what time, and what channel a program is on, the old viewers who miss the show will have a profound impact on the ratings: if new viewers don't see many exciting promos that convince them to watch a network's shows, their absence will certainly also have a profound impact on ratings.

It is crucial to understand that just a ratings point or two stands between the number one and number three network in most years (and maybe just a point more to number four) and that promotion on and off the air is vital to maintaining and increasing standing in that elite group. The same situation occurs among cable networks and at the local level. Cable networks vie to be among the

top 10 (or top 25) but differ by only fractions of a ratings point. The slight advantage given by effective promotion can be the difference between making that top list and falling to some lower grouping, and advertisers typically buy by grouping. Local stations often vary only minutely in popularity, too, and a great deal of promotion of a newscast or radio format can boost one station above its competitors.

Promotion of online programs takes a different form nowadays. It largely consists of gaining favored placement in Google lists and other created listings of favorites or types of sites. Virtually all top placement is purchased on Google, at least under generic terms. This revenue contributes to a large part of a search engine's income. Placement is no longer luck of the draw or someone's idiosyncratic whim except perhaps on individuals' sites.

Networks, stations, systems, and sites are also concerned with their overall images. Increasingly, fostering positive images around the world has value in building audiences for exported programs and associated products (this is called **branding**). Google and Microsoft have world recognition as brand names at least as widely known as those of Disney, CBS, FOX, NBC, and the biggest movie studios, and they allot enormous budgets to increasing and maintaining those brand names. *Promotion, then, is one path through the labyrinth leading to high visibility, high ratings, and thus high revenue.*

The Elements of Programming

The various strategies for selecting, scheduling, promoting, and evaluating programs are derived from a set of assumptions about audience behavior. These broad assumptions, which are here organized into five groups, become the basis for strategies capitalizing on them, even in the changing media environment:

- Compatibility
- Habit formation

- Control of audience flow
- Conservation of program resources
- Breadth of appeal

Compatibility

Scheduling strategies take advantage of the fact that programs can be timed to coincide with what people do throughout the daily cycle of their lives. The continuously unfolding nature of radio and television allows programmers to schedule different kinds of program material, or similar program materials in different ways, into various dayparts. Programmers strive to make their programming compatible with the day's round of what most people do-getting up in the morning and preparing for the day; driving to work; doing the morning household chores; breaking for lunch; enjoying an afternoon lull: engaging with children after they return from school; accelerating the tempo of home activities as the day draws to a close; relaxing during early prime time; and indulging in the more exclusively adult interests of later prime time, the late fringe hours, and the small hours of the morning. And, of course, compatibility calls for adapting to the changed activity schedules of Saturdays and Sundays. Programmers speak of these strategies in terms of dayparting-scheduling different types of programs to match parts of the day known by such terms as early fringe, prime time, and in the case of radio, drivetime.

Cable television's approach to compatibility has historically differed from broadcasting's approach. Because each broadcast station or network has traditionally had only a single channel at its disposal, broadcast programmers must plan compatibility strategies for what they judge to be the "typical" lifestyles of their audiences. Most cable networks target more narrowly. Like the internet, an entire cable or satellite system accommodates so many channels that it can devote some to every type of audience at all hours, ignoring dayparts. They can cater to the night-shift worker with sports at 6 A.M., to the single-person household with movies at 6 P.M., to the

teenager with round-the-clock videos-by using a different channel to serve each interest. On average, by the end of this decade, cable and satellite subscribers will receive more than 250 channels on their services, most of them digital, and have many in high definition.

As the graph in 1.6 shows, the daily share of viewing of the Big Four broadcast television networks (ABC, CBS, FOX, NBC) fell below the combined viewing of cable channels several years ago. Broadcasters' economics-and thus clout-have diminished dramatically because in such large metropolitan areas as New York City cable/satellite penetration has reached 91 percent.

Even so, many cable channels effectively shut down their program services during low-viewing dayparts (for example, 3 to 7 A.M.) and let infomercials reign. These channels find it hard to resist

the guaranteed advertising income from programlength commercials at a time of day when the audience size is both too small to attract mainstream advertisers and not large enough to generate viewer complaints that the usual shows are missing. By contrast, internet use climbs when television is weakest.

Habit Formation

Compatibility strategies acquire even greater power because audience members form habits of listening and watching. Scheduling programs for strict predictability (along with promotional efforts to make people aware of both the service as a whole and of individual programs) establishes tuning habits that eventually become automatic. Indeed, some people will go to extraordinary lengths to avoid missing

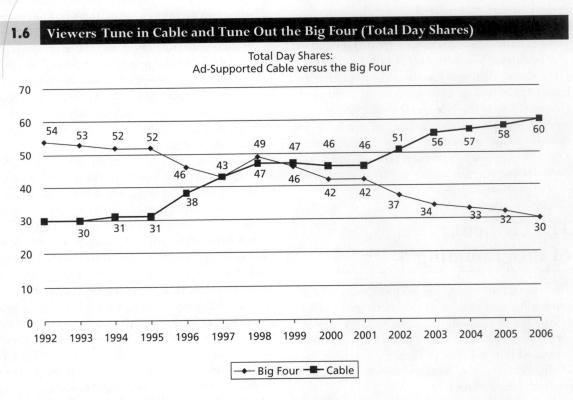

Source: 1992–1999 data from National Cable Television Association 2000-2006 data from Cabletelevision Advertising Bureau

the next episode in a favorite series. Programmers discovered this principle in the early days of radio when the *Amos 'n' Andy* habit became so strong that movie theaters in the 1930s shut down their pictures temporarily and hooked radios into their sound systems at 7:15 P.M. when *Amos 'n' Andy* came on. At about that time the fanatic loyalty of soap opera fans to their favorite series also became apparent, a loyalty still cultivated by today's televised serial dramas.

Ideally, habit formation calls for stripping programs-scheduling them Monday through Friday at the same time each day, just as evening news is stripped daily on network-affiliated stations. To strip original prime-time programs, however, would require building up a backlog of these expensive shows, which would tie up far too much capital. Moreover, networks want maximum latitude for strategic maneuvers in the all-important prime-time schedule. If a broadcast network stripped its three prime-time hours with the same six half-hour shows each night, it would be left with only six pawns to move around in the scheduling chess game instead of the two dozen or so pawns that the weekly scheduling of programs of varying lengths makes possible.

When weekly prime-time network shows go into syndication, however, stations and cable networks schedule them daily in strips (one episode daily at the same time), a strategy requiring a large number of episodes. A prime-time series has to have been on a network for four years (with the prospect of one more year) to accumulate enough episodes for a year's stripping in syndication (including a substantial number of reruns). Because few weekly shows survive five years of prime-time competition, the industry periodically faces a nagging shortage of quality off-network programs suitable for syndication. Necessarily, cable networks also pick up shows that had short runs, but for lower licensing prices.

Cable has adopted different patterns. Especially when just starting out, networks such as FX and Oxygen stripped sitcoms not only day to day but across most of each evening until their revenues permitted more variety in programs. Networks such as A&E, USA, and TNT also strip expensive

hit dramas that are freshly off-network in early evenings and prime time.

No one knows whether audiences find themselves more comfortable with the structured, compatible, predictable scheduling of traditional television than with a multitude of digital programming choices. Researchers investigating channel repertoire have often observed that, when scores of options are available to listeners and viewers, most tune in to only a handful of the possible sources. For example, surveys by Nielsen Media Research of homes with access to 200 or more television channels have consistently found that viewers watched only about 15 of them for more than one hour per week. Which 15 varies by household, of course. The increased variety of program choices made possible by digital cable/satellite television and DVRs seems to have weakened viewing habits. Only about half of viewers (mostly women) choose in advance the programs they watch. Furthermore, active channel switching occurs more often in cable homes than in broadcast-only homes.

Even so, some people may sometimes prefer to have only a limited number of choices. They find it confusing and wearying to sift through scores of options before settling on a program. Broadcast scheduling, as a consequence of compatibility strategies and a tendency toward habit formation, preselects a varied sequence of listening and viewing experiences skillfully adapted to the desires and needs of a target audience. People can then choose an entire service—an overall entertainment pattern (or "sound" in the case of radio)—rather than individual programs.

New technologies like DVRs are not likely to eliminate the average viewer's need to form patterns of behavior (see 1.7). Most people are creatures of habit, and television viewing is an activity that begs for routines. Indeed, DVRs may actually enhance habit formation because they make it easier to catch all the episodes of a favorite show, thus strengthening a habit. The grazing function popularized by remote controls is likely to be a casualty of DVR habits. Viewers can watch live TV and fill in the gaps when "nothing good is on" with favorite shows saved onto a convenient menu of choices.

1.7 The DVR Factor

igital video recorders (DVRs) are changing viewing habits. Those who own them grow very fond of (and dependent upon) them. Those who have original or updated TiVos are often fiercely loyal to them—more so than are the owners of unbranded models from cable and satellite operators. Those who do not own them cannot understand all the fuss. Some forecasters predict that DVRs will be in half of television homes by about 2010.

To the newcomer, DVRs appear to be glorified VCRs or recording DVDs, with video stored on a random-access hard drive. But DVRs can pause and instantly replay live TV, allowing more viewer control. DVRs play back while recording, allowing the viewer to time-shift more easily than ever before. The internal menu systems driven by daily downloaded program information make recording easy. They beat VCRs hands down: no codes, no stop-start times, no clocks to set; just choose a program from the menu of upcoming options (or during a live promo) and hit record. Record a show once or every time it is shown, regardless of what time or day. There is no need to know what night a show is on because the DVR does all the thinking. It even can be told to ignore any show reruns during daily or weekly recordings. Viewers simply visit their DVR program menu and find what they want, when they want it. Dayparts are irrelevant. And commercials are meant to be skipped.

Even more important to conventional viewing patterns is that DVRs usually come alongside enormous packages of digital services. Because these digital services commonly have informational bands that appear for a few seconds across the bottom of screens, they do two things: Besides distracting the viewer from immediate involvement in the upcoming program, they certainly make using the up/down channel changing buttons (old-style surfing) quite unappealing. Digital cable rapidly becomes menu-driven television, not channel-driven.

Satellite services already come bundled with DVRs to make pay-per-view possible, and cable operators usually supply DVRs to digital and HD subscribers for a modest fee, with the goal of encouraging pay-per-view sales. Indeed, manufacturers of television receivers promise to build the DVR functions into the sets themselves. Stand-alone models like TiVo may be replaced by devices bundled with cable or satellite service because many viewers don't want an additional box connected to their TV sets. In 2007, Comcast began offering DVRs with TiVo-patented features, a big step above most DVRs. Other multichannel operators may follow Comcast's lead to capture the unique capabilities and branding advantages of the TiVo model.

So what happens to programming strategies? Are the traditional practices of hammocking, tentpoling, bridging, and leading-in (see Chapter 4) relevant in a DVR-enabled home? Some say not, but some say not so fast. Will the added expense keep most people away or will bundling make the price insignificant? Guide channels are not universally popular. Some viewers may remain content with the way things were before DVRs. Stay tuned in the coming years and find out.

Control of Audience Flow

The assumption that audiences welcome, or at least tolerate, preselection of their programs most of the time accounts for strategies arising from the notion of audience flow. Even in a multichannel environment with dozens of choices, the next program in a sequence can capture the attention of the viewers of the previous program. At scheduling breaks, when one program comes to an end and another begins, programmers visualize the audience as flowing

from one program to the next in any of three possible directions: They try to maximize the number of audience members that *flow through* to the next program on their own channel and the number that *flow in* from rival channels or home video, at the same time minimizing the number that *flow away* to competing channels or activities.

Many scheduling practices hinge on this concept. Audience flow considerations have traditionally dominated the strategies of the commercial

1.8 Television Versus Books, Newspapers, and Movies

on rolling audience flow becomes problematic because listeners and viewers have freedom of choice. Unlike a consumer faced with the limited decision of whether to buy a book, subscribe to a newspaper, or attend a movie. electronic media consumers can choose instantaneously and repeatedly by switching back and forth among programs at will. Hence, programmers cannot count on even the slight self-restraint that keeps a book buyer reading a book or a ticket buyer watching a movie so as not to waste the immediate investment. And, obviously, the polite social restraint that keeps a bored ecture audience seated does not inhibit radio and television audiences. Programmers have the job of holding the attention of a very tenuously committed audience. Its members take flight at the smallest provocation. Boredom or unintelligibility act like a sudden shot into a flock of birds.

broadcast and cable networks and affiliates (see 1.8). Blocking several similar comedies in adjacent time slots, for example, takes advantage of audience flow. By contrast, counterprogramming (scheduling programs with differing appeals against each other) is crucial to the strategies of small-audience channels that seek to direct the flow away from competing channels to themselves.

Fortunately for programmers, many audience members remain afflicted by tuning inertia. Although hundreds of options often exist in a cable or satellite environment, people tend to leave the channel selector alone unless stimulated into action by some forceful reason for change. Many times, viewers are engaged in simultaneous activities that preclude a focused attention to what programs might be available on other channels. Moreover, programmers believe that children can be used as a kind of stalking horse: adults will tend to leave the set tuned to whatever channel the children chose for an earlier program. Chapter 4

describes the common strategies for taking advantage of tuning inertia, such as leading off with strength, using hit programs as tentpoles, hammocking weak shows, bridging the usual program starts, and creating seamless transitions between programs.

The greater number of program options provided by cable/satellite services and the convenience of remote controls and DVRs have certainly lessened—but not eliminated—the effect of tuning inertia. Researchers recognize several ways the audience uses the remote control keypad to manipulate programming: grazing, hunting up and down the channels until one's attention is captured; flipping, changing back and forth between two channels; zapping, changing the channel or stopping a taping to avoid a commercial interruption; and zipping, fast-forwarding a recording to avoid commercials or to reach a more interesting point. Moreover, the home playback unit has undermined Saturday evening ratings for both broadcast and cable programmers: Huge numbers of viewers regularly rent DVDs or videocassettes on Saturday nights (especially as rent-by-mail services like Netflix become popular with viewers who want to avoid trips to video stores and costly late fees). Home video recording can defeat the idea of tuning entirely. Thus, tuning inertia continues as only a modest factor to consider in broadcast programming strategies.

Program flow is nearly irrelevant for some formats such as all-news radio, all-weather cable channels, and specialized subscription channels, which actually invite audience flow in and out. Some formats aim not at keeping audiences continuously tuned in but at getting them to constantly return. As a widely used all-news radio slogan goes, "Give us 22 minutes, and we'll give you the world." One cable news service used to promote itself in variations of "All the news in 30 minutes." The Weather Channel doesn't expect even weather buffs to watch for hours, just to return periodically.

In any case, the overall strategic lesson taught by the freedom-of-choice factor is that programs must always please, entertain, and be easily understood. Much elitist criticism of program quality arises simply because of the democratic nature of

the medium. Critics point out that programs must descend to the lowest common denominator of the audience they strive to attract. This fact need not mean the absence of program quality. After all, some programs aim at elite audiences among whom the lowest common denominator can be very high indeed.

Conservation of Program Resources

Radio and television notoriously burn up program materials faster than other media. This is an inevitable consequence of the continuousness attribute. That fact makes program conservation an essential strategy (see 1.9). Cable networks actively compete for space on cable/satellite systems, suggesting an excess of programs. In fact, the reverse holds true. A high percentage of the programming on cable networks consists of repeats of the same items. The broadcast networks also repeat many programs in the form of reruns, and have now moved into

1.9 Reruns

nyone who doubts the difficulty of appeal-Ling to mass audiences need only consider the experience of the older media. Of 25,000 to 28,000 new books printed in any one year, only less than 1 percent sell 100,000 or more copies; of 12,000 or so records copyrighted, fewer than 200 music recordings go gold; of 200 feature film releases, only 5 percent gross the amount of money reckoned as the minimum for breaking even. And yet audiences for these media are small compared with the nightly prime-time television audience.

Sometimes audience demands and conservation happily coincide, as when the appetite for a new hit song demands endless replays and innumerable arrangements. Eventually, however, obsolescence sets in, and the song becomes old hat. Radio and television are perhaps the most obvious examples of our throwaway society. Even the most massively popular and brilliantly successful program series eventually loses its freshness and goes into the limbo of the umpteenth rerun circuit.

reusing their shows—repurposing—on their other owned broadcast and cable networks and on the internet, as well as reformatting them for cells and small-screen media. Cable has stimulated production of new programs and program types, but on the whole, cable heightens program scarcity rather than alleviating it, making the parsimonious use of program resources in electronic media all the more essential.

Frugality must be practiced at every level and in every aspect of programming. Consider how often audiences see or hear "the best of soand-so," a compilation of bits and pieces from previous programs; flashback sequences within programs (especially in soap operas); news actualities broken into many segments and parceled out over a period of several hours or days; the annual return of past years' special-occasion programs; sports shows patched together out of stock footage; the weather report broken down into separate little packets labeled marine forecasts, shuttle-city weather, long-term forecast, weather update, aviation weather, and so on.

The enormous increase in demand for program materials created by the growth of cable television and the internet would be impossible to satisfy were it not that the multichannel media lend themselves to repeating programs much more liberally than does single-channel broadcasting. A pay-cable channel operates full time by scheduling fewer than 50 or so new programs a month-mostly movies-and runs each film four to six times. Furthermore, movies first scheduled one month turn up again in the following months in still more reruns, which pay-cable programmers euphemistically call encores. Even the basic cable channels rotate the showing of their movies, based on the idea that the audience at 8 P.M. will be different from the audience at 1 A.M. For example, A&E double-runs (plays the same episode of) many of its prime-time series, and the internet makes available archives of thousands (even millions) of old programs-all of which makes frugality in sharing and repeating programs even more crucial.

Beginning in the mid-2000s, several of the broadcast television networks began offering regularly scheduled repeats as part of their prime-time line-ups (see Chapter 4). Borrowing a strategy from cable, the broadcast networks recognized that viewers (who now spend more prime-time hours with cable programs than with broadcast shows) were accustomed to having multiple opportunities to see first-run shows within the same week. "This is inevitable," said Preston Beckman, the executive vice president of FOX Entertainment. "No network can program 22 hours any more, or in our case 15 hours." Not surprisingly, the networks chose low-viewing nights for the repeats, conserving the cost of filler programming.

Programmers can also make creative use of lowquality shows. The Sci Fi Channel features packages of old monster movies; the Horror Channel reruns old scary movies; and SOAPnet replays old daytime soap operas for new generations of fans, just as Nickelodeon reruns old cartoons over and over. Another reuse strategy is evident in programs such as Soap Opera Digest.

A major aspect of the programmer's job consists of devising ingenious ways to get the maximum mileage out of each program item. One strategy is to develop formats that require as little new material as possible for the next episode or program in the series; another is to invent clever excuses for repeating old programs over and over; a third, the newest, is to adopt multiplatform strategies for each program as it is conceived. For the best programs, viewers seek more and more experience with each show, its characters, its plot twists, even merchandise. Programmers respond to the viewers' desire for more interactions by using extensions that may include sites for blogs, podcasts, and other feedback. Nowadays, extensions spin off all hit programs (see 1.10).

Going further than web extensions, programmers invent versions of a show for broadcast television, for pay-per-view, for various internet locations, for cell phone distribution, and so on, although such multiplatform approaches are usually only implemented when a show actually becomes a hit. The losers—without dedicated cult followings—just fade away. The point is that any beginner can design a winning schedule for a single week on a single channel; a professional has to plan simultaneously for all media as well as for

1.10 Ripple Effect TV[©]

ruly successful TV programs are so compelling that they draw an audience that is not content to merely watch. The audience is hungry to go beyond the passive and to commune with others in chat rooms and virtual environments—to post videos. download additional content, buy the T-shirt, and so on. If a program creates a deep enough sense of involvement (which is the currency of all interaction), then a creative extension backed up by a rewarding user experience will respond to that desire for further interaction with the program. The programming for which program extensions work best can be thought of as Ripple Effect TV®. These are the programs that people talk about—the ones that show up most often in the blogosphere. With Ripple Effect TV®, the first broadcast is like a stone dropping in water. The biggest splash occurs at the point of impact, but thereafter the ring of concentric circles fans out to ripple across a range of platforms, bringing with it further opportunities to profitably harness the audience's sense of nvolvement—to allow that audience to develop itself into a community and to satisfy its desires—before coming back (i.e., to the original TV show's next episcde) for more.

SOURCE: Michael Bloxham, Ph.D. Center for Media Design Ball State University

the attrition that inevitably sets in as weeks stretch into the indefinite future.

Breadth of Appeal

Stations and cable systems recoup their high capital investment and operating costs only by appealing to a wide range of audience interests. This statement might seem self-evident, yet initially some public broadcasters made a virtue out of ignoring "the numbers game," leaving the race for ratings to commercial broadcasters. But as Chapter 7 (national public television programming) explains, this fundamentally unrealistic viewpoint has given way to the strategy of aiming for a high cumulative number of viewers rather

than for high ratings for each individual program. This strategy coincides with that of cable/satellite operators, whose many channels enable it to program to small audiences on some channels, counting on the cumulative reach of all its channels to bring in sufficient subscriptions to make a profit. The internet inherently has this broad reach, although not the big profits—as yet.

The national television broadcasting networks continue to "cast" their programs across the land from coast to coast with the aim of filling the entire landscape. Of course, no network expects to capture all the available viewers. A top-rated primetime program draws between 7 and 10 percent of the available audience, although extraordinary programs get nearly double that proportion of viewers.

Nevertheless, by any standard, audiences for prime-time broadcast television networks are enormous. Although the audience shares of the Big Four broadcast networks had dropped from 90 percent of viewers to around 40 percent by 2005, a single program can still draw an audience so large it could fill a Broadway theater every night for a century. It is important to understand that a lowly rating of 10 still means more than 10 million households are watching a program, and since households average 2.6 people, that means that 26 million people watched a not-verypopular show. Such size can be achieved only by cutting across demographic lines and appealing to many different social groups. Network television can surmount differences of age, sex, education, and lifestyle that would ordinarily segregate people into many separate subaudiences.

A Model of Programming

As pointed out earlier, the process of actually doing the job of programming divides into four major parts. First, programmers must *select* programs to go into a program lineup. Then they must *schedule* them in an arrangement that maximizes the likelihood of their being viewed by the desired audience. Next, they must *promote* them to attract attention to new shows and new

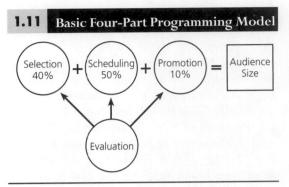

Art: Milt Hamburger

episodes of series and tell viewers where to find the shows. Finally, they must continually evaluate the outcome of their decisions. These complex decision-making processes of selection, scheduling, and promotion, modified by feedback from evaluation, ultimately determine the size and composition of the audience.

The model in 1.11 shows each of the major components exerting a proportional influence on the resulting audience. The model shows that the selection component contributes roughly 40 percent to ratings; the scheduling component contributes about 50 percent; and the promotion component contributes about 10 percent. These proportions, however, vary widely for particular media, for particular programs, for different times of day, and even at different times in history. Selection was probably much more important and promotion much less important in the 1950s when CBS and NBC dominated television viewing. Increasing competition in television came first from ABC and later from FOX, then from cable, then from even more broadcast networks (UPN and the WB which merged into CW). Then PAX morphed into ION, UNI grew up, and FOX invented MNTV). Now the internet and the cell phone compete directly, altering the relative importance of each component in the television programming process. Competition has boosted the importance of promotion and diminished the salience of scheduling, especially for new programs and new services.

In contrast to television, selection and scheduling are largely formulaic processes for popular

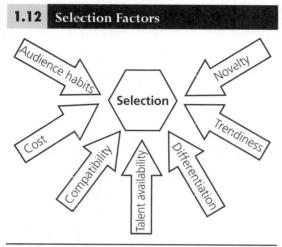

Art: Milt Hampurger

all-music radio stations, whereas promotion is becoming a more significant component in the determination of audience size and composition. On-air contests and games have a great deal to do with station popularity. For all-news radio and television, scheduling surfaces as the arena of competition and ongoing dynamism. For emerging internet video channels, selection remains the key component.

If the model in 1.11 appears mechanistic, though, that is quite misleading. Even after a half century of concentrated attention, programming remains as much an art as a science. And nowhere is that more evident than in the enormous wealth of online programming. As the subsequent chapters will reveal, at all stages the processes and outcomes of programming are affected by the sparkle of insight, imagination, and inspiration.

Selection

The figure shown in 1.12 illustrates some of the many components affecting the selection stage for broadcast network television that are spelled out in the chapters about prime-time and non-prime-time programming (Chapters 4 and 5). These components include the scarcity of top-notch writers, the high financial risk of trying markedly different program ideas, and the escalating costs per episode for the onscreen and offscreen talent. For cable networks,

the same factors are important for choosing programs, as is the need, usually, to target an underserved audience group. As significant as individual programs are, even more important is the overall composite that creates a "format" for the cable or radio channel or internet site. Additional factors that affect the selection of programs for cable networks include the need for differentiation from competing channels, costs relative to other program types, and the ability to capture space on local cable or satellite systems to reach an audience. On the internet, imaginative designs and antiauthority appeals to teen and young adults are key elements.

In radio and online music programming, enormous efforts go into choosing the songs that appeal to a particular demographic and psychographic group. Whether they are called music directors or programmers, the crucial task of the people making these efforts is to find and keep current the songs that the audience will tune in to hear.

Scheduling

It has been long understood that the size of the prime-time television audience is affected by the amount and type of competing programs, the amount of viewing inherited from preceding programs, and the compatibility between adjacent programs (see 1.13). The most studied of these elements, the amount of inherited viewing

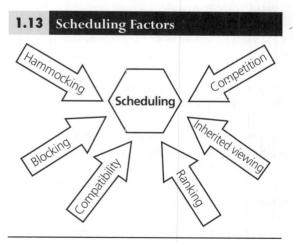

Art: Milt Hamburger

between adjacent programs, has been consistently shown to hover around 50 percent in prime time. This means that half of the viewers watching Program B on a channel had already watched Program A on that channel. Program B's other viewers come from other channels or are newly tuned in for the evening. Inheritance, however, is known to be much lower between incompatible programs and between nonadjacent programs. Few of the viewers of a romantic drama would choose to stay tuned for a violent action movie, for example.

Moreover, inheritance is dramatically lower outside of prime time in daytime and late night. One big exception is between two adjacent soap operas, when inherited viewing usually goes up. By contrast, only 10 percent of television viewers are likely to flow from program to program in the morning daypart because of the other activities and obligations of their daily lives—going to work, for example.

In radio, careful attention to each nuance of song rotation and news story rotation leads to ongoing scheduling adjustments. Similar attention to detail is required of online music, television, and news programmers, but, as Chapter 10 explains, the focus up to now has been on the technology, and scheduling strategies have not yet developed. Most websites schedule by topic, genre, or alphabetical name. YouTube and its many imitators let viewers know which clips and shows are "most recent" or "most popular" so that users can go directly to that programming.

Ordering by title or recency also applies to sites that replay actual television shows (TV-4-PC.com, your-free-satellite.com, free-internet-tv.com, the-free-tv.com, and others). One can guess that the flow between elements on websites is probably overwhelmed by rapid movement in and out of sites, but research findings are scarce. Counts of hits reveal movements, and measures of time-spent-watching a show tell the presumed length of viewing (only presumed because computer users are often doing more than one thing simultaneously), but content on so many sites that might be called "programs" doesn't divide into tidy half-hour-long and hour-long parcels.

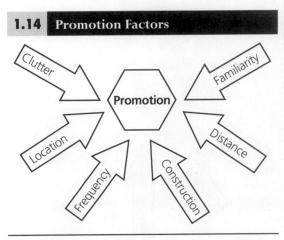

Art: Milt Hamburger

Promotion

The figure shown in 1.14 names some characteristics that impact the effectiveness of promotional spots on the air—such as the location of spots within a program, the position of those spots within breaks, the distance between the promotion and the promoted program (Next? Later tonight? Next week? Next month?), and the familiarity of the program to viewers or listeners. Such considerations as the physical environment of a message, the number of people reached, and the frequency of seeing or hearing the message also affect the efficacy of both on-air and print promotion. Program promotion is constantly manipulated in the struggle to gain and hold ratings.

Evaluation

Programmers must constantly appraise programs using ratings, hits, or other measures, interpreted by the honed instincts and experience of the programmer. Here, evaluation refers to the ongoing interpretation of quantitative information and qualitative judgments that results in revisions of show selections, changes in the scheduling of already selected programs, and modifications in their promotion. One important result of increased competition from cable and new broadcast networks, as well as from the internet, has been to drive the process of programming into

Tolerance levels Audience share Evaluation Rechnology Stock value

Art: Milt Hamburger

constant flux. At local stations and at national and global networks, a static program lineup tends to lose ground, while ongoing refinements help to maintain and even increase audience size.

In 1.15, evaluation has a wide range of constituents, some directly related to program audiences and others of larger social scope. For example, the success of the competing programs affects a programmer's interpretation of ratings. A show with low ratings scheduled against a megahit on another channel might well be considered reasonably successful, whereas the same show in a less challenging location would be expected to perform much better in the ratings. Consider, for example, the inherent difficulty of trying to target men viewers (on networks other than ESPN) on Monday nights during football season.

In addition, the programmers' specific assumptions about an audience's behavior and viewing or listening motivations affect how programs are selected, scheduled, and promoted. In one town, for example, workers start and end their jobs early, making afternoons a good time to program to them, whereas in another town, companies have varied schedules, lessening impact on the number of available afternoon viewers. Consider how different programming would be in a country where the

1.16 Television in Many Languages

ith a population of just 46 millian people, South Africa has only five national television channels and no regional channels. Of these five, the South African Broadcasting Corporation (SABC), similar to the BBC in Britain and the CBC in Canada, programs and distributes three channels nationwide. These channels have to serve a population that specks 11 different languages, and although much of the audience is bi- or multilingual, a large proportion coes not understand English.

Most of SABC's programs are nonetheless in English, including such American daytime and primetime shows as *Oprah*, *The District*, and *The Bola' and the Beautiful*. South African—made "soapies" and minidramas are also very popular. Within these shows, programmers mix languages and also use English subtitling to overcome the language problem. To serve educational and political needs, national and international news is broadcast in 7 of the 11 languages at various times and on different channels. As you might imagine, scheduling becomes an enormous challenge!

The two competing (non-SABC) channels in South Africa broadcast only in English, although one of them, e-tv, presently attracts the second-largest audience in the country. The other is a subscription (pay) movie channel. All five of South Africa's television channels carry advertisements.

SOURCE: Daan van Vuuren Consultant and Professor (retired Director of Audience Research, SABC, South Africa)

people speak not just two but many languages (see 1.16 for a description of television in South Africa today).

Programmers' understanding of the impact and use of the newest technologies is also vital. Remote-control and DVR use, for example, very much affects the processes of program selection and scheduling, and the growth of internet use for music listening has altered the strategies of traditional broadcast radio stations. Other factors that programmers must constantly scope out are the trends in popularity of particular program genres,

fads in star performers, styles in design and sound effects, and so on. The programmer's nearly unconscious awareness of what is going to become popular and his or her ability to capture it in programming decisions comprise much of what is meant by the creative side of programming.

Although some critics have decried the constant changes in television program lineups in the last decades, industry experience suggests that ongoing change is essential. Programmers tend to assume that audiences—especially the highly desirable young adults—are fickle, have short attention spans, become easily bored, follow fads, and find other forms of entertainment. It may be that many program ideas (and songs) wear out and become stale more rapidly than in the past, partly resulting from clones, reruns, repeat plays of music, or web chat about a series or song. It may be that performers peak for a shorter time than in the past as a result of constant media attention. It may also be that programmers perceive their careers to depend on identifying and eliminating tiny flaws in program lineups and formats. Whatever the reason, ongoing feedback from the evaluation process is a critical component of the programming process.

In sum, the basic model of selection, scheduling, promotion, and evaluation guides the approaches to specific programming situations that appear in subsequent chapters of this book. Collectively, the main model and its parts (1.11 to 1.15) illustrate the major components of the programming process that vary in the strategies for specific situations. These strategies, as well as the commonplace practices of programming—and the magical creative element—are the topic of this book.

External Influences on Programmers

Beyond learning the nuts-and-bolts programming framework, the novice programmer must deal with several external pressures that affect decision making. Five sets of influences are outlined in the following sections, but their order is somewhat arbitrary. Because the distribution system influences the kinds of programming chosen, technological issues are considered first. Without money (economic influences), of course, there can be no widespread development of new technologies. From economics flows some kind of structure, creating ownership influences. Whenever corporations and economies get in the way of individual rights, governments create regulatory influences. Finally, this chapter discusses what is morally right about the work of a programmer (ethical influences). For example, does the end (ratings success) justify the means (pandering to viewers)?

Technological Influences

The ultimate effect of digital television, digital audio, satellites, and high-definition television will be to lessen station dependence on traditional national networks for television (and radio) programming, both as sources of original material and of off-network syndicated material. HDTV is attracting top-notch production talent, but relatively little makes it to home television receivers. The broadcast networks find themselves less able to invest in high-cost programming because of the audience's shift to watching cable networks, playing back rented and purchased DVDs, and using the internet for long hours.

Contributing to this audience erosion is the increased difficulty of persuading affiliates to clear all requested time for network schedules. At one time the networks had considerable leverage over affiliates because the networks leased the coaxial-microwave relays that were the sole realtime program distribution system. Clearances of network programs were virtually automatic then. Now, however, satellite dishes, possessed by virtually all stations, give affiliates many alternate sources of instantaneous delivery at reasonable cost. All this encourages the emergence of new program providers. Nonnetwork group owners play a prominent role among them.

Another huge technological influence is the inevitable creeping convergence of computers, telephones, and television. There is little doubt that the various media have begun to come together in and out of the home. For example, the merging of personal communication assistants (Palm Pilots, BlackBerrys, Treos, and their clones, best known by the older name of PDAs) with cell phones and video and Wi-Fi internet access signaled the arrival of portable digital web/television. Surprisingly, convergence came to handheld devices before it fully arrived in living rooms!

Economic Influences

There is a saying in business: "Good, fast, cheap—choose two." The idea that quality, speed, and price cannot all occur at the same time is also true for programming. If most programming is like cheap fast food, then we should not be surprised that the quality is not high. The cost of extremely well-executed programming is high, if only because the cost of ordinary programming is so high. According to Gene Jankowski, former president of CBS:

Each network will review 2,000 program ideas a year. About 250 of these will be judged good enough to go on into the script form. About 30 or 40 of the scripts will move along into pilot production. About 10 pilots will make it into series form. Perhaps two or three series will survive a second season or longer. Each year, program development costs \$100 million. In other businesses it is known as Research and Development. In television it is called failure, or futility, or a wasteland.³

The high failure rate of television programs attracts constant attention in newspapers and magazines and in TV news and talk shows like *Entertainment Tonight*, but when television shows are compared to other sources of entertainment, such as movies, books, and Broadway plays, the TV failure rate does not seem so serious. The kinds of programs prevalent at any given time can be directly linked to economics. Some programs can be produced cheaply: soaps, game shows, talk shows, reality formats, and tabloid news. In each case, there is little expense involved because there is no need for top-name stars or sophisticated writing. These shows may not win many awards, but they create audience demand without incurring huge costs.

Economic pressures also include the cost of waiting for a show to "grow" into its time slot. Considerable lore has evolved about several programs that had early low ratings and might never have become successful but that were, for various reasons, allowed to stay on the networks' schedules despite their ratings. For example, The Dick Van Dyke Show in the early 1960s was not popular at first and would never have survived today's cutthroat marketplace. Some shows seem to need incubation time to "find an audience." Amazing Grace was such a series, almost getting cancelled several times before rising in the ratings in the fifth year. Some program producers feel that the audience never gets a chance to discover some shows because cancellations come too quickly.

Programmers have to be realistic when millions of dollars are at stake. For every show that really needs more time to build, dozens more were turkeys from the first day. Programmers can trust their hunches, or they can go with the ratings. Neither way is wrong or right, but very few programmers are fired for canceling a show too soon. If the program seems to be missing its audience (or vice versa), sometimes the wise decision is to try it on a different night or in a different time slot with a better lead-in and more promotion. If it fails there, it's time to admit defeat.

Finally, a situation can arise where a show is canceled even when it finishes among the top shows for the week. Anyone who remembers *The Single Guy* or *Jesse* will realize that some successful shows owe most of their success to the preceding program. If the lead-in show has a huge audience, even a precipitous falloff can leave a strong audience share for the weaker following program, but programmers want shows that maintain or build the audience shares from the preceding shows. Programs that "drop share" are canceled, regardless of seemingly high rankings.

Ownership Influences

To function in media programming, it is necessary to know who the major players are. The six media giants in 1.17 are the companies that have enormous interests throughout broadcasting, cable,

1.17 The Players

Time Warner

CNN • The CW** • CNN Headline

News • AOL • TNT • TBS • HBO •

Cinemax • Boomerang • The Cartoon

Network • Adult Swim • GameTap

Time Warner Cable Systems

New Line Cinema • Warner Bros.

Entertainment · CNN Pipeline ·

Time Inc. (publisher of magazines

and books)

Viacom

MTV Networks: MTV • MTV2 • VH1 • Nickelodeon • Nick at Nite • The N • Comedy Central · CMT · Spike TV · TV Land • Logo • iFilm • Noggin • Gametrailers.com · Dreamworks · X Fire • Atom Entertainment • Paramount Pictures • Paramount Home Entertainment • And more than 100 television networks around the world

Disney*

ABC • ESPN • Radio Disney • ESPN Radio · ABC News Radio · The Disney Channel • SOAPnet · Lifetime · ABC Family · E! Networks • Toon Disney • ABC Owned Stations • Miramax Films Pixar • Walt Disney Pictures • Touchstone Pictures • Buena Vista Television • Walt Disney Records • Disney Mobile (mDisney) • Disney Cruise Line • Disney Theme Parks · Resorts · Disney Consumer Products (toys, books, software)

CBS

CBS Television Network • The CW** • King World • CBS Television Stations
• Showtime • The Movie Channel • CSTV • CBS Radio • CBS Outdoor • CBS Interactive • CBS/Paramount Television • CBS Consumer Products
• Simon & Schuster

NBC Universal*

NBC • CNBC • MSNBC • BRAVO • USA • Telemundo • SciFi Channel Oxygen • Sleuth • Universal Production Studios • UHD • NBC Universal Television • Universal Pictures • Universal Theme Parks

News Corporation

FOX • FOX Sports • FOX News • DIRECTV • FX • SKY (BSkyB) • STAR (Asia, Australia) • SPEED • Fuel TV • FOX Television Stations • TV Guide • MyNetworkTV • Blue Sky Studios • 20th Century Fox • Fox Television Studios • Fox Interactive Media • Harper Collins Publishers • The Wall Street Journal and hundreds of newspapers and magazines worldwide

^{*} ABC, NBC Universal, and the Hearst Corporation jointly own A&E Television Networks (AETN), comprising A&E, The Biography Channel, The History Channel, The Military History Channel, and Crime & Investigation Channel.

^{**}The CW Television Network, formerly the WB and UPN, is jointly owned by CBS and Time Warner.

1.18 The Producers

he veteran movie and television producers were traditionally the Big Seven studios of the Hollywood entertainment motion picture industry until Sony bought MGM-UA in 2004 (reducing the seven to six). Currently the Big Six studios are Sony (Columbia TriStar, MGM), Walt Disney Studios (Buena Vista, Miramax, Touchstonel, Paramount, 20th Century Fox, NBC Universal, and Warner Brothers—though many would focus on the main four: Columbia TriStar, NBC Universal, 20th Century Fox, and Paramount.

In addition, the independent production nouses make Hollywood their base of operations. Among independent producers, Wolf Films, Carsey-Werner-Mandabach, WorldWide Pants, David E. Kelley, and Steven Bochco have been regular and prolific

producers for the networks and the syndication market. Independents are increasingly being acquired by large studios, as when New World bought Stephen Cannell Productions, Viacom purchased DreamWorks, and King World Productions went to CBS after its split-up from Viacom.

Consider the prime-time lineup in 2003–04.

According to the Coalition for Program Divers ty, that season CBS owned 98 percent of its programming.

FCX owned 80 percent, ABC owned over 70 percent, and NBC Universal owned nearly 60 percent of prime-time programming. The Coalition for Program Diversity unsuccessfully lobbied the Federal Communications Commission in 2003 to require that the broadcast networks buy 25 percent of their content from independent producers.

and the internet. The major commercial television studios and producers appear in 1.18. As these charts show, these big companies own powerful media interests and combine production, distribution, and exhibition of programs—the condition called vertical integration. The expansion of these megacorporations into all aspects of media was an outcome of the repeal of the financial interest and network syndication rules (Fin-Syn).

Because much of media content is produced by network-run or network-owned studios, programmers must make difficult choices among competing company interests when acquiring shows. Enhancing the parent corporation's stock market value might outweigh the importance of higher ratings on a particular channel, and executives at the highest levels are generally focused on maximizing revenue to the parent corporation. To achieve this, according to one insider, a network with a strong show and a strong time slot should air its own product.4 If the show is strong but the time slot is weak, it should sell the show to others (as Warner Brothers did with Friends to NBC). If the time slot is strong but the owned show is weak, the network should buy better programs from others (as NBC now does with the shows in its 9:30 P.M. slot on Thursdays). If both the show and the time slot are weak, then the network should recycle its own library (as ABC does on Sundays at 7 P.M. with Disney movies). Because there were few good options for early prime time, NBC has turned to cheap reality shows.

Ownership also directly affects programmers at the lower levels of the hierarchy. Most broadcast stations and the larger cable systems belong to companies that own more than one station or system. The profitability of broadcast and cable investments attracts corporate buyers, who gain important economies of scale from multiple ownership. Because they can buy centrally in large quantities, they can get reduced prices for many kinds of purchases, including programs. Federal Communications Commission (FCC) and Justice Department permissiveness also encourages the formation of multimedia companies and very large, diversified conglomerates, making group ownership the pattern of the industry. The AOL and Time Warner merger signaled the rise of the web to major-player stakes.

In broadcasting, the owner of two or more stations within a given type (AM, FM, TV) is called

1.19 Rupert Murdoch and News Corp.

ews Corp. (which might easily be called the FOX Empire) is a giant among giants. It owns all or most of 20th Century Fox, one of the major movie and television studios; the FOX television network, one of the four biggest broadcast networks; Fox News, a solid competitor to CNN; Fox Sports, which moved up from a regional service to compete successfully against ESPN: FX. SPEED, and Fuel TV: DirecTV, one of just two satellite services in the United States; SKY, the direct satellite company serving the United Kingdom and Italy; and STAR, the biggest satellite service in the Australia-South Asia region. News Corp. also owns major newspapers in America and Europe, recording studios, magazines (including TV Guide), book publishers, and Australia's National Ruaby League. The fox who controls all this is Rupert Murdoch, an Australian

turned naturalized American. (He once owned the Los Angeles Dodgers, too.)

Like all hugely successful moguls, Murdoch receives frequent criticism. While some of his television shows, such as *The Simpsons* and 24, are applauded for their wit and innovation, others, such as *The Simple Life* and *Totally Outrageous Behavior*, are derided for their crassness and debauchery. Murdoch has often claimed that he is "a catalyst for change" in media. One implication is that, while a few people always condemn new ideas, the success of his enterprises demonstrates that hundreds of millions want to buy his programs, services, and publications. Another implication is that his successes have forced others in the media business to change, too.

SOURCE: Edward J. Fink, Ph.D. California State University, Fullerton

a group owner, while in cable television the owner of three or more cable systems is called a multiple system operator (MSO). About three-quarters of the nearly 1,300 commercial television stations are under group control (one-third are controlled by the top 25 groups), and big groups control about three-quarters of the 12,000 radio stations. In cable, the percentage is even higher, with more than 90 percent owned by an MSO. Indeed, the number of subscribers controlled by the top 10 MSOs themselves also approaches 90 percent.

Group ownership of the right stations in the right markets can be remarkably profitable. ABC, CBS, FOX, and NBC's owned-and-operated stations (O&Os) constitute the most prominent group-owned constellations. The O&Os of just ABC, CBS, or NBC in the top three markets—WABC, WCBS, and WNBC in New York; KABC, KCBS, and KNBC in Los Angeles; WLS, WBBM, and WMAQ in Chicago—gross more revenue than any other groups. FOX, currently with the largest potential television reach, is owned by Rupert Murdoch, the international media

magnate (see 1.19). The FOX television network now has more than 220 affiliates, putting it slightly ahead of the three older networks, which each have about 200 stations. The CW (jointly owned by CBS and Time Warner), ION (formerly PAX), UNI, Telemundo (owned by NBC), and TeleFutura (owned by UNI) have far fewer affiliates (see 6.2 in Chapter 6). Some of the advantages and disadvantages of group ownership are spelled out in 1.20.

Because broadcast stations have a legal obligation to serve their specific communities of license, group owners must necessarily give their outlets a certain amount of latitude in programming decisions, especially decisions that affect obligations to serve local community interests. Beyond that, broadcast group owners generally employ a headquarters executive to oversee and coordinate programming functions at owned stations with varying degrees of decentralization.

As for cable, the days of adding bunches of new systems has largely passed. The largest MSOs focus instead on buying and swapping systems to create geographically close groupings, thus generating savings in management. Some MSOs have given slightly more autonomy to their local managers as they try to trim headquarters' budgets to reduce overhead. Nevertheless, cable group owners tend to centralize programming more than broadcasting groups do because cable has no special local responsibilities under federal law (as does broadcasting). Many of the largest MSOs also own several cable program networks, so they have a vested interest in distributing them to all the markets they reach, irrespective of local preferences.

Executives concerned with programming, like those in every other aspect of broadcasting, cable, and new media, constantly need to update their knowledge of the rapidly evolving field and the rapidly increasing competition. The trade press provides one source of updates, but even more important are the many trade and professional associations that provide personal meetings, demonstrations, exhibits, seminars, and publications. Dozens of such associations bring practitioners together at conferences on every conceivable aspect of the media, all of which touch on programming in one way or another—conferences on advertising, copyright, education, engineering, digital media, finance, law, management, marketing, music, news, production, programs, promotion, research, satellites, and telephone, to name just some. Licensing groups provide the legal and economic environment that ensures that artists get paid royalties for their works. The best-known of these associations, organizations, and groups are listed in 1.21, with more about the most important of all associations to programmers—the National Association of Television Program Executives (NATPE)—in 1.22.

Regulatory Influences

Broadcast radio and television, more than most businesses (including other media), must live within constraints imposed by national, state, and local statutes and administrative boards. Moreover, public opinion imposes its own limitations, even in the absence of government regulation. The most recent trend in media regulation has been to "let the marketplace decide" and remove the interference of government. Only a few rules

remain that programmers must know to avoid possible violations within their jurisdictions.

Fairness and Equal Opportunity

Both broadcast and local cable-originated programming must observe the rules governing both the appearances of candidates for political office (equal time) and station editorials. The equal-time rule for political candidates demands that broadcasters and cable access channels (not cable or satellite operators) provide equal opportunities for federal candidates, effectively preventing entertainers and news personnel from running for office while still remaining on their programs. Although the FCC has formally abandoned its specific Fairness Doctrine concerning discussion of controversial issues of local importance, many managers continue to adhere to the basic fairness concepts as a matter of station policy. Day-to-day enforcement of such rules and policies devolves largely on the production staff in the course of operations, but programmers often articulate station policies regarding balance and stipulate compliance routines. Fairness looms large in talk radio and talk television because the talk so often deals with controversial topics.

Monopoly

Traditionally, various rules have limited concentrations of media ownership, all of them aimed at ensuring diversity of information sources-in keeping with implicit First Amendment goalsalthough the recent trend has been to loosen the rules. Nonetheless, group owners of broadcast stations are particularly sensitive to regulatory compliance in this area because they have a high financial stake in compliance and, of course, are conspicuous targets susceptible to monopoly charges. For many years, cable franchises were regarded as "natural monopolies," because it seemed uneconomic to duplicate cable installations (overbuilds). If monopoly is construed as denial of freedom of speech, though, then even the "natural monopolies" created by franchising one operator seem to violate the First Amendment. Telephone companies, however, have stepped into this breach. Upgrading existing telephone lines to fiber permits

.20 Group Ownership

he main programming advantages of group ownership are the cost savings in program purchases, equipment buys (such as computers, servers, and cameras), and service charges (such as by reps and consultants) that accrue from buying at wholesale, so to speak. Insofar as groups produce their own programs, they also save because production costs can be divided among the several stations in the group—a kind of built-in syndication factor. Moreover, group-produced programs increasingly are offered for sale to other stations in the general syndication market, constituting an added source of income for the group owners.

Group buys often give the member stations first crack at newly released syndicated programming as well as a lower cost-per-station. Distributors of syndicated programs can afford such discounts because it costs them less in overhead to make sales trips to a single headquarters than to call individually on widely scattered stations, and the larger groups can deliver millions of households in a single sale.

Large group owners can also afford a type of negative competition called warehousing. This refers to the practice of snapping up desirable syndicated program offerings for which the group has no immediate need but which it would like to keep out of the hands of the competition by holding them on the

shelf until useful later (see Chapter 3). Also, group executives have bird's-eye views of the national market that sometimes give them advance information, enabling them to bid on new programs before the competition even knows of their availability. For their part, producers often minimize the risk of investing in new series by delaying the start of production until at least one major group owner has made an advance commitment to buy a series. Many promising program proposals for first-run access time languish on the drawing boards for lack of an advance commitment to purchase.

The stations in the top four markets that are owned and operated by the national television networks exercise extraordinary power by virtue of their groupowned status. Each such O&O group reaches about two-fifths of the entire U.S. population of television households, making their collective decisions to buy syndicated programs crucial to the success of such programs. Thus, these few group-owned stations influence national programming trends for the entire syndicated program market. So important to the success of programs is their exposure in the top markets that some syndication companies offer special inducements to get their wares on the prestigious prime access slots on network O&O stations. These inducements can take the form of attractively structured barter syndication

digital broadband delivery (called DSL) and distribution of video, starting the trend for phone companies to compete for cable consumers by offering packages of telephone, internet connection, and satellite television channels in some communities.

Localism

The FCC has traditionally nudged broadcasters toward a modicum of **localism** in their program mixes. The FCC expects licensees to find out about local problems in a station's service area and to offer programs dealing with problems. The informal **ascertainment** requirement, which is a quarterly list of local issues and the programming dealing with these issues that stations must place

in their public files, is one approach to enforcing this requirement. In licensing and license renewals, the FCC gives preferential points for local ownership, owner participation in management, and program plans tailored to local needs. Cable operators are not licensed by the FCC and so have no such federal public-interest mandate, and as a result, cable programmers differ fundamentally in their programming outlook from broadcast programmers.

Increased competition for audiences now drives broadcasters and cable operators toward increased localism. In many cases, localism has boosted the financial return for those stations with a long, honorable history of community ceals or cash payments to ensure carriage. The latter type of deal, known as a compensation incentive, occurs pr marily in New York, the country's premier marke⁻.

Although O&O stations remain legally responsible for serving their individual local markets, they naturally also reflect the common goals and interests of their networks. As an example of a rather subtle network influence, consider the choice of the prime access program that serves as a lead-in to the start of the network's evening schedule. An ordinary affiliate (that is, one bound to its network only by contract rather than by the ties of ownership) can feel free to choose a program that serves its own best interests as a station. An O&O station, however, must choose a lead-in advantageous to the network program that follows, irrespective of its advantage to the station. O&O stations also must take great care in choosing and producing programs to protect the group image, especially in New York, where they live next door to company headquarters.

MSOs have many of the same advantages as broadcast groups, however. Cable systems normally obtain licenses to carry entire channels of cable programming (cable network services) rather than individual programs or program series. Thus, major MSOs, negotiating on behalf of hundreds of local

cable systems, gain enormous leverage over program suppliers. Indeed, a cable network's very survival depends upon signing up one or more of the largest MSOs. Beginning as long ago as 1995, all but about 300,000 cable subscribers in America were served by systems owned by the top 100 cable MSOs, and the independence of the remaining small systems is threatened by the high cost of rebuilding to increase channel capacity.

Nongroup program directors (at the minority of independent stations and cable systems) enjoy more autonomy and can move more aggressively and rapidly than their group-controlled counterparts. Group headquarters programmers and their sometimes extensive staffs impose an additional layer of bureaucracy that tends to slow local decision making. Local program executives know their local markets best and can adapt programming strategies to specific needs and conditions. A group-acquired broadcast series or cable network that may be well suited to a large market will not necessarily meet the needs of a small-market member of the group. When a huge MSO such as Compast makes a purchase for hundreds of different systems, not every system will find the choice adapted ideally to its needs. Group ownership imposes some inflexibility as the price of its economies of scale.

orientation. It is good business to serve the community, not merely a requirement.

Copyright

With the exceptions of news, public-affairs, and local productions, all programs entail the payment of royalties to copyright owners. Programmers should understand how the copyright royalty system works, how users of copyrighted material negotiate licenses from distributors to use such material, and what limitations on program use the copyright law entails.

Broadcast stations and networks usually obtain blanket licenses for music from copyright licensing organizations, which give licensees the right to unlimited plays of all the music in their catalogs (in programs, promos, or song play). For the rights to individual programs and films, users usually obtain licenses authorizing a limited number of performances (plays) over a stipulated time period. One of the programmer's arts is to schedule the repeat plays at strategic intervals to get the best mileage possible out of the product.

Stations and networks obtain licenses for the materials they broadcast, with fees calculated on the basis of their over-the-air coverage, but cable television systems have introduced a new and exceedingly controversial element into copyright licensing. Importation of distant signals have stretched the original single-market program

1.21 The Associations

ere is a list of important organizations, along with the home page listings (when available) for the World Wide Web.

Major Industry Trade Associations

National Association of Broadcasters (NAB): www.nab.ora

National Cable & Telecommunications Association

(NCTA): www.ncta.com

Radio-Television News Directors Association

(RTNDA): www.rtnda.org

Programming Organizations

National Association of Television Program Executives (NATPE): www.natpe.org

MIPTV: www.miptv.com

Community Broadcasters Association (CBA): www.communitybroadcasters.com

Alliance for Community Media (ACM):

www.alliancecm.org

Media Communications Association (MCA), formerly the Independent Television Association: www.mcai.org

Music Licensing Groups

American Society of Composers, Authors, and Publishers (ASCAP): www.ascap.com

Broadcast Music, Inc. (BMI): www.bmi.com SESAC: www.sesac.com

Technical Societies

Society of Motion Picture and Television Engineers (SMPTE): www.smpte.org
Society of Broadcast Engineers: www.sbe.org
International Radio & Television Society (IRTS):
www.irts.org

Marketing and Sales Organizations

Television Bureau of Advertising (TVB): www.tvb.org Radio Advertising Bureau (RAB): www.rab.com Syndicated Network Television Association (SNTA): www.snta.org

Online Media, Marketing and Advertising Association (OMMA): www.mediapost.com/omma

Cabletelevision Advertising Bureau (CAB):

www.onetvworld.org

Cable & Telecommunications Association for Marketing (CTAM): www.ctam.com

Promax: www.promax.tv

license to include hundreds of unrelated markets all across the country—to the obvious detriment of copyright owners (the producers), the ones who stand to make money from the reuse of their programs. The Copyright Law of 1976 tried to solve this problem by introducing the compulsory licensing of cable companies that retransmit television station signals. It provided retransmission compensation to the copyright owners in the form of a percentage of cable companies' revenues that went directly to the Copyright Royalty Tribunal for distribution (mostly to sports rights holders). The Cable Act of 1992 went further and insisted that cable systems receive retransmission consent from broadcast stations for their signals, which

led some to believe that cable operators would finally pay broadcasters for retransmission. The issue seemed largely resolved when most affiliates of major television networks made deals with cable operators for a second local cable channel in lieu of cash payment.

In 2007, however, several small cable operators agreed to pay the CBS network a per-subscriber fee (cable compensation) for the right to carry its programming, a break-through for broadcasters. Although the initial amount was small (about \$.50 per subscriber), the deal set a new precedent in cable/broadcast relations that gave broadcasters leverage in eventually gaining a second revenue stream (in addition to advertising), something long

1.22 National Association of Television Program Executives (NATPE)

hen television programmers formed their own professional organization in 1962, they called themselves the National Association of Television Program Executives (NATPE)—tacitly acknowledging that membership would be dominated by general managers and other executives who play more important programming roles than those specifically designated as programmers. Although programmers may track the performance of programs and come up with the ideas for new purchases, the executives are the ones who authorize the money—and make no mistake, programs are enormously expensive, running into the tens and hundreds of millions in large markets just to rerun off-network hits.

The broadcast station programming team usually consists of the general manager, sales manager, and program manager. In cable organizations, the executive in charge of marketing plays a key management role and may have the most influence on programming decisions. In recent years, the role of program manager at many network affiliates has diminished as higher-level staff members frequently make programming decisions.

Syndicators put programs on display nationally and internationally at a number of annual meetings and trade shows. For showcases, they rely especially on the annual conventions of NATPE and the National Cable Television Association (NCTA) held each spring. Starting in 2003, NATPE faced some competition from the Syndicated Network Television Association (SNTA), which meets in New York in conjunction with the Association of National Advertisers (ANA) that every year holds its well-regarded Television Advertising Forum.

At the annual NATPE conventions, hundreds of syndicators fight for the attention of television

programming executives, offering a huge array of feature films (singly and in packages), made-for-TV movies, off-network series, first-run series, specials, miniseries, documentaries, docudramas, news services, game shows, cartoons, variety shows, soap operas, sports shows, concerts, talk shows, and so on. Trade publications carry lists of exhibitors and their offerings at the time of the conventions. (Chapter 3 gives a selection of syndicators along with examples of their offerings.) At the same time, the largest portion of sessions at recent NATPE conferences has been dedicated to the new media, but the attendees were largely new-media companies and content producers seeking ideas about how to gain distribution. One industry source estimated that 90 percent of NATPE attendees continued to be focused on the tradit onal buying and selling of programs, while 10 percent were focused or the new media.5

Europe has a similar annual program trade fair, MIPTV. Formerly at that fair, the flow of commercial syndicated programming between the United States and other countries ran almost exclusively from the United States. Public broadcasting first whetted American viewers' appetites for foreign programs. And with such specialized cable services as the Discovery Channel, featuring foreign documentaries, and Bravo, with foreign dramatic offerings, as well as AZN Television's Asian programs, and Univision's Mexican and Spanish programs, the international flow has become somewhat more reciprocal, although the United States is still much more often an exporter than an importer. Just as at the NATPE conventions, there is great interest at the MIPTV trade fair in innovation and new digital media.

desired by broadcasters and, until then, adamantly refused by cable operators.

A related copyright matter, the syndicated exclusivity rule, often called syndex, gives television stations local protection from the competition of signals from distant stations (notably superstations) imported by cable systems. The rule

is based on the long-held principle that a station licensed to broadcast a given syndicated program has normally paid for exclusive rights to broadcast that program within its established market area. Cable's ability to import programs licensed for broadcast in distant markets (especially the superstations) undermines this market-specific

definition of licensing and divides audiences. The rule requires cable systems to black out imported programs that duplicate the same programs broadcast locally. Most syndicators attempt to avoid selling their shows to superstations in order to make the shows "syndex-proof."

Lotteries, Fraud, Obscenity, Indecency

Federal laws generally forbid lotteries, fraud, and obscenity, and laws regarding them apply to locally originated cable as well as to broadcast programs. Conducting gaming and cheating audiences are definitely forbidden activities, and the fines are prohibitive. Shows that feature staterun lotteries, however, are an exception to the rule. If a state says stations can air the state lottery, the FCC doesn't care, but stations cannot run their own lotteries to make money. Programmers also need to be aware of special Communications Act provisions regarding fraudulent contests, plugola, and payola (see Chapters 11 and 12). Indecency, a specialized interpretation of obscenity laws, appears to apply only to broadcasting. The 1984 Cable Act sets specific penalties for transmitting "any matter which is obscene or otherwise not protected by the Constitution" (Section 639), but a subsequent Supreme Court decision affirmed that cable operators qualify for First Amendment protection of their speech freedom. This puts on those alleging obscenity the heavy burden of proving the unconstitutionality of material to which they object; in fact, several court decisions have overthrown too-inclusive obscenity provisions in municipal franchises. In practice, cable operators have greater freedom to offend the sensibilities of their more straitlaced viewers than do broadcasters. whose wider reach and dependence on the "public airwaves" (electromagnetic spectrum) make them more vulnerable to public pressure. Congress has shown some signs of tightening the restrictions on cable, however-including restrictions on nudity.

In a 1987 ruling, the FCC broadened the previous definition of prohibited words in broadcasting to cover indecency. That definition had been based on a 1973 case involving the notorious "seven dirty words" used by comedian George Carlin in a recorded comedy routine broadcast

by WBAI-FM in New York. Responding to complaints about raunchy talk-radio hosts (shock jocks), the FCC has repeatedly advised broadcasters that censorable indecent language could include anything that "depicts or describes, in terms patently offensive as measured by contemporary community standards for the broadcast medium, sexual and excretory activities or organs." Raunchy radio content from Howard Stern led the FCC to levy a \$1.7 million fine on his syndicator (see Chapter 12), eventually driving Stern to unregulated satellite radio. The increase in number and size of indecency fines that started in 2004 hastened the migration of most adult radio programming to satellite radio (the Sirius and XM networks), also called "pay radio." By 2007, pressure on stations to excise certain indecent words from programming seemed ironic—given that the U.S. president had publicly used some of them.

Moreover, the FCC has designated late night as a safe harbor on television and radio for adult material. It is noteworthy that in this designation the commission used the words for the broadcast medium, implying that broadcasting should be treated differently from other media, a concept out of keeping with much FCC-sponsored deregulation. Thus, cable networks feel free to schedule dramas at 7 or 8 P.M. that most broadcasters would only air at 10 P.M.

Libel

News, public-affairs programs, and radio talk shows in particular run the risk of inviting libel suits. Because of their watchdog role and the protection afforded them by the First Amendment, the media enjoy immunity from punishment for libel resulting from honest errors in reporting and commentary on public figures. Due care must be taken, however, to avoid giving rise to charges of malice or "reckless disregard for the truth." Though the media have traditionally won most libel cases brought against them, by the early 1990s this trend had been reversed, and juries awarded huge fines. Moreover, win or lose, it costs megadollars to defend cases in court. Managers responsible for news departments and

35

radio talk shows need to be aware of libel pitfalls and to institute defensive routines. These defenses include issuing clear-cut guidelines, ensuring suitable review of editing, and excising libelous matter from promotional and other incidental material. To assist local programmers, the National Association of Broadcasters (NAB) has issued a video that illustrates some of the common ways news programs inadvertently open themselves to libel suits.

Digital Must Carry

In the late 1990s, the FCC announced a plan to convert all U.S. television households to digital reception and have the traditional over-the-air (analog) channels revert to the commission for reassignment to other uses. Conversion, however, went more slowly than expected, and the original target year, 2006, was delayed to 2009. Although at first the diffusion of digital television receivers into homes also crept along, it was expected to exceed three-quarters of homes by 2012. The process went even more swiftly in Europe where digitalization had reached about half of homes by 2008 and as much as 95 percent of homes in a few countries, such as United Kingdom and Sweden.

Moreover, the transition to high-definition television over digital channels "loaned" to broadcasters is a major concern for broadcasters and cable operators alike. The FCC has been reluctant to require "must-carry" status for these new channels, and cable operators have been slow to incorporate them. Remarkably, considering the poor quality of HD marketing, most households that have digital television do pay extra to get the some or all of the high-definition channels.

Ethical Influences

Programmers continually wrestle with standards. They are not necessarily questions of media freedom but of taste. What is good taste? Like anything else, the definition depends on a consensus of the people who have to live with the definition.

Over a period of time, the erosion of public taste standards has mirrored the erosion of other aspects of public life (such as manners). Viewers might be more offended if television were the only culprit, but it is increasingly impractical to expect to be able to take a walk in the mall or go for a drive on the highway without being assaulted by someone's "free speech" in the form of a lewd T-shirt or scatological bumper sticker. In the process, the public consensus about "what is shocking" impinges on "what is good taste." Some viewers will defend a program with violent or sexual content by saying, "You think Show A is bad. It's not nearly as bad as Show B." Show A becomes the standard, and Show B is the exception, until Show C comes along. Then Show B becomes the new standard, and Show C the new exception.

The ever-widening spiral may not be rapid, but there seems to be a steady broadening of what is acceptable. Programmers are caught between the expectations of one audience that wants "in your face" entertainment and the complaints from another audience that struggles to hold onto civility. A minority of producers (and their networks) go for shock value and try to lower the standards one small notch at a time. Like the drops of limestone slowly accumulating on the floor of a cavern until a stalagmite forms, the amount of impolite language and situations has grown into high peaks in some programs on evening television, especially late-night shows. The exposed right breast of Janet Jackson in Super Bowl 2004's halftime show apparently was the final straw for the FCC, which immediately began to reassert its regulations against indecent programming, as it does periodically.

Not everyone agrees there is a problem with program standards. Here is a look at the arguments currently in vogue when the topic of ethical standards is discussed.

"It's just entertainment." The public derives its values from such institutions as family, schools, churches, and the mass media, but as the authority of families, schools, and churches declines, the content of radio and television programs takes on a larger role in the socialization of young people.

"If you don't like it, turn it off." True, but I can turn off only my own television set. My neighbors' kids will still be intoxicated by the

violence in afternoon children's programs. They will also learn from prime-time television and soap operas that it's all right to be promiscuous. The cultural values of a nation are not wired to my individual ability to shut off my set. If someone poisoned all the drinking water in my area, you might say, "If you don't like it, don't drink it." I guess I could buy bottled water, but I have to live in the same society that my neighbors' children inhabit.

"Parents have the responsibility to monitor programming." This argument rarely comes from a parent, unless it's a parent who works as an executive at one of the broadcast networks. Anyone who thinks this will work is overly wishful. Children will see what they want to see if it is readily available at a friend's house, their daycare center, the mall, or other group viewing locations. One person who has some control over the ready availability of seamy programming is the programmer.

"Censorship, even voluntary censorship, violates First Amendment rights." The Bill of Rights has 10 amendments, but somehow the first gets all the attention, perhaps because the media readily control what gets our attention. A lot of other freedoms are equally precious to the well-being of citizens, such as the right to a fair trial. The community standards of the present age would easily shock the framers of the Constitution.

A drinking water analogy is apt. If a very slow poison is released into the water supply and results in amoral, uninformed residents, then the culprits are those who work for the treatment plant. Likewise, those who choose and schedule programs for radio and television have the means to maintain some level of decency in the mass media.

How did things get so out of whack? When there were only three networks, the Standards and Practices departments held a pretty tight rein, but when pay movies and MTV came along, the competition for audiences heated up. Certainly, the most egregious examples of sex and violence come from movies and music videos, yet some viewers want still more adult content. The slow

erosion of civil public behavior also affects media limits, but the amounts of sexual and violent content are merely surface issues. What matters are deeper concerns about how people in society learn to solve problems and get along in spite of differences.

What Lies Ahead

Well into this new millennium, the landscape of broadcast and cable programming continues to undergo a sea change. Television remains the largest and most powerful advertising medium, but new media check its growth. For example, ads have begun appearing on cell phones, and Americans own nearly as many cell phones as television sets.

At the same time, merger mania brings together networks and studios, as with NBC and Universal Studios, who followed the lead of ABC and Disney (although no one wants the \$99 billion hangover that resulted from the joining of AOL and Time Warner, a merger that took several years to begin working profitably). Mergers bring together former competitors, such as the WB and UPN-two companies that morphed into the CW (and inadvertently sired MyNetworkTV too). The merging of XM and Sirius now threatens over-the-air radio stations by delivering local weather and traffic reports. Long-time competitors NBC and News Corp. (FOX) have joined forces to offer their video (with ads) to internet users in order to battle Google's very successful YouTube.

Until recently, audiences were necessarily passive receivers of most program content, but computer networking capabilities now being built into satellite television receivers, cable converters, music players, and portable telephones have created "smart" machines. The time is arriving when viewers with cable service will be able to web surf during commercial breaks on living-room television sets, or on streets and in their cars, using either handheld Wi-Fi access via cell phones or WiMAX for BlackBerrys and handheld computers.

Technological forces are changing the importance of scheduling: As more content moves to

online video servers, the potential for viewers to create their own schedules increases. Although most of the present generation may be comfortable with letting someone else package a programming service, no one can predict how computer-enamored viewers will react to advanced streaming technologies. At the same time, the home DVR threatens the traditional economics as well as the programming strategies of broadcasting and cable, reviving embedded product placements. NBC has experimented with starting its top-rated shows a few minutes earlier than the usual break point at the top of the hour, thus interfering with the recording of the ends of shows on other channels that lead up to the hour. Another idea is to intersperse serial minimovies in breaks inside and between prime-time shows to discourage viewers from skipping ads.

As the established economics shifted with the start of cash compensation from cable to broadcasters, the business model of selling content (such as the audio CDs that in turn influence radio stations) may eventually evolve into an advertiser-supplemented system where content providers erect giant servers to supply video, audio, and interactive materials online, on demand, thus eliminating such middlemen as local broadcast stations. In the meantime, advances in digital television now provide television stations with the opportunity to multicast virtual channels, much like the bigger cable networks do, thus supplying more than a single channel to viewers.

Another major force for change is international economics. The most popular cable networks on U.S. cable and satellite services already require extra fees from viewers, and still more tiers of sports, movies, and high definition necessitate more and more subscriber fees. Whereas in the United States such cable networks as A&E, the Disney Channel, and Galavisión had to move off pay tiers into basic service to survive in the 1990s, MTV Europe moved in the opposite direction in the early 2000s, taking its service off the basic tiers onto pay TV. This and other trends from the international programming arena are beginning to impinge on the domestic practices of media companies. Moreover, the growing importance of international markets cannot be discounted.

For several decades, networks and studios have reached out to less-developed nations with programming produced in the United States. So far, the influx of foreign-produced programming to U.S. TV networks (with the notable exceptions of PBS, A&E, and the Discovery Channel) has been a mere trickle, but that could easily change.

It is clear that the programmer's business is making money with media content, but on the ethical side, the programmer's responsibility is less clear. Is money all that matters? Do art and imagination have a place? What a can one person do? Oprah Winfrey is one of the highest-paid people in the media business, and she works very hard to keep her program "decent" (see 6.8). Drama and comedy in prime time need not pander to the lowest-brow viewer. The newest media accept audio and video messages from anyone, including you, and provide a potential audience as large as a broadcast network's. As a student and practitioner of the mass media, you can make a difference.

Sources

Bielby, William T., and Bielby, Denise D. "Controlling Prime-Time: Organizational Concentration and Network Television Programming Strategies." *Journal of Broadcasting & Electronic Media* 47 (4), 2003, pp. 573–596.

Brown, Allan, and Picard, Robert. G. Digital Terrestrial Television in Europe. Mahwah, NJ: Erlbaum, 2005.

Croteau, David, and Haynes, William. *Media, Society: Industries, Images, and Audiences*, 3rd ed. Thousand Oaks, CA: Pine Forge Press, 2003.

Eastman, Susan Tyler, Ferguson, Douglas A., and Klein, Robert A. *Media Promotion and Marketing*, 5th ed. Boston, MA: Focal Press, 2006.

Groebel, Jo, Noam, Eli M., and Feldman, Valerie.

Mobile Media: Content and Services for Wireless
Communications. Mahwah, NJ: Erlbaum, 2006.

McDowell, Walter, and Batten, Alan. *Branding TV: Principles and Practices*, 2nd ed. Boston, MA: Focal Press, 2005.

Miller, Philip. *Media Law for Producers*, 4th ed. Boston, MA: Focal Press, 2004.

Palmer, Shelly. Television Disrupted: The Transition from Network to Networked Television. Boston, MA: Focal Press, 2006.

Sadler, Roger J. *Electronic Media Law*. Newbury Park, CA: Sage, 2005.

Notes

- 1. Tartikoff, Brandon, and Leerhsen, Charles. *The Last Great Ride*. New York: Turtle Bay Books, 1992.
- 2. Carter, Bill, "TV's Loneliest Night of the Week Is Starting to Look Very Familiar," New York Times, 21 June 2004. http://query.nytimes.com/qst/fullpage.html
- 3. Jankowski, Gene F., and Fuchs, David C. *Television Today and Tomorrow*. New York: Oxford University Press, 1995, p. 37.
- 4. Wolzien, Tom. *Media Merger Concepts*. IRTS Faculty Seminar, New York, 23 February 2000.
- 5. Myers, Jack, "Big Thoughts on the Future of the Small Screen. Jack Myers' Weekend Think Tank: Transformation 2007–2008, Part 2," 19 January 2007. www.tvboard@mediapost.com.

2

Program and Audience Research

Douglas A. Ferguson, Timothy P. Meyer, and Susan Tyler Eastman

Chapter Outline

Decision-Making Information for Programmers

The Advent of People Meters The Threat from Home Digital Video Recording

Program Testing

Concept, Pilot, and Episode Testing Promotion Testing

Qualitative Audience Research

Focus Groups Music Research Television Quotient Data (TvQs)

Ratings Services

Television Services Radio Services Online Radio Video Games Specialized Audiences

Ratings Terminology and Measurement Computations

Survey Areas Ratings/Shares/HUTs PUTs/PURs AQH/Cume Reach and Frequency Analysis

Television Market Reports and Other Programming Aids

Daypart Audiences Time Period Averages Program Audiences Syndicated Program Reports Computerized Services

Radio Reports

Metro Audience Trends Demographic Breakouts Time-Spent-Listening Turnover

Cable Ratings

Premium Services Cable Penetration Measures

Online Research Services

Web Tracking Services Online Ratings Terminology Matching

Ratings Limitations

Future Challenges

Sources

Notes

ow could those idiots cancel that show? It was my favorite. Why do they always get rid of the good stuff and keep all the junk?" Sound familiar? It should. Most people have, at one time or another, heard the news that a favorite television show has been canceled. The reason? Usually the one given is "low ratings," a way of saying that not enough people watched the program. Why are the ratings so important? Why do so many shows fail? Can't a network executive tell whether a show will succeed in the ratings? In this chapter we look at ratings and other forms of audience research and explain what they are, how they are used and misused, and why.1 We will examine the industry's current program research practices and qualitative audience measurement techniques and then, because of their special position in industry economics, explain and interpret audience ratings.

Decision-Making Information for Programmers

Media programmers (and all others in the advertising-supported media) are interested in one goal: reaching the largest possible salable audience. Programmers define audiences differently depending on particular circumstances, but regardless of definition, determining audience size is the paramount concern. The separations between program creation and presentation and reception by the audience mean that programmers must always guess who will be there and how many there will be, estimating how predictable and accurate those guesses are. Because networks and stations sell commercial time at dollar rates based on predicted audiences, it is no surprise that program and audience research is critical for the financial health of the broadcast television, radio, cable, mobile, and online industries. Program and audience research, usually involving ratings, guides the process of selecting and scheduling programs to attract the desired audience and provide feedback on programming decisions.

The broadcast and cable industries use many research approaches to evaluate programs and audiences, most of which fall into one of three groupings (to date, internet companies have used only the third type):

- 1. Qualitative and quantitative measures of the programs themselves
- 2. Qualitative and quantitative measures of audience preferences and reactions
- 3. Quantitative measures of audience size

Qualitative research tries to explain why people make specific program choices and what they think about those programs. Quantitative research, in the form of ratings and surveys, reports what programs (and commercials, presumably) people are listening to or watching.²

Programmers use qualitative information on programs to select and improve programs and to understand audiences' reactions to program content; qualitative audience data help explain people's reactions to programs. Quantitative audience data generally provide measures of the size and demographic composition of sets of viewers, listeners, or subscribers. Of all findings, however, ratings are the major form of program evaluation, and they have the most influence on the other concerns of this book—program selection and scheduling—in the United States and, indeed, on the television industry worldwide (see 2.1).

The Advent of People Meters

In the late 1980s, a sweeping change occurred in the national television ratings—the shift by ratings companies from measuring people's viewing using diaries and simple passive meters to measuring viewing using people meters, a much more elaborate, interactive measurement process. People meters consist of a computer and an electronic, handheld device with which individuals signal when they are viewing. The "black box" computer is located near the television set, registering (from the handheld device) each viewer's presence and all channel selections; background demographic information (age and sex) on every viewer in the

2.1 Ratings Research Is Everywhere

r. Wally Langschmidt was the founder of ratings research in South Africa. He was the colleague of such American and European luminaries of early media research as Arthur C. Nielsen, Alfred Politz, and George Gallop. Dr. Langschmidt helped create the South African Advertising Research Foundation (SAARF). It promotes and monitors the use in South Africa of up-to-date standards in such audience measurement tools as people meters, diaries, and personal interviews. Dr. Langschmidt's most outstanding contribution, however, was to pioneer the concept of a single data source for all media—called the All Media and Products Survey (AMPS)—used today by both media and advertisers in South Africa. The AMPS survey gives the whole country a common trading currency that is used by both advertisers and

broadcast program planners to evaluate the use of all media.

One big difference from the American system is that funding of market research in South Africa comes from a 1 percent levy on each advertisement carried on radio, TV, print, outdoor advertising, and cinema that is paid by the marketers. SAARF is run by a series of industry committees, and although the actual research is presently commissioned to Nielsen Media Research, SAARF's importance to the reliability of South Africa's media research is widely recognized, and its contract has been renewed every five years.

Daan van Vuuren Consultant and Professor (retired Director of Audience Research, SABC, South Africa)

household is stored in the device's memory to be matched with the viewing information.

In 2005 Nielsen introduced further refinements to its measurement devices, counting program viewing up to seven days after the original time of showing, to accommodate time-shifting with analog and digital video recorders (VCRs and DVRs). These active/passive (A/P) people meters measure audiences with greater accuracy and less reliance on viewer participation by reading codes embedded into the programming—rather than by simply detecting the channel to which a set is tuned, as is done by the old metering system. At first, these meters measured only national audiences (a particular sample), but they soon moved into the larger markets for local measurement.

The Threat from Home Digital Video Recording

Currently, the greatest fear in the television and advertising industries centers on the adoption of DVRs, such as TiVo and various digital converters provided by cable and satellite operators. The DVR is a device that functions like a personal computer in that programs are digitally stored

on the machine's hard drive. Like computer files, programs can be kept in storage or deleted once storage capacity is reached, and programs can be burned to disks and saved as DVDs. Although home video recording has been available for more than 30 years, widespread use of DVRs affects two relationships: that between producers and program distributors and that between advertisers and program distributors. Less than a third of homes had DVRs by 2008, but penetration was expected to increase to nearly all digital households by 2015. All satellite service subscribers get a DVR, and cable subscribers have the option of having either simple or high-end DVRs with high-definition service, and all of their benefits.

Traditionally, the A/P meters counted only the number of minutes spent viewing a program within a few seconds of transmission (now eight seconds to allow for DVR lag), the definition of "live" viewing. The valuable **overnight ratings**, for example, include only "live" viewing. But Nielsen produces other important data sets, such as "live plus same day," which measures viewing within 24 hours (to include DVR recording and playback) and "live plus seven," which measures programs recorded and watched within a week. Currently, producers,

2.2 Tracking Bloggers

ot all ratings services track television or radio and not all come from Nielsen or Arbitron. Technorati, a blog trackina service, tracks about 55 million blogs worldwide, in several languages (English, Korean, French, German, Italian, Chinese, and others), to measure who is talking about which companies and what they are saying. Unlike ratings, this kind of surveying tracks both the buzz that aids new products and the negative writeups that often doom new products. Such a service benefits marketers of products by monitoring online chatter that can supplement or contradict traditional advertising. In the same way, American media marketers play close attention to bloggers who discuss television programs, and many large companies have their own specialists (like commentators) who create daily blogs on a variety of topics, some of which are their own products and services. Brandimetrics and Nielsen BuzzMetrics track blogs about specific client products and services in the U.S.

syndicators, and advertisers must negotiate with broadcast and cable networks about which set of numbers to accept as the standard.

The second concern is that DVRs may upset the delicate balance that permits the television industry to pay for producing and distributing programs. All DVRs have the ability to skip over commercials while playing back a recording. If more and more viewers watch more and more television but skip the commercials, the financial infrastructure of the television industry becomes seriously threatened. Advertisers rely on television networks and stations to deliver audiences for the programs in which their commercials appear, and advertising revenue pays most of the bill. If the viewing audience for commercials shrinks because of DVR use, then ad revenues will shrink correspondingly. At some point, revenues might be insufficient to pay for program production and delivery. This would require a shift to an alternative way to pay for television programs—perhaps a pay-per-program system-that would make television a much less affordable commodity.

At least a few years will pass before any effects are noticeable in the quantity of TV commercials viewers watch. How much of an increase will cause DVR use to have serious economic consequences for the TV industry is not known, at least with any precision, but penetration in the range of 30 to 40 percent may be the point at which serious financial ramifications are felt. Even if DVRs eventually change the economics of television, audience measurement will still be needed. Recent research from Nielsen on TV commercial viewing by DVR users has softened many advertisers' concerns about skipping commercials.

One response to the threat of DVRs has been to expand product placement in programs. Now research firms measure the value of product placements (in daytime and reality shows) and sponsorships and look at the opinions of bloggers as a way to gauge improvements in products and marketing (see 2.2). As product placement invades television programming, a trend that began many years ago in motion pictures, the line between program measurement and advertising measurement begins to blur. This chapter, however, focuses on program and audience measurement because they are crucial to current programming processes and strategies.

Program Testing

The enormous expense of producing television programs necessitates testing them before and during the actual production of a show. In addition, promotional announcements that advertise programs are usually tested to gauge their effectiveness and ability to communicate a program's most attractive features.

Concept, Pilot, and Episode Testing

Concept testing involves asking audiences whether they like the *ideas* for proposed programs. Producers generally conduct this type of test before a program has been offered to a broadcast or cable network. Pilot testing occurs when a network is considering the purchase of a new series, and audiences are asked to react to the *pilot* episode. This process is described in detail in Chapter 4

2.3 ASI Theater Testing

SI research has been criticized for its unrepresentative audience samples, yet it remains a major contributor to network and movie studio program testing in America. ASI provides valuable data because its audiences are consistent from one time to the rext. It has established norms from all its previous testing of programs, films, and commercials against which new findings are weighed. Given the many programs evaluated during past decades and the fact that few programs are really "new" in any significant way, comparing how well a new show tests to how others like it have tested in the past produces useful information. The results are especially noteworthy when a program produces a negative or low evaluation because the average ASI participant evaluates programs positively. Not all programs that test positively are successful when put on a network

schedule (factors independent of the show's content have more influence on ratings), but very few of those that test negatively at ASI later succeed.

Frequently, prime-time series that have slipped in the ratings are tested with live audiences to determine which aspects of the program, if any, can be manipulated to improve the popularity of the series. The testing instruments range from simple levers and buttons, such as those used in ASI theaters, to more controversial methods, such as skin conductance meters measuring respiration and perspiration. Programmers seek aids in understanding the weaknesses and strengths of a series that is performing below expectations. Sometimes the research suggests a change of characters or setting that revitalizes a program. (If research results are no help, the cynical programmer usually suggests adding a dog or a child.)

(network prime-time programming). Episode testing occurs when a series is under way. Plot lines, the relative visibility of minor and major characters, the appeal of the settings, and so on can be tested to gauge audience preferences.

ASI Entertainment, based in Los Angeles, is one of the best-known companies conducting program tests (and tests of commercials). Traditionally, ASI researchers invite people into a testing theater to watch a television program, a film, or a commercial, asking them to rate it by pushing "positive" and "negative" buttons that are attached to their seats. Generally the participants are paid, often in products rather than cash, for taking part in the test. Computers monitor individual responses, producing a graph of the viewer's "votes" over time. These data are correlated with demographic and other information (psychographics) obtained via questionnaires from each participant (see 2.3).

The latest in theater-style testing takes place at the Television City research center at the MGM Grand in Las Vegas. Visitors are recruited to watch pilots and participate in surveys and focus groups. Five minutes before the screening begins, viewers are led into one of four studios to watch the most recent programs from CBS, MTV, Nickelodeon, and other Viacom networks (this television-holdings giant manages the research center). A survey following the program lasts about 15 minutes; such incentives as T-shirts, caps, pins, key chains, and computer software are used to get participants to fill it out.

Concept and pilot testing stress general plot lines and main characters, seeking to discover if they are understood and appeal to a variety of people. Ongoing program testing focuses on more subtle evaluations of the voices, manners, style, and interactions of all characters. In fact, different actors and plot lines are sometimes used for separate screenings to find out which cast and plot audiences prefer. Postproduction research can discover a poor program opening or an audience's difficulty in understanding the main theme of an episode.

Unfortunately, the theater environment cannot reflect at-home viewing conditions and is thus a less than ideal research method. It does, however, supply detailed data that can be matched to screen actions, adding fodder for programming decisions. In many test markets where insertion equipment is available, researchers send alternate versions

of pilot programs (and commercials) to different cable homes and interview the viewers on their reactions. This necessitates producing alternate versions of a program, however—a huge expense not lightly undertaken.

A popular method for program testing is using streaming video over the internet to reach test audiences. Online data collection simplifies the research process and reduces the chance for error in the data. Participants can be recruited from far-reaching locations rather than just near New York or Los Angeles, but whether they adequately represent the real television audience is questionable. It is not yet certain whether these newer methods will replace theater and cable testing, both of which are still going strong.

Promotion Testing

Competition for audiences requires that most programmers continually produce effective promotional materials. Promotional spots advertise particular episodes of a series, special shows, movies, newscasts, or unique aspects of a station's or service's programming (images and identities).³ These promos can be tested before they are aired to find out whether they communicated what was intended.

Much of the promotional testing being done uses online audience samples. Strategic Media Research (SMR), a research and marketing company that has specialized in radio, began testing TV promos online at the turn of the century. Clients include MTV, VH1, Comedy Central, Country Music Television, and Spike. Some testing firms used to conduct tests in shopping centers, intercepting people at random to invite them to view promos in return for cash or merchandise. Promo evaluation, especially for radio, sometimes includes group and theater testing that emphasizes such measures as memorability, credibility, and persuasibility. After demographic data are gathered, other questions are asked and associated with participants' opinions. Promo-copy testing has become a standard practice in the industry.

As multichannel television moves closer to an on-demand era, promotion testing increases in

importance and becomes more widely used. Menudriven program selection (video-on-demand, or VoD) is more influenced by on-air promos and guide channels than by schedule-driven program selection, so media companies realize that promos need to be effective.

Qualitative Audience Research

In addition to program testing, which applies mostly to television programs and movies, stations use qualitative research to get audience reactions to program materials, personalities, and station or system image. Using focus groups is one such research method. Radio stations also use call-out research to test their programming, and network television and major-market stations make use of television quotient data (TvQs). *Qualitative audience research* is the most common phrase used in the industry to refer to all of these research techniques. (See 2.4 about the beginnings of qualitative research in the radio days.)

Focus Groups

One method of gathering information from a group of people is to conduct small group testing. A focus group is a set of 10 or 12 people involved in a controlled discussion. A moderator leads a conversation on a predetermined topic, such as a music format or television newscast, and structures the discussion with a set of questions. Predetermined criteria guide the recruitment of individuals for participation in focus groups. For example, station management may want people who listen to country music or women aged 25 to 34. Finding people who fit the predetermined criteria (screening) can be costly, however, and specifying more qualifications results in a greater turndown rate, increasing the price for screening. Assembling a typical focus group generally costs between \$4,500 and \$5,000, including the fee paid to each participant (\$50 is the standard fee, although it is sometimes as high as \$150 for individuals difficult to recruit, such as physicians and other professionals).

2.4 Herta Herzog and Qualitative Radio Research

erta Herzog is perhaps best known for her pioneering "gratifications" research on 1940s radio serial listeners: "What do we really know about daytime serial listeners?" This study, as well as several of her earlier projects, marked Herzog as a key developer of personal interviews as an approach to learning about radio audiences. Her method was the forerunner of much of today's qualitative research into television and the internet.

As a graduate student in Austria, Herzog trained with Karl Bühler, an experimental psychologist who made several contributions to the psychology of thinking. Bühler argued that there were three sources of knowledge about human psychology: observation of human behavior, observation of the products of human culture, and human introspection. By asking the proper questions, then, introspection could be obtained from ordinary people. Herzog's dissertation research was an early application of these ideas. She had six speakers, each different in sex, age, physical type, and occupation, read the same passage over the radio on subsequent days of the same week.

Then, Herzog distributed questionnaires in popular stores that shoppers mailed back to her, analyzing them to learn what kinds of social and personal characteristics listeners derived simply from voice and diction. Later, Herzog developed the "depth interview," which involved open-ended questions and probes. She used this technique in her gratifications research about radio serials and quiz shows. The day after the 1938 War of the Worlds broadcast, she used this method to find out why so many listeners were frightened. These early interviews were summarized in a memo to Frank Stanton and became the basis for the interview schedule for the larger well-known study, "The Invasion from Mars."

Just as television was peeking over the horizon, Herzog left academia in 1943 to join the McCann-Erickson advertising agency, where she applied her techniques to motivation research. She stuck to the qualitative aspects of radio programs and commercials and developed ideas that others later applied to other media.

Elizabeth M. Perse, Ph.D. University of Delaware

From Elizabeth M. Perse, Ph.D., University of Delaware, "Herta Herzog," in Women in Communication, edited by Nancy Signorielli (Westport, CT: Greenwood Press, 1996). Reproduced with permission of Greenwood Publishing Group, Inc., Westport, CT.

Focus group research is especially useful for eliciting reactions to visual material and gaining insight into subtle responses to televised characters and individuals. These small group discussions can be used to develop precise questions for later field surveys of a large sample of people. For example, researchers commonly use focus groups to evaluate whether a station has enough news programming, whether music is too soft or loud, how people react to the newscasters, whether personalities are perceived as interesting or friendly, and so on. The particular advantage of focus groups is that videotapes, newspaper ads, and recordings can be evaluated in the same session, providing immediate feedback while avoiding confusion in recall after a lapse of time.

Approximately 200,000 media-related focus groups are conducted each year. The latest trend is to use internet-based videoconferencing for

focus group observers to save travel costs and allow more people to observe the groups during the session. For example, SMR's NetLinx service uses this technique to test new promos and programs. The biggest pitfall of high-tech focus groups is that many nonverbal behaviors are lost in the mediated setting. Videoconferencing technology, while continuing to improve, presents limited information from participating individuals. In a face-to-face focus group, cameras can record each participant and the moderator during the entire focus group, enabling researchers or clients to study group member reactions while another person is speaking. There are many important reasons why the data and results obtained from focus groups cannot be generalized to a larger audience. An obvious limitation is the small size of the group. Even when a number of different focus groups are conducted, the sample size will

not allow for valid generalizations to thousands or millions of people.

Another major drawback is the selection process. Focus group participants are not selected using a statistically valid random sampling process. To generalize from a sample to the larger population from which the sample was drawn, random sampling procedures must be used. In a random sampling process, every person in the population has an equal chance of being selected. A random sampling process greatly increases the chances of the sample's responses representing the population from which the sample is drawn. Even then, there is always a slim chance that the random sample may be nonrepresentative.

In addition to not being randomly selected, focus group participants differ from the general public by their willingness to spend the necessary time and to provide the types of information of interest. Researchers can never be sure if those who participate differ in really important ways from those contacted who declined participation.

Other serious limitations that prevent generalizing to the larger population include participant responses that are elicited under highly artificial conditions. Normal viewing or listening behavior takes place in the household setting or at work (or in vehicles in the case of radio), not in the company of 9 or 10 complete strangers whom the participant has never seen before and will never see again. These conditions also increase the likelihood of groupthink or contagion of ideas. This means that one person's response shapes the subsequent responses of other group members and would not likely have occurred if each individual were interviewed separately. Sometimes a domineering and authoritative individual may intimidate other participants or pressure them to go along with a given expressed view, even if it is not what the others really think.

The specific questions asked, how they are worded, the order in which they are asked, and how they are presented verbally to participants also influence the quantity and quality of responses. Questions may elicit responses that would never have occurred spontaneously to participants outside the focus group setting. Finally, the quality of the moderator directly influences the focus group outcomes. Skilled moderators can make all group members feel comfortable and believe that their responses are equally valued, especially if participants disagree with what someone else has said.

Focus groups have enormous diagnostic value for programmers. "Why" questions are particularly well suited to focus groups, as well as any questions that require explanations that go beyond basic "yes or no" answers. And, just as group contagion can invalidate some responses, the group setting can successfully elicit responses that an individual may not have recalled when required to provide answers in traditional survey or individual interview settings; such responses may be elicited especially when members feel similar to other participants. Focus groups can also provide an effective means of developing appropriate questions to ask a larger random sample of audience members in future research that uses scientifically valid sampling procedures.

Music Research

Radio programmers want to know their audiences' opinions of different songs and different types of music. They need to know which songs are well liked and which ones no longer have audience approval (which songs are "burned out"). Callout research has been one popular, although controversial, method for discovering what listeners think about music selection.

Programmers conduct call-out research by selecting 5- to 15-second "hooks" from well-established songs and playing them for respondents over the telephone. A hook is a brief segment or musical phrase that captures the song's essence, frequently its theme or title. Using computers to place the calls, play the music, and record responses automatically, programmers are able to ask randomly selected respondents to rate 15 or 20 song hooks on a predetermined scale. Often a scale of 1 to 10 is used, where 1 represents "don't like" and 10 represents "like a lot." Call-out research indicates listeners' musical tastes at a given moment. If stations perform call-out research frequently (and some use it every day), a track record for each song develops, and based on it the music programmer can decide whether to leave the song in the station's rotation or drop it. When tied to the same songs for some time, it indicates song popularity but does not tell the programmer how often a particular song should be played. That remains the programmer's decision.

Another popular method of testing music is auditorium research. Programmers invite 75 to 150 people to a location where they jointly listen to and rate a variety of songs. Instead of rating just 15 or 20 hooks, as in telephone research, auditorium tests involve 200 to 400 hooks. Like call-out research, the method tells which songs are liked and disliked at the moment but not how often they should be aired.

Music testing is expensive. Call-out research requires an investment in employees to make the selections and maybe the calls—as well as investment in computer time to analyze the results. Auditorium tests involve recruiting costs and "co-op" money for participants (usually \$20 to \$35). Those stations lacking facilities and personnel for music testing can hire commercial firms specializing in such work. See www.musictec.com/method.html.

Television Quotient Data (TvQs)

Many programmers use Marketing Evaluation. Inc.'s proprietary television quotient data (TvQs) to supplement Nielsen ratings. While Nielsen provides information on how many people watched a program, TvQs measure the popularity/appeal (likeability) and familiarity of TV programs and performers (from TV, movies, sports, and other celebrity venues). TvQ data have been collected for over 40 years, relying on a panel of household members that since 1980 has included over 50,000 total households. Eight different services are provided: TvQ (programs), Performer Q, Product Q, Kids Product Q, Cartoon Q, Cable Q, Sports Q, and Dead Q (performers from the past). Of these, TvQ and Performer Q are the best-known measurements.

Networks and programmers use the various TvQ services to identify actors who have "star" potential, given the assessment of both *recognition* and *likeability* that the scores provide. Some

research companies use various Q scores to project the eventual success (or lack thereof) of a network series in syndication. Unlike ratings, these models factor in how people feel or felt about a program, not how many watched it. Like the Nielsen ratings, Q scores are numerical, but they are labeled "qualitative" because they assess how much performers and shows are liked. Nielsen ratings are objective measures of viewing, while Q scores are subjective measures of the appeal and familiarity of performers and programs.

Ratings Services

Ratings exert powerful influences on programming decisions by syndicators and station representatives (as illustrated in Chapter 3), by commercial network and station television programmers (as discussed in Chapters 4, 5, and 6), and by noncommercial television programmers (as covered in Chapter 7). Radio programmers also use ratings information to evaluate their market positions, choose formats, and convince advertisers to buy time (see Chapters 11 and 12). And ratings are used in cable and online in specialized ways (see Chapters 8, 9, and 10). In fact, all programmers use ratings in program decision making. Consequently, the rest of this chapter looks at the ways programmers interpret ratings data.

Using audience ratings is not restricted to programming applications. In fact, ratings were originally intended only to provide information for advertisers curious about audience size, and their value to advertisers continues to drive the ratings industry. Even today, unsponsored programs, including presidential addresses and political programs, are not rated by Nielsen exactly because they do not carry advertising.

One big change in 2007 was the inclusion of college students living away from home in the Nielsen database. Before then, only students who lived at home (or living-away students who came back to the parents' houses during holidays) were counted in ratings. Counting most students was expected to raise overall ratings for ESPN, FOX, and CW—and raise program ratings for such shows

as The Daily Show with Jon Stewart, The Colbert Report, and Drawn Together, as well as for the Adult Swim block on the Cartoon Network. Students are an especially valuable audience group because they continue to be channel surfers; high cost makes them unlikely to own TiVos or other DVRs in their campus housing.

Once the statistical reliability of ratings data became accepted, programmers began using these data to gauge the success of their decisions. As competition among networks and stations increased, ratings became the most important decision-making data in commercial broadcasting. Broadcast revenues, programs, stations, and individual careers depend on audience ratings. In the business of broadcasting, high ratings normally result in profits (and continuing careers). Broadcasting also has public service obligations and other aspirations and commitments, but on the purely economic side, a network or station will eliminate a program that receives low "numbers" if other, more viable options are available.

Cable and broadcast ratings cannot be compared directly because the potential audience viewing subscription channels is about 90 percent that of the commercial broadcast networks (67 percent cable and 23 percent satellite/other), and many of cable's programs are scheduled in rotating and repeating patterns rather than one-time-only patterns, although this is changing because broadcasters now repeat their shows and cable has more original fare. In addition to using standard ratings numbers, cable programmers analyze ratings to determine audience reach—how many people over a period of time viewed a repeated program or channel—much as public television programmers use ratings.

Articulating the power of audience ratings may sound crass to those who consider broadcasting an art form—or passé to those who are immersed in the internet—but in reality ratings continue to be the most important measure of commercial success. The efforts of most people involved in commercial broadcasting focus on achieving the *highest possible numbers*. Targeting more precisely defined audiences—such as women aged 25 to 54—is an alternate approach for television networks and

stations that cannot immediately achieve a numberone position in the adults 18+ category.

Ratings affect television and radio programming and sales at stations and at networks; they affect independent producers, Hollywood studios, distributing companies, and advertisers and their agencies. In 2006, Nielsen responded to the increased viewing of the Spanish-language networks by including them in its national audience measurements, ultimately legitimizing Univision as a fifth national network and spurring its advertising sales. Inclusion in weekly trade listings of network ratings is the strongest visible evidence of UNI's rise to full national competition with ABC, CBS, NBC, and FOX.

Like broadcasters, advertising-supported cable networks also need ratings information to convince advertising agencies to purchase time. Premium cable services such as HBO use their national ratings to convince local cable systems that their programs are watched and important for promoting the local system. Video game producers and online and telephone services have their own versions of measuring audiences to show that their content is viewed. Understanding the basics of the all-powerful numbers is essential in all of these businesses.

High ratings, demonstrating television's widespread household penetration, also carry clout with Congress. Legislators generally use television to get elected and reelected, and politicians pay attention to their local broadcasters and the five largest national networks because they reach such enormous numbers of people. Increasingly, the major cable operators and popular online sites have become influential with politicians because of their ability to reach certain types of audiences (especially upper socioeconomic levels).

Television Services

The most important distinction in television ratings is between *national* and *local* (also called *market*) ratings. Nielsen Media Research is presently the sole company in the United States producing nationally syndicated network audience measurements, although some of its clients are

not too thrilled with the monopoly it has on data collection. Nielsen is also the only company in the United States producing local station ratings for television (also leading to some criticism about methods and pricing). Other research firms collect and analyze television audience measurements of specialized types for only a portion of the country. Nielsen covers the entire country continuously for network ratings, using a separate sample of 12,000 households with people meters. The four largest broadcast networks and the top 50 cable networks contract with Nielsen for this ratings service. Nielsen Media Research is owned by the Dutch company VNU, which recently changed its name to The Nielsen Company; it also publishes SRDS, the leading advertising database, and owns Scarborough Research and Billboard Publications.

Nielsen conducts four nationwide sweeps of audiences for all local television stations—annually in *November*, *February*, *May*, *and July*—producing the vital local television reports (see 2.5). These market-by-market reports allow stations to compare themselves with the other stations in their market. A separate ratings report (electronic as well as printed in a book) is published for each of the 210 markets in the country for each ratings period. These data are based on local people meters in the largest markets, a mix of diaries and local meters in the middle-sized markets, and diaries only in the smaller markets. The metered markets operate on a sample of 400 to 500 homes that do not duplicate the national people meter sample.

Today's ratings software can track hundreds of channels—broadcast or cable, terrestrial or satellite, PC or TV-delivered—and scan every channel every three seconds to report the tuning status of every TV set in the sample households. The data can be downloaded by conventional telephone or cell phone, reported the following morning as the overnights, and later compiled into the national people-meter database.

A ratings period consists of four sequential weeks of data, reported week by week and averaged for the month. In addition to the four major nationwide television sweeps, large-market stations purchase ratings for as many as three more ratings periods (October, January, and March).

Midsized and smaller television markets perhaps purchase one ratings book beyond the four sweeps. The stations in a market contract individually with Nielsen for a ratings book, paying the cost of data collection, analysis, and reporting. In the very largest markets, stations pay as much as \$1.5 million a year for ratings; in very small markets, however, the price may be as low as \$10,000 annually. It is important to understand that stations pay for ratings in their market, and the quality could be better if stations could afford to pay more (advertisers, agencies, and reps cover little of the cost). For example, samples could be larger and more representative, diaries could be more carefully double-checked, more call-backs could be made, and data analysis could be more reliable, but each of these steps would substantially increase the cost of ratings to the stations.

Normally, station programmers purchase only the books for their own market, but programmers dealing with groups of stations may purchase all 210 local market reports for the entire country or a subset of books for markets where they have stations or cable systems. They can use these books to cross-compare the performance of programs in different markets, at different times of day, with different lead-in shows, and so on. Subsequent chapters contain discussions about how ratings are used in specific sets of circumstances and point out specific weaknesses (see 2.6).

Network viewing estimates now come from a nationwide people-meter sample of 10,000 households with and without cable. To be included in Nielsen reports, at least 3 percent of viewer meters (or diaries in local reports) must record viewing of a cable service. This means that only the top 30 or so cable networks figure in most ratings calculations. Multiple-set households are counted only once in total television households (TVHH), even though the sum of the audiences to several programs telecast simultaneously may be bigger than the number of households said to be viewing at one time (HUT) because one household may tune to more than one program. Indeed, the average household has more sets than people. As of 2007, one ratings point represented the viewing of 112,000,000 television households (usually

2.5

PART ONE

Nielsen Media Research

ielsen gathers and interprets data on a wide range of consumer products and services as well as on television and the internet (no radio). Nielsen's network audience estimates are reported in the Nielsen National TV Ratings (often abbreviated NTI for the division that collects the data), twice-ayear summary books, and in the abbreviated weekly booklets called The Pocketpiece Report (see Chapter 4 for a sample pocketpiece page). Besides the networkby-network ratings, pocketpieces now include the collective ratings for independent television stations, superstations, national public broadcasting (PBS), basic cable networks, and premium cable networks, giving network programmers a handy tool for comparing the performance of the networks and their competitors. DVD viewing is now fully incorporated into these reports. National viewing data are also reported in the other forms described in Chapter 3, often combined with product purchase and usage data.

Nielsen also collects nightly ratings called *overnights* in the top 56 metered markets, publishing this information every morning for the benefit of network executives and purchasing stations. Overnights, because of the smaller samples used and the big-city nature of the viewers, are only indicators of what the network ratings probably will be when the sixmonth NTIs are issued. But as more and more major markets are added to the overnight sample, the match between the overnight sample and the total sample comes much closer. In the period from 2005 to 2008, about 70 percent of U.S. TV homes were in the overnight sample.

Nielsen's other widely known task is the measurement of local market television viewing. These measurement reports are known as the Nielsen Station Index (NSI) and are published in *Viewers in Profile* for each market. Called the "ratings books," they are purchased by most television stations and advertising agencies. Nielsen household samples are drawn from the most recent national census, and the ratings are not weighted (adjusted to fit national or local population percentages). NSI prepares county-by-county reports on television viewing, various reports for commercial time buyers, several reports for cable networks and system operators,

and an online computer service for customized analysis of reach, frequency, and audience flow.

Nielsen also offers a tracking service called the ScanTrack National Electronic Household Panel. This national panel consists of about 30,000 households who use handheld bar-code scanners to record all purchases, including prices, and whether each item was on sale. This information is then correlated with television viewing data derived from people meters, as well as from magazine and newspaper data. Each household transmits all its media data (TV and print) weekly over phone lines to Nielsen's center for data analysis. This service has enormous benefits for corporate brand managers and advertising agency media buyers.

The measurement of television audiences now includes computer users as programs appear on the internet. Launched a decade ago, Nielsen//NetRatings is a service designed to provide high-quality information about the internet in a special pocketpiece and other formats. Nowadays, Nielsen uses two separate web addresses for its two divisions: Nielsen Media Research (www.nielsenmedia.com) and Nielsen//NetRatings (www.nielsen-netratings.com).

Nielsen has another service called Monitor-Plus, which uses computer recognition technology to identify all commercials airing in the top 50 major markets. The NSI data is combined with the commercial data to provide a minute-by-minute gross rating point measurement for each TV spot overall; the information is also broken out by brand category and by how it compares to competitors' spots. Monitor-Plus enables buyers and sellers to track advertising activity across 15 specific categories of media, including television, radio, and print. Nielsen's newest service rates television commercials, measuring the viewing of commercial spots—not programs—using its minute-by-minute ratings. The commercials are averaged across entire programs because per-spot data is too unreliable. This will be useful to advertisers because industry experts have long estimated that commercial ratings are about 5 to 10 percent lower than program ratings. That percentage can now be refined over time and eventually refined for different kinds of commercials in different program environments.

2.6 The People-Meter Furor

uch questioning has long characterized attitudes toward rating services, but until 2004. most of this debate staved well within the media industry. At the start of that year, Nielsen Media Research announced plans to introduce local people meters in New York City and Los Angeles, replacing set-top meters and paper diaries and providing previously unavailable demographic details about local viewers.

But when preliminary testing showed a large drop-off in total viewing, especially among minority audiences, Nielsen faced loud charges of racial and ethnic bias in the press. Much of the criticism came from a campaign spearheaded by Rupert Murdoch's News Corporation and a coalition of black and Hispanic community leaders. In addition, producers of programs targeted to minority populations became worried that the new system would underrepresent minority viewing. On the other hand, many experts claimed that minorities had been oversampled for decades, which led to an apparent drop in viewing

when they were more accurately measured. Attempts to quell suspicions were marked with numerous deays, and congressional investigations and audits were threatened, despite the issue being largely perceptual rather than substantive.

To improve its image and forestall legal action, The Nielsen Company had to lobby Congress, make big charity donations, and undertake sponsorship of community events for minorities in several cities. (Insiders chuckled to think of Nielsen Media Research handing out pens, T-shirts, and balloons in fair booths because the company does not sell anything to the public; its highly priced products are sold only to other media companies.) By the end of the year, the issue seemed resolved after outgoing NAACP President and CEO Kweisi Mfune announced support for Nielsen's use of people meters in local TV markets. But the issue could be resurrected. Ratings are less than perfect to start with, and the services do not have a history of accurately measuring minority viewing.

abbreviated 112.0 mill.), and each household represented 2.6 people.4

Radio Services

Only one company, Arbitron, provides quantitative local and national radio ratings. The consolidation of radio ownership in the late 1990s effectively drove out the need for competing services. Strategic Media Research converted its old Accuratings measurement (successor to Birch Ratings) into Accutrack, one of several similar services that qualitatively measure radio listening.

Arbitron measures radio audience sizes using paper diaries (and the internet for those who prefer responding online). Arbitron's Radio Market Report tracks both in-home and out-of-home listening (in cars, offices, and other places) for local radio stations in all of the 299 markets. The data come from weekly diaries mailed to a sample of households in each market. Each person 12 years or older gets a separate diary to fill out for one week, usually running from Thursday to Wednesday when it is mailed back to Arbitron. New random samples participate each week, and each participant sending back a usable diary currently gets \$3. The size of the sample depends on the history of response in the market and how much data collection the stations are willing to pay for (larger samples cost more money).

Arbitron collects ratings for 48 weeks each year in the larger markets and for as few as 16 weeks in the smaller markets. This system is called continuous radio measurement, although it skips three weeks around Christmas/New Year's and one week in late spring. Arbitron also offers county-by-county reports of radio listening reports for about 42 customized survey areas and annual ratings for internet radio. It also provides Arbitron Information on Demand (AID), an online computer service for radio diary research. Recent radio ratings from Arbitron are available at www.radioandrecords.com.

Experiments with Arbitron's Portable People Meter (PPM) are ongoing in the Houston and Philadelphia markets, and plans call for adding

New York, Los Angeles, and other major markets. A PPM is the size of a cell phone or pager, and it records all daily electronic listening for several months. Monthly rating reports for the top ten U.S. markets are the goal, but so far the technology has had problems. Discouraged by the slow pace of the PPM experiments, by 2007 several of the biggest radio companies had jointly funded a competing company, Media Audit, that uses "smart phones" as the measurement system. Like other such ventures in the past, its likelihood of success is small. A Nielsen and Arbitron joint venture, Project Apollo, probably has a greater chance of succeeding because of their greater experience and deeper pockets. Their new system uses software meters inside cell phones, PDAs, and other handheld media to measure radio consumption and product/service purchases.

Radio's All Dimension Audience Research (RADAR 91), owned by Arbitron, reports on the performance of the national radio services. RADAR reports cover the size and demographics composition of over 40 major radio services, including those from the ABC Radio Networks, American Urban Radio Networks, Crystal Media Networks, Dial Global, Jones MediaAmerica Radio Network, Premiere Radio Networks, Westwood One Radio Networks, and others. RADAR reports are published quarterly, based on analyses of 48 weeks of continuous measurement using 125,000 diarykeepers. Arbitron also uses Mediaguide's broadcast monitoring technology to verify whether the radio commercials that were scheduled to be aired on affiliated stations of RADAR-rated networks were broadcast as indicated on the network commercial clearance reports. RADAR ratings are the only nationwide radio network ratings, and are reported for the top 10, 25, and 50 markets.

Online Radio

Since 2004, *comScore*, Arbitron's online service, has provided broadcast-type ratings for the online radio industry. It passively and continuously captures the online radio behavior across the country of nearly 250,000 U.S. listeners. ComScore reports weekly cumes, quarter-hour ratings, and most

demographics in the 15 standard broadcast dayparts for AOL Radio, Clear Channel Online Music, ESPN Radio, Live 365, and Yahoo Music Launchout. Measurement is important to these big radio webcasters because it legitimizes a program service that reaches far beyond the usual geographic limits for a radio station and supplies advertisers with the data they need to make informed decisions about media buys.

Video Games

Until advertising began appearing in video games, user measurement was not a priority, even though video game playing was clearly replacing some traditional media behaviors (especially among the 18 to 34 male demographic). But by 2005, the video game industry was raking in more billions of dollars annually than the movie industry, a fact that made the advertising industry take note. Looking ahead in 2004, Nielsen expanded its definition of viewing to include "screen-based" advertising in order to include games, cell phones, wireless, and other portable media, and began testing ways to measure viewing by game users.

Console-based video game systems account for 15 percent of teenage males' daily use of media during prime time. One recently altered factor was the move of "television prime time for young males" into the late-night time period, leaving 8 to 11 P.M. for games. Nielsen has developed Game-Play Metrics as a way of mining people-meter data collected on television and internet use, adding the passive collection of game titles, and matching all the data to demographics and dayparts to inform the sale of advertising. GamePlay Metrics reports tell who is playing what game, the type of console used (applies to Sony, Microsoft, and Nintendo, so far), the genre of the game, and what other media the players consume. The weekly data comes from the same 10,000 households used to provide television ratings. The next generation of game consoles is likely to include special signals related to advertising in games that Nielsen can track, and such measurements will be extended to wireless (phone and PDA) receivers as fast as the technology can be developed. Selling advertising within games and consoles is part of a national media trend to place ads everywhere and closely measure media usage. Industry profits are needed to fund the enormous cost of developing subsequent generations of consoles, and later, wireless equipment and content.

Specialized Audiences

Programmers and advertisers constantly pressure the rating services for more information about aspects of the increasingly fragmented media audience. On the television side, the larger audience shares captured by cable create demand for an even more precise understanding of audience viewing habits. Thus, in local market reports, the ratings companies break demographic information into smaller units (such as 10-year jumps for radio) and more useful categories for different groups of advertisers: Both women 18 to 34 and women 25 to 49 are now included, for example, as well as similar subgroups of men, children, and teens.

In addition to local and national ratings reports, Nielsen and Arbitron offer various customized reports covering narrower views of the audience (for example, males aged 18 to 34, Hispanic women aged 25 to 54, or college students) and specialized programming, such as Nielsen's analyses of syndicated program ratings, which are particularly useful to stations making program purchases. Chapters 3 and 6 make a special point of the importance of syndicated program reports, which are illustrated later in this chapter.

Ratings Terminology and Measurement **Computations**

Nielsen collects television audience estimates by randomly selecting viewers from the 210 U.S. broadcast television markets. The number of markets varies slightly from year to year and has grown along with population increases. Nielsen calls the markets Designated Market Areas (DMAs). These areas are roughly equivalent to Areas of Dominant Influence (ADIs) as determined by Arbitron for measuring radio markets. Many more radio markets exist, however, to account for listening in low-population-density areas. Nielsen collapses these very small markets with the nearest big city television audiences.

Survey Areas

For each market, Nielsen collects ratings data from more than just the DMA, as shown in 2.7. The smallest measurement unit is the Metro Area, the next largest is the local DMA, and the largest unit (part shown) is the Nielsen Survey Index Area (NSI Area). The NSI Area includes the DMA and the Metro Area but also encompasses counties outside the DMA where viewing can be attributed to a station in the DMA. These three geographical areas are described more fully in the following sections.

NSI Area

The NSI Area includes all counties measured in a ratings survey, including counties outside the DMA when substantial viewing of stations inside the DMA occurs in them—viewership is usually the result of carriage by cable systems. Rarely used by commercial television programmers (because DMAs are more useful), NSI Area figures show a station's total estimated reach or circulation. As indicated earlier, reach tells how many people have viewed or listened to a station in the past, and it therefore suggests how many could view or listen in the future. In cable, reach tells how many households subscribe to basic cable service. Reach is an important measure for radio, public television, cable, and online websites. Another name for reach is cumulative audience, or cume.

DMA

Each county in the United States is assigned to only one DMA. Generally, a DMA centers on a single city, such as Charleston, Denver, or New York, but in some cases two or even three cities are linked in hyphenated markets, as in the Florence/Myrtle Beach and Springfield/Decatur/Champaign markets. All stations in these multiple markets reach most viewers, making the cities one television viewing market. Nielsen ranks each DMA according

Reprinted by permission of Nielsen Media Research.

to the estimated number of television households within its counties. As of 2008, the top five DMAs in rank order were New York (with over 7 million TV households), Los Angeles, Chicago, Philadelphia, and San Francisco/Oakland/San Jose.

Metro Areas

The third geographical area, the Metro Survey Area (MSA) in radio and Metro Rating Area (MRA) or simply "Metro" in television, is the smallest of the three survey areas and is the one most frequently used for radio programming. The Metro includes only a small number of counties closest to the home city of the DMA and consists of only a single, large county in some parts of the United States,

especially in the West. Because competing big-city radio signals generally blanket the Metro, urban radio programmers use it to determine the success or failure of programming decisions. (Coverage patterns in outlying areas may vary too widely to compare.) The Metro represents the majority of urban radio listeners, the bulk of office and store listening, and a large part of in-car listening. Altogether, more than 280 Metro areas are measured by Arbitron for radio listening. Radio stations on the fringe of the Metro area are more likely to refer to Total Survey Area (TSA), which is comparable to NSI area measures. But television programmers rarely use Metro ratings because no demographic breakouts are available.

To use any of these ratings services for programming decisions, programmers must understand how the estimates are produced. Using ratings without this knowledge is like trying to play chess without learning the rules. Pieces can be moved, but winning the game is unlikely. As the saying goes, "Audiences count, but only in the way they are counted." The following subsections provide an overview of the basics of audience computations.

Ratings/Shares/HUTs

A rating is an estimate of the percentage of the total number of people or households in a population tuned to a specific station or network during a specific time period (daypart) such as morning drivetime or prime access (7 to 8 P.M. eastern/Pacific time). A share is an estimate of the percentage of people or households that are actually using radio or television and are tuned to a specific station or network during a specific daypart. The sum of all program shares equals 100 percent, but the sum of all ratings equals the percentage of total viewers (one must include nonviewers to get 100 percent). Ratings depend on a count of all receivers; shares on a count of all users. Shares are always bigger percentages than ratings for the same program or station because some people who could watch television (or listen to radio) are not watching (they are sleeping or playing games or actually working).

Ratings are always a percentage estimate of an entire population, whether the population refers to all households in the country or all people aged 25 to 54 or all adults 12+ or all women aged 18 to 49. A share is always a percentage of those households or people in that population using the particular medium at a specific time. To restate, *shares always appear larger than ratings because they are based on a smaller sample of people*. Fewer people use television (or radio or cable or the internet) than could use it if all were at home, awake, and choosing television above other activities. Both estimates are percentages of an entire group, although the percent sign is often omitted.

Sales staffs use ratings to set advertising rates. Programmers generally use shares in decisions about programs because shares show how well a program does against its competition. Shares eliminate all the people who are not watching TV and show how many of those watching TV are tuned to a program or station. Programmers at broadcast networks and stations as well as cable services typically refer to their *shares of an actual audience*, not their percentage (ratings) of potential households, although newspaper articles often report ratings.⁵

The combined ratings of all stations or networks during a particular daypart provide an estimate of the number of households using television (HUTs), persons using television (PUTs), or persons using radio (PURs). HUTs, PUTs, and PURs are used to compute the shares for each station or network.

To illustrate these concepts, let's assume there are only four network television options in the United States and that Nielsen's 10,000 metered households indicate the following hypothetical data for prime time:

Network	Household Viewing
ABC	1,904
CBS	1,928
NBC	1,976
FOX	1,222
None	2,970
Total	10,000

The HUT level is .703 or 70.3 percent (7,030/10,000), calculated by adding the households watching television and dividing by the total number of households with television (1,904 + 1,928 + 1,976 + 1,222 divided by 10,000 equals .703). The answer is changed from a decimal to a percentage by multiplying by 100. A HUT of 70.3 means an estimated 70 percent of all households had a television set on at the time of the measurement. The individual ratings and shares for the four networks can now be calculated.

$$RATING = \frac{\text{Households Watching a Network}}{\text{Households with Receivers}}$$

 $SHARE = \frac{Households\ Watching\ a\ Network}{Households\ Watching\ TV}$

To calculate a rating, the number of households watching a network is divided by the total number of households that have receivers. To calculate shares, the number of households watching ABC, for example, is divided by the total number of households watching television.

Network Ratings	Share
$ABC \frac{1904}{10000} = .190 \text{ or } 19\%$	$\frac{1904}{7030}$ = .271 or 27.1%
CBS $\frac{1928}{10000}$ = .193 or 19.3%	$\frac{1928}{7030}$ = .274 or 27.4%
NBC $\frac{1976}{10000}$ = .198 or 19.8%	$\frac{1976}{7030}$ = .281 or 28.1%
$FOX \frac{1222}{10000} = .122 \text{ or } 12.2\%$	$\frac{1222}{7030}$ = .174 or 17.4%

The individual ratings for all the stations in a market during a given daypart should approximately equal the HUT. Network programmers primarily use rating and share estimates to compare program audiences, but often they also are interested in the specific number of persons in the audience. Ratings can be used to project to any particular population. For example, the data for the four networks listed produced these estimates for the entire United States (having a total population of about 112 million households):

Network	Rating	\times Population	Population = HH Estimate
ABC	.190	× 112 million	= 21,280,000
CBS	.193	\times 112 million	= 21,616,000
NBC	.194	\times 112 million	= 21,728,000
FOX	.122	\times 112 million	= 13,664,000
	.699 (o	or 69.9%)	= 78,288,000

The number 21,800,000 represents the 21+ million people estimated to be watching ABC (at this specific time). These calculations can be verified by multiplying the HUT, 69.9, by the total number of households: $.699 \times 112$ million = 78,288,000, the total for the four networks.

Using part of a page from a Charleston (SC) Nielsen book (see 2.8), we can see how ratings and shares were computed for the local television stations WCBD, WCIV, and WCSC. To calculate the rating and share for WCSC, in this

morning/midday example, Nielsen first analyzed diaries from a sample of households (HH) in the Charleston DMA. It then projected the sample returns to the DMA household population. Approximately 8 percent of the total diaries were tuned to WCSC from 12 noon to 3 P.M. If we assume that 8 percent of the diaries reflects 8 percent of the total households, the number of homes watching WCSC can then be calculated. An estimated 266,400 television households in the Charleston DMA (this information is supplied on another page) yields 21,312 homes for WCSC $(.08 \times 266,400 = 21,312)$. The share for WCSC was computed by using the HUT (see the H/P/T totals), which was 24 (percent). Twentyfour percent of 266,400 yields 63,936 HH, and when that figure is divided into WCSC's 21,312 HH, a share of 34 results. (Actually, the calculation is 33, but because the reported ratings are rounded to the nearest whole number, the math does not always work with whole numbers. Either the 8 rating is actually slightly larger than 8 and rounded down, or the HUT rating is slightly lower than 24 and rounded up.)

Further evidence of Nielsen's rounding can be seen in the 12 noon to 4:00 P.M. time period on the same page. In that time period of the Nielsen report, you will see that WCBD and WCIV both have "2" ratings, but each station's share is different. We can compute more accurate ratings by manipulating the basic formula, usually written as

$$\frac{\text{Rating}}{\text{HUT}} \times 100 = \text{SHARE}$$

The calculated value is multiplied by 100 to create whole numbers instead of decimals for shares and ratings. If we transpose to

$$RATING = \frac{Share \times HUT}{100}$$

we can rate more accurately:

WCBD Rating
$$\frac{7 \times 30}{100} = 2.1$$

WCIV Rating
$$\frac{8 \times 30}{100} = 2.4$$

Keep in mind that all ratings and shares are percentages and must include decimal points for all

2.8 Daypart Ratings Page

	RO	DAVEART	D	MA	HC	annianti il retto	JSEHOLD PERS									DMA RATINGS PERSONS WOMEN																-			-		RCENT DIST			-	RAT	TV HH RATINGS IN		
H		DAYPART TIME (ETZ)			IN MKT	SHA	RE	TRE	ND			T	-	-	-	T	_	_	+		T	T	1	-	-	1	-	-	ME	7	_	-	THS	CHI	LD	MET	HOME	ADJ D	ACE	NT)	ADJ	ACE MA'S		
1	SHR	STATION	RTG	SHE	SHR	MAY '03	FEB TO3	'02			12- 24				21- 49	- 1	35 3	- 1	- 1	- 1	12-	- 1	- 1	- 1		Ĝ	+ 3	34	18-	_	25- 49	_		2-		MEI	DMA			#3				
+	2	MONFRI.	7	8	OD.	10	11	12	13	15	17	18	19	20	21	22	23	24	25	26	27	28	29	31	32	34	35	36	37	38	39	40	41	42	43	44	45	46	47	48	49	50		
< 4			<< 24		16	25	25	26	22	12	4	6	7	11	11	13	17	16	20	15	4	9	12	14	15	14	13	1 6	9	10	11	11	3	7	6	-								
5	34 19 19 2	MONFRI. 7:00A- 9:00A WBLN W WCBD N WCIV A WCSC C WITV P WMMP UP	5 1	30 16 17 3	47 26 27	15	116	17	22 18 18 4	2 2	1	2 1 1	2 1 2	4 2 2	4 2 2	4 2 2	6 4 3	4 3 3	654	6 3 3	1	4 2 2	5 3 2	6 3 2	6 3 2	5 4 2	3 2 3	1	2 1 2	2 1 2	2 1 2	2 1 3	4"	3	3	88 87 84 60	95 94 92 100	2	4 5	53153		The second secon		
< 1 < 1 < < <	2	WTAT F DSNY LIF NIK TNT USA WTBS IT	<< << << << << << << << << << << << <<		7	2 NR			4		1					-			CARBONS OUR ASSESSMENT OF STREET STREET		1							1	1					1	1									
8		MONFRI.	27		17	26	26	26	26	14	5	7	8	11	12	14	19	17	23	18	6	11	14	16	16	15	13	5	9	9	10	11	4	10	9				-	+	-			
3 3 1 <	13 13 14 4	9:00A- NOON WBLN W WCBD N WCIV A WCSC C WITV P WMMP UP	3 1 <<	11 13 5	27 26 31	9 24 3	12	10 21	10 10 21 4	1 2 1	1		1	1 1 1	1 1 1 1	1 1 1	2 2 3	1	3 2 4	2 2 2	2	1 1	1 2 1	1 2 1 1	2 2 1	1111	1 1 2			1	1	1		3	2	78 93 75 63	93 99 91 100	2 1 6	2	3				
2 1 < 2 1 < 1 3	7 3 7 3 3	WTAT F DSNY LIF NIK TNT USA WTBS IT H/P/T.*	1 1 1 1 1 23	2 3 6 3	15	4 4 NR	NR NR 7 NR	NR 3 4	NR 3 8	1	1 9	1 1 1 8	1 1 1 1 8	1 1 9	1 1 1 9	9	1	1	17	1 16	1 2 12 12	1 1 1 1 1 1 1 1 1 1 1 1 1 1 1 1 1 1 1 1	1 1 1 1 1 1 1 1 1 1 1 1 1 1 1 1 1 1 1 1	1 1 1 1 1 1 1 1 1 1 1 1 1 1 1 1 1 1 1 1	1 1 1 1 1 1 1 1 1 1 1 1 1 1 1 1 1 1 1 1	1 10	1	1	1 1 6	1	1 1 6	1	1 1 9	1 1 4	3	79	93	5		2				
< 1 2	6 9 36 4 2 4	MONFRI. NOON- 3:00P WBLN W WCBD M WCIV A WCSC C WITV P WMMP UP WMMP UP DSNY LIF NIK TNT	<< 1 2 8 <<	6	11 13 67	13 3 38 4 NR	10 8 34	9 6 35 NR 2	6 8 30 2 3 5 NR 4 5	1 1 4	1 2 1 1 1 1	1 2 1	1 2	1 1 3	1 1 3	1 1 3	1 1 6	1 1 3 3	1 1 8 8	1 1 7 7	1 5 6 71	2 1 5 1 1 1 1	1 1 5 1	1 2 4	1 2 4	1 1 3	2		1		1	1	2 1	1 1 1 2	1 1	72 100 72 75 93 52	95 100 89 100 100 66	1 5	4	4 1 34				
1	3	USA WTBS IT	<< 1	4	12	NR 2	NR 2	2	3	12	1	10	0	10	10	10		12		10	1	15	15	14	14	10	7	2			-	0	1	1		,								
2		MONFRI. NOON- 4:00P WBLN W	24		12	23	24	22	29	12	11	10	g	10	10	10	15	12	18	18	15	15	15	14	14	10	1	3	5	5	5	6	12	9	9									
2	7 10 32 4 3	WCBD N WCIV A WCSC C WITV P WMMP UP WTAT F DSNY LIF NIK		8	14 16 60 7 6	4 35 4 NR	32	8 32 2 3 NR	9 28 2 4 5 NR 4	1 3	1 2 1 1 1	1 1 2 1 1 1	1 2 1	1 1 3	1 1 3	1 1 3	1 1 5	1 1 3	1 1 7	2 2 7 1 1	1 1 3 2 1 1 1 1	2 1 4 1 1 1 1 1	2 2 4 1	1 2 4	1 2 4	1 1 1 1	2		1	1	1	1	1 2 1 1 2	1 1 2	1 1	74 100 71 68 83 68	90 100 89 97 100 78	5 5 3	5	5 1 22				
V V		TNT USA	1	2		5 NR	NR	2			'				The second				1		1	-											2		1			-						
1 3	3	WTBS IT H/P/T.* MONFRI. 3:00P-	1 24	3	12	2		1	28	12	1 12	10	9	10	10	10	15	12	18	18	16	15	15	14	14	10	7	3	5	5	5	6	1 13	9	10									
3 5 < 1 2 1 <	2 6 3	5:00P WBLN W WCBD N WCIV A WCSC C WITV P WMMP UP WTAT F DSNY LIF	25 < 1 1 1 1 < <	8 19 2 5 3	32 16 38 5	4 24 3 NR	9 23 5 NR 2	9 20 3 4 2 NR	6 4 NR 3	1 2	1 1 2 1 1 1	1 1 1 1 1	2 1 2 1 1	2 1 2 1	2 1 2	2 1 2 1	3 1 4	3 1 2 1	3 2 5 1	4 2 5 1	1 2 3 1 1 1 1 1	3 1 3 1 1	3 1 3	4 2 2	4 2 3	3 1 2 1 1 1	1 1 1	1 1 1	1	1	1	1	2 1 1 2 1	1 1 2	1	100 78 93 66 65 68 71	100 87 93 86 95 100 85	8 55	2 3 7	3 3 2				
7 4 4	3	NIK TNT USA CON'T	1 1	3 2		4 2 NR	NR	1 3	5	1	2	1					-		1	1	1	1											3	1	2									

#1=COLUMBIA, SC #2=SAVANNAH #3=FLORENCE-MYRTLE BEACH 357,810 284,160 253,630

A Visual Aid for Remembering the Formula

he basic relationship among the three variables (rating, share, HUT) is easy to understand but sometimes difficult to remember. Here is a visual aid:

R S

(Putting the R "on top" is easy to remember because ratings are most important to the station or channel for advertising purposes.) Here's how to calculate: If you want R (ratings), cover the R with your finger. The result is S (share) multiplied by H (HUT). If you want share, cover the S with your finger. The result is R divided by H. Likewise, cover the H to calculate HUT: The result is R divided by S. (The number you get must be adjusted to provide a meaningful answer: If you multiplied, then divide the result by 100; if you divided, multiply the result by 100.) You may not get the exact result shown by Nielsen because the reported figures are rounded.

calculations, although to make their reports easy to read, ratings companies do not print the decimals (see 2.9).

One final point concerning the 12 noon to 3 P.M. example is that the HUT/PUT/TOTAL line is 24, but if we add all the stations, the total rating is actually 16. The uncounted rating points mean that 8 percent of the households in the DMA were viewing cable channels for which no one channel received a 1 rating. Individual shares for all the stations should equal 100 percent when totaled, even if the tiny shares for cable viewing are unreportable.

PUTs/PURs

Ratings and shares for television generally represent households but occasionally refer to specific demographic groups such as women aged 18 to 49. Radio ratings always represent individuals or persons, and therefore, the term *persons using radio* (PUR) is used. *Persons using television*

(PUT) is appropriate when calculations of individual viewers are made. Sales staffs and time buyers tend to be more interested in these calculations than programmers are, and one of the big advantages of people meters is that they supply individual-person data as well as household data for the advertising industry.

AQH/Cume

Programmers use two very important computations in calculating ratings: average quarter-hour (AQH) audiences and cumulative audience (cume) estimates. Program audiences are typically measured in 15-minute intervals, hence "quarter-hour audience." Meters can, in fact, measure one-minute audiences (or even one-second audiences in comedy research, for example), but a person or household is counted in a quarter hour if the television was turned on for a minimum of five minutes during the measurement period.

Although radio and television diaries also measure audience size in 15-minute intervals, TV programmers use these data in much larger units—by whole program or daypart. Quarter hours are the particular concern of those who try to count fickle radio listeners. (Both time units may be too broad for accurately measuring remote control grazers and radio button pushers.)

Cumulative audience measures are appropriate for small audiences that would not show up in rating/share measures. Cume measurements indicate the number of different people tuned in during a 15-minute (or longer) time period. Cume figures are always larger than AQH figures, which are averaged.

The basic difference between AQH and cume is that in the average quarter-hour calculation, persons can be counted more than once in a total daypart. For instance, a person could tune to a station for five minutes, switch stations or tune out, and then tune back in to the original station during a later quarter hour. This viewer would be counted twice in an AQH calculation but not in an exclusive cume calculation because it counts only the number of different persons listening. Cume is considered to be the reach of a station

because it tells you how many different persons were in the audience during a time period or daypart. It also reflects the growth or decay of an audience over time.

Public television and basic cable audiences are often too small for accurate measurement within one quarter hour, but cumulative ratings over a longer period of time may reflect more substantial audiences. Cumes can also be calculated for a single program over several airings, a common pattern in public television and cable measurements, permitting programmers to estimate the total number of people who watched a program. Commercial broadcasting with its special interest in the number of people watching one commercial spot generally uses AQH ratings.

Reach and Frequency Analysis

Salespeople most often use the concepts of *reach* and *frequency*. As we said earlier, **reach** refers to circulation or potential exposure—or the net size of the audience that actually gets the signal (gross would be all the people living in the country). Frequency refers to the number of times a person was exposed to a particular advertising message (or program). A high frequency means exposure to a message several times and indicates the "holding power" of a station, network, or program. Programmers usually schedule several interesting programs in succession, trying to create audience flow and achieve a high frequency for advertisers among successive programs appealing to the same viewers.

Television Market Reports and Other Programming Aids

Market reports (or "books") are divided into sections to allow programmers, salespeople, and advertisers to examine an audience from many perspectives for a particular local DMA. In television, the major sections are: Daypart Audiences, Time Period Averages, and Program Averages.

Daypart Audiences

The Daypart Audiences section divides viewing into 37 dayparts, a highly useful format for analyzing a station's overall performance in specific time blocks. For instance, Monday through Friday noon to 6 P.M. provides a quick summary of the ratings and shares for all stations during that daypart. The page from a Nielsen book in 2.8, presented earlier, shows the crucial 3 P.M. to 5 P.M. period in the Charleston market toward the bottom.

Nielsen divides the viewers into 26 demographic (age and sex) classifications for both the DMA and the NSI station totals. For just one station, 754 ratings cells are required in order to fill out all 26 Nielsen people categories and 37 daypart categories for station totals alone. A single ratings book page contains an immense amount of data. Most programmers use computers to analyze the data.

A look at 2.8, presented in the previous section, shows that WCSC was the strongest television station in the market in the afternoon daypart, with a 7 rating/30 share in the DMA and 7/32 in the Metro. It was very strong with both W 18–49 and W 18–34 (the usual shorthand used in ratings analyses). No doubt this station was delighted because these demographics are very easy to sell to advertisers.

Programmers normally compare the current numbers to previous performances. Tracking a daypart shows how the station or program is doing over time. It is also important for selecting syndicated programs (see Chapters 3 and 6). Rarely will program decisions be based on only one book unless the numbers are very low and very credible, and no hope for improvement is in sight.

Time Period Averages

Television programmers are interested not only in broad dayparts but in quarter-hour or half-hour segments within them. This information, found in the Time Period Averages section of ratings books, is useful for determining a program's strength against the competition for a specific quarter hour or half hour. Managers of affiliates look here, for example, to see how their local newscast stacks up against its competitors. The Time Period Averages section also has an overview of access time and early fringe competition and shows lead-in and lead-out effects. Programmers use these data to analyze performance in time segments. (Salespeople use these data to determine spot ratings.)

Averages for the whole week, Monday through Friday, are included in the Time Period Averages section along with most prime-time network programming because it varies from night to night. These figures show performance during a daypart or time period when all days are averaged together, crucial data when a programmer is looking at stripped programming in early fringe and prime-time access.

Program Audiences

The last major section of a television ratings book, the one television programmers most often use, is the Program Audiences section. Rather than lumping a program into a daypart, this section breaks each daypart and program into 30-minute segments (and some 15-minute ones) to isolate individual programs on different days of the sweep weeks. The Program Audiences section is considered the "pure programming" section because each program is analyzed individually here. It shows the titles of the shows and any scheduling variations from night to night. This allows programmers to examine ratings for their local news, say, night by night—and to eliminate the odd night when a sporting event, for example, cuts into the news time.

Look at the Program Audiences data for Charleston at 6 P.M. in 2.10. The numbers are the DMA rating/share and Metro rating/share for all weekdays (AV5—average for Monday through Friday). Notice that in DMA measurements, WCSC dominates the competition with a 25 share for its local newscast. The local news shows on WCBD and WCIV have a 15 share and an 11 share, respectively. The FOX affiliate WTAT came in fourth with a 7 share for *Judge Judy*. This section permits analysis of individual programs without interference from ratings for adjacent programs.

In summary, the sections of a television book provide programmers with at least four different ways to evaluate station performance. Daypart Audience data show broad time periods without regard to specific programs. Time Period Averages listings provide programming data by quarter hours and half hours on a daily basis and are useful in analyzing competitive performance. Finally, Program Averages information isolates the "pure program" data. Each section answers different questions, and television programmers use every section as their questions shift.

Nielsen also issues reports on specific demographic groups or types of programs or station market sizes in easy-to-use formats, on which stations, reps, and ad agencies rely heavily. They also depend on other companies to reanalyze Nielsen's ratings data and to supplement the data with other research. Of all these additional services, programmers find analyses of syndicated television programs the most valuable.

Syndicated Program Reports

Affiliates and independents rely on off-network and first-run syndicated programming to fill parts of their broadcast days. Because syndicated programs are expensive, however, station decision makers want to know about a program's past performance. Will a program perform well in their market? Will its ratings justify its cost? Reps and program consultants especially want this information because they advise station programmers. Projecting or estimating ratings success for a first-run product is an involved process that finally comes down to an educated guess. The potentials of off-network programs are somewhat easier to evaluate, but even here no hard-and-fast rules exist. Lead-in programs, local competition, and audience fads always influence ratings. Even the most successful network program may fail in syndication or perform below its network numbers at a given time or in a given market.

In making decisions about syndicated programs, Nielsen's *Report on Syndicated Programs* is helpful. (The major television rep firms also provide similar analyses in less bulky and unwieldy formats, such as the Comtrac report example featured in Chapter 3.) A page from the Nielsen analysis

2.10 Program Audience Ratings Page

See Program Index for complete details of program start time, duration and weeks of telecast.

of *The Simpsons* is shown in 2.11. At the top-left corner of the page, you will find the number of markets telecasting the program, the distributor, and other data such as the program type and the number of episodes available.

The second section provides overall ratings and share data by market rank and by daypart. It shows the number of stations carrying The Simpsons in both early fringe (138 DMA markets) and in prime access (39 DMA markets), presumably to appeal to young viewers in the late afternoon time period. The Simpsons averaged a 4 rating and 7 share in both dayparts, higher than for any other daypart. This section shows which dayparts and market sizes a program has played most effectively in, quite useful information for programmers. Demographic data by daypart fill out the rest of this section.

The third section of the page shows a market breakout of specific stations carrying The Simpsons in syndication. The first market, alphabetically, that carried the program was Abilene-Sweetwater, where The Simpsons ran at 5:30 P.M. central time on KXVA, a FOX affiliate on Channel 15, and it had a 3 DMA rating and a 6 DMA (Monday through Friday) share. In that market, The Simpsons got lower ratings than the three nightly network newscasts but was a close fourth place to the NBC Nightly News (4/9). The Simpsons held most of its lead-in, That 70s Show, which had a 3 rating and a 7 share. Programmers use this information to purchase or renew the show and to schedule it during a daypart with a lead-in that will make it maximally successful.

This third section of the page also provides data on the total number of persons viewing a program in key demographic groups. In Albuquerque-Santa Fe, for example, The Simpsons was viewed at 5:00 P.M. by 11,000 women aged 18 to 49 (representing 55 viewers per 100 homes using television), a substantial increase over the lead-in. Nielsen's report does not show the demographic breakdown for competing stations. The programmer can, however, turn to the page for Jeopardy (not shown here) and see fewer women aged 18 to 49. Because Jeopardy also has many more women 18+ than The Simpsons, the programmer can deduce that Jeopardy skews toward older women who may not fit the advertisers' target.

Before purchasing a syndicated program, station programmers typically choose markets that are similar to their own in size and regional characteristics; they chart the performance of that program to determine its best daypart, its strengths and weaknesses against specific competing programs, and its demographic appeal. The Report on Syndicated Programs enables programmers to estimate the likely performance of a syndicated program and to schedule it effectively in their lineup. If a program proves unsuitable (demographically or in terms of ratings projections), the analysis is helpful in targeting another program to meet a station's programming needs.

The Report on Syndicated Programs is limited to program data about syndicated programs already on the air. Quite often stations must decide whether to purchase a program before it is released in syndication (or even produced). This is particularly the case with first-run syndicated programs (never on a network) and popular off-network programs (often purchased before any station has tried them out). (The subject of purchasing futures on programs is covered in Chapter 3.) In the case of offnetwork programming, national and local data from a program's network performance can be projected to the local market, although many markets differ substantially from the national market. Purchasing first-run syndicated programs is much riskier, though, because they lack both network and station track records.

Computerized Services

All operations, including programming, are routinely computerized at broadcast stations and cable services of all sizes. Television ratings and syndicated program reports come on diskettes or online, and are more commonly accessed on computers than in paper "books," though the old name sticks. Local station programmers use computer software to schedule shows; print daily, weekly, and annual program logs; and keep track of competitors' program purchases in the same way that reps track purchases for many markets (see Chapter 3).

2.11 Syndicated Program Report Page on the Simpsons

MARKETS REPORTING STATIONS REPORTING TOTAL TV HH'S IN DMA'S DMA % OF U.S. EPISODES AVAILABLE DIST: 20TH TELEVISION TYPE: SITUATION COMEDY

REPORT ON SYNDICATED PROGRAMS

NSI AVERAGE WEEK ESTIMATES NOV 2003 SIMPSONS M-F

30 MIN.

		-			_						-		-	DAYPA		-	*	_		-						
			AMC	HOU			SHA	RES	BY M		TRA		_							MA HO		OLD SHAP			T	
DAYPART		1-25		-		5-50		-	51-1		+	101+	_	1	AYP	ART		-	1-25	+	26-	-	01	100		01+
	NO.OF DMA'S	SH	% ARE		O.OF		ARE		D.OF MA'S	% SHAR			% HARE					NO.C			NO.OF DMA'S		NO.OF DMA'S	% SHARE	ND.OF DMA'S	SHAI
DAYTIME (M-F)† EARLY FRINGE (M-F) PRIME ACCESS (M-SAT) PRIME (S-S)	23 9 4		8 8 4		23 5 5		7 6 5		42 13 4	6 4 3		50 12 7	5	POST PE WEEKEN WEEKEN AVG. AL	D DAY	TIME(S	E(S&S)	11 25		7 5 6 7	8 1 2 25	7 10 9 7	5 10 8 49	6 4 6 5	16 3 11 73	3 6 5
	NO.	NO	T	%	T	DM	A HE	1							OTAL	L HO	USE	IOLD	SAN		RSO	NS				
DAYPART	OF MKT's	OF	:	U.S. TV	1	VG. QH RTG	SI	НR	TOTA HHLD (000)	S	11	B+ V/CVH		OMEN 18-49 W/CVH	(000)	25-54) V/	СУН	(000)	8+ V/CV	MEN (18-4	-	TEE 12- (000)		2- (000)	DREN 11 V/CV
DAYTIME (M-F)†							_	_	005	-		44	1430		94		26	2000	6		1994	55	1328	36	1145	31
EARLY FRINGE (M-F) PRIME ACCESS (M-SAT)	138	13		86 28		4		7	365		622 598	47	532		38		30	2222	6		748	59	473	37	377	29
PRIME (S-S)	20	2		13		3		5	45		240	53	193		14		31	252	56	6	200	44	158	35	91	20
POST PRIME (S-S)	40	4		40		3		6	144	6	777	54	646	45	42	26	29	988	6	-	853	59	281	19	124	8
WEEKEND DAYTIME(S&S)	17	1		10		3		5	30		140	45	121		11		38	162	5		140	45	122	40	89	29
WEEKEND PRE-PRIME(S&S)	32	3		29		3		6	109	-	506	46	421		32		30	688	6		584	53	336	31	308 998	21
TOTAL DAY	172	17	2			4		7	383		799	47	1571		107	71 9	28	2412	6		2144 18	56	1252	33	998	21
AVG. ALL TELECASTS INE 1 REPORTABLE		EC	IIID	ME	EK	AV	ED	AGE		7	15			- 10						0	10	30		MPETI		
STATIONS MARKET T.Z. ON AIR		TIM	E P	ERI	OD	AU	DIE	NC	S)		4		GRAM SYNDICA					ł			FO TIME	UR W	EEK A	VERAC	CES
INE 2 TOTAL DAY TATION CH. NET. DMA SHARE		DES	IGN	ATE	D M	IAR	(ET	AR	EA		ΛA				ST	TATIO	N TO	TALS				CORI	RESPO	ONDING	TIME	DM
INE 3 START NO. OF	DMA	%	-	-		NS S	-	-		-	6	(000) VS	TOTAL			-	S (000	-		-		PE	RIOD-	3 HIGH	ST	%
DAY TIME T/CS.	HH	SHR		OMEN			IEN		TNS CH	_ nn	SHR	V/100VH	HHLD			VOMEN		ME	-	TEENS						HI- RTG
INE 4		-				18+			12- 2 17 1							10 10	25-54		10 10	12-17	2-11	STATIC	N	PROGR	AM	22
LEAD-IN-PROGRAM BILENE-SWTWATR CE 5	1	2	3	4	5	6	7	8	9 10	11	12		13	14	15	16	17	18	19	20	21					22
XVA CH.15 F 5% M-F 5.30P 16T/C THAT 70S SHOW	3 3	6	3 4	10	7 10	6	15 18	14 16	32 23	6 3	6	(000) V/CVH	3	3 93	1 39	1 39	1 25	2 54	2 54	1 43		KTAB KTXS KRBC	ABC-	EVE NWS WORLD I NITELY I	WS.	7 7 4
LBANY-SCH-TROY EA 8 XXA CH.23 F 5% M-F 6.00P 20T/C #ACCESS HOLLYWD	2	3 2	2	5	2 3	3	6	5	6 1	0 2	3	(000) V/CVH	9	8 94	4 42	41	2 23	5 51	4 47	1 12	3 30	WNYT # WTEN+ WRGB	NWS	CH13 LIV 10-6 OCL NEWS A	oak	12 9
M-F 7.30P 20T/C #SEINFELD	3	5	3	7 4	5 4	6	10	8 9	4 1	0 3	5	(000) V/CVH	14	16 118	7 50	6 43	5 34	9 68	8 55	1 8	3 22	WTEN+ WRGB WNYT	JEOF KING FRIE	OF QUE	ENIS	12 6 6
MARKET AVG.		-	1							2	4	(000) V/CVH	1	1 12	5 47	5 42	3 29	7 62	6 52	1 9	3 26	AMALI	FRIE	NUS		0
LBANY, GA EA 4 FXL CH.31 F 5% M-F 11.00P 16T/C SEINFELD	1 2	3 4	2 4	2 4	2 4	2 4	1 4	25	4 3 2	21	3			1 98	1 58	1 38		1 40				WALB WVAG WABW	NWS NOT VARI	CNTR10- AVAILAE	11PM BLE	16
LBUQ-SANTA FE MT 8 ASA CH. 2 F 5% M-F 5.00P 20T/C	3	6	6	14	6	8	17	9 2	22	2 :	6		21		11	11	6 28	11 55	11 54	7 36	6 32	KOAT+#	ACTI	N 7 NWS	5	9 7
#SHARON OSBOURN	1	3	3	4	3	2	3		3	1		V/CVH		112	56	55	28			36	32	KOB +#	EYE	NTNS NE	WS-5	6 9
M-F 10.00P 20T/C #KASA F0X2NWS-9	3	5	6	8	5	7	13	10	17	9 :	5	(000) V/CVH	1	3 21 117	8 47	8 44	29	13 71	12 65	23	5	KOB +#	EYE	NTNSNV	IS-10	9
MARKET AVG.											3 6		1	9 22	10	10	5	12	11 59	6	4		KRQ	E NEWS-	10	8
MARILLO CE 6 CIT CH.14 F 6% FRI 1.00A 1T/C	<<		8	12	15	2		4		<		(000) V/CVH	<	115	52	50	28	63	59	30	19	KVII+#	J KN	ML-/ACC	SS	1 1
FRI 1.30A 1T/C #EXTREME DATING	<<		8	12	15	2	3	4		<-		(000) V/CVH	<<	<								KDBA KVII+# KFDA	ACC HM I	MERCIA SS H/JD/ MPRV/CN	L G JID IN HD	1
MARKET AVG.								-		<		(000)	<	<								KDBA	INFC	MERCIA	L .	*<
NCHORAGE YU 7 TBY CH. 4 F 6% M-F 5.3OP 2OT/C DHARMA-GREG	3 2	7	4 5	8 9	6	4 2	9	5 2	17	23	3 7	(000) V/CVH	:	5 3	2 34	1 31	1 29	2 35	2 34	1 26	2 46	KTVA	CBS	NITELY EVE NW	S	1772
M-F 6.30P 20T/C THAT 70S SHOW	3 5	7	5 9	8	6	6 8	10	6	15 16	21	3 7	(000) V/CVH		5 100	2 47	2	38	3 56	3 51	1 24	37	KYES KTUU KIMO #	CH 2	W CARE NEWSH EL-FORT	OLR	20
SUN 5.30P 4T/C	4	-	4	7	6 2	5	10	9			4 9	1	1	5 3	1	4	-	2	2		- 1	KYES		NDS -NWS SU	M	10

64

A ratings book represents only a fraction of the data available from Nielsen. The books exclude county of residence, ZIP code, specific viewing and listening patterns, and each individual diarist's reported age (in ratings books, age is presented only as group data, for example, women 18 to 34). A diary also tells what the diarist was watching at 5:45 P.M. before he or she began watching the 6 P.M. news. Nielsen stores this raw diary information on a secure website that stations can examine by means of a computer. The information allows programmers to analyze nonstandard dayparts, specific groups of ZIP codes, nonstandard demographics, county-by-county viewing, and audience flow patterns. In addition, sales staffs use the terminals to compute audience reach and frequency. If a programmer wants more information on selected programs on a market-by-market basis, Nielsen offers its ProFile Ranking Report (part of the Galaxy software), which provides detailed comparisons.

The management of any station, network, or cable service that subscribes to Nielsen (or Arbitron for radio) can personally review viewer or listener diaries, an important service for popular music radio stations. The main reason for inspecting diaries is to search for unexpected entries such as how listeners or viewers recorded the station's or service's name or call letters (or slogan or air personalities). Sometimes diarists name things differently than stations expect them to. A station can remedy incorrect attributions in subsequent ratings periods by submitting a limited number of different "nicknames" to Arbitron (or by changing a slogan if it is easily confused with a competitor's). Before computerized systems became available, firsthand diary reviews (usually performed by specialist companies located near the diary warehouses) were standard procedure after each ratings book was published. Computer tape now permits the information to be examined anywhere if the appropriate software is purchased.

On the national level, television programs are introduced, launched, bought, and withdrawn constantly. Keeping tabs on the daily changes in the program market involves constant record

keeping based on information from the trade press and reports from reps and distributors. Local programmers try to keep track of local program availabilities (syndicated programs not yet under contract in their markets) and their own station's program inventory, including contract details, plays, and amortization schedules. Only the largest stations and rep programmers, however, have the resources to track all this crucial programming information and keep timely records.

A great deal of information about program performance comes from third-party processors that sell research reports on national and syndicated television programs, using purchased Nielsen data. These services are based on the premise that raw information is less usable than processed information. For example, the Nielsen overnight ratings are analyzed by WRAP, a Windows ratingsanalysis program from Audience Analysis, Inc. (AAI). Third-party processors like WRAP compete with Nielsen's two services (ProFile and Navigator) and with another major service, Galaxy, which offers additional analysis. Nielsen also offers a software package (N-Power) that provides access to household and individual-level viewing for television, and TAPSCAN is a third-party processor of Arbitron radio ratings. Station program directors can create rankings (called rankers) of all radio stations in a market based on daypart or demographic criteria. For example, stations could be ranked on exclusive cume, which is a measure of listeners who listened only to a certain radio station and no other. Some other third-party processors are described in 2.12.

Radio Reports

Audiences for the nearly 14,000 radio stations in the United States are more fragmented than broadcast television audiences (although the spread of cable and satellite dishes is altering that condition for television). The largest radio markets such as Los Angeles have more than 80 stations, dividing the audience into tiny slivers per station. In general, radio stations compare their share of the

2.12 **Third-Party Analyses of Ratings**

carborough Research provides a syndicated research service to newspapers, television stations, radio stations, cable systems, internet companies, advertisers, and agencies. Scarborough is a joint venture of Arbitron and VNU Marketing Information. Scarborough provides syndicated studies to print and electronic media, new media companies, sports teams and leagues, agencies, advertisers, and yellow pages. Categories include consumer shopping patterns, demographics, media usage, and lifestyle activities for local markets. Scarborough surveys more than 180,000 adults 18+ using a two-phase methodology. Phase I is the telephone interview, and Phase II is a self-administered questionnaire and television diary. A total of 75 leading U.S. markets are measured. Every market has two six-month field periods each product year, eliminating any seasonal bias in the data and allowing users to account for new store openings and media changes.

One of Scarborough's premier products is called PRIME NExT, composed of four separate reports: Profile, which compiles lifestyles and habits of a specific audience group; Crosstab, which classifies several audience groups at once for comparisons; Schedule Analysis, which combines various proposed schedules of media and cost for analysis; and Media Analysis,

which collates media reach information into Cumulative (more than one spot or insertion minus duplication) or Ranker (average) reports, or into graph mode (visually combining elements from either report).

Media Audit is a near competitor to the kinds of studies done by Scarborough, except that the formeis accredited by the Media Ratings Council. Media Audit bills itself as a multimedia, qualitative audience survey covering about 450 target items for each rated media's audience. These qualitative data points cover things such as socioeconomic characteristics, lifestyles, business decision makers, product purchasing plans, retail shopping habits, travel history, supermarket shopping, stores shopped, products purchased, fast-food restaurants eaten in, soft drink consumption, brands purchased, health insurance coverage, leisure activities, banks used, credit cards used, and other selected consumer characteristics important to local media and advertisers.

Wimmer-Hudson Research & Development is also well known for its expertise in austom-designed telephone perceptual studies. These include music testinc, interactive software, focus groups, micro/macromarket studies, the Persuasion Process seminar, and optical scanning data collection services.

audience and their cumulative audience to that of other stations with similar formats in the same market. The most popular stations use shares, and the least popular use cumulative audiences, although formats that lend themselves to tuning in and out (such as all-news stations) use cumulative audience ratings even when they are popular. The top 100 radio markets correspond closely to television DMAs, but because some areas of the United States have radio but no television (largely in the West and South), the total number of radio markets (299) is thus greater than the 210 television DMAs.

Ratings books for radio are organized differently from those for television. An Arbitron radio ratings book contains Share Trends, followed by Demographic Breakouts, Daypart Averages, Cume Estimates, Hour-by-Hour Estimates, and a few smaller sections. The age and sex categories used in radio differ from those used for television because radio stations target their programming to more precisely defined demographic groups. Thus, age ranges for radio are smaller than those used in television:typically just 10 years (for example, 25-34). Most classification groups end in "4" for radio (24, 34, 44, 54, and so on); the groups used for television (18-49, 25-54, and so on) are broader, reflecting the more heterogeneous nature of television audiences and thus television advertising sales.

Metro Audience Trends

The Metro Audience Trends section reports a station's Metro shares for five ratings books—the current survey and the previous four surveys—covering

2.13 Metro Audience Trends Page

	MO	NDAY - SI	JNDAY	6AM -	MID	WEEKEND 6AM - MID					
	Spring 04	Summer 04	Fall 04	Winter 05	Spring 05	Spring 04	Summer 04	Fall 04	Winter 05	Spring 05	
NAAA											
SHARE AQH(00) CUME RTG	3.3 168 10.7	3.7 187 11.6	::	3.2 163 10.8	2.6 133 10.0	3.0 128 5.9	3.7 163 5.9	::	2.9 125 6.2	2.1 96 5.1	
WBBB						196 (197			0.2	0	
SHARE AQH(00) CUME RTG WCCC	3.6 183 11.7	3.7 187 11.1	::	3.5 179 11.6	4.4 228 13.2	3.0 128 5.6	3.2 143 6.4	::	3.0 129 5.8	3.4 150 6.8	
SHARE AQH(00) CUME RTG	8.0 404 16.7	7.6 385 14.9	::	7.8 395 15.7	9.4 488 17.1	7.5 324 10.4	7.0 315 9.5	::	7.8 331 10.0	9.5 426 11.1	
WDDD SHARE AQH(00) CUME RTG	2.5 124 7.4	2.7 140 8.4	::	2.1 108 6.4	2.3 120 7.1	3.2 136 4.7	3.4 150 5.5	::	2.3 97 4.3	2.5 112 4.7	

Footnote Symbols: ** Station(s) not reported this survey.

+ Station(s) reported with different call letters in prior surveys - see Page 5B.

Arbitron Ratings Co., used with permission.

a period of about one year. These data show a station's share pattern (its "trend") over time for four separate demographic groups: 12+, 18–34, 25–54, and 35–64. A hypothetical example for the demographic category of Total Persons 12+ is shown in 2.13. A programmer can get a quick overview of all stations' performance in the market from the Metro Audience Trends section.

Consider as an example the Monday to Sunday 6 A.M. to midnight period section 2.13. It shows that from spring 2004 to spring 2005, WCCC clearly led the market and continued to have climbing shares and cume ratings (cumulative audience) in the last book. WBBB was the numbertwo station and had an upwardly trending cume. WDDD was at the bottom of the market with flat ratings. WAAA's 12+ share declined from 3.3 to 2.6, but the drop is less than a full ratings point, and the station's cumulative rating remained at 10 percent of the market (near the bottom of the hypothetical market). Up-and-down data tell a program director that the music probably needs some fine-tuning in the Monday to Sunday 6 to midnight slot. WAAA's programmer needs to examine additional pages in the book, however, before making any major decision.

Demographic Breakouts

Pages from Arbitron's Specific Audience (see 2.14) and Listening Locations (see 2.15) sections illustrate different ways to display ratings and share data serving different purposes. Metro and TSA AQH ratings for several 10-year age groups broken out by gender (and Men 18+ and Women 18+), with Persons 12+ and Teens 12 to 17 listed separately, are presented in 2.14. In 2.15, Metro AQH population estimates are detailed for the three different places people hear radio (At Home, In-Car, and Other) for drivetime and three other time periods. These data are reported separately for Persons 12+, Men 18+, and Women 18+ (2.13 shows only Men 18+). These Specific Audience and Listening Locations data help programmers see which dayparts draw which audience subgroups and where listeners most use the station. In combination with other information provided in an Arbitron book, they suggest how different programming (or additional promotion) can improve audience composition (and therefore salability).

Arbitron also reports an hour-by-hour analysis that includes 10 demographic groups by AQH

Specific Audience

Teens 12-17

11

2.14 Specific Audience Page

							AQH	(00)					
	Persons 12+	Men 18+	Men 18-24	Men 25-34	Men 35-44	Men 45-54	Men 55-64	Women 18+	Women 18-24	Women 25-34	Women 35-44	Women 45-54	Women 55-64
WAAA METRO TSA	174 186	55 55	8 8	15 15	21 21	8 8		112 124	28 39	35 35	30 31	6	12 12
WBBB METRO TSA + WCCC	322 370	142 167	18 18	68 78	43 56	1	6	177 200	39 42	69 87	41 42	13 13	9
+ WCCC METRO TSA WDDD	636 667	269 281	12 12	23 23	36 36	47 53	59 60	366 385	22 22	19 27	5 1 5 1	44 46	88 95
METRO TSA WEEE METRO TSA	135 135	55 55	9	8 8	18 18	4 4	8	69 69	5 5	11	19 19	7 7	13

Footnote Symbols: * Audience estimates adjusted for actual broadcast schedule. + Station(s) reported with different call letters in prior surveys - see Page 5B.

Arbitron Ratings Co., used with permission.

2.15 Listening Locations Page

	MON	DAY- FRI BINED DI	RIVE	MON	DAY - FR DAM - 3P	IDAY M	10	VEEKEND DAM - 7P	M	MONE	DAY - SUI	YADAY
L	At Home	In - Car	Other	At Home	In - Car	Other	At Home	In - Car	Other	At Home	In - Car	Othe
	18	26	13	9	27	21	12	8	6	14	18	11
	31	46	23	16	47	37	46	31	23	33	42	25
	36	43	57	27	31	92	25	17	18	30	27	43
	26	32	42	18	21	61	42	28	30	30	27	43
	129	49	77	122	33	140	118	29	14	114	34	56
	51	19	30	41	11	48	73	18	9	56	17	27
	29	26	7	19	22	6	22	10	4	24	17	5
	47	42	11	40	47	13	61	28	11	52	37	11

Footnote Symbols: * Audience estimates adjusted for actual broadcast schedule. + Station(s) reported with different call letters in prior surveys - see Page 5B.

Arbitron Ratings Co., used with permission.

for the Metro area. A programmer can track a station's performance hour-by-hour from 5 A.M. to 1 A.M. to isolate particularly strong or weak hours during the broadcast day. Other sections of the Arbitron radio book include Exclusive Audience and Cume Duplication, both of which help radio programmers understand how listeners use radio.

Arbitron radio data also come on diskette or online in a format called Arbitrend, which reflects the continuously measured markets and contains demographics. Programmers for music radio stations can also purchase (or write) software to accomplish most of the tedious work involved in developing a station's music playlist. (See Chapter 11 on creating music wheels.) One widely used software program on the market accounts for 50 different characteristics of a song when selecting its position and rotation.

Time-Spent-Listening

Programmers are rarely content with the bare facts reported by Arbitron (or Nielsen in the case of television), so they use all these various ratings to make many different computations. For example, radio programmers generally want to know how long their audience listens to their station. Time-spent-listening (TSL) is computed by multiplying the number of quarter hours in a daypart times the rating and dividing by the cumulative audience.

To illustrate, assume we have the Los Angeles *Radio Market Report* and want to compute the 18+ TSL for KABC-AM. We can pull the AQH and cume from the book to produce the TSL. The TSL for adults 18+ for this station, Monday to Sunday, 6 A.M. to midnight, is calculated using the following formula:

$$TSL = \frac{AQH \text{ in Time Period} \times AQH \text{ Audience}}{Cume \text{ Audience}}$$

AQH in Time Period = 504*

AQH Audience = 872 (00)**

Cume Audience = 9,875 (00)

$$TSL = \frac{504 \times 872}{9875} = 39.9$$

Therefore, the programmer concludes that the average length of listening to KABC for an adult 18+ is 39.9 quarter hours during a given week, 6 A.M. to midnight. A high TSL indicates that people (who listen) are listening for long periods of time, not that a lot of listening goes on. TSL refers only to the amount of listening by those who do listen. Television programmers also calculate time-spent-viewing using the same formula.

Turnover

Turnover indexes the rate at which an audience changes, or turns over, during a time period. Turnover is calculated by dividing the cumulative audience by a quarter-hour rating:

$$Turnover = \frac{Cume \ Households \ or \ Persons}{AQH \ Households \ or \ Persons}$$

A low turnover rate indicates a loyal audience, and high turnover means a station lacks "holding power." *Television stations expect more turnover*

than radio stations and go after greater reach. Turnover is calculated for public broadcasting and cable as well as for commercial radio and television. Tracking the amount of turnover on a graph over time provides a quick clue to changes in audience listening or viewing patterns for an individual station or service.

Cable Ratings

Nielsen reports cable network ratings data separate from broadcast network data for the larger basic and premium cable services (in addition to cumulative totals for all basic and pay networks within the *Pocketpiece* and *NSI Reports*). More than 90 percent of Nielsen's 10,000 people-meter sample are cable or satellite subscribers, and Nielsen issues its *Cable National Audience Demographics Report* covering the national audiences for the largest services drawn from people-meter data.

In general, the introduction of people meters has benefited cable services far more than most broadcast stations or their networks. In those 50 or so local markets measured with paper diaries, viewers tend to fill in diaries at the week's end, losing track of where VCR or DVD recordings came from and forgetting the names of the many cable networks, so the more familiar-sounding networks tend to get undeserved diary entries and consequently high ratings. Digital service adds a hundred or more to the usual list, only exacerbating this problem. People meters, however, record the exact channel viewed, the length of viewing (which is also recorded by traditional passive meters), and the composition of the audience. Many smaller local markets, however, continue to be measured with diaries or diaries plus passive meters.

On the local market level, individual cable networks are included in Nielsen's *Cable Activity Report* when they achieve a 3 percent share of audience (and pay the cost of data analysis and reporting). Nielsen measures cable service audiences along with broadcast station audiences in the all-market sweeps (using diaries or meters or both). Cable lineups differ from franchise to franchise within one market, however, and accurate tracking

^{*}There are 504 quarter hours from 6 A.M. to midnight, Mon.–Sun.

^{**}Zeros indicate that these numbers are in thousands, for example, 87,200.

of channel attributions ("I watched Channel 3") has been difficult. For example, the Washington, D.C., area has about 30 cable franchises, which place the dozens of cable networks (and some broadcast TV stations) on widely differing channel numbers. Moveover, digital cable lineups can locate the same channel in two or three places (say, 24 and 316, and 627, with no apparent numbering logic). In consequence, ratings for the smaller services have not been stable even within a single market (see Chapter 8 on uniform channel lineups). Even though the Nielsen metered markets (covering more than 60 percent of all U.S. viewing) may eventually migrate to Active/Passive people meters (A/P) or portable people meters (PPM) that read codes embedded in the programs by the producers, there will always be less reliable diary measurements in the smaller markets.

To qualify for inclusion in the standard television sweep reports, a cable service must reach 20 percent of net weekly circulation. In other words, 20 percent of the market's television households must view it for at least five minutes during the survey week. In the first year of reporting (1982), only HBO, WTBS-TV (the former Superstation, now the TBS cable network), Showtime, and ESPN qualified. Two decades later, however, nearly all of the top 20 cable networks qualified in most markets, including (in 2008 rank order) Discovery, ESPN, CNN, USA Network, TNT, Lifetime, the Weather Channel, ESPN2, Nickelodeon, Spike TV, A&E, TBS, the Learning Channel, CNN Headline News, MTV, Home & Garden Television (HGTV), C-SPAN, ABC Family Channel, the History Channel, and Cartoon Network, each of which reaches over 90 million subscribers. Galavisión qualifies where Hispanic viewers make up much of the population, and other cable services such as WGN and WWOR easily qualify in some regions of the country. Cable networks appearing on only some of a market's systems, however, have more difficulty meeting the minimum viewing level, even when they are regularly watched by the cable subscribers able to receive them.

Although each large cable system operator and network purchases cable ratings from Nielsen, they are also interested in research that identifies their most likely customers. Two services, Claritas and Looking Glass, offer detailed demographic and behavioral information in annual reports. Claritas's PRIZM (Potential Rating in Zipped Markets) report combines ZIP code information with Nielsen data, information from local governments, magazine subscription lists, automobile registrations, and other data sources. Such geodemographic information creates groups of population segments by lifestyle.

Arbitron competes with Nielsen on the cable front, using two techniques: Set-Top Solutions (STS) and the PPM mentioned earlier. STS collects viewer information directly from the cable converter box. The portable meters collect information from a pager-sized device carried by the viewer. Arbitron also offers three services to cable operators and networks: Scarborough, RetailDirect, and RetailDirect Lite. These services provide qualitative media and market consumer behavior information.

Premium Services

Pay-movie services have special measurement problems. Movies, the largest element in their programming, appear in repeating and rotating patterns to attract large cumulative audiences for each feature. This contrasts with the broadcast television pattern of scheduling a movie or series episode only once in prime time (typically) and seeking the largest possible audience for that one showing. In digital households, subscribers may have six channels of HBO, six channels of Starz, eight channels of Encore, seven channels of various ESPNs, plus additional multichannel versions of the same networks in high definition. Even TNT appears in three places: analog, digital, and high-def; thus, counting and matching viewing from system to system has nearly insurmountable difficulties. In addition, six channels of ESPN Sports Pay-Per-View in digital and the same six again in high-def appear on one cable system. And there are several InDemand channels on which older programs and events can be pulled up, for a fee. These kinds of pay channels are measured by their buy rates, not household ratings.

Indeed, viewers shift the times they watch pay cable so much more than they do broadcast television (by recording movies at home) that it becomes problematic to use the same measurement criteria. (See Chapters 8 and 9 on program evaluation and audience measurement.) Moreover, the total number of pay households is relatively small for all services except HBO, although nearly half of all television households take one or more pay services, in addition to digital service. And the large number of basic and pay-cable television networks subdivide the ratings into slivers much as radio stations do in major markets. Premium-channel cable programmers use the ratings information available to them to judge individual program popularity and channel popularity, but as yet such cable networks rarely win specific time periods in competition with broadcasters. Frequently, however, the cumulative audiences for all showings of a top-notch movie on HBO equal the size of a television network's audience. Although pay-cable movies usually draw small audiences, original programming like The Sopranos attracts critical acclaim, Emmy awards, and stronger viewing levels.

Nielsen publishes a quarterly *Pay Cable Report* and a comprehensive *Video Recorder Usage Study*, which can help pay-cable programmers make sense of reported viewing. The Nielsen Homevideo Index, as contrasted with the Nielsen Station Index, provides many additional specialized reports for cable programmers.

Cable Penetration Measures

Using figures supplied by Nielsen and the industry itself, the industry regularly updates cable statistics, reporting how many households have access to cable at the present time; such households are called homes passed (HP). As of 2008, more than 99 percent of U.S. households were passed by cable wires; that is, people in virtually all homes and apartments *could* subscribe to cable if they wanted to. Cable penetration is the percentage of television households actually subscribing to basic cable service (shown as household penetration in 2.16), which has held steady at about 61 percent. Actually, the total penetration by the cable *networks* had neared 91 percent by 2008, thanks to other

2.16 2008 Cable Summary Report

Total Subscribers	68,000	
(universe = 113.3 million)		
Homes Passed	112,200,000	
(99% of universe)		
Total Cable Systems	7,090	
Household Penetration	60.7%	
Premium Channels Subscribers	50,500,000	
(74% of basic cable subscribers)		

www.ncta.com (Statistics), estimated, 2008

multichannel distributors and the conversion to all-digital television, but because exact figures for the two satellite television distributors, DirecTV and DISH, are proprietary, the ratings services have continued to report merely cable-only penetration.

Another important figure to the industry is pay as a percentage of basic cable subscribers because those are the homes actually signing up. Dividing 50.6 by 68 (million) total cable subscribers results in about 74 percent of basic cable subscribers. In other words, three-quarters of basic cable subscribers take one or more pay channels. It is estimated that, in addition to 68 million subscribers to cable systems, about 31 million households subscribe to DirecTV or DISH, and another 3 million or so households get their cable networks from other kinds of services, such as wireless cable, home satellite dishes in their yards, or telephone companies. Giants like AT&T are ramping up to bring the same cable networks to private homes and offices, but their penetration is, so far, below the level for separate measurement.

Like radio, cable, satellite, and telephone services are also concerned with audience turnover. In cable, **churn** is the ratio of disconnecting subscribers to newly connecting cable subscribers (the number of **disconnects** divided by the number of **new connects**). The problems associated with a high rate of churn are described in Chapter 8.

Because the audiences for many advertisersupported networks are too small (at any one

2.17 **Viewer Loyalty Rankings for Cable Networks**

Viewer Loyalty Rankings for Adults 18-49 Prime Time, Based on Figures for November 2003

		Average Length of	LOT Indexed		Total Average Events per			
#	Network	Viewing Events	to TP Average	Lot Rank	Unique Person (FOT)	FOT Indexed to Average	FOT Rank	Lcyalty Index
1	SOAPnet	19.6	139	5	12.5	234	2	326
2	ESPN	15.7	111	19	14.0	263	1	293
3	Lifetime	24.4	173	2	5.7	107	21	184
4	-NT	19.3	137	8	7.0	131	8	180
5	USA	19.4	137	7	6.8	128	9	176
6	TLC	18.1	129	11	7.0	132	7	170
7	TBS	16.7	119	16	7.2	134	6	159
8	Sci Fi	19.2	136	9	6.1	115	17	156
9	BET	17.8	127	12	6.3	118	14	149
10	Lifetime Movie Network	24.5	174	1	4.5	84	30	147

GSD&M analysis of Nielsen Media Research data from NPower.

time) to show in Nielsen ratings books, a number of smaller basic cable networks estimate their audiences on the basis of customized research that adjusts the size of the universe of homes to match cable penetration in the markets the cable network already reaches. Many cable networks reach only a portion of cable households, and of course, the audience for any one channel can be minute. Direct comparisons of such customized cable ratings to ordinary ratings can lead to confusion because nonsubscribers are not counted. Especially for narrowly targeted cable services, advertisers want detailed demographic breakouts. which necessitate expensive customized cable research at the local level.

One newer measure of cable viewing is channel loyalty. In 2004, an Austin-based advertising agency, GSD&M, developed a loyalty index that ranks networks by combining length of tune (LOT) and frequency of tune (FOT) information for prime time. ESPN, which ranked number 19 in LOT but number 1 in FOT among adults 18 to 49, has a loyalty index of 294, second only to leader SOAPnet. Lifetime Movie Network, number 1 in LOT, ranks 30 in FOT, giving it a loyalty index of 147, which places it at number 10 overall. See 2.17 for illustrative estimates for some well-known cable channels.

Online Research Services

Because of interrelationships among internet websites and the traditional media of cable, satellite, telephone, and broadcasting, it is not surprising that Nielsen rapidly developed a system for measuring internet audiences. Nielsen//NetRatings is one of two major competitors in this field, the other being Media Metrix, the web's oldest rating service. Both use samples of home and at-work web surfers to monitor and estimate usage patterns.

Although cable, home satellite, and telephone delivery of television have certainly had a huge impact on audience behaviors, this impact pales in comparison to the profound and sweeping effects of the internet, and it is still in the early stages of its development. How and why people use the web, what they use it for, and how these things affect other traditional or "old" media are yet evolving, but some trends can be gauged with fairly high accuracy (although others remain highly speculative). The situation for web audiences is extremely dynamic, almost volatile in many respects. Chapter 10 discusses in detail what online ratings show about audience behavior. One example is the measurement of time-spent-online (TSO), which by 2007 was 14 hours a week, on average, creeping up toward the amount spent watching television weekly. The methods and terminology used for measurement of online computer use are quite different from those used for broadcast and multichannel measurement.

Web Tracking Services

Nielsen//NetRatings publishes regular reports that include five sections: Audience Summary, Audience Profile, Daily/Hourly Traffic, Average Usage, and AOL Audience Report. Audience Summary reports give a comprehensive profile of the entire web audience, including the unique audience (average number of different people who visit a site on each day during the course of the month), page views, audience demographics, frequency, and time-spent information. Audience Profile shows demographics for the total U.S. internet population. This report shows audience composition, number of sessions per period, average time spent per session, and average pages viewed per session. Daily/Hourly Traffic breaks down the Audience Profile data by specific day and hour. Average Usage includes statistics on the number of sessions, pages viewed, pages visited per session, time spent per session, and duration of the viewing of a page. AOL Audience Report shows average time spent and audience demographics for use within the AOL service.

The Nielsen//NetRatings audience-tracking software has several advantages over other approaches because of its accuracy. The software "sits in the datastream" and provides an unobstructed log of all web activity. This unique technique for tracking users automatically measures the viewing and clicking of ad banners (bannertrack), e-commerce activity (commercetrack), page views cached (that is, stored) by the browser program (cachetrack), and page loading times. The tracking is unobtrusive to users in order to limit bias and requires the absolute minimum in company intervention once installed. Software updates are also wholly automatic.

The other leading web tracking service, com-Score's Media Metrix, produces a variety of reports from the continuous monitoring of internet audience behavior. Formerly called Jupiter Media Metrix, the company surveys 120,000 internet users recruited though random-digit dialing. Media Metrix also offers in-depth tracking of online transactions, at-work usage, and activity on AOL networks.

Media Metrix uses its own patented metering methodology, which continuously captures actual usage data from randomly recruited, representative samples of tens of thousands of people in homes and businesses around the world (excluding college labs, cyber cafes, airports, hotel business centers, public libraries, and K-12 schools). The meter is a software application that works with the PC operating system to passively track all user activity in real time—click by click, page by page, and minute by minute, measuring only those users who visit the internet at least one day per month.

The unduplicated audience (cume, or reach) is calculated by adding all at-home users to all at-work users and then subtracting all users who use both locations. Only the base-page universal resource locator (URL), or page address, is counted, even if other files and items are associated with it.

By recording whatever keyboard or mouse activity is taking place, Media Metrix keeps track of each time the computer is turned on or off, when the machine is on, and whether a user is actively using the machine. Sixty seconds after keyboard or mouse activity ceases, the machine is declared to be "idle." Viewing time is not credited when the machine is in the idle state. As soon as a user moves the mouse or presses a key, the meter resumes accumulating viewing credit to the page or application.

When the computer first boots up, the user must select his or her name from the list of registered users and press OK. After 30 minutes of "idle" time, the meter presents its user identification screen again to ensure that a change in user is captured. If at any time the user changes, it is a simple matter of clicking the meter's icon to recall the user identification screen. The meter applies viewing credit to only one application or program at a time. If, for example, the user is using a wordprocessing application while his or her browser is in the background downloading web pages, the word-processing application receives viewing credit—not the browser. Whenever a page from the web is displayed in a browser, the meter records the full URL. The Media Metrix Meter records the name and details of each file coming into the PC over a network connection. The meter also records information about each graphic file, banner ad, sound file (wav, mid, mp3), streaming media, and so on. The meter also can record additional detail on demand, such as specific activity within applications. For example, one of the applications for which Media Metrix captures additional information is AOL. Specifically, the meter records the content of the AOL parent and child window titles. The meter records stepby-step action through the AOL application.

Once or twice per year, a certain percentage of respondents are asked to complete qualitative questionnaires to more fully describe their lifestyles beyond the key demographic data. Household-level demographics are updated annually by asking a representative from the household to visit a website and update the profile. Additionally, twice per year, a portion of the sample is provided with "scanning" software, which scans the PC to record the technical configuration and to log which software programs are installed. The weakness of the Media Metrix method is that it favors heavy web users and excludes light users (many of whom may be fearful of viruses and worms or wary of providing fodder for commercial advertising messages).

In addition to Nielsen//NetRatings and Media Metrix, other services "audit" server-based information supplied by websites. I/Pro offers its I/Audit service, and Audit Bureau of Circulation (the same

ABC that audits newspaper and magazine circulation) provides a service called the ABC Interactive Web Site Activity Audit Report.

Online Ratings Terminology

Page views (also known as page impressions) are usually defined as one or more online files presented to a viewer as a single document as a result of a single request received by the server. Visits are a series of interactions with a site by a visitor—without 30 consecutive minutes of inactivity.

Companies that focus on advertising measurement, such as ABC Interactive Audits, are concerned with such variables as ad display, ad download, ad impression, ad impressions ratio, ad request, and click/ad interaction. Banners have been one of the most successful internet advertising media. For programmers, it is important to understand that advertising banners are not separate from the "program" content; they are somewhat like having a changing billboard in a live sporting event. Online, there is no flow, no break, and no need to zip or zap, although plenty of ad messages encourage the user to click away. The key measurement in e-commerce is the click-through, defined as the result of clicking on an advertisement that links to the advertiser's website or another page within the website (exclusive of nonqualifying activity and internal users).

Different web tracking services use slightly different terminology. Media Metrix estimates a site's (1) unique visitors (the number of different people visiting the property in a 30-day period); (2) reach (percentage of projected individuals who visited a designated website or category among the total number of projected individuals using the World Wide Web during a given reporting period); (3) average usage days per user; (4) average unique pages per user per day and month; and (5) average minutes spent per person per page, per day, and per month. Media Metrix's measure of unique pages counts the number of different URLs visited by a person on a particular day. For example, a user viewing a stock-price page who hits the refresh button repeatedly throughout the day will be counted as visiting a single unique page for the day. Nielsen//NetRatings has similar terminology, covering three critical areas: site activity (sites visited, URLs within a site visited, duration of visits, and duration and frequency of sessions), advertising activity (actual ad banners viewed, advertisers, sites the ads ran on, and ads clicked on), and user profile (age, gender, marital status, education, occupation, income, and ethnicity). Of all these measures, programmers are most interested in unique visitors and reach, because they are most like broadcasting and cable audience measurements, and also perhaps site activity as an assessment of content popularity.

Matching

Attempts to combine the traditional media content of print or TV and related internet sites first occurred when NBC collaborated with Digital-Convergence.com to allow viewers to link their personal computers with television programming and advertising during NBC's 2000 Olympics, its national election coverage, and its fall 2000 network television season. Advertisers could then track consumers interested in their products and tailor online information accordingly. The system enabled advertisers to communicate directly with these potential customers and not waste resources on those consumers for whom the brand is either irrelevant or not the preferred one. Whether the potential customers thought it was such a good idea is an open question.

By 2005 all television networks were looking for ways to "involve" the television and web audiences. Court TV (now truTV) argued that cost per involvement (CPI) was a key measure of return on investment for advertisers who fund programming. Originally, Court TV introduced its "lean forward" campaign, noting that viewing TV while connected to the internet was different than the old "lean back" model of passive viewing. Next, the channel used custom analysis of Nielsen data to assess the "stickiness" of its website for program viewers. It did, however, stop short of measuring the direct effects of product sales because, like most other advertiser-supported channels, Court TV felt it could not

be accountable for the creativity of the advertising message. By late in the decade, the issue had become click fraud, or concern for the accuracy of click counts. Two kinds of fraud have been detected. In one case, a group of people flood a site with clicks in order to earn money (hosts of search ads make money according to how many people access the ad, and an extra-large number of clicks earns more money-enough to pay off conspirators). In another case, companies with display ads normally pay to stay up on the site only until they attract a certain number of clicks, and then excess clicks can knock the ad off early (an advantage to a competitor). Beyond this purposeful deception, measurement definition is an issue. For example, is a person two unique visitors or one if he/she accesses the same site from home and work on the same day? Eventually, the Media Rating Council is expected to establish uniform definitions for valid, invalid, and fraudulent clicks, as well as standards for auditing tracking numbers.

Ratings Limitations

Although many broadcast, cable, and web programmers are aware of the limitations of ratings and user counts, in practice these limitations are rarely considered. This does not result from ignorance or carelessness so much as from the pressure to do daily business using some yardstick. Programmers, program syndicators, sales staffs, station reps, and advertising agencies all deal with the same numbers. In any one broadcast market, all participants—those buying and selling programs, those selling and buying time—refer to the same sets of numbers (Nielsen reports in TV, Arbitron in radio), and they have done so for decades. The "numbers" for any single market usually show a consistent pattern that makes sense in general to those who know local history (such as changes in power, formats, and ownership). Although broadcasters and the ratings companies know that the "numbers" are imperfect, they remain the industry standard. In practice the numbers are perceived as "facts," not estimates.

Occasionally a gross error will require a ratings company to reissue a book, but for the most part, small statistical inequities are simply overlooked. To eliminate as much error as possible, the major ratings companies use advisory boards that suggest how to improve the ratings estimates. Because a change in ratings methodology always means additional costs passed on to broadcasters, the rate of improvement will continue to be conservative now that the shift to people meters has been accomplished.

The major limitations of broadcast and cable ratings can be briefly summarized. Readers interested in further information should consult the references listed at the end of this chapter. (Until use of the internet as an advertising medium grows considerably, the problem of limited use overwhelms all other methodological considerations, and advertising pays for ratings research.) The following seven practical and theoretical problems limit the validity, reliability, significance, and generalizability of broadcast and cable ratings data.

1. Sample Size

Although each ratings company attempts to reach a sample that represents the population distribution geographically (by age, sex, income, and so on), a shortfall occasionally occurs in a market. Such shortfalls are in fact routine in radio market ratings and also occur, although less frequently, in television market ratings. In these instances, certain demographic groups have to be weighted to adjust for the lack of people in the sample (such as too few men between 25 and 49).

Weighting by large amounts makes the estimates less reliable. The amount of unreliability is related to the (unknown) differences in responses between those who did respond in the sample and those who did not cooperate or bother to comply with all of the procedures. An expected return rate of 100 diaries from teenagers, for example, with an actual return rate of 20, should create strong skepticism about how representative the 20 responders are. The 80 who did not respond would undoubtedly represent this segment of the audience better and more accurately, but because

their media usage is not known, the ratings services use the 20 responses and compound the error by assigning a weight of 5 to each of the 20 responses (to calculate the number of respondents in this age group as a proportional part of the total sample). Although weighting is a scientifically acceptable and perfectly valid procedure, it assumes that those responses being weighted closely represent those responses that are missing (see 2.18 for more on sampling errors). In our hypothetical example, the responses of too few individuals represent too many other people/households.

Sample size is the one limitation that comes to most people's minds when they hear about how ratings are compiled. The typical "person on the street" response is "How can a few thousand people be used to measure what millions of people watch or listen to?" They are mistaken; the sample sizes used by the ratings companies are not the major problem. The representativeness of those selected for the sample is.

2. Lack of Representation

The major ratings companies long refused to sample from group living quarters such as college dormitories, bars, hotels, motels, hospitals, nursing homes, military barracks, and so on. The problem with measuring such viewing is that the number of individuals who are viewing varies, sometimes greatly, making it nearly impossible to determine how many diaries or people-meter buttons need to be provided. The Nielsen people-meter ratings also fail to measure the number of people viewing in offices, workplaces, and country clubs-or who are watching battery-operated TV sets on beaches and at sporting events (there are more than 10 million portable TV sets in the United States, to say nothing of watching via computers or iPhones).

In the latest Total-TV Audience Monitor (T-TAM), a national survey, Nielsen Media Research estimated that about 44 million adults (and 32 percent of adults aged 18 to 49) watched television in out-of-home locations each week. As a result, Nielsen finally began including college students living away from home in its ratings because the

2.18 Standard Error

he concept of standard error is not a ratings limitation but rather part of a mathematical model whose use reduces some of the problems associated with rating procedures. In practice, however, very few people using audience ratings ever take standard error into consideration. The "numbers" are seen as factual; sampling errors and other errors or weaknesses in research methodology are not considered in any way.

In essence, using the standard error model compensates for the fact that ratings are produced from a sample of people, not a complete count of an entire population. Whenever researchers project sample findings into the general population from which that sample was drawn, some error necessarily occurs. A standard error figure establishes the range around a given estimate within which the actual number probably falls. The range suggests how high or how low the actual number may be. The formula for standard error is

$$SE = \sqrt{\frac{p(100 - p)}{n}}$$

where SE = standard error

p = audience estimate expressed as a rating

n = sample size

For example, suppose that a random sample of 1,200 people produces a rating of 20. The standard

error associated with this rating is computed as follows:

$$SE = \sqrt{\frac{20(100 - 20)}{1200}}$$
$$= \sqrt{\frac{20(80)}{1200}}$$
$$= \sqrt{1.33}$$
$$= 1.15$$

A rating of 20 therefore has a standard error of plus or minus 1.15 points—meaning that the actual rating could be anywhere from a low of 18.85 to a high of 21.15.

Another difficulty in calculating error is determining how confident we want to be of the results. It is possible to be very confident (with a 95 percent probability of being right) or somewhat confident (with only a 65 percent probability of being right). Nielsen ratings are generally calculated to the lesser standard. Most social science research uses the higher standard. Nielsen includes standard error formulas in all their ratings books for those wishing to calculate error in specific ratings and shares, but undeniably, printing the range for each rating/share would make ratings books unusable. Nonetheless, the range is the most accurate version of each rating or share, given its database, which may itself introduce a great deal more error.

survey showed that college apartments and residence halls were among the most common outof-home locations for TV viewing. Nonetheless, only students whose families already participate in Nielsen's surveys can be included—so they do not represent new, independent families—but at least dorm, fraternity, sorority, and off-campus apartment viewing now can influence ratings.

The rest of out-of-home viewing only appears in special reports, not the weekly ratings. Nielsen argues that such viewing accounts for only a small percentage of total national television viewing and is therefore not worth pursuing (that is, is not cost-effective for broadcasters to pay to measure). Critics argue that, given that the number of

TV households in America is 111.4 million, representing (× 2.55) 284+ million people, the loss of 44 million more out-of-house (OOH) viewers is very much affecting program ratings, and that other OOH viewers need to be added.

TV programs and some radio formats that appeal to narrow demographic segments are widely known to go uncounted in calculating the ratings. Estimates for *Late Night with Conan O'Brien*, for example, indicate that as much as one-fifth of the actual audience used to go uncounted by Nielsen's ratings largely because of the exclusion of the types of locations where many people watched the program (college dorms and bars). Also, cable services such as ESPN, watched in

nearly every bar in the country, suffer from the omission of group audiences. At least 59 percent of ESPN's 5.4 million adult viewers watch outside the home each week. The wide popularity of sports bars in recent years (with multiple TV screens and patrons switching among different channels of ESPN) adds substantially to the inaccuracy of samples used to measure sports viewing. Group viewing of soap operas is another unmeasured phenomenon.

3. Ethnic Representation

Data for ethnic groups are among the most hotly debated aspects of broadcast and cable audience estimates. Ratings companies have long grappled with the difficulty of getting randomly selected minority households to cooperate with the ratings company by filling out a diary or having a meter installed. Companies have offered higher honoraria for participating in order to gain a representative sample of both Hispanics/Latinos and African-Americans. Nonetheless, many minorities understandably remain apathetic to the needs of ratings companies, despite financial incentives.

Critics argue that those minorities who agree to go along with prescribed procedures are much more like white sample participants and are atypical of the ethnic group they are intended to represent. Thus, a participating black family may not be like the vast majority of black families in a given viewing area. Ethnic populations are undoubtedly undercounted, and those who are counted are often unrepresentative of their ethnic groups. Because no standard of "truth" exists by which to compare samples to an entire ethnic group, ratings companies and advertising agencies inevitably use the numbers in front of them to make decisions.

Nielsen does identify African-American and Hispanic audiences in its local market rating reports, but the information in some markets is limited to penetration, counting their presence in the same table as multiset, cable, and DVD homes. At the national level, however, Nielsen's monthly reports have an added 20 African-American demographic categories. Primarily to serve Univision and Telemundo, Nielsen started its Nielsen Hispanic Television Index (NHTI) in 1992, but more recently,

Hispanic viewers of Spanish-language networks were folded into national people-meter ratings just like other television viewers. For markets with a significant Hispanic population, Nielsen offers local ratings in its Nielsen Hispanic Station Index (HSI).

In other countries, the complexity of the racial and economic situation goes far beyond what U.S. ratings companies must deal with (see 2.19 on what is measured in South Africa). For example, advertisers and media programmers need to know what languages their viewers or listeners prefer and what electronic capabilities their households have. In many developing countries, viewing and even listening may take place in large groups, which alters the relationship between a program and its audience from a programming perspective and certainly makes counting viewers or listeners problematic.

4. Cooperation

All ratings companies use accurate and statistically correct sampling procedures: People/ households are selected at random to represent (within a small margin of error) the population from which they were drawn. For representativeness to occur in practice, however, the people/ households originally selected must cooperate when the ratings company invites their participation. In the past, when Nielsen used the passive TV-set meters (before people meters were ceveloped), cooperation was not an overwhelming problem. Since the late 1980s, cooperation rates for allowing the installation of the more complicated people-meter technology by Nielsen have steadily declined to alarmingly low levels. Studies have reported refusal rates of one-half to twothirds for people-meter installations among those contacted in original random samples. Refusal rates were highest among ethnic minorities and younger adult males.

The same studies also reported sharp declines in the area of diary cooperation. Nielsen diary response rates for the November sweeps went from about 43 percent in the early 1990s to around 28 percent by 2000. Arbitron diary response rates went from 40 percent in 1995 to 35 percent

PART ONE

2.19 **Going Beyond Race**

nce freed from apartheid, South Africa's volatile history of racial division and tension led its broadcasters and marketers to seek out ways to avoid categorizing people primarily by race in research. A Living Standards Measure (LSM) was developed that clustered people into 10 distinctive segments on the basis of degree of urbanization, ownership of cars and major appliances, languages spoken, and access to basic services (water, electricity, telephones, media). Because LMS is a multivariate segmentation tool constructed from 29 variables, it is a far stronger differentiator than any single demographic variable. The full list includes such variables as the following:

Electricity

Electric stove or hot plate Water in home or on plot

Traditional hut Washing machine Refrigerator/freezer

Dishwasher

Sewing machine

TV set

Home telephone Pay/satellite channels

PC in home

One or more sedan cars

Home in Gauteng/Western Cape

Flush toilet in house or plot

Microwave oven Hot running water Built-in kitchen sink Tumble dryer Deep freezer No domestic worker

Vacuum cleaner or floor polisher

VCR in household

No cell phone in household Stereo or music center

Fewer than two radio sets in home

Home security service

Home in nonurban area outside Gauteng/Western Cape

The LSM is widely used in both programming and advertising to define target markets. It is also used in customized formats in other parts of Africa, and efforts have begun to use LSM as a global marketing tool.

> Consultant and Professor (retired Director of Audience Research, SABC, South Africa)

by 1999. Again, participation differs among key demographic and lifestyle groups. Ratings for children and teens are most problematic. Moreover, long-term cooperation from all viewers continues to be a problem. Using a diary requires participants' willingness to train themselves to fill it out as they view or listen and to learn how to fill it out correctly. People meters require pushing buttons every 15 minutes as onscreen reminders interrupt viewing. They also require the householder to assign spare buttons to casual guests.

Another way of collecting data, the telephone coincidental method—usually assumed to be the most reliable method—has its defects, too. A 2004 study conducted by Ball State University indicated that phone surveys are "largely useless" for determining media behavior. The threepart study combined phone surveys, diaries, and observation with vastly different results: On average, people reported through phone surveys that they watched only 121 minutes of television per day. At the same time, diarists logged 278 minutes, and researchers observed individuals actually watching 319 minutes. Other results showed that phone survey responders said they spent only 29 minutes online per day, but diarists said they logged on for 57 minutes each day, while observations recorded people going online for 78 minutes a day.

Whenever cooperation rates are low, for whatever reason, the participating sample probably differs from those who declined. Those who cooperate typically demonstrate a highly favorable view of the medium and generally use it more often than those who refuse to cooperate. Refusals may indicate a lack of interest in the medium or, at the least, too light a use to warrant learning a fairly complicated but infrequently applied process. It is easy to visualize a single person or a young, childless couple who says to the ratings company, "No thanks, I'm (we're) almost never home. I (we) hardly ever watch TV at all." Thus, those who view more or use the medium more are probably overrepresented in the sample, resulting in correspondingly inflated viewing estimates and unrealistic measures of the total television audience's preferences. Of all the limitations on ratings, cooperation remains one of the two most significant and persistent problems.

5. Definition of Viewing/Listening/Visiting No one seems to be even remotely certain of precisely what it means to "view" television or "listen" to radio. It sounds so simple on the surface, but consider this: For those using people meters to be counted as "viewers," household members must activate the people-meter computer with the handheld device only while in the room where the television set is on. At regular intervals, viewers are reminded of the need to "log in" by pointing their handheld device at the TV set. In all systems, the sole criterion for being a viewer is being in the room. Viewers can very easily be reading magazines, talking, thinking, playing a game-in short, paying little or no attention to the picture or sound—but are still counted as viewers. Conversely, a viewer might be in a nearby room doing a menial task and listening intently to a program's sound. This person is normally not counted as a viewer. Being there may or may not constitute "viewing." Moreover, watching the same content via computer screen is not included as viewing. What the ratings services measure, therefore, are potential viewers—with the option of letting traditional television (or radio) receivers

occupy their attention. To date, no commercial techniques measure viewing as a function of the attention paid to what is on or to the way that content is used. And viewing or listening via the new reception media appears only in special studies, not regular ratings.

Among radio audiences, the parallel problem is no uniform definition (or no definition at all) of what it means to "listen" to radio. When in someone else's car on the way to school or work while this person has the radio on, should the passenger be counted as a "listener" to station WXXX? How about offices where a radio station plays in the background while people work? Are they "listening"? Is the music or information what each person would have chosen had they been able to select the station? Moreover, what does "listening" mean? If a person is paying attention to other things and has the radio on for background noise or a kind of companionship, should that person "count" as a listener?

As for what it means to "visit" a website, the absence of universally agreed-upon definitions poses inherent interpretation problems when trying to understand what the numbers mean or represent. In this instance, the problem centers on defining what it means to "use" a website, a parallel to what it means to "view" television. To be counted as a site visitor, does one merely have to access the site to be counted or, perhaps more importantly, should that person count the same as someone who, while at the site, goes to other options or pages that are components of the site? Other questions that need to be answered include "What exactly does someone look at when at the site?" "For how long does the user look at a particular item or the site generally?" "Why were none of the options accessed?" "Why were one or more options accessed?" As difficult as it is to come up with a valid definition of what constitutes "viewing" television, it seems easy by comparison to defining what goes on with a user while he or she is at a website.

Both television and radio ratings are plagued by the industry's unwillingness to provide a standardized, widely agreed-upon definition of viewing and listening, and now the problem is extended to the online world. So long as the advertising industry remained satisfied with the ratings numbers generated for TV and radio, there was little reason for concern. As Nielsen moved to people meters, however, and as media choices proliferated rapidly through cable and satellite-delivered media services to the internet and mobile handheld media, the reported numbers for conventional media showed progressive shrinkage. Advertisers began to ask what was going on, and the broadcast and cable industries began to scramble for explanations. Broadcasting and cable have continued to point the finger of blame toward the ratings services, questioning their methods and the validity of the numbers they report. Lost in all the ongoing measurement arguments is the crux of the problem-no one knows what the ratings services are supposed to be measuring in the first place. This debate has no satisfactory means of resolution until basic definitions are standardized.

6. Station Tampering

A continuing problem for ratings is that sometimes stations attempt to influence the outcome of the ratings by running contests during the measurement period. Arbitron and Nielsen place warnings on the cover of their ratings books advising users of stations' questionable ethics. Of course, there is a gray area: Was the promotional activity (called hyping or hypoing) really a normal contest or one designed to boost (hypo) the ratings?

Warning labels are especially ineffective for the advertising industry when the agencies get their numbers from computer tapes or online services. There is no "book" on which a warning can appear. The problem of hyping has grown in recent years, with some local newscasts promoting huge cash giveaways during sweeps. Many industry experts predict year-round measurement for television that abolishes sweeps periods will eventually solve the hyping problem.

7. Device Limitations

Not everyone has faith in the reliability of people meters. After 30 years of depending on one ratings system, Nielsen's abrupt change in 1987 from passive meters and diary-based national television ratings to people meters created an uproar. The shift happened all in one year, and, with so much at stake, many in the industry felt unprepared. One objection to people meters centers on what happens when the handheld devices are not correctly operated. When mistakes are made, as is inevitable, viewing is invalidated and not counted in the ratings. Given the high likelihood that people will have occasional mechanical difficulties and that children and teens will "fool around" with the meter, much legitimate viewing may be lost. Nielsen argues the necessity of omitting figures where the device was misused, claiming that such inclusions would produce unrealistic figures. Nielsen further claims that in a national sample of 12,000 households, occasional omissions have only a negligible impact on ratings. Not everyone agrees, however.

Another people-meter problem occurs with sample composition. The difficulties previously discussed concerning who chooses to become part of the sample and who refuses are worsened, not resolved, by people meters. Nielsen's own studies show that people-meter cooperators differ from noncooperators in that the former are younger, more urban, and have smaller families (they may also differ in other unreported ways). Older people and those living in rural areas are underrepresented in the people-meter sample, in part because of many people's reluctance to learn to use "another new technology." It is, however, recognized that Nielsen's previous national sample overrepresented older viewers and that the post-1987 sample composition more accurately represents the country's overall population.

A third limitation centers on a new form of resistance to allowing Nielsen to install the people-meter hardware. Installing the older passive meter involved little or no hassle for participants. People meters, however, require a substantial amount of wiring and hole drilling. For many people, allowing workers into their homes to do such work is an intolerable intrusion. And, of course, if households allowing the installation do so in part because they are eager to be part of the television sample, they do not represent

the overall population and probably produce inflated viewing estimates and distortions in program preferences.

A fourth and final device-related limitation occurs because people meters transform generally passive viewers into active viewers. Every time a participant enters the television room or leaves, the handheld device must be activated. Such behavior involves more conscious decisions to view, and about what to view and when to stop viewing, than does usual television behavior. Research shows that most viewing gets done with little self-awareness on the viewer's part. Now, viewers with people meters must actively record their behavior, and the results are probably atypical viewing. Nielsen maintains that people-meter users rapidly become accustomed to them, and "normal" viewing habits soon return, similar to the way viewers become accustomed to using remote controls.

Nonetheless, problems with sample, hardware, and the unnatural state of "active" viewing resulting from using handheld controls has prompted Nielsen to forge ahead with passive people meters. These are electronic devices equipped with infrared sensors that identify people present in the room and record that information along with the tuned program. While these new passive people meters may overcome the "activity" criticism, testing shows that many people feel that the camera needed to record a person's presence in the room has spied on them. Nielsen and Arbitron have also been testing various kinds of portable people meters for many years, including a pagersized PPM. It has to be carried around or worn on the belt or wrist. Until the technology of such ratings devices improves and is demonstrated as effective and appealing to audience participants in test samples, the problems inherent with the present system remain and pose major obstacles for interpreting what audiences are actually listening to or watching.

Whether a ratings system uses people meters, infrared sensors recording the presence of viewers in a room, diaries, household meters, portable devices, or some yet-to-be-developed variation on these methods, ratings remain *estimates* of

audience preferences, always subject to a certain undetermined margin of error (this margin may be quite small or very large; it is not known with any certainty). Previously, the media industry's temporary solution was to examine more than one set of numbers, but maturation of the industry has resulted in fewer independent sources of information about audiences (see 2.20 which discusses overreliance on Nielsen). Moreover, considering numbers from multiple sources and multiple methods is a stopgap while awaiting a more valid measuring system. When all the numbers from different sources agree, certainly confidence in their accuracy rises. When there are variations, programmers and advertisers are left in the uncomfortable quandary of deciding which numbers to trust and which numbers to use. Some television programs and radio formats will not receive a completely fair rating regardless of which system is used—or even if a combination of measures is used. Children's and very light adult viewing will probably always remain uncertain.

Future Challenges

As the broadcast/cable and online/interactive worlds collide, one can expect many changes in the years to come. Traditional measurement services will have to improve in order to measure smaller and smaller audiences with even greater accuracy. Google is set to challenge Nielsen with a media ratings system that links home computers wirelessly to television sets. At some time in the future, this type of real-time data collection could eventually supplant Nielsen's people-meter ratings system. Fortunately or not, technology to embed a "signature" into all forms of media content has been established. Devices that track audience behavior are likely to solve the counting problem-if only the issue of what is to be counted can be decided (with sufficient agreement among the parties concerned).

If DVRs make the practice of skipping commercials widespread, the future of advertising support for programming is also in question,

2.20 The Trap of Overreliance on Nielsen

ne serious manifestation of the broadcast and cable companies' continued reliance on Nielsen data as their major if not sole source of audience viewing data occurred in the fall of 2003 and remains a matter of considerable controversy with huge consequences for advertisers and media distributors alike. As the ratings numbers came in for the first month of the fall network prime-time season, sharp, statistically significant declines in young adult males appeared. Among males aged 18 to 34, Nielsen reported declines as high as 12 percent; among males aged 18 to 24, the drop was 20 percent. For many advertisers who specifically buy programs that the network guarantees will have certain percentages of males in these age groups, this drastic reduction represented potential losses of millions of dollars in sales (and losses of millions in anticipated advertising revenue for the guaranteeing networks).

Network executives were quick to respond that Nielsen's sample was not representative of the total population of males aged 18 to 34 and that Nielsen's measurement methodology was responsible for the reported declines. Advertisers, by contrast, argued that such declines reflected a lack of interest on the part of young males in many network programs. Others pointed to the many activity choices that appeal more to young males than watching network television in prime time. Such choices include playing video games (for example, PlayStation II or Xbox) or computer games, surfing the web, writing blogs, and

downloading and listening to music, as well as passively viewing DVDs and other prerecorded materials. Nielsen fiercely defended its numbers and methodologies, providing detailed explanations that supported four conclusions.

- 1. Men aged 18 to 34 watched prime-time television with about the same frequency as in previous seasons, but they viewed for shorter periods of time; there are more days in which men in the key age group did not watch television at all.
- Newly added sample members showed less decline in viewing than those continuing in the sample.
- **3.** A combination of incentives and "coaching" of sample participants was successful in overcoming the fatigue of button-pushing.
- **4.** Playing video games and watching DVDs did increase for men aged 18 to 24 years, but somewhat at the expense of VCR use; total usage of VCRs by all viewers, however, showed a 9 percent increase over the previous year.

It is clear that Nielsen numbers remain limited in their accuracy. While once the various parties were willing to overlook inaccuracies and agreed to accept ratings numbers as a common currency required for "doing business," the rise of competing media such as the internet and the threat of DVRs has generated a widespread challenge to traditional measurement practices.

leaving the likelihood of a pay-per-use system (on demand). Audience measurement is largely for the benefit of advertisers. If the audience pays for individual programs or channels, will the ratings really matter? Restaurants don't live or die by the little response cards people fill out at the end of the meal! The price of the meals, the number of patrons, and the potential return visits measure success. So, too, networks may become retailers of their wares, just as book publishers and motion picture studios are. In the meantime, branded products with the name of major companies proliferate in television programs.

The latest challenge to the broadcast and cable industries comes from Nielsen's plan to introduce regular "commercial ratings" in addition to the usual program ratings. When specific commercials have numerical audience estimates attached to them, advertisers will be able to evaluate the program contexts in which their commercial appear, and this information may have major consequences for programmers. It may influence the selection as well as scheduling of shows if the evidence is clear that some types are better suited for gaining audience attention to commercials, as is already believed.

Sources

- Mandese, Joe. "Arbitron Begins Looking Beyond the PPM, Apollo Too." www.mediapost.com. 20 February, 2007.
- McDowell, Walter. Troubleshooting Audience Research. Washington, DC: National Association of Broadcasters, 2000.
- R&R Ratings Report. Semiannual special reports. Los Angeles: Radio & Records, Inc.
- Webster, James, Phalen, Patricia F., and Lichty, Lawrence W. Ratings Analysis: The Theory and Practice of Audience Research, 3rd ed. Mahwah, NI: Erlbaum, 2006.
- Wimmer, Roger D. Mass Media Research: An Introduction, 8th ed. Belmont, CA: Wadsworth, 2006.

www.ncta.com www.nielsenmedia.com www.tvweek.com

Notes

1. The word ratings had a clear meaning for much of the history of broadcasting until the introduction of content ratings in the late 1990s. Content ratings serve

- as labels to adults who supervise children's viewing. As the motion picture industry did in the late 1960s, the television industry bowed to government pressure and began putting program content ratings on shows in the late 1990s. This chapter deals with ratings in the traditional sense of audience measurement, not content labeling.
- 2. Quantitative data come from audience diaries, meters on television receivers, and occasionally from one-time telephone measurements (called telephone coincidentals) during or immediately following a specific program.
- 3. For more on this topic, see Eastman, Susan Tyler, Ferguson, Douglas A., and Klein, Robert A. (eds.). Media Promotion and Marketing, 5th ed., Boston, MA: Focal Press, 2006.
- 4. The number of households varies annually, and the number of people varies according to census reports. These estimates are from Nielsen Media Research.
- 5. The use of shares is endangered by Nielsen's redefinition of viewing to include DVR playback up to seven days later. Advertisers still get a meaningful measure of the total audience using ratings, but programmers can no longer estimate the competitive situation using shares because programs do not "run against" one another in an asynchronous viewing situation.

3

Domestic and International Syndication

John von Soosten

Chapter Outline

The Syndication Chain

The Producer and Production Company The Syndicator The Rep

Program Acquisition Scheduling Strategies

Deal Points A Pitch Syndicator/Rep Rules

Ratings Consultation

Key Questions Research Data National Reports Local Market Reports Specialized Program Analysis

The Decision Process

Determining Need Analyzing Selection Options

Calculating Revenue Potential

Negotiation Bidding

Payment

Cash and Amortization Amortization Schedules Barter and Cash-Plus-Barter

Cable and Syndication

The International Marketplace

The Traditional Pattern
The Emerging Pattern

What Lies Ahead for Syndication

Sources

Notes

he programs seen on hometown television stations usually get there by one of four routes: network, paid, local, or syndicated. The biggest television networks—ABC, CBS, FOX, NBC, MNTV and CW—supply network programs for which stations receive compensation payments. These programs usually air simultaneously on all affiliates of the network. Stations also receive money from program suppliers to air paid programs, often in low-viewership time periods; these shows include paid religion (for example, The 700 Club), paid political programs, and infomercials (such as how to make a fortune in real estate or beauty tips from a celebrity).² Stations often create their own local programs, such as news, talk shows, or public affairs, for which they assume all costs.

This chapter deals with the fourth type of program, syndicated programs, which are series, specials, and motion pictures generally sold to individual stations or station groups for exclusive showing in a single market for a limited time. (A group owner is a company that owns television stations in two or more individual markets, and relaxed FCC cross-ownership rules now permit a single company to own two stations within some larger markets.) Most programs are distributed by satellite, especially if the subject matter is timely. However, as station technology improves, programs can be distributed by firewire delivery, a technology that is proving more convenient and flexible. Known technically as IEEE 1394, the system provides high-definition audio/video connections for speedy transfer of programming.

The local television station licenses a syndicated program from a syndicator, a national company that also licenses the same program to other stations in other markets but generally not to others in the same market, unless the station is owned by the same group owner. (Under the FCC's cross-ownership rules, programs are frequently licensed to a group owner for airing on either of the co-owned stations in the same market. It is not uncommon for the same program to air on both stations, generally in different time slots. Alternatively, a given program may air for a period of months or even years on one station in

a market and may subsequently be moved to the other co-owned station in that same market.)

Nationally, the program probably will not air simultaneously in the same time period in all markets and maybe not even in the same day or daypart. It probably will not air in every market, and it probably will not air solely on affiliates of any single network. Hence, the program is said to be *syndicated*.

Although some programs may be licensed to national cable networks (which often precludes sale to local television stations), the term *syndication* applies only to broadcasting. Although this chapter focuses on broadcast television, most of the principles and considerations discussed here apply equally to cable syndication and international syndication. The topic of radio syndication is discussed in Chapters 11 and 12 and noncommercial syndication in Chapter 7. The most common arrangements and methods of buying and evaluating syndicated programs are described in this chapter, but new permutations keep appearing. It is best to remember the old adage, "Just when you thought you'd seen it all..."

The Syndication Chain

The syndication chain reaches from the producer through various intermediaries to the station, and it begins with the program itself. Programs for syndication arise in one of three ways.

- 1. If the program was originally created exclusively for syndication and has not previously aired in any other venue, it is said to be first-run; it is a program created for first-run syndication. Xena, Entertainment Tonight, and Judge Judy are some examples of syndicated first-run programs. Foreign programs produced for airing in other countries and later placed into domestic U.S. syndication are usually considered first-run because they have not previously been seen in this country. The rare program made for syndication that later gets sold to a cable or broadcast network is called off-syndication.
- **2.** Programs that were originally created for one of the broadcast networks and are subsequently sold in syndication are called **off-network**. Previously aired episodes of *Friends*, *CSI: Miami*,

Everybody Loves Raymond, and The Simpsons are examples of off-network programs. Programs that were created for the national cable networks are also included in the off-network category. (As the number of such programs put into syndication increases, a separate off-cable designation is developing: StarGate: SG1 is one such program.)

3. The third category consists of feature films, including theatricals (made originally for exhibition in movie theaters) and made-for-TV, made-for-cable, or movie-of-the-week (MOW) films. MOWs may be off-network/cable or first-run in syndication.

Unlike off-network shows, which are sold for a number of years with a certain number of runs per episode, first-run programs are generally sold in syndication for one or two years at a time with a predetermined number of weeks of original programs and repeat programs. For example, a 52-week deal might include 39 weeks of original programs (195 shows) and 13 weeks of repeats (65 of the original 195 shows). If the program is successful, the contract may be renewed for a year or two, often at a higher price. Fresh episodes are produced for each subsequent season.

Examples of the three types of programs are described in 3.1. First-run and off-network programs may also be categorized according to program genre.

The syndication chain involves both direct participants—one or more producers and financial backers, a distributor, and the buyer (a broadcast television station, cable network, or foreign network)—and indirect participants, such as the programmers at the national station representative firms. All must talk in a mutually understood language. Although several systems for classifying programs exist, syndicators and programmers commonly use eight easily recognized genre categories (see 3.2).

The Producer and Production Company

Many people think of producers as cigar-smoking, fast-talking, jewelry-bedecked guys "taking meetings" by the pool. A few may fit this description,

3.1 Types of Syndicated Programs

ff-Network: Friends, Frasier, Seinfeld, Ed, Cosby, Everybody Loves Raymond, Will & Grace, CSI: Crime Scene Investigation, The Parkers, King of the Hill, My Wife and Kids, King of Queens, The West Wing, Boston Public, The Practice. (Note that off-network shows may run simultaneously with new episodes on the broadcast network and with reruns or multiplexed episodes on cable networks and in off-network syndication.)

First-Run: The Oprah Winfrey Show, The Ellen Show, Dr. Phil, Montel Williams, Jerry Springer, Live with Regis and Kelly, Inside Edition, Entertainment Tonight, Star Trek: Voyager, Andromeda, Jeopardy!, Wheel of Fortune, Judge Judy.

Feature Films: Nearly any movie title once it leaves the movie theaters except recent movies still playing on pay-per-view, pay cable, or a broadcast network before they go into syndication.

but most would not stand out in a crowd. Actually, the producer—or showrunner—is the person who coordinates the diverse elements that constitute a television program. In some production companies, this person is called the executive producer; in others he or she is the line producer. Showrunners (or executive producers) oversee on-air talent, directors, writers, technical crew, line producers, production managers, production assistants, and researchers. They "run the show" as the on-the-set boss, and often come from a writer background. Showrunners often deal with talent agents, personal managers, union officials, the press, and lawyers. They are answerable for everything: the program concept, the program content, the tone or mood of the program—in other words, the overall production.

If a program is not delivering satisfactory ratings, its showrunner is responsible for "fixing" or improving it. This person is also responsible for delivering the program on time and on or under budget and is directly accountable for contacts with the production company and syndicator who financed the program.

3.2 Eight Common Syndicated Genres

- Situation comedy. Most sitcoms are off-network (for example, Friends, Will & Grace, Seinfeld, Everybody Loves Raymond, The Parkers, My Wife and Kids), although in the past some have been created for first-run syndication—for example, some episodes of Mama's Family and all episodes of Small Wonder.
- Drama. These may be off-network [Judging Amy, Crossing Jordan, Smallville, Monk, Without a Trace, The West Wing, CSI, The Practice), off-cable (Sex and the City, Stargate SG1), or first-run (Star Trek: Voyager) and may include action-adventure/sci-fi shows (24, Alias) and dramatic shows (The Practice, Ed, Boston Public, Dawson's Creek, The X-Files). Although these shows are or were nearly all one hour long, a very few are half-hour shows.
- Talk. Generally these are first-run, one-hour shows.
 They include The Oprah Winfrey Show, Dr. Phil,
 Live with Regis and Kelly, Montel Williams, The
 Jerry Springer Show, and others.
- Magazine. Most commonly half-hour, first-run programs, these include Entertainment Tonight, Access Hollywood, Inside Edition, and Extra. This category also includes the weekend editions of the same programs: Entertainment Tonight Weekend, for example.
- Reality. This category is a catchall comprised mostly of first-run half hours (although the occasional first-run hour creeps in) and includes reality shows (Martha Stewart Living, Texas Justice, Cops), court shows (The People's Court, Judge Judy, Judge Joe Brown, Divorce Court), comedy shows (stand-up comedy routines), music shows (videos, dance music), and comedy-based shows (America's Dumbest Criminals).
- Games. These half-hour, first-run shows include "pure" game shows (Jeopardy!, Wheel of Fortune), celebrity-driven, humor-based shows where the entertainment value is often more important than the game itself (Hollywood Squares), and "gamedies"

- (The Newlywed Game/Dating Game Hour), which combine a game with humor.
- Children's. For years, children's programming was dominated by syndicated programs from a variety of companes; then production shifted to the networks. In recent years, syndication of children's programming has virtually ceased to exist. Kids' CW consists mainly of sitcoms and youth dramas that originally aired on CW/WE. Fox Kids has been rebranded as 4KidsTV and is children-oriented programming on Saturday mornings on FOX stations. Unlike the 1980s and 1990s, when syndicated children's programming ran on weekday mornings and afternoons on many stations (particularly FOX, WB and UPN affiliates. and independent stations), the children's syndication business today is virtually nonexistent. The few syndicated kids programs that are available come from DIC Entertainment and independent producers and are aired by stations seeking to fulfill FCCmandated educational/instructional programming on weekends, often in early-morning time periods. Along with public television, cable networks, especially Cartaon Network, Disney Channel, and Nickelodeon, are the major forces for reaching kid viewers nowadays. Whether provided by the retworks or acquired through syndication, children's programs fall into several basic categories: animation (Yu Gi Ch, SpongeBob SquarePants, Jimmy Neutron, Fairly Odd Parents, Pokémon), live action (That's So Raven, Sister Sister, Hannah Montana, Ned's Declassified School Survival Guide), reality (Bill Nye the Science Guy), and theatrical cartoons Bugs Bunny, Tom and Jerry).
- Weekly. This category includes virtually all the
 aforementioned program types, but the shows are
 first-run and designed for broadcast once or twice
 a week, generally on Saturdays or Sundays (She
 Spies, WWE Bottom Line). After several years
 of weekly runs, some of these shows may amass
 enough episodes to be played Monday through
 Friday (Star Trek: The Next Generation, Baywatch).

A production company finances and produces television programs, hiring the showrunner and the staff and possibly proposing program ideas or financing producers who bring in the ideas. Based on a pilot or merely a written presentation, the production company sells programs directly to broadcast or cable networks or, alternatively, strikes a deal with a syndication company to distribute (syndicate) its programs to individual television stations. Often the production company is the syndicator itself and distributes the programs it has created.

The decision to begin production of a new program depends on whether a broadcast or cable network is interested in the idea and advances development funds (see Chapters 4 and 5) or whether the program is suitable for domestic and foreign syndication. U.S. cable and sales to foreign television networks are an important aftermarket for off-network programs and theatrical movies.3 For many years, hour-long dramatic shows had only modest syndication potential even after network airing, but cable channels such as TNT, USA, A&E, and Spike have shifted to off-network dramas for early evening and prime-time weeknights (for example, Law & Order, CSI, Without a Trace), raising the prices for long runs of such series. Comedy has always been a gold mine, although most programmers insist that sitcoms must have young adult and youth appeal to succeed in syndication. Network carriage is important for giving a program high visibility, but syndication is where the profits lie.

The Syndicator

Although some syndicators produce programs and others merely handle programs produced by different companies, all syndicators (also called distributors) supply programming to local stations on a market-by-market basis throughout the nation. Unlike ABC, CBS, FOX, NBC, CW, ION, MNTV, TeleFutura, Telemundo, and Univision, syndicators do not have a single "affiliate" in any particular market. (The parent companies of ABC, CBS, FOX, NBC, and Univision also operate syndication companies as separate entities.) Instead, syndicators can and often do sell their programming to any and all stations in a market.

Depending on the kind of programs offered by the syndicator, certain stations in a market may be more frequent customers than other stations. For example, some affiliates build programming blocks around game shows, others around talk shows. Although the syndicator may have more than one customer in a market, only one station is licensed to carry any particular program at a time. Thus, one station may license such first-run syndicated programs as The Oprah Winfrey Show and Dr. Phil from King World (owned by Viacom/CBS); a second station in the same market may license Inside Edition and Bob Vila's Home Again, also from King World, and a third station in the same market may simultaneously license syndicated reruns of Everybody Loves Raymond and CSI, again from King World. And it's very likely that King World's Wheel of Fortune and Jeopardy! have been airing on one of these stations for decades.

Each station will have the exclusive right in its local market to all episodes of the series it bought during the term of the license, even though each program is distributed by the same syndicator. And the syndicator King World may try to upgrade the time period of one or more of these shows from a lesser-rated to a higher-rated time slot (even though the show may compete against another King World program on another station in the market) or upgrade a show from a weaker station to a stronger station. For the syndicator, such upgrades usually result in more income from higher license fees, as well as higher rates for barter spots because of higher ratings.

The United States has dozens of domestic syndication companies, and there are scores of others worldwide. Most of the major and medium-sized domestic program syndicators and their hottest properties in the mid-2000s are presented in 3.3. Off-network hits such as Seinfeld, Friends, and Everybody Loves Raymond average as high as \$2 to \$3 million per episode in combined syndicated revenue (from all stations). Of the two dozen or so firms listed in 3.3, seven companies command more than three-quarters of the domestic syndication business: Buena Vista Television, King World Productions, Paramount Domestic Television, Sony Pictures Television, Twentieth

3.3 Program Syndicators

	Syndicators	Programs
đ	Buena Vista Television	Home Improvement, My Wife and Kids, According to Jim, Alias, Scrubs, Less Than Perfect, 8 Simple Rules, Live with Regis and Kelly, Who Wants to Be a Millionaire?, Honey, I Shrunk the Kids, Ebert & Roeper, Disney movies
	Carsey-Werner-Mandabach Distribution	Grounded for Life, 3rd Rock from the Sun, The Cosby Show, Roseanne, That '70s Show
	DLT Entertainment Ltd.	Benny Hill, Three's Company, Too Close for Comfort, The Ropers, Three's a Crowd, The Saint, Dick Francis Mysteries
	Entertainment Studios	Designers, Fashions and Runaways, The Writer's Hotlist, Travel in Style, Recipe TV
	Hearst Entertainment Distribution	B. Smith with Style, Popular Mechanics for Kids, movies, cartoons
0	King World Productions	The Oprah Winfrey Show, Dr. Phil, Wheel of Fortune, Jeopardy!, CSI, CSI: Miami, Everybody Loves Raymond
	Litton Entertainment	Hot Topics, Food and Family, Jack Hanna's Animal Adventures, P. Allen Smith Gardens
	MG/Perin	Jim Fowler's Life in the Wild, specials
	MGM Worldwide Television Group	She Spies, Stargate SG1, Dead Like Me, The Outer Limits, In the Heat of the Night, movies
	NBC Enterprises	Ed, Fear Factor, Access Hollywood, The George Michael Sports Machine, The Jane Pauley Show, Providence, Rebecca's Garden, Saved by the Bell, The Wall Street Journal Report
	New Line Television	The Twilight Zone, Nancy Drew/Hardy Boys Mysteries, movies
	October Moon Television	That's Funny, Road Rules, The Real World, firs-run series, movies
e	Paramount Domestic Television	Entertainment Tonight, Judge Judy, The Montel Williams Show, Girlfriends, Spin City, Frasier, Cheers, Family Ties, Happy Days, Nash Bridges, Matlock, Star Trek, Star Trek: The Next Generation, movies
	Raycom Sports	ACC Basketball, Big 12 Conference Football, Pac 10 Conference Football, L ² GA Golf, specials
	SFM Entertainment	Movies, specials, documentaries, animated specials
0	Sony Pictures Television	Seinfeld, Mad About You, The Nanny, Ricki Lake, Judge Hatchett, Dawson's Creek, Married with Children, Designing Women, Barney Miller, The Facts of Life, Who's the Boss?, movies
	Telepictures Distribution	ER, The West Wing, elimiDATE, Change of Heart, Celebrity Justice, Family Matters, The Fresh Prince of Bel-Air, This Old House, movies
	Tribune Entertainment Company	Mutant X, Family Feud, B. Smith with Style, Beastmaster, Gene Roddenberry's Andromeda, Soul Train, U.S. Farm Report, Pet Keeping, Famous Homes & Hideaways, Ron Hazelton's House Calls, movies. specials
0	Twentieth Television	24, The Bernie Mac Show, Reba, On Air with Ryan Seacrest, The Practice, Dharma & Greg, Divorce Court, The X-Files, The Simpsons. Malcolm in the Midale, Yes Dear, Still Standing, M*A*S*H, Cops, Doogie Howser M.D., movies
a	Universal Television	Jerry Springer Show, Maury, Xena: Warrior Princess, Coach, Gimme a Break, Rockford Files, The A-Team, movies
	Warner Brothers Domestic Television Distribution	Sex and the City, The Ellen DeGeneres Show, The Sharon Osbourne Show, Will & Grace, George Lopez, Smallville, Everwood. The Drew Carey Show, Friends, Full House, The People's Court, Access Hollywood, Extra, Judge Mathis, movies
	Western International Syndication	Live in Hollywood, It's Showtime at the Apollo, action series, specials
	World Wrestling Federation	WWF Metal, WWF Jakked, WWF Shotgun, WWF Shotgun Saturday Night

Television, Universal Television, and Warner Brothers Domestic Television Distribution. With the exception of King World, which had been an independent syndicator for decades but is now owned by Viacom/CBS, all the other very large syndicators are divisions of the Hollywood studios (see 1.17).

Syndicators "sell" (license for a fee, hence license fee) the telecast rights to a program to a local station for a certain term and for a set number of plays. The syndicator or the producer of the program continues to own the rights to the show. Some syndicators create, produce, and distribute their own programming while others merely distribute (for a commission) programs created and produced by others. Additionally, syndicators often increase their revenues by selling national barter time (advertising spots) within programs. The syndicator licenses ("sells" or leases) the program to a station for a specific term or period of time. During the license term, the syndicator grants the station the exclusive right to broadcast the program. At the end of the license term, the broadcast rights revert to the syndicator, who may now license the program all over again to any station in the market, including the station that ran the program in the first cycle or any of its competitors.

The syndicator's client is both the group owner and the local television station or the cable network. After the FCC relaxed limitations on ownership of television stations in terms of both the percentage of the U.S. population covered and the number of stations permitted under common ownership in a single market, the dynamics of the sales process changed. Increasingly, program purchasing and scheduling decisions moved toward corporate or group management and away from local television stations. This is partly the result of the rapidly increasing costs of acquiring programming (as a percentage of a station's operating budget and expense versus revenue) and also because of the greater negotiating clout a group programming executive has when bargaining on behalf of several television stations—as opposed to the leverage a single station has.

At the group level, there are generally one or more programming executives. Frequently, upper management is involved in negotiating for programming on a group level, especially because of the consequences for multiple stations and the huge dollar amounts involved. These upper-level executives may include the CEO, president, CFO, executive and senior vice presidents, and even owners.

At the station level, the people most commonly involved are the general manager, the business manager (financial person), and the program director (also called program manager, director of programming, or other similar titles). Many important program purchasing or scheduling decisions may be made by corporate management or station owners, bypassing the local general manager and program director altogether. These corporate executives, including the group programming executive, are generally not located in the same city as the station itself, a potential source of friction and poor judgment. In another twist, because of consolidation, the same program director may program two stations in the same market that are owned and/or operated by the same company. While in effect these stations compete against each other, the programmer will likely set up complementary program schedules on the two stations, hoping to maximize viewership on both of them.

To save money, at some stations, the position of program director has been entirely eliminated and the responsibility shifted to either the station general manager and/or the group programming chief. And some program directors have been reduced to merely scheduling episodes and creating liaisons with the community rather than wielding the power such positions once had. Yet, though the situations vary depending on corporate philosophies, most stations still employ program directors and give them due respect and authority.

The Rep

The outside party involved in the syndication chain is the rep programmer, who works for the national station sales representative firm that sells national advertising time for the station. The rep programmer acts as an ally for and consultant to the station. In recent years, there has been much consolidation in the sales representative business. There are now

just three major rep firms, each of which has separate sales organizations/divisions under its corporate ownership. This structure enables the firms to represent more than one television station in the same market, since the "separate" sales divisions within the same firm "compete" with one another.

- Clear Channel-owned Katz Media has Millenium (formerly Seltel and Katz Independent),
 Eagle, and Continental divisions.
- Cox-owned TeleRep consists of MMT, TeleRep, and HRP divisions.
- Petry Media, owned by Petry, has Petry and Blair divisions.

The ABC, CBS, FOX, and NBC O&Os are self-repped and have their own major rep divisions. Similarly, Univision stations and a few other large television stations are also self-repped. Adam Young is the last of the independent, non-networkowned station reps. These names can be seen in trade publication articles, in advertisements, on research materials, in directories, and even on television station letterheads—all these companies (and several smaller ones) are station representatives, national sales organizations selling commercial airtime on behalf of local market television stations.

Although the station representative is primarily a sales organization (selling national spot commercial airtime on local stations), reps provide additional services to client stations including marketing support, sales research, promotion advice, and programming consultation. Through these support services, the reps help client stations improve their programming performance in terms of audience delivery, which will in turn lead to increased advertising rates and, presumably, increased profitability for the station and the rep. (Although revenues may go up, profitability for the station sometimes does not because of increased programming and operating costs and other expenses.) Usually, no additional fee is charged for support services; they are included in the rep's sales commission (see 3.4). The major rep firms have programming staffs that work with programmers at client stations to shape and guide the stations' programming schedules.

3.4 The National Sales Rep

eps sell commercial airtime on local client stations to national spot advertisers. As the advertising agency represents the advertiser in buying commercial time, the station rep represents its client station in selling the national time. Local stations sell commercial time to local merchants and other advertisers within their markets, and all commercial stations employ a local sales force for this purpose. In most cases, it is not economically feasible for a single station to employ a sales force to sell commercial time to national advertisers because there are far too many advertisers and advertising agencies in too many cities to be covered by a station's sales force. That's where the rep comes in. Reps employ sales people in major cities on behalf of local stations to sell to advertisers in those cities. (Several reps have offices in more than 20 cities.) Because reps sell on behalf of mary stations, they can maintain sales forces of hundreds of people, selling on behalf cf dozens of stations. The largest station representatives have client stations in as many as 200 markets.

The rep receives a negotiable commission from its client stations for the commercial time the rep sells. As a rule of thumb, a 10 percent commission rate is the industry norm, but because of the competitive nature of the rep business, such considerations as the overall state of the economy and market size may cause the commission rate to vary widely. Stations in larger markets and stations owned by large group broadcasters often pay cnly single-digit commission rates to their representative. Conversely, stations in smaller markets generally pay a higher commission rate because the dollar volume is considerably less than in large markets.

Rep programmers provide ratings information that may support or call into question information that syndicators supply, and they advise client stations on the programs that will attract the most viewers in the demographic groups advertisers most desire to reach. At the same time, rep programmers must consider each station's programming philosophy, the mores of the community, and the quality of each program.

One of the rep's most important functions is to regularly disseminate generic national research information and market-specific research to client stations. Most reps maintain close contact with all the big networks (ABC, CBS, FOX, NBC, CW, and Univision), enabling them to supply an affiliate with competitive information regarding the other networks. Reps also publish ratings summaries and analyses of new programs, and they provide exhaustive ratings information after each rating sweep period. Because of their national overview of programming and their own experience and that of their colleagues, rep programmers can often look at programming decisions from a perspective not available to a local station's general manager or program director.

Program Acquisition

Syndication is the arena in which most programmers expend much of their energies—and with good reason. For most stations, the money spent annually to acquire syndicated television shows is their single largest expense. The station that buys a syndicated program that turns out to be a dud or the station that overpays for a syndicated show may be in financial trouble for years to come. And the station that makes several such mistakes (not uncommon) has serious problems.

The general manager and the program director get recommendations from their rep on which shows should be acquired, along with a rationale for the acquisition and recommendations on the program's placement in the station's lineup. Although reps spend most of their time dealing with syndicated programming and therefore work closely with syndicators, agent reps do *not* work for the syndicators. Reps work for the stations; rep firms are paid commissions by client stations based on advertising sales.

Both the station program director and the rep programmer spend many hours meeting with syndicators, listening to sales pitches, and watching videocassettes or DVDs of sales pitches, research information, program excerpts, or actual pilots. In the pitch, the syndicator's salesperson tries to

convince the programmer of the program's merits and that the program, if scheduled on the station, will improve the station's ratings. Although the reps do not actually purchase the program, and although the syndicator must still pitch the station programmers directly, a rep's positive recommendation to the station paves the way for the salesperson when he or she contacts the station. Most syndicators' agents maintain close and frequent contact with the station program director and the reps. They inform reps of ratings successes, changes in sales strategy, purchases of the program by leading stations or station groups, and any other information they feel may win support from the rep. Syndicators often try to enlist the rep's support for a show in a specific time period on a specific station the rep represents.

Syndicators can be good sources of information about competing stations in a given market because they generally deal with all stations in a market and have a good idea of each station's programming needs and philosophy. Frequently, syndicators inform reps of programs during their developmental stages—like trial balloons that serve as a way to gauge the rep's reaction prior to beginning a sales campaign or shooting a pilot of a program.

Syndicator contacts with reps do not replace contact between syndicator and station. Rather, syndicators take a calculated risk with reps to gain support for a program. If a rep dislikes the show or does not feel it suits a station's needs, the rep's advice to the station can damage the salesperson's efforts.⁴ Many stations have refused to buy syndicated shows because their reps did not endorse them.

Scheduling Strategies

When a television station acquires a program from a syndicator, its managers generally have a pretty good idea of how they will use the show. Frequently, they look not only for a program that meets their needs but also for one that fits certain scheduling and business-deal criteria. As discussed in Chapter 4, several scheduling strategies are widely accepted.

 Stripping. Syndicated series can be scheduled daily or weekly, and programs that run daily in the same time period Monday through Friday are said to be stripped. In the case of offnetwork programs, 65 episodes (three network seasons) are generally considered the minimum for stripping, allowing 13 weeks of Monday to Friday stripping in syndication before a station repeats an episode. Between 100 and 150 episodes are considered optimum for stripping, whereas 200 or more episodes can be a financial and scheduling burden to a station. First-run daily programs are created specifically for stripping. Producers will generally shoot 195 original episodes (39 weeks) a year, with 65 episodes (13 weeks) repeated. Some first-run strip shows will be produced fresh every day with no repeats (260 episodes over 52 weeks). as in the case of timely magazine shows like Entertainment Tonight.

- Audience flow. As a general strategy, programmers try to schedule successive shows in a sequence that maximizes the number of viewers staying tuned to the station from one program to the next. The shows flow from one to the next, with each building on its predecessor. The lead-in and lead-out shows are carefully selected to be compatible with a program in any given time period. Theoretically, the audience flows with the shows. Additional audience may flow into the program from other stations and from new viewers just turning on their television sets. Thus, audience flow is a combination of (1) retention of existing audience from lead-in, (2) dial switching from other stations, and (3) attraction of new tune-in viewers.
- Counterprogramming. This tactic refers to scheduling programs that are different in type and audience appeal from those carried by the competition at the same time. For example, within one market from 4 to 5 p.m. Monday through Friday, station WAAA might schedule a talk show, WBBB might carry two court shows, WCCC might carry a magazine show and a reality show, WDDD might carry two situation comedies, and station WEEE might also schedule two sitcoms. And with WDDD and WEEE both carrying situation comedies

opposite one another, one station might schedule sitcoms with ethnic appeal against the other station's general-appeal sitcoms, hoping to pick up a disproportionately large share of minority viewers. Thus, all stations are counterprogramming each other. In another example, within one market during prime time at 10 P.M., while the ABC, CBS, and NBC affiliates carry network entertainment programs, the FOX, UNI, and CW affiliates might schedule news; and while the ABC, CBS, and NBC affiliates air late-evening news at 11 P.M., the other stations might counterprogram with situation comedies, reality shows and other non-news programming. Again, one station might schedule programs with strong appeal to minority viewers in hopes of picking up additional viewers in what has become a highly competitive and increasingly fractionalized marketplace.

Deal Points

When the syndicator approaches the station or rep programmer, he or she outlines the terms and conditions of the offering. Most deals include the following deal points or terms:

- Title. In the case of programs entering syndication after a network run, the syndication title may be different from the network version. Thus, *Happy Days* became *Happy Days Again* in syndication. Sometimes the title of a first-run program is changed from the time the program is marketed to the time it starts airing, often in an attempt to entice more people to watch the show.
- Description of the program. This includes whether it is first-run or off-network, the story line or premise, and other pertinent information. While not an actual deal point, the syndicator may also indicate potential strong points for audience appeal, including gender (fcr example, sitcoms having high female appeal or sports shows with strong male appeal), age (reality dating shows with young adult appeal or sitcoms that have kid/teen appeal), or ethnic (sitcoms with large minority casts).

- Cast, host, or other participants. Big-name or emerging talent is often a draw. In some cases, an ethnic host or cast may be a selling point. If additional episodes of a series are planned, notice of long-term contracts with the talent has value.
- Duration. The program may be 30, 60, or 90 minutes long, or another length entirely.
- Number of episodes. This point includes original episodes and repeats. Sometimes a minimum and maximum number of episodes are offered.
- Number of runs. The syndicator indicates the maximum number of times the station may air (run) each episode. In situations where a single company owns two stations in the same market, a provision might be negotiated in the contract to allow the program to run on either station, but the total number of runs in aggregate on the two stations will generally be the same as if only a single station were to run the show. In large part this has to do with the amount of money paid by the syndicator or production company in residuals to actors, talent, producers, directors, and other creative personnel and the amount paid in music licensing and other rights payments. Generally, the greater the number of runs permitted, the higher these payments will be, regardless of the number of stations carrying the program. These additional payments go right out of the syndicators and/or the production company's bottom line, hence reducing profits. Another factor limiting the number of runs in syndication might include future sale to cable networks, which affects both the term (length) of the contract and the number of runs during that period.
- Start and end dates. Programs are sold for specific lengths of time, such as six months, one year, three-and-one-half years, five years, or seven years. They may be sold months or years in advance of the start date (futures).
- Commercial format. Each show is sold with a fixed number of commercial spots. For example, a typical half-hour program might be formatted for (1) six-and-a-half internal commercial minutes (in other words, thirteen

- 30-second units) in two breaks of two minutes each and one break of two-and-a-half minutes within the program plus (2) an *endbreak* (external) following the program, typically of 92 seconds. Some of the commercial time within the program may be retained by the syndication company for sale to its own national sponsors; this is considered barter time and is part or all of the license fee.
- Price. The cash price may be stated as either a per-episode fee (which is one inclusive amount for all runs of a single episode) or as a weekly fee (a fixed amount regardless of the number of times each episode is ultimately shown). The price charged for a program will generally vary by market size, with stations in larger markets paying more for a program than stations in smaller markets would pay because at any given rating, there are more viewers per rating point in larger markets than in smaller ones. Therefore, stations in larger markets can charge more for commercial airtime and with those higher revenues can pay more for programming than stations in smaller markets can. However, competition for a certain program in a highly competitive market can result in a higher license fee than in a somewhat larger market that is less competitive. Reasons for competitive levels can include the number of stations in a market (more stations means more competition for a show and fewer shows to choose from-each show has a better chance of being sold because there are more potential customers), more intense rivalries between competing stations or corporate owners, and the personalities and abilities of the programmers and the syndicators. Keep in mind that highly successful shows like The Oprah Winfrey Show and Dr. Phil can command significantly higher license fees than less popular programs. Often the "buzz factor" has something to do with program pricing, like a car or movie that becomes hot because people are talking about it and not necessarily because it's the best car or movie for the price. A syndication company's sales, research, and publicity people can often create or enhance a program's perception in the

marketplace. The price goes up for the show everybody is buzzing about, like Oscar winners.

- Payment method. Programs are sold for cash, for barter, or for cash-plus-barter.
- Down payment. In cash or cash-plus-barter deals, the syndicator might request a down payment (typically 10 to 20 percent) when the contract is signed, which is sometimes several years before the station receives the rights to the show.
- Payout. Cash the station still owes to the syndicator (after the down payment) must be paid when the program begins to air. Typically, the balance is paid in installments over the life of the contract, similar to mortgage or auto loan payments.

A Pitch

Using the hypothetical syndication offering of the equally hypothetical off-network *The Bill Smith Show* as an example, let's look more closely at the syndicator's sales pitch to a station.

About 9:30 one morning, the telephone rings in the office of the program director at a mediumsized market station on the East Coast. The caller is a Los Angeles-based syndication sales person (calling at 6:30 A.M. Pacific time from his home) with whom the programmer has developed a professional friendship. After a minute or so of how'syour-family chatting and two or three minutes of exchanging trade gossip ("Did you hear Jane Green is out as general manager of WBBB? Do you know who's going to replace her?"), the syndicator tells the programmer that he's coming to the market next week and would like a few minutes to tell the program director about his company's latest offering, The Bill Smith Show. And how about lunch too? The programmer agrees to see the syndicator the following Tuesday at 11 A.M., followed by lunch.

Tuesday morning arrives, and so does the syndicator, shortly before the appointed 11 A.M. time. There's amiable conversation about the syndicator's rough flight east, the hot, rainy, humid weather the city has been experiencing for a week, and the good weather the syndicator left behind in

Los Angeles. The salesman asks about the sale of one of his competitors' off-network programs, trying to ferret out competitive information. The program director asks about the status of one of the syndicator's somewhat shaky first-run programs, to which the syndicator replies that the program is stronger than ever—but, after a few minutes of verbal fencing, he acknowledges it is still not performing up to expectations. Finally, at about 11:10, the pitch begins.

The syndicator removes a glossy, expensively printed, full-color sales brochure from his briefcase. Bill Smith's smiling face and the title of his show are on the cover. The salesman guides the program director through the first few pages, elaborating on the printed descriptions of the show's plot, characters, and leading stars. The syndicator doesn't have to mention that the character Bill Smith is African-American and that most of the cast is white (the program director would have had to be living on another planet for the past few years to have not seen the show on network and to not be aware that the show stars a popular African-American comic actor as Bill Smith), but he does point out in a seemingly offhand manner that the program in its network run has demonstrated a high appeal to black viewers while being very popular with whites and other ethnic groups as well. (The syndicator will elaborate on this fact in much greater detail later in the pitch when he reviews the research on the show's viewer composition and appeal.) He makes reference to the show's "outstanding" network history, "the best since Home Improvement or Seinfeld," he claims, but he offers no research to support his assertions. (That will come later in the video presentation.) The program director takes the following notes.

TITLE: The Bill Smith Show

DESCRIPTION: Off-network sitcom about a zany recluse and the lovable neighbors in his apartment building

CAST: John Jones as the zany but sensitive Bill Smith; Jane Doe as Bill's amorous neighbor Helga; Max Brown as the bumbling building superintendent Sam

DURATION: 30 minutes

The syndication salesman suggests that the program director watch a 15-minute video presentation. As they watch, the programmer sees a succession of hilarious *Bill Smith Show* highlights, followed by clips of several tender, emotional scenes designed to show John Jones's acting range as Bill Smith. Although *The Bill Smith Show* has been on network television for two years, the producer of the tape is taking no chances that the programmer may not have seen the show. The presentation's producer has also put together many of the show's more memorable or funnier scenes, hoping to create a highly favorable impression of the show.

Now the focus of the tape shifts to the program's network performance. The presentation shows that *The Bill Smith Show* has taken a previously moribund time period on the network and has increased the network's household audience share in the time period by 50 percent over the previous occupant's performance, despite a weak lead-in program and strong competition from the other networks. In fact, in its first season, *Bill Smith* had single-handedly taken the network from a weak third place to a strong second place. As a result, the network moved *The Bill Smith Show* in its second season to a different night and time, where the results have been similarly impressive.

The research focuses on similar gains made by the show in women 18 to 34, 18 to 49, and 25 to 54; children 2 to 11; and teen demographics. Throughout the presentation of this research, the tape shows that the program has high appeal to ethnic audiences, especially black viewers. It omits all mention of male viewers older than age 17. (The programmer makes a mental note to check the syndicator's claims against research supplied by the station's rep programmer, especially the program's ethnic orientation in a market with a low minority population, such as this one.)

In the tape's final minutes, the enthusiastic voice-over announcer stresses the usefulness of *The Bill Smith Show* in syndication as a lead-in to an affiliate's early newscast (typically 5 P.M. or 6 P.M.) or an independent station's 6 to 8 P.M. schedule. The tape also compares the show's writing, cast

of characters, and network performance to such perceived network and syndication successes as Seinfeld, The Cosby Show, Friends, Cheers, and Home Improvement. (The programmer mentally notes that this program seems to have strong general audience appeal, similar to programs with no minority cast members and, of course, to Cosby as well. If the rep's research bears this out, the program could be a good acquisition, even in a market with a relatively small minority population.) The tape ends with several additional hilarious scenes and the syndication company's logo.

Now the syndicator hands the programmer a packet containing research studies. Much of the research mirrors the information shown in the video presentation, but it is more detailed. A copy of last week's overnight ratings in the metered markets is included showing that *Bill Smith* finished in first place for the fourth week in a row. A major section in the research shows the program's appeal to minority audiences and mentions that its performance compares well with other hit sitcoms that are not aimed at minority viewers. There are even several pages that show the program's strong performance on the local network affiliate (another station) in the programmer's own market.

The programmer and syndicator discuss the research data. The programmer questions the obvious omission of data for the male demographics, which she deduces is one of the show's weaknesses. The syndicator claims that lack of male appeal is not a shortcoming because the time periods in which the program will play in syndication have relatively few male viewers available and because women and children control the television set anyhow. The programmer continues to question the point; the syndicator uses his laptop to show her research data demonstrating that The Bill Smith Show, does, indeed, have male appeal. Still unable to completely satisfy the program director, the syndicator promises to have his company's research director provide additional information to show that males also like the program.

The programmer also presses the syndicator on the appeal of the show to nonminority audiences, such as the racial composition of her market, and gets a similar defense of the program and an "I'll get back to you with more research" response. And so it goes for about half an hour, with the program director questioning research data and making counterarguments based on her own research. Finally, the program director is satisfied that the syndicator's research is generally accurate—as far as it goes. The program director will check all of the syndicator's claims with her station representative and against her own research and market knowledge.

Now the discussion turns to the deal itself. In a presentation punctuated by frequent questions and requests for elaboration, the syndicator outlines the rest of the offering. The program director takes notes of the deal points.

PROGRAM TYPE: Off-network situation comedy EPISODES: Minimum of 66, maximum of 176 if the program runs eight years on the network RUNS: 6 per episode

YEARS: 3 to 5 (depending on number of episodes produced)

START DATE: Fall 2009

FORMAT: Cut for 6½ minutes

PAYMENT: Cash 1 barter

BARTER SPLIT: 1:00 National (two 30-second spots); 5:30 Local (eleven 30-second spots)

DOWN PAYMENT: 10 percent

PAYOUT: 36 equal monthly installments

ASKING PRICE: \$12,500 per episode for the first five network years plus an additional 10 percent per episode beginning with the sixth production season (if the show runs that long on the network) with a maximum of eight production years

(In a similar pitch to a rep, the asking price is usually not discussed because the syndicator is pitching the rep on all markets at one time and would prefer to quote the price directly to the customers, the stations. Also, the price will vary by market size, station rank, and number of stations in a group buy.)

Finally, the syndicator has made all his points, and the program director has asked all her questions. It's now time for lunch. (Most syndicator meetings do not involve lunch, but when they do, it's a chance for less formal discussion of the program and other issues.) The programmer and the syndicator go to a nearby restaurant. During the meal, the syndicator suggests specific spots in the station's schedule where the show might fit and tries to get a reaction from the program director. The programmer plays it close to the vest.

Eventually the discussion turns to other topics. The programmer and syndicator touch on renewals of one older show. They discuss the syndication company's plans for future first-run shows. At one point, the salesman says he'll be back in town in a few weeks with a new package of 30 movies his company is about to offer. The program director manages to pry out of him three "typical" titles, probably the three most popular films in the package.

Finally lunch is over. The syndicator picks up the check. The syndicator goes to his next appointment at another station in town, and the program director returns to the office, possibly for another meeting with another syndicator. Later in the day and during the next several days, she discusses the program and the research with her station representative. In her decision-making process over whether or not to recommend acquisition of *The Bill Smith Show* to the general manager and the corporate group programmer, she must consider

- whether or not the station actually needs the program.
- the potential danger if the show ended up on a competitor (a virtual likelihood if her station passes on purchasing it).
- whether there is another program available that might be a better acquisition for her station.
- the time period when her station would schedule the show (and a backup time period if it didn't perform up to expectations).
- the actual network performance versus the show's projected performance in syndication.

- all the research (from the syndicator, the station rep, and her own).
- the cost of the program (raising the question of whether there is money allocated in the station's five-year future budget projections for a show at this price level).

Finally, she must put aside personal feelings or biases for or against the show (it happens to be one of her favorites; in fact, she usually TiVos it to be sure she doesn't miss an episode) and make the decision on as much of a nonemotional business basis as possible. However, even the most conscientious programmers can rarely put aside all personal feelings and overlook either positive or negative buzz in both the television industry and their own personal worlds.

Syndicator/Rep Rules

The relationship between syndicators and reps is generally friendly and mutually dependent. The syndicators need the reps' support in client markets; the reps need to get programming information from the syndicators. Yet the relationship must also be guarded. Because the reps are agents of their client stations, they must maintain their independence from the distributors with an impartiality befitting the trust placed in them by the stations.

Therefore, certain unwritten rules govern the relationship between syndicator and station rep. Reps rarely make blanket program recommendations, and they do not endorse any particular syndicator. Although reps often support or oppose a particular genre or programming trend, they are generally quick to point out that not every station in every market necessarily can be included in their assessment. Few programs will appeal equally in every market, and the stations' competitive needs differ greatly from market to market.

Another unwritten rule is that rep programmers do not supply syndicators with privileged client-rep information. As an extension of the station, the rep programmer does not want to supply information to syndicators that would help the syndicator negotiate against the station. Privileged information includes prices the station would be prepared

to pay for programs, prices it already paid for other programs, other programs the station is considering purchasing, its future plans and strategies, contract expiration dates, and any other information that might harm the station's negotiating position; however, syndicators frequently provide such information to the reps.

Ratings Consultation

Station general managers and program managers talk regularly with their national reps. Rep programmers and station sales management and research directors are also in contact, albeit less frequently (most stations do not even have a research department). The rep programmer occasionally meets clients, either by visiting the station or when station personnel travel to New York, where all reps are based, to meet with rep sales management and with advertising agencies. Most general managers/program directors and reps endeavor to meet with one another at the annual conventions of NATPE (National Association of Television Program Executives), NAB (National Association of Broadcasters), and at network affiliate meetings.

A good working relationship between the station and the rep programmer is important. Consultation is not a one-way process; a rep does not presume to be an all-knowing authority dispensing wisdom from a skyscraper in New York. The consultation a rep programmer provides is a give-and-take exchange of ideas. Just as the rep has a national perspective, enabling him or her to draw upon experiences in other markets, the station programmer generally knows his or her market, local viewers' attitudes and lifestyles, and the station's successes and failures over the years better than almost anybody else.

Key Questions

Station management and rep programmers must consider some key questions as they work together.

• How well is the station's current schedule performing?

- Has there been audience growth, slippage, or stagnation since the previous ratings report? Since the same period a year ago? Two years ago?
- What audience demographics are the advertisers and the station and rep's sales departments seeking? Is current programming adequately delivering those demos?
- Are older shows exhibiting signs of age?
- Has the competition made schedule changes that have hurt or helped the client station?
- Does the client own programs that can be used to replace weak programs, or must the client consider purchasing new programs for weak spots?

Generally, a station seeks audience growth over previous ratings books. Of course, for one or two stations to experience audience growth, other stations in the market must lose audience. And competition from cable also siphons viewers away from over-the-air broadcast television. The rep programmer seeks to help the station stem audience erosion and create growth instead.

Reps also help station programmers analyze the most recent ratings report. Both parties look for trouble spots. If a program is downtrending (showing a loss of audience from several previous ratings periods), the programmers may decide to move it to a different, perhaps less competitive time period. Or they may decide to take the show off the air entirely, replacing it with another program. Sometimes a once-successful but downtrending program can be rested or "put on hiatus," perhaps three months minimum to a year maximum, or for a part of the year, such as the summer. When the program returns to the air from hiatus, it often recaptures much of its previous strength and may run successfully for several more years. (If the station does take the program off the air, it must still pay the cash portion of the license fee to the syndicator, and it must run the barter spots in the agreedupon time period where the show had run.)

The programmers may also note that a certain daypart is in trouble. A wholesale revision of that part of the schedule may be in order. They may need to rethink a station's programming strategy to decide whether current programming is still viable or whether the station should switch to another genre. For example, if a two-hour off-network action-drama block is not working, should the station switch to sitcoms or talk shows? A change of this magnitude is often quite difficult to accomplish, for the station usually has contractual commitments to run current programming into the future. Also, most viable programs of other genres are probably already running on other stations in the market. It is usually easier to rearrange the order of the existing shows to see if a different sequence will attract a larger audience. It is also easier to replace a single show than an entire schedule block.

Although household ratings are an important indicator of a program's relative performance, programmers are primarily concerned with audience demographics. Though there are dozens of demographic groupings, the most important demos are women 18 to 34 years old (W18-34), women 18 to 49 (W18-49), women 25 to 54 (W25-54), men 18 to 34 (M18-34), men 18 to 49 (M18-49), men 25 to 54 (M25-54), teenagers (T12-17), and children (K2-11). Generally, these are the demographic groups most desired by advertisers and therefore the target audiences of most programs, with W18-49 generally regarded as the single most important demo. And as shown earlier in the hypothetical example of The Bill Smith Show, ethnic appeal can be an important consideration, especially in markets with relatively high minority populations.

Although most programs probably don't appeal equally to all of these groups, programmers try to schedule shows that reach at least several of these demos at times of the day when those people are available to watch television. Even if a program is not number one or two in household rating and share, a strong performance in a salable demographic may make the program acceptable despite the household rating. For example, the program may be number two or three in household rating and share but may have very strong appeal to young women, making it number one in the market in W18-34 and W18-49. And strong ethnic appeal to Hispanics or African-Americans may be an important factor in many markets. These groups have attractive demographics for many advertisers. Thus, the program might be acceptable for the station's needs despite its lower household ratings performance.

In another example, the program might be the third-rated show in its time period but may have exhibited significant ratings growth over previous ratings books. Therefore, the programmers may decide to leave the program in place because it is **uptrending** rather than downtrending. They may decide instead to change the lead-in show to try to deliver more audience to the target show. They may also decide to promote the show more to build audience.

A key issue in all these decisions is that programming is usually purchased far in advance of its actual start date. In the autumn of any year, stations are already planning for the following September, even though the current season has barely begun. Successful first-run shows are often renewed for several years into the future. Off-network programs are frequently sold two or three years before they become available to stations in syndication.

Once purchased, the station is committed to paying the agreed-upon license fee to the syndicator regardless of the program's subsequent network or syndication performance. Not uncommonly, a once-popular network program will fade in popularity in the two or three years between its syndication sale and its premiere in syndication. Although the station may be stuck with a program of lesser value than originally perceived, the syndicator does not waive or offer to drop the license fee. A deal is a deal. Conversely, some network shows increase in popularity as they continue to run; a station that bought early may pay a smaller license fee than it would if it had purchased the program a year or two later when its popularity was greater. Reps and their client stations thoroughly research, analyze, and plan acquisitions carefully in order to purchase wisely.

Research Data

Much station/rep consulting time is spent preparing information, researching program performance, and formulating programming strategy using ratings information from Nielsen Media Research. Station, syndicator, and rep programmers and salespeople regularly use the quarterly ViP ratings books (see below) to make programming decisions, sell syndicated shows, and sell advertising time. The syndicators and reps also have available to them additional Nielsen ratings information not generally purchased by stations because of its cost. These Nielsen studies include both national and local market reports.

National Reports

- NTI. Nielsen Television Index, based on people meters, provides daily ratings performance on a national basis for all network programs, including household and demographic audience estimates. The NTI ratings are also available as a weekly pocketpiece.
- NTI Pocketpiece. The Nielsen Television Index Pocketpiece Report weekly report provides national household and persons audience estimates for sponsored broadcast network programs. The Pocketpiece provides demos and household numbers for various dayparts. It is small enough to fit into a man's suit jacket pocket (hence the name) or a woman's purse, making it handy on sales calls. The Pocketpiece is also the oldest and best known Nielsen report.
- Galaxy Explorer. Nielsen's overnight NTI service provides national household ratings and shares and HUT levels. As a Windows-based system, users can analyze broadcast, cable, and syndication audience estimates across user-selected demographics and user-defined dayparts for programs and time periods on both a daily and a weekly basis.
- Galaxy Lightning. Galaxy Lightning is a quick way to process standardized reports and to load data onto spreadsheets, which can then be manipulated and printed.
- NPOWER. Nielsen's NPower is a software package that allows individual users to analyze Nielsen data and create custom ratings reports on desktops or laptops. Subscribers can access a centralized Nielsen database, which is

- continually updated by Nielsen. The data includes audience estimates for broadcast, cable, syndication and Hispanic viewing.
- NAD. Nielsen's National Audience Demographics Report provides comprehensive estimates of viewership across a wide range of audience demographic categories. The NTI NAD is published monthly in two volumes and provides information on national network program viewership. The NSS NAD is a monthly book providing similar data for syndicated programming. CNAD is a quarterly report of cable network viewership. Unlike the other NAD reports, CNAD does not provide data on individual programs; it provides viewing estimates only for time periods and dayparts.
- HTR. Nielsen's monthly Household Tracking Report tracks program performance by individual network within half-hour time periods.
- PTR. Nielsen's monthly *Persons Tracking Report* tracks program performance in terms of household audiences and viewers per 1,000 viewing households (VPVH). The PTR includes both regularly scheduled programs and "specials."
- CPT. The Household and Persons Cost Per 1000 Report is an NTI report that gives advertising agency media planners and buyers estimates of the efficiency of network audience delivery.
- HUT. Nielsen's quarterly Households Using Television Summary Report provides HUT levels for individual half-hour time periods for individual days and weeks.
- NTAR. Nielsen's quarterly *Television Activity Report* compares the audience levels of all broadcast network affiliates, independent television stations, PBS stations, and individual basic and pay cable networks. (This report replaced Nielsen's similar *NCAR* report.)
- NHTI. The *Nielsen Hispanic Television Index Report* evaluates Spanish-language television viewing using the same methodology as the company's other national television reports; however, the data are gathered by people

meters from a separate sample of randomly selected Hispanic households.

Local Market Reports

- NSI. Since 1954, the *Nielsen Station Index* has been the system used to measure viewership in local Designated Market Areas (DMAs), including local commercial and public broadcast stations, and viewership of some national cable networks, superstations, and spill-in stations from adjacent markets. *NSI* provides metered market overnight ratings reports in more than 50 major markets and diary measurement in all Nielsen DMAs.
- ViP. Nielsen's Viewers in Profile report is the bible of local television stations, the infamous "book" by which stations (and sometimes careers) live and die. Most commercial TV stations subscribe to this report, for it is the basis for the advertising rates the stations charge. All advertising agencies, syndication companies, and station reps get this report as well. Using NSI data, the ViP books show viewership over specific four-week periods (the "sweeps") in quarterly reports (November, February, May, July) in 210 markets and in October, January. and March in selected large markets. The information is broken down for dayparts, programs, and individual quarter hours. Ratings and shares are shown for households and key demographic groupings based on age and gender. There is also a section that tabulates viewership as thousands of people rather than as rating or share. The data is shown as a four-week average and is also broken out for the four individual weeks and the 28 days of the ratings period. Both program averages (showing data for only a single program as a single number for the entire length of the show) and time period averages (which may include two or more programs in the same time period during the four weeks and are broken down by quarter hours or half hours) are provided.
- NSS Pocketpiece. Nielsen's National Syndication Service weekly report provides national

audience estimates (in small size) for barter programs distributed by subscribing syndicators or occasional networks, including barter specials, syndicated sporting events, and barter movie packages.

- ROSP. Nielsen's Report on Syndicated Programs provides a complete record of all syndicated programs. The ROSP aids in the selection, evaluation, and comparison of syndicated program performance.
- Network Programs by DMA. Nielsen's reports provide audience information for network programs by station within each DMA (market).
- DMA TV Trends by Season. This Nielsen report shows viewing trends throughout the year for all DMAs. It is produced once a year following the July ratings period.
- TAR. Nielsen's quarterly DMA Television Activity Report compares the audience levels of all broadcast network affiliates, superstations, independent television stations, PBS stations, and individual basic and pay-cable networks. This report is similar to Nielsen's national NTAR report, except it is for individual local markets and includes spill-in stations from other markets.
- NSI Report on PBS Program Audiences. This report shows viewership of public television during each of the major ratings sweeps periods (November, February, May, July).
- NSI Report on Devotional Program Audiences. This report shows viewership of religious programs during each of the major ratings sweeps periods (November, February, May, July).
- NHSI. The Nielsen Hispanic Station Index report evaluates Spanish-language television viewing in 16 local markets that have significant Hispanic populations.
- Galaxy Navigator. Similar to Galaxy Explorer, Nielsen's Galaxy Navigator provides household ratings and shares and HUT levels for the individual local metered (overnight) markets. Using a Windows-based program, Galaxy Navigator enables the user to manipulate the reported data to customize reports.

 Galaxy ProFile. Galaxy ProFile is a PC-based analysis tool that the client can use to manipulate Nielsen data for all DMAs. Users can study the performance of individual programs across any and all markets, including comparisons in user-selected demos and with previous sweeps performances. Galaxy ProFile also provides time period analysis, genre analysis (that is, game shows, talk shows, and so on), program block analysis, benchmark analysis, and grid analysis.

In addition to this mountain of reports, which may also be purchased by syndicators, major station groups, and large-market stations, Nielsen offers various internet (Media Metrix), sports, DVD, game-show, local-cable, pay-cable, and other studies. If all this isn't enough, Nielsen can prepare special research reports exclusively for an individual station or tailored for a group of stations such as a rep firm's client list.

Specialized Program Analysis

Before the advent of personal computers, Nielsen provided printed reports to stations, syndicators, and station reps, often at significant expense. Now the station reps themselves provide much customized research formerly available only from Nielsen. One example of such customized ratings research is the Katz Comtrac system, which has become an industry-standard research tool because it provides easy-to-use comprehensive overviews of station and program performances (see 3.5). Nielsen originally computed the Comtrac reports on its mainframe computers and then printed them as books, but since the late 1980s Katz has prepared the reports in-house for its clients on its own PCs more quickly and at significantly lower cost. Katz now distributes the reports to its client television stations on CD-ROMs. The stations can then analyze the data on their own computers, printing the individual reports in which they are interested.

Katz's first page for Friends (one of several pages that cover all markets) tracks the show's shares in syndication in a condensed format. It shows which stations in which markets purchased Friends and when they scheduled it. Then it lists

3.5 Comtrac Sheets for Friends

Demos : HH = Ho	Demos : HH = Hornes, W1 = W18-49, W2 = W25-54, M3 = M25-54	W2 = W25-54, 1	M3 = M25-54			SH SH	SH SH SH	S I H	포공	ΩHr Leadin H	SH H	HH %CHG SH May '03	lay '03	W1 W2 SH SH	SHS	WHr Leadout H	HH 100 HS	l op Competrior	SH SH	NS €	Znd Compellor	iOil	SH	SH SH
32 CINCINNATI 33 MILWAUKEE	NATI	XIXW	F 19 20T W 18 20T	07 7:30P 07 6:00P	M-F M-F	11 12	6 4	0 9 7	11 6	FRIENDS KING OF QUEENS	4 2	4 8	-33	11 1	15 14	VARIOUS EVRYBDY-RAY MF	12 WKRC 8 WTMJ	C ENT TONIGHT 30 J 6P REPORT	1	11	WCPO JEC WISN WIS	JEOPARDY WISN 12 NEWS	18	14
	JKEE	WYTV		-		6 7	9	7 5	9	EVRYBDY-RAY MF	5 2.4	4 5	-29	8		KING-QUEENS B			22 1	-		ACCESS HOLLYWD	16	=
	COLUMBUS, OH	WTTE	F 28 20T	OT 6:00P	M-F	13 13	12 8	127	120	SIMPSONS B	4. 4	9 10	-53	22	15	WILL & GRACE	9 WCMH	H NEWSCH 4 AT 6	16	17 16 0	WBNS 10-	10-EYWT NWS-6P	17	17
35 GREEN	GREENVILLE-SPAR	WHNS	F 21 20T			7 6	9	7	1		9 8	8 7	17	14		FRIENDS B			16	15		ABC-WORLD NWS	12	2 2
	GREENVILLE-SPAR	WHNS	F 21 20T	1-		6 7	7	8 7	1	FRIENDS	7 3.	.8 7	0	14	12	SEINFELD			13			ENT TONIGHT 30	15	13
36 SALT LV	SALT LAKE CITY	KJZZ	14 201	OT 5:30P	H-W	7 8	7	2 0	4 4	HOME IMPROV MF	2 2	9 9	-25	21	0 0	FRIENDS	6 KSL	NBC NITELY NWS	11 9	13 14	KUTV+ 2N	2 NEWS AT 530P	91	4 0
	SAN ANTONIO	KENS	C 5 20T	-		18 13	20 1:	3 21	13 0	/S-10	20 6.8	8 12	P op	12 1	10	D LETTRMAN-CBS	10 WOAI		18			INSIDE EDITION	16	2 =
	GRAND RAPIDS-KA	WOOD	z			5 7	6	9	6				4	6	. 80	VARIOUS		_	25			EVRYBDY-RAY MF	6	10
	GRAND RAPIDS-KA	WXSP	0	=		2 1	7	2 2	t (VARIOUS	1 0.4	1 4	0 10	- 5	- 0	KING OF QUEENS	1 WOOD		17	20	_	VARIOUS	9 9	16
39 WEST	WEST PALM BEACH	WTVX	11 34 207	01 11:00P	M-F	4 3	- 6	3 0	0 6	VARIOUS	3 -	3 0	67-		00	IIIST SHOOT ME	3 WPTV	NWSCHNI 5 AT 11	18	12	WPBF WH	WHEEL-FORINE	9 8	ي م
	GHAM	WTTO+	WTTO+ W 21 20T	. 4)		2 2	4	2	7	SIMPSONS	6 3	8 7	40	12	9 14	FRIENDS B	8 WBRC		17	15 14 V	WBMA+ AB	WBMA+ ABC-WORLD NWS	2 8	4
	GHAM	WTTO+	WTTO+ W 21 20T	9			2	8 7	80	FRIENDS	7	89	0	19 1	12	EVRYBDY-RAY MF		WBMA+ 33/40 NEWS-6	4	12	WBRC FO	FOX 6 NWS AT 6	15	15
	NORFOLK-PORTSMT	WTVZ		_		3	9	9	9	SIMPSONS B	3	0 2	0	12	10 9	FRIENDS B			13			ENT TONIGHT 30	14	12
41 NORFO	NORFOLK-PORTSMT	MTVZ	W 33 201			20 0	9 1	9 4	9 4	FRIENDS	6	2 2	-17	9	000	VARIOUS	6 WVEC		44	13 1		JUDGE-BROWN B	= ;	= 9
	NEW ORLEANS	MONO		9:30P	L U	9 4	n a	0 0	ח ע	ABC-NITELINE	0 0	0 0	200	0 4	0 10	MILL & CDACE	S WWW	NARIOUS DIETTEMANICES	15		WDSU VAI	VARIOUS TONITE CHIM NIBC	4 5	2 0
43 MEMPHIS	IIS IIS	WHBO	< ц			. 4		10 8	10 0	KING OF HILL R	8 5.6	1 6	-18	13 1	3 0	THAT 70S SHOW	11 WMC		20			D LETTRMAN-CBS	2 8	0 00
	0	WIVB	C 4 20T			14 10		-	0		14	8 9	-20	12	17	VARIOUS		>	17			ENT TONIGHT 30	0	2 00
	0	WNLO	U 23 20T	-		2 1	2	2	2	WD	2 1.0	0 2	100	2		COPS			20 %	18		CH2 NWS NTSIDE	19	6
	OKLAHOMA CITY	KOCB	3			5 8	9	8	1	ON AIR-RYAN	3	7 6	-12	17 1		FRIENDS B			18			9-6 SMN	13	16
	OKLAHOMA CITY	KOCB	3			8 .	œ ·	7	8	FRIENDS	7	3 7	-12	15 1		VARIOUS			15			NWSCH4-630	19	16
46 GREEN	GREENSBORO-H.PO	WIWB	W 20 201	400.90 TO	- L	9 4	4 4	4 11	0 0	THAT 705 SHOW	2.8	0 0	200	1 5	5 0	FKIENDS B	5 WFMY	Y WEMY NEWS 2-6	10	13 0	WGHP FO	FOX8 NWS-6.00P	4 4	9 1
	HARRISRI IRG-I NCS	WHIM	3 4			4 cc	+ 1-	0 40	0 4	HOLLYWD SOLIARS	2 0	3.0	-17	5 4		VARIOUS			10		-	FVRVRDY-RAY MF	000	4 -
	PROVIDENCE-NEW	WLNE	<			4	4	6 4	3	ENT TONIGHT 30	3 1.8	9 8	-25	4	2	VARIOUS			15	12 1		ACCESS HOLLYWD	12	0
	PROVIDENCE-NEW	WLWC	_	-		3 2	2	3 1 2	8	WILL & GRACE	2 0.7	7 2	0	9	5 3	DREW CAREY			24	31		D LETTRMAN-CBS	14	Ξ
49 ALBUQI	ALBUQUERQUE-SAN	KASA	F 2 20T			2 2	8	4	4	DHARMA-GREG	4	4	43	00	8 7	FRIENDS B			14	12		EYEWTNS NW-600	10	12
	ALBUQUERQUE-SAN		F 2 201	0T 6:30P	ų u	11 8	4 α	τ α	4 α	FRIENDS FOX NEWS AT 10	4 6	τί π 4 α	200	æ å	2 4 8	8 VARIOUS	8 KROE+	E+ WHEEL-FORTNE	122	12 9	KOAT+ EN	WAYE NIME 11D	13	- 4
	III E			-		10	0 00	7 . 10	0	ľ	10	0 0	13	18	3 12	FRASIER			14 1	14	1	CONITE SHW.NRC	+	2 2
51 LAS VEGAS	GAS	KWU	F 5 19T			0 80	0 00	8	0 0	THAT 70S SHW R	5 h	4	0	15	8 0	FRIENDS B	9 KVBC		13 1	100	- ш	EYEWT NWS-630	12	2 =
	GAS	KW	5			8 10		6 01	10	FRIENDS	7 5.	9	-10	14	11 10	EVRYBDY-RAY MF			15			ENT TONIGHT 30	Ξ	12
52 JACKSC	JACKSONVILLE, B	WJWB	3	<u>_</u>		2	7	2	2	HUGHLEYS B	3	2 4	-20	7	7 4	JUST SHOOT ME	3 WJXT		16			FIRST CST NW@6	13	4
	JACKSONVILLE, B	WJWB W	W 17 201	TOOP TO		o c	0 +	90	90	JUST SHOOT ME	n c	0.0	-1-	n =	2 0	WILL & GRACE	WTLV	WHEEL-FORTNE	12			ENT TONIGHT 30	12	- 0
	WILKES BARRE-SC	WSWB+			L L	- 8	- α	4 4	7 4	FOX56 NWS-10PM 1	100	9 4	25.0	4 00	2 6	BECKER	2 WYOLL		14	17 15 1	WREE VAN	INSIDE EDITION	14	2 4
54 AUSTIN			. 3			8 10	-	8	7	WILL & GRACE	4	9	8 8	15 1	3 4	FRIENDS B			13			24 NEWS AT 6	16	2 00
		KNVA	W 54 20T			10 9	80	7 1 7	5	FRIENDS	6 3.	3 6	-33	13 1	9	VARIOUS			14	00		ENT TONIGHT 30	13	Ξ
- 1	ALBANY-SCHENECT	. 1	N 13 197	12		12 10	17 1	2 15	12	NWSCH13-NOON 1	11	8 8	-20	15 1	16 7	DAYS-OUR LIVES		- 1	29	32		JEOPARDY	16	=
	ALBANY-SCHENECT	TYNW	N 13 20T	07 7:30P		13 10	15	15	10	ENT TONIGHT 30	13	6 9	-10	16	9 2	VARIOUS		N+ JEOPARDY	21	9 9	WRGB KIN	KING OF QUEENS	= ;	0
30 LITTLE	LITTLE ROCK-PIN	KIDT	F 16 201	4	M-F	4 0	4 0	0 0	0 6	FOX 16 NIVIS AT 9	4 6	0 0	100	2 4	3 0	THAT 70S SHOW	A KATA		12 0	24 10 10		KTHV NEWS OF	4 0	2 2
	FRESNO-VISALIA	KMPH+	ш	-		13 14	15	1 17	130		14 .	11 1	5 5	14	0 0	FRASIFR	7 KESN		1 4			SH NEWS IOF	0 0	3 4
	FRESNO-VISALIA	KMPH+	ш	+		16 10	17	5 m 14	9		14	9 12	20	19	17 10	SEINFELD			17			ACTION NWS 11	=	9
58 RICHMC	RICHMOND-PETERS	WWBT	z	L	M-F	18 14	18 1.	3 19	13	ENT TONIGHT 30	18 7.	4 12	-14	17 1	7 14	VARIOUS	14 WRIC		12			MILLIONAIRE	6	6
	z	WDTN	A 2 201			9 01	9	80	0	ABC-WORLD NW3	7	4 7	-22	0	0 0	JEOPARDY			25	25 20 V	_	SIMPSONS	9	1
		KWBT	W 19 201			2	91	2	. 2	THAT 70S SHW B	2 5	4 1	-20	4 0	0 4	FRIENDS B	5 KOTV	_	23			NWS CH 8 AT 6	12	0
60 TULSA 61 KNOXVILLE	ILLE	WBXX	W 20 201	01 6:30P	¥ ₩	7 8	- 00	0 0	4 0	THAT 70S SHOW	4 6	9	-25	2 4	0 0	VARIOUS	7 WBIR	WHEEL-FORTNE	23 2	N 61 02	WATE MIL	MILLIONAIRE	9 4	2 2
a: VARIOUS	-	83																						Ш
C. FRIENDS		F FRASIER E THAT 70S SHOW																						
6: THAT 70S SHW B		m: SEINFELD																						
		A STATE OF THE PARTY OF THE PAR																						

source: COMTRAC Syndicated Program Schedules, May 2004. Used by permission.

the shares for the time period performance in the three previous ratings books (May 2003, November 2003, and February 2004, as well as May 2004 in this example), also telling what kind of lead-in it had and the lead-in's shares. (In some cases Friends was not the program in the time period in previous ratings surveys, so the performance of whatever previous program was in the time period is shown. The previous program is indicated by a small letter next to the share number, and the title is in the footnote at the bottom of the page. For example, in San Francisco the small letter b indicates Cheers ran in the three previous time periods; in Los Angeles, Friends was the February 2004 program because there is no small letter next to the number.) Next the Comtrac report shows Friends' current lead-in and shares in each market, and then Friends' own shares and ratings under the heading May '04 Target (including some abbreviated demographics), and its lead-out. Finally, the Katz Comtrac page shows Friends' two main competing programs in each market and their audience shares.

The Decision Process

The syndicator has visited the station and made his or her pitch to either the general manager or the program manager or both. The rep has consulted with the station, providing research support combined with experience and judgment—resulting in a recommendation regarding the program the syndicator is selling. The station and the rep have analyzed the terms of the deal, and the programmers now must determine how they might use the program, if at all.

Each programming decision is different from any other. Each show is different; each deal is different. Markets and competitive situations differ; corporate philosophies and needs not only differ but may also change over time. The personalities and opinions of the syndicator, station general manager, program director, and rep programmer all enter into the decision. Although innumerable permutations and combinations exist, the basics of the decision-making process involve an assessment of need and an analysis of selection options.

Determining Need

Perhaps the most important part of making any programming decision is establishing whether a program is needed and determining whether the program in question is the best choice to meet that need. Sometimes this task is easy. The need may be quite obvious. For example, a first-run program that many stations carry may fail to attract a large enough national audience and be canceled by its syndicator. It needs to be replaced on all the stations carrying it. In another example, despite increased promotion and a strong lead-in, a particular program on a given station continues to downtrend in several successive books and from its year-ago performance in the time period. It needs to be replaced.

At other times the need may be less obvious. A show may perform reasonably well but show no audience growth and finish second or third in the time period. Should it be replaced? Will a replacement show perform as well, better, or not as well?

When a syndicator is pitching a station, he or she tries to identify or create a need for the station to buy the particular program being offered. Although the syndicator's assessment that an existing program should be replaced may be correct, he or she is looking at it strictly from the perspective of selling a program in the market. The syndicator's need to sell a particular show may not be the same as the station's degree of need (if any) to replace an existing program. And the syndicator doesn't have to find money in an operating budget to pay for the program, even if it fails to perform up to expectations. (When people buy new cars or televisions or hair dryers, they come with warranties. If they don't work properly, the consumers have recourse to the manufacturer. Television programs don't come with warranties; the station assumes all the risk, even if the show fails.)

The station and rep programmers approach the determination of need by first looking at the performance of the existing schedule and identifying trouble spots, including individual programs and entire dayparts. For example, three out of the four programs from 4 to 6 P.M. may be performing quite well, but one may be a weak link and therefore a

candidate for replacement. In another situation, the entire 4 to 6 P.M. schedule might be performing poorly and need to be replaced, perhaps including a switch from one program type to another, such as from talk shows to reality and magazine shows.

Analyzing Selection Options

Once a need to replace a program has been established, a replacement must be selected. Programmers have six basic options at this point. Think baseball, for the alternatives are analogous in both television and baseball.

- Do nothing at all. If a station or a baseball team is trailing, it's sometimes best to leave the lineup unchanged, hoping for an improved performance or a mistake by the competition. Sometimes there's no alternative because the bench strength is either depleted or no better than the current players, so no stronger players or programs can be substituted.
- Change the batting (or programming) lineup. Swap the lead-off hitter with the cleanup batter, or swap a morning program with an afternoon show, or reverse the order of the two access shows. (There are many more examples.)
- Go to the bench for a pinch hitter or go to the inventory of programs "on the shelf" (already owned by the station but not currently on the schedule) for a replacement show.
- Hire a new player or buy a new show.
- Send the player to the minors or switch stations, but only if a company owns two stations in the same market.
- Do not renew the player's contract when it expires, and do not renew the program contract. This is no immediate remedy, but at least the station is no longer on the hook when the current contract expires.

Let's look at each option in greater detail.

1. Do Nothing

Although a time period may be in trouble, sometimes nothing can be done to improve the situation.

The station may not own any suitable replacement shows. Other shows already on the air might be swapped, but the station and rep programmers might feel that such a swap would hurt another daypart (perhaps a more important daypart) or that the other program might not be competitive in the target time period. Then, too, potential replacement shows available from syndicators may be perceived as no improvement over existing programming, or they might be too expensive. Often, increasing promotion can help the show "grow." Finally, the programmers may decide to leave the schedule intact because it may take time for viewers to "find" the show and form a viewing habit. The rep may research the performance of the program in other markets to see whether the program is exhibiting growth. Sometimes the only choice is to do nothing at all.

2. Swap Shows

The second alternative is to change the batting order. Generally, the station and rep programmers look first at the station's entire program schedule to see whether the solution might be as simple as swapping time periods for two or more shows already on the air. Often a program originally purchased for one time period can improve an entirely different time period when moved. See 3.6 for an example.

In most cases, syndicators are delighted when a station moves a show from a time period with a lower HUT level to one with higher HUTs. A higher HUT level means a higher rating, even if share stays the same or drops slightly. For syndicators selling barter time in a program, higher ratings in individual markets contribute to a higher national rating, which translates into higher rates charged by the syndicator to the barter advertiser.

For a station, however, such a move may also mean paying higher license fees to the syndicator. In the case of first-run programs, syndicators often make tier or step deals with stations. At the time the deal is made, stations and syndicators agree on price levels for different dayparts, with higher prices for dayparts that have higher HUT/PUT levels and thus more potential viewers available.

3.6 Example of a Swap Alternative

he Oprah Winfrey Show premiered in syndication in September 1986. It was positioned by its syndicator as a morning program (9 to 11 A.M.), meaning a reasonably low risk and low purchase price to stations because morning HUT levels are low. After Oprah's dramatic and very strong ratings performance in the November 1986 and February 1987 ratings books, many stations moved the program to the more important and more lucrative early fringe (3 to 6 P.M.) daypart to improve their afternoon performance. Oprah quickly became a dominant early-fringe program, vastly improving the time period performance of many stations and increasing audience flow into affiliate's early newscasts. In some cases, the program Oprah replaced was merely moved to the morning time period previously occupied by Oprah. In other situations, stations had to purchase a replacement morning show to fill Oprah's vacated time period.

One price is agreed upon for morning time periods, a higher price for early fringe, and perhaps a still higher price for access. Four-tier agreements, which may also include late night, are not uncommon. Moving a program from one daypart to another triggers a change in license fee. It is to the station's advantage to negotiate a step deal to avoid a potentially expensive program playing in a low-revenue time period.

Step deals are relatively rare for off-network programming, which generally has a single license fee level priced by the syndicator that is based on the revenue potential of the daypart in which it is presumed the program will play. Thus, when a station buys an off-network sitcom or hour-long action-adventure show for access or early fringe, the price the station pays remains the same over the life of the contract. If the show is a ratings failure in access or early fringe and must be moved to a less lucrative morning or late-night time period, the station's financial obligation to the syndicator remains unchanged. Thus, a station can find itself

with a very expensive "morning program," a daypart of significantly lower revenue potential than early fringe or access (meaning that the program may cost the station far more than the time period can generate in advertising income).

If the station buys an expensive off-network show that later is downgraded to a time period with lower HUT levels, the station may experience some discomfort in its bottom line (low profitability or a loss), but the consequences are generally not disastrous. If, however, the station buys several expensive shows that do not perform and must be moved to time periods with lower advertising rates, the economic impact can be quite serious. Because of the relatively long license terms of off-network shows (typically three to four years), a station may not recover for years when several such "mistakes" are made.

Depending on the program and how the contract is structured regarding stripping or weekend runs, it may be possible to move a Monday to Friday program from a weekday schedule to the weekend. Generally this is not possible with firstrun strip programs (such as talk or court shows), which are designed for a five-day run, but the strategy may be possible with some off-network shows, particularly older sitcoms that are purchased on a per-episode basis.

3. Substitute Shows

The third alternative is to go to the bench for a pinch hitter. Programmers have a responsibility to manage existing products and at the same time remain competitive. It's not always necessary to spend more money to buy a new program. Sometimes the station already owns the solution to a problem. A simple swap of programs already on the air may not be the best answer. A station with strong bench strength may have enough programs "in the dugout" to replace a failing show in a competitive manner. Corporate accountants like this sort of solution because it does not add to a station's expenses, and it uses existing products that must be paid for whether or not they air.

The station and rep programmers look at the strengths and weaknesses of the shows on the shelf, which generally have aired before. They must ask some questions at this point. How well did these shows work? Have they rested long enough to return at their previous performance level, and if not, is their reduced level still superior to the current program's performance? Are the shows dated? Will they look "old"? Are the potential replacement shows suitable for the time period? Are they compatible with the other programs in the daypart? Are they competitive? Are they cost-effective? Do they appeal to the available demographic?

4. Buy New Shows

If the first three solutions have been examined and rejected, the programmers at the station and the rep generally consider purchasing a program. Because an added expense is involved whenever a purchase is made, the programmers must determine whether a new program will be superior to an existing show, and if so, whether it will be strong enough to offset the additional cost.

Although expense is a consideration in any programming decision, programmers as well as corporate and station management should always keep in mind one very important factor: They must keep the station competitive. Remember, their job is to deliver the largest mass audience with the strongest demographics. Although they must always keep an eye on the bottom line and therefore program in a cost-effective manner, a false economy will result from trying to avoid expense if the result would be to lose even more revenue. If ratings decline, eventually revenue will also decline.

Instead, programmers must balance expense against returns, determining the ratings potential and projected revenue when deciding whether a new purchase is practical and, if so, how much the station can afford. The rep's research can help project the future performance of a program, whether it is already on a station's schedule or will be a future acquisition. Anticipated performance plays a large role in determining the purchase price.

5. Switch Stations

When two stations in the same market are commonly owned, the contracts may have been negotiated to allow some programs to run on either station. Sometimes a program can take on a new life and appear fresher when switched from one station to another. Sometimes a program will become a better fit in the "other" station's lineup because of other program acquisitions or changes made to either or both stations. And sometimes it's just prudent to put a weakening program on the weaker of the two commonly owned stations to reduce the negative impact on the strenger station's performance. While in baseball the team might send a struggling player to its farm club, in television this works *only* in a situation where two stations in the same market are commonly owned, and the show can be put into the schedule of the other, presumably weaker station.

6. Don't Renew

Most companies own only one station in a market, and therefore, when a program is performing poorly, that station is stuck with it. Unlike baseball, where a player can be literally traded to another team run by a different owner, this is generally not possible in television during the term of the program contract. At contract renewal time, the current station may, in effect, turn a program into a "free agent" by not renewing it; the syndicator can then try to sell it to another station in the market. Moreover, unless the incumbent station has a contractual right to meet or beat any offers from competing stations, the syndicator may elect to sell the show to a different station for its next cycle anyway, because the other station is stronger, can offer a better time period, is willing to pay more money, or offers to pick up additional programming from the syndicator if it takes the program in question. Sometimes, stations will warehouse (store unused) programs to prevent competitors from getting them.

Calculating Revenue Potential

Based on a program's ratings and the sales department's estimate of cost per point (the number of dollars advertising agencies or advertisers are willing to pay for each rating point the station delivers), programmers can determine the amount

of money the station can pay for a show. It works like this: A rating point equals 1 percent of the television households in a market. If there are 500,000 television households in market A, a rating point represents 5,000 households (HH). A show that receives a 15 rating in market A would deliver 75,000 households (5,000 HH per rating point \times 15 rating points = 75,000 HH). Let's say that market B has 250,000 households. By a similar calculation, a 15 rating in market B would represent 37,500 households. Likewise, a 15 rating in market C with only 100,000 households would represent just 15,000 households viewing the program. This simple arithmetic illustrates the point made earlier in the "Deal Points" section that programs generally are sold at a higher price in larger markets than in smaller ones. Thus, even at the same rating, the larger the market, the larger the number of viewers. Conversely, the smaller the market, the fewer the viewers. And the amount of revenue a station can expect varies accordingly by market size, as does the license fee for the program.

Advertising agencies pay a certain amount for each thousand households, called **cost per thousand** (CPM). Let's say the agency assigns a \$5 CPM. A 15 rating in market A would be valued at \$375 for a 30-second commercial (\$5 CPM \times 5,000 HH per rating point \div 1,000 = \$25 per point, then \times a 15 rating = \$375).

Let's say the station is considering a half-hour, off-network sitcom cut for six local commercial minutes and sold with six available runs over four years. (While the program may actually be cut for 6:30, including a 30-second barter spot, the general manager and program director at the station and the rep are concerned only with the six minutes that are available for sale to the station and rep.) The six commercial minutes in each episode translate to twelve 30-second spots per day. Revenue potential is calculated by multiplying the projected rate per spot at the anticipated rating by the number of commercials to give a gross revenue potential. The gross is now netted down (reduced) to allow for commissions paid by the station to salespeople, reps, and advertising agencies. At a 15 percent commission rate, the station nets 85 percent of the gross. The net is now netted down again to a projected sellout rate (the number of spots actually sold over the course of a year is generally less than the number available). Most stations use a conservative 80 percent sellout rate for planning purposes; if they actually sell more than 80 percent of the available time, that's all to the good, and to the bottom line. This final revenue figure is called the net net. The calculation per episode would look like this:

\$ 375 rate per 30-second commercial

×12 30-second commercials

\$4,500 gross per day

×.85 net revenue level

(after 15% commission)

\$3,825 net per day

×.80 sellout rate

\$3,060 net net per day

The \$3,060 is the daily income the station can expect to generate during the current year for each run of the program.

To compute what the show would generate when it goes on the air, the station and rep sales managers inform programmers of the potential rate for all future years the show will be available. A typical increase in cost per point from year to year might run from as low as 3 percent to as high as 12 percent depending on inflation and local market economy. Using figures supplied by sales, programmers use this formula to project the net net revenue potential of the program over the life of the show. In this calculation, they also revise the rate based on the show's ratings delivery. A program that produces a 15 rating in its first run might be moved by its fifth and sixth runs (because it can be expected to weaken as it is repeated) to a time period with lower HUT levels, such as late night, and may generate only a 5 rating. Therefore, although CPMs are increasing, the lower rating will bring down the spot rate, lowering the revenue potential for the program in that run.

Let's look at a simplified example of the complete calculation. We'll assume the program is available two years from now. There will be 130 episodes of six runs each (780 total runs) over

four years. The station plans to trigger the episodes as soon as the contract starts, running five episodes a week for three years, with no hiatus, until all 780 runs are exhausted. Coincidentally, this will take exactly three years (5 days/week \times 52 weeks = 260 days per year \div 780 total runs = 3 years).

The various calculations of the revenue potential for each individual episode are shown in 3.7. The percentage rate increases are estimated by sales. This year and next year are the two years between the time the station buys the show and the time it goes on the air. Years 1, 2, and 3 are the years in which all runs will be taken. The years are not necessarily calendar years; generally they begin in September with the start of the new season or the program's availability date.

Now that we've figured the revenue potential per run of each episode as shown in 3.7, it's easy, based on projected usage, to compute the total revenue potential for each episode over the life of the contract.

Run 1, Year 1	\$3,439.44
Run 2, Year 1	3,439.44
Run 3, Year 2	1,945.34
Run 4, Year 2	1,945.34
Run 5, Year 3	1,313.76
Run 6, Year 3	1,313.76
Total net net revenue	
per episode	\$13,397.08

But we're not quite done. Now let's figure how much the station can pay per episode. Stations assign percentage ranges in three areas: program

3.7 Calculation of Revenue per Episode

\$5.00	current CPM	Year 1: Runs 1 & 2 of each episode ir access at 15 rating.
× 1.05	(5% increase estimate)	
\$5.25	CPM next year	
× 1.07	(7% increase estimate)	Year 2: Runs 3 & 4 of each episode in early fringe at 8 rating.
\$5.52	CPM Year 1 of show	70-
× 1.06	(6% increase estimate)	Year 3: Runs 5 & 6 of each episode late night at 5 rating.
\$5.96	CPM Year 2 of show	
8C.1 ×	(8% increase estimate)	
\$6.44	CPM Year 3 of show	

	lear 1	Y	ear 2	Y	ear 3
\$5.62	CPM	\$5.96	CPM	\$6.44	CPM
× <u>5000</u>	households	× 5000	households	× 5000 1000	households
\$28.10	cost per point	\$29.80	cost per point	\$32.20	cost per point
× 15	rating	× 8	rating	× 5	rating
\$421.50	rate	\$238.40	rate	\$161.00	rate
× 12	commercials	× 12	commercials	× 12	commercials
\$5,058.00	Gross	\$2,860.80	Gross	\$1,932.00	Gross
× .85	net revenue	× .85	net revenue	× .85	net revenue
\$4.299.30	Net	\$2,431.68	Net	\$1,642.20	Net
× .80	sellout	× .80	sellout	× .80	sellout
\$3,439.44	Net Net per run	\$1,945.34	Net Net per run	\$1,313.76	Net Net per run

purchase cost, operating expense, and profit. Program purchase cost may run as low as 20 to 30 percent of total revenue for an affiliate, which gets most of its programming from the network, to as high as 50 percent for an independent, which must purchase or create all of its programming. Let's use a median figure of 40 percent for our example.

With a total revenue projection of \$13,397.08 per episode, the station using a 40 percent program cost figure would estimate the price per episode at \$5,358.83. Because nobody figures so closely (that is, to the exact dollar), a range of \$5,000 to \$5,500 per episode would be a reasonable working figure. Multiplying these figures by 130 available episodes would establish a total investment of \$650,000 to \$715,000 for the program. The station would certainly try to negotiate a lower cost for the show but might be willing to go higher, even considerably higher, depending on how badly the station needed the program or if it perceived that the show was important to the station's image (to viewers and advertisers) and to its competitive position.

Unfortunately for the station, syndicators perform the same calculations. They generally quote a purchase price significantly higher than the station wishes to pay. In our example, knowing that the station could expect to make as much as \$20,000 in the access-time period if all six runs of each episode ran in access, but not knowing that the station might plan to take some runs in early fringe and late night, the syndicator might ask \$10,000 to \$15,000 per episode. The station might want to pay \$3,000 to \$4,000 but expect to pay \$5,000 to \$6,000 per episode and go as high as \$7,500 if it really needed the show.

Obviously, the two parties have to reach a middle ground or the show will either be sold to another station in the market or go unsold to any station. And now the fun begins-negotiation.

Negotiation

Syndicators sell most programs to stations through good old-fashioned negotiation. Generally, the syndication company "opens a market" by pitching the program to all stations in the market. The pitch will be the same to every station in the terms and conditions of the deal (episodes, runs, years, availability date, price, barter split, payment terms) but may differ subjectively depending on the stations' perceived needs, strengths, weaknesses, and programming philosophy. The syndicator will try to determine or create a need at each station with the hope that several will make an offer. In this ideal situation, the syndicator will be able to select which station receives the show based on the following considerations:

- Highest purchase price offered (if cash or cashplus-barter)
- Size of down payment
- Length of payout
- Ability to make payments
- Best time period (particularly important to the syndicator for shows containing barter time)
- Strength of station
- Most compatible adjacent programming

Often the syndicator receives no offers initially but may have one or two stations as possible prospects. Negotiations may continue for weeks or even months, with syndicator and station each making concessions. The station may consider paying a higher price than originally planned or may agree to also purchase another program. The syndicator may lower the asking price or may increase the number of runs and years (if possible). The station may raise the down payment, and the syndicator may allow the station to pay out over more time. Negotiation is basic horse trading.

Bidding

Some syndicators of hit off-network programs have sold their programs by confidential bid to the highest bidder in the market rather than through negotiation. In 1986-87, Viacom sold the megahit The Cosby Show at megaprices, shattering records in all markets. Shortly thereafter, Columbia Pictures Television (now Sony Pictures Television) sold Who's the Boss? at astronomical prices, in some cases eclipsing even *Cosby*'s prices. Both *Cosby* and *Boss* were bid rather than negotiated.⁵

Here is how bids work. The syndicator opens half a dozen or so markets in a week. Each station receives a complete pitch, including research data. terms, and conditions. Financial terms are omitted during the pitch. After several days, when all stations have been pitched, the syndicator faxes all stations simultaneously, revealing the syndicator's lowest acceptable price and certain other financial details. Stations are given a few days. perhaps 72 or 96 hours, to bid on the program. Bids from each station in the same market are due simultaneously so that no station has a time advantage over another. The syndicator analyzes the bid price, the amount of down payment offered, and other financial terms to determine the highest bidder. The highest bidder wins the program, pure and relatively simple.

The rep programmer usually becomes involved in advising client stations during the bidding process. Syndicators notify the reps of the markets coming up for bid, and the reps immediately notify their respective client stations. The reps provide their usual research analyses of the program's performance, coupled with their subjective views of how well the show will play in syndication and in the client's lineup. While the reps advise the stations whether or not to bid, it is ultimately the station's decision (with corporate approval) whether or not to bid and how much to offer. The reps frequently project the rating and help clients determine the amount of the bid if a bid is to be made.

Perhaps most important, the reps track reserve (asking) prices and reported or estimated selling prices in other markets. The rep programmer informs the client of these pricing trends to help the station determine a bidding price based on previously paid prices in similar markets. The rep also informs the client of down-payment percentages and payout terms in other markets, which serve as a guide to successful bidding.

Bidding is a fairly simple, clear-cut procedure for syndicator and station alike. There is no messy, drawn-out negotiation. The syndicator makes only one trip to the market, not repeat visits over many weeks or months. The sale can be accomplished quickly if there is a bidder at an acceptable price. Competition between stations is established, often turning into a frenzied escalation of prices by stations reaching ever deeper into their piggy banks to be sure they acquire the must-have program. And the syndicator generally achieves prices far in excess of the amounts that might be realized through negotiation. But bidding works only for the must-have shows that are truly megahits. An atmosphere of anticipation has to preexist, and stations must have a strong desire to own the program.

Stations generally dislike bidding. It often forces them to pay more than they normally would. In a negotiation, station management usually gets a feel for the degree of competing interest and the syndicator's minimum selling price. In a bidding war, stations get little sense of the competition for the show. A station may be the only bidder, in which case it bids against itself. It may also bid substantially more than any other bidder, a waste of money. In this situation, each station works in the dark, which can be unsettling. However, stations realize that if they want to be in the ball game for a bid show, the syndicator not only owns the bat and ball but also makes the rules.

Payment

Payment for programming takes one of three basic forms: *cash*, *barter*, or *cash-plus-barter*. Payout arrangements vary and are usually negotiated.

Cash and Amortization

Cash license fees are paid as money (rather than in airtime, as with barter). In most cases, cash deals are like house mortgages or auto loans. An initial down payment is generally made at the time the contract is signed, followed by installment payments over a set period of time. The down payment is generally a comparatively small portion of the total contract amount, perhaps 10 or 15 percent. The remaining payments

are triggered when the station begins using the program, or at a mutually agreed-upon date, either of which may be a month or two or several years after the contract is signed. If the contract is for a relatively short amount of time or a low purchase price, the payments will be made over a short period of time. A one-year deal may have 12 equal monthly payments, and a six-month deal may be paid in only two or three installments; however, a five-year contract may be paid out over three years in 36 equal monthly payments, beginning when the contract is triggered. No payments would be due in years four or five of the contract.

When stations buy programs for cash, whether negotiated or bid, they pay out the cash to the syndicator on an agreed-upon schedule, but they allocate the cost of the program against their operating budget via an amortization schedule. Amortization is an accounting principle wherein the total cost of the program is allocated as an operating budget expense on a regular (monthly) basis over all or a portion of the term of the license. Thus, stations control and apportion operating expenses to maintain a profit margin. Amortization does not affect the syndicator or the amount paid to the syndicator (payout).

Depending on the intended method of airing the program, amortization may be taken at regular weekly or monthly intervals or as the runs are actually used. In the case of programs intended to be played week in, week out without hiatus (such as most first-run and some off-network shows), amortization is taken every week or month without exception. This allows a station to predict its ongoing program costs, but it does not allow the station to avoid those costs should it remove the program from its schedule.

Alternatively, for most off-network shows and feature films, the show or movie is expensed (amortized) as runs are taken of the individual episodes or titles. The amount amortized each week or month will vary depending on the number of runs used. If a station must reduce operating expenses, it can do so by resting (placing on hiatus) a program or running less expensive movie titles. Conversely, in a period of strong revenues, a station can play off (run) more expensive shows or movies. In this manner, a station can control its operating costs to a degree. If, however, a station does not play off all the episodes before the end of the contract, it may find itself with unamortized dollars that have to be expensed. Thus, amortization can be a double-edged sword, and the programming executive has to be a bit of an accountant as well as a creative programmer.

Amortization Schedules

Amortization schedules differ from station to station, depending on corporate policy. Some stations use different schedules for different program types or planned usages. The two most widely used amortization schedules are straight-line and declining-value.

Straight-line amortization places an equal value on each run of each episode. If a program cost a station \$10,000 per episode for five runs of each episode, straight-line amortization would be computed by dividing the five runs into the \$10,000 cost per episode, yielding an amortized cost per run of \$2,000 (20 percent of the purchase price, in this case). If the station had negotiated more runs at the same per-episode license fee, the cost per run would decline. For example, had the station purchased eight runs for \$10,000, the straight-line amortized cost would be \$1,250 per run. The lower amortized cost would reduce the station's operating budget by \$750 each time the show is run. On a five-day-a-week strip over 52 weeks (260 runs in a year), the \$750-per-run savings would total \$195,000, a sizable amount. (Thus, it is important to negotiate well to get as many runs as possible.) The station would still pay the syndicator the full \$10,000 per episode, multiplied by the total number of episodes.

With declining-value amortization, each run of an episode is assigned a different value on the premise that the value of each episode diminishes each time it airs. Thus, the first run may be expensed at a higher percentage of total cost than is the second run, and the second run may be expensed higher than the third run, and so forth.

A typical declining-value amortization schedule for five runs of a program might look like this:

First run	40 percent
Second run	30 percent
Third run	20 percent
Fourth run	10 percent
Fifth run	0 percent

If we compared the same program under straightline and declining-value amortization systems, operating expenses would be as follows:

	Straight-line	Declining-value
First run	\$ 2,000 (20%)	\$ 4,000 (40%)
Second run	2,000 (20%)	3,000 (30%)
Third run	2,000 (20%)	2,000 (20%)
Fourth run	2,000 (20%)	1,000 (10%)
Fifth run	2,000 (20%)	0 (0%)
Total	\$10,000 per episode	\$10,000 per episode

In both schemes, the total amortized amount over the five runs is the full per-episode cost of the program. In the straight-line method, the station expenses each run (or "charges" itself) equally, even though the show's performance may decline as more runs are taken of each episode. An advantage of this method is that the initial run or runs are comparatively inexpensive, especially if the show performs well. A disadvantage is that the final run is just as expensive as the first run, even though the show's popularity may have faded and the ratings declined.

Under the declining-value method, the bulk of the amortization is taken on the initial runs, when the ratings would presumably be at their highest. Relatively few dollars would remain to be expensed in the final runs. In this example, 70 percent of the program's cost is taken in the first two runs under the declining-value system, but only 40 percent is taken for the same two runs straight-lined. If the show falls apart in the ratings after two or three runs, the station using the declining-value method has already put most of its financial obligation behind it, but the station using straight-line amortization has the bulk of the expense still to come.

In the example, using the declining-value method amortizes all the expense of each episode over the first four runs. Because stations sometimes fail to use all the available runs of a program, the fifth run at no charge can be quite helpful to a station. If the run is not taken, there is no charge against the show as there would be in the straight-line system. (Not all declining-value amortization schedules provide free runs; some companies place some value even on the final run, which serves to reduce the expense on the earlier runs, at least slightly.)

The straight-line system is frequently used to amortize first-run shows that are expensed on a weekly basis and generally run no more than twice per episode. The declining-value system is often used for off-network programs and feature films that are generally expensed on a per-run basis and are sold with 5 to 10 runs per episode or film.

Finally, amortization is only an internal allocation of dollars against usage. It does not change the payout of the license fee to the syndicator. The program may be fully run and amortized before payout is completed, or the station may continue taking runs of the show for years after the payout to the syndicator is complete, with the amortization of the episodes allowing the expense against the operating budget to be delayed until the programs are actually run. When all episodes are fully amortized and all payments made to the syndicator, the final dollars expensed in both amortization and payout will be identical.

Barter and Cash-Plus-Barter

The second payment method is *barter*. Barter is a fairly simple payment system. The station agrees to run national commercials sold by the syndicator in return for the right to air the program. No money changes hands. The syndicator makes all of its money from the sale of commercials to national advertisers, and the station gives up some of the commercial time it or its rep would have had to sell. A typical straight barter deal might give half of the advertising time within a program to the syndicator, with the other half available for station sale. For example, a half-hour program with six minutes of available commercial time might allocate

three minutes to the syndicator and three minutes to the station.

Cash-plus-barter means exactly what the name suggests. Part of the license fee is paid in cash, albeit a lower cash license fee than if the show were sold for straight cash, and part of the license fee is given by the station to the syndicator as commercial time, which the syndicator sells to national advertisers. A typical cash-plus-barter deal for a half-hour show might be a cash license fee plus one minute of commercial time (1:00 national) for the syndicator, with the station retaining five-anda-half minutes (5:30 local) for its own sale.

Barter can be both a blessing and a curse. On the plus side, barter can be a way of reducing cash expense at a station. In some cases, especially for untried and unproven first-run shows, stations may be more willing to give up commercial airtime than to spend money. If a syndicator takes three minutes of commercial time within a half-hour show and the station receives three minutes, the syndicator has received 50 percent of the available commercial time, and the station retains 50 percent. As you saw earlier, stations generally figure 30 to 50 percent of their revenue goes to programming expense, so barter may seem expensive. But because stations are rarely 100 percent sold out and may average only an 80 to 90 percent sellout over a year, the barter time the station gives up really represents only 30 to 40 percent of revenue potential.

Because most syndicated programs today contain some barter time, barter can be problematic. Some stations embrace barter so they don't have to spend real money. Others dislike it because commitments to many shows with heavy barter loads mean significantly less time for the station to sell, hence less revenue. A typical barter deal could result in as much as half of the commercial inventory not being available to the station to sell. Also, the station may not want to give its time to a third party to sell, often at lower rates than the station itself is charging, because the syndicator is selling many markets as a package.

Regardless of a station's feelings regarding barter, it has no choice about whether to pay cash or give up barter airtime for a show. The syndicator determines the payment terms, not the station. The station's only option is whether to run the program. If it doesn't like the terms, it doesn't have to clear the show.

Barter and cash-plus-barter are used primarily for the sale of first-run programs and the first syndication cycle of off-network programs because barter is an effective way for syndicators to maximize revenues to fully cover production and distribution costs. Producing first-run shows is generally expensive, and stations are often unwilling to pay sufficiently high license fees for untried first-run programs. The syndicator's other choice is to cover production and distribution costs by bartering a program. By combining cash payment and several barter commercials a day in the first syndication cycle of an off-network program, the syndicator can maximize revenue while allowing the station to spend less actual money than if the program were sold for cash only. Older off-network sitcoms, action hours, and dramas are generally sold for straight cash with no barter because production costs have already been covered and demand for these programs is less.

Even though clearance in every market in the country is the goal, the syndicator must sell the show to stations in enough markets to represent at least 70 to 80 percent of all U.S. television households. Based on this minimum figure, the syndicator projects a national rating and, using a national cost per point, determines a rate for each 30-second commercial. The syndicator then attempts to sell all the national time in the show to national advertisers at, or as close as possible to, the determined rate. The syndicator tries to clear the show in the strongest time periods on the strongest stations to achieve the highest rating. The ratings from all markets clearing the show are averaged to produce a national rating that will, it is hoped, equal or exceed the projected rating. If the syndicator can get the 70 to 80 percent national clearance, sell all the spots at or near the rate card price, and deliver the rating promised to advertisers, the syndicator will make money, and the show will stay on the air. If not, the syndicator will likely lose money, and the show might not be renewed.

In an effort to increase the rating and therefore the revenue potential, some syndicated programs are run twice during the same week. For example, a program that runs Monday through Friday during prime access and averages a 5 rating may be rerun the same night during the overnight hours (between 1:00 and 5:00 A.M.), where it might average a 1 rating. The prime-access 5 rating and the overnight 1 rating can be added together to cume a 6 rating. This cumed (or cumulative) rating is considered unduplicated viewing because most people would not watch the same program twice the same day. Thus, the program has a cumed rating of 6. which is 20 percent higher than the 5 it achieved in prime access. A 20 percent higher rating can translate into 20 percent more revenue, which could represent significant money during the course of a year to the syndicator.

Although no standardized ratio of national-to-local commercial time exists, half-hour straight barter shows typically range from two minutes national/four minutes local (generally expressed as 2:00N/4:00L) to as much as 3:30N/3:30L. Hour-long barter shows typically contain from 3:30N/10:30L to as much as 9:00N/5:00L. A one-hour cash-plus-barter program would typically be cut in the ranges from 2:00N/12:00L to 3:30N/10:30L, plus that would be the cash payment. The amount of national barter time the syndicator can withhold depends on the perceived demand for and strength of the program and the ability of the syndicator's station sales force.⁶

Cable and Syndication

Broadcast syndicators have found cable networks to be a ready and growing market for programs. Instead of sending a large sales force to call on three to eight stations in each of the 210 local markets to sell a program in syndication, that same program might be sold to a national cable network in a single deal. Sometimes the cable price exceeds what might be made in broadcast syndication. Also, sales staff salaries and travel expenses are saved. With more potential customers needing to fill 168 hours a week of airtime, cable syndication has become an extremely lucrative marketplace.

More recent and vintage off-network programs, not to mention new and continuing first-run programs, are available than can be fit into traditional broadcast station schedules. The huge supply of programs and reduced broadcast demand have thus forced the creation of a cable aftermarket. Some cable networks program their schedules much as independent broadcast television stations once did, stripping off-network shows and movies (for example, USA's Law & Order: Special Victims Unit followed by a feature film) and vintage programs (Nickelodeon/Nick at Nite's Coach, The Cosby Show, Roseanne, Wings). Others buy failed network or syndicated programs at appealingly low prices because these shows either don't have enough episodes for syndication or have already failed in syndication.

A cable network can make an opportunistic purchase and program the shows effectively for its needs. (For example, 22 syndicated episodes each of the failed *Highlander: The Raven* and *The Crow: Stairway to Heaven* were snatched up at bargain prices by the Sci Fi Channel because they were fresh, relatively unseen, and a cheap way to fill hour-long time slots.) Basic cable has become a hot competitive marketplace for feature films after their pay-cable and network exposure and before broadcast syndication.

To maximize revenue potential for network programs, a recent trend has been to sell off-network rights simultaneously to both traditional broadcast stations and cable networks. Although the types of deals may be limited only by the imagination and creativity of the sellers and buyers, perhaps the most common arrangement has become a weekly run on a television station (one showing of each episode) followed by a Monday through Friday strip run on a cable network. A popular and longrunning program might also run simultaneously on different venues: (1) on the original broadcast network with newly produced episodes for the network, (2) weekly repeats from previous seasons on local television stations once a week, and (3) the same weekly repeats on a cable network as a strip (Nash Bridges was an example).

Yet another arrangement is a simultaneous run of brand-new episodes on both a broadcast

network and a cable network. For example, from the beginning of its network run, Law & Order: Special Victims Unit ran on the NBC television network with a repeat play several days later on the co-owned USA cable network.

In still another arrangement, a program may be created for a basic cable network and simultaneous first-run syndication. For example, *The Invisible Man* was created with this idea in mind, taking its first run on the Sci Fi Channel followed by a first-run syndication appearance of the same episode two weeks later on broadcast television stations in syndication. Somewhat similarly, *Monk* was created for initial runs on USA and at a later date was played on the traditional ABC network.

Certain shows created expressly for cable have later found their way into broadcast syndication. Some programs made the transition to broadcast television directly (without being reshot), as in *Brothers*, whereas others were produced anew for syndication (*Double Dare*) or even network airing (FOX's *It's Garry Shandling's Show*).

Inevitably, the once-rigid relationships of syndication, broadcast television, and cable will continue to evolve with new and evermore innovative marketing schemes. Just when all participants think they understand how the business works, someone invents a better (or at least different) mousetrap.

The International Marketplace

From the earliest days of television syndication through the late 1990s, the international syndication marketplace was fairly predictable and understandable. A program created in one country for domestic syndication, network, or cable might also be sold in other countries, thus extending the revenue potential for the program. The basic syndication "rules" were pretty much the same in international syndication as in domestic. Then, as the twenty-first century approached, something entirely unforeseen happened: A totally new and exciting arena opened up, producing vast new creative and sales potential. Although the traditional international syndication market is still very active

and important, new programming and marketing concepts are changing the face of the international marketplace. Let's look first at the traditional, tried-and-true international syndication realm.

The Traditional Pattern

Just as American syndicators have found multiple program sales opportunities in this country in network, syndication, and cable, they have also extended the revenue potential of programs through syndication in international markets. Although most American television programs are produced in English, foreign broadcasters and cable networks find American programming very attractive. There is a worldwide appetite for things American (Mickey Mouse, Coca-Cola, and McDonald's hamburgers, to name but a few); people in other nations also love American television shows and movies. Thus many, but certainly not all, American television programs find life in other countries. Often they are dubbed into another language. They may also be aired in English, either with or without subtitles, depending in part on the level of English spoken by citizens of a particular country and on the expense of dubbing or subtitling.

Even within the same country, some broadcasters may opt to dub, while others may choose to subtitle, and still others may air the program in its original language. Though policies among companies may differ for various reasons, often the expense of dubbing is the determining factor. As a matter of course, programs for young children are almost always dubbed: They can't read yet!

In many ways, the syndication process in the international marketplace is very similar to the domestic sales effort. Salespeople visit stations and cable networks in cities throughout foreign countries. A domestic salesperson may go on the road for several days in the southwestern United States, traveling from Dallas to Albuquerque to Lubbock. Conversely, the international syndicator may go on a sales trip of several weeks, ranging throughout the Pacific Rim from Hong Kong to Tokyo to Fiji to Samoa. Although a domestic syndicator's biggest cultural problems may be regional accents and

local food, the international salesperson encounters language barriers and quite different customs. Many certainly find this makes their jobs both more challenging and more interesting.

As in this country, programs are sold for various combinations of cash and barter time. The amounts of cash involved, however, are generally substantially less. The production costs of a program are usually recouped in the United States through sales to broadcast networks, local television stations, and cable networks. International sales become the icing on the cake.

In some instances, especially for first-run syndicated shows, a program is created with American and international partners cofinancing the production and distribution costs and then splitting the revenue. For example, an American company may team with French and Australian partners. Generally, each coproduction partner retains the rights to the production in its own country or territory. The American partner may retain North American rights, the French company the rights to France and Europe, and the Australian producer the rights throughout the Pacific Rim. Rights in Asia, South America, and Africa might be sold to an entirely separate company. The divvying up of rights often depends on the individual clout of the production partners and how much they are contributing to the production, including both money and facilities.

A program may even be shot in one of the partner countries such as Australia and may use talent and production crews from one or more of the countries represented. Sometimes this is done to meet national employment quotas or for nationalistic pride, but more frequently the purpose is to lower production costs. In the United States, we enjoy a high standard of living; we also have high labor and other production costs. Although shooting a series in a country such as Australia may sound exotic, it is usually done primarily with an eye on the bottom line.

Unlike program production in the United States, when shows are produced in other countries for airing in those countries or in the international marketplace, the producers must generally conform to various quotas. Often a country will require that certain percentages of the people

employed for the production of a program be citizens of that country. This extends from the stars and other on-camera talent to the behind-thescenes people, including producers, writers, technicians, wardrobe people, stagehands, secretaries, and even drivers.

Quotas of a different sort must also be considered. Many countries regulate the percentage of a program schedule that must originate within that country, leaving the remaining portion of the schedule that may be made up of programs produced in other countries. For example, the European Union is very restrictive regarding the amount of programming that must contain European content. Furthermore, within a single European country, certain percentages must be created within that nation. In France, for example, not only must a certain percentage of the programs carried on the French network Canal+ be European, but some must also be produced in France. Within Europe, quotas are the same among all European countries, but quotas may be significantly different in other areas of the world.

In the United States, there are no restrictions or quotas whatever regarding either national program origination or employment. American producers are subject only to U.S. labor laws regarding noncitizens.

When a program is produced by or taped in several countries, quotas become even trickier. When a syndicator attempts to sell foreign-produced programs to customers in another country, that nation's employment and content quotas must be considered. This is one of the reasons why fewer and fewer American prime-time series are finding their way onto other nations' television screens.

For years, most programming went in one direction: from the United States to other countries. Relatively little programming flowed from other nations into the United States. American dramatic and action shows generally sold best in other countries. Although car crashes, whodunits, and prime-time soaps seem to have universal appeal, comedy shows often didn't fare as well. What's a knee slapper or rib tickler in one part of the globe may not seem so funny in other areas. American movies have also been popular in other countries.

During the 1980s and 1990s, the Hollywood studios increasingly made output deals in which substantial amounts of programming from a studio were sold in advance in other countries. This helped to finance the production costs of the shows and to give relative assurance that a program actually would be produced. Some people have dubbed this period the Golden Age of Export.

The birth of new broadcast and cable networks in the United States and throughout the world in the 1980s and 1990s created a tremendous demand for fresh programming. The rise of the FOX network had enormous impact not only in the United States but also around the world. FOX programs such as Beverly Hills 90210 and The Simpsons became so popular in other countries that they became global brands, much like Nike and Microsoft. Many American cable networks have also become global brands. MTV has cable networks in many areas of the world programmed in the languages of the local countries. The Discovery Channel is also global, with localized programming in Africa, Asia, Europe, Latin America, and the Middle East as well as in individual countries, including Australia, Brazil, Canada, Germany, Italy, and India. E!, Fox Kids Network, and TNT are also seen in many countries. And CNN is the original worldwide network, viewed around the globe since the 1980s.

Global branding has become commonplace in broadcast and cable circles. Often branding goes beyond an individual program or character (see 3.8).

The Emerging Pattern

As the twenty-first century began, an extremely significant change had occurred in the international marketplace. With deregulation and a single monetary standard sweeping Europe, there was a desire for strong locally produced programming coupled with an ability to export such programming-to America among other places. As a result, format programming emerged as a dominant trend. (Formatting is essentially the same as franchising.)

To understand format programming, think of Wheel of Fortune and Who Wants to Be a Millionaire?. Both programs were created in one country

3.8 Global Branding by Nickelodeon

ickelodeon has created branded blocks of programming both for its own international services and for sale to other companies in countries where Nick does not have its own operations. Nickelodeon provides not only several hours of the programs themselves but also interstitial materials such as promos and IDs and website content. As a further extension of branding and its image, Nickelodeon also licenses ancillary rights and services. Included are product licensing and merchandising (toys and games), video and audio products (CDs, videocassettes, and DVDs), and publishing rights (books and magazines). Like many other companies, Nickelodeon believes its trademark is valuable, and it carefully guards the environment in which its programming and image are presented around the world.

As communications shrink the world, programs and program concepts are becoming both more global and more utilized. For example, Nickelodeon created Rugrats as a U.S. cable program. The show has since been aired around the world. In Great Britain alone, Rugrats can be seen on the BBC (the British Broadcasting Corporation's terrestrial broadcast network), Nick UK (basic cable and direct broadcast satellite), and Nick Replay (digital TV). With an eye to the future, when Nickelodeon develops programs or acquires program rights, their programmers attempt to do so for all Nickelodeon venues (Nick US, Nick UK, Nick Australia, and so on). Such strategy is not unique to Nickelodeon; indeed, many multinational companies employ the same approach.

(Wheel by producer Merv Griffin and syndicator King World Productions in the United States, Millionaire by producer Michael Davies and the BBC in England). In each case, the format is licensed to broadcasters in other countries. Many of the production elements (scripts, music, scenery design, sound effects, questions, and so on) are provided by the program creators, but local hosts and contestants are used in each country. Scripts are tailored to local interests, habits, and language (the American word cookie would be changed to biscuit in England, for example). Even the name may be changed to reflect local culture and language. (For example, the most popular syndicated show in the United States is still called Wheel of Fortune in Australia, but its name becomes Roda a Roda in Brazil, La Ruleta de la Fortuna in Ecuador, Glücksrad in Germany, Roda Impian in Malaysia, Carkifelek in Turkey, and Chiêc nôn kŷ diêu in Viet Nam. And Jeopardy! becomes Your Own Game [in Russian].)

In some cases, actual video portions of the program may be supplied. (For its preschool program Blues Clues, Nickelodeon provided all the animation; the various international broadcasters then chromakeyed their own local live actors over the animation.) Perhaps most important, the shows are produced in the local languages. Thus, Wheel has its own British Pat Sajak and successors to the classic Vanna White, and the British host of Millionaire was replaced by Regis Philbin in this country. Both shows air in Japan with Japanese hosts, in France with French hosts, and so forth.

Format programming has tremendously affected international syndication. What had been pretty much a one-way flow of programs from the United States to other countries has been abruptly changed. Product flow from Europe to the United States and other countries is now the largest ever. This phenomenon has resulted in vast new creative and sales potential.

What Lies Ahead for Syndication

Syndication is a rapidly changing business. Headlines in trade publications frequently herald new and innovative syndication deals. Although it is speculative at best to imagine how the industry might look by the end of this decade, several scenarios are plausible.

1. Innovative deal structuring. As the financial stakes get higher and competition becomes fiercer, syndicators and stations alike will become more

and more creative in their deal making. Broadcast syndicators will make offers more attractive to stations while simultaneously finding new ways to increase revenue to their own bottom line. This may involve barter, payout, additional daily or weekend runs, sharing use with cable, cofinancing with station groups, hiatus periods, and ancillary revenue sources. Deal structure will be limited only by the ingenuity of the participants and will be driven by the need to maximize profits for both syndicators and stations.

- 2. Cost control. Stations and syndicators are continually striving to manage costs. The days of heady economic growth and comfortable profits between the 1970s and early 1990s seem only a pleasant memory in the 2000s. In the wake of new competition from cable and the softening of the world economy, costs must be controlled. Therefore, whether in deal making, station operation, or expansion of facilities or staffs. broadcasters and syndicators alike share a common goal: the need for efficiency, streamlining, mutually beneficial dealing, and use of all assets. With FCC regulations allowing increased station ownership by single broadcasting companies, and with mergers of many syndicators, cost controls become ever more important, even as the programming deals are becoming bigger.
- 3. Consortiums/coproduction/co-ventures. All these terms mean much the same thing: Station groups and syndicators are increasingly finding new and exciting ways to work together as partners. Spurred by tough economic times and the need to control costs, station groups and syndicators can share costs and risks and, perhaps, profits. Station groups will continue to join forces with one another in noncompeting markets to develop and launch first-run programs to meet specific station needs. Increasingly, syndicators will join in these co-ventures. Because stations will hold an equity position in some shows, these shows will probably gain some extra promotion and perhaps be given a longer time on the air to prove themselves. In other words, coproduced shows will get a good shot at succeeding (if the audience likes them!).

4. Cable, internet, and mobile media. Increasingly, programs created for original telecast via one delivery system are finding their way to another: over-the-air to cable and vice versa: network to either broadcast syndication or cable; cable to syndication; cable to foreign; foreign to domestic syndication. And the internet and various mobile media will become increasing parts of these aftermarkets. Several crisscrossing paths already exist, and the line between network/syndication/cable is now blurring. In fact, the broadcast networks routinely promote their cable programs on network shows airing on local affiliates; talent is frequently utilized for both network and cable telecasts. As cable has grown and solidified its economic base, syndicators have played to that strength. Once traditional adversaries, now cable and broadcast have formed co-ventures that will benefit both. Just as politics make strange bedfellows, so too do the economic needs of the television industry.

The internet and mobile media have rapidly become the next challenges for broadcasters, syndicators, and networks. Although the World Wide Web and the iPhone offer great opportunities for extending program and product reach and for promoting a program or an entire brand, they also create huge challenges—even threats. Decisions must be made on how to sell a program on the internet and mobile media, how to charge, and how to protect a copyright. Once a program or portion of a program is on the internet, it essentially becomes available to any person or company in the entire world. The owners of the program and the content copyright need to figure out how to protect their interests, financial and otherwise. Producers usually make programs because of their enormous revenue potential from domestic and international syndication, and the syndication process involves hundreds of millions of dollars annually across the United States. The rise of the internet and mobile media potentially challenges all these assumptions.

5. Increasing role of reps. Programmers at station representative firms will play an even greater role in the syndication process. As costs escalate and programming decisions become riskier, the rep programmer's expertise becomes more valuable.

To control costs, many stations have eliminated the program director position and are using rep programmers instead. This trend is likely to continue.

6. Increasing role of networks. With the demise of the FCC's financial and syndication rules, the networks have become actively involved with the production of syndicated shows. Many expect the prime-access period (7 to 8 P.M. EST) to attract more off-network programs now that the Prime-Time Access Rule (PTAR) is long gone. First-run game shows and magazine formats have outlived their protected existence in the top 50 markets. Increased competition for hit off-network programs will affect the price for these shows.

Just as the children and teenagers of the 1950s and 1960s grew up watching I Love Lucy, The Flintstones, and The Brady Bunch, so too the next generation found enduring favorites in The Cosby Show, The Simpsons, and Married . . . with Children. Today's teens and adults expect police departments to conduct advanced crime-scene investigation because they watched so many episodes of CSI, Without a Trace, Cold Case, and their clones. This generation has taken Ugly Betty and Grey's Anatomy into their lives. Television shows are valuable assets that can enjoy a long economic lifespan. Old favorites in broadcast syndication continue to play and play and play. And the needs of cable have extended the life of many seemingly lesser programs.

While sitcoms are still important in syndication, hour-long network dramas generally are not as desirable for television stations because it is harder to find one-hour blocks of time on stations. Also, because many hour-long shows tend to be serial in nature (*Grey's Anatomy*, 24, *Lost*), once the outcome is known from the original network run, the dramatic tension and viewer interest surrounding these programs tend to lessen. Their network rerun ratings are generally considerably lower than their original run rating, foretelling potential lower ratings in syndication.

Some of these hour programs may be sold in syndication as once-a-week hours for weekend runs, while others are sold directly to cable networks

following their over-the-air network runs. Other hours (such as *Law & Order* and *CSI*) are sold directly to cable networks, bypassing syndication. For the rights holders, the lack of domestic syndication potential is often offset by sales to international buyers for broadcast in other countries.

The Peter Allen song "Everything Old Is New Again" at one time may have applied to syndication potential for most programs directly to television stations. Nowadays, especially with the rapid growth of cable networks, program producers have many more potential buyers for programs when they finish their originals runs on network television.

Sources

- Blumenthal, Howard J., and Goodenough, Oliver J. This Business of Television. New York: Billboard Books, 1997.
- Broadcasting & Cable. Weekly trade magazine. New York: Cahners Publishing Co., 1931 to present. Brotman, Stuart N. Broadcasters Can Negotiate Any-

thing. Washington, DC: National Association of Broadcasters, 1988.

Elasmar, Michael G. The Impact of International Television: A Paradigm Shift. Mahwah, NJ: Erlbaum, 2003.

Nevaer, Louis E. V. The Rise of the Hispanic Market in the United States: Challenges, Dilemmas, and Opportunities for Corporate Management. Armonk, NY: M. E. Sharpe, 2004.

Variety. Weekly trade magazine of the television and film industry.

Television Week. Weekly trade magazine published by Crain Communications. www.tvweek.com.

Waisbord, Silvio. "MCTV: Understanding the Global Popularity of Television Formats." *Television & New Media 5* (4), November 2004, pp. 359–384.

Wirth, Michael O. (ed.). The Economics of the Multichannel Video Program Distribution Industry: A Special Issue of the Journal of Media Economics. Mahwah, NJ: Erlbaum, 2002.

Notes

- 1. The Spanish-language networks have more complicated payment relationships in part because they *own* all or part of many of the stations carrying their programs.
- 2. When is an informercial not a television program? Apparently the issue is complicated. In a dispute between Leeza Gibbons and Paramount, it was debated whether her infomercial was a television program, a commercial, or a hybrid. Gibbons contended that her contract with Paramount allowed her to do commercials but not other television programs without the studio's permission. Paramount contended that her infomercial was a program, presented in a talk-show format. Regardless of the actual outcome of that case, the status of infomercials is still unclear.
- 3. A few shows move the other direction. The game show *Remote Control* went from cable to broadcast syndication, the first of a new stream of programs for the syndication market.
- 4. In cases where the rep is negative toward the program, avoiding an in-person pitch to reps generally has the advantage of minimizing the strength of the rep's recommendation to stations. Opinions tend to be stronger about shows that have been evaluated first-hand. Reps eventually see pilots or sample tapes of all shows their client stations are interested in, but delay sometimes works to the temporary advantage of the syndicator.
- 5. By the early 1990s, stations had become more cautious about bidding because of competition for offnetwork shows from cable networks, some of which had big bucks to spend.
- 6. Barter splits may vary widely, even among essentially similar programs. For example, *Jerry Springer*, *Oprah*, and *Jenny Jones* are all cash-plus-barter, one-hour talk-show strips, but the national/local barter splits are quite different, with *Jenny Jones's* syndicator having considerably more national time to sell than *Jerry Springer's* distribution company: *Jerry Springer*, 2:30N/12:00L; *Oprah*, 3:00N/11:00L; *Jenny Jones*, 3:30N/10:30L.

Prime-Time Network Entertainment Programming

William J. Adams and Susan Tyler Eastman

Chapter Outline

The Scandals

Vertical Integration

Diminishing Audiences
The Prime-Time Advertising
Game
Prime Hours

Audience Targeting

Ideal Demographics and Flow Classic Scheduling Strategies Appointment Viewing

Prime-Time Ratings

Sweeps and Overnights Pocketpieces, MNA Reports, and the National Syndication Index

Prime-Time Scheduling Practices

Shifting Network Seasons Limited Series Summer Schedules Fall Premieres

Program Renewal

Program Lifespan and License Contracts Pivotal Numbers Program Costs

New Program Selection

Program Concepts Scripts Advances and Pilots Schedule Churn

Promotion's Role

Changing Format Emphases

Network Decision Making

The Critics
The Censors

The Risks and Rewards Ahead

Sources

Notes

Ithough ABC, CBS, FOX, and NBC are the most recognizable parts of their parent corporations, the broadcast television networks are not the most profitable segments. They often function as loss leaders, outdone by profits from owned stations, sets of cable networks, theme parks, publishing, and other commercial interests. Indeed, it can be argued that the major networks' advertising and entertainment roles are most useful because they deflect criticism from other aspects of the entertainment business. They act as magnets for people who want something to complain about and the networks in effect, manage national news, thus limiting negative stories related to their corporate interests. On the positive side, the networks represent brand names that are known around the world, and carry programs with devoted fans. The CW, ION, and MyNetworkTV (MNTV), the newer English-language networks, strive to catch up with the established entities, just as the Spanish-language networks of Telemundo (owned by NBC) and TeleFutura (owned by Univision) strive to catch up with the enormously successful Univision (UNI).

Television networks act as giant public-relations arms for other parts of their parent corporations. For example, the press barely mentioned the fact that the President of Pakistan told the Washington Press Corps he could not answer their questions because his book deal with Simon & Schuster required him to be on 60 Minutes first. To this day, few people realize the publisher and the television program are actually part of the same corporation.

There's nothing unusual in that. Viacom (CBS, CW), Time Warner (CW, too), GE (NBC), News Corp. (FOX), and Disney (ABC) not only control the major and most minor broadcast networks, but also control the record labels that dominate 80 percent of the music market. They own or have a financial interest in most for-profit cable networks, control all but one of the major motion-picture studios, control all the big television production houses, control most of the book publishing market, and own hundreds of magazine titles and newspapers (look back at 1.17 to see who owns what). These five companies manipulate most aspects of today's entertainment market.

The Scandals

When we talk about broadcast television, we are really talking about one small part of five giant entertainment monopolies that use their control to endlessly cross-promote the various parts of their businesses. The network morning shows have become thinly disguised vehicles for promoting the parent company's prime-time and cable interests. The magazine business is obsessed with promoting the latest stars, newest series, and happenings on the company's cable and broadcast networks. Even the venerable 60 Minutes finds it necessary to interview the latest author from Simon & Schuster, something the producers don't find at all interesting should an author happen to be published by a non-Viacom-owned publishing house.

They all do it. Fox News runs the latest insults from *American Idol* or the last people to be thrown off the FOX reality show as if they were the news equivalents of another war, while ABC news programs endlessly hype the goings-on at Disney, and NBC loves to work GE news into its newscasts. In 2006, this cross-promotion resulted in a disaster for FOX when the public responded with outrage over O. J. Simpson's book on "here's how I would have committed the murder if I had done it." The reaction grew so loud it forced the cancellation of the book deal and a primetime "news" special interview, and resulted in the firing of a well-known editor at HarperCollins (owned by News Corp.).

CBS executives breathed a sign of relief as people forgot about their Super Bowl disaster, about which the official line remains "we knew nothing." If Viacom and News Corp. are to be believed, the top people in the companies were unaware of the actions of their many entities. On the other hand, there is little doubt that both the industry and Hollywood were truly shocked by the public's reactions. FOX's book debacle and CBS's Super Bowl disaster showed just how out of touch with a huge portion of the audience the entertainment business has become. As Bob Lee, CBS Affiliates Board Chairman, put it, Jackson's right breast was only the final straw in the "whole crotch-grabbing,"

flag-wrapping flavor of the halftime show." The outrage wasn't coming from "the screamers or the hardcore right as the media would have you believe," he added. It was "mainstream people" who were giving them an earful.1

It is ironic that a halftime incident set off a monumental outcry despite its not being unusual by the standards of MTV and other cable channels or, for that matter, the standards of the broadcast networks, as tuning in some so-called reality shows would reveal. Why did an uproar happen after the Super Bowl? What was different from every other day on television? The answer is that 90 million homes were tuned into that game. In contrast, nightly television audiences are small nowadays. Yet, on this one night, just for the Super Bowl, almost half of the country's population came face-to-face with what mainstream television had become. They didn't like it.

Vertical Integration

During the 1980s and 1990s, broadcast ratings fell. Stockholders panicked, and the networks were sold to other companies, which themselves were then taken over by giant international entertainment corporations. Although the giants became more and more powerful, they could not stop the ratings slide. Faced with eroding audience shares, declining revenues, and increased competition for viewers (often from another part of their own companies), the broadcast networks turned to the Federal Communications Commission. In response, the FCC relaxed many of the rules governing broadcasters. The most dramatic changes in regulations affected ownership, eventually permitting the networks to own stations reaching almost half the population. With this enormous potential clearance for a network's programs (unlike affiliates, owned-stations can't decline any network programs, no matter how poorly some are doing), combined with the power of affiliation and very deep corporate pockets, the Big Four quickly took over the best stations in the top markets.

Moreover, the FCC also removed program ownership limits (the so-called financial interest rules), thus permitting the networks to actually own the programs they broadcast. The networks then used their clout to put an end to independent production houses, reverting to a system in which the networks' executive producers controlled the production of programs. Thus, the entire programming process, from production of programs (by owned studios) to distribution via the broadcast or cable network through owned stations and cable systems, to publicity from the units that promote everything, is controlled by the same enormous companies.

Being vertically owned limits what programmers can do. For example, each network increasingly feels pressure to program with series owned by its parent company. By 2004, no programs were aired that the network did not at least partially own. Indeed, in an ironic turn of events, the production arms of the Big Five companies (particularly that of Time Warner, which was strong in production but much weaker in distribution) were complaining that other members of the Big Five wouldn't even look at their proposals for new shows until they had been given a share of ownership.

Problems arise when business decisions made by the parent corporation fail to adequately consider their impact on the television network (see 4.1). In the early 2000s, both FOX and ABC were in clearance fights with large cable or satellite systems over rights payments and over which other company-owned networks would have to be carried. These battles actually resulted in these two major broadcast networks being pulled off the air for a short time in some areas, with devastating results for short-term ratings and advertising revenues, as well as for long-term audience sizes. (One axiom of programming is that loyal viewers who are forced to change their viewing habits rarely change back.)

Diminishing Audiences

As 4.2 shows, American broadcast network ratings have been falling over the last two decades. Indeed, the average rating in 2007 was about 6 or 7 for all but one of the broadcast networks (NBC was lower). Indeed, by mid-decade, cable's collective

4.1 Owners and Audits

recent event that showed how corporate profits can dominate the business decisions of subsid aries occurred at Time Warner. Peter Jackson, internationally recognized for his Lord of the Rings movies, broke off relations with New Line Cinema, a Time Warner company, and would not participate in a New Line Hobbit preguel because it refused an independent audit of the reported \$4 billion income from the Lord of the Rings trilogy. It is widely believed that New Line was only allowing companies that its parent owned to bid on such things as foreign distribution, broadcast and cable rights, DVDs, merchandising, and so on. For the parent company, such arrangements provide a great advantage: All profits come to it, and money can be moved around so that taxes are lessened. The difficulty is that for independent producers such as Peter Jackson, this closed bidding practice costs tens of millions of dollars. However, insiders say this is just how things are done these days.² No one par of the company is allowed to threaten the overall picture.

ratings in prime time had passed those of the combined broadcast networks. By 2007, individual programs carried in prime time on cable—like *The Closer*—were beating competing broadcast shows in the ratings. However, by decade's end, broadcast ratings will probably have bottomed out because recent slippage has been minimal. Nonetheless, if such megahit shows as *CSI* and *American Idol* were removed from the analysis, the average ratings would drop another 2 points. It's easy to understand why the retirement of one show, such as *Friends* from NBC, can throw an entire network into panic.

In actual numbers, although the ratings look small, each point represents a percentage of the 112 million television households in America. Thus, a 2.7 rating stands for about 3 million households, each with an average of 2.6 people viewing. Even a rating as small as 2.7 means the program is attracting 7 to 8 million people at one

time. Such ratings are sufficient for many acvertisers and still slightly better than what the typical cable programs earn, but the biggest advertisers are getting nervous.

The Prime-Time Advertising Game

Up to now, prime time has been the financial jewel in the media crown, pulling in billions of dollars each year for the networks. So far, the drop in audience size has been compensated for by higher advertising rates and by adding more spots within programs (many prime-time shows now air 20 minutes of ads per hour). Increases in advertising rates, as high as 15 percent per year, have not been uncommon, and complaints from advertisers have been shrugged off to date.

Most prime-time advertising spots are sold in late May and early June during the up-front sales period. Advertisers guarantee their access to top programs or desired time slots by locking them in at least three months in advance. Of course, because the programs have not aired, there are no ratings with which to set prices. Therefore, the prices for ads are based on *estimated* ratings provided by advertising agencies and *guarantees* provided by the networks. If a network does not make the guaranteed rating, it will have to run spots for free until the number of missed points is made up. If a program does much better than predicted, the advertisers get a bargain. The system seems to favor the advertisers, but that is seldom the case.

The ability to predict ratings is weak at best, and the networks tend to be very conservative in their guarantees. For the last few years, the networks have further protected themselves by refusing to sell the top-rated shows except as part of package deals. In other words, if sponsors want to buy time in a program like *CSI* or *ER*, they also have to buy time in much weaker shows. In this way the networks assure the sale of time slots that might otherwise be left open. Of course, this means the sponsors have to take programs they don't really want and spend more than they would if they just bought the strongest shows. Although sponsors object, they continue to buy just as they always have. After all, where else are they going to go?

4.2 Average Network Rating from September to May, 1980 to 2008

Year	АВС	CBS	NBC	FOX	WB/UPN/CW	UNI/TEL
1980-81	18.0	19.0	17.2			
1981-82	17.7	18.5	15.2			
1982-83	16.6	17.7	14.5			
1983-84	16.2	16.8	14.5			
1984-85	15.0	16.5	15.8			
1985-86	14.3	16.0	17.1			
1986-87	13.6	15.4	17.1			
1987-88	12.7	13.4	15.4			
1988-89	12.6	12.3	15.4			
1989-90	12.9	12.1	14.5			
1990-91	12.0	11.7	12.5	6.1		
1991-92	12.2	13.8	12.3	8.0		
1992-93	12.1	12.9	12.0	8.1		
1993–94	12.1	11.7	10.3	7.1		
1994-95	11.7	10.8	11.5	7.1	1.9/4.1	
1995-96	10.5	9.6	11.6	7.3	2.4/3.1	
1996-97	9.2	9.6	10.5	7.7	2.6/3.2	
1997-98	8.4	9.7	10.2	7.1	3.1/2.8	
1998-99	8.1	9.0	8.9	7.0	3.2/2.0	
1999-00	9.3	8.6	8.5	5.9	2.6/2.7	
2000-01	8.4	8.6	8.0	6.1	2.5/2.4	
2001-02	6.3	8.1	8.8	5.7	2.5/2.7	
2002-03	6.0	7.9	7.4	5.8	2.5/2.2	
2003-04	5.9	8.5	7.3	6.0	2.5/2.3	
2004-05	6.4	8.4	6.6	5.3	2.4/2.3	
2005-06	6.0	7.3	5.8	5.5	1/9/1.5	
2006-07*	6.2	7.8	5.7	6.2	2.0	2.0/0.5
2007-08**	6.6	7.4	5.3	6.0	2.2	2.0/0.7

Note: The FOX network started broadcasting before 1990, but for the first few years its ratings were not reported in the trade press. Similarly, Univision and Telemundo were not included until 2007. ION and MNTV get ratings of less than 1 (as small as .4 or.3) and shares of just 1, so they fall within Nielsen's margin of error and are not reported.

Until recently, that question ended all discussion. It has been easier for the industry just to do what has always been done. For 20 years the compensation rates for the agencies placing advertisements declined steadily (from around 15 percent in the 1980s to the low single digits), giving them no incentive to make any extra effort. As audience size continued to decline and network ad rates

skyrocketed, however, the corporate sponsors themselves began to get back into the act. During the 2004–05 season, many of the biggest sponsors refused to go along with network attempts to make double-digit increases in advertising rates, forcing the broadcast networks to drop increases back to 6 to 8 percent. For the first time in that season, almost half of all prime-time slots had not been

^{*}WB and UPN were combined, for the most part, into CW in 2006.

^{**}Estimates based only on early fall 2007-08 season.

sold by the end of the up-front sales period, and cable and the internet reaped the benefits.

But cable networks and the internet are no longer the only real competitors for advertising dollars. Much of the challenge for advertising revenues seems to be coming from cash-plus-barter syndication deals (discussed in Chapter 3). Some syndicated programs outdraw most network shows, and the prices they can demand from the spot ad market are beginning to reflect that power. By mid-decade, the syndicated *Friends* and *Seinfeld* pulled more than \$200,000 per 30-second spot, and several others drew at least half that amount.

In short, networks are no longer the economic powerhouses they once were, but the profits for their parent companies keep growing. Nonetheless, program production is becoming an area of real concern. So far, the broadcast networks are still expected to produce the original programs that then feed the rest of the system. But as networks rely more and more on cheap reality programs, the pool of programs with an afterlife dries up. Many reality shows can't be syndicated, can't be rerun on the air, can't be sold overseas, and have no value as DVDs. Once the audience knows who won, it doesn't want to see the shows again. FOX, however, has figured out how to make money from American Idol. The program builds the careers of singers who are then signed by FOX-owned record companies and who tour through FOX-owned promoters.

Too many spots and high rates have caused a rethinking among advertisers, and the result has been an enormous increase in product placement within programs. Until advertisers lost control of programming in the late 1950s, product placement had been standard practice in prime-time television. It has also been a big moneymaker in movies ever since ET followed that trail of Reese's Pieces. Cable networks have aggressively sought out companies to place their logos or products in prominent positions on original cable shows. But until recently, the broadcast networks were reluctant to follow the trend, seeing it as demeaning, cheapening the value of the traditional spot advertisement, and possibly raising

legal issues. However, the smaller networks, with less to lose given their lower ratings, were willing to try. Soon, the cast of *Buffy the Vampire Slayer* was not only drinking but also mentioning Coke products, and a yellow VW was a prominently featured in *Smallville*. As the money began to roll in, the other networks wanted a piece of that action, and soon brand-name products were appearing everywhere. By 2004, product placement had become so common that Nielsen Media Research launched a new service called Product Placement Measurement to allow subscribers to track their products and those of their competitors through various TV shows.

Also, product placement began to affect program content. Sears, while not the actual producer of Extreme Makeover: Home Edition, did make a huge investment, in return for which the reality show prominently featured Sears products. Perhaps the most interesting development, however, was illustrated by a deal TNT made to insert products into reruns of Law & Order. Generic products were digitally replaced with brand names that paid for the privilege. Sometimes described as virtual advertising, this is the next logical step in computer-generated content. Already widely used in sporting events, virtual ads do not require the actual placement of a physical product. The advertisement exists only in the computer.

With virtual ads, advertisers can aim their messages to specific markets. For example, Coca-Cola now pays to have the judges on American Idol drink their product. But through the use of vertual ads, in New York those judges could be drinking Vanilla Coke, while in California they sip Caffeine Free Diet Coke, and in the South it might be Classic Coke filling those glasses. The same process can be used to replace the generic products shown in older TV shows with high-paying brand names. Of more concern to advertisers is the fact that the same process can be used to replace an existing brand name with a higher-paying competitor. In the past, product placement was forever. No more. If Coke won't kick in more money, the stars may be drinking Pepsi in the reruns and Dr. Pepper on the DVD. The maker of M&M'S could finally

Two k

correct its earlier marketing mistake and have ET follow their little chocolate product instead.

The multiplatform strategy was the next response to declining advertising revenues. The networks began distributing their most valuable properties across many media, packing the additional ad time—at high rates—with broadcast. Advertisers who wanted mass network exposure were then forced to develop plans for internet, cable, and even iPod media.

Prime Hours

Of the more than 50,000 hours the 10 broad-cast networks program yearly, about one-quarter is singled out for special critical attention—the nearly 170 hours of commercial prime-time programming each week. That figure, multiplied by 52 weeks, equals 8,788 hours of prime-time network programs a year provided collectively by ABC, CBS, NBC, FOX, CW, ION, MNTV, UNI, TEL (Telemundo), and TEF (TeleFutura).

Audience ratings throughout the day are important, of course, but prime-time ratings are the ones everyone takes note of. The 22 prime-time hours—from 8 to 11 P.M. (EST) six days each week and from 7 to 11 P.M. on Sundays—constitute the center ring for the traditional networks, the arena in which their mettle is tested. FOX programs 15 hours on seven nights of the week, competing head-to-head with the older networks. CW programs 13 hours (avoiding Saturdays), and ION and MNTV each program 10 hours, dodging both Saturdays and Sundays. Univision fills 28 hours week, starting at 7 and running until 11 P.M.; some of this programming is duplicated on TeleFutura. Filled with syndicated Mexican and South American programs, Univision nonetheless beats all competition in some markets-although its overall U.S. ratings are the equivalent of CW's (see 4.2).

Prime-time programs are still the source of virtually all off-network syndication and, in consequence, remain the center of long-term profit potential. Also, while the rating difference between prime-time and non-prime-time periods may not be as large as it once was, prime time is still the

most heavily promoted and most talked about part of any schedule. It remains the focus of critical and regulatory concern. The prime hours make or break a network's reputation and continue to be the most visible part of an entertainment corporation's businesses.

The major difference between the broadcast networks and cable networks has been the amount of original programming. The top five broadcast networks (ABC, CBS, FOX, NBC, UNI) have it throughout their schedules; on the others, only a small portion is original. Even though such cable offerings as The Sopranos, The Closer, Oueer Eve for the Straight Guy, Nip/ Tuck, Monk, The Dead Zone, and Battlestar Galactica get huge amounts of press and critical raves, the very highest-rated series among them (The Closer) pulls about a 5, and most cable networks produce only two or three original series a year. By comparison, the Big Four average about 7.5 for all of a year's prime-time ups and downs, while hits like Grey's Anatomy and Lost easily reach 13 or more. For all its weaknesses, network prime time is still the only real outlet for most original production, and thus an inability to generate hit series for prime time eventually affects all other aspects of the business.

Audience Targeting

In 2003, James Poniewozik, writing for Time magazine (owned by Time Warner), noted the falling numbers for broadcast television and asked, "Does the mainstream still exist?" He might better have asked whether the networks would know the mainstream if they were drowning in it (see 4.3). For the last 30 years, the broadcast networks have relentlessly pursued one segment of the audience to the exclusion of other television viewers. Programs have been targeted toward the younger, more urban audience in the major population centers matching the coverage area of the network owned-and-operated (O&O) stations—and away from the more thinly populated rural markets where the networks have no direct ownership interests.

4.3 The Aging Audience

ronically, network audiences are aging, far beyond what most can imagine. As of middecade, these were the median ages of network viewers:

The CV	V	34.1
FOX		37.3
ABC		45.8
NBC		49.1
CBS		51.8

A median is a midpoint, meaning half the viewers fall above and half below these numbers. Such changes scare network executives because the trend potentially affects advertising revenue and the viability of many kinds of programs (see Chapter 5 on network news), so this fact is largely ignored in favor of ideal demographics.

Ideal Demographics and Flow

When NBC programming head Paul Klein first proposed the concept of ideal demographics back in the early 1970s, he believed the networks could go after his so-called ideal demographic group without losing the rest of the audience because at the time it was widely agreed that people watch television, not shows. In a three-network era, Klein reasonably assumed that viewers would stay with the networks regardless of what was actually on. So why not go after the most desirable audience? To Klein, that meant urban women 18 to 34 years of age. He believed they were the most susceptible to advertising and controlled the economy. They were also, it was claimed, the largest segment among the many demographic divisions.

When faced with critics who pointed out that the over-50 crowd had more money and that the potential television audience consisted of as many men as women, Klein simply dismissed the older audience as too set in its ways (to respond to advertising) and dismissed men as nonshoppers. Almost at once, there were signs he might be wrong. The year CBS and NBC introduced ideal demographics to the schedule, their ratings plunged, and ABC found itself in the unaccustomed position of

being number one. Klein thought that just proved his point. The audience hadn't left; they had just changed channels.⁴

By the mid-1970s there were clear signs of audience erosion. The networks denied it, claiming methodology errors in the ratings. By the mid-1980s there were no more denials. What had been a trickle was now a flood. Broadcasting was hemorrhaging viewers, largely to cable. Considering this, one might assume the networks would have run as far from the ideal demographic approach as possible. One would be mistaken.

As the audience got smaller, the ideal changed slightly and shifted to consist of urban women 25 to 49 years (all races). By 2004 "women" had been dropped from official statements, but many argued that it was still understood. When network ratings showed a massive loss of male viewers during the 2003-04 season (a combined broadcast network loss of almost two million men a night), advertisers weren't surprised, and they implied (to paraphrase what they told New York Times interviewers), "What are the networks offering that men would want to watch?"5 Indeed, targeting Klein's ideal audience had produced a programming "gender gap" between male and female viewers. Moreover, the basic assumption, that younger women control shopping, could now be challenged by a trip to any supermarket.

An obsession with 18- to 49-year-olds, called "the most desirable audience" or "the audience most demanded by advertisers," applies to cable and syndication as well as to broadcasting. Programmers for E!, for example, when commenting on their generally low numbers said, "I could create a stunt pretty easily that would pop a household rating, but I would bring in people my parents' age." Many syndicators seek the younger 18 to 34 audience, particularly for their daytime programming, even though this demographic group is practically nonexistent during daytime hours.

When asked about the popularity of reality shows, Betsy Frank, executive vice president of research and planning for MTV and one of the most quoted professionals in the business, pointed to the appeal to young audiences. She went on to argue that the ideal viewer should be under 25. She pointed out that this group represents 70 million

people, only 7 million fewer than the baby boomers. It is ironic to note that MTV itself pulls ratings of only about 1, implying that only about 1 million of those 70 million potential viewers actually watch MTV.

At the broadcast network level, the programmers argue they know that targeting the ideal demographic group creates problems, but they have little choice because most advertisers demand this audience. ABC and NBC claim that twothirds of all prime-time advertising money is spent on this group. Of course, this argument is a little like ESPN looking at its advertising and claiming advertisers only want sports. Realistically, what else could they buy on prime-time broadcast networks? To be fair, CBS argues the ideal should be higher, 25 to 54 years to be exact, and FOX argues that 18 to 34 year old urban men should be included, but advertisers argue that the question itself is wrong. It may be that any demographic approach is outdated because so many companies now use psychographics, or lifestyle data, to target ads, not just age, sex, and ethnicity.

Aside from a program's demographics, the networks look for audience flow from program to program. Each network hopes to capture and hold the largest possible adult audience, especially from 8 P.M. until 11 P.M. or midnight, with a recent emphasis on late-night offerings (younger people's main viewing time). Network strategies are usually directed at achieving flow-through from program to program within prime time—that is, encouraging the audience to continue to watch from show to show, although this tendency grows weaker as the number of program options increase and as the hour gets later. Networks continue to try to produce flow by careful scheduling, such as placing programs with similar story lines one right after another, although the remote control and digital guides make flow-through difficult to achieve. Virtually all traditional scheduling strategies have been designed to maintain this flow.

Classic Scheduling Strategies

Programmers believe that surrounding a newcomer with strong, established programs of the same type ensures the best possible opportunity for the newcomer to rate as high as the established hits. Several strategies have long been used to achieve protection for new and underperforming series. A dozen strategies now dominate prime-time scheduling: anchoring, leading-in, hammocking, blocking, doubling, linchpinning, bridging, counterprogramming, blunting, stunting, supersizing, and seamlessness. Several of these protect new programs, others build flow or challenge competitors.

1. Anchoring. All schedulers use the strategy of beginning an evening with an especially strong program, the anchor show. Also known as the lead-off, this first prime-time show sets the tone for the network's entire evening. It is believed that this maneuver can win or lose a whole night and thus affect the ratings performance of a full week. Programmers have traditionally believed that the network winning the ratings for the first hour of prime time also usually wins the entire night.

A strong lead-off used to be considered so important that the major networks routinely moved a popular established series into the 8 P.M. (EST) position on every weeknight, even if it meant raiding, and thus weakening, strong nights to get proven shows for lead-offs. A classic example occurred in 2003 when the WB moved *Smallville* to the first spot on Wednesday and on Sunday to shore up those nights, while FOX moved *The O.C.* to strengthen its weak Thursday night lineup.

As ratings continued to slide, and fewer successes were left to move around, this strategy began to fade, even though network programmers continue to express faith in it. In 2007, NBC began scheduling cheaper scripted or reality shows to lead-off prime time; inherently, such shows are low-rated, at least to start. In the same year, however, FOX led off Mondays with its hit *Prison Break*, and CW led off Thursdays with the strong *Smallville*, using these as evening anchors.

2. Leading-in. Closely related to the anchor show, the lead-in strategy places a strong series before a weaker (or any new) series to give it a jump start. Theoretically, the strong lead-in carries part of its audience over to the next program. A new

series following a strong lead-in has a modestly better chance of survival as compared with a new series with no lead-in or a weak lead-in. To get a strong lead-in, the networks often shift strong series to new nights or times. No show is safe in any schedule position, as *King of Queens* and *Becker* found out when they were moved from their strong Monday slot to act as lead-ins for the short-lived *The Brotherhood of Poland, N.H.*, and subsequently sagged in their ratings.

3. Hammocking. Although scheduling strategies can help bolster weak programs, it is obviously easier to build a strong schedule from a strong foundation than from a weak one. Moving one of a pair of established series to the next later half hour and inserting a promising new program in the middle time slot can take advantage of audience flow from the lead-in program to the rescheduled familiar program, automatically providing viewers for the intervening series. This strategy is known as hammocking the new series—in other words, a possible audience sag in the middle will be offset by the solid support fore and aft (also called a sandwich, with the new show as the filling).

The 2003–04 season provided a classic example with *The Apprentice* shoved between *Friends* and *ER*. Hammocking is one strategy that continues to be effective, but it can provide misleading information on the strength of the center show. For example, much was made of the ratings for *The Apprentice*, but in truth, even in its protected spot, it lost almost 4 points compared with the *Friends* lead-in and 2 points compared with *ER*. Moreover, when moved to the unprotected Wednesday night slot, it dropped into the bottom third of the ratings.

4. Blocking. The networks also use block programming, which is placing a new program within a set of similar dramas or sitcoms filling an entire evening, a venerable and respected practice. The risk with this strategy is that the new comedy may lack the staying power of its "protectors" and damage the program that follows. The theory of blocking is that an audience tuning in for one situation comedy will stay for a second, a third,

and a fourth—if the sitcoms are of the same general type. The first show in a group usually aims at young viewers or the general family audience. Each ensuing series then targets a slightly older audience, thus taking advantage of the fact that as children go to bed and teenagers go out or do homework, the average age of the audience goes up. Blocking works best during the first two hours of prime time but typically loses effectiveness later in the evening.

Examples of blocking (also called stacking) used to be easy to find in prime-time schedules every year on all the networks. During the 2006–07 season, for instance, CBS placed four family-oriented sitcoms on Mondays, running from How I Met Your Mother to Old Christine. In the same season, FOX formed an animated/family sitcom block on Sundays of The Simpsons, American Ded, Family Guy, and War at Home. In recent years, the networks have turned increasingly to hourlong dramas, games, and reality, blocking whole evenings—for example, CBS's NCIS to The Unit to Without A Trace on Tuesdays or FOX's Prison Break to House, two cult hits one after another.

5. Doubling. In the last few years, a new form of blocking called doubling has become popular. It started with FOX, which ran Cops, followed by Cops—and then finished the block with America's Most Wanted. In 2005–06, ABC doubled Lost on Wednesdays, while FOX doubled That 70's Show and NBC doubled Scrubs. As the number of true hits continued to fall, the broadcast networks began doubling up on the few hits that remained, usually running one episode right after another, often a rerun followed by a new episode. By mid-decade, hit comedies, reality series, and even a few hour-long dramas were being doubled and even tripled.

In some cases, doubling involves placing episodes on different nights like a miniseries. By 2007–08, it was hard to tell if this was a clever strategy or merely an attempt to fill time. Shows such as *According to Jim, Two and a Half Men, Deal or No Deal*, and *Arrested Development* were appearing night after night, but usually just for one month. Copying cable networks like

USA, TNT, and A&E, the broadcast networks occasionally turned an entire evening over to one show, as ABC did sporadically with *Desperate Housewives* and CBS did with the original *CSI*.

- 6. Linchpinning. Most scheduling strategies rely on having enough strong programs around which to build a schedule for new series. However, with fewer and fewer real hits, the networks have had to find ways to use the few strong shows still left to them. This is one of those ways. Also known as tentpoling, the network focuses on a central, strong show on weak evenings, the linchpin, hoping to use that show to hold or brace the ones before and after it. This strategy was the basis for NBC's move of Law & Order: SVU to Saturday nights and CBS's move of Cold Case Files to 9 on Sundays. These moves also formed blocks, an added bonus, and demonstrated that scheduling strategies are often combined. NBC's shift of focus to its 9:00 shows—away from 8:00 anchors—exemplifies the use of linchpins.
- 7. Bridging. The bridging strategy is not as common in commercial broadcasting as the other strategies, but it has been useful to public broadcasting and such cable networks as TBS and HBO. Bridging has three variations. The best-known one is the regular use of long-form programs (one-and-a-half hours or more) that start during the access hour and continue into prime time, thus running past the broadcast networks' lead-offs and negating their strategies (for viewers who might have changed channels). HBO, for example, often schedules a hit movie starting at 7 or even 7:30 P.M. (EST) to bridge the start of network prime time.

The second variation of bridging involves starting and ending programs at odd times, thus causing them to run past the starting and stopping points for shows on other networks. This creates a bridge over the competing programs, which keeps viewers from switching to other channels because they have missed the beginnings of the other shows. For example, TBS regularly starts its programs at 5 minutes after the hour. As a result, TBS viewers are forced either to watch the next TBS show or tune into another program already in progress.

CBS has used the bridging strategy successfully in its Sunday night lineup. The network regularly runs Sunday football games (or other sports) beyond the hour point, thus throwing the rest of the night off by about 10 minutes. This means that the huge audience that watches 60 Minutes is stuck with CBS for the rest of the night. NBC has copied this practice with its Sunday afternoon sports broadcasts. The alternatives for viewers are to leave a CBS or NBC show before it is over or to tune in to the competition late.

A third variation on this strategy involves scheduling half-hour shows against hour-long shows on the competing networks. FOX, by placing a strong show like *King of the Hill* first, forces the audience to watch the weaker *Oliver Beene* or tune into the middle of hour-long programs on the other networks. The risk is that viewers may go to cable or put in a DVD.

8. Counterprogramming. The networks also schedule programs to pull viewers away from their competitors by offering something of completely different appeal than the other shows, a strategy called counterprogramming. For many years, for example, ABC successfully countered the strong, women-oriented series offered by CBS and NBC on Monday nights with Monday Night Football—until 2006 when the games went to ESPN. To counter Desperate Housewives and Cold Case, NBC introduced Sunday Night Football. FOX directly challenged the reality hit The Amazing Race on CBS by placing its new-at-thetime medical show House on Thursdays (and then moved it to Tuesdays, a safer spot). In 2007, ABC clearly counterprogrammed CBS's Survivor and NBC's My Name is Earl with Ugly Betty.

Traditionally, counterprogramming challenged the ideal demographics approach because it relied on finding a large, ignored group of viewers and scheduling a program for them. Given the broadcast obsession with ideal demographics, however, ABC, CBS, and NBC nowadays tend to go after the same ideal audience with different genres of programming. As of the late 2000s, the CW was countering the older networks by programming for young women. Univision

counterprograms the English-language networks by stripping three shows, *Heridas de Amor, La Fea Mas Bella*, and *Mundo de Fieras*, across the week from 7 to 10, Monday through Friday, then varying its 10 P.M. and weekend shows.

9. Blunting. Networks that choose to match the competition by scheduling a show with *identical* appeal are blunting the competition. For example, in the 2006–07 season, CBS and NBC ran CSI: New York and Medium against each other on Wednesdays, and ABC and NBC ran Grey's Anatomy and ER against each other on Thursdays, in each case effectively splitting the legal-show fans and medical-show fans. Such blunting attempts often don't last long as one show usually proves more popular than the other.

If two networks are already blunting each other, a third network that counterprograms often gets higher ratings than either of the other two networks. In other words, the two networks running similar programs split part of the audience, while the counterprogrammer, in theory, gets everyone who likes its program plus all those who dislike the genre being blunted on the other two channels. One example occurred when ABC ran the magazine show *Primetime* against *CSI* and *Medium*; another occurred when CBS ran *Shark* against *Grey's Anatomy* and *ER*.

10. Stunting. The art of scheduling also includes maneuvers called stunting, a term taken from the defensive plays used in professional football. Stunting includes scheduling specials, adding guest stars, having unusual series promotion, and otherwise altering the regular program schedule at the last minute. Beginning in the late 1970s, the networks adopted the practice of deliberately making last-minute changes in their schedules to catch rival networks off guard. These movescalculated and planned well ahead of time but kept secret until the last possible moment—were intended to blunt the effects of competitors' programs. Generally these maneuvers are one-timeonly because their high cost cannot be sustained over a long period.

Scheduling hit films, using big-name stars for their publicity value, and altering a series' format for a single evening are common attention-getting stunts. The Drew Carey Show has provided a number of classic examples such as doing the sitcom as a musical or the now famous April Fools' Day episodes that ask viewers to "find what is wrong." Such stunts have high promotional value and can attract much larger-than-usual audiences. Of course, the following week, the schedule goes back to normal, so these efforts get people to sample shows but rarely create long-term improvements in series ratings.

CBS used another form of stunting when it paid more than \$4 billion for rights to sporting events (including Major League Baseball) during the 1990s. This proved to be a financial disaster. Although the network expected to lose money most years, it hoped that the rewards from promoting CBS shows during the World Series and championship games would be worth the cost. Those hopes proved fruitless, and CBS lost tens of millions of dollars. Investing in popular but unprofitable specials to promote other shows on the network remains a popular form of stunting, however. The Olympics are a perfect example. NBC acknowledged that the money paid for the 2004 Summer Games would probably be more than it could get back, but it planned to use the games to promote and then lead directly into the new fall season, thus justifying the cost. Strangely enough, ABC, which first discovered the real value of sports, has pulled out of most megasports bidding, arguing that the big sporting events have become too expensive to be worth their price tags.

- 11. Supersizing. In recent years, the networks have developed a form of stunting used mainly for the sweeps months. This method, called supersizing, allows them to pull questionable series off the air without having to find another show to fill their time slots. To fill the time, the network adds length to their biggest hits and advertises them as *specials*. Supersizing is now common for hit sitcoms and reality series, although rare so far for hour-long dramas. Doubling can be considered a similar strategy with the same goal.
- **12. Seamlessness.** In the 1990s the networks turned to still another strategy intended to

accelerate the flow between programs. First NBC, followed by the other networks, eliminated the breaks between key programs (*Seinfeld* to *Frasier*, for example). Because viewers normally make most use of their remote controls in the two minutes or so that has traditionally occurred between programs, running the end of one program right up against the start of the next avoids the opportunity for remote use. This is called a **seamless transition**, and its goal is to keep viewers watching whatever network they began with.

In another twist, ABC (soon copied by the other networks) instructed producers to cut out all long title and credit sequences and to begin every program with an up-tempo, attention-getting sequence. Titles then appear later in a program after viewers have, presumably, been hooked. At the ends of programs, all networks have experimented with split screens and squeezed credits. Originally, some program action (or "bloopers") filled part of the screen to hold viewers' attention right into the next program (or very close to it). However, this space now usually contains ads or promos for the upcoming series. Another variation on this strategy involves running a "next" icon or a promotional crawl for the upcoming series over the last segment of the preceding show.

Although these twelve scheduling practices can be identified in the lineups of more than threequarters of the prime-time schedule, there is little reason to assume they have any large impact on viewing. Most were developed at a time when few people had remote controls and digital cable's wealth of channels and the internet didn't exist. On-demand options and recording via DVRs also allow encourage viewers to do their own scheduling. Today, the audience has little reluctance to change channels, and there is no shortage of places to go. Today, the web carries rebroadcasts of highly rated or much-talked-about shows, further undermining network efforts to manipulate audience flow on television during prime time. Nonetheless, most experts believe that well-defined and executed application of these programming strategies helps a broadcast network hold onto significant portions of the viewership. They continue to

believe this even in spite of falling numbers for network programs.

Appointment Viewing

For decades, scholars have argued about how people watch television. For most of the last 50 years, practitioners assumed people passively watched the set-not programs (the least objectionable program theory). In short, when they had time (availability), viewers tuned in and then looked for something to watch. About a decade ago, some researchers began contending that people actively planned their viewing around specific programs that would continue their current mood or change a bad mood. This view proved to be a hard sell in an industry that had long dismissed the idea of program loyalty in all but a few cases. For example, everyone recognizes that many soap opera viewers plan their activities so they can watch their favorite afternoon programs—that is, appointment viewing. But, experts argued, this happened rarely in prime time, perhaps only with such megahits as American Idol, live sporting events, or occasionally with highly touted miniseries.

As the network ratings slid downward, the gap between the average programs and the highestrated ones increased. In one recent year, CSI was pulling a 14 rating, Grey's Anatomy a 15, and American Idol a 17, while the average for other shows on ABC, CBS, FOX, and NBC ranged between 5 and 8 (and much lower on the other six networks). In consequence, more researchers began looking at program preference. They found that viewers develop strong mental images about when their favorite programs are on and tune in with those programs in mind. This presented a very different view of habitual viewing, which had always been assumed to be a factor in channel or network loyalty. This understanding of the power of viewers' mental images of network schedules led to intensification of the amount and type of on-air, print, and online promotion in order to create and manipulate such mental images. Simultaneously it led to renewed interest in creating programs that spur viewing by appointment—that is, shows that are so special that viewers plan their time

around them. On the other hand, it did nothing to slow the continual shuffling of the schedule, a practice that breaks down habitual viewing and thus increases viewer frustration.

It must be understood that despite program loyalty and appointment viewing, people do not tune in every week. Most viewers do not change other plans to watch even their favorite television programs. They find great comfort in knowing the series will still be there next week and that they can watch missed episodes in rerun.

DVDs and DVRs have also profoundly changed people's views of when they have to watch. The time-shifting of favorite programs is now a common practice because DVRs make it easy, and many programmers were surprised to find that people were willing to buy DVD sets of complete seasons of their favorite television series. This changing concept of viewing behaviors makes the successful selection and scheduling of mass-audience programs increasingly difficult for programmers. The truth is, as far as the major networks are concerned, programming is bait. It is a lure to get viewers to

4.4 The Value Question

o further complicate matters, the industry can't figure out which shows have resale value. FOX, for example, planned *The Simple Life*, their "Paris Hilton meets *Green Acres*" reality series, for fast DVD release. The network applauded as the series' ratings climbed, got the DVD set to the stores only one week after the series finished its run on the air, and then watched as sales went nowhere.

Meanwhile, Firefly, which FOX had dumped without even using all of the ordered episodes, hasn't left the top-20 sales list since its DVD release, and it was subsequently rushed into production again as a theatrical movie. At the same time, the success of Family Guy on DVD, another of FOX's canceled series, was so great FOX uncanceled it. Its performance on the network, however, was only mediocre (ratings of about 4 or 5), revealing that loyalty and a willingness to buy a series on DVD are not necessarily related to broadcast audience size.

watch commercials and a commodity that can be resold to stations as syndicated bait to get viewers for their ads. The discovery that series could be resold as DVD packages forced programmers to begin to consider the actual value of the program itself. (see 4.4)

Many people who are fans of a series may be using the DVD sets to view episodes they missed. As one person put it when talking about her love of *The West Wing* and the fact that her schedule didn't allow her to always watch it, "I watched eight episodes in one night." Another person, discussing *Stargate SG1*, a cable series not available in all markets, said he finally got to see all 22 episodes. In short, appointment viewing may not only refer to the planning of activities to allow the viewing of a series; it may also be a measure of how much a viewer enjoys a particular series and how much money and time he or she is willing to invest in it.

Prime-Time Ratings

Regardless of whether an advertiser wants sheer tonnage or a specific audience segment, currently, commercial spot costs depend mainly on the absolute ratings (total estimated audience) of the programs in which the commercials occur. Nielsen is developing ratings for commercials from its minute-by-minute people-meter data, but those are not common usage as yet. A television advertiser, in contrast to an advertiser on a formatted radio station, must pay for all viewers, whether or not they fall within the desired target audience. Estimated program ratings are the major determinant of the cost of a commercial spot.

Ratings, however, lack precision. As pointed out in Chapter 2, network ratings *estimate* the viewing of 112 million television households using data collected from 12,000 cooperating families, and it is very unlikely that these estimates are exactly right. In fact, statisticians sometimes claim that no substantial difference exists between the 10th-rated and 30th-rated shows in prime time; the differences in their ratings could result from nothing more than inevitable sampling errors. Because

advertisers (and ad agencies) have agreed to base the price of a commercial spot on the absolute number, however, they ignore this inability to measure small differences. A top program such as *Everybody* Loves Raymond that has a rating of about 10 and an advertising price of \$400,000 per 30-second spot will generate millions of dollars more in revenue than a program such as Becker with a rating of about 7 and a spot price of \$130,000, even though the difference in ratings between the two is statistically meaningless at the levels normally set by statisticians.

The treatment of ratings as absolute numbers by both advertisers and networks has led to fights over unmeasurable fractions of a rating point and demands for more measurements, produced more often. These demands have led to ratings being reported continually and in a number of different ways, many of which were outlined in Chapters 2 and 3. As a quick reminder, for prime-time programming, the most common of these are the sweeps, overnights, pocketpieces, and multinetwork reports.

Sweeps and Overnights

Four times each year a highly controversial rating event occurs—the sweeps. In November, February, May, and July, Nielsen Media Research uses people meters in the larger markets and diaries in the smaller markets to gather audience viewing behavior that is converted into ratings, shares, and demographic information for local television stations and a growing number of cable networks. The sweep results, particularly the November and February periods when audience viewing levels are at their highest, directly affect the rates these cable networks and local stations (including network-affiliates and O&Os) charge for advertising time. Traditionally, the summer sweeps were of less importance. One summer the ratings dropped so badly that affiliates began to balk at clearing network summer shows, but in recent years some of the biggest hits have actually started during the summer. This has led the networks to claim they have moved to a full 52-week season.

The stations demand that the networks display their highest-quality merchandise during the sweeps periods to attract the largest possible audiences and maximize ad revenues. The practice of stunting (the deliberate shuffling or preempting of the regular schedule for specials, adding celebrity guests and extraordinary hype) makes the four sweeps periods, especially November and February, highly competitive and, at the same time, not always the most valid indicators of a network's or station's real strength.

As described previously in Chapters 2 and 3, national ratings take several different forms. Aside from the sweeps, the overnights are the most avidly monitored ratings data. They are gathered through people meters in 77 million households in 56 major markets. The overnight ratings are used to monitor overall urban audience reaction to such "program doctoring" as changes in casts, character emphases, and plot lines, and to compare the viewing of major sporting events on broadcast and big cable networks. The overnights also indicate immediately whether a new program has "taken off" and captured a sizable audience in the urban markets. Advertising agencies also use the overnight numbers to make predictions about specific shows that then become the basis of ratings expectations (and sales rates).

For example, when Smallville first started, it was predicted to get a share of 3 but actually got a 7, thus making it a hit, even though its ratings were in the bottom third for all series. Missing the predicted number (getting one much lower than expected) in the overnights during the first few weeks of a newly introduced program's run spells cancellation unless the ratings show a hint of growth-or unless the program is expected to have stronger appeal to a specific audience. JAG was canceled by NBC but picked up and run successfully by CBS, which argued that it had a strong rural and male appeal not represented in the city-based overnight ratings. CBS was subsequently proven right.

Sometimes international appeal is a factor in letting a show build an audience. For example, Prison Break was only a moderate rating success for FOX, but it showed strong international potential and offered a racially diversified cast during a year with little other racial diversity in prime time. Thus, Prison Break was renewed while higher-rated series were canceled. Still other shows that are cheap to produce but have no aftermarket potential may be held because the shows' concepts are so valuable. For example, *Big Brother* has always had ratings of about 4 or 5 for CBS, hardly great numbers. But the show is inexpensive to make, and the concept has been sold to producers in other countries, who use the same program idea and title but staff the house with people from their own countries. In Brazil, for instance, *Big Brother* is one of the highest-rated programs, and the contestants are considered major stars.

Other series, such as The West Wing and Bones, were only moderate rating performers but generated strong critical and special-interest appeal and thus remained on the schedule, giving them time to grow into true rating success stories, which led to big sales as DVD sets. Still other programs, such as Heroes, were designed to run on both a broadcast network and a cable network at the same time. requiring advertisers to predict combined ratings/ shares. Even though the ability to accurately predict the numbers, especially for new series, is very low, advertising agency predictions still have tremendous power. For example, during the 1999-00 season, advertisers predicted Secret Agent Man would get barely a 2 share. As a result, the series was canceled without airing even one episode. Who knows? Given a chance, the audience might have turned to it as they did to the summer surprise hits Who Wants to Be a Millionaire? and Survivor (the first one), both of which were predicted to generate ratings so low they didn't even get a regular season start. On the other hand, the same agency experts predicted that Coupling would be one of the highest-rated new series in 2003-04. It certainly did not live up to that prediction.

Pocketpieces, MNA Reports, and the National Syndication Index

The ratings report traditionally of greatest interest to the *creative* community, and the one most familiar to the public, is published every other week in a small booklet known as *The Nielsen Pocketpiece* (see 4.5). It comes from the 12,000 national peoplemeter households selected to match census demographic guidelines for the entire country. Though

this information is published only every other week, these data are available to Nielsen subscribers through a computer data bank on a next-day basis for 52 weeks a year. This data bank provides, upon request, data not only for the nine major broadcast networks but also for selected cable networks.

As 4.5 shows, more than 11 million people watched CBS's Cold Case that Sunday from 8:15 to 9:15, and the program's average rating for the hour was 10.5 with a share of 15. At the same time, more than 10 million people watched FOX's Major League Baseball game, getting a rating of 9.5 and a share of 17 or so for that 8:15 to 9:15 P.M. hour of the game. ABC also did well with Extreme Makeover: Households, watched by nearly 9 million people; that show got a rating of 8.8 and a share of 13. NBC did less well in the competition, attracting just under 5 million people to American Dreams that week. The show got a rating of 4.3 and a share of 7. Just over 3 million people watched WB's Charmed, and it got a rating of 3.0 and a share of 5 (quite satisfactory for WB, now called the CW). The rating for the series Doc on PAX (now called ION) averaged about a 1.0, with about a 1 share.

At present, Nielsen is handling almost 1,300 computer requests for pocketpiece data monthly, suggesting that its people-meter data may eventually replace or diminish the importance of the overnights. Unlike the urban nature of the overnights. the pocketpiece provides estimates for the entire nation, including ratings/shares and the all-important demographics for both prime time and daytime, plus general information such as average ratings by program type, number of sets in use by days and by dayparts, comparison of television usage between the current season and the one preceding, and other details. This same rating and share information is also widely available each week to the public through such publications as Variety, Television Week, and Broadcasting & Cable.

Network programmers also find Nielsen's Multi-Network Area Report (MNA) very useful. The statistics in this report cover the 70 leading population centers in the country, represent about two-thirds of total television homes nationally, and break out the O&O markets. The networks use MNA reports to compare the performance of the

Sample Pocketpiece Page NATIONAL NielsenTV AUDIENCE ESTIMATES EVE.SUN. OCT.17, 2004 00 7:15 7:30 7:45 8:00 8:15 8:30 8:45 9:00 9:15 9:30 9:45 10:00 10:15 10:30 10:45 11:00 11:15 57.1 58.5 60.0 61.9 64.2 65.3 66.5 68.2 68.8 69.6 69.7 69.7 67.4 65.1 62.5 60.4 55.6 51.2 -AMER FUNN HOME VIDEOS-> ← EXTREME MAKEOVER:HM → ← DESPERATE HOUSEWIVES--BOSTON LEGAL-(10:01-11:00)(PAE ABC TV HHLD AUDIENCE% & (000) 7.4%, AVG. AUD. 1/2 HR % SHARE AUDIENCE % AVG. AUD. BY 1/4 HR % -60 MINUTES-(7:23-8:23)(PAE) -COLD CASE-**CBS TV** 11,460 HHLD AUDIENCE% & (000) 74%, AVG. AUD. 1/2 HR % SHARE AUDIENCE % AVG. AUD. BY 1/4 HR % 12,120 LAW AND ORDER:CRIM-**NBC TV** HHLD AUDIENCE% & (000) 74%, AVG, AUD, 1/2 HR % SHARE AUDIENCE % AVG, AUD, BY 1/4 HR % **FOX TV** HHLD AUDIENCE% & (000) 74%, AVG. AUD. 1/2 HR % SHARE AUDIENCE AVG. AUD. BY 1/4 HR % ←S HARVEY BIG TIME - WB--CHARMED - WB-JACK & BOBBY - WB WB TV ←AMR MOST TAL KIDS-PAX-DOC-SUN--SUE THOMAS, F.B. EYE-(PAE) PAX TV 03 U.S. TV Households: 109,600,000

For explanation of symbols. See page B

For SPANISH LANGUAGE TELEVISION audience estimates, see the Nielsen Hispanic Television Index (NHTI) TV Audience Report

Reprinted by permission of Nielsen Media Research.

(2) FOX MLB NLCS GAME 4.ST LOUIS AT HOUSTON FOX.(S).(4:38-7:41)(PAE)
(3) FOX MLB ALCS GM4 PRE-SUS NEW YORK YANKEES AT BOSTON FOX.(7:47-8:17)(SUS)(PAE)

major networks without the distortion caused by the one- and two-affiliate markets included in the national Nielsen reports (although few now exist). MNA reports include the so-essential demographic breakouts and give the networks figures related to their own stations without distortion from smaller markets where they have no ownership interests.

Though traditionally of limited interest to the national networks, the National Station Index (NSI) is of major importance to group owners. As Chapter 3 reported, it is published yearly and lists all syndicated shows on a market-by-market basis. Few syndicated series have national penetration equal to network programs, and as a result the off-network series appear to have lower ratings than when they were on the national networks-but that is now changing. NSI's market-by-market approach shows how each series did against specific competition and in specific dayparts. It therefore provides a realistic picture of how syndicated programs performed and is considered the bible for local stations and group O&Os when doing their own programming.

As network ratings have fallen, the way the networks report them has also changed. Very few press releases or promotional materials actually refer to the ratings or shares anymore. Rather, they report the millions of people who viewed something (the rating times 2.6). They point to the percentage increase over last year, a show's first-place position in a time slot, the percentage of the ideal audience it captures, and so on—anything but the actual rating numbers, which are usually dismal. A decade ago programmers joked that the ratings books were designed to be complicated so that any programmer could find something that he or she was doing right. Or, as Johnny Fever from *WKRP* in *Cincinnati* put it, "look what I'm doing with young boys"—a joke that some find hits too close to reality.

The general public does not have access to most of these proprietary reports. Although some weekly ratings appear in *Broadcasting & Cable*, *Television Weekly*, and *Variety*, the best sources for recent ratings are www.allyourtv.com, www.tvweek.com, and www.tv.zap2it.com.

Prime-Time Scheduling Practices

The entire process of prime-time programming breaks down into three major phases: deciding to keep or cancel already scheduled series, developing and choosing new programs from the ideas proposed for the coming season, and scheduling the entire group. To understand program scheduling, evaluation, selection, and promotion, the changing concept of a season needs to be spelled out. To recapture viewers from cable and movie rentals, the networks say they have moved to a 52-week season, but the claim is far from actual practice as yet.

Shifting Network Seasons

From the 1950s to the present, the main viewing year has periodically expanded or contracted until it settled on 40 weeks, usually running from late September to the end of May. The remaining 12 weeks (off-season) occur in summer. By the early 1970s, high per-episode costs had cut back the typical number of episodes produced for a series to 32 per year, requiring specials to fill the other six slots in the regular season. The

top 20 series would then be rerun to fill out the off-season (more normally only about 16 would rerun and summer holiday specials would fill the remaining time). Further cost increases combined with a high mortality rate forced an end to that pattern, decreasing episode orders for renewed series to 26 in the late 1980s, falling to 20 or 22 episodes in the early 1990s.

Nowadays, ABC, CBS, and NBC tend to order just 6 to 10 episodes at a time, although occasional 22-episode guaranties are given to capture a high-profile producer or star. And network contracts now say "cancelable any time." In the mid-1990s, however, a problem became apparent: Having just 22 episodes no longer covered the May sweeps, but these sweeps were increasingly important to affiliated stations and had become expensive for the networks when filled with specials.

Because the network license fee gives the right to two showings of each episode for the one payment, and the networks need to get their money's worth out of every episode, for the last decade reruns have begun early and often. They are usually scheduled at the end of the fall season in December (no ratings then) and between the February and May sweeps. Traditionally, weaker episodes used to be rerun in summers, but the need to fill 40 weeks has resulted in reruns of nearly all episodes during the main viewing year, with episodes of quickly canceled series, p.lots, and original reality series saved for summers.

Specials, sports, miniseries, and limited-run tryouts fill the remaining weeks of the regular season. However, the definition of a "special" has become extremely loose. For example, during a recent season, specials included rejected pilots, such fluff shows as ABC's 21 Hottest Stars Under 21, and so-called news specials that were indistinguishable from the regular news magazines and reality shows.

Limited Series

Starting back in the 1990s, the networks began interrupting the regular season with tryouts of new series in strong prime-time slots. March, April, and the summer months became tryout months for limited series (generally four to six

episodes). This off-and-on method of scheduling allows the networks to test a new program under the best possible conditions while preserving original episodes of the most popular series for the May sweeps. Whether inserting a new series into the ongoing prime-time schedule is an effective strategy is debatable. New shows usually get highly inflated ratings while in a popular show's time slot, but such ratings seldom hold up when the new show moves into its much weaker permanent slot. Series tried out during the summer months suffer from the opposite effect. Because summer ratings are so low, even if a program significantly improves ratings for the slot, the numbers seldom look good, and the common result is quick cancellation.

Many reality series, including American Idol, Survivor, and Dancing with the Stars, were planned as limited-run series, usually scheduled during sweeps weeks. Having only a few episodes reduces production costs, and allow the producers to stage much publicized tryouts around the country (that people pay to watch and participate in) between actual runs of the program.

In truth, the majority of new series are aired first in limited-run experiments. The majority of new programs tried by ABC, CBS, NBC, and FOX run for fewer than eight weeks. UNI, TEL, and the CW tend to leave new series on for a full season, but some programmers argue that this stems not from a different philosophy but from a lack of the money required to constantly develop replacements. (ION and MNTV, as well as TEF carry mostly rerun entertainment series.) But programmers argue that limited-run series are the wave of the future. They point to the success of such cable programs as Monk and The Sopranos, which ran 8 to 12 weeks, went off, and then came back later for another 8 to 12 weeks. This allowed cable programmers to stretch the run of popular original series into the summer months, when they often wiped out the networks in the ratings.

However, as with most things concerning the networks, the situation is not quite that simple. In broadcasting, the combination game/reality formula used in *The Apprentice, Survivor, The Amazing Race*, and *American Idol* forces programmers into

a scattered scheduling approach. A new game has to start and run its course as one person is thrown off the show each week, and then end the game. It then takes several weeks to get the next episode of the game ready for broadcast. Something has to fill the weeks between the main reality series, so why not use another cheap reality game and then alternate them back and forth in the schedule? In cable, programmers used the broken-run strategy largely because they could not afford a full 22 episodes. They needed the money from the first run to produce the second run. This scattered approach to scheduling helped disguise the fact that there weren't very many original episodes produced.

Network-planned limited runs of such high-cost series as *Lost* serve much the same purpose. Limiting the number of episodes produced each season keeps production costs down. Theoretically, this type of scheduling also builds anticipation in the audience, allowing a network to promote an upcoming series almost like a special event that hypes the ratings during sweeps weeks. ABC shocked many fans in 2007 by announcing *Lost's* end date of 2010, after a six-season run. The producers claimed that fans deserved the security of knowing that all the show's convoluted storylines would play out fully as intended.

It used to be that placing a program on hiatus (a rest or break) meant that it was awaiting cancellation. Over the decades, a few series came back from a hiatus with a new actor or plot line, and stayed on the schedule, but most just disappeared. Nowadays, with only 22 episodes to air, and sinking ratings for reruns, such limited series as 24, Lost, and Jericho end before Christmas and then return in February or March to run uninterruptedly with original episodes to the season finales in May sweeps. Lost's last three seasons will consist of just 16-episode stretches rather than 20 or 22, which eases the production schedule for this complex series.

Another option for filling gaps in the schedule is **stripping**, which refers to scheduling episodes of a program, usually a magazine series like *NBC Dateline*, on several different days across the week. This practice has not seemed to harm the numbers for news format shows, but it killed *Who Wants*

to Be a Millionaire? as a network show. However, after a hiatus of a year Millionaire returned as a syndicated series, and later went back on ABC as a special. In more limited form, stripping has been employed with such situation comedies as Till Death, Scrubs, and Arrested Development, and with such reality shows as Big Brother, Survivor, and Nanny 911, which often run two and sometimes three times a week.

Summer Schedules

In the late 1980s, the networks began using March and April, as well as summer, for testing new program ideas in short runs and airing rejected pilots that did not make the fall schedule. (Previously, these pilots would never have been seen by anyone outside the network programming department.) By the 1990s, not only were network ratings down but the costs for program development were so high networks could no longer absorb the expense of the development stages for new shows that never reached the air.

Summer became the arena for reruns of weak series episodes or episodes of quickly canceled series that were paid for but never used, and for episodes of never-scheduled shows or reruns of canceled series. Running pilots as made-for-TV movies, summer specials, and short-run tests of series became three ways to recoup much of a network's investment. The practices of doubling and tripling episodes during the regular season, combined with airing many unscripted series, which cannot be successfully rerun, was leaving little that was fresh for the summer months. By 2007, the networks had begun to repeat their top shows on Saturday nights, further exhausting their rerun potential for summers. Indeed, the neglect of the summers by ABC, CBS, and NBC made them a gold mine for the cable networks, which began killing the broadcast networks in the summer ratings. In addition, the affiliated stations worried about the extreme ratings drop during the July sweeps.

FOX further complicated the picture when it discovered that summer was a good time to get people to sample series they did not normally watch. The network was able to build an audience

for several of its regular series by continuing original episodes into summer, which were supported by active promotional campaigns. To take advantage of the potential for discovering its shows, FOX began heavily promoting its reruns as a "second chance to see what you have been missing." FOX's success was later copied by NBC in its "New to you" promotion that emphasized the fact that "if you haven't seen it, the program is new to you." By the early 2000s, this strategy was sufficiently successful to force the other three networks to pay more attention to their summer schedules. Most networks now schedule at least one or two new series during the summer, although none seems intended to continue during the main season. Even when a summer series generated a lot of talk or higher-than-expected ratings, as was the case with the short-run FOX series Roar, the show was dropped the minute September rolled around.

Until the breakthrough by extremely cheap unscripted series like Survivor, even when a summer series outperformed expectations, it was seldom picked up. Programmers generally wrote these offerings off before they ever went on the air. As a result, a show must break all records to get attention from programmers who have already moved on to next season's planning. The original Survivor, on CBS, which ran only during the summer of 2000, was such a surprise megahit. It spawned several clones (look-alike shows) for the subsequent season (Temptation Island, the Mole, and Big Brother), and then American Idol, a summer copy of a British series, did the same thing for FOX. Suddenly summer was seen as the time to try reality series. With the advent of original summer schedules and the promotion of reruns as original programming for people who normally watched the competition, the July ratings books took on more importance as a measure of network and pay-calle pull, as a limited vehicle for pre-fall testing, and incidentally, as a way to satisfy affiliates (see 4.6)

Fall Premieres

Traditionally, the networks premiere their new series during a much-publicized week in late September. However, in 2004, because of the late

4.6 The 52-Week Season

y mid-decade, the networks had begun to claim that they were programming year-round (the 52-week season). The networks began saving their second showing of the best episodes of a few hit series to be rerun in summers, instead of using them up during the regular 40-week season, and began touting that network summers were filled with original series. Despite the destabilization of the regular season schedule (from loss of episode reruns) and the problem of needing even more filler or the problem of the expense of additional episodes of regular series, this new approach was an effort to recapture viewers from cable programming. In addition, because reality shows are so cheap to make and there seems to be an infinite supply of ideas for such series-many can be produced and promoted as original summer programming. The battle for summer audiences will play out over the next decade.

summer Olympics, the networks were declaring there would be no fall premieres as such. The reality is that series have debuted in scattershot fashion for the last decade, usually throughout September and October (and occasionally as early as August or as late as November).

Theoretically, spreading out the premieres keeps new programs from getting lost in the rush, gives viewers maximum opportunity to sample each new network show, and accommodates interruptions caused by baseball playoffs, the World Series, and other major events such as the Olympics. In fact, spreading out "premiere week" has diminished the excitement associated with a new season and actually reduced the sampling of new shows. For example, viewers who find an appealing show at a certain hour in early September are unlikely to check out new shows when they debut some weeks later at the same hour. Viewers also won't stay around when they find a new show they like only to see it vanish for several weeks while the networks stunt before bringing it back again.

In addition, a large number of new network programs, particularly replacement shows, begin their runs in January or February, thus creating a second season on the networks. By late fall each year, the fate of most prime-time programs already on the air has become clear. Holiday specials usually preempt those destined for cancellation or restructuring, while more popular series go into reruns and special holiday episodes. By January or February the networks are ready to launch their second seasons—with almost the same amount of promotion and ballyhoo as are accorded the new season premieres in September or October. Nonetheless, they then promptly preempt the new schedule to promote and run special programming for the February sweeps, and then they introduce more new series in March. As a result, it is hard to argue that there are clear seasons any longer. Rather, network programming has become a round of constant changes. As a strategy, this is called the continuous season approach.

Program Renewal

Evaluation of on-air shows goes on all year. The final decision on whether to return a program to the schedule the following fall is usually made between March and May because the networks showcase their fall lineups at their annual affiliates meetings during those months and up-front sales begin. Last-minute changes, however, occur right up to the opening guns in the fall. The critical times for new programs starting in September are the four or five weeks at the beginning of the fall season (September/October) and the November sweeps. Typically, programs that survive the waves of cancellation at these times and last into January or February are safe until April (when preemptions of soon-to-be-canceled shows occur).

Program Lifespan and License Contracts

The average lifespan of popular prime-time series has declined steadily over time. In the 1950s and 1960s, such shows as *The Ed Sullivan Show*, *Gunsmoke*, *What's My Line?*, and *The Wonderful World of Disney* endured for more than 20 years.

These records for longevity will probably never be matched again in prime time—with the sole exception of the news magazines. By 1980, a program lifespan of 10 years was regarded as a phenomenon. By the 1990s, 5 years was an outstanding run for a successful series, and that remains the standard today.

Several factors account for this shortened lifespan:

- The increased sophistication or, some argue, the shortened attention span of the viewing audience
- The constant media coverage of television shows and stars (as in *Entertainment Tonight*, *People* and *US* magazines, the morning talk shows, and so on), which wears out each series idea quickly
- The practice of syndicating a series while it continues its network run, of releasing DVD sets, and of doubling and tripling (or other overusing while on the network), which leads to burnout
- The scarcity of outstanding program forms and fresh, top-rated production and writing talent, as well as a network propensity for formulaic series, which leads to a great deal of copying and very low levels of originality
- The high cost of renewing writers, directors, and actors after an initial contract expires
- The loss of key actors because they become bored or move on to other projects
- The move toward the cloning of prime-time hits, which results in a sameness that causes even the best ideas to wear out faster

The shortened lifespan of prime-time series especially reflects the complexity of program license contracts that generally run for five to seven years. When a series first makes it to the air, the network controls the contractual situation and usually requires several concessions from everyone involved. At this time, the producer commonly has to sign over such rights as creative control, spin-off rights, limitations on syndication, and scheduling control. Everyone also agrees to a specific licensing fee for the run of the five-year contract,

regardless of the program's success (after all, most shows fail). Typically, this licensing fee makes no concession for sharing the profits should the program become a hit.

Traditionally, producers practice deficit financing (paying more to produce a series than the network pays in license fees) because the potential profit from off-network syndication can run into the hundreds of millions of dollars. The repeal of the financial interest rule added a network demand for ownership of programs so they could get all the profits from the hits they generated, and all others would get only royalties. (In some cases, the networks accept joint ownership, meaning the network and the producer share any profits from syndication.) The shift to network ownership means the networks must now handle the cost of production and come up with their own ideas for new series, but in return they largely control the immensely profitable domestic and international syndication markets. Because the networks control all domestic outlets, the producers, directors, and particularly stars have little choice but to go along with the contracts they offer just to get a series produced at all.

At the end of the first contractual period (normally 5 years) however, the tables are turned. Now the producers and stars enjoy the advantage. The series has a track record. In short, if the network wants to keep making the series, concessions will have to be granted, usually in the form of much higher salaries or bigger shares in profits. Friends illustrated this dilemma when the stars each demanded \$1 million an episode in 2003-04 even before any other salaries or production costs were figured. Under such renewal conditions, a network can often profit by dropping a popular show with a marked-up price in favor of an untried newcomer or by replacing a popular star with a newcomer, as ABC did with NYPD Blue. Because finding hits is so difficult, the networks generally decide it's better to give in rather than have another huge hole open up in their schedules. For example, NBC did bite the bullet with the moderate hit ER, paying \$13 million per episode for one year just to keep this centerpiece for its Thursday night schedule.

Pivotal Numbers

Choosing which programs already on the air will continue and which will be pulled (renewals and cancellations) is perhaps the easiest decision network programmers have. The decisions are based squarely on the network's profit margin—in essence, subtracting the cost per episode from advertising revenue. Normally, revenue is directly related to ratings. Until the 1980s, a weeknight rating below 20 (or an audience share of less than 30) almost always resulted in a program's cancellation on any network. But because of steady network audience erosion, by the mid-2000s, the Big Four's numbers had plummeted to a minimum weekday prime-time rating of 5 and a share of 9. These numbers will sink even further if the broadcast networks' share of viewers continues to decline.

If the profit margin is high enough, such as with CBS's series Big Brother, a show will be retained with even lower numbers. Thus, profitability is the source of the power of reality programs. A few, such as Survivor and American Idol, have great numbers, but most do far worse than hour-long dramas. But most types of unscripted shows are incredibly cheap to produce, making the profit margins enormous.

Entertainment programs stalling in the bottom third of the Nielsens are usually canceled as soon as possible, while programs in the top third are usually renewed. The most difficult decisions for network programmers involve programs in the middle third—the borderline cases—or programs that

- are weakening but are nearing their fifth year.
- are only just beginning to slide in the ratings.
- are highly rated but draw the wrong demographics.
- produce low ratings but draw a high percentage within a desirable demographic group.
- have low ratings but high profit margins.
- produce strong critical approval but marginal ratings.

Occasionally, the personal preferences of a top network executive, the reaction from critics, letterwriting campaigns, or advertiser support may

influence a decision, but the prevailing view is that cancellations had far better come too soon and too often than too late. Indeed, network programmers insist that advertisers and corporate headquarters will not tolerate a program that doesn't offer instant success.

Replacement series, however, almost never do significantly better than the original program in the ratings (see 4.7), and they push development prices even higher. Therefore, large group owners occasionally pressure their networks to hold on to problematic shows. Group owners can affect cancellation decisions, as can direct participation from key sponsors, but this happens only rarely. Such pressure can also be positive (to hold) or negative (to kill). For example, in 2003 Procter and Gamble pulled its advertisements (purchased during the up-front buying) from Family Law, saying the content was not what the company had been promised. As a result, CBS was forced to pull the offending episodes from the rerun schedule.

Program Costs

In addition to ratings, profits left after subtracting licensing costs from advertising revenues influence program cancellations. Two prime-time programs of the same length, on the same network, with identical ratings will, ideally, produce identical amounts of revenue for that network. If, however, one of them has slightly higher per-episode licensing costs, say as little as \$100,000 an episode, over the length of a season that difference would equal just over \$2 million. It is clear that the program with the higher licensing cost will be canceled before the lower-cost series.

In recent years, the networks have scheduled more program genres with low production costswitness the proliferation of news magazines and reality shows in prime time. Listening to the media, one would think such programs as ABC's Member of the Band, which followed a group of young hopefuls trying to get into a band, or MTV's The Real World were pulling in big audiences. In truth, the ratings were very low, and the number of hits to their reality sites on the web (often used as a justification for such series as Big Brother) was

Time Slot Ratings

he history of ratings for the time slot a program fills may be the strongest measure of how that program will perform. After all, a "history" takes into account such factors as the competition, the leads in and out on all channels, the network's myths and policies, and the public's viewing habits and expectations. The reality is that more than 80 percent of the series scheduled in new time slots (new or moved shows) do not alter either the ratings or the ranking for their slots significantly. This means that a series placed in a toprated time slot probably will be a top-rated series, and conversely, a series placed in a weak position will be weak. The majority of the remaining shows get lower ratings than their time slot averaged in the previous season. This means that when a series does change the historical pattern, the change is usually for the worse. Chances are less than 5 percent that a program will significantly improve the ratings for the time slot even at the generally accepted 68 percent level (one standard deviation rather than the two normally used in research).

Low-rated shows are subject to a widely accepted condition called **double jeopardy**. According to this idea, low-rated shows have both low exposure and little chance of getting more exposure. This is because popular programs are chosen by more people, and those viewers are more committed to the shows. Thus, unpopular programs suffer from increasingly fewer and less-committed viewers.

Obviously the best scheduling ploy would be to place every series in an already strong position, an impossibility in programming. The slots open

to programmers are usually ones where previous programs failed. In the last 20 or so years, more than half of all new shows have been scheduled in primetime slots that already ranked in the bottom third of the ratings, and most were also in slots ranked third compared to the competition. Clearly, the strength of a time slot should be considered when the decision is made to hold or cancel a series.

This, however, has not usually been the case at the networks: In practice, a program's rank and absolute rating overrule expectations for a time slot. As a result, a series with a 9 rating would usually be held, while a series with a 4 would be canceled, even if that 9 represented a loss of several points (by comparison with the lead-in program or the previous program in that slot) and the 4 represented a gain. Because there is only a small chance that a series will significantly improve the ratings for a time s ot, considering ranking an absclute rating appears to be self-defeating in the long run. Because the major ty of available slots are going to be weak in any case, wisdom suggests holding onto series that improve the numbers and slowly rebuilding holes in the schedule would be sound practices. Because a short replacement series is very unlikely to do any better and is expensive to develop, common sense would also seem to advocate holding onto new procrams longer to give them time to build audiences. After all, Seinfeld generated ratings of only 11 and 12 during its first year, losing badly to Home Improvement. Nonetheless, the pattern of the three major networks has been "decide quickly" and "cancel fast."

minimal when compared to the number of people required to make a network sitcom or drama successful. (A hundred thousand hits to a website are nothing compared to the millions of viewers needed week after week.)

Nonetheless, unexpected megahits like Survivor and American Idol have led programmers to promote "the new reality revolution" because of the genre's low cost, in spite of disastrous rerun numbers and no syndication potential. As of 2008, a new reality show costs around \$350,000 per episode. Even such megahits as Survivor

cost only about \$1 million per episode, whereas the price tag for an episode of *ER* is close to \$20 million. (Original cable series cost much less than the broadcast equivalent because they are done in non-union shops.) Especially interesting is that reality shows are the only new genre to join the major types of prime-time programming—alongside sitcoms, dramas, sports, movies, and news magazines—in more than two decades.

Each new episode of a program is assigned a license fee, whether the show is produced by the same company that owns the network intending

to carry the program or another entity. The license fee size varies with cost factors such as costumes, special effects, sets, stunt work, the amount of location versus studio shooting, cast size, the producers' and stars' reputations, the program's track record, the demand for series in the same genre, and so on. Traditionally, this cost represented about three-quarters of the actual cost of production and told the executive producers how much they were going to have to kick in to actually make the program. Because the company controlling the network now usually owns the production, it has to cover all costs, so the fee itself is largely irrelevant. But for accounting purposes, the license fee is still used to allocate the actual cost of production to various departments, and it tells the network how much it has to earn during first run and then during rerun to break even. How networks allocate these costs varies enormously.

At present, one of the biggest cost factors is how a program is produced from a technical standpoint. According to data from NATPE, producing a program on film runs about \$4,000 per five minutes of product (not including any other costs such as cast and other salaries). Tape is less expensive but still around half that cost. Producing the program digitally-using a digital camera and a computer for editing, special effects, and so on-runs about \$7,000 for 45 minutes of high-definition product (less than \$800 for five minutes), and that includes transferring back to analog for distribution. This enormous cost differential—about one-fifth the cost of film drove the high-definition revolution in Hollywood. Despite having high-definition products, however, the broadcast networks and most stations continue to distribute most programs in the digital 3×4 aspect ratio that fits traditional TV screens. Moreover, they still had not agreed on a single format for home HD recording as of 2008.

Because there are only a limited number of top producers and writers for any given genre, especially high demand for a particular type of show forces costs up. By 2008, the fee for a successful reality series had also gone up almost 400 percent but was still far below the cost for any other type

of programming (with the exception of news magazines like 20/20).

A show's potential for profits in syndication also affects how high its license fee can go. Action hours have traditionally been expensive to produce but have been highly syndicatable in both the domestic and international markets. They are also highly desirable for the parent companies' own cable networks. However, following the takeover of most independent production houses, the number of original action series dried up. In 2004-05 there were only three action hours available in syndication, Andromeda, Stargate SG1, and Mutant X, and Sci Fi Channel had tied those up. By 2007, no original action hours were on the market. For the broadcast networks, this meant a lucrative part of the syndication market had evaporated in less than five years.

Crime dramas then surfaced as a means to fill network schedules at a somewhat lower cost than action hours, resulting in schedules full of *Law & Order* and *CSI* look-alikes. Although the network studios were cranking out afternoon talk shows and judges banging various gavels, they were generating few dramas outside of crime shows. At the same time, the networks were having no luck producing new hit sitcoms as of 2008, resulting in a certain amount of panic in the syndication market.

New Program Selection

Phase two in planning a new fall season—selection and development of new program ideas—poses more difficult problems than ongoing program evaluation. The four networks consider as many as 6,000 new submissions every year. These submissions vary from single-page outlines to completed scripts. Decision makers favor ideas resembling previously or presently successful shows. They even quietly agree that almost all so-called original successes are in fact patterned after long-forgotten programs. American Idol, for example is just the Original Amateur Hour with a snotty Ted Mack. American Dreams merges the musical variety show with a dramatic series, a modestly innovative idea, but not a tremendously successful

one, at least initially. One year, NBC promoted its move toward new and daring ideas with *Titans*, described as a "quirky yarn about a big city lawyer returning to his hometown in Ohio," despite this being the same plot as *Providence*, *Judging Amy*, and *Ed*. But then, none of the other networks have been any more original.

The newest way of generating additional network programs is franchise programming—cloning an hour-long series into several more programs with only minor changes. Originality has never been a big selling point for broadcasters, but franchising programs creates extreme sameness because a franchised show merely has a different cast and perhaps location. By the mid-2000s, CSI had been cloned to three different cities (Las Vegas, Miami, and New York) and blended with IAG to form Navy NCIS. Law & Order had added a Special Victims Unit and Criminal Intent, and followed them with even more analysis in Criminal Minds. People were only half joking when they suggested that next we would have Law & Order: SUV where the characters would investigate crimes from large sponsorplaced vehicles. Over at FOX, they were working on turning American Idol into a franchise by changing music styles or featuring contestants of different ages. For network programmers, franchising has three enormous advantages:

- 1. Generating hour-long programs for foreign syndication
- 2. Reducing decision making for new series ideas
- 3. Creating signature programs to be identified with a network, thus helping to set it apart from other program suppliers

Viewers have generally had to look to cable for fresh ideas in such programs as Six Feet Under, Nip/Tuck, and so on. But the most popular cable shows are sometimes reused on sister broadcast networks, as was the case with Monk and Queer Eye for the Straight Guy. This double scheduling of the same show is called repurposing and goes both ways. For example, NBC ran all three versions of Law & Order on its co-owned USA and later syndicated the original series to TNT. It also ran Heroes on the co-owned Sci Fi Channel. In fact,

the entire SOAPnet channel seems to be a way for ABC to rerun its afternoon soap operas at night for women who work during the day. But *Heroes* proved so popular with younger viewers that NBC broke the "avoid sci-fi" rule in 2008 and experimented with *Journeyman*, *Bionic Woman*, and (unbelievably) the weird *Chuck*.

Program Concepts

Many program concepts are dismissed out of hand; others are read and reread, only to be shelved temporarily. A few, usually variations on present hits or programs linked to top stars or producers, get a favorable nod with dispatch. Such big-name directors as Barry Levinson, Oprah Winfrey, or Rob Reiner are courted and given contracts to develop anything they want, but without premises to actually run the shows. The networks fight desperately to find that immediate hit or something that will pull in a young audience.

Of the thousands of submissions that land on the networks' desks, roughly 600 are chosen for further development. At this point, all parties sign a step deal, a contract providing development funds in stages to the producer, setting a fee schedule for the duration of the contract, and giving the network creative control over the proposed program.

Scripts

As a rule, step deals authorize scripts or, in some cases, expanded treatments. The approved concepts often take first form as special programs, made-for-TV movies, or, increasingly, test characters in established shows. For example, the Green Man and Aquaman were introduced in *Smallville*, both of which became strong contenders for their own series. If a concept was submitted initially in script form, a rewrite may be ordered with specific recommendations for changes in concept, plot, or cast (and even new writers). Until recently, ABC traditionally supported many more program ideas at this stage than CBS, NBC, or FOX, but ratings shifts have led first CBS and then NBC to allot more money to develop new program ideas. FOX

had been more daring and more willing to hold onto new programs until it moved solidly into fourth position, now challenging NBC for number three in the ratings. The network that has recently dropped the most in the prime-time ratings is always the hungriest for fresh ideas and the most willing to risk trying them.

Before authorizing any production, the program executive will first order one or more **full scripts** and a **bible**. Nowadays, a network typically pays about \$50,000 for a half-hour comedy script and \$70,000 for a one-hour drama script. Exceptional (read *successful*) writers demand much higher prices. The bible outlines characters and their relationships, suggests sets that will be needed, and summarizes future script ideas or the way the program can develop during its proposed five-year run.

Advances and Pilots

A pilot is a sample or prototype production of a series under consideration. Pilots afford programmers an opportunity to preview audience reaction to a property. Each of the Big Three networks orders between 30 and 45 pilots to fill expected gaps in its new season lineup (fewer for FOX and CW). Once a network decides to film or tape a pilot, it draws up a budget and advances start-up money to the producer. The budget and advance may be regarded as the third major step in the program development process. Half-hour pilots cost from \$1.5 million to \$3 million, depending on things like sets, costumes, special effects, star power, and so on, with one-hour drama pilots costing more than twice that amount. Traditionally, pilot production costs were generally higher than costs for regular season shows because new sets had to be built, crews assembled, and start-up costs paid. (However, the ongoing costs for the few megahits have recently risen far higher than the costs of their pilots.)

FOX and many producers have denounced the pilot system because of its incredible expense and abysmal success rate. FOX demands 5- to 10-minute presentation films in place of full-blown pilots for many shows, but this radical idea has met strong resistance from the other

major broadcasters. Nowadays, of the approximately 130 pilots produced annually, many are formatted as made-for-TV movies. These can be played on regular movie nights and sold internationally as parts of movie packages, thus recouping the investment even if the series idea is not picked up. Series failing to make the final selection list for the fall season are held in reserve in anticipation of the inevitable cancellations. After seeing the pilots, the networks also "short order" some backup series, authorizing production of four to six episodes and additional scripts in case a backup show used as filler is unexpectedly successful. For a visualization of the development process, see 4.8.

The decisions to select series for airing based on their pilots usually take into consideration the following:

- Current viewer preferences as indicated by ratings
- · Costs type, cost
- Resemblance between the proposed program and concepts that worked well in the past
- Projected series' ability to deliver the targeted demographics for that network and its advertisers
- Types of programs the competing networks air on nights when the new series might be scheduled

The following are of secondary weight but also relevant to a judgment:

- The reputation of the producer and writers
- The appeal of the series' performers (the talent)
- The availability of an appropriate time period
- The compatibility of the program with returning shows
- The longevity of the concept

Finally, increasingly relevant are these factors:

- The number and type of countries that might buy the show in syndication
- The ability to reuse the show in another co-owned venture (another broadcast or cable

4.8 The Program Development Process

Process begins with the review of new ideas submitted in the form of pitch sessions, requested submissions, open submissions, or company-developed proposals.

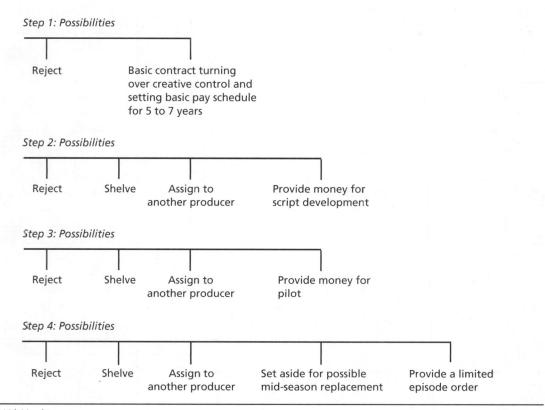

Art: Milt Hamburger

network) or platform (internet or mobile media)

- The size of the potential DVD sales market
- The viability of inviting other production houses to share the initial expenses

Whether first-world countries will buy the show and whether it has very wide appeal that crosses cultural divides have become major considerations, as has the show's reuse and resale value. Of equal importance is whether the parent corporation can control the entire process from production to multiplatform distribution. The chief programmer juggles all 14 of these considerations and perhaps others.

Schedule Churn

Stunting has resulted in a continual shifting of prime-time schedules, called scheduling churn. (Here the term *churn* refers to the continual shifting of programs within the network schedule and should not be confused with the term *subscriber churn* as it is used in the cable and pay-television industries.) The number of series introduced or moved into new time slots during each month between the 1971–72 to the 2006–07 seasons is shown in 4.9. The September/ January figures represent the traditional first-and second-season starting points. Therefore, series introduced in other months represent

4.9 Prime-Time Churn: Time Shifts and New Program Introductions from 1971 to 2007

Season	Sept.	Oct.	Nov.	Dec.	Jan.	Feb.	March	April	Total	Percentage Outside of Sept./Jan.
1971-72	24	_	3	3	14	_	_	-	44	14%
1972-73	19	_	_	3	13	1	_	_	36	11%
1973-74	20	_	1	_	20	2	2	_	45	11%
1974-75	25	2	T-	3	13	3	6	1	53	28%
1975-76	29	4	7	6	17	1	4	_	68	32%
1976-77	20	_	15	4	21	6	10	_	76	46%
1977-78	22	7	2	12	13	8	7	12	83	58%
1978-79	25	5	11	1	20	14	19	4	99	55%
1979-80	24	8	2	16	11	2	25	8	96	64%
1980-81	7	4	8	10	13	6	13	8	69	71%
1981-82	6	13	15	4	13	5	18	20	94	80%
1982-83	15	10	2	_	12	10	20	9	78	65%
1983-84	16	5	4	11	17	3	19	5	80	59%
1984-85	21	7	4	10	12	2	14	12	82	62%
1985-86	22	2	5	6	13	5	15	12	80	56%
1986-87	26	2	17	2	11	8	23	8	97	62%
1987-88	30	8	7	15	13	6	17	7	104	58%
1988-89	4	19	8	6	18	7	10	19	92	75%
1989-90	36	4	8	8	13	7	12	21	109	55%
1990-91	32	3	13	5	17	8	17	17	112	56%
1991-92	40	9	11	7	11	8	9	18	113	55%
1992-93	38	3	10	10	12	15	22	17	127	61%
1993-94	29	19	8	6	11	7	5	12	97	59%
1994-95	33	12	7	7	22	6	13	21	121	55%
1995–96	59	11	18	7	12	5	22	15	149	52%
1996-97	43	14	4	4	20	11	23	15	134	53%
1997-98	44	20	12	9	27	10	26	18	166	57%
1998-99	27	34	6	14	20	3	21	16	141	74%
1999-00	39	17	19	8	25	9	14	15	146	56%
2000-01	19	31	10	8	21	12	24	10	135	70%
2001-02	26	31	25	11	21	18	24	17	173	73%
2002-03	39	19	13	5	37	23	18	22	176	57%
2003-04	20	38	13	22	31	11	29	29	193	74%
2004-05	56	12	21	10	24	11	22	18	174	54%
2005-06	69	8	5	20	23	16	25	12	178	48%
2006-07	75	24	21	11	25	21	18	17	211	53%

Variety and Broadcasting & Cable listings, prepared by William J. Adams, Kansas State University. The FOX network is included in the figures beginning in 1989. The WB and UPN are included in figures from 1996 to 2006, the CW and Univision from then on. Movies, sports, and specials are not included. For January through April of 2008, the numbers are estimates based on the average of changes in the last 10 years.

4.10 Explanations for Network Churn

ndustry expert Tim Brooks, author of The Complete Directory of Prime Time Network and Cable TV Shows blamed much of network churn on "panic." He pointed out that ratings had been declining since the mid-1970s but that the decline was not steady. Rather, ratings would first drop and then stabilize for a few years. When this happened, programmers would proclaim success, claiming they now had control of the problem (and then they would continue doing exactly what they had been doing). These periods of stability were related to specific programs that, for a time, according to Brooks, brought in big audiences. During the 1980s, it was Cosby; then in the mid-1990s it was Roseanne and Home Improvement. Later the numbers again stabilized when ER and Seinfeld became hits, then Survivor further solidified them for a

time. When one of these shows eventually slid dowrward, though, the overall ratings for that network went into a free fall. When this happens, as it nevitably does, programmers panic. Instead of changing the practices that seem to be driving the audiences away, they do more of them. For example, when ratings began another free fall in 1997, programmers went into another schedule-shufling frenzy. By 2004, the heavy reliance on reality series had multiplied the problem because such series almost always decline significantly in audience size in their second seasons and have no afterlife in either syndication or as DVD sets. Those based on a gimmick, like The Simple Life, often fall apart completely. Franchise shows seem to hold up better in syndication, but never match the original in ratings.

changes in the schedule that took place while the season was in progress.

The chart shows the schedule churn caused by moving established series into new time slots (program shifting) if the show stayed at least one month, the introduction of new programs (replacements, requiring the cancellation of old programs), or filling out the season when series have limited runs, for example, *Dancing with the Stars, Lost*, and *Survivor*. Included are figures for the only regular 32-week season, excluding summers, because they represent the networks' main programming efforts.

The September 1980 and 1981 figures and the 1988 figures reflect the effects of strikes that delayed the start of those seasons. For other years, however, there is very little explanation for the high levels of churn (see 4.10). Indeed, the table in 4.9 shows only part of the picture. It shows only actual changes in the schedule. It does not show preemptions, which are now common. Indeed, over the last four years, each of the four major networks has averaged a 33 percent preemption rate. In most cases, this preemption was caused by running extra episodes of an already existing series (for example, running back-to-back episodes

of *Reba*)—or by reversing the existing shows (for example, flipping *Grey's Anatomy* and *Desperate Housewives*) for just one week. Very few examples of churn were the result of airing specials. In short, one can say regularly scheduled series were missing from their scheduled slots one out of every four weeks between September and May. The picture was even worse during the summer.

Examination of all 52 weeks of the 2005-06 seasons revealed a frenzied picture. The WB changed its schedule 44 times: Because it had only 14 programs in prime time and didn't actually cancel or add to this number, the extent of the WB's programming instability stands out. Similarly, UPN moved its shows around 9 times, which is limited, but it must be remembered—they had virtually no shows to move. The eventual result was the merger of these two channels into CW. At the same time, ABC, running 24 series, made 40 changes, while NBC changed its 29 series 50 times. FOX changed its 16 programs 59 times, and CBS was the most conservative, making only 33 changes in its 25-series lineup. Humorously, just over 30 percent of the moves involved nothing more than putting a program back into the time slot it had been moved from, often just four or six weeks earlier. It is hard not to agree with Brooks (see 4.6) that this constant motion represents panic.

A program that a network wants to get rid of can be canceled outright or manipulated (timeshifted or churned) until its ratings fall. Manipulation sometimes makes good public relations sense when a show is critically successful or widely popular-but not quite popular enough among the desired demographic groups. Some critics have suggested that this was the problem with Touched by an Angel. Analysis of program churn over the long haul leads to two conclusions:

- 1. An individual program's ratings almost always fall when it is moved two out of three weeks (especially when moved in the second season).
- 2. A new series—one that had improved upon the time slot it was originally given—always fails when moved.

Prime candidates for purposive schedule manipulation include programs with higher-than-average production costs that would cause managerial problems if abruptly canceled (because they are supported by a highly placed executive or advertiser). The 1995 shift of Murder, She Wrote on CBS from Sundays to Thursdays may have been an example of this type of move. The shift of The West Wing from Wednesday to Sunday in 2005-06 and King of Queens in 2006-07 from Monday to Wednesday are probably examples of purposive schedule shifts. Once low ratings or even a downward trend is achieved, network programmers can point to the numbers to justify cancellation (on the few occasions when some justification seems useful). During panics, however, programs seem to be moved for no apparent reason: Merely showing the parent company that something is being done seems to be the real programming strategy at such times.

Promotion's Role

All nine networks use frequent on-air promotion and online promotion, as well as paid advertising, to introduce new and moved programs. Beginning as early as mid-July and continuing through November (after especially heavy season-opening salvos), networks intensify promotion of both their programs and their overall images on their broadcast and owned cable channels. For some bigbudget or especially promising shows, paid advertising in program guides and magazines also helps draw audience and advertiser attention. Concurrently, the networks open elaborate websites for each new program containing character bios and pictures, the backstory of the series and the current plot line, merchandise to buy, interactive chat groups, feedback options, and other elements. On-air promotional announcements play a pivotal role in the ratings success of a program. Indeed, effective on-air promotion may alter prime-time ratings as much as 10 or even 20 percent, probably maximized by additional cable and online promotion, although much of the remainder of ratings must be attributed to the appeal of the program. Websites are thought to build loyalty to the program and involvement with specific characters, both contributing to satisfaction with a series and to frequent viewing.

In the fall, on-air promos plug every program scheduled to appear in a season lineup. Weak or doubtful offerings needing extra stimulus get extra exposure on all platforms, at least until the network surrenders. Not until a program is safely past the rocks and shoals of its first several airings (or until it becomes clear that nothing can help to get it past these early trials) does promotion let up. At least minimal on-air promotion continues as long as a show is on the schedule, but websites fade away (from lack of updates) when a show seems destined for cancellation.

In addition, networks use print promotion, especially television guides and newspaper listings, to catalog offerings for particular evenings. For a long time, TV Guide magazine was so important to network television that programmers sometimes delayed schedule changes so that the alterations could make TV Guide's deadline for affiliate program listings. The promotional value of TV Guide is both local and national, although its format became unwieldy as the magazine sought to incorporate more and more program services. Digital cable systems now provide electronic guides, essential because of the huge numbers of channels. In addition, magazines like *People* and *Us* are major outlets for printed promotional materials. Cross-promotion using morning shows and cable outlets carrying popular behind-the-scenes specials is also critical for capturing attention. Some networks also join with major businesses, such as Kmart or McDonald's, to jointly promote the new season or a specific program.

Promotions in print, on the air, and on the web are the primary ways networks invite viewers to try out programs. They are also the means by which the networks convince viewers to associate a program with a particular network (franchising or branding). At the same time, parent corporations are demanding heavy cross-promotion of a company's many subsidiaries—like the CW using its series to promote music from Atlantic, Elektra, Reprise, Rhino, and Warner Bros. Records—which uses up air time that would previously have been used to promote episodes of individual programs and leaves less and less program time.

Changing Format Emphases

To minimize risk, networks continue to rely on the traditional winners in prime time—situation comedies, dramas, and movies—and have somewhat reluctantly added unscripted programs (in shorthand, reality) to this exclusive list. Another change has been the increased use of *specials*, a term encompassing one-time entertainment programs, major sporting events, and more infrequently, news documentaries. Nonetheless, the proportions as well as kinds of formats dominating evening schedules have altered over time (see 4.11).

Situation comedies and crime dramas have a long history in network television, stretching back to such shows as *The Life of Riley* and *Dragnet* in the early 1950s all the way through *Everybody Loves Raymond* and *CSI* in the late 2000s. In one recent season, the broadcast networks offered over 75 sitcoms and 30 crime dramas; in a subsequent season, the distribution had flipped to 17 sitcoms and 38 dramas plus 26 unscripted shows (and another 22 dramas on Univision).

The concentration of shows into sitcoms and dramas occurred because they

- attracted sizable audiences in the young female demographics.
- syndicated well off-network.

Unscripted shows supplanted some of this concentrated group because they

were inexpensive to produce.

Because of demand the cost of sitcoms and crime shows produced in the United States has escalated beyond that of most other formats. (Univision buys its soap-like dramas—telenovelas—less expensively from Mexico.) As a result, the crime drama has moved to the franchise route, and situation comedies have begun to all look alike. Although examples of top-rated shows in both of these types are easy to find, their overall success rate has declined steadily. Most years, the networks do not produce even one truly successful new sitcom.

Situation comedies fall into two main types: family-based comedies like Two and a Half Men, Malcolm in the Middle, and How I Met Your Mother—and occupational comedies like Becker, Whoopi, and Scrubs. Together, these two types account for more than three-quarters of all situation comedies offered over the last 20 years. More unusual sitcom formats such as Friends or That '70s Show occasionally turn up, but only in limited numbers. Crime dramas have slowly changedfrom private citizen do-gooders like Magnum P.I. to gritty police dramas like NYPD Blue to investigations of somewhat revolting body parts like CSI. The mid-1990s also saw the return of courtroom dramas, often in connection with a police show (as was the case with Law & Order and Law & Order: SVU), or on their own (as in The Practice, Judging Amy, and Without a Trace). Smallville may become a franchise for the CW using the Justice League characters.

Of the approximately 700 specials each year, more than 500 have been entertainment specials for young adults, such as the Justin Timberlake specials, the Charlie Brown Christmas specials, and Univision's long-running Sabado Gigante.

4.11 Is There a Doctor in The House?

lways a runner-up. That might be that way to describe medical dramas on the broadcast networks. Never the dominant format, but always there, usually in the top 10. However, over the years, they changed.

Back in 1948, medical programs were serious science. Starting on the old Dumont Network (and then moving to CBS), The Johns Hopkins Science Review was one of those shows critics loved and very few people watched. It offered the latest breakthroughs in medicine and other areas of science (a topic that has moved to evening newscasts). In the early 1950s, the program was where people went to get the latest word on the polio epidemics and the treatments. It was also where they went to see the latest information about rockets. When it went off the air in 1954, it was replaced with two shows: Medical Horizons on ABC-a series, like Johns Hopkins, which presented the latest breakthroughs, but only in medicine, and Medic on NBC, which dramatized case files from the Los Angeles Medical Association. Medic was more successful, but both typified the ways the medical profession was dealt with during the 1950s. Medicine was serious stuff, and even when stories were dramatized, they came "theoretically" just from the facts.

That all changed in 1961 when two groundbreaking shows hit in the same year. Dr. Kildare (taken from the movie of the same name) and Ben Casey both featured a brilliant, but nonconformist young doctor and his wise, older mentor. These doctors did more than cure sickness—with almost God-like success. They also solved an endless array of other people's personal problems. For the next 20 years, right up until Trapper John, they set the formula for successful medical dramas. But in 1972, a slight change began to creep in with the premiere of Emergency.

It's hard to think of Emergency as groundbreaking but for the first time, a medical show had an ensemble cast, not just two major characters. What was meant to form a bridge between action-adventure and medical drama also formed a bridge between the existing formula and its next incarnation, which occurred in 1982 with St. Elsewhere. Set in a big-city teaching hospital, St. Elsewhere was a complete break from the programs with the God-like doctors that preceded it. Here doctors were all too human, with some driven by money, others by a yearning for fame. Instead of solving everyone else's problems, doctors started worrying about their own. The whole show was somehow less antiseptic, grittier, more inner-city, and the topics they dealt with ranged from breast and testicular cancer to AIDS to rape and gang violence, and so on. This was the show that made it okay for men to appear nude, at least from behind. Doctors on television would never climb back up on the pedestals they had previously occupied. Even when the doctor is a certified genius, such as in FOX's House, he's still an arrogant jerk.

St. Elsewhere's most enduring legacy, however, was the ensemble cast. From that time, right through Gray's Anatomy, no one or two stars carried a medical drama. From the point of view of producers this has the huge benefit of allowing stars to leave and new ones be brought in without damaging the show. As a result, ensemble programs can run forever, so long as there's a sickness to tackle. Not a single character that appeared in the early episodes of NBC's ER is still there, and yet the show continues to be a top-10 contender. By evolving over time, the medical drama has not only kept itself healthy but has been longer-lived than most formats.

> William J. Adams, Ph.D. Kansas State University

A fast-paced variety, talk, and game show, it airs every Saturday evening and attracts huge Spanishspeaking audiences inside the United States and throughout South and Central America. About 100 specials each year on U.S. television are sports specials, including the annual Super Bowl and World Series games. The remaining 100 divide among dramatic specials and news specials, including interviews such as those by Barbara Walters, and occasional documentaries.

Entertainment specials often attract superstars (such as Dustin Hoffman) whose regular motion picture work, performance schedules, or health prevents them from participating in series programs. Star-studded specials can invigorate a schedule, encourage major advertiser participation, provide unusual promotional opportunities, and generate high ratings and critical approval. However, they cost a lot of money and are consequently rare. A flood of award shows, clones of the Academy Awards and Country Music Awards, are now promoted as "Star-Studded Specials," but few are as big a draw as the annual Academy Awards. Indeed, many so-called entertainment specials are merely long forms of regular series or regular episodes with big-name guest stars.

For example, the record-breaking final episode of M*A*S*H (amassing an extraordinary 77 share) was an extended episode of the existing series, as

was the final episode of *Seinfeld*. *Friends* did several long-form shows leading up to their final episode, all of them called specials. Network programmers are awake to the possibility that too many specials differing sharply from the regular programming might interrupt carefully nurtured viewing habits beyond repair—hence, the trend toward long-form episodes of regularly scheduled series. Such shows also have the advantage of being relatively inexpensive to produce and promote, and they exploit existing audiences, thus reducing risk. However, the frequent use of specials has the effect of destabilizing a network's entire prime-time schedule.

Nowadays, network prime-time sports consist of playoffs and championships in the major sports, as well as special events such as the Olympics (see 4.12 about Roone Arledge's extraordinary influence).

4.12 Roone Arledge: The Man Who Brought Sports into Prime Time

hen Roone Arledge was first hired by ABC in 1960 as a lowly assistant producer, the television networks considered sports to be second-rate entertainment. Even professional team owners at the time believed that televised sports existed to sell tickets for the ballparks. Roone Arledge could not have disagreed more. He was convinced that sports programming could entertain the fans at home, and under his leadership, the sports broadcasting industry was completely recreated.

Arledge came up with a revolutionary approach to producing sports: He borrowed the production techniques of entertainment and used them to duplicate the experience of actually attending a game at the stadium. He used many more cameras, microphones, and graphics in his sports telecasts than his competitors had ever used, and he experimented constantly with new technologies. Arledge and his team of talented engineers pioneered or refined the use of underwater cameras, handheld cameras, isolation cameras, field microphones, split screens, instant replay, slow motion, and freeze frames. Their efforts resulted in new production techniques that heightened the drama of sporting events. Arledge also began the practice of focusing on the personalities and stories of the athletes. He invented what was called "up close and personal"

coverage—airing pretaped biographical features of athletes right before their events—to involve viewers emotionally with the players and the outcomes.

During the 1960s, the television networks aired sports only on weekend afternoons. But ABC's successful prime-time broadcasts of the 1968 Olympic Games convinced Arledge, by then the president of ABC Sports, that sports programming could compete with sitcoms and dramas in prime time. Morday Night Football, an Arlecge creation, premiered in 1970 and quickly became a phenomenal success in the ratings. (It is worth noting that CBS and NBC had both rejected the NFL's proposal for the show.) During the 1970s, one sport after another moved into prime time, and fees for broadcast rights for sports skyrocketed because of soaring revenues from prime-time advertising.

Despite starting with very limited resources, Arledge transformed ABC Sports into the preem nent sports network of the day. Although Arledge died in 2002, his immense influence will continue to be seen for decades to come. He forever changed ABC, network programming schedules, sports economics, and the way that viewers watch sports on television.

Timothy B. Bedwell Media P-oducer FOX and NBC, in particular, often use sports to fill the first two months of the new prime-time season, introducing regular scheduled programming as late as November. Although the networks carry a great deal of football, basketball, baseball, tennis, and golf, and Univision has soccer, most of these shows are relegated to the weekends (see Chapter 5). Most soccer, wrestling, and other sports command prime time only on cable, not on the broadcast networks. Cable has become the true home of sports. Even ABC responded to pressure for the network to do something to attract more "ideal women," even at the expense of its traditional audience for the longrunning Monday Night Football, and shifted the show to ESPN. Big sporting events do bring prestige to the network, are popular with affiliates, and fill out advertising packages by delivering male viewers of all ages, but the costs paid by broadcast networks for the biggest events no longer match returns.

Unscripted programming is the overall term now being used by the industry to cover reality programs, news magazines, and game shows. It refers to the types of programs that do not require the expensive writing and controlled production used for other series. While such shows have writers providing ad-libs for hosts and outlining situations, the talent cost is minimal compared with other genres. These three types of programs are certainly not new. The magazine format goes back decades, game shows ruled the airwaves during the 1950s, and artificial situation shows can be traced back at least as far as *Candid Camera*. What is new is the power they command.

Like the sitcom, there have been some true hits in the reality genre. American Idol, Survivor, and Dancing with the Stars seem to have staying power, but others, such as Joe Millionaire, did well once but fell apart once the gimmick was known. To date, nearly all reality series have dropped substantially in the ratings during their second outings. Even the most popular series in this format (with the two notable exceptions of American Idol and Survivor: Vanuatu) don't match on a regular basis the ratings of a Friends, CSI, ER, Law & Order, Will & Grace, or other top scripted series.

The power of reality is that it is incredibly cheap to produce: less than one-tenth the cost of

scripted programs. The networks have also been able to standardize reality shows by fitting them into a rigid formula: A group of people you hope you never meet in real life backstab and cut each other's throats on the way to a big prize; during each show, one participant is thrown off after the group performs some outlandish stunt; the outcast then hits the morning talk shows and news circuit to hype the ongoing program. The only thing that changes is the situation. One variation that makes critics groan is the dumbed-down quiz show, epitomized by Are you Smarter Than a Fifth-Grader?. Because reality shows are so cheap to produce, they also provide a way to create original summer programming, thus helping the move toward a full 52-week schedule.

But the flurry of creativity that characterized some of the early entries has now settled into as formulaic a pattern as most sitcoms. One problem with reality series is that we borrowed the ideas from popular shows in Japan and Europe, and thus our versions are very hard to sell back. The other major problem is that each show needs a gimmick, and to maintain the shock value (and thus generate hype), the situations have been pushed closer and closer to outright pornography.

Magazine series like 60 Minutes, 20/20, Primetime, Dateline, and so on are almost as numerous as reality series in prime time. The shows are produced directly by a network's news division and have earned consistent though middle-of-the-pack ratings for years. Like the other unscripted formats, magazine series are, comparatively, very cheap to produce, and unlike reality series, several have been able to run forever with little decline from their initial ratings. They also serve as prestige programs for the networks. But like reality series, magazine shows have no afterlife. Neither type works well in rerun, and they have no life as a DVD set and no syndication potential, although in some cases their ideas may be franchised to other countries.

Game shows enjoyed a brief resurgence in the late 1990s, were badly overused, and then appeared to vanish. Actually, they merged with reality series, most of which are now games, but in its purer form, the game show has been relegated to access time.

Although increased costs have led to fewer movie nights over the last few years, three types of productions regarded as movies still fill large amounts of prime time on the broadcast television networks: (1) theatrical feature films, those made originally for release in theaters; (2) madefor-TV movies, similar to feature films but made specifically for network television airing in a two-hour format containing commercial breaks; and (3) miniseries, multipart films made especially for broadcast airing in installments. All three types share these major advantages for the networks:

- They fill large amounts of time with material that usually generates respectable ratings.
- They make it possible to air topical or controversial material that may be deemed inappropriate for regularly scheduled network series or can be taken directly from the headlines.
- They permit showcasing actors and actresses who would otherwise never be seen on television.
- They allow the network to reward stars from their popular series by giving them a movie.

The three kinds of movies also share one major disadvantage—extraordinary high cost for the networks. Miniseries are typically the most expensive, and theatrical movies the second-most costly. Both are more risky in ratings than madefor-TV movies, but all three remain widely popular because they fill big chunks of time and can be used to temporarily plug holes in the schedule until programmers can figure out something to schedule.

Theatrical movies have declined in popularity because of exceptionally high costs and generally low ratings when run on the Big Three networks. The truth is that by the time a theatrical movie makes it to broadcast TV, it is already very late in its life cycle. It has played the theaters, run on pay-per-view, and may have been released for rental, run on cable movie channels, and sold as a DVD. Consequently, ratings on the networks are almost always disappointing, even for the biggest blockbusters. Made-for-TV movies just perform better. Miniseries not only perform better but also

have a strong afterlife in foreign syndication and as DVDs.

Many viewers and critics bewail the disappearance of the dramatic anthology format: a set of single-episode television plays presented in an unconnected series. What actually happened was that the anthology format went through a style change and returned as the made-for-TV movie. During the 1955–56 season, the very peak of the anthology era, dramatic anthologies made up about 526 hours of prime time. In the 1989–90 season, a peak year, 624 made-for-TV movies aired in prime time (not including those made for cable).

The best of these movies compare favorably with the best of the dramatic anthologies of the earlier era. Such movies also allow the networks to respond quickly to major news events. The Scott Peterson case was a movie even before it went to trial. The Elizabeth Smart and Jessica Lynch stories became competing films on more than one network, and the big guys fought about who was going to be first to do the Anna Nicole Smith story almost as much as the lawyers fought about who was going to get to bury her. Hot topics like drugs, sex, and teenage problems can be dealt with in movies in ways a prime-time series just doesn't allow (see 4.13).

The made-for-TV movie has replaced the pilot as the major method for testing new series ideas. Programs such as Walker, Texas Ranger and Providence succeeded as television movies before becoming series. Made-for-TV movies as pilots have four distinct advantages:

- They can be profitable.
- They can target a desired demographic group.
- Audiences and affiliates like them.
- They have international syndication potential as theatrical movies.

TV movie pilots now average \$5 million to make (some as high as \$10 million), but they pay their way whether or not the concept ever becomes a series. Even when they fail, the networks usually have made a healthy profit on the TV movie's initial run, its foreign syndication, and the DVD sale. Moreover, the made-for-TV movie has the

4.13 The Movie Mistakes

ccasionally, made-for-TV movies can show how badly out of touch with their audiences the networks can be. CBS was truly shocked by public reaction to its docudrama on President Reagan. It seems to have never occurred to CBS's higher-ups that much of the public would take offense at its portraval of Mrs. Reagan as a shrew and the former President as a bumbling but affable storyteller. The public's reaction to the tendency to make things up for dramatic effect seems also to have stunned the Hollywood community. When the press picked up on the public outcry, Viacom quickly pulled the show from CBS and moved it to Showtime, which immediately declared it a hit and never showed it again. ABC reacted to the success of Mel Gibson's The Passion of the Christ (in spite of negative Hollywood and mainstream press) by rushing its alternative version of the Passion out for the 2004 Easter season, but the network seems genuinely surprised that Judas bombed. After all, the made-for-TV movie had a religious theme; why didn't it work?

advantage of being made-to-order to fit within a network's existing schedule. It can target a specific audience to maintain a night's flow and avoid the disruptions that specials often cause.

Because their ratings equal and sometimes surpass those for feature films shown on television, the made-for-TV movie pilot has become very popular with networks, affiliates, and, fortuitously, with audiences. However, as of 2007, these movies had become so expensive to make that they were used mainly as specials for sweeps weeks or holidays (or made-for-cable where union rules don't apply). Regular movie nights on the Big Four networks have disappeared, and only a couple are left on Spanishlanguage networks. The more popular method for trying out characters, story lines, or plot ideas now is to fit them into cable movies, such as The Librarian, or bring the character into an existing show, such as the Green Arrow into Smallville.

The success of limited series on PBS's Masterpiece Theatre led the commercial networks into the production of multipart series presented in two to six episodes on successive nights or in successive weeks. Called miniseries, they could run for as long as 10 or more hours, typically beginning and ending on Sunday nights—the night of maximum viewing. Shorter miniseries tend to be scheduled on sequential nights, while longer series stretch over two weeks, skipping the evenings on which the network has its most popular programs. These extreme long forms, however, have become very rare because of their exceedingly high cost (although the Sci Fi Channel did have great success with Steven Spielberg's Taken and the combined Dune and Children of Dune saga as long-form miniseries). Despite the advantages of blockbuster ratings, prestige, critical acclaim, and series potential, the broadcast networks have switched from long-form to short-form miniseries (four to six hours) and from broadcasting to cable where production costs are less.

Such high-level fantasy concepts as Merlin, Alice in Wonderland, and Leprechauns, the Romeo-and-Juliet takeoff, earned high ratings on the networks but also sold well internationally and as DVD sets marketed on the air during the original network showing. NBC also began the practice of putting delayed repeats on its cable networks about one week after initial broadcast airings, thus producing another round of advertising revenues. Widespread adoption of this multistep profit system, similar to the one used for Hollywood motion pictures, made the miniseries more popular than ever by the turn of the century. But a decade later, such event programming has become rare for broadcasting, shifting instead to limited original production for cable.

Network Decision Making

Few program decisions precipitate as much controversy as the cancellation of programs. Because commercial television is first of all a business with tens of thousands of stockholders and billions of dollars committed for advertising—the networks' overriding aim is to attract the largest possible audience in the ideal demographic range at all times, or at least to appear to be trying to do that. Networks always aim at the number-one position. Traditionally, ratings have been considered the most influential prime-time programming variable, and the networks make many controversial decisions each year based on these numbers. This often results in (1) canceling programs favored by millions of viewers, (2) countering strong shows by scheduling competing strong shows, (3) preempting popular series to insert special programs, and (4) falling back on reruns late in the season when audience levels begin to drop off.

However, the type of program, the ranking as compared with the competition, the size of production fees, and the target demographic group may be as important as the ratings in cancellation decisions. New situation comedies and realitybased series are much more likely to be held than other kinds of series producing equivalent ratings. Also, series with low production fees are more likely to be held than more expensive programs, and finally, series that appeal to the network's concept of "proper demographics"—and some would now argue "political correctness"—may be held even when ratings are low. And occasionally, like once in a decade or so, audience outcry restores a favorite for a while, as in the case of cancelled and then revived jericho on CBS.

The Critics

Critical approval and the extraordinary promotional opportunity that public acclaim provides also figure in decisions to cancel or hold low-rated new programs. Acclaim usually has some effect only in the absence of other rating successes. The kudos for *Hill Street Blues*, for example, bolstered NBC's image at a time when it was sorely in need of prestige, persuading programmers to stick with the show even in the face of low ratings. The same connection between critical acclaim and patience even in the face of low ratings can be seen for the moderately rated *The West Wing* on NBC. Sometimes the networks decide to go along with the critics, at least until something with better numbers comes along.

On the other hand, critical shock also seems to be desirable as far as the networks are concerned. The WB openly admitted that it added a love affair between a high school student and a teacher to *Dawson's Creek* to generate negative press. ABC did the same thing with *NYPD Blue*. The nude scenes were there to stir up controversy. After the press furor generated by the Madonna/Britney Spears kiss, CBS was probably trying to trigger similar press attention with its 2004 half-time show at the Super Bowl. It just didn't count on how negative the public reaction would be. Many argue that the atomic bomb detonations on 24 and *Jericho*, the grittier aspects of *Prison Break*, and the graphic details in *CSI* have also been designed to generate such shock. Instead of being bowled over, however, the critics have raved about the new realism.

The Censors

The broadcast Standards and Practices Department, a behind-the-scenes group, theoretically exercises total authority over all network programming. Cynically and often angrily called "censors," the department once acted as policeman and judge for all questions concerning acceptability of material for broadcast. It often found itself walking a thin line between offending viewers or advertisers and offending the creative community. It had to decide between the imaginative and the objectionable. Members of the department typically read submitted scripts; attended rehearsals, filmings, or tapings; and often previewed the final products before they aired. If, in the department's judgment, a program failed to conform to network standards in matters of language or taste, it could insist on changes. Only an appeal by the chairman or president of the company could overturn its decisions. However, in practice, Standards and Practices was one of the first areas cut back when budgets grew tight in the 1990s, and as a result, this department has little day-to-day impact today (although its existence is loudly touted during election years when an increase in media criticism usually occurs).

Moreover, even when it had considerable power, over the years the department's criteria for acceptability were forced to change. In the early 1920s, one of the hottest issues was whether such a personal and perhaps obscene product as toothpaste should be allowed to advertise over the radio airwaves. By 1983 the hottest question was whether NBC's censors would permit a new series, *Bay City Blues*, to air a locker-room scene

series, *Bay City Blues*, to air a locker-room scene that included nude men photographed, as the producer put it, "tastefully from the back." By the mid-1980s, child abuse, abortion, and homosexuality were the problematic topics, while the 1990s brought the thorny questions of AIDS, condoms, obscene language, and, as always, how explicitly sex could be shown.

By the mid-2000s, concern focused on violence, nudity, drinking, and smoking, and one of the hottest issues was whether some reality shows were rigged. This question surfaced with the discovery that certain exciting scenes in *Survivor* were staged and that ABC network executives had overruled the judges in their *American Idol* clone, *Last Comic Standing*—a show in which the audience supposedly selected the next top comedian—to produce a more demographically friendly result. At the same time, gay groups and other liberal organizations were demanding more positive portrayals of gays in programming, and some producers wanted even more graphic and controversial depictions of sex in prime time.

The present situation has led to some very strange reactions, especially noticeable on cable. The Sci Fi Channel, for example, owned by NBC Universal, bleeps out bad words on some shows but runs *Tripping the Rift*, which is little more than animated porn. Now the network censors seem focused on political correctness and on gaining points with minorities, not on offending special interest groups like gays. As long as programs don't cross the lines set by the FCC, pretty much anything goes.

The Risks and Rewards Ahead

Supposedly, the major networks prowl for the breakthrough idea—the program that will be different but not so different as to turn away audiences.

The Cosby Show was one such show in 1984–85, as was ALF in 1986. Married...with Children astonished viewers in 1987, Roseanne made a splash in 1988, Friends reintroduced the buddy sitcom in 1995, and Malcolm in the Middle suggested an entirely new idea for the family sitcom in 1999. The biggest change was the rebirth of the prime-time game show with Who Wants to Be a Millionaire? in 2000—after an absence of nearly 40 years—and its combination with reality in the form of Survivor. Next came graphic special effects and mystery that produced the huge success of CSI beginning in 2002, and then the blatant sex in Desperate Housewives. Its success relaxed standards all through the broadcast networks.

In recent years, all four major networks have had entire seasons without a single new hit. In truth, network programmers can only guess what the next hit will be and why it succeeds. A program failure is easier to analyze. It can result from the wrong time period, the wrong concept, the wrong writing, the wrong casting, poor execution of a good idea, poor execution of a bad idea, overwhelming competition, the wrong night of the week, and a dozen other factors. Conversely, success is very hard to analyze or copy, even though that has become the driving goal of the broadcast networks.

Although the actual cost of production has gone down dramatically through the use of digital technology and computer-produced effects, other factors have canceled out the savings and caused the full cost of production to continue to skyrocket. Some of those factors are directly related to programming decisions and seem to be the opposite of what many would naturally assume would happen. For example, the inability of programmers to produce successful shows has actually caused the price of production to go up. With so few true hits, programmers seem willing to pay almost anything to keep a successful program, as demonstrated by the incredible amounts paid to renew such series as ER and Friends. The networks are also locked in bidding wars for top specials and sporting events, again causing the prices to go through the ceiling. In a strange type of domino effect, however, as the top price

levels have gone up, directors, writers, actors, and people in all other branches of production have also demanded more. As a result, costs at all levels have gone up even as ratings have gone down. The network takeover of production not only didn't slow this process, it actually increased the rate of its rise. Because of the variety of pressures on them, the networks' executives seem much less able than the old-line executive producers when it comes to controlling costs.

At the same time, the incredible failure rates have resulted in an insatiable demand for replacement series. It is not at all uncommon for half of new prime-time series to fail within their first six weeks. These shows have to be replaced, and because development is the most expensive phase of production, the constant demand for new series has sent development costs out of sight. As these new programs rarely do better than the preceding series in those time slots on the same channels, one would presume, just considering the economics, that programmers would leave most new series alone for at least a year to see if they could build audiences. The continual hope for that one elusive program that will break the trend, however, produces a type of feeding frenzy in which no programmers are willing to deviate from the present destructive cycle.

Predicting the future of any medium is a risky undertaking at best. As ratings and compensation continue to fall, eventually the largest nonnetwork group owners may decide they can do better on their own. It would be natural for such group owners to either increase their participation in original syndication production for their own systems or join with disgruntled old executive producers like Stephen I. Cannell to form new production houses, thus in essence becoming networks themselves. For 10 of its owned stations, FOX created MyNetworkTV (MNTV) to replace the prime-time shows that UPN formerly supplied. Such scenarios suggest that the future American broadcasting system could more closely resemble the system that presently exists in such countries as Japan, rather than what is now familiar. In short, there would be more networks but fewer affiliates. That is to say, the networks would be doing their own productions, which would then be distributed through stations that they also own as part of a much larger entertainment wing of a corporation.

Companies like Hallmark have been doing production for years (nowadays Hallmark has its own cable network). Is it possible that they could join with other large companies to make their own shows? Many, like Sears and Procter and Gamble, seem to be threatening that now, arguing that they couldn't possibly do worse than the present broadcast system. Only time will tell how the present situation will work itself out. Only three things seem to be sure bets right now:

- 1. Television is not going to go away.
- 2. The power of the big broadcast networks to control information and entertainment will continue to decline.
- **3.** The division between broadcasting and cable will continue to blur as the companies buy into one another and begin to mirror each other and make greater use of the internet.

Indeed, the mixed broadcast/cable/online model now used by ION and Univision may be the future of the business. In any case, one thing is clear: The next 50 years will bear little resemblance to the last 50 years.

Sources

Bielby, William T., and Bielby, Denise D. "Controlling Prime-Time: Organizational Concentration and Network Television Programming Strategies." Journal of Broadcasting & Electronic Media 47 (4), 2003, pp. 573–596.

natpe@dailylead.com (send e-mail to the site to receive daily summaries of and links to newspaper and magazine articles dealing with all aspects of broadcasting and cable)

Variety. Weekly trade newspaper of the television and film industry.

Wasser, F. Veni, Vidi, Video. Austin, TX: University of Texas Press, 2001.

www.abc.com
www.allmytv.com
www.allyourtv.com
www.cbs.com
www.disney.com

www.fox.com

www.ionline.com

www.MediaPost.com (daily media articles and summaries)

www.mntv.com

www.nbc.com

www NewsCorp.com (FOX)

www.thecw.com

www.telefutura.com

www.telemundo.com

www.TimeWarner.com

www.univision.com

www.viacom.com

Notes

1. Eggerton, J., "Sexy Halftime Stunt Has Affiliates Fuming," Broadcasting & Cable, 9 February 2004, pp. 6, 37.

- 2. Roston, T., "For Pete's Sake," Premier, March 2007, pp. 56-59.
- 3. Poniewozik, J., "Has the Mainstream Run Dry?," Time, 29 December 2003.
- 4. Klein, P. "Programming." In S. Morgenstern (ed.), Inside the TV Business. New York: Sterling, 1979.
- 5. Schwartz, J., "Leisure Pursuits of Today's Young Man," New York Times, 29 March 2004.
- 6. Romano, A., "At E!, Youth Will Be Served," Broadcasting & Cable, 22 July 2002, p. 22.
- 7. Frank, B., "Check Out Why Young Viewers Like Reality Programming," Broadcasting & Cable, 7 July 2003.
- 8. Werts, D., "TV Shows on DVD Creating Their Own Form," Newsday, 13 January 2004.

5

Non-Prime-Time Network Television Programming

Robert V. Bellamy, Jr., and James R. Walker

Chapter Outline

Non-Prime-Time Dayparts

Scheduling Strategies

HUT Levels
The Struggle for Clearances
Advertisers and Demographics
Genres of Non-Prime-Time
Programming

Sports

Sports Programming in a Multichannel Environment Non-Live-Event Sports Programming Rights Fees and Ratings

Daytime Soap Operas and Game Shows

Time Zone Complexities Soap Operas Game Shows

Weekday News and Information

Early-Morning Newscasts Morning Magazines Evening News Late-Night News Overnight News

Weekend News and Information

Weekend Magazines Sunday News Interviews

Children's Programming

Production and Development Processes Weekdays and Weekend Mornings

Talk Shows

Daytime Talk Late-Night Talk/Variety

Late-Night Weekend Entertainment

The Effects of Consolidation

Sources

Notes

or the popular press, prime-time television is television. Much of national and local coverage of television focuses on evening programs. Critical reviews, star interviews, and Nielsen ratings for the top prime-time programs are readily available. Because prime time is the subject of such intense reporting, one might think the rest of the day is insignificant. Not true. Early-morning talk, afternoon soap operas, and late-night comedy are frequently the most provocative and—significantly for the U.S. broadcast networks—most profitable shows on television. The difference between what a program costs to produce and the advertising revenue it generates is its profit. Because non-prime-time programs are generally inexpensive to produce and carry more ads than prime time, their ratings can be relatively modest and still supply huge profits for the networks. In addition, non-prime-time audiences are less demographically diverse, making it easier for advertisers to target their commercials to consumers most interested in their products. This means more compatibility between program and spots (less viewer annoyance) and less advertising waste (commercials directed to wrong viewers) than in prime time with its larger but more diverse audiences.

Non-prime-time viewers are often more loyal to their programs than prime-time viewers. Many football fans plan their whole week around Saturday college and Sunday professional games, and the network programmer who preempts a weekday soap opera for a special program will receive an avalanche of unpleasant e-mails and phone calls. For millions of Americans, the network evening news is a daily information ritual, and Letterman or Leno a daily bedtime ritual.

Networks generating the largest advertising revenues have the most non-prime-time programming. Programmers cannot ignore the non-evening programs because there are many more hours to program than in prime time. More than any other type of programming, the non-prime period distinguishes the oldest broadcast networks (ABC, CBS, NBC) from their more recent competitors. The longestablished presence of the Big Three in virtually all nonprime dayparts provides them with heaps of commercial availabilities to sell to advertisers. ABC, CBS, and NBC each sells more than three times as many commercial minutes as FOX, the most active of the other English-language networks.

The primary reason for this vast disparity in the networks' most basic product, advertising availabilities, is that the newer networks take a different approach to non-prime-time programming. With the important exceptions of sports on FOX, newer networks have not competed successfully in non-prime time. Instead of challenging longrunning programs in early morning, daytime, and late night, the CW tries to capture comedy fans in prime time, ION strips older family-oriented reality shows, and MNTV reruns FOX programs and syndicated fare for fans who will readily switch networks to watch favorite shows. Univision, by contrast, successfully fills many of its nonprime hours with talk shows and telenovelas (television novels similar to soap operas, but with a definite ending after some months or years) and carries major international sports on weekends.

Non-Prime-Time Dayparts

Non-prime time is a broad term encompassing all the programming dayparts other than prime time. The U.S. broadcast television networks program some or all of the following dayparts (reflected in eastern/Pacific times) with several types of programming.

Weekday Programming

Overnight

Early morning 6 A.M.-9 A.M. Magazine Daytime 10 A.M.-4 P.M. Soaps/game shows Early fringe 4 P.M.-6 P.M. Children's 6:30 p.m.-7 p.m. News Early evening Late night 11:35 P.M.-2:05 A.M. Talk/news

2:05 A.M.-6 A.M. News

Weekend Programming

8 A.M.-1 P.M. Children's/ Weekend mornings information Weekend afternoons 1 P.M.-7 P.M. Sports

Weekend late night 11 P.M.-1 A.M. Comedy/ music

5.1 Longest-Running Network Series

Top-10 Longest-Running Programs as of 2009*	Years on the Air				
1. Meet the Press, NBC (premiered 1947)	62				
2. CBS Evening News (premiered 1948)	61				
3. The Guiding Light, CBS (premiered 1952)	57				
4. The Today Show, NBC (premiered 1952)	57				
5. Face the Nation, CBS (premiered 1954)	55				
6. The Tonight Show, NBC (premiered 1954)	55				
7. As the World Turns, CBS (premiered 1956)	53				
8. General Hospital, ABC (premiered 1963)	46				
9. The Price Is Right, NBC, ABC, CBS (1956-65, returned 1972)**	46				
10. Days of Our Lives, NBC (premiered 1965)	44				

^{*}The evening newscasts for NBC and ABC are not included due to changes in titles, formats, and anchors over the years. However, NBC, starting with The Camel News Caravan (1948–56) and then The Huntley-Brinkley Report (1956–70) to the present NBC Nightly News (1970–1), has had an evening newscast on the air continuously for 56 years. Sabado Gigante has been on the air 47 years (since 1962), but the first 24 were on a local South American channel; it has been a network show on Univision for 24 years.

The size of the audiences in non-prime dayparts is considerably smaller than in prime time, but all non-prime-time dayparts contribute competitively and economically to a network's performance. There is big money in daytime programming especially. Programming executives responsible for nonprime dayparts are as dedicated to competing for available viewers as are their evening counterparts. In prime-time programming, the "war" fought night after night is measured in daily ratings gains or losses. Although daily ratings are important to shows in non-prime time, the key to the battle is to get viewers into the habit of watching weekday nonprime programs every day or from week to week. With the exception of Univision's Sabado Gigante, all 10 of the longestrunning programs on the networks are non-prime series (see 5.1).

In prime time, ratings for the Big Four broadcast networks average between 7.0 and 8.0 nowadays and range from 3.0 at the bottom end to about 18.0 or occasionally higher for top-rated shows. This huge variation means sharp differences in the advertising rates and profit ratios for the networks.

For daytime soap operas, the average is about 3.3 with a range from 2.2 to 5.0, a quite different ball game. Although the revenues generated are more modest, the risks are also more modest. Non-prime programmers use a low-risk approach when building their schedules.

Using a low-risk programming strategy, programmers concede that blockbuster ratings and their accompanying high advertising rates are virtually impossible to attain. They take a more conservative approach, which limits production costs and uses tried-and-true formats. In addition, developing a schedule using a different series each weekday would be far too expensive. Thus, weekday programming is stripped (the same programs are scheduled on Monday through Friday at the same time). Stripping allows viewers to build ongoing loyalty to a series while lowering the financial risks involved in program development. To program effectively in non-prime time, the networks must assess the available audience in a particular daypart. To do this, programmers examine HUT levels, clearances, potential advertisers, and likely demographics of audience members.

^{**}While in syndication, *The Price Is Right* had a concurrent prime-time run from 1956 to 1964 and two brief runs on prime time in 1986 and 1993.

Scheduling Strategies

Scheduling programming in non-prime time presents a unique set of challenges for programmers. The programmer wants to build two types of audience flow: flow-through from the first program to the second one in the daypart and flow across the weekdays from one day to the next. Flow-through is usually accomplished by using block programming; flow across the weekdays is promoted by stripping the program in the same time slot each weekday and by using such program genres as soap operas, where the program's narrative structure connects each episode with the next day's episode. For news, talk, and magazine programs, the program's anchor or host promotes continuity from one day to the next, and a latenight talk show is usually followed by another talk show.

Weekend programming is scheduled weekly—like prime time—with one episode per week at the same time from week to week. Viewers return each Saturday or Sunday to get programming that is less available on networks during the rest of the week, such as sports, cutting-edge comedy, music, or extended news interviews. Viewers of Sunday morning political talk, for example, typically return week after week to keep up, and fans of a particular NFL team will religiously tune in every Sunday afternoon to see their local favorite.

HUT Levels

HUT levels reach around 60 percent in prime time, while non-prime-time levels can be less than 10 percent. Because so few homes are using their television sets (or home computers), the potential ratings and advertising revenue are limited. But the opportunity to create a winning franchise for a time period does not suffer. Even small audiences have value to advertisers. In fact, many clients cannot afford to advertise in prime time, so creative programming targeted to the "right" small audience is often very attractive to these sponsors. Weekends are a good example. Viewers who tune in on the weekend have a different mindset than prime-time viewers do. They often want more

movies or sports than they have time to watch during prime time. Longer chunks of leisure time can offset smaller HUT levels: Weekend viewers wind up spending more time watching television, despite their smaller numbers.

The Struggle for Clearances

Non-prime time and prime time especially differ in the crucial matter of affiliate clearances. When a network schedules a program, an affiliated station has three options: It can clear the program (air it when scheduled by the network), it can decide not to clear it (preemption), or it can ask permission to air the program at a later time (delayed carriage). Both preemption and delayed carriage, especially by major-market stations, hurt a network's national ratings because they reduce the potential audience for the program. In order to increase clearances of network programming, especially in non-prime time, the networks succeeded in getting the FCC to raise the percentage of U.S. households they can reach with their owned-and-operated stations. Although most affiliates clear about 90 percent of their network's total schedule, the percentage in non-prime time, especially in the daytime, Sunday morning, overnight, and late-night dayparts, is substantially lower.

In a surprising move after nearly 50 years of daytime programming, around the turn of the century, NBC (which ranked third in daytime programming throughout the 1980s and early 1990s) decided to scale back its daytime schedule because of low clearances. When NBC first offered The Other Side, a daytime talk show, it received only a 61 percent clearance rate; in other words, almost 40 percent of NBC's affiliates decided to schedule some syndicated series instead. When CBS premiered the talk show The Late Late Show (featuring Tom Snyder) in midseason, the "live" clearance rate was a dismal 30 percent. In this case, the network's affiliates had decided either to preempt or, more commonly, delay the show. Low clearance rates were a major factor in the low ratings this show received in its premiere season.

Besides eroding its potential audience, preemption and delayed carriage disrupt the scheduling

strategies used to foster audience flow from one program to another. For example, an ABC affiliate that carries Nightline following the local newscast provides a stream of viewers who are looking for information. When Nightline is delayed to allow the affiliate to carry a sitcom, much of the potential audience goes to bed or switches to an all-news cable channel. The delayed Nightline is less likely to attract a large audience when it follows comedy rather than news.

The corporate owners of the broadcast networks are also hedging their non-prime-time bets by offering programming to their own and other network affiliates through their syndication arms. Viacom, owner of CBS, also owns King World, the syndicators of daytime powerhouse *Oprah* and its popular spinoff, *Dr. Phil.* When affiliates of ABC or NBC purchase these talk programs, the shows compete with whatever CBS affiliates offer, a situation that more than irks CBS affiliates.

Advertisers and Demographics

A network has to determine which segment of the available audience it will go after (target), mindful of its competitors' programming and influenced to some degree by advertiser support for its programming. Then the network programmer's task is to put together a schedule of programs that will, at the lowest possible cost, do four big things:

- Attract the most desirable demographic groups
- Maximize audience flow-through
- Build viewer loyalty
- Capture the largest possible audience

One big difference between the major dayparts is that audiences during non-prime-time dayparts are more homogenous (similar in demographic composition) than prime-time audiences. Typically in non-prime time, the three networks schedule the same program type head-to-head (all soaps, all talk, all games, all soft news, and so on), which creates fierce competition for single audience group. When selecting the shows for a particular daypart, the networks necessarily give primary consideration to

these elements:

- Demographics of available audiences
- Competitive counterprogramming opportunities
- Economic viability

The questions are whether an audience group is large enough to split profitably, whether there is a chance to capture another big group, and what the cheapest option is that will still please enough advertisers.

Indirect influences on programming practices also come into play. Daytime programs rely on drug and food companies for advertising revenue. Hence, programmers are wary of scripts or interview programs that tackle subjects such as tampering with painkillers, or rat hairs in cereal. For three reasons, daytime programming is in much closer touch with its advertising messages than prime time. First, daytime programs contain more commercial minutes per hour. Second, because many programs were once both sponsored and produced by advertisers, there is a tradition of sensitivity to advertiser needs. Finally, two major companies, General Foods and Procter & Gamble, dominate the advertising time in daytime, and the networks cannot afford to offend them.

Genres of Non-Prime-Time Programming

There are seven key genres of non-prime programming: (1) sports, (2) daytime soap operas (including telenovelas that also air in prime time), (3) game shows, (4) news, (5) children's programming, (6) talk shows, and (7) comedy/music programming. Most of these program types are identified with particular dayparts: sports with weekend afternoons; soaps and game shows with daytime; children's programming with early fringe and Saturday mornings; talk/comedy shows with weekday late night; and comedy/music with late nights on Fridays and Saturdays. Different strategies and practices necessarily associate with each genre of programming, as well as different levels of cost, and the development processes for new shows vary considerably.

Sports

On the broadcast networks, weekend afternoons (1 to 7 P.M.), running on into prime time if the event is popular, are dominated by live sports coverage. Sports are one of the most important forms of programming in television. One of the chief reasons for sports' popularity is their consistent ability to attract an audience of young men who are extremely difficult to attract with other types of regularly scheduled programming. In addition, sports provide a much-valued location for zapproof advertising and promotion. Sports telecasts are brimming with opportunities for the insertion of ads, promotional spots, and announcements that cannot be avoided by the viewer unless she or he also risks missing part of the action. Sports also are one of the programming forms that provide excellent branding opportunities for networks, such as "NBC—The Home of the Olympics," FOX NFL Sunday, and so forth.

A network's sports division is responsible for acquiring the rights to games and events and for producing the telecasts. It must work closely with the programming division because of the complexities associated with live sporting events, including overtime pay and weather-related cancellations. The networks' sports divisions negotiate with the sports leagues to guarantee that start times occur when the majority of viewers can watch. The sporting events that do not attract a prime-time-sized audience are scheduled so as not to interfere with prime-time entertainment programs.

Noninterference with prime time diminished as a concern in recent years because of the rising popularity and cost of major team sports, particularly football. The late afternoon NFL games and even post-game programs regularly run into Sunday prime time and often contribute to high prime-time ratings, bumping 60 Minutes and other Sunday shows. NBA (National Basketball Association), MLB (Major League Baseball), and NCAA (National Collegiate Athletic Association) playoff games now regularly appear in prime hours. When Disney shifted ABC's Monday Night Football to its ESPN cable network because of declining rat-

ings, NBC promptly filled the prime-time broadcast NFL void with Football Night in America (on Sundays). For the moment, most regular season team sports coverage will remain in weekend afternoons and early evenings (and on cable), while most major postseason contests will be featured in prime time.

Sports Programming in a Multichannel Environment

Although major sports are not the low-cost programming option they were in the early days of television, programming costs are always relative in television. Although CBS claimed to have lost millions of dollars on sports rights in the early and mid-1990s, within a few years the network once again spent enormous sums to regain a piece of the NFL Sunday afternoon package and to renew its NCAA Men's Basketball Tournament coverage. This occurred after the network's prestige was seriously damaged by its loss of the NFL to the lessestablished FOX network in 1994. FOX used the NFL and later MLB, NASCAR (National Association for Stock Car Auto Racing), and, to a limited degree, the NHL (National Hockey League) to establish itself as a legitimate member of the Big Four to both viewers and the financial community. One result of FOX's new leverage was its ability to upgrade its affiliates in several markets, mainly at the expense of CBS. The question of cost, then, involves more than simply the profit or loss made from the ratio of program costs to advertising revenues: Losing major sports can undermine the legitimacy and degrade the financial value of a broadcast network.

Cable has also had a large effect on sports programming. Networks such as ESPN, ESPN2, ESPNU, Versus (VS), and the regional Comcast Sports and Fox Sports Nets exist only because of their sports coverage. Cable's saturation coverage has raised the profile and value of sports on television, even as it drains ratings from broadcast networks for all sports but the NFL, which continues to see regular-season ratings increases at a time when most all other broadcast network ratings have declined. ESPN, for example, now pays

5.2 Major League Sports Broadcast Network Daytime Ratings

	2001	2006
NFL	10.1	10.4
MLB	2.6	2.4
NASCAR		4.7
<u> </u>	2000-01	2005-06
NBA	3.0	2.2
NHL	1.1	1.1

"By the Numbers," Street & Smiths SportsBusiness Journal (special issue), Regular season, 29 December, 2003. "NFL Scoring Big in the Ratings," www.dailycamera.com/news/2006/dec/17/nfl-scoring-big-in-the-ratings/. "NHL's Strong Comeback Marred by Poor TV Ratings," www.washingtonpost.com/wp-dyn/content/article/2006/06/04/AR2006060400897.html. "Is NASCAR Momentum Stalling?," www.jacksonville.com/tu-online/stories! /021307/spr_7960051.shtml.

the NFL more per year (\$1.1 billion) than any of the Big Four broadcast networks. The lessening of sports ratings overall (see 5.2) has been offset somewhat by their increased value as one of the few programming types that can attract the male audience so valued by advertisers, in spite of everproliferating entertainment options. In addition, such high-profile events as the Super Bowl and the World Series continue to draw enormous audiences and provide substantial promotional opportunities for the host networks at critical times of the year (the February sweeps and early in the new broadcast season).

The solution to the tug-of-war over sports has been for broadcast networks to partner with cable networks to share rights to sports programming. The most prominent examples are Disney's ownership of both ABC and the ESPN networks, which have shared NFL, NBA, and NHL packages, and the FOX/Fox Sports Net combination, which shares MLB. Cable networks are able to offer most of the near-daily regular season games, leaving broadcast networks to focus on the postseason and key regular season contests. There are also shared rights arrangements among separate companies where early rounds of team playoffs and golf and tennis matches appear on cable networks,

with later rounds shifting to networks. The split of NBA and NASCAR rights between ESPN and ABC is another example of leveraging the value of sports television. In fact, the sports divisions of ABC and ESPN have been merged and now operate in tandem more often than they operate as competitors.

The sports anthology program, exemplified by ABC's long-running Wide World of Sports, was a casualty of the changes in sports television.1 The minor sports that were typically covered by anthologies have, for the most part, benefited from the explosion in televised sports by gaining individual contracts on broadcast or cable (NASCAR, WNBA, Major League Soccer). This exposure, combined with a redefinition of what constitutes a successful program (that is, more emphasis on the "quality" than the quantity of ratings), has enabled NASCAR to become one of the most widely broadcast and lucrative network television sports (see 5.3). The "a little something for everybody" approach of sports anthologies is less viable as a means of keeping program audiences in the multichannel environment because it virtually encourages channel changing.

The idea of multiple sports in one program lives on in the biannual Olympic Games and the various X Games (the "extreme" sports that have a particular appeal to young audiences). Although the Olympics cannot be regularly scheduled in a conventional sense, the 1992 decision of the International Olympic Committee (IOC) to have the Summer and Winter Games alternate every two years substantially increased the value of the games to television. NBC, in fact, gave up competing for rights to the NFL, MLB, and NBA in the mid-1990s in favor of NASCAR and, even more important, in favor of branding itself as the "Network of the Olympics." ABC Sports had used this same branding strategy with great success to build its ratings and credibility in the 1960s and 1970s.

With the Winter Games scheduled in the February sweeps and the Summer Games coming right before the fall season rollout, the various Olympic events provide many hours of prime-time and nonprime programming and also supply a key promotional platform for touting NBC's other

5.3 NASCAR on Television

Imost \$4.5 billion. That's the price FOX, ABC/ESPN, and TNT paid to carry NASCAR races for the eight years that started in 2007. The deal's hefty tag recognized NASCAR's high television ratings as the second most-watched sports programming after the National Football League. Among its most valuable assets are the Nextel Cup races.

Starting in the 1960s, ABC aired NASCAR races as part of its Wide World of Sports program, and after two decades, shifted NASCAR off broadcasting and onto cable (ESPN), a relationship that lasted another 20 years. ESPN is widely credited for popularizing NASCAR—so much so, indeed, that at the turn of the century, NBC and FOX snapped it up-but unexpectedly, the ratings slid in mid-decade. The slide led to the creation of the "Chase for the Nextel Cup," an end-of-season playoff series in which only the top 10 drivers were eligible for the final ten races. These races energized the entire season and attracted much larger audiences, taking NASCAR to the No. 2 spot. When NBC decided not to renew NASCAR's contract in 2005, ABC/ESPN jumped at the opportunity to air the races again, agreeing to pay an estimated \$270 million to air 17 Nextel Cup races (the remaining races were split among broadcasting and cable outlets). NASCAR is widely popular, but whether ABC/ESPN's investment will pay off over that long a haul remains to be seen.

> Debbie Goh Indiana University

programming. The Olympics were also the first major experiment with multiplatform programming, a practice that has now become standard for the Olympics and other long-season sports.

Non-Live-Event Sports Programming

Non-live-event sports programming on the networks today generally consists of (1) pregame and postgame programs and (2) sports-league-produced programming for children and young adults. Since the success of CBS's *The NFL Today* in the 1970s,

broadcast and cable networks have developed similar shows for other sports. These wraparound shows help networks to more fully brand programming blocks and expand the programming hours devoted to sports without paying additional rights fees. In addition, powerful sports entities can demand airing of league-produced shows. This began when the NBA forced former broadcast partner NBC to schedule NBA Inside Stuff, a youth-oriented feature magazine about the league, as a condition of its contract with the league. Similar programming and a variety of promotional spots are now standard in major sports television rights deals.

Rights Fees and Ratings

The table illustrated in 5.4 shows the present broadcast network rights fees for major sports. These fees include some, but not all, of the rights to playoffs, all-star games, and championship series that are often scheduled in prime time as well as in weekend daytime. Comparing 5.2 and 5.4 provides the best evidence that increased rights fees do not reflect increased household ratings. Despite the consistent decline in average network ratings in virtually every time slot, most sports rights fees continue to increase. The four biggest sports leagues have had, at best, stagnant ratings and, in the case of MLB and the NHL, significant declines. However, sports has the nearly unique ability to break through a cluttered television landscape, attract desired male viewers, and generally increase network prestige.

Moreover, networks with strong cable siblings (ABC, FOX) can amortize their sports investment over multiple channels/platforms, something that NBC and CBS cannot do at present. This makes ABC and FOX more likely to continue spending huge amounts of money for sports rights. Nonetheless, both NBC and CBS continue to be major sports players. In the past, CBS has lost millions by overpaying for the rights to MLB and the NBA, but it has also remembered the lesson of the dangers of losing the NFL. This lesson was also learned by NBC, which, after an eight-year hiatus, picked up the network prime-time NFL telecasts previously held by ABC.

5.4 Major Sports Broadcast Television Rights

League	Networks	Contract Term	Contract Amount
NFL	FOX	6 years (2006–11)	\$4.275 billion
	CBS	6 years (2006–11)	\$3.735 billion
	NBC	6 years (2006–11)	\$3.6 billion
NBA	ABC/ESPN	6 years (2002–08)+	\$2.4 billion
MLB	FOX	7 years (2007–13)	\$1.8 billion
NASCAR	FOX	8 years (2007–14)	\$1.62 billion
	ABC/ESPN	8 years (2007–14)	*
NHL	NBC	2 years (2005-07)+	* *
NCAA Men's Basketball Tournament	CBS	11 years (2002–12)	\$6.0 billion
Olympics	NBC (2004-12)	5 Games	\$4.3 billion

^{*}Value of the contract has not been disclosed although the total value of NASCAR's 2007–14 television contracts with FOX, ABC, ESPN, TNT, and the Speed Channel have been estimated at \$4.8 billion.

Daytime Soap Operas and Game Shows

Daytime programming (9 A.M. to 4 P.M.) is one of the most lucrative dayparts for television networks. Its profit margin often challenges that of prime time because the cost per program in daytime is substantially less. The money needed to pay for one hour of prime-time drama will cover the costs of a week's worth of daytime soap operas. Because viewer loyalties are strong and developing new programs is difficult, however, the newer networks have been reluctant to develop daytime programming.

Currently, of the major English-language networks, only ABC and CBS have a substantial stake

in daytime programs Monday through Friday (see 5.5). NBC has cut back in favor of expanding the *Today* show. However, the Spanish-language networks Telemundo and Univision have a major presence in daytime with telenovelas that air during several hours of their Monday through Friday schedules.

In addition to having lower programming costs in the daytime, the networks schedule about 21 minutes of non-program material (commercials, promos, public service announcements, and so on) per hour compared with about 17 minutes in prime time. Although daytime audiences are much smaller than prime time, daytime programming fills more hours per day, and each hour provides more commercial slots. *Daytime profits belo*

Network*	Hours	Programs
ABC	4	The View, All My Children, One Life to Live, General Hospital
CBS	5	The Price Is Right, The Young and the Restless, The Bold and the Beautiful, As The World Turns, The Guiding Light
NBC**	1	Days of Our Lives

^{*}FOX and ION do not program this daypart.

^{**}The NHL and NBC contract is a revenue-sharing agreement with no upfront rights fees paid by the network. Source: Street & Smiths SportsBusiness Journal (various issues).

⁺ In some sports, seasons extend across two calendar years, so 2007-08 refers to a single season.

^{**}NBC's Tocay has expanded into this daypart in recent years, first from 9–10 A.M. ET in 2000 and from 9–11 A.M. ET in 2007.

networks offset extraordinary program investments in other dayparts. In prime time, top dramas, situation comedies, and ambitious miniseries have enormous talent costs, sports programming has huge rights fees, and breaking news coverage is expensive. Such programming becomes a loss leader, often costing far more than the advertising revenue it generates.

Although the primary genre on network daytime schedules is the soap opera, the networks offer occasional talk or game shows. But daytime programmers face enormous competition from cable television and syndicated programming. The collective number of viewers for syndicated programming, for example, now regularly surpasses that for daytime television on the major networks.

Time Zone Complexities

Time zone complexities particularly disrupt daytime schedules. Consider the scheduling of a 1 P.M. eastern-time-zone soap opera. Its noon start time in the central time zone would interfere with the schedules of those affiliates who program a noon newscast. Networks have to schedule costly multiple feeds of some soap operas to make it easier for their affiliates to schedule them and, thereby, maximize clearances. This explains why The Young and the Restless is an afternoon show in the eastern time zone but a morning show in the central and Pacific time zones.

Daytime television seems to have the most potential for audience erosion. Compared with the 1950s and 1960s, the number of viewers who are at home in the daytime has decreased. Because many more women work, children stay at childcare centers rather than at home. The networks have additional worries as the numbers of younger viewers (aged 18 to 34 and 18 to 49) continue to decline for each of the networks. Cable/satellite networks, the internet, video games, and home video (tapes and DVDs) also contribute to this decline.

Soap Operas

Developing popular soap operas has been the key to success in daytime network television. Soap operas build loyal constituencies that last for decades, because viewers follow a set of compelling characters nearly every weekday. Networks develop this habitual viewing by stripping daytime soaps in the same time slot five days a week. The soap opera viewer is an active viewer, seeking information from the internet (for example, Soap Opera Central and network websites), newspaper columns, and publications such as Soap Opera Digest. Networks reinforce this information-seeking behavior by offering show-specific chat rooms, actor photos, and plot summaries on their websites. Viewers are so determined to see their favorite soaps that daily activities are planned around making time to watch, and episodes are regularly time-shifted (recorded on a VCR or DVR) when necessary. Soap operas continue to be one of the most time-shifted programming genres.

A hit soap opera is a cash cow for its network. Production and talent costs are considerably less than for prime-time programming. Soaps are shot primarily in digital studios with multiple cameras and receive far less costly postproduction editing and sound "sweetening." Typically, the producers, directors, writers, and actors hired for soaps produce five hours of programming a week, compared with the 30 minutes of a prime-time sitcom produced. Despite the seemingly lower quality, CBS's highly rated The Young and the Restless does better at making a profit and delivering its target audience-women 18 to 49-than many of the network's prime-time offerings.

Both ABC and CBS have strong daytime lineups featuring many long-running soap operas (see 5.6), whereas NBC has curtailed its lineup to one daytime drama. Soap viewing is highly predictable; viewers watch their favorite programs nearly every day. This habituated viewing means that established soaps are rarely canceled and rarely created. Instead of a new season appearing each year as it does in prime time, a few new soaps may appear each decade and sometimes not even then. In the last decade, the broadcast networks developed only three new daytime soaps: NBC's Passions and Sunset Beach, and ABC's Port Charles, a spinoff of General Hospital. Of

5.6	Network Soap Opera Ratings		
		Rating/ Share	
CBS	The Young and the Restless	4.3/14	
CBS	The Bold and the Beautiful	3.1/10	
ABC	General Hospital	2.7/8	
CBS	As the World Turns	2.5/8	
ABC	One Life to Live	2.5/8	
NBC	All My Children	2.4/8	
NBC	Days of Our Lives	2.3/8	
CBS	The Guiding Light	2.3/7	
NBC	Passions	1.5/5*	

*Cancelled in 2007.

Soap Opera Central, week of 19 February 2007. www.soapcentral.com/soapcentral/ratings.php.

these, only *Passions* lasted as much as eight years on the air, but it was cancelled despite being toprated in key women demos (especially 18- to 34-year-olds).

Although rarely entirely new, soap operas do change. As characters and viewers age, producers and writers must introduce new characters to entice a new generation of viewers. Established leads yield to younger actors, and they in turn fade in the glow of the next generation of daytime stars. Changing characters also reflect the changing characteristics of viewers. The last two decades have seen a substantial rise in the number of minority soap opera characters, reflecting demographic shifts in the U.S. population.

Development

Establishing a new soap opera demands a longterm commitment. It takes years to achieve audience identification with new characters in their fictional affairs. Development begins with an independent producer providing the network programmer with a basic concept for a new series. If it seems promising, the network will commission a treatment, sometimes called a bible, which analyzes each of the characters and their interrelationships and describes the settings in which the drama will unfold. For a treatment, the writers receive development dollars or seed money. The final step is to commission one or more scripts, advancing more funds to pay writers. The entire development process can take one to two years and an investment of thousands or even millions of dollars.

Usually, several development projects are abandoned each season; only a few have ever made it to the daytime schedule. Once a network picks up a soap opera, however, casting begins. Casting the appropriate, charismatic actor for each role is crucial to a soap's success. To this end, CBS, ABC, and NBC maintain their own casting directors who work with producers.

Most network television is digitally recorded or filmed on the west coast, where producers contend they can produce programs for less money than in New York. This is due, in part, to the more favorable weather conditions for exterior shooting. Most soap operas have also shifted to the west coast, but some continue to be taped in New York because much of the shooting is interior and the Broadway theater provides a large pool of actors who are available during daytime shoots. Young actors vie for soap roles because a bit part can bring high visibility and a decade of financial security. And soaptaping schedules leave plenty of time for stage and screen acting jobs.

Expanding Markets

The international market has become a lucrative secondary outlet for American soaps. Nowadays, many soaps incorporate plot sequences that take place overseas to appeal to specific foreign markets. The networks have also developed cable outlets for their off-network daytime and primetime soaps. In 2000, Disney/ABC launched SOAPnet, a cable/satellite network featuring reruns of its weekday soaps. Increasing competition from cable during daytime and perhaps the availability of soap operas anytime on SOAPnet appear to be eroding the ratings of daytime soaps. The average daytime soap opera rating in the table shown in 5.6 has declined from 3.9 to about 2.4 in less than a decade. The long, stable, and very profitable era of the daytime soap opera may be gradually ending.

Game Shows

From the 1950s until the 1990s, game shows were a profitable mainstay of network daytime programming. Typically, several episodes of a game show were taped in a single day, and these shows used the same sets and props for years. In exchange for onair announcements, advertisers provided the prizes awarded to contestants. Usually only the host got a big salary, and production costs were very low.

Games virtually disappeared from daytime network lineups because of competition from first-run syndicated game shows (including Jeopardy! and Wheel of Fortune), from cable/satellite networks dedicating some or all of their schedules to games (GSN, formerly the Game Show Network), and from network prime-time big-money games (Deal or No Deal and Who Wants to Be a Millionaire?). In addition, the rise of syndicated talk programming, which is much more lucrative for most stations than network game shows, hurt the clearance rate for game shows and led to their virtual demise as a network daytime staple.

The "last dinosaur" of traditional network game shows is CBS's The Price Is Right, now one of television's all-time longest-running programs. The Price's octogenarian host Bob Barker retired in 2007 after 36 years. The first hour-long game show (it was even 90 minutes for a short time), Price developed a near-cult following among homemakers. Its network run seems secure as the program has also developed a devoted following among young people, and his successor, Drew Carey, is popular with college students, as well as with more traditional daytime audiences. Although the prognosis is poor for other daytime network game shows, plenty of syndicated game shows survive, and NBC's Deal or No Deal has rapidly gained top-10 ratings in prime time, signaling the rebirth at night of the big-time network game show.

Weekday News and Information

In addition to their own intense competition, the broadcast networks face increasing competition from strong local stations in major markets in the early daypart. Local stations in large markets, including New York, Miami, Chicago, and Washington, are producing their own early newscasts and magazine programs (see Chapter 6). Because of their strong local emphases, these competing shows have garnered strong ratings against network offerings.

If network programs are to remain strong competitors in the major markets in the morning dayparts, they must adjust to the changing environment by doing what local competitors cannot. Because network morning shows cannot compete for local appeal, the key to successfully attracting mega-audiences lies in continuing to interview the most important national and international news and entertainment figures, and sending their popular morning show personalities to exotic locales or the sites of national news events.

Early-Morning Newscasts

All three networks provide early-morning newscasts of at least two hours' length on weekdays, running from 4:30 or 5 A.M. to 7 A.M. The networks hope to bolster their 7 A.M. programming by getting flow-through from these earlier programs, but they also realize that many affiliates produce their own morning news shows during part of this time period. Therefore, they try to accommodate affiliates with multiple feeds of these early newscasts. All have beginning and end points at the top and bottom of each hour, so an affiliate can "dump out" or join a network morning newscast after 30 or 60 minutes.

Morning Magazines

In the period between 7 and 9 A.M., the Big Three networks compete head-to-head with magazine format programs. The long-running Today, Good Morning America, and a CBS challenger appearing under a variety of titles (The Early Show since 1999), have contested this time period for several decades. Since 2000, NBC has placed all its morning bets on Today, extending it into the 9 to 11 A.M. time slot. These morning magazines provide news headlines, weather forecasts, and interviews ranging from soft entertainment to hard news. Because they resemble print publications, they are called

magazines. Like print magazines, they contain a series of feature articles, have a table of contents (billboard) at the beginning to inform viewers about what will be on that day, and are bound together with a common cover and title.

The magazine format is especially suited to the early-morning daypart when most viewers do not watch for extended periods of time. As people ready themselves for the day ahead, they catch short glimpses of television (see Chapter 6 on dayparting). The segmented magazine format allows viewers to watch for short periods of time and still see complete stories. News and weather updates allow viewers to start their day with useful information. All national magazines include local breaks in which affiliates air brief local news, weather, or traffic updates. FOX affiliates usually compete with their own long-form local newscasts.

Morning magazines are a valuable tool for promoting the network's prime-time offerings. For instance, when a network has scheduled a prime-time miniseries, the hosts of the morning magazine interview the stars or appear on the set of the miniseries. Correspondents from prime-time news magazines (20/20, Dateline) frequently make guest appearances on their network's morning shows to promote features on that night's program. Conversely, prime-time programs can help boost the ratings of morning magazines. For example, CBS's The Early Show's ratings increased when it began to capitalize on the success of the network's prime-time Survivor series. Each of the morning magazines has weekend editions that further extend their brands.

By the late 2000s, NBC News's *Today* was long established as the highest-rated morning news program with an average of 6.7 million viewers, ABC News's *Good Morning America* was second with 4.9 million viewers, and CBS's *The Early Show* was third with 3.4 million viewers (see 5.7 for more on the battle for morning magazine leadership). To some extent, the relative popularity of the leading morning shows is connected to the night-before ratings (tuning inertia). If NBC is the number-one network, the television set is often switched off at night with the channel position on NBC, and a disproportionate number of viewers turn on their sets and see morning programming from NBC.

Similarly, ABC has an advantage when its shows win the ratings the night before. Despite leading the pack in prime time at this time, CBS has never had much success in the morning and probably does not benefit much from tuning inertia.

Audiences for this daypart are usually reported in millions of viewers rather than ratings because the size of the ratings seems so small. *Today*, for example, has an average rating of about 2.9 while *GMA* gets just 1.9 and *The Early Show* just 1.4. It must be remembered that a 1.4 rating means that more than one-and-a-half million households are watching.

Despite the ratings' seemingly small size, the ratings competition between the networks for early-morning viewers is always intense, because the advertising revenue is so great. The stakes get even higher during ratings sweeps. To make the shows more attractive, the cast and crew often travel to exotic locations during a sweep. Although the cost of remote productions is higher, they often return higher ratings and create a promotional hook to tempt audiences. During one sweeps period, CBS scheduled an entire week of its morning magazine inside the studios of *Late Night with David Letterman* while *Late Night* was in London. This provided cross-promotion for both shows.

Evening News

Although ratings have declined, the evening newscasts are the centerpieces of the ABC, CBS, and NBC television news organizations, and the same is true of Univision. Along with daytime and latenight programming, evening newscasts help distinguish these full-service networks from their more recent competitors (FOX, the CW, MNTV, ION), thus enhancing their brand identification.

The advertising revenue generated by these news programs is substantial. Evening newscasts also give the broadcast networks prestige as major players in national and international politics. In the early days, evening newscasts provided a service to affiliates, most of which then had very limited, if any, news operations. CBS and NBC introduced the nightly 15-minute newscast to network television in 1948, and by the 1960s, the newscasts

5.7

176

The Morning Magazine Shows

NBC's Today

NBC pioneered the magazine format with the 1952 premiere of The Today Show. Over the years viewers have become very attached to the personalities associated with The Today Show. Popular Today Show personalities have included Dave Garroway (its original host), John Chancellor, Hugh Downs, Barbara Walters, Tom Brokaw, Jane Pauley, Willard Scott, Bryant Gumbel, Katie Couric, and Matt Lauer. Each of these hosts and regulars had a long run, bringing stability and familiarity to the program. These are essential ingredients for ratings success in a daypart where viewers' behavior becomes routine, as most people start each of their weekdays in much the same manner. The Today Show's sole big ratings dip, which took place in the early 1990s, has been attributed mostly to revolving hosts following the departure of Jane Pauley. The Today Show successfully rebounded in the mid-1990s with a new generation of morning stars and, renamed Today, has been the clear leader in morning network ratings and the only network morning program that runs four hours (7 to 11 A.M. EST). Meredith Vieira and Matt Lauer are the present hosts/anchors, supported by a roster of familiar specialists (weatherman Al Roker and newscaster Ann Curry) and big-name contributors (Tim Russert, Chris Matthews).

ABC's Good Morning America

Like the newer networks of today, in its first decade or so (prior to 1975) ABC did not offer any network service until 11 A.M. ABC challenged the well-established Today Show when it introduced AM America, aiming for a younger early-morning audience. ABC believed that its target audience, women 18 to 49, were less-habituated viewers than the over-50 age group that were drawn in large numbers to The Today Show, and these younger women would sample the new program. By 1980 the retitled Good Morning America (GMA) had moved into first place overall in the ratings. Although Today had reestablished its first-place position by the mid-1990s, GMA remains securely in second place. After unsuccessfully experimenting with younger, supposedly "hipper" anchors in the late 1990s and early 2000s following the

departure of long-time anchors/hosts Charles Gibson and Joan Lunden, ABC returned Gibson and added popular prime-time news personality Diane Sawyer. When Gibson became the *World News* anchor in 2006, newscaster Robin Roberts was promoted to cohost, making Sawyer and Roberts the first all-female morning magazine program hosting team. The network also invested millions in a new studio, complete with *Today*-like windows showing adoring fans outside. Increasing stability has closed some of the ratings gap between number-two-rated *GMA* and number-one-rated *Today*.

CBS's The Early Show

CBS has languished in third place in the morning news ratings since the beginning of three-network competition in early mornings in the 1970s. Even when ABC was out of the picture, CBS always ran a dismal second to The Today Show regardless of whether they were trying straight news or "infotainment," The failure of CBS to establish a morning franchise is one of the enduring mysteries of network television. The network has always trailed the competition regardless of format, personalities, or ratings for the rest of its morning performance. CBS's most recent attempt at a star-driven Today/GMA-style program (complete with a window for fans to gather!) was The Early Show hosted by former Today host Bryant Gumbel. Debuting in late 1999, Gumbel (and cohost Jane Clayson) lasted barely three years before being replaced by four (!) coanchors-including Harry Smith, a veteran of a previously unsuccessful CBS attempt at developing a morning program. The other current hosts are Julie Chen, Hannah Storm, and newcomer Russ Mitchell. The money that successful morning programs generate makes it unlikely that CBS will give up on its nearly 40-year effort to create a successful morning news and infotainment magazine. Although CBS is doing better in the ratings, the great number of options for viewers even at this time of the day (ranging from CNN's American Morning to ESPN2's Cold Pizza) make for increasingly long odds that CBS can capture enough of the audience and buzz to compete strongly with NBC and ABC in the early-morning ratings race.

had expanded to 30 minutes. Although modest by today's standards, the expenses incurred by a network news operation during those early years were often far more than the income derived from advertising on the newscasts.

Today, evening newscasts face difficult competition from cable news networks and internet news services. There is no need for busy viewers to wait until 6:30 or 7 p.m. for a network newscast as 24-hour news channels (CNN, CNBC, CNN Headline News, MSNBC, Fox News Channel) and hundreds, maybe thousands, of news websites sponsored by newspapers, television and radio stations, wire services, and the networks themselves, can be reached anytime. In addition, the newscasts on the larger local affiliates compete with the network newscasts for national and sometimes international stories using satellites to bring in high-quality coverage with on-the-spot video.

Thus, network news may not remain a staple of non-prime-time programming if current trends persist. By 2008, little more than a third of the American adult public regularly watched network evening TV news broadcasts, down from more than half in 1990 and almost three-quarters in 1980. Also, network, local, and CNN news audiences slipped precipitously in viewers younger than 30, perhaps because younger adults are more likely to seek news from other alternatives, such as cable, the internet, or mobile media. This demographic trend suggests that audiences for evening newscasts may continue to decline.

Nonetheless, they continue to bring in sizable advertising revenue for the networks. Despite increased competition and lower ratings, network newscasts also remain important as promotional tools. Affiliates benefit because the networks promote the evening's prime-time schedule during commercial breaks. Just as with early-morning magazine programs, the network's news division can promote other news programming within the newscast. For example, ABC promotes *Nightline* as well as its website (*abc.com*) within its nightly newscast, while each of the networks generally incorporates promotion for its own news magazines (CBS's 60 Minutes and 48 Hours Mystery; NBC's Dateline NBC; and ABC's 20/20 and Primetime Live).

Time zone differences present a challenge to both the programming department and the news department. The solution has been a multiple-feed schedule. The first feed of a network newscast is generally 6:30 to 7 P.M. eastern time. Because some affiliates delay this newscast and the time would be inappropriate for the mountain and Pacific time zones, a second feed is scheduled for 7 to 7:30 P.M. eastern time and a third from 6 to 6:30 P.M. Pacific time. Breaking or updated news stories can be inserted into the later feeds.

Because most network newscast elements (news gathering, scheduling, and technology) are about the same, news personalities become critical for winning the ratings competition (see 5.8). News anchors who can connect with other members of the news team and the audience are essential as the centerpieces for building loyalty. All three networks produce high-quality newscasts for which the ratings have been nearly equal for a very long time, but they risk losing the next generation of news viewers to cable and the internet if younger personalities are not developed to anchor these programs. Prime-time newsbreaks, vacation replacements, and weekend newscasts often are the training grounds for new anchors and reporters.

As of the November 2006 sweeps, the *NBC* Nightly News seemed solidly in first place in the evening news ratings with an average audience of 9.57 million viewers. ABC World News was second with 8.92 million, followed by the CBS Evening News with 7.78 million. But by the spring of 2008, ABC had moved ahead with a 9.4 rating, and NBC had slid to second with a 9.1 rating. CBC remained a distant third with a 6.9 rating.

The networks have tried to distinguish the three newscasts from each other and from cable by creating segments within the newscasts. CBS's "Eye on America" and "Everybody Has a Story," NBC's "Healthbeat," and "It's Your Money," and ABC's ongoing "Person of the Week" provide hooks for promotional announcements. The networks believe that viewers will link "Eye on America" to a particular network, and get into the habit of watching a particular network for a favorite segment or follow up on the network's news website for more information. The news websites also offer viewers

5.8 The Evening Newscasts

NBC Nightly News

NBC first offered a regular nightly newscast in 1949, the Camel News Caravan with John Cameron Swayze. Swayze was not an experienced journalist and eventually was replaced in 1956 by Chet Huntley and veteran reporter David Brinkley. The renamed newscast, The Huntley-Brinkley Report, was a ratings hit, becoming the top-rated news program in the late 1950s and for most of the 1960s. When Huntley retired in 1970, NBC retitled the show the NBC Nightly News with Brinkley and John Chancellor as the main anchors. Following NBC's declining news ratings in the late 1970s and early 1980s, Tom Brokaw was moved from The Today Show to the Nightly News anchor position in 1982. As NBC added cable networks (CNBC, MSNBC), the Nightly News became a source of programming material for these newer news/talk outlets. Nightly News's stories are frequently the major focus of evening programming on these cable networks, and archived Nightly News reports have been repackaged to provide new programming for its cable partners. Brokaw stepped down as Nightly News anchor after the 2004 presidential election and was replaced by Brian Williams, a frequent guest anchor on the Nightly News and former anchor of a long-running CNBC evening newscast.

CBS Evening News

Walter Cronkite replaced Douglas Edwards as anchor of the CBS Evening News in 1962 and remained until his retirement in 1981. In times of crisis, more people tuned in to Cronkite than to any other newscaster. During the 1970s, polls repeatedly showed Cronkite as the most trusted source of news. Dan Rather took over the helm of the CBS Evening News upon Cronkite's retirement, but Rather's credentials as a highly experienced journalist would have meant little had his chemistry not matched that of his predecessor. Even though the ratings of the CBS Evening News declined after Cronkite's retirement, Rather continued to dominate the evening news ratings until the late 1980s when the

reign of ABC's Peter Jennings began. In June 1993 CBS decided to pair Rather with veteran reporter and weekend anchor Connie Chung. The combination did not work out, and ratings did not improve. Two years later, Chung was demoted from the anchor desk, and the president of CBS News was fired. In 2005, Dan Rather stepped down following criticism of his role in a news story that used faked documents. Veteran CBS correspondent Bob Schieffer was interim anchor until September 2006 when Katie Couric (long time cohost of NBC's Today) became the sole weeknight anchor.

ABC World News

ABC has been airing nightly newscasts since 1953, but for three decades it failed to pose a serious news threat to CBS and NBC. In 1977, in a bold move, ABC appointed the head of ABC Sports, Roone Arledge, to supervise both its news and sports divisions. Arledge had made ABC the number-one network sports organization with his unconventional strategies—introducing offbeat sporting events and building up the dramatic aspects of sports competition. During his tenure as head of news, ABC assembled a team of highly respected journalists, including Peter Jennings, Sam Donaldson, Diane Sawyer, Ted Koppel, and David Brinkley, catapulting ABC into the lead in the evening news ratings for some years. Most observers credit anchorperson Peter Jennings with the success of World News Tonight, as he actively served as executive editor and wrote (or rewrote) many of the stories, adding his own wry style. After the departures of Brokaw and Rather, Jennings' 2005 death was a shock to many viewers and industry insiders, closing an era of network news stability, now called the classic era. After an interim period, Elizabeth Vargas and Bob Woodruff were named as Jennings' successors in 2006. However, Woodruff's grievous injuries suffered while he was covering the Iraq war put an end to the new anchor team after less than one month. Charles Gibson became the anchor of the renamed ABC World News later that year.

a chance to view features or even full newscasts on demand, although with reduced picture and sound quality.

Late-Night News

In November 1979, ABC News seized on the American viewing audience's fascination with the Iran hostage crisis and began a late-night newscast to summarize the major events of the day. The show evolved into Nightline, an in-depth news program hosted by Ted Koppel until 2005. Then a threeanchor multitopic format was developed, hosted by Martin Bashir, Cynthia McFadden, and Terry Moran. Critics, however, pointed to less depth than in the single-story format and frowned on the rise in popular culture stories. Because it counterprograms the network and syndicated talk shows, Nightline continues to draw a loyal, upscale audience. Traditionally, the series' ratings fell or rose sharply depending on national crises, wars, and other disasters. Although the program is typically a halfhour in length, it sometimes expands for extremely important stories. On those evenings, Nightline can obliterate all the competing programs.

Such major news events as the disputed 2000 presidential election, the events of 9/11, and the invasion of Iraq triggered big upward spikes in the size of the audience. Even when major events are not taking place, *Nightline* has become a solid ratings performer (although typically finishing third behind both *Late Night* and *The Tonight Show*). The key to its success has been ABC's vigorous campaign to have the show cleared live in most TV markets.

Overnight News

The overnight time period (2:05 to 6 A.M.) has the lowest viewership of any daypart. Be it second-shift workers, nursing mothers, bottle-feeding fathers, or insomniacs, however, there is some television viewing in the overnight period, although the competition is not as spirited as in other dayparts. Unlike in prime time, where HUT levels are around 60 percent, overnight HUT levels are just 10 percent. Given the relatively low number of viewers, the potential ratings for individual over-

night programs are thus quite low. Some affiliated stations sign off in the overnight hours, leading to lower clearance rates that further reduce ratings. Therefore, in the overnight time period, a 1.0 rating (meaning 3 million people) is considered very strong (even in a nation of 300 million people).

Given the low ratings and the low HUT levels, one might wonder why a network would bother to schedule any programming overnight. Even with 16 minutes of commercial time per hour, the entire daypart is worth only a few million dollars to each broadcast network. If the network can keep costs below the advertising revenue in the daypart and promote forthcoming shows, however, the effort is worthwhile because the risk is low. In addition, overnight news gives network affiliates programming at no cost to sustain their broadcast signal for 24 hours a day.

ABC's World News Now and CBS's Up to the Minute are the traditional overnight news series, although their names have changed over the years. Scheduled about 2 A.M., these shows compete against syndicated news programming offered to local stations by CNN Headline News. NBC's cable partners, MSNBC and CNBC, also offer information alternatives on cable/satellite networks. Each network does what it can to keep the costs of production low. Up to the Minute was one of the first network news services to provide video stories on demand over the internet, now common practice for television news organizations.

Following their overnight programming, networks offer early newscasts that lead into and provide updates for their local affiliates' news programming. At 4:30 A.M., NBC enters the competition with Early Today, a joint venture with its cable/satellite partner CNBC. At the same time, ABC airs America This Morning and CBS carries CBS Morning News. These early-morning news efforts lead into the networks' morning news magazines: Today, Good Morning America, and The Early Show.

Limited testing of value-added programming, such as talk shows with product selling and extra runs of programming, has been attempted in the overnight daypart. News continues to dominate the time period for the networks, however, vying with cable's movies and rerun entertainment series.

Weekend News and Information

Although weekday news and information programs receive the most attention, weekend programs include some of the longest-running series in television. In addition, weekend news and information slots allow networks to extend successful program brands such as *Today* and *Good Morning America* into new hours.

Weekend Magazines

CBS and NBC have opted to program weekend morning magazines. On both Saturdays and Sundays, NBC airs a one-hour *Today* and ABC carries a one-hour *GMA*. CBS offers a two-hour Saturday version of its weekday magazine, Saturday Early Show, and also Sunday Morning, a 90-minute program that reviews news of the past week and surveys the world of fine art, music, science, and Americana. Sunday Morning, first with host Charles Kerault and then with Charles Osgood, has been a fixture on CBS for 30 years and delivers a surprisingly solid rating for the time period. These weekend shows allow network news divisions to utilize veteran news staff members while also developing and experimenting with new talent on the air.

On Saturday mornings, the addition of the Fox Kids block all but knocked NBC into the basement after what had been a three-network race for children's audiences. NBC decided that it would counterprogram on Saturday mornings, dropping kids' programs in favor of *Saturday Today*.

Sunday News Interviews

ABC, CBS, and NBC have traditionally aired publicaffairs interview programs on Sunday mornings, and FOX has joined them. The format usually consists of a panel of journalists interviewing recent newsmakers about current issues and events. These shows have a longevity rare in modern television: NBC's *Meet the Press*, network television's longest-running program, began in 1947, and CBS's *Face the Nation* began in 1954. ABC inaugurated its own public-

affairs show, Issues and Answers, in 1960, which was replaced by This Week with David Brinkley in 1981. After Brinkley's retirement, the title was shortened to This Week, and former Clinton White House aide George Stephanopoulos now hosts it (now called This Week with George Stephanopoulos). FOX News Sunday, which is allied with the Fox News cable channel, joined the competition in the 1990s. Meet the Press draws the largest audience with about 4.2 million viewers (a rating of about 3.1), followed by Face the Nation with 2.9 million viewers (rating about 2.3), This Week with 2.5 million viewers (rating about 1.9), and News Sunday with 1.7 million viewers (rating about 1.3).

Although these news interviews do not attract large audiences, they remain on the air for a number of key reasons. First, all four of these programs have become important news events in and of themselves. Elected officials and top reporters appear on them to be seen and quoted; they have a chance to express themselves at length on important issues; and they themselves watch these programs avidly. Their words on Sunday morning television often become Sunday night's and Monday morning's news. This is especially important because Sunday is usually a slow news day. Second, the programs attract desirable upscale audiences, and as a result, prestigious advertisers are drawn to the shows.

Despite attractive attributes, many stations are hesitant to clear these relatively low-rated programs on weekends. Affiliates can make more money carrying infomercials or paid religious programming. To provide affiliates with more flexibility, multiple feeds of the programs are scheduled, giving affiliates plenty of scheduling options. However, many affiliates still refuse to clear the time.

Children's Programming

Children's television programming best illustrates the massive industry changes caused by the proliferation of program outlets. Because a child's brand loyalty is to the program and not to the network, an upstart network such as the former WB can leverage its *Pokémon* program in several time spots, making the WB, at least for a time, the number-one

5.9 Top - Rated Children's Programs

Rank	Program	Network	Rating	
1	SpongeBob SquarePants	NICK	6.2	
2	SpongeBob SquarePants	NICK	5.8	
3	The Fairly Odd Parents	NICK	5.5	
4	The Adventures of Jimmy Neutron	NICK	5.2	
5	Avatar: The Last Airbender	NICK	4.5	
6	The Adventures of Jimmy Neutron	NICK	4.1	
7	Mr. Meaty	NICK	4.1	
8	Avatar: The Last Airbender	NICK	4.0	
9	Danny Phantom	NICK	3.8	
10	Danny Phantom	NICK	3.4	

November 2006 Nielsen sweeps data from http://forums.toonzone.net/showthread.php?p=2399330.

network in both the weekday kids' and the traditional Saturday morning children's block.

The dominant position of basic cable network Nickelodeon is further evidence that children are major users of cable television services (see 5.9). Consistently ahead of any of the Big Four broadcast networks in children's ratings, Nickelodeon has used such popular series as *SpongeBob SquarePants*, *The Fairly Odd Parents*, and *Jimmy Neutron*, among others, to become *the* major force in children's television (both on cable and at sister company CBS) and an increasingly powerful force in motion pictures and product licensing.

After decades of dominating Saturday morning children's programming, the rise of Nickelodeon, Cartoon Network, and then the powerful Fox Kids network drove all three of the older broadcast networks into downplaying the time period. Post-2000, a pattern of leasing kids' shows from cable became the norm. The four-hour ABC Kids, for example, is provided by parent company Disney, which recycles its Disney Channel and Toon Disney cable programming on the network. ABC calls this "New-to-ABC Kids' episodes. Not surprisingly, popular Disney animated theatrical films, such as

Toy Story and The Lion King, provided the inspiration for many of the programs in the block.

NBC, which abandoned most cartoon programming in favor of tweens live-action programming (Saved by the Bell) in the 1990s, formed (with ION) the more economical Qubo Kids lineup, airing shows on Saturday afternoons that target 4- to 8-year-olds. FOX is programmed by 4 Kids Entertainment, an offshoot of the major children's television syndicator Saban. The CW, as part of the Time Warner media colossus, features the programs of sister cable provider the Cartoon Network under the Kids WB! umbrella.

For some years, CBS "rented out" its Saturday morning block to Nickelodeon; then it tried education-blended-with-entertainment for older children, for example, Wheel of Fortune 2000 and Sports Illustrated for Kids. Still slipping in the ratings, in 2007 CBS rediscovered animation, installing a lineup of six new animated half-hour series from Canadian producer Nelvana, including The Dumb Bunnies, Franklin, and Guardians of the Legend, under the KOL brand name. Despite major efforts, all the broadcast networks must continually struggle against the attractions of cable and websites directed toward children (see 5.10).

In addition to ratings and economics, programmers must also consider factors specific to children's programming. One factor is that federal rules mandate minimum amounts of prosocial and educational programming (see 5.11). Although such rules are often perceived as vague and easily satisfied, programmers in other dayparts do not face such content-specific rules.

The Children's Television Act also required broadcasters to air educational and informational children's programming. At license renewal time for stations, the FCC is required to consider whether a television station has served the educational and informational needs of children. Broadcasters are now obligated to air programs serving a child's cognitive/intellectual or social/emotional needs. These rules, of course, apply to stations, not networks, but many affiliates and all the O&Os want help from their networks in fulfilling the children's requirements. Even Univision has had trouble figuring out what would be acceptable (see 5.12)

5.10 "Watching" in New Ways

hile kids and tweens still watch a great deal of television, not all viewing habits are equal, and traditional television shows are finding it harder to appeal to older children. Because entertainment programming is now accessible through a myriad of platforms, from home computers to cell phones and iPods, television programmers are increasingly employing cross-platform initiatives to reach school-age kids. Instead of delayed rollout, Cartoon Network's animated series Class of 3000 launched with a website featuring online sneak previews, streaming episodes, downloadable songs, podcasts, ringtones, wallpapers, and messenger icons, plus a funkbox game that lets kids create their own music. Nickelodeon has renamed its 5-7 P.M. programming block ME:TV to reflect the proliferation of web-based activities for kids.

Interstitials between episodes of SpongeBob SquarePants feature short videos of kids participating in polls and games, and the program showcases videos submitted to Nick.com by kids. Viewers can go online to submit questions to Nick's hosts and celebrity guests or visit www.Nicktropolis.com, a virtual world where kids create their own avatars and personal rooms in order to play games, interact with network characters, and connect with friends. Such activities may seem secondary enhancements to adults, but for children, they are becoming the new definitions of watching television.

> Nancy C. Schwartz, Ph.D. The Academic Edge, Inc.

However, the FCC has not specified the number of hours or the actual series that would satisfy the

After the Act was in place, the FCC cited statistics showing that educational programming on the networks had actually fallen from 11 hours a week in 1980 to just 5 hours by the early 1990s. The Commission reacted to these findings by adopting new rules in 1996 designed to strengthen the existing Act. Chief among these were rules that did the following:

5.11 Children's Programming Requirements

he FCC has long studied children's television programming. Members of the public, including special-interest groups and parents, have stated their concerns about "kidvid." The main concerns regarding children's television programming have long been the overcommercialization of children's programming, the blurring of distinctions between program content and advertising messages, and the absence of educational content. In 1990, Congress passed the Children's Television Act, requiring the FCC to impose advertising limits on children's programming of up to 10.5 minutes on weekends and 12 minutes during the week. The Act also restricted the use of host-based commercials, ones that feature characters from the program in the advertiser's message. At the time, for example, a number of commercials featured the Mighty Morphin Power Rangers; the Act eliminated those ads featuring the Power Rangers or products with the Power Rangers pictured on them during the airing of Mighty Morphin Power Rangers or within 90 seconds before or after the program. Had the commercials aired, then the entire program would have been considered a programlength commercial and, therefore, in excess of the maximum allowable advertising time for one hour of children's programming. This was a clever stratagem to force stations to exhibit some sensitivity to children's vulnerabilities. The prohibition on host-based commercials was aimed at decreasing the confusion a young child likely has in distinguishing commercials from a show's content. Even before the Children's Television Act, networks (as well as syndicators and broadcasters) usually placed interrupters or bumpers between programs and commercials. Nonetheless, research shows that young children remain confused.

- Established a guideline of a minimum of three hours per week of core programming per television station
- Defined core programs as those that are regularly scheduled on a weekly basis, broadcast between 7 A.M. and 10 P.M., at least 30 minutes

5.12 Univision's Expensive Mistake

n its most aggressive action regarding children's programming to date, the FCC fined Univision \$24 million in 2007. This was the biggest fine ever for an individual company and a shock to an industry that has a history of being rather casual about what is and is not "educational." In the early 1990s, for example, several stations were using The Flintstones and The Jetsons to fulfill their educational requirements. Univision's fine arose from two years of labeling one of its soap operas as "children's" programming. Complices al Rescate ("Friends to the Rescue") follows the lives of two identical 11-year-old airls who swap identities, lose family members and friends, and suffer injustice. Because of the plots' complexity and the many adult themes, the FCC determined that the episodes had little value for children. The telling point was that about 80 percent of the advertising in the episodes was directed toward adults.

long, and that have as their significant purpose "serving the educational and information needs of children"

 Adopted new public information initiatives to benefit parents, such as requiring on-air identification of core children's programs and providing this information in parents' guides.

Another factor is that children's programming is very much fad driven: Children's interests are fickle and change quickly. Chances are very good that the current *SpongeBob* phenomenon will fade in a few years and be replaced by the next big thing. *Scooby Doo, Power Rangers, Pokémon,* and *Teenage Mutant Ninja Turtles* have all had their days in the ratings' sunshine.

Still another factor is that children's television is often an excellent example of the synergy so heralded when corporations merge. The most popular programs are used to market a dizzying array of toys, games, clothing, fast food, snacks, videos, and motion pictures. One has only to walk through the various children's sections of a major store to see how popular children's programs

become strong franchises for marketing a vast array of products.

Production and Development Processes

The development process for animation is different from that of prime-time or other daytime programs. Development of an animated children's series begins about 12 months before telecast, with pickups of new series exercised in February or March to allow producers six to seven months to complete an order for a September airing. The first stage is a concept pitched to the network programmers. The next steps are the outline, which describes the characters and the setting, and the artwork, which provides the sketches of the characters in several poses and costumes. If a project passes these stages, the next step is to order one or more scripts, which usually go through many drafts before final acceptance.

Pilot programs are rarely commissioned for cartoons because of the long production time and high costs. The usual contract for a season of animated programs to be aired weekly specifies production of only 13 episodes. If it airs any cartoons, the network generally schedules each episode four times during the first season.

The development process for *live action* is similar to that of animation, but it substitutes a **casting tape** for the artwork. In hopes of lowering per-episode production costs or of targeting a slightly older target audience, the broadcast networks have focused on live-action programs for several years.

The large number of repeats that networks can employ offsets the high cost of children's programming to a large degree. Popular children's programs can have each episode broadcast dozens of times over a period of years (besides spending time on cable and being syndicated to stations). Unlike most programs, which lose substantial audience share with reuse, both live-action and animated children's programs are less affected by repeats because the audience changes frequently with a new generation of youngsters to discover every old program. In addition, children generally enjoy the familiarity of program reruns more than adults do.

Weekdays and Weekend Mornings

The Big Three abandoned children's programming on weekdays more than a generation ago. Even on weekends, the Big Three have narrowed their target audiences, gone after synergy with toys and other products, and sought multiplatform programming for kids, much as they have adopted similar strategies for prime and daytime programming. Another change shows the influence of children's cable networks on broadcast children's programming: the development of program blocks (ABC Kids, Kids' WB!, Fox Kids). On digital cable, these are promoted as separate children's networks just like Nickelodeon or the Disney Channel (but also function like syndicated packages of series for stations and foreign syndication). Even the term kids that once only Nickelodeon dared to use to designate its children's audience has now become ubiquitous in children's television.

Despite network efforts, the most popular of children's shows remain on cable. While younger children avidly watch cartoons such as *Lilo and Stitch* on Disney and *Rug Rats* on Nickelodeon, older kids tune regularly into *Dexter's Laboratory, Jimmy Neutron*, and *Fairly Odd Parents*, and still older ones to *Family Guy, The Simpsons*, and the problematic *South Park*, all cable shows and most carried across the week.

Nonetheless, the children's television market remains strong, vital, and profitable to networks that have carved out a substantial niche with the genre. Even with their recent ratings problems, the Big Four are also likely to maintain at least some Saturday morning presence through co-ventures that allow the broadcast networks to maintain a reduced Saturday morning schedule, but that target young viewers more carefully and use programs proven popular on cable and/or in syndication. The advantages for the Big Four are that they no longer have developmental responsibilities for children's programming and no longer need take on the entire financial responsibility for children's programming. In addition, even in an era of continuing deregulation of television and equation of the public interest with the corporate interest, the FCC and Congress would likely object to a complete abandonment of children's programming by a network. Although always affected by economic cycles and the fickleness of the audience, children's programming is likely to remain popular and profitable because it can be linked to other entertainment media, motion pictures, video games, and the internet.

Talk Shows

The studio-based talk show is a prime example of low-risk programming. Its minimal start-up and ongoing production costs make it a perfect format for the low-budget realms of both daytime and late-night television.

Daytime Talk

Traditionally, the talk show was used to fill hourlong gaps in a network's daytime schedule and target the desirable 25 to 54 female audience. Further, if a talk-show host connected with the audience, a series attracted very loyal followers who watched daily. With studios and equipment almost always available, talk shows are one of the most easily instituted and adaptable of genres. Indeed, with outstanding success, syndicators have stolen the genre away from the broadcast networks with such syndicated talk as Oprah, Dr. Phil, The Jerry Springer Show, and The Ellen DeGeneres Show. Back in the 1980s when Donahue, Oprah, and Geraldo were redefining the daytime talk show, the networks stuck with their successful soap operas and game shows in daytime, losing the programming initiative to their syndicated competitors. In the era of corporate consolidation, some of these programs began being syndicated by the same media conglomerates that owned the networks. Currently, the only English-language broadcast network daytime talk show is ABC's The View. The late-morning show (11 A.M. currently) has a unique four-host format that includes Barbara Walters. Both Telemundo and Univision, however, rely on popular talk shows to fill substantial parts of their daytime schedules.

Late-Night Talk/Variety

Despite its near disappearance in daytime, the talk show remains the network genre with the greatest longevity in the late-night time period. Currently, NBC airs three consecutive talk shows (The Tonight Show with Jay Leno, Late Night with Conan O'Brien, and Last Call with Carson Daly) in the late-night period; CBS airs two talk shows (Late Show with David Letterman and The Late Late Show with Craig Ferguson); while ABC competes with *Iimmy Kimmel* Live following Nightline (see 5.13 and 5.14). FOX has failed several times to develop competing talk/comedy programs (The Late Show Starring Joan Rivers, The Wilton North Report, The Chevy Chase Show) and presently does not program the daypart.

As in prime-time series development (see Chapter 4), pilots are often produced for night-time talk shows. Producers test a variety of elements prior to a talk show's release in attempts to gauge a show's potential. Commonly examined are the sets, the band, the sidekick, and the pacing of the show, but of course the key is the appeal of the host. When a network signs a major star to a talk-show contract, the network may decide to economize by producing rehearsal shows rather than a full-scale pilot.

Late-night shows often travel to remote locations. In one sweeps week, for instance, the New York-based *Late Show* traveled to Los Angeles; ironically, the California-based *Tonight Show* traveled that same week to New York. Such remote locations become promotable events, and the competition is fierce. After an initial lead over *The Tonight Show*, Letterman continues to trail Leno (see 5.14).

The late-night talk show has some of the same benefits of the morning talk show. The talk show can promote network offerings by booking same-network guests. A well-known celebrity appearing in a forthcoming made-for-TV movie can make a timely appearance on Leno or Letterman to promote the show's exact airdate and airtime.

Late-Night Weekend Entertainment

Programmers of late-night (11 P.M. to 1 A.M.) weekends generally attempt to reach viewers aged 18 to 34, but they face competition from a variety of sources in this daypart. First of all, on any given Saturday night, many in the desired target audience have other things to do than watch television. Second, cable and syndicated movies capture substantial audiences among this age group. As a result, to reach young adults, networks have tried to grab attention with truly unique programs on Friday and Saturday nights, including outlandish comedy, news, and music formats. With only a handful of exceptions, however, they have been unsuccessful, so affiliates fill late-night weekend time with syndicated fare and infomercials.

One of the rare successes in network late-night weekend programming history is NBC's Saturday Night Live (SNL). Debuting on NBC in 1975, SNL is an innovative 90-minute comedy/variety program airing on Saturdays at 11:30 P.M. SNL features regular cast members and a different gueststar host each week. Ratings sometimes reach 6.0 and 7.0 for new episodes, and the program overall has an average rating of 4.0—which is a huge rating for a time period when HUT levels are low. Many former cast members have become famous film and prime-time television stars, including Chevy Chase, Jane Curtin, Mike Myers, Bill Murray, John Belushi, Eddie Murphy, Dana Carvey, Adam Sandler, and Will Ferrell. Producing a fresh 90-minute sketch-driven comedy is demanding, and to give cast and writers a rest, NBC has offered some specials and a variety of packaged, thematic best-of-SNL shows. During the crucial November, February, and May ratings sweeps, however, firstrun shows air for at least three consecutive weeks.

As is the case with most successful series, *SNL* has had its imitators over the years, the most obvious being ABC's *Fridays* in the early 1980s. So far, *SNL* has had only one lasting network competitor, FOX's *MADtv*, which premiered in 1995. Similar to *SNL*, it uses a repertory company of young

5.13 The Late-Night Merry-Go-Round

Ithough not the first network late-night program (NBC's Broadway Open House has that distinction), NBC's The Tonight Show, with an over 50-year run, is the model for all television talk/comedy/variety programs and a model of stability with only four regular hosts in five decades: Steve Allen, Jack Paar, Johnny Carson, and Jay Leno. Carson, the host of The Tonight Show from 1962 to 1992, was such a mammoth ratings success that the network added a one-hour show following Tonight: The Tomorrow Show with host Tom Snyder, which ran from 1973 to 1982.

After guest-hosting frequently for Carson, David Letterman was given his own daytime show on NBC in the 1980s. Because of low clearances and low ratings, his program lasted only four months. NBC thought Letterman's offbeat style might better suit latenight audiences, and it replaced Snyder's program with Late Night with David Letterman. Letterman developed a cult following among young viewers, particularly college students, who made up a large portion of the show's audience.

Letterman's show attracted an especially desirable target audience with little falloff toward the end of the program, and to capitalize on the potential viewership. NBC added another half-hour to its late-night lineup in 1988. The show, Later, was originally hosted by NBC sportscaster Bob Costas. When Carson retired in 1992, NBC had to decide who would replace him. Of its two final candidates, the network chose stand-up comic and frequent guest host Jay Leno over Letterman. Because Tonight's audience had aged dramatically toward the end of Carson's reign, Leno retained the opening monologue that Carson had made famous but changed the show's style, band, and routine to draw a younger audience. Leno's musical guests were selected with careful attention to the younger target audience. The Tonight Show with Jay Leno is consistently the highest rated of the network late-night programs. It is currently followed on the NBC schedule by Late Night with Conan O'Brien (Letterman's successor on NBC and another consistent time-slot winner) and Last Call with Carson Daly (a popular MTV personality). Conan O'Brien is slated to replace Jay Leno in 2009, and Jimmy Fallon, a former star of Saturday Night Live, will take O'Brien's slot.

CBS, which was struggling in third place in late night, decided to take a gamble on David Letterman after he left NBC. This new Late Show with David Letterman gave CBS an instant ratings success in late night. Following Late Show's success, the network lured Tom Snyder away from his cable talk show on CNBC and gave him his own program, The Late Late Show, following Letterman. After Snyder retired, CBS hired Craia Kilborn, former host of Comedy Central's news spoof The Daily Show. After Kilborn's departure, comedian/actor Craia Ferguson took over the hosting duties. Prior to acquiring the services of Letterman, CBS had run original dramas (most of which were relatively inexpensive international coproductions) and repeats of prime-time programs. However, CBS had long sought its own "signature" talk-show personality to compete with Carson. First with Merv Griffin in the 1960s and 1970s and then Pat Sajak in the late 1980s, the Eye network failed to make a dent. Carson's departure and NBC's choice of Leno over Letterman to host The Tonight Show allowed CBS to obtain Letterman. Although rarely winning the time slot, Late Show has been a highly lucrative program for CBS.

The success of Letterman led ABC to try unsuccessfully to woo him away from CBS. ABC, even more than CBS, has consistently failed to establish late-night stars. From Les Crane in the early 1960s through Joey Bishop, Dick Cavett, Jack Paar, and Rick Dees over the years, ABC has found limited late-night success with repeats of prime-time dramas and, since 1981, with ABC News's Nightline. Before 2003, ABC tried Politically Incorrect, a comedy/political discussion program, in the post-Nightline slct, but declining ratings and, according to many observers, the controversial post-9/11 comments of host Bill Maher led to cancellation. Its replacement, Jimmy Kimmel Live, is a Hollywood-based talk program hosted by a cable personality best known for his appeal to young men via Comedy Central's The Man Show.

FOX had three notable late-night talk-show failures prior to withdrawing from the daypart. None of the three—The Late Show Starring Joan Rivers (1986 to 1987), The Wilton North Report (1987 to 1988), and The Chevy Chase Show (1993)—attracted significant audiences away from competing talk shows.² Neither FOX nor the newer broadcast networks offered late-night programming as of 2008.

Program	Network	Number of Viewers
Tonight Show (Leno)	NBC	5.9 million
Late Show (Letterman)	CBS	4.5 million
Nightline	ABC	3.6 million
Late Night (O'Brien)	NBC	2.7 million
Late, Late Show (Ferguson)	CBS	2.1 million
Jimmy Kimmel Live	ABC	1.8 million

Late-night ratings obtained from www.usatoday.com, April 2007.

comedians performing comedy sketches, including popular culture satires and recurring character bits. The one-hour program starts at 11 P.M., a half-hour earlier than SNL, allowing it to counterprogram the local news on NBC affiliates and bridge the start of SNL, thus capturing viewers interested in comedy before SNL takes the stage. Despite this advantage, MADtv trails SNL by 1.5 points with an average rating of 2.5. In late 2006, FOX began to program the 12 to 12:30 A.M. post-MADtv spot with Talkshow with Spike Feresten, and alternate this with repeats of prime-time series.

The Effects of Consolidation

Network non-prime-time programming is in transition. There is no question that daytime, weekend, and late-night programming can be lucrative dayparts. The combination of relatively low costs for program production (with the exception of sports) and loyal audiences has produced substantial profits. Why then are many of the remaining network programs losing audiences? Why have the networks scaled back or abandoned their programming in some of these dayparts (for example, NBC on weekday afternoons, FOX in late night)? The answers to these questions lie in the changing nature of the broadcast network television industry in the early years of the twenty-first century.

The huge profits from daytime and some other non-prime dayparts are no longer a secret. Local stations now realize that they can generate much more revenue from syndicated programs or even infomercials than they can from the compensation (cash and/or advertising availabilities) offered by networks for clearing their programs. This has reduced clearance levels for non-prime dayparts and led to the scaling back of network offerings. Because of low clearances, the newer broadcast networks have not even attempted to program many of the non-prime dayparts.

However, there is no need to worry about the networks. Their corporate owners are increasingly the owners not just of cable networks, but of both the local stations and the syndicated programming that has replaced network programming on those stations in many nonprime dayparts. The Big Four networks constitute the largest owners of major television stations, and their O&Os are typically much more profitable than their networks. In addition, co-ventures, such as seen on Saturday mornings between cable networks, broadcast networks, and syndicators, are likely to become the norm in other time periods and spill over into the internet and as offerings for mobile media. The old lines of demarcation are rapidly dissolving in the television industry—as they did a generation earlier in the radio industry.

Several of the remaining non-prime network programs continue to have fiercely loyal audiences. The problem for the networks is that these audiences are aging and not being replaced by younger viewers who are divided among many more viewing options (and other entertainment media) than were their parents. In particular, programs that have traditionally drawn a loyal but older audience (soap operas, news) must adapt or run the risk of becoming less profitable—at which point they will likely be radically altered or simply disappear.

The most important factor to consider with regard to both the present and future of nonprime network programming is this blurring of the traditional distinctions between network, syndicated, and cable programs. Relaxation of the financial interest and syndication rules (see Chapter 1) allowed networks to establish themselves as program suppliers to affiliates and nonaffiliates. By the mid-1990s, NBC

owned all of its Saturday morning properties, allowing the network to sell its series to any station in the United States and overseas. Increasingly, broadcast networks are both programmers and syndicators both domestically and internationally. The continuing relaxation of the television station ownership cap has made the corporate owners of the broadcast networks more active program buyers.

While the integration of station and network ownership can be used to guarantee clearance for a network program, it can also be used as clout for "sibling" syndicated programming. For example, the revenue goals of a Viacom/CBS-owned television station might be fulfilled by a CBS network program. On the other hand, it might be more lucrative for the station to acquire a syndicated program such as Dr. Phil from King World (a syndicator owned by Viacom) or a film from Paramount (another Viacom Company). The parent company (in this case, Viacom) cannot lose in any of these scenarios. Moreover, Viacom can use its clout to gain the necessary clearance for a new syndicated offering in exchange for the rights to a successful show. In addition, Viacom is not tied to the needs of CBS or its local affiliates and can auction off its syndicated offerings to whatever local stations are willing to pay the most. Viacom (or Disney, FOX, NBC Universal, Time Warner) cannot lose.

This is the new television. The low HUT levels in non-prime time have allowed the big media conglomerates to experiment in the "new world" of television programming. There is much more to come in all dayparts, as the decades-old distinctions between broadcast networks, cable networks, syndicators, and program producers fade into the fog of corporate consolidation.

Sources

"By the Numbers." Street & Smith's SportsBusiness Journal (weekly). Since 1998.

Children's Educational Television, FCC Consumer Facts. Federal Communications Commission, 11 December 2006. www.fcc.gov/cgb/consumerfacts/childtv.html.

Dintrone, Charles V. Television Program Master Index: Access to Critical and Historical Information on 1,927 Shows in 925 Books, Dissertations, and Journal Articles, 2nd ed. Jefferson, NC: McFarland, 2003.

Fisch, Shalom M. Children's Learning from Educational Television: Sesame Street and Beyond. Mahwah, NJ: Erlbaum, 2004.

Palmer, Shell. Television Disrupted: The Transition from Network to Networked Television. Boston, MA: Focal Press, 2006.

Raney, Arthur, and Bryant, Jennings (eds.). Handbook of Sports and Media. Mahwah, NJ: Erlbaum, 2006.

Tolson, Andrew. Television Talk Shows: Discourse, Performance, Spectacle. Mahwah, NJ: Erlbaum, 2001.

www.abc.com
www.cbs.com
www.cbs.com
www.fox.com
www.fox.com
www.mediaweek.com
www.nbc.com
www.pbs.org.
www.soapcentral.com
www.sportsbiznews.blogspot.com
www.sportsbusinessjournal.com
www.zap2it.com/tv

Notes

- 1. Despite the demise of regularly scheduled sports anthologies on the networks, the *Wide World of Sports* brand continues to exist as an umbrella title for some stand-alone minor event coverage, and as the name of a sports entertainment attraction at Disney World.
- 2. Arsenio Hall was a syndicated program that aired successfully for a brief time in the early 1990s on many FOX affiliates.

6

Television Station Programming Strategies

Robert B. Affe

Chapter Outline

Sources of Television Programs

Network Programming for Affiliates

The Big Four
The Small Three
The Spanish-Language Three
The Network–Affiliate
Agreement
Preemptions

News and Local Programming

The Role of Local Newscasts Other Local Programming

Syndicated Programming

The Prime-Time Access Rule Off-Network Syndication Movies Infomercials

Station Dayparts

Early Morning (6 to 9 A.M.) Morning (9 A.M. to 12 Noon) Afternoon (12 Noon to 4 P.M.) Early Fringe (4 to 7 P.M./
4 to 6 P.M.)
Prime Access (7 to 8 P.M./
6 to 7 P.M.)
Prime Time (8 to 11 P.M./
7 to 10 P.M.)
Late Fringe (11 to 11:35 P.M./
10 to 10:35 P.M.)
Late Night (11:35 P.M. to 2 A.M./
10:35 P.M. to 2 A.M.)
Overnight (2 to 6 A.M.)
Weekend Programming

Station Promotion

On-Air Promotion of Programs Promotion in Other Media

What Lies Ahead for Stations

Digital Technology Competing Newscasts Channel Migration The Mutation of Broadcasting

Sources

Notes

he business of broadcasting, that is, overthe-air television, continues to cope with the consequences of convulsive change. On many levels-technological, financial, demographic, marketing, and regulatory-broadcast programming is hurtling through creative and economic developments that are breathtaking to its viewers and gut-wrenching to its participants. Now that the predictability and easy profitability of past decades have declined markedly, station owners, programmers, and industry observers warily look to the horizon to see what lies ahead.

No business operates in a vacuum, immune to outside forces. Television programming is no exception, and many factors affect the environment in which a station makes decisions about program selection, scheduling, evaluation, and promotion. In technology, the major change has been the adoption of digital signal transmission. As of 2009, all licensed stations (which excludes cable) were required to broadcast a digital signal (although some stations sought exemptions from the FCC). This has resulted in superior-quality signals, although they are not necessarily in high-definition formats and do not necessarily result in better reception for all receivers.

At the same time, stations acquired the ability to multiplex—to send several channels of programming on their assigned frequency—while previously they could send only one channel. From an economic perspective, going digital has required an enormous financial outlay, and multiplexing remains the major hope for compensating income. Moreover, as an advertiser-supported medium, broadcast television is hyperresponsive to the overall national economy. When the economy expands, advertising budgets likewise expand; in a period of economic contraction, advertising budgets are usually among the first budgets cut by companies.

Another pressure comes from new and intensified competition. Networks and their affiliates no longer capture the majority of television viewing. Combined ratings for the top-20 cable networks now approximately equal or pass broadcast ratings. And the demography of the audience is altering. More affluent viewers are abandoning the networks in droves; younger viewers are,

too, finding that the flexibility of the internet and mobile media better suits their lives. This signals a demographic train wreck for mass advertising via broadcasting in the not-too-distant future. Moreover, Hispanics now form the largest ethnic group in America, a shift that newer programs have begun to reflect.

Finally, on the regulatory front, the FCC has backed away from its traditional insistence on a local orientation for broadcasting, instead increasing the percentage of national coverage that a single media company may reach. The result has been an increase in the quantity of affiliates and owned stations for each network and an overall decrease in the number of unrelated (independent) station owners. Another by-product has been more substitution of remote owners for local ones and a concomitant decrease in locally produced programs.

Sources of Television **Programs**

In nearly all circumstances, station decisions about programs are evaluated for both their creative (content) and financial (business) consequences. When home viewers enjoy-or disparage-a program on the screen, what they see is the result of professional programmers' evaluations of that show's relative creative and financial merits.

Nearly all programs are produced by one of four entities: the networks, the television production divisions of the movie studios, the few remaining independent producers, or the local stations themselves. A producer needs a distribution outlet for any program, and television programming comes to stations to be redistributed to homes via one of three outlets-from a network to its affiliates, from a syndicator when purchased by the station or its group, or from original production at the station (called local). The chart in 6.1 illustrates how several popular programs have come to the screen via different producers and modes of distribution.

Not all networks are program producers because some are co-owned and operated as a unit

6.1 Programming Distribution

Produced by:

	Network/Station	Movie Studio	Independent Producer
Distributed via:			
Network	NBC Nightly News (NBC Universal)	ER (Warner Bros.)	The Practice (David E. Kelly Prods.)
Syndication	Who Wants to Be a Millionaire? (Buena Vista, ABC/Disney)	Entertainment Tonight (Paramount)	Ask Rita (Litton Syndication)
local station	Local newscasts (self- produced or repeated from another local station)	_	_ //

with the dominant network. ABC, CBS, FOX, and NBC are active producers, but CBS/TW-owned CW, ION, and FOX-owned MMTV are not; they carry mostly syndicated or replayed product from their parent companies. Both Univision (UNI) and Telemundo (TEL—owned by NBC) produce a wide range of Hispanic programming—and import from Mexico as well—but TeleFutura, owned by UNI, produces primarily sports.

For purposes of discussing programming, here are three classifications of stations. Most visible are the network owned-and-operated stations (the O&Os, pronounced "oh and ohs"), which are generally the top stations in the biggest markets. For example, ABC-TV, Inc., (owned by Disney) in turn owns the ABC Television Network, which owns and operates 10 television stations, among them WABC-TV (New York), KABC-TV (Los Angeles), WLS-TV (Chicago), WPVI-TV (Philadelphia), and KGO-TV (San Francisco). In the shorthand of the television trade press, it is often reported that a network has "made" or "lost" money. That is a largely inaccurate way to report the fortunes of a broadcasting company. It is important to remember that network television is a program service; in other words, it is an expense. Network service is not designed to maximize profit. The real money is made at the network-owned stations. This is why the networks continue to beef up their roster of owned stations and aggressively lobby Washington to raise the limits on ownership.

It used to be that the majority of American television stations were *not* O&Os but owned by other companies and might or might not be affiliated with one of the commercial networks. Since the FCC, in effect, loosened its restrictions on the number of owned-stations a network could have, the major networks have purchased many more top stations, and the newer networks also own many, tying up nearly all stations as owned or affiliated and leaving only a handful of independents. In addition to affiliations with broadcast stations, a network wheels and deals to get digital cable and satellite carriage, making the same network signal available different ways.

Affiliates are stations that have agreed to run all the programs distributed by one of the 10 commercial networks and have signed an affiliation contract. The Washington Post Company, for example, owns six television stations, and its Houston station (KPRC) is affiliated with the NBC network and has the exclusive right to run NBC's programs in the Houston television market. It is called a network-affiliated station. Other stations owned by the Washington Post Company, however, are affiliates of other networks.

A true independent station has no formal relationship with a network and instead obtains its programs from a variety of sources. During a brief 15-year period (roughly from 1980 to 1995),

Network Affiliates and Owned Stations Owned Stations Affiliates* **U.S. Penetration** 218 96.8% ABC 96.9% **CBS** 17 204 CW (CBS/TW) 195** 95% 96.1% 25 180 FOX 50 95 83% ION 96% 167 MNTV (FOX) NBC 207 97% 33 34 75%+ TeleFutura (Univision) Telemundo (NBC) 50 93%+ 11 97%+ Univision 26 66

independents sprang up across America, corresponding to a spurt in the economy and consequent demand for advertising time. The economy was so good, in fact, that four new networks—FOX, PAX, UPN, and the WB—were formed, and most of the then-independent stations chose affiliation. Today, most of the former UPN and WB stations are affiliated with the CW or MNTV, and PAX eventually reemerged as ION. In addition, more than 200 stations are O&Os or affiliates of one of the Spanish-language networks (Univision, Telemundo, TeleFutura, or one of the smaller networks). However, the number of owned stations and affiliates varies widely for the 10 commercial networks (see 6.2).

Altogether, 95 percent of all commercial broadcast stations today are either O&Os or affiliates of one of the 10 commercial broadcast networks. A few very small broadcast television networks exist alongside the well-known ones, for example, America One (formerly Channel America), MTV2 (formerly The Box), and Trinity Broadcasting Network (TBN) and other religious networks. They tend to have secondary rather than primary affiliations, largely with digital-cable or low-power or very small market stations. If they have primary affiliations, these tend to consist of less than a handful of stations.

Network Programming for Affiliates

In television, the station-network relationship is modeled on the pattern established in the days of radio. The operators of the first radio stations quickly realized that broadcasting's programming demands were an all-consuming flame. As difficult as it was to create programming for large-city stations in the early days, it was nearly impossible for smaller-market stations to fill their program days. The owners of WEAF, including General Electric, fed that station's programming to their co-owned station in Washington, D.C., WCAP. In effect, the cost of that program to the local station was zero. That experiment was so successful that when stations outside the company clamored for programs, General Electric created a relationship in which the company would send programs through longdistance telephone lines to the local station. In return, GE inserted their commercials inside the program, and at the program's conclusion, the local station could air its own commercials. Thus the first network was created.

Subsequent networks, including television and cable, continue to be patterned after this model.

^{*}America One, for example, has 152 affiliates, but they are low-power, cable, and satellite affiliates only; moreover, the network is not promoted on the air, so its affiliates appear to be independents.

^{**}CW also has 15 cable-only digital affiliates.

⁺ These percentages are of Spanish-speaking households, not total TV households.

The network model maximizes the economies of scale in the broadcasting business because the cost of producing one program can be spread over hundreds of affiliates. In return, with one commercial, an advertiser can have its message sent nationwide in the same program at the same time. In network-distributed programs, the network keeps approximately three-quarters of the commercial time, and the affiliate retains a quarter of the time for sale, traditionally the source of immense profitability.

Another advantage is that the local affiliate has exclusivity, the sole right to the network's programs (or at least, the right of first refusal). The full-service networks (ABC, CBS, and NBC) supply about 12 to 16 hours of programming daily to their affiliates—nearly 100 hours per week across all time periods—which is about one-half to two-thirds the amount a station needs. UNI supplies even more hours to its affiliates. Getting the rest is the primary occupation of programmers at the stations (and the other networks supply even fewer hours, making the programmer's job much larger).

But downsides to the network-affiliate relationship exist. Some affiliates are weak stations with poor signals, low-rated newscasts, or overall inadequate performances, all of which disadvantage a network, and cause it to look for stronger affiliates. From the affiliates' perspectives, some networks' programming is rated lower (the CW, ION, MNTV, TeleFutura) than that of other networks—or a network's specific programs might not be as popular in a particular market as in the country overall. For example, ABC has traditionally targeted the urban audience, but some of its affiliates are in rural locations where urban material doesn't always suit the viewers. Nonetheless, both networks and affiliates need each other to provide what they themselves lack: The networks lack local presence, and the affiliates lack the financial resources to program all their broadcast days.

The Big Four

At the apogee of their dominance and profitability in the late 1970s, the Big Three—CBS, NBC, ABC—attracted more than 90 percent of all

prime-time viewing and advertising dollars. By the early 2000s, their collective share of prime-time viewing had slipped beneath 35 percent. Although alternative forms of video entertainment, in the aggregate, have chipped away at the networks' near-monopoly of television, commercial network television continues to remain the best vehicle for mass advertising in America and thus continues to be economically viable. The newer broadcast networks, the cable networks, and internet websites attract higher concentrations of narrowly targeted audiences, but they cannot come close to contesting the networks for delivery of mass audiences.

In 1994, FOX upended the cozy three-way balance that had operated for four decades. Initially, FOX's affiliates were former independent stations, usually the highest-rated independents in their respective markets, but still inferior in audience share and revenue to their competitors, the affiliates of the long-established networks. In addition, most of the FOX affiliates lacked newscasts. Chairman Rupert Murdoch soon put them on notice that his affiliates would have local news-or lose the FOX affiliation. FOX successfully raided many traditional affiliate rosters, especially those of CBS, and the Big Three reluctantly became the Big Four. FOX captured the crown jewels of the industry by acquiring the broadcast rights to NFL football starting with the 1994 season. By securing the NFL rights, other affiliates suddenly saw the immediate threat of losing loyal viewers, irreplaceable revenue, and an unmatched platform for promoting network programming. The impact of the NFL deal shook the underpinnings of the relationship between the Big Three networks and their affiliates, particularly for CBS, whose affiliates opened their eyes to the advantages of switching their allegiance to FOX.

Before 1994, affiliation switches were rare. Viewers, broadcasters, and networks basked in the security of loyal, long-term relationships. When FOX announced a series of affiliation switches in major markets, it unleashed a flurry of activity, breaking a logjam and causing a downstream realignment of affiliates in nearly every large market in which the Big Three networks did not already own stations. In Philadelphia, Boston, Detroit,

Dallas, Atlanta, Cleveland, Seattle, Tampa, Miami, Phoenix, and many other markets—covering nearly one-quarter of the U.S. population—one or more long-term affiliation relationships were broken up, and FOX substantially upgraded its affiliate lineup. By doing so, it achieved station parity in network television (reaching equal numbers of households via roughly the same number of owned-stations and affiliates—see 6.2).

CBS was severely wounded by the raid on its affiliates. The network lost decades-long relationships in large markets and had to spend scores of millions of dollars in advertising, promotion, and publicity, introducing viewers in many markets to the local channel that was the new home of CBS. The costs were more than monetary; in many cases they were a slap to the prestige of the "Tiffany Network." In Detroit, for example, CBS lost its Channel 2 affiliate to FOX and had to decamp way up the dial to Channel 62. (It was not exactly in the same spectrum with police and fire calls, but it was close, from CBS's perspective.) In Miami, CBS lost its traditional position on Channel 4 and moved to Channel 6, which had a serious signalreception problem in the northern half of the market. In Atlanta, CBS lost Channel 5 and moved to Channel 46. CBS was staggered by the FOX raid, and it took years for the network—and thus its affiliates—to recover.1 Today, CBS, NBC, ABC, and FOX have between 200 and 230 affiliated stations each (including O&Os) on their rosters.

The Small Three

In 1995, two new networks debuted in the same week: the WB, owned principally by Time Warner, and UPN, originally owned by Paramount and Chris-Craft Broadcasting, then Viacom/CBS. These so-called netlets did not provide the full programming slate to their affiliates. Instead, the WB and UPN focused on the heart of a station's schedule, the prime-time hours, adding young-adult-skewing programming and children's animation on week-days and weekend mornings. The new networks patterned their rollout on the model devised by FOX in its early years, introducing one or two nights of prime-time programming per year.

After a decade of low ratings, CBS and Time Warner shut down the networks, and in about the blink of an eye, came up with the CW, cherrypicking the old schedules for the best programs. Since the new network could have only one affiliate per market, it captured the best ones (sometimes stealing from the Big Three because NBC's programming was ailing at the time). That left dozens of former UPN stations (many owned by FOX) and others without a network, so FOX invented MyNetworkTV (MNTV, named like FOX's MySpace.com).

The new networks' game plans avoid competing for ratings with the Big Four across all dayparts. Instead, the CW and MNTV program only when they can be competitive, which means primarily prime time, and primarily weeknights. Even FOX does not program three hours of prime time every night, unlike the Big Three. FOX programs two hours, then expects its affiliates to air late news at 10 P.M. (9 P.M. central) to get the jump on the late newscasts aired by affiliates of the other networks. Affiliated broadcasters are left with large portions of weekdays and weekends to fill.

The seventh English-language network, Paxson, launched its PAX service in 1998, concentrating on family-friendly programming, both first-run and syndicated, and morphed into ION in 2007 (after a couple of other tries at a new name), but it lags in ratings and familiarity to audiences. In order to foster programming without sex and violence that is suitable for family viewing, it attempts to tightly control the programming of its affiliates using a contract that limits the carriage of syndicated series. Many affiliates have abandoned the contract, ignoring it and eventually jumping ship for more popular programming from MNTV or the CW.

One of the major benefits of the FOX, CW, and MNTV affiliations is that they give a network-quality look to their affiliated stations, which were predominantly weak independent stations before the mid-1990s. As much as any other factor, by their guerrilla style of picking off younger network audiences, the newer networks have contributed to the blurring of identities between affiliates and the former independents. Independents used to be

characterized by a "local" look ("local" used pejoratively in this case), providing prime-time programming consisting of old movies and even older syndicated products. Today, it is virtually impossible to distinguish between the two former classes of stations in network prime time. ION affiliates get little by way of network identification; they still appear to be independents, but are always family oriented.

The Spanish-Language Three

Some of the most significant changes in television have occurred in non-English-language broadcasting. The three major Spanish-language services-Univision and its sister network, TeleFutura, and Telemundo, owned by NBC Universal—overwhelm markets that have a strong Spanish-speaking presence. Indeed, UNI typically outdraws Englishlanguage competitors in many time periods and has altered the national advertising market. Spanishlanguage broadcasting is concentrated in markets with large absolute numbers of Hispanics (New York, Los Angeles, Chicago, San Francisco, Dallas, Miami) and also with large percentage numbers (Austin, San Antonio, Albuquerque, Bakersfield). The Hispanic population of the United States was officially (at least) 15 percent as of 2007.

Univision, a publicly traded independent company (formerly Spanish International Network or SIN), owns 18 full-power and 8 low-power outlets, has 66 broadcast affiliates, and is carried on about 18,00 cable systems, giving it reach into nearly all of the 210 broadcast markets. It has been the fifthlargest U.S. television network for many years. Its best-known programming consists of Mexican telenovelas produced by Grupo Televisa, major international sporting events—especially soccer, and Noticiero Univision, its nightly newscast. Its co-owned sister service, TeleFutura, schedules to compliment Univision's programming on another 18 full-power and 15 low-power owned stations and 34 broadcast affiliates, along with about 270 cable affiliates. In addition to blockbuster programming, both network carry newscasts and some noncommercial programs. In 15 markets, their duopoly status makes UNI/TEF stations near the top in all Hispanic markets. Univision also owns the cable network Galavisión, some music services, Univision Radio, and *www.univision.com*, a very popular website.

Telemundo, a subsidiary of NBC Universal, owns six full-power and five low-power stations, has 50 broadcast affiliates, and is carried on about 600 cable systems, giving it a total video presence in about a quarter of U.S. television markets. Its popular movies, reality programs, talk shows, and telenovelas make it the number-two network for Spanish-speaking viewers, but it has cut back on local newscasts in many southwestern markets in favor of a regional newscast from Denver.

The rising Hispanic population in the United States makes the profit potential of these networks and their stations self-evident. For example, in Los Angeles, Miami, and Fresno, Univision stations have led their markets in adults aged 18 to 49 and adults aged 18 to 34 across the entire broadcast day. Combined with the increasing household income of Hispanic families, Spanish-language broadcasting is a growth segment in an otherwise-mature broadcasting business.

The Network-Affiliate Agreement

Each party to an affiliation makes specific promises to the other party; the legal document binding both parties is called an affiliation agreement. To summarize, the network agrees to provide its program service to the affiliate on an exclusive basis. Exclusive means that only one station in each market may broadcast the network's programs (except that refused programs can be licensed to another station). Further, the network will pay the affiliates a negotiated fee for broadcasting its programs. This fee is called network compensation, or just plain comp. Network compensation can easily exceed \$1 million per station in the larger markets. Ironically, comp is more important to stations in the smaller markets, where it can represent up to 10 percent of total revenues and spell the difference between profit or loss for the affiliate.

In return, the affiliate promises to broadcast the programs as delivered by the network and to allow the network to retain about three-quarters of the commercial time within each network program. The exchange of local commercial airtime for network programming is the justification and foundation for the entire network-affiliate relationship. This is the central idea of the network-affiliate relationship. For example, one variable in a commercial station's profit formula is the number of advertisements it can air. Although the number of commercials allotted to an affiliate is only about one-quarter of the total number of ads in a given program, small variations in that "about" can mean a lot of money to the station.

The commercial breaks for the local station are called station breaks or adjacencies. In a half-hour program, the affiliate's commercials come at the end of the program; the network's commercials fall within the more desirable real estate—within the program itself. In an hour-long program, half the affiliate's commercials fall at the end of the program, half within, and (again) all the network's commercials occur within the program. Thus, hour-long programs have more value to stations—ratings being equal—because some of the "within spots" can sell at higher rates.

Tension between a network and its affiliate governs the entire relationship. In the networkaffiliate detente, each party thinks that the other is getting the upper hand in the deal. The networks believe that the affiliates are reaping windfalls from obtaining high-quality and commercially attractive network programs plus receiving compensation. In contrast, the affiliates grouse that the networks are hogging most of the commercial inventory during network programming as well as piggybacking on the affiliates' success and reputation in the market for news and local programming. These arguments raged back and forth for decades, indicating that the relationships were roughly equal in strength. Of course, in markets where the affiliate is competitively superior (because of strong news performance or such outside factors as signal strength or lack of strong competitors in the market), its resentment of the network is correspondingly higher than in a market in which the affiliate is weak.

In truth, networks and affiliates need each other. Each party trades what it has for what it needs:

The network needs local affiliates to gain access to the market, and affiliates need the economies of scale that enable the network to provide the bigbudget entertainment/sports/news programming that affiliates would otherwise be unable to produce on their own.

Preemptions

Occasionally, an affiliate might decide not to air (i.e., might preempt) a network program for any of a number of reasons. Most commonly, the station might do the following:

- Have a local news emergency that requires live, on-the-scene coverage
- Decide to air a program it produced on its own, such as a local parade, local news special, sporting event, and the like
- Deem the content of the network program inappropriate for local viewers
- Want to keep all the advertising time and revenue for itself (which occurs most frequently on weekends during the Christmas shopping season, when local stations try to maximize commercial revenue during the busiest advertising time of the year)

Usually, when an affiliate preempts a network show, the station will reschedule the program in another time period (called delayed carriage) but will lose whatever compensation accompanied the regular airing. If the affiliate refuses to clear (air) the program at all, a Big-Four network will then offer it to another station in the market in order to have some audience in the market for the program and its ads. As you can imagine, the networks keep careful track of exactly how many preemptions each affiliate makes, and that number can be a powerful bargaining chip at the time of affiliation agreement renewal or when affiliates request higher compensation. To protect themselves, affiliates negotiate in advance for the right to preempt a limited number of programs during the year.

It is important to recall that networks are not licensed by the FCC—only stations are—and affiliates must keep their eyes on their next license

renewal dates by offering programming in the public interest. Sometimes an affiliate contests its network's complaints about preemptions on the grounds that the substitute programs better served the community's interests and made the affiliate a stronger station in the market. This is a compelling argument when a network repeat episode is preempted in favor of a news special about education in the locality; it is a plausible argument when a network is preempted in favor of a championship game in which a local college team is playing; and it is a weak argument if the network is preempted in favor of a syndicated entertainment program, broadcast solely for the purpose of selling more commercials to improve the station's quarterly revenues.

News and Local Programming

Television, like its parent, radio, was developed as a community-oriented medium, serving both local viewers and advertisers. Limited by unreliable equipment and the financial/organizational constraints of an infant industry, early television was predominantly a *live*, *local* medium. The early days of television were experimental, thrilling, agonizing, and just plain chaotic.²

The U.S. Congress passed the Communications Act of 1934, establishing the FCC as broadcasting's licensing and regulatory authority. This enabling legislation authorized the Commission to regulate broadcasting "in the public interest, convenience, and necessity." As a matter of philosophical and practical forbearance, the FCC has historically given broad latitude to stations in the programming area to meet their statutory obligations, even though the epicenter of a station's mandate remains serving the public interest. The surest path to public service has been through news and local programming. Why television news is so omnipresent and its prospects for the future undiminished is explained in this next section, but there is always some criticism of its quality and presentation. (see 6.3).

6.3 Television News versus "Real News"

ne of the most enduring criticisms of television news is that it is not "real news": that television news is samehow counterfeit when compared with print journalism. Many complaints about contemporary television journalism begin with the cliché, "Edward R. Murrow would be spinning in his grave if he saw television's coverage today of [insert candidate for favorite v deo news shortcoming]." Then the critic offers what Murrow's opinion would have been, were he still alive to have one. Interestingly, Murrow himself clearly anticipated the distinctiveness and limitations of the new medium and said, in effect, "Television news is a compination of show business, advertising, and news." "

Television journalism, being so invasive in our lives, is often compared on an apples-to-apples basis with print journalism, a comparison which is unfair to both. Newspapers have been regularly published in America for nearly 300 years, largely without government regulation, while television has been plugged in for over 65 years and remains a captive of its technological, regulatory, economic, and competitive environment.⁴

The Role of Local Newscasts

Newspapers devote a minority of their pages to news reporting. This so-called **newshole** amounts to no more than 20 percent of newspaper space; the rest of the paper is devoted to advertising and features (syndicated columns, recipes, crossword puzzles, and so on). Though television is justifiably criticized for its excessive interruption by commercials, in its defense, we should note that it allots about 75 percent of its newscasts to news-related content and only about 25 percent to advertising.

In addition, technology affects the two businesses in different ways. Newspapers and magazines are printed on tight, regular schedules, but in response to a major, breaking story or emergency they can delay a press run. In contrast, television has *zero* tolerance for delays. Television cannot stop the clock in response to a just-breaking

story. The 10 P.M. news must begin at 10 P.M., not 10 minutes past 10 P.M. or even one minute past. When covering a breaking story, this immediacy requires television to perform many of its news-editing functions live on the air, in full public view.

A third difference between video and print journalism is that print lends itself to consumer self-editing more than video. If a consumer buys a newspaper and wants to learn what tomorrow's weather will be but has no interest in a big national story, all that person has to do is skip past the front page and turn immediately to the weather page. That same person, as a television viewer wishing to know the forecast and having no interest in the lead story, must sit through the first half of the newscast before hearing the local weather report. Put another way, print is selective in nature; video is sequential. Of course, this failing leads many viewers away from traditional television to self-selected news on the internet and in mobile media.

In addition to the obvious community benefits of having news content on the air, local news programming serves the broadcaster's commercial objectives quite well in the following six ways:

- 1. Risk mitigation. When a station buys a syndicated program, the result of that purchase can be a hit, a dud, or any measure in between. Admittedly, no station sets out to deliberately buy a failure in the syndication marketplace. No matter; regardless of the ratings of the program, the station must honor its contract and continue to pay the broadcast license fee and continue to air the barter commercials, even if the program is taken off the air. News programs, in comparison, are rarely abject failures and can nearly always be resuscitated by a "news doctor."
- 2. Exclusivity of product. No competitor can steal a station's newscast or copy the name of the newscast. The names, faces, and personalities of the on-air talent are exclusive to the station, too.
- 3. Brand-building. The newscast's content and production values can be styled so as to match the station's desired market identity, which results from its entire mosaic of network programming, syndicated programming, news/local programming, and other community exposure. Affiliates

that are number one in news generally are number one in their markets in prime time as well. How much their news ratings are attributable to their network's appeal in prime time and how much the prime ratings can be linked to the affiliate's news success is debatable; what is *not* debatable is that *local news and prime-time success are linked*.

- 4. Customization of product. In response to market forces beyond their immediate control—such as time of day, competing programs, changing popular tastes—the station can alter its newscast's content and format. For example, the news can be modified to offer more or less of hard news or softer coverage (such features as health or personal finance stories), or the weather report can be expanded or given more prominence in the newscast. If those alterations do not work, the original format can be restored and other changes put into place. No network or syndicated program can offer such a luxury.
- 5. Cost containment. Any locally produced telecast is a budgeting challenge to a business as sensitive to cash flow as a broadcast station. News is particularly expensive because of the need for sophisticated news-gathering electronic equipment, on-air talent, newscast sets, and behind-thescenes producers, editors, and so on. The start-up price tag is high, but such costs can be accurately estimated and budgeted—unlike the syndicated market, where the law of supply and demand causes fluctuations from year to year in the price of syndicated shows. In addition to reliable budgeting, the cost of adding an additional newscast is incrementally small; most of the expenses (equipment, sets, talent) are fixed and therefore already covered. Adding another half-hour of news in some cases might require only an additional news crew consisting of a single reporter and a photographer.
- 6. Revenue enhancement. News programs can be enormously profitable for stations. First, unlike the limited amount of commercial inventory allowed to stations in network and some syndicated programs, the station owns all of its newscast inventory and, if budgetary needs require, can easily expand that supply by shortening the newscast and adding commercial time. Second, advertisers

usually object to their products' commercials being placed during controversial network or syndicated programs. An airline, understandably, probably won't want to sponsor the movie Airplane. Such programs are said to be on an advertiser's hit list. Newscasts, fortunately, are usually not hit-listed. and a large universe of potential advertisers is available for the sales department to approach. Third, another benefit is that the advertising community regards news as the most prestigious category of television programming. An imageconscious company that would reject the notion of advertising in an entertainment program might well consider advertising in a news program as an acceptable alternative. Often, once a company discovers how effective television advertising is, its advertising efforts are expanded to other programs and dayparts. Stations use their newscasts as bait. as a means of enticing new or reluctant potential clients to advertise on television.

Other Local Programming

There are two categories of local programs: regularly scheduled shows (mostly produced out of the news department, such as public-affairs discussion programs and weekend sports wrap-ups) and special events (such as ball games and parades). Some nationally important programs that are produced locally still exist-mostly in the biggest markets for such special events as Philadelphia's Mummers' Parade on New Year's Day, the Boston Marathon, and so forth—but local programs no longer drive the financial or programming goals of a station, and most of the few remaining are produced by the news department. Even in the largest markets, the number of locally produced, regularly scheduled programs in important dayparts has dwindled to a precious few. The venerable Chronicle, at 7:30 P.M. weekdays on Boston's WCVB, for example, has been on the air since 1984 and is the only large-market, locally produced newsmagazine program in America. The exception illuminates the void (see 6.4).

For group-owned stations, local production can be a laboratory, a means of field-testing programming before a launch in syndication. For instance, Oprah Winfrey hosted a local talk show on WLS-TV in Chicago before her program went to national syndication in 1986. Maury Povich and Regis Philbin reached syndicated fame after their respective programs' successes at local stations. At the other end of the personality spectrum, Howard Stern had a test run on local television in New York (WWOR-TV), years before his program went to national broadcast syndication in the late 1990s and ultimately found its level on late-night cable and then satellite radio.

Syndicated Programming

To fill the time periods when a network does not supply programs, the station usually must enter the syndication marketplace for substitutes. There are two kinds of syndicated fare: off-network programs that originated on the network, and first-run programs that are made specifically to be sold in syndication, having never before been exhibited on any network. See Chapter 3 for a detailed discussion of the syndication process.

The Prime-Time Access Rule

In an attempt to encourage stations to live up to their public service mandate and, not incidentally, make the network-affiliate relationship more balanced, in 1970 the FCC issued a regulation that chopped off one hour of prime-time television per night. (Until then, network prime had started at 7 P.M. eastern/Pacific/6 P.M. central/mountain and aired for four hours.) The 7 to 8 p.m. hour was dubbed prime-access time, and the regulation was called the Prime-Time Access Rule (PTAR). Under PTAR, the commission limited affiliates to three hours nightly of network programming and prohibited stations in the largest 50 markets from airing any off-network syndication in prime access. (An exception was made for network news programs so that they would not count toward the three hours. A second exception was made for Sundays because, at the time, the networks aired family-oriented programming on the most heavily viewed night of the week, reasoning that seems silly today.) The FCC naively imagined that the 7 to 8 P.M. time period

6.4 Why So Little Local Programming?

ocal programming has four main liabilities. They are primarily related to its labor and cost structures.

- 1. Labor-intensive. In contrast to the physical simplicity of airing a network or syndicated program (which can require—at most—one or two technicians to supervise master control, videotape machines, and digital servers), a local program can require as many as dozens of personnel working over weeks or months to plan, produce, and edit just one program. Even the most modest of programs requires personnel to host, write, edit, produce, direct, and crew the production.
- 2. Cost-intensive. Budgeting is complex for a local production: There must be an accounting for talent fees, production crew, equipment, insurance, storage, construction, rentals, and all other related expenses of the production, all of which are borne by the station. To keep the production's on-air "look" comparable with network and syndicated programming, the show's budget must not skimp. Although television is said to be a "forgiving" medium for production quality standards, the local program would defeat its own purposes if it looked amateurish. Occasionally, some production costs can be recouped if the station is able to syndicate the program to other stations. The most frequent example of this is when a sporting event gets syndicated to a regional cluster of stations.
- **3.** Advertising considerations. If the local program is a one-time-only telecast, it might be difficult to find

- advertisers willing to buy time in it. Advertising agencies desire predictability; they want to have some pre-telecast notion of the kind of program they are buying and some realistic estimation of what the program's ratings will be (to justify the advertising buy to their clients, who are usually much more careful with spending their own money than the advertising agencies are). Unless the production is a regularly scheduled program or a local traditional event, the advertiser might shy away from a novel program. This is particularly true of national advertisers, who generally will not sponsor an unknown local program. Local advertisers, however, are more likely to support a local program because their advertising is less ratings-sensitive than that of national businesses. Local businesses can measure advertising success by other factors, which are sometimes as basic as an increase in the number of telephone calls or customer traffic at their stores.
- **4. Promotion intensive.** Unlike the help they get for purchased programming from networks or syndicators, stations are solely responsible for promoting their own products. Heavy promotion of a local production, especially if it meets with resistance from the sales department (because promos use up time), is dangerous; it could result in a disproportionate creative effort for a minimal revenue return.

would be occupied by local productions, publicaffairs shows, and more local news.

Instead, the "rule of unintended consequences" applied. Rather than produce more (low-rated) public-affairs programs, local stations realized that they had just been handed a great gift. They could now run syndicated programs (so long as they were not of the off-network variety) in what was formerly prime-time territory, and they got to keep all the extra commercial inventory and the revenue that went with it!

Although PTAR was repealed in 1995, it is highly unlikely that the Big Three networks will get their lost hour back. Access is the highest-viewed nonnetwork time period during the day, and stations generate too much commercial revenue to acquiesce in returning the time to the networks. Now that off-network reruns can air in access in any market, the increase in potential programs has driven prices down for both off-network and firstrun programming, and local stations make even more money.

Off-Network Syndication

Unlike other tangible properties for which a price can be established (such as land, automobiles, textbooks, and even personal services), there is no inherent value to any given television program. Ultimately, the market value of a program is set by the price at which the buyer's offer price and the seller's acceptance price overlap. As explained in Chapter 3, a program entering the syndication marketplace can sell at wildly varying prices, depending on such factors as a station's programming needs, the demographic "fit" of the program, the financial resources of the station, and the competitive landscape in the market. There is no set formula for calculating a price based on market size or location. Programs are not a fungible commodity where comparison shopping can be undertaken; each program is different, and its syndication performance is unpredictable.

The contract is an exercise in simple mathematics. The syndicator sells the exclusive right to air the program in one of two ways—on a weekly license basis or on a per-episode basis.

- 1. Weekly license. This is the most commonly structured form of syndication. The station pays a weekly rate for the program (paid monthly), which is satellite-fed to the station. There is barter advertising in the program, where the syndicator has sold advertising time within the program, and the station has no say in the scheduling of individual episodes. The station must play the program once every day. (The station may choose to contract to play the program twice a day if the license fee is increased, usually by about 50 percent.)
- 2. Per episode. This is the original method, in which the station enjoys more control over the scheduling of the program. As long as the syndicator gets paid (monthly), it does not care whether the station airs the program every day, twice a day, or not at all (called resting or shelving). There is generally no barter in this method. The station contracts for a specific number of telecasts over a stated period of time. In general, the station may play each episode up to six times before additional residual rights kick in.

In either case, when a program is sold into offnetwork syndication, it enters the marketplace upward of two years before its actual syndication date on the air. For example, when Everybody Loves Raymond launched on the CBS network in 1996, it was immediately evident that it would have a future in syndication. Eyemark, the program's syndicator, began the sales process in 1998, anticipating a syndication start date of 2000. From that date and until the eventual network run ends, episodes of Raymond will air on both the network and in syndication. Once enough network episodes have accumulated ttypically after four seasons of 22 episodes each), approximately 90 episodes are released into syndication. So, in the fifth year of network production, typically, a program begins its syndication life. In network seasons five through cancellation the program is simultaneously in syndication. As each network year ends, and the network's broadcast rights expire and return to the syndicator, those 22 episodes pour over into the syndication contract, adding to the number that the local station is able to air.

While a program is still on the network, the station benefits in three ways from having the syndicated version:

- National exposure. A network previously spent heavily to promote the show as a hit, not only on its own network but also through advertising in the rest of the media. The national name recognition rubs off on the syndicated version of the program.
- New episodes. Every year the station gets the rights to the previous season's network episodes, which were broadcast only twice each. These "new" episodes (new to syndication, anyway) are underexposed because even fans of a program cannot be expected to catch every episode during its network run.
- Advertiser access. Advertisers are businesspeople. They crave predictable results. They know and respect the drawing power of network programs, but if a network asks too much money for commercials, advertisers know that they can buy spots for less money in the same program at the syndication level, and the commercials will still be seen nationally.

From an economic standpoint, syndicated programs pose both opportunities and perils. On the opportunity side, the big benefit is the commercial inventory. After the station exchanges three-quarters of its potential commercials for the right to receive network programs, it still has a 90-second station break for sale. In off-network syndication ("off-net," for short), the station keeps most (if not all) of the commercial time, creating the possibility of generating more revenue from airing a syndicated program than a network one.

Another benefit lies in brand-building for the station. All day on quasi-independents and during nonnetwork dayparts for affiliates, stations have the entrepreneurial challenges of selecting and scheduling programs of strong appeal to their viewers. Each station can create blocks of sitcoms, movies, talk shows, or court shows, perhaps with a mix of sports and news, to develop a particular identity in the minds of the local audience. In their affiliate incarnations, however, stations are somewhat hamstrung because they are legally committed to air the programs their networks distribute and must work around those. Moreover, when stations are located in more socially traditional parts of the country, and a network program is "too cool for the room" (that is, has content inappropriate for the audience), the stations still must clear it—in the absence of an overwhelmingly compelling reason that justifies preemption (and the outlay for a substitute show).

For the afternoon lead-in to local evening news, affiliated stations can often acquire syndicated programs that are more complimentary to their highprofile afternoon and evening news programs than those their network provides. Finally, stations can use syndicated programs to cater to local tastes. Networks have to program for a national audience or audiences reached by their owned stations, which tend to be in the largest markets necessarily having different demographic and socioeconomic characteristics than small-city and rural America. The syndication marketplace makes available programs that might be a better fit for regional or market tastes.

At the same time, there are perils in not having network programming. First, there is the cost

of program production. The financing of network programs is not the responsibility of the affiliate, whose only "cost" is the opportunity cost of allowing the network to retain commercials within the program. Conversely, if an individual station commits to licensing a syndicated program, it bears the entire financial risk of that decision. If a network program fails, the network will eventually replace it, at no cost to the affiliate. If a syndicated program fails, the station is still obligated for all the costs of the program throughout the contract period.

Second, the station itself has to undertake the cost of promotion for its syndicated commitments. Whether the station bears cost of financing by making cash payments to outside advertisers or by "spending" some of its immensely valuable commercial inventory, the responsibility belongs to the station. In contrast, network programs generate national exposure and national publicity—to the eventual downstream benefit of local stations. On a network schedule, a given program is aired on the same day, at the same time, everywhere: 60 Minutes is on every CBS station on Sundays at 7 P.M./6 central, for example. In contrast, syndicated programs are on the air at different times everywhere. Although syndicators do support their programs with advertising and promotion (to add value to their barter spots), there is no comparing that effort with a network advertising campaign, and a station must bear the lion's share of promoting the program locally. If the off-network program has no barter spots in it, the syndicator will have no financial incentive to spend any money on advertising.

Another risk lies in the absence of exclusivity. Once a program is on a network, it seldom moves to another network. A local affiliate can be confident its network hit will continue to be aired on its station for the length of the program's run. In contrast, a syndicated program is under the control of the syndicator. A first-run syndication contract can be as short as one year and often is as short as two or three years. Once the contract period is over, the syndicator can move the program to another station that offers to pay more, and there is little loyalty to stations in the syndication business.

Movies

By the time a local broadcast station can air a syndicated movie, the film's appeal is often exhausted from overexposure. As a result, a once-valuable program franchise has been co-opted by bigger and deeper-pocketed cable competitors. Today it is highly unusual to discover a movie on local television that one has not had many opportunities to see elsewhere. Movies in syndication have devolved; once a marquee attraction carrying a premium purchase price, movies are now an economyof-scale program choice, a low-cost product for a moderate return on the investment. The situation differs for affiliates of the Spanish-language networks, where movies imported from South and Central America may still be fresh for American audiences.

Infomercials

The infamous program-length commercials, euphemistically called infomercials, sell everything under the sun—kitchen appliances, weight-loss "systems," real-estate seminars, exercise equipment, and self-improvement courses. Infomercials are the "elephant in the parlor" of television that station executives prefer not to discuss. These misfits of the programming world are pilloried in the industry, ridiculed by the public, and parodied on programs ranging from Saturday Night Live to The Simpsons ("Hi, I'm Troy McClure, and you might remember me from other infomercials such as Smoke Yourself Thin and Get Confident, Stupid!").

So why would a station air such easy-to-scorn programs? The answer is that infomercials are usually paid for in advance, and thus they provide quick cash to stations. No station brags about airing these programs, but at the end of a budget period, a station can preempt a program in a low-rated time period and sell the time period to an infomercial provider for a rate far in excess of what the station could otherwise generate in revenue. Most infomercials run in such out-of-the-way time periods as overnight and early mornings on weekends, although occasionally one will pop up in plain sight—for example, opposite a Super Bowl or other mega-telecast. And the lowest-ranked

stations in a market are the most likely to fill part of their days with infomercials.

How can the infomercial provider afford to pay such a premium rate? The success of an infomercial depends not on its rating but on the so-called response rate, the number of persons who call the toll-free number and sign up for a service or order the merchandise. No matter how seemingly odd the product being pitched appears, rest assured that somewhere there is a person on the phone right now ordering it. Infomercials are proof, indeed, that television continues to be the world's most influential advertising medium.

Station Dayparts

There are 24 hours in a day, 168 hours in a week, 8,760 hours in a year. It is literally impossible for programmers and advertisers to work with every one of all these hours on an individual basis, and not every hour in the day is equally important. For example, on any station, 9 P.M. is a far more significant time period than 2 A.M. In the name of efficiency and expediency, for the benefit of all parties in the business—programmers and advertisers alike—the hours of the day have been grouped into dayparts. The dayparts represent the approximate behavior of the imaginary typical American television household. The best-known daypart, of course, is prime time. Although it might at first seem to be an arbitrary division, the grouping of hours of the 24-hour day into dayparts generally reflects the presumed lifestyles and viewing patterns of the average American viewing household. The generally accepted dayparts and their time periods appear in 6.5.

Although necessarily arbitrary, the division of the day into dayparts does indeed reflect large portions of most people's lives. For example, most people awaken in the morning between 6 and 9 A.M. (corresponding to the early-morning daypart), get off to work or school by 9 A.M. (start of daytime), and return home in the afternoon between 4 and 6 P.M. (early fringe). About two-thirds of American households watch television during the evening, peaking around 9 P.M. (prime time), although peak

6.5 Time Periods and **Dayparts**

Early morning 6 to 9 A.M. 9 A.M. to 12 noon Morning Afternoon 12 noon to 4 P.M. 4 to 7 P.M. Early fringe Prime access 7 to 8 P.M. Prime time 8 to 11 PM Late fringe 11 to 11:35 P.M. 11:35 P.M. to 2 A.M. Late night 2 to 6 A.M. Overnight

These dayparts are standard for the eastern and Pacific time zones. In the central and mountain time zones, the dayparts change slightly: Essentially, prime time starts an hour earlier and ends an hour earlier, and early fringe, access, and late fringe move an hour to accommodate prime time.

Central Time Differences:

Early fringe 4 to 6 P.M. 6 to 7 P.M. Prime access 7 to 10 P.M. Prime time Late fringe 10 to 10:35 P.M. 10:55 P.M. to 2 A.M. Late night

viewing by teens and young adults occurs later. Between 10 and 11 P.M., viewing levels begin tapering off as families and older people prepare for bed, then drop precipitously after 11 P.M. (late fringe).

Broadcasters and advertisers must agree on these dayparts, which are established by the Nielsen Media Research company, in order to conduct the multibillion-dollar business of setting advertising rates and selling commercial time at America's more than one thousand commercial television stations. In addition to configuring advertising expenditures and revenue, the dayparts also set the boundaries for the programming strategies that capture the time, money, and effort of broadcasting producers and executives.

Early Morning (6 to 9 A.M.)

As a lead-in to network morning news programs (Today, Good Morning America, The Early Show) that commence at 7 A.M. local time, many network affiliates air local news (or the early early network show). In response to the evolution of American lifestyles toward more working couples, single working parents, and longer commuting times, America's workday is starting earlier and ending later. Although HUT levels are modest at dawn, most people who are awake before 7 A.M. are awake for a reason: They are preparing to go to work. These people are likely candidates for news because they are employed (and are disproportionately commuters), and they therefore have the attractive qualities of income, education, and the accompanying lifestyle and purchasing patterns of working people. Because of these viewers, advertisers are attracted to early-morning news programs.

These viewers usually cannot commit to watching an entire program, however, so the information is frequently repeated, with headline, traffic, and weather updates occurring throughout the hour or half-hour newscast. In fact, viewers "listen" to the morning news as much as watch it as they get dressed, prepare breakfast, shoo schoolchildren out the door, and prepare to leave the house themselves. The video product is treated as background sound, much like radio. In larger markets that have the longest commute times, the early-morning news starts as early as 5 A.M.

The 7 to 9 A.M. time period has traditionally been a network preserve. Today has been on NBC for 60 years and Good Morning America on ABC for 35 years, deeply embedding viewing patterns. Most daytime viewing is habitual viewing, and the networks try to establish that habit as early in the day as possible. CBS affiliates have suffered the most anguish in this daypart because their network has had only indifferent success over the years with its many morning efforts (see Chapter 4). Its affiliates obviously want their network to succeed, but they cannot wait indefinitely for it to do so; thus, lack of clearance exacerbates the network's problems.

During the first decades of television, when most television markets had only three stations, a network program could not finish worse than third in the ratings. Today, with nearly every available channel position occupied by an operating station, a network program can-embarrassingly-place beneath a syndicated program, falling to fourth, fifth, or worse in the ratings. Despite CBS's expenditure of tens of millions of dollars to build a successful morning news franchise, many CBS affiliates are preempting their network's *Early Show*. They are producing their own local news programs or scheduling syndicated programming more attractive to their lead-out audience at 9 A.M.

In deliberate contrast to their network competitors, FOX affiliates blaze their own trail. In an attempt to capture a share of news-related advertising dollars, FOX affiliates in most markets avoid a head-on competition with network affiliates, instead producing a news product heavily weighted toward local news, local entertainment, and personalities. In many markets the distinct FOX formula works to great success, beating the traditional network newscasts. The FOX philosophy is that copying the approaches of CBS, NBC, and ABC is futile; the international/Washington/New York orientation of the networks is both redundant and unimportant to viewers more interested in events in their own towns.

On UNI, the early morning program *Tu Desa-yuno Alegre* ("Your Happy Breakfast") is a magazine program with news elements. Its newshole, however, tends to be even smaller than that of the English-language morning "news" programs. At 7 A.M., UNI carries *Despierta America* ("Wake Up, America"), which is the Hispanic equivalent of *Today* or *Good Morning, America*, and contains talk, entertainment, and half-hourly news updates.

Affiliates of the smaller networks counterprogram this daypart with syndicated entertainment, predominantly sitcoms or reality programming (or the dreaded infomercials). Using entertainment is an effective strategy. It avoids competing with the news business and concentrates on the smaller audiences of children and adults who don't watch news. The business strategy of these stations is not so much to maximize profit as to minimize programming costs in a low-priority daypart.

Morning (9 A.M. to 12 Noon)

The Big Three networks do not program the entire three-hour morning block; the supply varies from

one to two hours, depending on the network. Recently, NBC extended Today for a fourth hour until 11 A.M., CBS has continued with The Price Is Right in late morning, and ABC airs The View at 11 A.M. Affiliates then complete their lineups with a mixture of first-run programs, talk, and local news. The scheduling strategy is to complement the demographic appeal of programs supplied by the network. With a relatively low HUT level providing a shaky foundation for success, the attrition rate for syndicated morning programs is high. Programmers do not have the luxury of allowing a program sufficient time to attract its audience. There are no "out of town" tryouts, unlike in the motion picture or theatrical industries. If a program fails to attract a stable audience within a reasonable period of time, then, like their network counterparts, station programmers move it to another time period or, more often, cancel it.

An intriguing characteristic of both morning and afternoon daytime is that if a new program can hang on for a couple of years and attract a loyal audience, a kind of TV inertia takes over, and the program enters "Video Valhalla," remaining on the schedule seemingly permanently. (The Price Is Right, for example, has been on the CBS daytime schedule for nearly 40 years.) Viewers during daytime tend to be homemakers, senior citizens, students, and shift workers. Although they have large blocks of time to watch programs, they are not fully engaged with the programs. So producers structure their programs to enable viewers to join, depart, and rejoin a daytime program easily; that is why game shows have lots of noise and require minimal levels of sustained concentration and why soap opera plots proceed so slowly.

In the rest of the morning, UNI carries Casos de Familia ("Family Cases"), in which guests relate their emotional true-life stories about serious family issues (much as in Maury Povich). Before noon, Necesito una Amiga ("I Need a Friend") is scheduled. In it, actors recreate personal histories in a dramatic combination of talk show and daytime drama, a staple of Hispanic daytime programming.

PART TWO

oap operas are the most venerable program format. ABC's All My Children debuted in 1965 and General Hospital in 1963. On NBC, Days of Our Lives premiered in 1965. Of all the networks, CBS soaps have had the greatest longevity: The Young and the Restless, As the World Turns, and The Guiding Light, which wins the grand prize because it moved to CBS Television in 1952 after appearing for 15 years on CBS Radio, starting in 1937. Networks and advertisers love soaps for the same reasons:

- **1.** They are seriously habit forming. Fans of soap operas watch not for years but for decades.
- 2. That viewing loyalty can be translated into consumer loyalty when the same products sponsor the same soap for many years. Advertising relies on repeated messages to be effective. A viewer watching the same program every weekday for years, with the same products advertised over and over, is a rare commodity in an increasingly fragmented advertising environment.

Lest one conclude that all first-run television in daytime is devoted to exploiting the dark or voyeuristic side of human nature, there are more lighthearted categories of programs. The popularity of program formats is cyclical. Game shows might be out of favor for some years, then return to popularity seemingly overnight. Game shows are traditional and quintessential daytime television fare. They are suitable for all viewers; the content is mostly questions and answers; viewers can play along at home—and feel superior when the contestants muff an easy question. To keep the pace of the game interesting, game shows are usually a half-hour in length. Research has shown that the best companion program for rounding out the hour is another game show. That is why so many game shows are found together in a one-hour block. Even though technology has ramped up the production values of game shows, the basic elements remain unchanged: question/ answer format, relatively low skill level, vicarious viewer participation, and a clear payoff or disappointment. None of life's ambiguities for game shows; every game produces a winner or a loser. Speaking of winners, even though one might think that a cash prize would be a more desirable or useful prize, an underrealized appeal of prizes is the "fantasy" aspect: the opportunity to win a dream vacation, a world cruise, or an expensive car. The vicarious enjoyment of watching a contestant win a fabulous prize is always greater than watching someone win cash money.

Afternoon (12 Noon to 4 P.M.)

The only local newscasts before evenings are generally at the noon hour, a vestige of an era when more adults were home in midday, and they have shifted to focus on office workers. In addition to reporting on that morning's news stories and aggregating more news-targeted ad dollars, the midday news promotes the station's other programming, particularly the late afternoon news.

The four main choices for the afternoon time period are soap operas, court shows, talk, and game shows (see 6.6). For affiliates of the Big Three, after the midday break for local news, the afternoon daypart is the mother lode for soap operas. (Network executives get irritated when "the soaps" are referred to as such, preferring to have them called "daytime continuing dramas.") Affiliates of ABC will certainly

carry All My Children and General Hospital. Affiliates of CBS will doubtless air The Young and the Restless, As the World Turns, and the venerable Guiding Light. Affiliates of NBC will carry Days of Our Lives. The Hispanic stations follow the same pattern, using first-run or rerun telenovelas in the afternoons. These Spanish-language serials resemble soaps in their close focus on individual emotional ups and downs, but they have a much shorter length (maybe a year or so) and contain a moral or educational point about families or society.

The remaining stations in a market counterprogram with various judges (Judge Judy, Judge Alex, Judge David Young, Judge Joe Brown) and justices (Texas Justice, Celebrity Justice). If the best court shows are not available, stations usually go for talk such as Martha or The Ellen Degeneres Show, and in

6.7 Filling the Air with Talk

alk-show formats run the emotional spectrum. At one extreme is the soufflé of nearly lighter-than-air content; interviews with celebrities publicizing their latest movie, television program, or successful drug rehab (for example, Live with Regis and Kelly). In the middle are decorating and homemaking hints (Martha) or light humor with chat (The Ellen Degeneres Show). At the other extreme is the exploitative treatment of guests' troubled psyches or relationships, where personal and interrogatory confrontations delight or repel viewers (for example, Montel Williams, Tyra Banks, Jerry Springer). Industry research indicates that there is a vicarious appeal to these exploitative programs: Viewers at home, no matter how troubled their own personal circumstances, feel relieved that their own lives are not as pitiful as those of the victimized guests who are telling their tales of woe to Jerry Springer on national television.

Why are talk shows so common (in both senses of the word) in television syndication? The major reason is cost or, more accurately, lack of cost. Syndicated ta k programs are relatively inexpensive to produce in contrast to scripted shows, talk programs are seemingly improvised. There are no screenwriters, only low-paid "researchers": there is no expensive location shooting because all programs are shot ir studios; there is no cast of expensive stars, usually just one or two hosts; and many hosts are paid less than "stars" (but not Oprah-see 6.8) because the more relaxed schedule allows them to take on other work after that day's program is taped. In contrast, the shooting schedule for a scripted Hollywood program requires 12-hour days, script rewrites, memorization of lines, laborious camera setups. and so on. The low cost threshold makes it easier for a talk-show producer to adjust the content to appeal to viewers' changing rastes and interests.

urban markets such games as *Blind Date* or *Extreme Dating* if they can. Otherwise, hundreds and hundreds of episodes of old game and reality shows are available as reruns, but talk dominates.

Needless to say, the afternoon is the most programmatically stable and consistent daypart for viewers, networks, and advertisers. Talk programs have become a mainstay of daytime program schedules, but the mortality rate for such syndicated talk is high. Approximately 80 percent of all syndicated shows that make it to broadcast do not make it to year two. But once a program has established itself as an audience favorite, it can stay on the air for almost as long as the distributor wants. Even if a popular host departs, the program can remain if the format is popular (see 6.7). The daily syndicated talk show Live with Regis and Kathie Lee enjoyed a successful 12-year run and even survived the departure of Kathie Lee Gifford in 2000, Kelly Ripa joined the program (retitled Live with Regis and Kelly) in 2001, and the ratings increased.

Another popular daytime program category is court shows, in which a real or ersatz judge hears

disputes and rules on them. The appeal of programs like Judge Judy is twofold: First, the personality or character of the magistrate is entertaining; second, the actions and reactions of the litigants are heartrending, comical, or just plain irritating. In any case, for societal good or ill, such programming makes for compelling television. A good court program is one part confrontational talk show ("Your Honor, he stole my pen." "I did not." "He did, too, Your Honor." "Did not."), one part game show (who wins the ruling?), and one part (a small one) introduction to the U.S. legal system. The overwhelming litigiousness of our society is mirrored in the court shows appearing on television as of the date of this writing: The People's Court, Divorce Court, Judge Judy, Judge Joe Brown, Judge Mathis, Judge Hatchett, Cristma's Court, Judge Alex, and Judge Maria Lopez.

The "reality" program craze, kicked off by Survivor in 2000, spawned daytime progeny in the form of "relationship" shows. Television has a proud legacy of relationship shows: The Dating Game (1965), its direct spinoff, The Newlywed

6.8 Oprah Winfrey

orn in Kosciusko, Mississippi in 1954 to unmarried teenagers, Oprah Winfrey lived the first six years of her life in rural poverty with her arandmother. At the age of 6, she moved to Milwaukee's inner city to live with her mother who worked as a maid and was on welfare. She was molested by her cousin, uncle, and a family friend at the age of 9 and became pregnant at the age of 14 but lost the baby. She was then sent to live with her father in Nashville, Tennessee.

This is not a very likely resume for one of the most influential women in America and, according to Forbes, the richest African-American of the twentieth century. As the story goes, while attending a party at a ranch in Montecito, California, she fell in love with the location and wrote a check for \$50 million to buy the 42-acre estate. At the same time, according to urbanmecca.com, she is the most philanthropic African-American of all time. She has helped raise hundreds of millions to fight AIDS in Africa and to fund a girls' school in South Africa. Her Angel Network alone has raised more than \$50 million dollars, and since she covers all administrative costs. 100 percent of donations go to charity. But that is the widely publicized background of Orpah Gail Winfrey. (Named after a person in the Bible's Book of Ruth, she found her name hard to pronounce and spell, so she shifted the p and the r and became Oprah.)

On the other hand, her bios say, her grandmother taught her to read by the age of 3, she skipped two of her earliest grades, and she won a scholarship to attend Nicolet High School at age 13. In Tennessee, she was an honor student, voted Most Popular Girl, placed second in the nation in dramatic interpretation, secured a full scholarship to Tennessee State University, and won the Miss Black Tennessee beauty pageant. Her broadcast career began at Tennessee State on a local radio station. When she started to anchor the news at Nashville's WLAC-TV, she was not only the youngest anchor, but also the first black woman anchor in the station's history. In 1976 she moved to Baltimore to coanchor WJZ's six o'clock news, and then cohosted a local talk show and a local version of Dialing for Dollars. In 1983 she

moved to Chicago to take over WLS's low-rated morning talk show AM Chicago. Within morths the show had passed Donahue and was Chicago's highest-rated talk show. Renamed The Oprah Winfrey Show in 1986, Oprah decided to go national at a time when the experts "knew" the country was not ready for a black woman host of a talk show.

In the preceding year, the country had been introduced to Oprah. Her role as Sofia in The Color Purple won her a nomination for best supporting actress—but a nationwide TV talk show host? Many of the stations that picked up her syndicated program were last in their markets with nothing to lose. Astoundingly, Oprah quickly passed Phil Donahue, the reigning talk show king, and soon had double his audience. Critics and experts were perplexed, and most reacted with left-handed compliments at best. Time magazine wrote, "Few people would have bet on Oprah Winfrey's swift rise to host of the most popular talk show on TV. In a field dominated by white males, she is a black female of ample bulk." A TV columnist referred to her as "a roundhouse, a full-course meal, big, brassy, loud." The Wall Street Journal was marginally kinder when it reported: "It's a relief to see a gab-monger with a fond but realistic assessment of her own cultural and religious roots." But it was Newsday who hit the nail on the head when a columnist wrote, "Oprah Winfrey is sharper than Donahue, wittier, more genuine, and far better attuned to her audience if not the world."5

Since that time Oprah has founded a successful production company, cofounded the cable television network Oxygen, published two successful magazines, produced a musical version of The Color Purple, founded a website visited by 3 million people monthly, cowritten five books, developed a channel for satellite radio, and agreed to produce two new reality shows for ABC. To quote Bill O'Reilly, "I mean this is a woman that came from nothing to rise up to be the most powerful woman, I think, in the world . . . and she's done it on her own."6

> William J. Adams, Ph.D. Kansas State University

Game (1966), and Love Connection (1984) all drew on our natural curiosity about the personal lives of others. In the twenty-first century, that has all changed. The relatively sweet, innocent relationship programs of the past that masqueraded as game shows have yielded to voyeuristic hook-up segments. Programs such as Blind Date, Elimidate, Extreme Dating, and 5th Wheel focus less on locating Mr. Right and more on finding Mr. Right Now.

Afternoons fill with talk because it is absolutely the cheapest programming, and afternoon HUT levels are too low to justify anything else. Occasionally, a station will run a sitcom that failed in a higher-revenue time period or a sitcom that has outlived its usefulness and is being programmed purely for amortization purposes.

Early Fringe (4 to 7 P.M. EST/PST//4 to 6 P.M. CST/MST)

This daypart's unusual name harkens back to the first 25 years of commercial television, when this time period immediately preceded prime time (which started an hour earlier than it does today). Therefore, the hours before prime time were said to be on the "fringe" of prime time and, thus, *early fringe*.

For the networks, early fringe is a low-priority time period when the tide of network soap operas in the afternoon ebbs. From 4 to 7 P.M. (4 to 6 P.M. central/mountain time), the networks rely on their affiliates to schedule local news or syndicated talk. Industry research has consistently demonstrated that the best lead-in program for a newscast is . . . more news! This is intuitive: Viewers who are predisposed toward watching any one newscast are interested in news and therefore more likely to watch an additional newscast than would a viewer who doesn't usually watch the news. The results of this research happily match the budgetary facts of life for news production: that it is expensive to start a news operation but relatively economical to expand it. Over the last 15 to 20 years, newscasts have replaced expensive and unpredictable syndicated programs at 5 P.M. In the largest markets-New York, Los Angeles, Chicago, and Philadelphia among them—newscasts start as early as 4 P.M.

A station can generate more advertising revenue in early fringe than in prime time with a judicious combination of programs. HUT levels during early fringe, while not as high as those in prime time, nevertheless average two-thirds of prime viewing. During winter months, especially, viewing spikes upward once darkness falls. In this time period, station programming strategies generally have either a news or an entertainment orientation. As the afternoon progresses and older children return home from school, followed by employed adults, the average age of the audience increases, and so does the appeal of the programs. This technique of matching program content to changing demographics is called aging an audience, and most stations, whether news- or entertainment-oriented, follow this pattern in the daypart.

The most content-malleable of programs, newscasts vary their topics over the course of this daypart to go along with the audience. The earlier afternoon newscasts tend to be lighter on news, emphasizing the features and afternoon rush-hour reports that reflect the interests of the available audience. As the afternoon wears on into early evening and more paycheck-earners return home, the news becomes harder-edged, with more news content and less fluff. News stations surround their newscasts with news-compatible programs. These programs might be such female-oriented talk shows as Oprah or Dr. Phil or such court shows as Judge Judy or People's Court. Oprah is the number-one talk show in syndication (see 6.8). This program is scheduled with devastating effect in most markets at 4 P.M., and it funnels viewers into the local newscast. Oprah's ratings frustrate competing stations' attempts to get ratings traction in the late afternoon. Only when a show with an equally strong personality comes to the television screen, like Dr. Phil, is Oprah challenged.

Stations that decide not to compete head-to-head against the Big Three affiliates' newscasts usually opt to counterprogram—with comedy. While news attracts an audience that trends older, with higher-than-average incomes and education—by contrast, comedy audiences in early fringe are younger, but they are also less affluent and less well educated. One might find young-skewing sitcoms appearing at 4 or

5 P.M. (My Wife and Kids, Reba, The Nanny), followed by slightly older or family sitcoms opposite the news programs (The Simpsons; King of Queens; Yes, Dear; Still Standing), which in turn are followed by the strongest sitcoms on the station's schedule in access (Everybody Loves Raymond, Will & Grace, That '70s Show, Friends, Seinfeld).

Whether a station is programming from a network, syndicated, or news/local source, it wants to retain as many of its viewers as possible through the sequence of programs in its schedule. As explained in Chapter 1, this is called audience flow: the strategy of scheduling programs similar enough in appeal that current viewers will stay with the next program while new viewers tune in. As the audience composition changes during the day, the program lineup changes along with it. But as 6.9 discusses, the strategy of seeking flow has been challenged by the growth of cable.

Prime Access (7 to 8 P.M. EST/ PST//6 to 7 P.M. CST/MST)

In television's infancy, prime time started at 7 P.M. (6 P.M. central/mountain time). As the industry reached adolescence, most of television's participants-stations, advertisers, producersbelieved that the networks exercised a stranglehold on both the access to the airwaves and the pricing of advertising and production. After years of lobbying pressure, in 1970 the FCC imposed the Prime-Time Access Rule (PTAR). In essence, PTAR prohibited stations from running more than three hours of network-originated entertainment programming per night during prime time. (Recall that the FCC cannot regulate networks; the FCC's writ extends only to the stations it licenses. Networks are not licensed and therefore cannot be regulated by the FCC. There is a backdoor, however; the FCC can regulate the stations—that is, the O&Os—that a network owns.)

The impulses behind the FCC's Rule were twofold, and while the first was idealistic, the second was as subtle as a blow to the head. The first impulse was to create opportunities for stations to produce their own local programs, given that their mandate from the FCC was to operate in the

The Impact of Remotes and DVRs

low is not as critical a concept as it once was. Before cable brought multiple channels to the home screen and before ubiquitous remote control handsets made channel changing a pushbutton procedure, the viewer had to physically rise from the sofa to change the channel. The incentive to change the channel had to be greater than the inertia to remain on the sofa. Once a channel was selected, the viewer tended to stav with that station for the rest of the evening, and programming executives obsessed over the idea of program flow. Today, with hundreds of viewing options available and the ability to change channels as easily as pushing a button, viewers can surf channels at whim. In addition, DVRs make saving programs or stopping momentarily (without missing anything) easily possible. Flow is a fading programming strategy, and the objective of consumer retention now takes place in an infinitely more challenging universe.

public interest. This opening gave stations access to prime time; hence the name of the new daypart: brime access or just access.

The second impulse behind the Rule was to create a more level playing field between the following:

- The networks and their affiliates
- The networks and the advertising community
- The networks and the program production community

After initially celebrating their victory over their network partners, suddenly affiliates realized that they had to come up with one hour of programming each night. Not only was making programs a costly time- and labor-intensive proposition, but it turned out that the public as a whole wasn't interested in watching the second-rate programming that was produced.

Into the breach came the program producers, creating new programs for what formerly was prime time. The viewers were there, the advertisers

were there, and the games and magazines appeared. A handful of first-run syndicated shows (Wheel of Fortune, Jeopardy!, Entertainment Tonight, Extra. Access Hollywood, Inside Edition!) have dominated the ratings in this time period for many years. The magazine shows are hybrid programs consisting of entertainment, show business, and celebrity news wrapped in a newscast format. The upside is that, unlike sitcoms in syndication, which can be expensive and risky, magazine programs are plentiful. The rough equivalence of supply to demand results in stable purchase prices. Plus, entertainment talk and celebrity news never seem to go out of style, which results in steady ratings and predictable advertising purchases, an ideal scenario for a business characterized by novelty, fads, and the fickleness of public tastes. As a result, new shows have a tough time breaking through. Demographics play a key role in selecting programs, especially for stations that cannot buy the top show but can counterprogram to a different advertising target (for example, men aged 18 to 49).

Prime Time (8 to 11 P.M. EST/PST//7 to 10 P.M. CST/MST)

This marquee time period for the networks is discussed in detail in Chapter 4. Viewing levels are highest, industry prestige is highest, and potential advertising revenue is highest during this daypart, and for Big Four affiliates, profit margins are higher than in other dayparts. Affiliates preempt these most visible of network-supplied dayparts carefully—only with cause.

There is local programming in prime time; it is news. The FOX, CW, MNTV, and ION networks supply their affiliates with only two hours of programming nightly, not three as the older networks and Hispanic networks do. FOX, in particular, has compelled its affiliates to program local news immediately after two hours of prime time—at 10 P.M. eastern/Pacific, 9 P.M. central/mountain. This is not just a bold counterprogramming move (news against three entertainment choices); It allows FOX affiliates get a one-hour jump on the affiliates' late newscasts as well; many early risers cannot stay awake past 11 P.M. to watch news.

Many affiliates of the smaller three networks, with only a two-hour supply of network primetime programming, follow the path of FOX. News departments are a profit center for major broadcast stations, and the facilities (or more commonly, the output) of a big news department can be leased to a smaller station in the market that lacks the budget to produce its own newscast. Many UPN and WB stations thus outsourced their newscasts. airing news produced for them by larger stations (usually ABC, CBS, or NBC affiliates) in their markets. These newscasts are not time competitive for the Big Three affiliates but run at the earlier hour while these affiliates still carry network shows. All of the advantages of newscasts come together with an early late newscast.

- It counterprograms the broadcast and many cable networks.
- It gives the station a one-hour jump on the affiliates' local news.
- It gives access to broadcast-wary advertisers.
- It fulfills a station's public service requirements.
- It gives a high-ratings track record in the time period.
- It displays the station's identity in a highvisibility time period.

Another advantage, albeit more minor, that comes from the news franchise is the occasional practice of repeating the late-fringe newscast during the overnight hours. While it might at first seem that a news rerun is stale programming, there are viewers who did not watch the original telecast, and the "news-lite" content of much local news does not detract from its timeliness. Also, there is no programming cost for a repeat, unlike the cost (in dollars or advertising time) of an outsourced program from a syndicator.

Late Fringe (11 to 11:35 P.M. EST/PST//10 to 10:35 P.M. CST/MST)

As dayparts are delineated to reflect the typical behavior of the "average" viewer, a new daypart comes into play at 11 P.M., as older viewers begin getting ready for bed and younger viewers eventually turn from the internet to television. Late fringe is another example of the interconnectedness of the network-affiliate relationship. The local affiliates of ABC, CBS, and NBC rely on their networks to provide popular programs during prime time, thus generating a strong lead-in audience for local late news. Even though news viewing for any given station is acknowledged to be a form of habit, viewers do not always act like they are "supposed to". Local affiliate late-news ratings can spike up or head downward, depending on the network leadin. HUT levels, however, start dropping precipitously around 11 P.M. (10 P.M. central). The Big Three networks, after three hours of prime programming, take a rest and throw the time period back to their affiliates, which invariably program their own local news.

With three hours of prime-time programming momentum as a lead-in, late fringe is a key ratings and revenue daypart for a Big Three affiliate. In the early days of television, late news was regarded as little more than an update of the early-fringe newscast, but in recent years, with the advent of the 24-hour news cycle and cost efficiencies in news production technology, late-news programs are regarded as separate programs and are important profit centers.

As a revenue-enhancement technique, affiliates of the Big Three networks stretch their newscasts to 35 minutes in late fringe, creating another commercial break. Going to all that trouble to add just one more commercial break might not seem like a dramatic addition, but over the course of one year, the arithmetic compounds into large multiples. If four commercials are placed in that extra pod five days a the week, 52 weeks a year, that translates into 1,040 extra commercials in a year. If a large-market station charges only \$2000 for a commercial, adding just one more break means \$2,080,000 gross dollars in a year—with virtually no additional costs to generate that revenue! An intelligent media executive can turn a minor scheduling change into a financial "force multiplier."

Not everyone wants to watch news before going to sleep, or perhaps some viewers watched an earlier newscast. These viewers are likely customers

for the many kinds of syndicated entertainment programs available. Stations not airing news have a wide choice of syndicated programs to offer viewers uninterested in news and information just before going to sleep. Late fringe is a strong time period for stations without a network feed; the strongest ones often outperform local affiliate news. FOX-owned stations during the last few years have adopted the strategy of acquiring top-performing (and expensive) off-network sitcoms as a counterpunch to what they see as the sameness of local news. Seinfeld and Sex in the City work well here. Even stations with smaller program budgets can select from a wide range of first-run barter programs with appeal to all parts of the demographic spectrum.

With the rise in the popularity of talk shows, another effective programming move has been to schedule a repeat telecast in late night for viewers unable to watch the original telecast during the day. Oprah, for example, has been rerun late at night in several large markets, including New York, Los Angeles, Chicago, and Philadelphia. Smaller stations also rerun daytime content, soaps, games, and sitcoms—or turn to older movies.

For the programming executive, one advantage of late fringe over early fringe is that late fringe reaches an elusive quarry-men (particularly young men) aged 18 to 49 or 25 to 54. Men watch less television overall than women or childrencalculated either by hours spent watching or variety of programs viewed. Young men, in particular, are more likely to watch narrow categories of broadcast programs: sports, some action-oriented movies, and more sports. In late fringe, however, men are available, and in addition to sports they do watch comedies and risqué, first-run late-night programs, making these shows ideal for stations that can program to appeal to men.

Late Night (11:35 P.M. to 2 A.M. EST/PST//10:35 P.M. to 2 A.M. CST/MST)

Affiliates of CBS and NBC virtually always clear their network's programming during this daypart— The Tonight Show with Jay Leno, followed by Late Night with Conan O'Brian; and Late Show with David Letterman, followed by The Late Late Show with Craig Ferguson. Counterprogramming with more serious fare, ABC covers the newsbeat with Nightline, followed by the lighter Jimmy Kimmel Live. The overwhelming majority of Big Three affiliates are content because these programs attract larger audiences than they could lure with first-run or off-network syndicated programs. Moreover, the program content is not as restricted as it is in prime time because there is presumably no children's audience at such a late hour.

For the competing stations, late night is an ideal time period to experiment with offbeat syndication ideas. HUT levels are relatively low, so a failed idea will not hurt much financially, and an unexpected hit can generate a long-term occupant of a latenight time period. Expectations are not very high; there are disproportionately more men available, and if a program is a hit, it can make money in the daypart and perhaps even be moved to a daypart that generates higher revenues.

Overnight (2 to 6 A.M.)

Networks do not program first-run entertainment overnight because HUT levels are too low to justify the costs of daily production and distribution. Thus, overnight becomes an arena for repeated telecasts of syndicated programs and repeated newscasts as well as a sanctuary for failed programs or old movies to fill the long predawn hours.

Although HUT levels are at their nadir (about 10 percent) and the time period is a low priority, stations wisely do not completely ignore these hours for three reasons. First, in the 24-hour world, some viewers are always available at all times, and advertisers can still be found to buy commercial time, even if at very low rates. (Commercial spots run in very cheap time periods are rather affectionately called "a-dollar-a-holler.") Even if an overnight commercial costs as little as 20 dollars, a small news station may air two dozen of them per hour or 100 per overnight period. Multiply \$20 by 100 commercials a night, seven nights a week, 52 weeks a year, and the result is a not inconsiderable \$728,000 per year. Every time period counts, and every dollar counts.

A second important reason for not ignoring overnight is more tactical. If the station signs off the air, the local cable company might use the now-empty channel space to carry a service with content that might alienate the broadcaster's regular viewers when they turn the television on the next day. The content could be as mild as a homeshopping channel or as spicy as an adult movie service. Suffice to say that the station wants to keep control over all programming coming from "its" cable position.

Third, if a station signs off, the few viewers who were still watching at that hour will turn away to another channel. When they turn the set on again, it will be on a different channel. Why invite customers to sample a competitor? There is enough free or cheap programming, combined with old movies, to fill up the overnight schedule. All else failing, another format ideally suited for late night is that of the infamous program category known as infomercials.

Between midnight and daybreak, little locally produced news exists. The syndicated *Poker After Dark* is as popular in the middle of the night as anything could be. If stations want news overnight, they either clear the overnight services offered by ABC (*World News Now*) or CBS (*Up to the Minute*) or go into the syndication marketplace to broadcast, for example, CNN's broadcast service or specialized newscasts offered by other program vendors. Financial newscasts are becoming increasingly popular, given the universal viewer interest in the subject of money and the advertiser attraction that upscale viewers represent.

Weekend Programming

On Saturdays and Sundays, networks readjust their programming away from their heavy viewers (women) to attract the demographic that watches most of its television during the weekend: men. Predictably, sports programming dominates the screen on weekends, especially on affiliates of ABC, CBS, FOX, NBC, TeleFutura, Telemundo, and Univision. Advertisers are willing to pay a premium rate to attract men, who watch little in prime time but account disproportionately for expenditures on

big-ticket items (automobiles, financial services, sporting equipment) and specialty purchases (alcohol, men's personal care). Even with relatively low HUT levels, affiliates find their adjacencies in top network sports events enormously valuable. If a station's network is not providing sports programming, odds are that the affiliate is counterprogramming with female-oriented movies or similar syndicated fare, although a few stations go after teens with weekly syndicated dating programs.

Station Promotion

A station's two constituencies, viewers and advertisers, need to be continually reminded of the existence of specific station programs. While the promotion manager is ultimately responsible for *promoting*, *advertising*, and *publicizing* the schedule, the programmer's intimate knowledge of program audiences and viewing behavior may be invaluable for designing on-air promotional announcements.

On-Air Promotion of Programs

Among all the mass media available for publicizing a lineup, the station's own air time is the most effective for reach- and cost-efficiency. The station's loval viewers can easily be located in the market—they are already watching the channel! The station can then redeploy its unsold advertising time by scheduling on-air promos. To ward off the sales manager's pressure to preempt important promos to place last-minute commercial buys, stations will often reserve a position for a promo, called a fixed spot. Very generally speaking, these fixed spots are the equivalent of a 30-second spot in each network hour or a 30-second spot in each half hour of syndicated programs. A promo might be dedicated to one program or to two or more programs. The latter is called a combination spot, or combo spot. With sales pressure always on, stations favor combo spots for two reasons: It is more efficient to promote as many programs as possible in one space (or amount of time), and using combo spots increases the chances of program flow.

The trend in the last several years has been toward fewer on-air promos. Since many former independents have aligned with the newer networks, much of their promotion comes from their networks in prepackaged spots. Also, consolidation has compelled corporate owners to eschew the longterm strategy of brand-building in favor of running more commercials (and thus fewer promos) to meet short-term financial targets. Having said that, the fundamental principles apply. The most practical way to design an on-air promotion strategy is to remember that "like goes to like." In other words, similar programs or programs with similar audiences should be promoted toward each other. The trade name for this technique is cross-promotion. The station sets its priorities for on-air promotion according to two criteria: the potential profitability of the program and the importance of the program to the station's overall branding strategy.

One category of programs generally fits both criteria: local news. Local news is one of the station's most significant profit centers. The local-production aspects of local newscasts make this program genre amazingly customizable in content, audience appeal, and commercial format. News programs remind viewers of other news programs; therefore it makes sense for the 7 A.M. network news to contain a promo for the 12 noon news. The noon news likely will promote the next news program at 5 P.M. The early-fringe newscast will promote the next newscast, and during prime time, there will likely be several reminders to "stay tuned for the late news."

There are two general kinds of promos: topical and image. For newscasts, a topical spot is a promo about a specific story: the update on the day's biggest trial, or a live shot of a traffic accident accompanied by a promise of coverage of the wreckers hauling away the vehicles during the next newscast. A topical promo is timely and story-specific. By contrast, an image spot for news should create a general impression of the news product's overall identity in viewers' minds. Typical image spots might be fast-paced scenes of anchors in motion who are interviewing people out in the field, prodding unseen faces over the telephone to make dramatic revelations, then racing to the news

set with their hot stories just in time for the beginning of the program. (Irrespective of whether this is what they actually do, such promos are designed to create positive images of experienced, professional journalists.)

Topicals and image spots are also the norm for nonnews program promotion. After the news promos are scheduled, the remaining promo time is allocated according to station needs. Most often, the lion's share of promos belongs to the programs that produce the highest revenues, for example, those programs during early fringe and access. Lastly, those programs "on next" usually get a promo—a vestige of the time when the forces of program flow were stronger than they are today.

Promotion in Other Media

Outside media—radio, newspapers, billboards traditionally occupied a large proportion of the television station's advertising efforts. Over the last several years, however, the downstream effects of deregulation have created many unintended (and unforeseen!) consequences, largely as a by-product of concentrated media ownership. For example, before the Telecommunications Act of 1996 became law, a company could not own more than one (two, if grandfathered) radio stations in a market. If an average-sized market had 20 or 30 stations, ownership was sufficiently spread out that advertising rates were kept competitively low, and advertisers could make cost-efficient and frequent radio buys. Today, however, when companies can own up to eight radio stations in a market, radio ad rates are too aggressive (meaning very high) for television stations to afford the same kind of saturation radio campaigns seen just a few short years ago.

Cable, too, is starting to price itself out of the broadcast advertising market, particularly in those markets with a heavy concentration of ownership or an aggressive interconnect (electronic connection among a consortium of separately owned but geographically contiguous cable companies). Although the price per commercial seems beguilingly low on many channels, the number of viewers per cable program is so small that it drives the cost-per-viewer price inefficiently upward. *In short*,

television is a victim of its own attractiveness as an advertising vehicle. Compared with other media, television remains the most cost-efficient buy—but that efficiency is declining.

One solution for most stations has been to develop enticing internet sites that both supply extended content for viewers who want more news and program information, and promote the station's news, programming, and overall image. The downside of internet promotion is that only viewers who make the effort to go to the site are exposed to the promotion, and network sites tend to be bigger lures than local station sites—except in the area of local weather and local events. Thus most web programmers place sidebars that promote entertainment alongside key news items—to draw the user's attention to additional content that is above and beyond what drove the person to the site.

What Lies Ahead for Stations

Predicting the future of the local television station business has been difficult for the last decade. On one hand, the technology is moving away from program-source scarcity to program-source abundance. On the other, media corporations are deriving their best profit margins from local affiliates.

Digital Technology

The number-one threat to over-the-air broadcasters (as well as advertising-supported subscription television) comes from technology that frees the viewer from the tyranny of passive viewing: digital video recorders (DVRs), portable handheld media, and, to a lesser extent, video-on-demand. Although these technologies have done little harm to broadcast revenues so far, their household penetration is likely to be swift; certainly some attrition had become noticeable by the mid-2000s. Losing control of viewers spells the eventual end of commercial breaks as they presently exist because DVRs allow viewers to "skip over" breaks entirely. Unlike the VCR and DVD, which are largely auxiliary devices that viewers might or might not choose to use, the DVR intrudes significantly on the viewing PART TWO

process by enhancing the viewing of live or real-time programming. As the country shifts over to digital television sets, the set-top boxes (that don't go on the top of sets anymore because flat-screen sets are too skinny) increasingly incorporate DVR functionality.

The remarkable thing is that digital television and DVR use is not diffusing slowly the way new media technologies have in the past-instead, in a period of less than three years, digital has almost totally supplanted analog television. The newest generation of converters allows for storing lots of recorded programs in memory and represents a marriage between the computer and the television set, a plus for cable and satellite viewers but not for broadcast stations.

On the other hand, the predominant motivation to watch television is to relax. Given their history with new technologies, it is clear that much of the American audience is unwilling to read any instructions, learn any sequences or steps, or wait for their TV set's operating system to boot up. The safe money says that new media innovations should bend over backward to accommodate Jerry Springer fans in such a way that they won't need to know about bandwidths or protocols—so they can swim in the digital stream without understanding it. All of this is predicated on the effective design of very smart converters and their remote controls, of course, and because there are so many ifs, broadcasters must watch and worry.

Competing Newscasts

It is an axiom of the business that news will continue to be a mainstay of television programming into the indefinite future. Television's eternal appeal is that it is a "live" medium. No other medium has the immediacy of television. Increasingly sophisticated and miniaturized technologies give stations a level of production quality and time-responsiveness that were unimaginable only a few short years ago. In addition to providing an advertiser-friendly environment, stations can mold their newscasts to create market identities derived from their network, syndicated, and local programming.

The main challenge will be competition, not just at the local level—where competitors are expanding and upgrading their news product—but also from competing industries jumping into the news business. One of the viewer benefits arising (albeit indirectly) out of the massive consolidations in cable ownership in the 1990s is that many cable franchises in large markets now offer around-the-clock local news channels of their own (see Chapter 8). To varying degrees, these local news channels are like mini-CNNs. They represent a serious threat to the dominance of broadcasting as a local medium because their lack of network commitments means they can cover ongoing local stories as they unfold during the day, whereas broadcasters usually are forced to wait until their regularly scheduled newscasts. Moreover, local cable news shows can undercut the relatively high advertising rates of broadcast newscasts by offering more commercial availabilities, lower spot rates, and more flexible packaging opportunities to local advertisers. What is particularly grating to affiliates is that some of these national and local news outlets are owned by their own network partners! (For example, News Corp. owns Fox News Channel as well as the FOX Broadcasting Network; Time Warner owns CNN as well as New York 1 News.)

Other emerging competitors are the internet and mobile media. Use of the internet for news programming offers the ultimate of both extremes: global instantaneous distribution and individualized news products for the consumer. At present, the web's news capability rests largely in distributing news that is originally generated for television or print and then adapted for the internet, accompanied by mountains of professional and amateur blogging. It was thought that true news competition would wait until computers were as easy to use and as plentiful as television sets, but then Wi-Fi proliferated, making computers mobile. People began accessing news from practically anywhere they could open a portable computer. Next, cell phones, personal assistants, and music players added video to their equipment, meaning internet access could be truly anywhere, anytime, if a bit reduced in size.

At this writing, the major media companies are extending themselves into all these new media, using their branding power to stake claims to content areas in an attempt to follow the audience wherever it goes. Although internet-generated news products are not yet profit centers for their participants, the ultimate profits and marketing advantages of these new media are too potentially enormous to be ignored.

Channel Migration

As of February 19, 2009, all analog television transmission stopped, and television stations began sending digital signals. The largest stations (and networks) broadcast now in high definition-which uses the entire allotted bandwidth—but many stations have chosen standard definition with the option of multiplexing additional signals. So far, the options for paid use of that extra bandwidth are scarce, but it is expected to become a revenue stream that will help cover the enormous cost of digitalizing station facilities. Individually, broadcasters have spent millions of dollars per station to purchase and assemble the new-generation electronic equipment required to transmit digital signals on a wider bandwidth, but high-definition content has been slow to appear.

Two advantages to broadcasting a digital signal are pertinent to stations. The first is the option to send high-definition images with greatly improved color and increased clarity. Because a digital signal has no attenuation (loss) as it travels the link from point of origination (network or station or cable system or satellite) to the home, the program picture is demonstrably superior to the analog method of transmission. The resolution is at least comparable to that of a feature film in a movie theater.

The second most-salient characteristic of a digital signal is wider bandwidth. To broadcast in high definition with excellent clarity, each station has been allotted the signal equivalent of six analog channels. If the station chooses not to broadcast in high definition, the station, in effect, has up to five more digital channels. The problem is that there is never enough desirable network or syndicated programming in the marketplace—whether high definition or not—so stations need to locate or create some kind of program services to occupy the empty channels. Stations will be faced with

daunting choices in the management of their new frequency space. Their three options include the following:

- 1. Broadcasting in high definition, using the entire bandwidth, during most or all hours
- 2. Reselling all or a portion of the channel bandwidth to another programmer
- 3. Offering a specialized service, such as an all-weather service, all-traffic service, all-news service, or all-classified-ad service alongside a non-HDTV service

But the FCC may eventually require some number of hours of HDTV and may place limits on reselling or reusing channel bandwidth. Because of pressure from other users of the airwaves, the FCC may also reclaim bandwidth resources from stations long before many are ready to give them up. Another problem is that more than 90 percent of homes get their broadcast television from cable and satellite operators who must pass on multiplexed and high-definition signals to their subscribers, or the subscribers only get to "see" regular television. And the operators are concentrated on pay-per-view and video-on-demand—not hi-def as yet.

The Mutation of Broadcasting

Network affiliates are no longer the exclusive electronic gatekeepers to their markets. Their former monopoly of access to the viewer is fading because cable, satellite, the internet, and the telephone are all breaching the ramparts of local exclusivity. Although broadcasting has traditionally been a free service, the American consumer is increasingly becoming accustomed to paying for media. Smaller companies owning stations in markets with network-owned stations but not producing programs themselves face heavy leverage and consequent pressure to sell to the larger companies. The traditional local orientation of broadcasting has begun to flicker, to be rekindled by industries that have economies of scale on their sides: cable and the internet. These competitors now provide not only local service but also increasingly customized entertainment and news content to individual consumers.

Broadcasting of some sort will stay around because it is universal and free, which is in the nation's best interest, but the number of stations per market may fall drastically in another decade or so. For the foreseeable future, however, local broadcasting will remain a highly profitable business.

Nonetheless, the maturation of the television industry means that the original business model of distant networks and local affiliates is disintegrating. Competition from newer media means that free television has to resign itself to no longer being the biggest and gaudiest float in the television parade. Video entertainment has become global, instantaneous, and customizable in a way unimaginable just one generation ago. Local stations were once the sole gatekeepers, and now they survive by adapting themselves to those niches in which they can be competitive. Despite the fears of media Cassandras who prognosticate the end of broadcasting, however, history tells us otherwise: Television did not kill off the movie industry, FM radio did not eliminate AM, cable did not eliminate local broadcast, and satellite-delivered television did not defeat cable. Instead, each industry had to adapt itself to the new challenge.

Like many businesses, broadcasting is organic: It expands, contracts, mutates into different forms. Unlike many businesses, broadcasting is a fascinating mix of technology, creativity, and commerce. The impacts of computers, digital technology, and regulatory requirements are strong but not fatal. In the 1930s, even before U.S. commercial television began, RCA Chairman David Sarnoff predicted that television would someday become a "video jukebox," a programmable device that would be under the control of the user. That day of liberation appears to be arriving, and how broadcasters respond will determine whether they settle into a lowbrow form of entertainment or rise to become part of a new Golden Age of Television.

Sources

Mogel, Leonard. This Business of Broadcasting: A Comprehensive Guide to the Broadcast Industry for Job Seekers and Working Professionals Alike. North Hollywood, CA: Billboard Books, 2004.

Snider, I. H. Speak Softly and Carry a Big Stick: How Local TV Broadcasters Exert Political Power. Self-published through iUniverse, 2005. www.jhsnider.net/. www.abc.com www.adage.com (online version of Advertising Age magazine) www.broadcastingcable.com www.cbs.com www.fox.com www.hollywoodreporter.com www.katz-media.com www.mediaweek.com www.nbc.com www.tvweek.com www.variety.com www.warnerbros.com www.upn.com www.fcc.gov

Notes

- 1. This disproportionate amount of discussion of FOX's raid indicates the level of disruption that FOX caused in the relatively calm network landscape. It was as if a starter's gun had fired, and all networks and affiliates scrambled for new partners. Murdoch's audacity created turbulence, which distracted his competitors, thus leveling the playing field for him. The raid gave FOX a chance to be sampled by new viewers and, not incidentally, to deeply wound a major competitor. If there was any doubt about Murdoch's intentions when he started his network in the 1980s, it was now clear that the game was being played for keeps. And he did it again after CBS and Time Warner closed UPN and the WB and cozied up to form the CW. FOX's left-out stations got their own competing network, MNTV.
- 2. For an unsurpassed anthology of hilarious, believe-it-or-not stories of television during its first decades, read The Box: An Oral History of Television 1920-1960 by Jeff Kisseloff (Viking Press, 1995). The book is currently out of print.
- 3. Murrow (1908 to 1965) was one of the earliest broadcast journalists to achieve professional notoriety and, later, celebrity. Murrow joined the CBS Radio Network in 1935 and was sent to Europe in 1937. He is most remembered for his on-scene reporting of harrowing Nazi Luftwaffe bombing raids in London during World War II. Morrow moved to television after the war. His onscreen news career notched highs (with his award-winning documentary series See It Now) and lows (he hosted Person to Person, an early personality-interview program, during which Murrow

often looked physically stricken to be interviewing celebrities rather than newsmakers).

4. News is a money-loser for networks. Budgets for production, talent, and the overhead of maintaining many news bureaus are gargantuan, but the prestige value of being number one in news spills over beneficially into other network programming endeavors. (Additionally, news budgets can be spread over early-morning newscasts and, increasingly, prime time.) Network evening news ratings have been damaged by the rise of CNN, MSNBC, Fox News, and 24-hour news services on the internet and mobile media. Consumers and viewers correctly reason, "Why wait until evening for the news, when I can have it right now?" Consequently, news viewership on broadcast television

has not only declined but also has become demographically older, poorer, and more downscale, and thus less attractive to advertisers. News, however, is a prestige part of network programming, and it will likely remain so indefinitely. In the last few years, the network news divisions have tinkered with their content, changing the focus from harder-edged international and political stories with remote personal consequences to more individualized issues such as health, education, and personal finance.

- 5. See http://en.wikipedia.org/wiki/OprahWinfrey, p. 2, for these quotes.
- 6. http://mediamatters.org/items/2006102400G3, 17 October 2006.

7

Public Television Programming

John W. Fuller and Douglas A. Ferguson

Chapter Outline

Program Philosophy

The Network Model

Station Scheduling Autonomy The Carriage Agreements

PBS Responsibilities

Types of Station Licensees

Program Production

Program Financing The Major Producers Balance in Selection

Syndicated and Local Programming

Noncommercial Syndication Noncommercial Adult Education Commercial Syndication Local Production

Scheduling Strategies

Counterprogramming the Commercial Networks

Stripping and Stacking Limited Series Audience Flow Considerations at the Station Level

National Promotion

Audience Ratings

Nielsen Data Audience Accumulation Strategy Loyalty Assessment Demographic Composition

Developments Ahead

Sources

Notes

ublic television, its mission, and its public service objectives occupy a unique position in American broadcasting. (See Chapter 12 for a discussion of public radio.) Contrary to broadcast development in nearly every other country in the world, public service broadcasting in the United States developed long after the commercial system was in place. This fact has had an immense effect on the general public's attitude toward American public television programming and on public broadcasters' self-definition.

The public debates whether public television programs are even necessary and whether they should occupy the time and attention of the nation's communications policymakers in Congress, the executive branch, and the FCC. Opponents of public broadcasting argue that the advent of such distribution developments as large-capacity cable systems, direct satellite broadcasting, DVDs, and so on obviate the need for public television. Proponents counter that the marketplace fails to provide the specialized programming that public television offers and that any belief that emerging

technologies will be different from existing media is unfounded.

At this writing, the future of the Public Broad-casting Service (PBS) is not rosy. PBS went from an average 2.0 rating overall in the 1999–2000 season to 1.5 nationally in the 2004-05 season, not a precipitous drop but a troubling trend. A more serious problem for PBS was the loss of a third of its corporate underwriting between 2001 and 2004, partly because of a tough economy and partly because some past sponsors migrated to support competitors on basic cable, where they can also run advertising. Even public broadcasting in Europe has undergone a transition (see 7.1).

Program Philosophy

The debate over programming content has persisted within the industry since public television began. For stations, the debate centers on the meaning of noncommercial educational broadcasting, which is what the Communications Act of 1934 and

7.1 Public Broadcasting in Europe

ntil recently, the European model of public television was viewed by many American public broadcasters as the ideal situation: strong government support for a public system that predated commercial broadcasting. But as Eric Pfanner wrote in 2004*, the winds have changed in European public television. By the turn of the century, England, France, and Italy were experiencing woes with public broadcasters. The British Broadcasting System (BBC) and France 2 came under fire after journalists made egregious mistakes in their reporting. In Italy the RAI lost autonomy when Prime Minister Silvio Berlusconi (himself a media mogul on the same level as Rupert Murdoch or Ted Turner) accused the public network of bias.

Just as some complain about the cost of supporting the Corporation for Public Broadcasting in the United States (which in turn funds public

television and radio), some European viewers and commercial companies have begun to object to the \$25 billion from license fees or taxes spent on public TV and radio in Europe. Also, private broadcasters view public networks as unfair competitors, and by the mid-2000s, the main issues had become competition between state-run and private networks (Germany), political interference from leaders (Italy), and outright media bias (France and England). In particular, controversy over the BBC's reporting of the Iraq War became an untimely issue for the BBC, whose charter is to be reexamined in 2006. (Anyone in Britain with a television set must pay £131.50 a year, about \$250 in the United States.) Some observers believe that digital services will make public broadcasting obsolete and that government subsidies will eventually give way to more commercial or hybrid services in both Europe and America.

^{*}Eric Planner, "State-Aided Broadcasting Faces Scrutiny Across Europe," International Herald T-ibune, 16 February 2004. www.nytimes.com/2004/02/16/business/worldbusiness/16stater.un.html.

the FCC call public television's program service. Noncommercial service came into existence in 1952 when educational interests lobbied the FCC into creating a special class of reserved channels within the television allocations exclusively dedicated to "educational television."

One argument defines *educational* in the narrow sense of *instructional*. From that viewpoint public television should teach—it should direct its programs to school and college classrooms and to out-of-classroom students. The last thing PTV should do is to compete for commercial television's mass audience. Others define *educational* in a broader sense. They want to reach out to viewers of all kinds with programs that enrich lives and respond to needs. This group perceives "instructional" television as a duty that sometimes must be performed, but their devotion goes to the wide range of programming the public has come to think of as public television.

The Carnegie Commission on Educational Television introduced the term *public television* in 1967. The Commission convinced many in government and broadcasting that the struggling new service had to generate wider support than it had in its fledgling years. One of the impediments to such support, the Commission felt, was the word *educational*, which gave the service an unpopular image. They suggested *public television* as a more neutral term. Thus, a distinction has grown between instructional television (ITV)¹ and public television (PTV).

Lacking a truly national definition for public television's program service, a PTV station's programmer must deal with the unresolved, internal questions of what it means to be a noncommercial educational broadcasting service. The PTV programmer must come to grips with a station's particular program philosophy. Philosophies vary widely from one station to the next, but two common themes persist: being educational and being noncommercial. These terms imply that public television must directly serve "the people"; it must be educational and different from commercial television. One of the implications of such a fundamental difference is that public television programming need not pursue the largest possible audience at whatever cost to programming. Public broadcasting has a special mission to serve audiences that would otherwise be

neglected because they are too small to interest commercial broadcasting. This difference in outlook has great programming significance. It means that the public station programmer is relieved of one of the most relentless constraints inhibiting a commercial programmer's freedom of choice.

At the same time, public television cannot cater only to the smallest groups with the most esoteric tastes in the community. Broadcasting is still a mass medium, whether commercial or noncommercial, and can justify occupying a broadcast channel and the considerable expense of broadcast facilities only if it reaches relatively large numbers of people. Public broadcasting achieves this goal cumulatively by reaching many small groups, which add up to a respectably large cumulative total in the course of a week (roughly half of U.S. television households). Moreover, on the commercial side, PBS has recently had to do two things: to appeal more powerfully to large underwriters, it has had to expand the time devoted to underwriting credits, which now sound a lot like commercials, and it has had to form partnerships with commercial entities (DirecTV, Comcast, and others) to generate income. Thus, PBS is not as completely "noncommercial" as it once was . . . in attitude or practice.

The Network Model

Programming the national Public Broadcasting Service is a little like trying to prepare a universally acclaimed gourmet meal. The trouble is that a committee of 177 plans the menu, and the people who pay the grocery bills want to be sure the meal is served with sufficient regard for their images. Some people coming to the dinner table want the meal to be enjoyable and fun; others want the experience to be uplifting and enlightening; still others insist that the eating be instructive; and the seafood and chicken cooks want to be sure the audience comes away with a better understanding of the problems of life underwater and in the coop.²

The analogies are not farfetched. A board of 35 appointed and elected representatives of its member stations governs the PBS during three-year terms. The board is expected to serve 168 public

television licensees operating 354 public stations all over the country and in such remote areas as Guam, American Samoa, and Bethel, Alaska.

Because PBS produces no programming, it uses a host of program suppliers and tries to promote and schedule their programs effectively. In addition, constituencies ranging from independent producers to minority groups constantly pressure public television to meet their special needs. And, of course, the program funders have their own agendas too.

In *commercial* television, programming and money flow *from* network headquarters *to* affiliates. Production is centrally controlled and distributed on a one-way line to affiliated stations, who are paid compensation to push the network button and transmit what the network feeds. Most of the economic incentives favor affiliate cooperation with the network, placing tremendous programming power in network hands.

In public television, money flows the opposite way. Instead of being paid as loyal affiliates, member stations pay PBS, which in turn supplies them with programs sufficient to fill prime time and many daytime hours. Stations pay membership dues to cover PBS's operational budget and, entirely separately, fees to cover part of the program costs. PBS is both a not-for-profit network and a membership organization responsible for developing, maintaining, and promoting a schedule of programs while also providing services to its dues-paying members. None of the stations are owned by the network. A public station's remaining broadcast hours are typically filled with leased syndicated fare (movies; off-network reruns; madefor-syndication series; and instructional programs for local schools), local productions, and programs supplied by other public television networks.

Four noncommercial networks also distribute programming to public stations. Once thought of as a regional network, American Public Television (APT, formerly Eastern Educational Network) is the second-largest national program supplier for public stations after PBS, and it distributes such favorites as Globe Trekker, This Old House, Farmer's Almanac, and The Seasoned Traveler on digital and HD channels. As with PBS, member stations pay APT for the programs, which then delivers the requested content to them during off hours via

satellite for local recording and scheduling, more like syndicators. *PBS*, however, delivers its programs in a prearranged schedule.

An entire week of daytime PBS programming in 2007 appears in 7.2, covering the hours from 6 A.M. to 8 P.M. The daytime schedule emphasizes programs for preschool children early in the day and for older children after school gets out. Many of these series have run for decades.

Station Scheduling Autonomy

In public television, much clout rests with the stations. They spend their revenues as they see fit, expecting to be treated fairly and with the deference due any consumer. PBS, as a consequence, has a limited ability to get stations to agree on program scheduling. Citing the principle of localism as public television's community service bedrock, station managers display considerable scheduling independence, ostensibly to make room for station-produced or acquired programs thought to meet some local need.

After the nationwide satellite system was phased in (1978) and as low-cost recording equipment became available in the 1970s, stations carried the PBS schedule less and less frequently as originally programmed. Until a networking agreement was worked out with the stations, no two stations' program schedules were remotely alike. National promotion, publicity, and advertising placement were, if not impossible, extremely difficult to achieve. Nor were corporate underwriters pleased at the scheduling irregularity from one market to the next.

Decision making is quite complicated at the local level. The public broadcasting culture supports multiple layers of choosing what gets on the air. Those who work within the local stations consider that freedom from powerful commercial interests is worth extra effort (and autonomy justifies their relatively low salaries). The culture at most stations fosters round-robins of endless consultation, a pattern preferred by most who choose to work in public television.

The Carriage Agreements

A 1979 common carriage agreement gave some order to this networking chaos, at least from the national perspective. Common carriage refers to

7.2 PBS Daytime Programming (March 2007)

	Monday—Friday Schedule 501	Monday-Friday Schedule 502	Saturday	Sunday
6:00	The Berenstain Bears			George Shrinks
6:30	Jakers! The Adventures of Piggley Winks			Jay Jay the Jet Plane
7:00	Maya & Miguel			Caillou
7:30	Arthur			Clifford's Puppy Days
8:00	Curious George			Sesame Street
8:30	Clifford the Big Red Dog			
9:00	Dragon Tales		Angelina Ballerina	Barney & Friends
9:30	It's a Big Big World		Nanalan	Teletubbies
10:00	Sesame Street		Franny's Feet	Dragon Tales
10:30			Make Way for Noddy	Zoboomafoo
11:00	Caillou	Bob the Builder		Sagwa, the Chinese Siamese Cat
11:30	Barney & Friends		Thomas & Friends	Arthur
12:00	Teletubbies		Julia Child—Cooking with Master Chefs	Between the Lions
12:30	Mister Rogers' Neighborhood			The Berenstain Bears
1:00	Reading Rainbow	ading Rainbow		Zoom
1:30	Between the Lions		This Old House	Cyberchase
2:00	Dragon Tales		Ask This Old House	Jakers! The Adventures of Piggley Winks
2:30	It's a Big Big World		Hometime	It's a Big Big World
3:00	Clifford the Big Red Dog The Woodwright's		The Woodwright's Shop	Boohbah
3:30	Curious George		Real Simple	Wishbone
4:00	Cyberchase			
4:30	Arthur		Your Brush with Nature	
5:00	Maya & Miguel			
5:30	Postcards from Buster			
6:00	Clifford the Big Red Dog	The NewsHour with Jim Lehrer	In the Mix	
6:30	Dragon Tales			
7:00	Caillou	The NewsHour with Jim Lehrer		
7:30	Barney & Friends			

a nonbinding agreement among stations that, in this case, established a core schedule on Sunday, Monday, Tuesday, and Wednesday nights. During the hours of 8 to 10 P.M (with time zone delay feeds), PBS fed those programs most likely to attract the largest audiences. In turn, stations committed themselves to airing the PBS core offerings on the nights they were fed, in the order fed, and within the prime-time hours of 8 to 11 P.M.

For several years the common carriage arrangement worked well. The typical core program received same-night carriage on more than 80 percent of stations. Core slots thus took on a premium quality; underwriters and producers, looking for favorable treatment for their programs, began to insist they be assigned a time slot within the core period. Maximum carriage was thought to mean maximum audience size. With more core-quality programs on their hands than available hours in the eight-hour core period, PBS programmers were forced in the early 1980s to move some long-standing core programs (Mystery! and Great Performances, for example) outside the core period to make room for other programs in the hope that the stations would still carry the moved shows on the feed night.

This move was partially successful; even though same-night carriage for the rescheduled programs fell, it was only to about 55 percent for these non-core programs. Station programmers, however,

soon took these moves by PBS as a sign that core programs could be moved around at will, and station independence began to reassert itself. By the 1985–86 season, same-night carriage of the core itself had slipped to 73 percent overall. PBS, concerned with complaints from national underwriters that "their" programs were not receiving fair treatment, moved to bolster same-night carriage. In fall 1987, PBS began a new policy of same-night carriage by which selected, broad-appeal programs would be designated for carriage the night they were fed. This policy had little effect, however, because PBS did not strictly enforce it.

In 1995 PBS once again attempted to get control of unpredictable station scheduling. Wanting to encourage new corporate underwriting because Congress had reduced its federal funding, a committee of the PBS board presented the stations with a new common carriage agreement—this time with financial penalties. Some 40 stations refused to sign the agreement until the penalties were removed. The new agreement went into effect in September 1995, requiring stations to carry certain programs within prime time on the feed night (see the programs identified in 7.3). The agreement promised that PBS would designate no more than 350 hours per year for common carriage, of which stations could choose up to 50 hours not to carry on feed night, a provision allowing local programming

7.3 2007 PBS Prime-Time Schedule

	Monday	Tuesday	Wednesday	Thursday	Friday	Saturday	Sunday
8:00 p.m.	Antiques Roadshow	NOVA	America's Ballroom Challenge (miniseries)	This Old House Hour	Washington Week	(Not scheduled by PBS)	Nature
8:30 p.m.					NOW		FI V 75 1 1 1 1 1 1 1 1 1 1 1 1 1 1 1 1 1 1
9:00 P.M.	American Experience	Frontline	(Specials)	Antiques Roadshow (repeat)	America's Ballroom Challenge (repeat)		Masterp ece Theatre
10:00 P.M.	(Specials)	Independent Lens	(Specials)	Soundstage	Monty Python's Flying Circus		

Reprinted by permission of PBS.

flexibility. Within these limitations, the agreement stated a goal of 90 percent carriage or better for designated programs.

Most programs designated for common carriage were receiving the requested carriage by at least 90 percent of stations as of 2005, and the maximum number of designated hours had risen to 500 per year. As for shows not designated, program managers often tape-delay them outside of prime time, using the vacated evening slots for other programming. Carriage on feed night typically averages less than 90 percent for undesignated programs.

PBS Responsibilities

Since its founding, PBS has had two key responsibilities: to accept or reject programs and to schedule those accepted. The program acceptance/rejection responsibility is grounded in technical and legal standards established by PBS during the 1970s. The technical standards protect stations from FCC violations and maintain high levels of video and audio quality. By their very nature, they can be applied with reasonable consistency. As the steward for underwriting guidelines, PBS maintains rules for on-air crediting of PBS program funders to prevent violations of FCC underwriting regulations and to ensure against public television's appearing too "commercial." The legal standards protect stations from libel and rights infringements and alert them to equal time obligations that may result from PBS-distributed programs.

Underwriting and advertising are fundamentally different, although they both share some elements. The key difference is that advertising in the form of a paid commercial usually contains a call to action (for example, "Stop by our showroom today"). Underwriting presents the name and makes neutral statements (for example, "Funding provided by Kellogg's, makers of quality breakfast cereal") that serve to reinforce brand awareness. Eventually, the length and kinds of supporting content permitted by PBS rules became less restrictive, and now on-air crediting is both longer and more detailed but continues to lack action statements.

Another PBS function is warning stations in advance of programs that contain offensive language or sensitive scenes (nudity or violence). It makes edited versions of programs that contain extreme material available to stations. In rare cases, controversial programs such as *It's Elementary* (a documentary on gay issues in grade school) have been canceled or postponed, but in general PBS tends toward airing programs as produced.

Day-to-Day Management

An executive vice president heads PBS's National Program Service (NPS).3 This senior executive sets policy for and oversees the content and array of formats within the program schedule, directing long-range development of major programs. Other managers assist in the day-to-day activities of program development, scheduling management, and acquisition of international programs, while content departments within the NPS concentrate on the development of news and public-affairs, children's, cultural, and fundraising programs. PBS Plus offers a menu of "user-pays" programs to supplement local schedules. Other departments deliver programs for adult at-home college education and in-school instruction for children. Interactive and online services, extensions of PBS's programming, were introduced in the mid-1990s including Mathline for students and PBS Online on the internet (www.pbs.org). Thus, programming for the station broadcasts is only part of PBS's activities.

Satellite Distribution

The broadcast operations department manages the daily details of the national schedule much as a traffic department would at a commercial network. All the pieces of the jigsaw puzzle must be plugged into place across an array of satellite schedules, ensuring, for example, that (1) the end of a 13-episode series coincides with the start of another ready to occupy its slot; (2) dramas with profanity or nudity have an early edited feed available on another transponder; and (3) replacement programs are available when, for example, the Saturday morning schedule of how-to programs runs short in the summer.

PBS now delivers instructional and general audience services via direct-to-home satellite channels (TVRO) as well as the regular national programming feed provided to PBS member stations retransmitted by DirecTV and DISH Network, but delayed by 24 hours to allow member stations the opportunity to air the programming first. In late 1999, PBS launched two more satellite program services, PBS Kids Channel (children's programming) and PBS U (adult learning service for college credit) carried on DirecTV, and in 2004, PBS launched PBS HD (a high-definition and widescreen channel).

By 2002, however, PBS Kids Channel had to compete with Viacom's Noggin, a digital cable/ satellite channel that features Sesame Street reruns and other satellite channels targeting children. Withdrawal of DirecTV's support in 2005 led to the formation of PBS Kids Sprout and PBS Sprout On Demand, digital commercial channels on cable owned by Comcast, HIT Entertainment, PBS, and Sesame Workshop. They carry such shows as Angelina Ballerina, Curious George, Barney & Friends, Bob the Builder, Teletubbies, Thomas & Friends, Dragon Tales, Zoboomafoo, and of course, the so-essential Sesame Street. The term "PBS Kids" returned to the main network as an umbrella brand for preschool children's programming (offering Arthur, Clifford the Big Red Dog, and Curious George', along with PBS Kids GO! for early elementary kids (which provided such shows as Kidsworld Sports, Arthur, Maya & Miguel, and Wishbone). All these over-the-air and digital services are supported with clever online sites, www.pbskids .org, www.pbskidsgo.org, and www.sproutonline .com.

Similarly, PBS U folded in the same year, its service as a middleman between college students and universities no longer profitable to the network supplanted by the internet (see 7.4). PBS HD, however, continues as a digital cable and satellite channel, programming different material than the regular PBS channel. PBS suffers from the same ailment as the commercial over-the-air and cable networks—a lack of sufficient programming in hi-def.

Fundraising Assistance

The Station Independence Program (SIP), a division in PBS's National Program Service, is a very successful station service. The SIP schedules and programs three main on-air fundraising drives a year, called pledge drives (a 16-day event held annually in March and two 9-day drives held in August and December). Stations wishing to avail themselves of the SIP service (and most do) pay PBS additional fees for it. A key SIP function is acquiring, funding, and commissioning special programs for use during local station pledge drives. Programs with emotional payoff, not necessarily those programs with the largest audiences, tend to generate more and higher pledges. Self-help programs and inspirational dramas, for example, generally make money for stations, but documentaries on topics such as world economics do not do well. In general, such performance events as Yanni and Three Tenors do very well in pledge drives.

Types of Station Licensees

One of the difficulties in describing PTV programming strategies is that the stations are so diverse. The 168 licensees (as of 2008) operating 354 stations (many of which are unstaffed transmitters) represent many management viewpoints. More stations (that is, transmitters) than licensees exist because in 20 states a legislatively created agency for public broadcasting is the licensee for as many as 16 separate transmitters serving the whole state. Also, in several communities, one noncommercial educational licensee operates two television channels. In these cases (San Francisco, Boston, Pittsburgh, and Milwaukee, among others), one channel usually offers a relatively broad service of PBS programming while the second channel is used for more specialized programming, often instructional material. In addition, seven noncommercial television stations are not members of PBS because of signal overlap with other PBS stations.

Much of public television's diversity is explained by the varying auspices under which its stations operate. Licensees fall, in the proportions

7.4 The Demise of the Adult Learning Service

DBS began its Adult Learning Service (ALS) in the early 1980s, offering over-the-air instruction leading to college credit for more than two decades. With over 100 telecourses, the ALS was the largest source of such programming in the world. Enhanced by the web and then programmed as a network (PBS U), the service supplied college credit to more than 5 million students in academic areas including arts and humanities, business and technology, history, professional development, science and health, and the social sciences.

Shortly after its launch, ALS received a significant boost from Walter Annenberg, then owner of TV Guide, who established the Annenberg/CPB Project. For this project, the Annenberg School of Communications gave \$15 million to CPB each year for 10 years (1983 to 1993) to fund college-level instruction via television and other new technologies. The project resulted in such high-visibility public television series as The Constitution: That Delicate Balance, French in Action, Planet Earth, The Africans, War and Peace in the Nuclear Age, Art of the Western World, Discovering Psychology, and Economics USA, with subject matter ranging from the humanities to science,

mathematics, and business. The net result of Annenberg's entry into this field was not only an increase in the number of adult instructional programs available through ALS but also, thanks to their above-average budgets, an increase in production values (quality).

Colleges and universities that wanted to offer credit for these telecourses normally arranged for local public television stations to air the series, and all registration, fees, testing, and supplementary materials are handled by the school. Some of the courses use computers, and all are keyed to special texts and study guides. ALS offered programmers one of the most challenging additions to their program schedule. Because such programs required close cooperation with the institutions offering credit, they required a reliable repeat schedule that would permit students to make up missed broadcasts. In time, however, the wide availability of internet access ended the need for PBS to act as distributor. Universities could e-mail course materials and video straight to individual students, irrespective of the number taking a particular class, and now with Wi-Fi on campuses and larger towns, people can take courses whenever and wherever they like.

stated in 7.5, into four categories: community, university, public school, and state agency, and each approaches programming in different ways.

Community Licensees

In larger cities, particularly those with many educational and cultural institutions but without a

7.5 **Distribution of Station** Licensees

Jublic station licensee counts by type (as of 2008) were 86 community, 6 local public school authority, 20 state government authority, and 56 college or university. Adding those noncommercial broadcasters that are not PBS members makes a total of 175 public television stations (but reported counts can vary slightly).

dominant institution or school system, the usual licensee is the nonprofit community corporation created for the purpose of constructing and operating a public television station. Because the governing board of such a station exists solely to administer the station (as compared with university trustees who have many other concerns), many feel that community stations are the most responsive type of licensee. As of 2008, about 90 such licensees operated in the United States.

Compared with other licensees, community stations have traditionally derived a higher proportion of their operating support from fundraising activities (including on-air auctions). As a result, on-air pledge-drive programming reflects their urgent need to generate funds from the viewers they serve. Programmers at these stations, therefore, are more likely to be sensitive to a proposed program's general appeal. They will lean toward high-quality production values to attract and hold a general audience. Within the community category, several stations stand apart because of their metropolitan origins, their large size, and their national impact as producers of network-distributed programs. These flagship stations of the PBS are located in New York, Boston, Los Angeles, Washington, Chicago, Baltimore, Seattle, and Pittsburgh. The first four are particularly notable as production centers for the nation, originating such major programs as NOVA, Nature, and The NewsHour with Jim Lehrer (see 7.6). Although other public stations and commercial entities often participate in their productions and financ-

ing, these large, community-licensed producing stations generate most of the PBS schedule.

Community stations, because of comparatively high levels of community involvement and because of a prevalence of clearly receivable VHF channels, have tended to attract larger local audiences than have other types of noncommercial licensees. For example, Nielsen reports that about half of the households in San Francisco, one of the nation's largest media markets, tune weekly to community-operated KQED. With such a high audience level, more of its viewers see its fundraising appeals and contribute money to the station. WNET,

7.6 The NewsHour With Jim Lehrer

In 1973 Robert MacNeil and Jim Lehrer joined together to cover the Watergate hearings for PBS. The results were an Emmy and a new news program for Public Broadcasting. Unlike the commercial nightly newscasts, MacNeil and Lehrer were actually throwbacks to Edward R. Murrow and See It Now. Instead of doing many two-minute stories, they concentrated on one major story and went in-depth. They let people tell their own versions of the story in interviews that lasted several minutes; they also avoided sound bites and ran extended portions of news conferences. These were usually followed by nonjudgmental cross-examinations that questioned what had been said.

In 1983, the program, then called *The MacNeil/*Lehrer Report, saw its only major format change as it went from 30 minutes to a full hour. It added a news summary of major stories at the start and increased the number of in-depth stories from one to three or four, each running 10 to 15 minutes. Because the show airs on PBS, it has no interruptions (except during pledge drives). Mondays through Thursdays, the program often wraps up with a "reflective essay." On Fridays, it ends with a discussion between two regular columnists, currently Mark Shields and David Brooks, who replaced Paul Gigot. When Robert MacNeil retired in 1995, the show became *The NewsHour with Jim Lehrer*, and in 2006, acquired new graphics and a new version of the show's theme song, but otherwise stayed about the same.

The NewsHour is one of PBS's most popular programs, reaching over 8 million different people during

a week in the United States and averaging 2.7 million viewers each night. The program also airs in Australia, Japan, and New Zealand and is broadcast by Voice of America and Armed Forces Radio. Keeping up with the PBS traditior of trying new technologies, the program has archived all broadcasts on the web since early 2000, and they can be accessed as streaming video. In addition, audio segments are also released in podcast form.

Strangely enough, on a network often criticized for its left-leaning shows and a tendency to slant the news, The NewsHour has been attacked for being too "mainstream" and for having a "pro-establishment bias." A 2006 study released by Fairness and Accuracy in Reporting, a "left-oriented" media watch group, accused the show of being too balanced, of favoring Republicans and business, and of not having enough minorities. One of the group's major objections was "not one peace activist" had appeared on the show during the six months analyzed. The PBS Ombudsman, Michael Getler, agreed, saying: "These are perilous times. As a viewer and journalist, I find the program occasionally frustrating; sometimes too polite, too balanced when issues are not really balanced, and too many political and emotion-laden statements pass without factual challenges from the interviewer."4 In this day and age, The NewsHour may have a unique distinction in being critic zed for being too fair

> William J. Adams, Fh.D. Kansas State University

New York's largest public television station, is an exception among community stations. It receives a portion of its funding from state government.

University Stations

In many cases, colleges and universities have activated public television stations as a natural outgrowth of their traditional role of providing extension services within their states. As they see it, "the boundaries of the campus are the boundaries of the state," and both radio and television can do some of the tasks extension agents formerly did in person. Fifty-six licensees make up the university group.

Here, too, programmers schedule a fairly broad range of programs, often emphasizing adult continuing education and culture. Some, typically using student staff, produce a nightly local newscast, and many produce a weekly public-affairs or cultural program, but they tend not to produce major PBS series for the prime-time schedule, lacking both budget and permanent staffing. University-licensed stations such as WHA (Madison, Wisconsin) and KUHT (Houston, Texas) contribute occasional specials and single programs to the PBS schedule. WUNC-TV at the University of North Carolina in Chapel Hill produced *The Woodwright's Shop* series, and other university-licensed stations have supported shortrun series aired in the daytime PBS schedule.

As operating costs mount and academic appropriations shrink, some university stations turn to over-the-air fundraising to supplement their institution's budgets. In doing so they use tactics similar to those of community stations, including airing programs specially produced for fundraisers. Expanded fundraising efforts are generally accompanied by broadening program appeal throughout the station's schedule, although the shows target a wide range of small, niche audiences.

Public School Stations

Local school systems initially became licensees to provide new learning experiences for students in elementary school classrooms. From the outset, some schools augmented instructional broadcasts with other programming consistent with the school system's view of its educational mission. By 2008 only six of these school licensees remained. Most

of them have organized a broadly based community support group whose activities generate wider interest and voluntary contributions from the community at large. As a result, the average local-school licensee now draws about 7 percent of its income from subscriber contributions.

Naturally, programmers at these stations are heavily involved with in-school programming—but because they desire community support, they are also concerned with programming for children out of school and for adults of all ages. Other than ITV series, most rarely produce original programs for PBS, and they obtain most of their schedules from national, state, and regional suppliers of instructional programming. Of course, they usually carry such general (non-ITV) PBS educational children's programs as *Sesame Street*, too.

State Television Agencies

About 186 of the nation's 354 public television transmitters are part of state networks operated by legislatively created public broadcasting agencies. Networks of this type exist in 20 states. Most of them were authorized initially to provide new classroom experiences for the state's schoolchildren. Most have succeeded admirably in this task and have augmented their ITV service with a variety of public-affairs and cultural programs furnished to citizens throughout their states.

State networks, such as those in South Carolina, Maryland, Kentucky, Nebraska, and Iowa, are very active in the production and national distribution of programs. Their efforts range from traditional school programs for primary and secondary grades to graduate degree courses offered in regions where colleges and universities are few. These production efforts are the counterpart to the national production centers of the community-based licensees. Although state networks rarely produce prime-time PBS series, they frequently join consortia generating specific programs for series such as *Great Performances*. The Maryland Center for Public Broadcasting produces the long-lived PBS series *Wall Street Week*.

Although in recent years these state network stations have gotten more foundation, underwriter, and even viewer support, state legislatures still appropriate more than three-fifths of their budgets. This fact, plus the perception of their "community of service" as an entire state rather than a single city, gives programmers at these stations a different perspective.

Similarities among and Differences between Station Licensees

It should be evident from these brief descriptions that each category of public television station poses special problems and special opportunities for programming strategies. Each station type is ruled by a different type of board of directors—community leader boards, university trustees, local school boards, state-appointed central boards. Each board affects program personnel differently:

- Community representatives try to balance local power groups.
- University boards, preoccupied with highereducation programs, tend to leave station professionals free to carry out their jobs within broad guidelines.
- School boards are similarly preoccupied with their major missions and, in some cases, pay too little attention to their responsibilities as licensees.

 State boards try to protect their stations from inappropriate political influences.

All licensees struggle to function with what they regard as inadequate budgets, but there are wide funding discrepancies between the extremes of a large metropolitan community station and a small public-school station. Significantly, all types of stations have broadened their financial bases in recent years to keep up with rising costs and to improve program quality and quantity. Licensees having the greatest success in securing new funding have, in general, made the strongest impact on national public television programming. In turn, successful public television producer-entrepreneurs working through their local stations are motivated to create attractive new public television programs with broad audience appeal in the hope of securing still more underwriting. Such programs increase viewership and draw more support in the form of memberships and subscriptions. Public-affairs programs and those of interest only to specialized smaller audiences—the "meat and potatoes" of public television—do not always receive corporate support and must be funded by CPB, PBS, or foundations (see 7.7).

7.7 Corporation for Public Broadcasting

he Corporation for Public Broadcasting is the largest single source of funding for public television and radio programming in the United States. The private nonprofit organization was established with the passage of the Public Broadcasting Act in 1967 to support and fund the development of educational, locally relevant and culturally diverse programs for public broadcasting. It created the Public Broadcasting Service (PBS) in 1969 and National Public Radio (NPR) in 1970. Most of CPB-funded programs are distributed through PBS, NPR, American Public Media, and Public Radio International.

Though it awards federal grants, CPB has a legal mandate to be nonpartisan and ensure objectivity on public programming. Yet, controversies continue to plague CPB. In 2005, Democrats called for an investigation into whether CPB violated federal law when its former Bush Administration—appointed chairman Kenneth Y. Tomlinson commissioned a review of several PBS and NPR programs in order to investigate liberal b as. Programs under review included the Now With Bill Moyers show, which had been criticized for being left-leaning. Tomlinson resigned in 2006 after investigations by CPB's inspector general revealed he "had made improper hires, had tried to tamper with PBS's TV programming, and appeared to show political favoritism in selecting CPB's president while he was chairman' (Farhi, 2007).

Debbie Goh Indiana University Early in its history, PBS developed a characteristic schedule of dramatic miniseries and anthologies; documentaries on topics in science, nature, public affairs, and history; concert performances; and a few other types of programs, none of which ABC, CBS, FOX, or NBC offers on a regular basis. PBS's marketplace position has thus historically been that of an alternative to the commercial networks. Today, however, several cable networks (including the Discovery Channel, A&E, the History Channel, The Learning Channel, the Food Channel. House & Garden) offer some programs similar to PBS's. From time to time, some members of Congress-important critics because, through CPB funding and grants, Congress supplies public television with about 16.4 percent of PBS's annual revenue—argue that PBS has become superfluous because it duplicates programming available on cable. The argument lacks merit because about 10 percent of U.S. TV households do not subscribe to cable or satellite, while 99 percent can receive PBS. Moreover, fewer cable subscribers actually watch the cable networks that have PBSlike programs; PBS's ratings are two to four times larger.

Program Financing

How a program gets into the PBS schedule contrasts with the process at its commercial network counterparts. At ABC, CBS, FOX, NBC, and most cable networks, program chiefs order the programs they want, pay for them out of a programming budget, then slot them into the schedule. To minimize ratings failures, the networks first pay for the production of pilot programs each year. Additional episodes of the most promising pilots are ordered, and each of these series receives a place in the schedule (see details in Chapters 4 and 5).

At PBS, however, program funding is more complex. A program may have a single financial backer or several. More frequently than not, funding comes from a combination of sources, especially when the project runs into millions of dollars. PBS will partially fund and, on occasion, fully fund a project out of its station program assessment funds, but many programs must find their own backing. Of course, producers would prefer to walk away from PBS with a check for the full amount. Owing to PBS's limited purse, they must usually "shop" a project from one corporate headquarters to the next, perhaps even to foundations and CPB. Given the daunting process, producers have been heard to say that they spend more time chasing after dollars than making programs.

Program assessment fees, now levied on PBS member stations, were begun in the early 1990s. They represent public television's response to growing cable network competition for the limited supply of programs to buy (see 7.8). Stations voted to streamline the program funding process so that newly offered productions could be snapped up

7.8 PBS Competing for Kids

ross-platform initiatives are not restricted to the commercial networks, PBSKIDSGO.org introduced "KidsWorld Sports," a website based on an international documentary series that profiles kid-athletes who have the talent and drive to succeed in various sports. On the site, kids can watch short clips from the series, learn about different sports from videos featuring real kids, send video e-cards, and compete in sport-related games. "News Flash Five," another PBS effort, is a current events website aimed at tweens aged 8-11. It features a cast of five kids, rendered in flash animation, who report on national and world news, technology, entertainment, sports, and weather. On the site, kids are able to play games such as Just the Facts (news quiz), Pin Point (finding places in the news on a map), Match It (connecting photos to newsmakers), and Get the Scoop (news gathering and writing). PBS's efforts match those of Nickelodeon, the top commercial channel for kids, and are far beyond the efforts of the broadcast networks.

> Nancy C. Schwartz, Ph.D. The Academic Edge, Inc. Bloomington, Indiana

without delays. In the first year of program assessment, nearly \$80 million was transferred from stations to PBS; by 2007, the figure had grown to more than \$125 million. The chief program executives now handle selected program funding as a centralized responsibility (in contrast to the long-beloved notion that program decision making should be tightly controlled by public television's 168 station program managers). To form this fund, stations are assessed in proportion to their market size. Programs produced either wholly or in part from this fund carry an announcement crediting "viewers like you" because station money is involved—a large part of which comes from viewer contributions.

A program on PBS can have several "fathers," that is, multiple producers. Typically, separate production units shoot film for partners in a coproduction deal, as when PBS joins with the BBC to produce a science or nature program. In such an arrangement, both have usage rights. Rather than share a program with a U.S. competitor, such as a cable network, public television prefers foreign coproduction over domestic coproduction.

The Major Producers

A very large portion of PBS's schedule comes from series produced by or in conjunction with four major producing stations—WGBH in Boston, WNET in New York, and WETA in Washington, DC. In most years, these producing stations account for well over half of PBS's new shows (see 7.9). Other stations contribute an occasional series or special to the PBS schedule, but most local efforts either focus too narrowly on a topic to be of wide national interest or fall short of national standards for writing, talent, and technical characteristics because they lack a sufficient budget. PBS seeks programs equivalent to commercial efforts in terms of content and production quality.

British programs such as *Masterpiece Theatre* and *Mystery!* have become staples of American public television because they are high-quality programs available at a small fraction of the cost of producing comparable fare in the United States. But they, along with other foreign productions,

7.9 Major Producing Centers

Stations	Program Series			
WGBH, Boston	American Experience			
	Antiques Roadshow			
	Arthur			
	Frontline			
	Masterpiece Theatre			
	Mystery!			
	New Yankee Workshop			
	NOVA			
	This Old House			
WNET, New York	American Masters			
	Charlie Rose			
	Great Performances			
	Live from Lincoln Center			
	Metropolitan Opera Presen*s			
	Nature			
WETA, Washington, DC	In Performance at the White House			
	The NewsHour with Jim Lehrer			
	Washington Week in Review			

occupy only a fraction of all PBS programs. PBS programming comes from a mix of foreign producers, international coproductions, commercial independent producers, public television stations, and the producing organizations that have traditional ties to PBS, such as Sesame Workshop (formerly Children's Television Workshop). This pattern of sources has been consistent over recent years, although increased competition from cable networks for foreign programs has narrowed PBS's options. The greatest change in funding in recent years has been the acquisition of funds by means of program assessment, not in the actual program sources.

Balance in Selection

Responsibility for acquiring programs falls to one of several "content" managers, including the directors of Factual Programming, Fiction and Performance Programming, and Children's Programming. They must view sample tapes (demonstrations) and sift through many hundreds of proposals each year. Based on these written proposals or sample tapes (pilot episodes are very rarely made), the manager decides whether to purchase the program or provide some portion of production funding. In the case of foreign productions, a program can be purchased ready for broadcast because it is already "in the can" (produced). If the decision on a proposal for a new production is favorable, a small research and development grant is usually the first step, perhaps with a promise of larger amounts to follow. Once production is under way, the content manager will consult with the producer during the production process to guide the outcome toward a satisfactory result. It is important to note that, by law, PBS can order programs to be produced, but it does not itself produce them.

Through all this, National Program Service executives attempt to maintain balance in the national schedule so that the network doesn't find itself one season with, for example, too many symphony concerts and too few investigative documentaries in the schedule. To better regulate the flow of new productions into the national schedule, PBS established the Public Television Pipeline, a management system for monitoring and coordinating all program development activity from the proposal stage through delivery to PBS. Throughout the year, the Pipeline sends signals to producers about PBS's overall schedule surpluses and shortfalls as well as specific content needs. Proposals are submitted and approval (and perhaps seed money) obtained from PBS, and the final selection process is under way.

Corporate Pressure

Corporate underwriters of programs invest not only prodigious sums from corporate treasuries but also personal effort and reputation, and they feel entitled to choice slots in the prime-time schedule. Of course, PBS cannot always fit a program in the time slot the underwriter wants and still maintain a balanced schedule.

Corporate fiscal needs can also affect scheduling. Often, the underwriting corporation requires that a program be played within its fiscal year—irrespective of audience and schedule needs. PBS

program executives attempt to accommodate such cases, knowing that if they do not, the corporation in its pique may refuse future requests for support.

The major producing stations also attempt to influence program decisions at PBS on behalf of their program underwriters. For those stations, financial health depends on corporate support, which pays for salaries, equipment loans, and other production expenses. Were just one major underwriter to withdraw support, the financial effect on a producing station could be devastating.

Station Pressure

Other programming pressures occur. Many stations, for example, *refuse* to telecast a program at the time fed because their programmers decide it

- 1. lacks prime-time quality.
- 2. contains too much profanity or violence to air in early evening.
- **3.** occupies a slot the station wants for its own programs.
- 4. has little appeal for local viewers.

Although each of these reasons has merit at times, the combined effect of 168 station program managers exercising independent judgment has often left portions of the PBS schedule in a shambles. PBS program executives assembling a schedule must anticipate these concerns to minimize defections.

Program Rights

PBS programmers must also wrestle with program rights. In public television as in commercial television, standard program air-lease rights are set by contract with the producer, who owns the rights. PBS has traditionally negotiated with producers for as many plays as possible so that by airing the same program several times, the typically small (per airing) PBS audience snowballs. Extra plays also fill out the program schedule.

At the same time, the program syndicator seeks as few airings as possible over the shortest time period to retain maximum control and resale

potential for a program. A compromise between various producers and PBS that permits *four program plays within three years* is now the standard rights agreement in public television.

Syndicated and Local Programming

American Public Television licenses a large number of programs to PBS stations, programs such as British sitcoms; documentaries; travel, cooking, and music programs; how-to series; and movies from Warner/Turner and 20th Century Fox (for a more complete listing, see *www.aptonline.org*). This company is a significant player in public television programming and a prime source of entertainment programs for public stations.

In addition, because of its role in formal education, public television has had to develop its own unique body of syndicated material to meet instructional television needs. A number of centers for program distribution have been established to perform the same function as commercial syndication firms, but on a noncommercial, cooperative basis (see 7.10 for more on these centers).

Noncommercial Syndication

The abundance of ITV materials means that it is no longer necessary to produce instructional programs locally, except where desired subject matter is unique to a community. Local school authorities usually select instructional materials for in-school use, although the public television station's staff often serves as liaison between sources of this material and users. The state may appropriate funds for instructional programs, giving them to public stations within the state, or school districts may contract with a local public station to supply particular ITV programs at certain times.

The National ITV Satellite Schedule (NISS) is coordinated by the National Exchange Carrier Association, a regional network. More than half of all public schools make use of ITV. More than 1,200 hours of the most-often-selected ITV series

7.10 Noncommercial Syndicators

he Agency for Instruct onal Technology (AIT) in Bloomington, Indiana, produces series for primary grades, high school, and postsecondary students. Among the best known are All About You, Math Works, Assignment: The World, and Up Close and Natural. AIT took the lead in developing innovative classroom programs that operate in conjunction with desk-op computers, creating the first interactive lessons on DVD.

Great Plains National (GPN) in Lincoln, Nebraska, offers dozens of series for elementary and junior high use along with a great many materials for college and adult learning. Titles in ts catalog range from Reading Rainbow (for first graders) to The Power of Algebra, Tombs and Talismans, and Truly American (for high schoolers and adults).

Western Instructional Television (WIT) in Los Angeles offers more than 500 series in science, language arts, social studies, English, art, and history. TV Ontario also supplies U.S. schools with dozens of instructions series, especially in science and technology, including Read All About It, The Landscape of Geometry, and Magic Library. Ever PBS, through its Elementary/Secondary Service, cffers a slate of ITV programs, such as The Voyage of the Mimi, Amigos, and Futures with Jaime Escalarte.

for kindergarten through 12th grade are made available to subscribers by satellite every day, 33 weeks per year. Subscribers include public television stations, state departments of education, regional educational media centers, and other authorized educational entities.

Noncommercial Adult Education

Quality programming for adult learners is also now available in quantity to public stations. Beginning in the late 1970s, various consortia began to turn out telecourses (television courses) for integration into the curricula of postsecondary institutions. These efforts have centered particularly in community colleges, led by Miami-Dade (Florida), Dallas (Texas), Coastline Community

College (Huntington Beach, California), and the Southern California Consortium. With budgets ranging from \$100,000 to \$1 million for a single course, they have proven to be sufficiently well produced to attract casual viewers as well as enrolled students.

Meanwhile, faculty members at other leading postsecondary institutions began developing curriculum materials to accompany several outstanding public television program series distributed nationally through PBS for general viewing. The first of these was The Ascent of Man, with the late Dr. Jacob Bronowski, a renowned scholar as well as a skillful and effective communicator on camera. More than 200 colleges and universities offered college credit for that course. Others quickly followed (The Adams Chronicles, Cosmos, Life on Earth, The Shakespeare Plays) as programmers discovered that such series furnished the casual viewer with attractive public television entertainment and simultaneously served more serious viewers desiring to register for college course credits.

This experience led many public television programmers to realize that too much had been made of the supposed demarcation between ITV and PTV. Too often during earlier years, many program producers would not even consider producing so-called instructional television. The first Carnegie Commission in 1965 strengthened this presumed gap by not concerning itself with television's educational assistance to schools and colleges and by adopting the term *public television* to mean programming for general viewing.

The lesson for public television has been that ITV and PTV programs can appeal to viewers other than those for which they were especially intended. The Annenberg/CPB series is only one example. Another is *Sesame Street*, which was initially intended for youngsters in disadvantaged households—yet the in-school use of *Sesame Street* has been one of the significant occurrences in kindergarten and lower elementary classrooms throughout America, leading to new and more complex attitudes toward television in and out of the classroom (see 7.11). Ironically, *Sesame Street* may also contribute to the gap in knowledge between advantaged and disadvantaged children

because it is widely watched (and learned from) by already advantaged children, perhaps making the disadvantaged more disadvantaged.

Commercial Syndication

More extensively tapped than noncommercial sources, however, are such commercial syndicators as Time-Life, David Susskind's Talent Associates, Wolper Productions, Granada TV in Great Britain, and several major motion picture companies including Universal Pictures. Public television stations sometimes negotiate individually for program packages with such syndicators; at other times they join with public stations through regional associations to make group buys. Commercially syndicated programs obtained in this way by PTV include historical and contemporary documentaries, British-produced drama series, and packages of highly popular or artistic motion pictures originally released to theaters. Such programming, because it was designed for general audiences, is thought to bring new viewers to a public station. Many programmers believe those new viewers can then be persuaded, through promotional announcements, to watch more typical PTV fare.

The proportion of commercially syndicated programs in public television station schedules, nonetheless, averages less than 5 percent of broadcast hours. The number is small partly because those syndicated programs that public stations find appropriate are relatively *expensive*; unless the station secures outside underwriting to cover license fees, it usually cannot afford them. Stations now pay as much as \$100,000 for an hour of British television that cost as little as \$50,000 a few years ago. Another reason is *philosophical*: Although much commercially syndicated material has strong audience appeal, its educational or cultural value is arguable.

Local Production

The percentage of airtime filled with locally produced programming has gradually decreased over the years as both network and syndicated programming have increased in quantity and quality.

7.11 Remembering Sesame Street

enerations of preschoolers learned the clphabet—and a whole lot more—from watching the Muppets. Sesame Street premiered in 1969 on National Educational Television Network, now the Public Broadcasting Service, and after 40 seasons and nearly 4,300 episodes, it's one of the longest-running shows in television history. Created by Jim Henson, Sesame Street is probably the most respected educational program in the world.

The original, U.S.-produced show currently airs in 120 countries, and more than 20 international versions are produced in such countries as Brazil, Mexico, France, Turkey, China, and Russia. More than 75 million Americans watched Sesame Street as children, as well as millions more worldwide. Nielsen reports that nearly 8 million people tune in each week, and the show appears continuously among the top 10 children's programs on television.

Sesame Street teaches letters and numbers, as well as basic word recognition, mathematics, and science, but its goals include basic social skills. Sesame Street has worked toward teaching children about how to make friends, practice good hygiene, and eat healthfully. Known for its rigorous ongoing research, the program's overall curriculum has changed over time to reflect the problems of growing up in America. At the same time, using witty humor and fast pacing, the show tries to appeal to parents and older siblings as well as preschool children.

While the elaborate hand-held puppets called the Muppets are central to Sesame Street's broad appecl, its live actors keep the show grounded, and the program has led the way in portrayals of minorities on television. The program has been much praised for

its multicultural cast, as well as for the acors' overall longevity. Sesame Street boasts the longest-running Hispanic character in the history of television (Luis) cs well as the longest-running character with a disability (Linda, who is deaf) and what are believed to se the longest-running African-American characters (Gordon and Susan). The changing relationships among the characters get incorporated into the program: For example, Luis married Maria, the owner of Sesame Street's Fix-It-Shop, and Maria later gave birth to Gabby; Maria's pregnancy became par of the show's storyline. Gordon and Susan's story included the adoption of their son Miles. When original cast member Will Lee, who had played store owner Mr. Hooper, died, producers chose to include the death of Mr. Hooper into Sesame Street's story. The producers believed that the inclusion of Mr. Hopper's death would educate children about the death of a loved one.

The popularity of the Muppet characters and the show's overall success turned Sesame Steet into one of the earliest and most enduring multiplatform brand names. In addition to its 109 Emmy award wins (more than any other series in the history of television), the show has won 11 Grammys, has its own theme park, publishes magazines on five continents, and generates movies, toys, books, DVDs, and video games. The clever use of Muppets, animation, music, and live actors in brief modular segments results in a broad-appeal program capturing the imagination of millions of children while involving them and their parents in the learning process.

James Angelini Indiana University

Owing mostly to its high cost, the percentage of total on-air hours produced solely for local use by public television stations had declined from 16 percent in 1972 to much less than 5 percent by the mid-2000s. Moreover, production quality expectations have risen. More time and dollars and better facilities must now be used to produce effective local programs.

Locally produced programs, nonetheless, are far from extinct in public television. A survey of station producers found that, among the 79 licensees responding, more than 3,000 programs had been produced during the past year Among them were weekly and occasionally nightly broadcasts devoted to activities, events, and issues of local interest and significance. Many stations regularly cover

their state governments and legislators. Unlike commercial stations, which concentrate on spot news and devote a minute or less to each story, public stations see their role as giving more comprehensive treatment to local matters. But news and public-affairs programs were not the only kinds being produced. The survey found stations turning out a spectrum of arts and performance, documentaries, sports events and sports talk, history, comedy, science, nature, and even children's programs.

Scheduling Strategies

Nowadays, PBS programmers want to maximize audiences. Gone are the educational television days when paying attention to audience size was looked upon as "whoring after numbers." The prevailing attitude at PBS recognizes that a program must be seen to be of value and that improper scheduling prevents full realization of a program's potential. Member stations now recognize that bigger audiences also mean a bigger dollar take during on-air pledge drives.

Counterprogramming the Commercial Networks

Competition, of course, is a key consideration. There are three ways to respond to it:

- 1. Offensively, by attempting to overpower the competitor
- 2. Defensively, by counterprogramming for a different segment of the audience than the competitor's program is likely to attract
- 3. By ignoring the competition altogether and hoping for the best

PBS has never been able to go on the offensive; its programs lack the requisite breadth of appeal. Prime-time PBS shows average around a 1.5 household rating. ABC, CBS, FOX, and NBC regularly collect ratings of 8 and higher (although their figures are much smaller than a decade ago—the result of audience defections to the many cable networks).

PBS, then, must duck and dodge, a strategy called counterprogramming. By studying national Nielsen data, programmers learn the demographic makeup of competing network program audiences so they can place their own programs more advantageously. For example, a symphony performance that tends to attract well-educated women older than 50 (upscale in socioeconomics) living in metropolitan areas would perform well opposite FOX's The Simpsons, NBC's Deal or No Deal, or CW's WWE Friday Night Smackdown!, all having downscale (lower socioeconomic) audiences. Similarly, in searching for a slot for the investigative documentary series Frontline, PBS did not consider for a moment the 8 to 9 P.M. slot on Sundays because football overruns often push 60 Minutes into this slot.

PBS tries to avoid placing a valued program against a hit series in the commercial schedules. The network also has traditionally avoided placing important programs during the three key periods of all-market audience measurement (sweeps) in November, February, and May-times when commercial television throws its blockbusters at the audience. Because the commercial networks have cut back on sweeps blockbusters in recent years (especially costume-drama miniseries, which lure away many PBS viewers), PBS has grown more willing to run an important series through a sweeps month. This is clearly a calculated risk, a kind of TV "minefield"; a powerful commercial network special could draw off so many viewers from a weekly PBS miniseries that few would return to see its continuation and conclusion.

Further, because public as well as commercial stations are measured during the sweeps, PBS's stations demand a "solid" schedule, with a minimum of "mission programs." This is a mildly pejorative reference to public television's mission to serve all Americans, specifically referring here to narrowappeal programs of interest only to some very small groups of viewers. Many programs are "good for the mission" but earn small ratings. Thus, during the sweeps, PBS now displays many of its strongestnot weakest-programs.

By the mid-2000s the top programmers at PBS had decided to stop using ratings as a "rear-view mirror" and had begun to state goals for their programs, using a formal process that judges primetime programs according to predetermined goals. Some stations are nervous about the transition to objective standards, preferring to balance critical acclaim and awards against audience size. Nevertheless, PBS must be accountable to an evershrinking number of underwriters who want their programs to be seen.

Stripping and Stacking Limited Series

A standard among PBS's offerings, the limited series includes both nonfiction and fictional miniseries (continuing topics with a fixed number of episodes, usually ranging from 3 to 12 or more). Some notable examples of limited series in recent years include Texas Ranch House; Jean-Michel Cousteau: Ocean Adventures; African-American Lives; and Ken Burns' The War. Most limited series appear once a week in prime time, much as weekly series are scheduled on commercial television.

Because short-run series lose viewers across the first few weekly telecasts, however, PBS schedulers have experimented with alternative play patterns in the hope of staunching the dropoff. Borrowing jargon from computer technology, they asked whether limited series scheduling could be made more "user friendly." Experiments with the Holocaust series and Shoah in 1988 showed that limited series that have sufficiently engaging material lend themselves to airing on consecutive nights, a practice known in commercial television as stripping. This ploy not only attracted at least as many viewers as tuned in to similar programs on a weekly basis but also encouraged viewers to spend significantly more time watching the series. Moreover, the episode-to-episode ratings dropoff disappeared.

Which limited series receive special treatment and which must air in the usual once-a-week way has hinged on a decision about what "sufficiently engaging material" means. This is in part a function of production budget, advance promotion, casting, subject matter, and less well-recognized variables such as timing, quality, and appeal to the public television audience. Such decisions cannot be

supported by audience research alone; the programs must be screened (watched) as well. Ultimately, the chief program executive now makes the call.

When a limited series has too many episodes for convenient stripping, PBS bunches episodes together, stacking two episodes per evening. Ken Burns's epic on World War II, *The War*, for example, was scheduled in this pattern, thereby limiting the magnitude of nightly commitment on the part of viewers. PBS's practice is to schedule limited series on a maximum of five consecutive nights (although *The War* required seven evenings).

Audience Flow

Certain PBS series are especially dependent on audience flow from a strong lead-in. New, untried programs especially need scheduling help. *The Ring of Truth*, a six-part series on the scientific method, for example, was not expected to build a loyal following the way a predictable series such as *Wall Street Week* has. Thus it was placed following an established, successful science series, *NOVA*, which regularly draws large audiences (large, that is, for public television) and itself has no need of a powerful lead-in.

Particularly in need of a lead-in boost—on a regular basis—is another PBS staple, the umbrella series. These are anthologies of single programs with loosely related content that appear under an all-encompassing title (or umbrella) such as *American Experience* (history programs) or *Great Performances* (ballet, plays, operas, orchestral music, Broadway shows, and so forth). Because the material offered under the umbrella changes from week to week, the audience never knows what to expect. Clearly, the format works *against* habit formation. Thus, it is essential that a strong audience be introduced to each week's episode, if not by costly media advertising (usually out of public television's reach), then by a substantial lead-in.

Considerations at the Station Level

A public television program schedule is notable for its variety; it is meant to serve the total population over time but not the complete needs of the individual viewer. Although this is also true of commercial stations, it especially applies to public television schedules. Because they usually are so focused in content, PTV programs tend to be watched by small, often demographically targeted population segments. Seeking the most opportune time slot for reaching those target groups is the local program manager's challenge.

No PTV programmer ever builds an entire schedule from scratch (unless the station has just signed on for the first time, of course). Rather, the manager's ongoing responsibility is to maintain a schedule while considering the following factors:

- 1. Licensee type, as each carries its unique program priorities
- 2. Audience size and demographics
- 3. Competition from commercial stations, other public television signals, and cable networks
- 4. Daypart targeting, such as daytime for children's programs and instructional services, and early evenings for older adults
- 5. Program availability

No single element overrides the others, but each affects the final schedule. Public television programmers seek programs that meet local audience needs and schedule those programs at times most likely to attract the target audience. Because all audience segments cannot be served at once, the mystery and magic of the job is getting the right programs in the right time slots. High ratings are not the primary objective; serving the appropriate audience with a show they will watch that adds to the quality of their life—is.

National Promotion

Still another consideration is the importance of national promotion. Fledgling programs and episodes of an umbrella series need extra help for viewers to discover them. Although an effective lead-in program is essential, advertising and promotion can alert other potential viewers to a new program and persuade them to try it. Unfortunately, public television budgets permit little advertising. Only a

few underwriters include some promotional allotment in their program budgets.

Still another PBS practice is to carefully schedule on-air promotion announcements for a particular program in time slots where potential viewers of that program (based on demographic profiles) are likely to be found in maximum quantity. Such on-air promotion is crucial because it reaches known viewers of public television, but its effectiveness is somewhat hampered by public television's limited prime-time reach. In one week, a massive on-air campaign promoting one program could hope to reach at best only 20 to 25 percent of all television households.

Audience Ratings

Public television must always demonstrate its *utility*. Many have contributed to its continuance—Congress, underwriters, viewers. If few watch, why should contributors keep public television alive? Programmers have come to realize that critical praise alone is insufficient; they need tangible evidence that audiences feel the same way. That most convincing evidence comes from acceptable ratings.

Nielsen Data

PBS evaluates the performance of its programs with both national and local viewing data, each having its own particular usefulness in analysis. National audience data are provided by the Nielsen People-Meter service (NPM); the Nielsen Station Index (NSI) provides the individual market data (see Chapter 2).

PBS's limited research budget permits the purchase of only one national audience survey week per month. Forty weeks therefore go unmeasured. (The commercial networks, as described in previous chapters, purchase continuous, year-round national data.) However, NSI's ever-expanding Metered Market Service (56 markets in 2008) provides PBS with a comparatively inexpensive proxy for daily national ratings because 66 percent of the country's TV households are within these markets. Of necessity demographic data on viewing

and viewers continues to be collected by the diary method in the smaller markets.

Public stations use the same Nielsen local diary surveys (and the resulting ratings books) during the four sweeps as do their commercial counterparts. Nielsen surveys the largest markets in October, January, and March, and public stations in those markets can also purchase these reports.

Commercial network programmers, to the irritation of advertising time-buyers, have traditionally inflated affiliates' ratings by stunting with unusually popular specials and miniseries during the sweeps weeks (see Chapter 4). These higher ratings provide the local affiliates with an opportunity to raise advertising rates. PBS programmers schedule some new product during sweeps but lack enough truly top-notch programming to stunt for an entire four-week period. PBS does, however, try to schedule a *representative mix* of PBS offerings during each of the national survey weeks. No more than one opera is permitted, for example, nor are too many esoteric public-affairs programs scheduled during that week.

PBS itself indulges in stunting during its pledge drives. Just as networks stunt for economic reasons, so too does public television. The difference is structural: Rather than raise revenue by selling advertising time on the basis of ratings, PBS stations raise revenue by direct, on-air solicitation of viewer contributions. Programs specially produced for the drives are scheduled alongside regular PBS series. To an extent, larger audiences mean larger contributions, but a low-rated program may find a small but appreciative audience and prove a lucrative fundraiser. At the same time, high ratings (relative to the whole schedule) have considerable appeal to uncommitted funding agencies and potential underwriters.

Audience Accumulation Strategy

PBS strives for maximum variety in its program schedule to serve as many people as possible at one time or another each week. Unlike commercial network programs, not all public television programs are expected to have large audiences. Small audiences are usually acceptable so long as the weekly

accumulation of viewers is large, an indication that the "public" is using its public television service. And so, an important element in assessing PBS's programming success is its weekly cumulative audience, or cume. This statistic, along with timespent-viewing, constitute the two basic elements of audience data.

The most important data come from the cumes. As explained in Chapter 2, Nielsen defines a cumulative household audience as the percentage of all U.S. TV households (unduplicated) that have tuned in for at least six minutes to a specific program or time period. (Six minutes is a minimum figure, the "ticket" for admission into the cume. Even if the viewer watches for 50 minutes, or leaves and rejoins the audience five or six times during a telecast, that person is still counted only once in the cume, provided the six-minute minimum has been met.)

Public television's weekly national cumes for prime time (8 to 11 P.M., Monday through Sunday) averaged 23.2 percent of U.S. households in 2005–06. When all times of day are included, the weekly cume rises to 43 percent of the country's households (but down from 55 percent a few years earlier). Thus, nearly half of households tune in to PBS at least once a week. The competing "comparison channels" on cable (A&E, Discovery Channel, Learning Channel, History Channel) attract less than two-thirds of PBS's audience.

A more typical statistic for public television than cumes are average audience ratings. For the major ongoing series in 2006, the ratings were as follows: nature and science programs, 2.3 rating; dramas, 1.8; musical performances, 1.1; news and public affairs, 1.2. Based on prior experience, PBS programmers apply informal guidelines for what rating levels constitute adequate viewing. Because ratings are not the sole criterion by which PBS program performance is evaluated, however, failure to meet predicted levels never triggers a cancellation. Repeated failure to earn the minimum expected cumes, though, could eventually result in nonrenewal.

Loyalty Assessment

PBS researchers also study *audience loyalty* (tenacity) as a way to evaluate a program. Using ratings

from the 56 metered markets, which Nielsen provides quarter hour by quarter hour, it is possible to plot an audience's course across a single program or across an entire multiweek series. If the audience tires quickly of a program, the overnight ratings will slip downward during the telecast (a fate to which lengthy programs are especially susceptible). If the audience has weakened in response to the appeal of competing network programs—such as when a special starts a half hour after a PBS show—the overnight ratings will suddenly drop at the point where the competing special began. This information tells the programmers (roughly, to be sure) the extent to which their program has engaged viewers. Noncompelling programs are vulnerable to competition. Shows failing this test have to be scheduled more carefully when repeated, preferably opposite softer network competition.

The National People-Meter Service, in addition to TV ratings and cumes, provides a different but equally valuable analytical statistic: the number of minutes spent by people (or households) viewing a single program or even a whole multi-episode series. This time-spent-viewing figure reveals how much of a production was actually watched, in contrast to the cume, which simply tells how many watched. As mentioned previously, some miniseries earn higher time-spent-viewing figures when stripped on consecutive nights than when scheduled weekly.

Demographic Composition

Another useful way to evaluate a program is by observing exactly who is watching. If a program is designed for the elderly, did the elderly in fact tune in? When African-Americans were the goal, did sufficient numbers switch on the program? Although households tuning to public television each week are, as a group, not unlike television viewers generally, audiences for individual programs can vary widely in demographic composition. Programs such as NOVA and Masterpiece Theatre attract older, college-educated, professional/managerial viewers because these programs can be intellectually demanding. Demanding shows are numerous on PBS, thus its cumulative primetime audience composition reflects this tendency. Many programs, though, have broader-based followings, among them Nature and This Old House.

PBS's evening programs have also been found to have an age skew (tendency) favoring adults 35 years of age or older. Few young adults, teenagers, or children watch in prime time. The reason for this skew probably lies in the nature of the evening schedule, which, despite the occasional light entertainment special, consists largely of nonfiction documentaries. According to CBS's top research executive:

Our analysis shows that over age 35, you get an adult programming taste. Under age 35, you still have a youth orientation. It is only when people reach their mid-30s that their viewing tastes become more like older adults'.... And their appetite grows for news and information programming.7

Still, public television's overall (24-hour-a-day) cumulative audience demographically mirrors the general population on such characteristics as education, income, occupation, and racial composition, as shown in 7.12. That is partly because it is a large audience, with more than half of all U.S. TV households tuning to public television each week and about four-fifths tuning in monthly. Another reason for PBS's broad profile is that the overall audience includes the viewers of daytime children's and how-to (hobbies and crafts) programs, many of whom are not frequent users of the prime-time schedule.

Public television representatives frequently are called upon to explain a seeming paradox: How can public television's audience duplicate the demographic makeup of the country when so many of its programs attract the upscale viewer? The question is second in importance only to that of how many people are watching; it is often tied to charges of elitism in program acquisition, implying that PBS is not serving all the public with "public" television.

PBS replies that it consciously attempts to provide alternatives to the commercial network offerings; to do so, the content of most PBS programs must make demands of viewers. Demanding programs, however, tend to have less

7.12 U. S. Population and PTV Demographics

TABLE 8 PTV AUDIENCE DEMOGRAPHICS Winter Quarter 2006

	% DISTRIBUTIONS DIFFERENCE								AVG MIN			
	U.S.		PTV Audience		FROM U.S.		CUME %*		CUME (000)		VIEWED	
	Population		Full		Full		Full		Full		Full	
	(000)	%	Day	Prime	Day	Prime	Day	Prime	Day	Prime	Day	Prime
TV HOUSEHOLDS	110,200	100.0	100.0	100.0			45.2	24.2	49,865	26,615	185	89
PERSONS 2+	280,500	100.0	100.0	100.0			29.1	13.6	31,625	38,145	137	80
HOUSEHOLDS (by He	ad of House	hold):							.,020	00,110		00
SPANISH ORIGIN	11,230	10.2	10.3	7.0	0.1	-3.2	45.5	16.7	5.115	1,870	192	71
RACE					0.1	0.2	40.0	0.7	3,113	1,070	172	/ 1
Black	13,280	12.1	11.6	9.2	-0.5	-2.8	43.6	18.7	5,790	2,480	226	80
Non-Black	96,920	87.9	88.4	90.8	0.5	2.8	45.5	24.9	44,075	24,135	180	90
EDUCATION												
Less Than 4 Yrs HS 4 Yrs High School	15,900	14.4	14.0	11.1	-0.5	-3.4	43.6	18.3	6,930	2,910	223	83
1-3 Yrs College	30,080	27.3	26.8	27.3 27.3	-1.3 -0.5	-2.6 0.0	43.1	21.7 23.8	14,220	7,175 7,160	1 <i>7</i> 8	86 87
4+ Yrs College	31,230	28.3	30.6	34.3	2.3	6.0	48.7	28.8	15,210	8.980	185	95
OCCUPATION												
Prof/Owrer/Mgr	27,600	25.0	24.7	25.3	-0.3	0.3	44.9	24.5	12,380	6,765	162	79
Clerical & Scles Skilled & Semi-Skd	18,140 28,080	16.5 25.5	15.9 22.7	14.8 17.9	-0.6	-1.7 -7.5	43.9	21.8	7,955	3,955	161	70
Not In Labor Force	36,380	33.0	36.6	42.0	3.6	9.0	40.5	17.1	11,375	4,815	187	73 111
INCOME						,	00.1	00.7	10,020	11,245	214	
Less Than \$20,000	24,400	22.1	21.7	20.2	-0.5	-2.0	44.3	21.9	10,810	5,355	237	94
\$20,000-\$39,999 \$40,000-\$59,999	25,440	23.1	22.5	21.7	-0.6	-1.4	44.0	226	11,205	5,750	201	96
\$60,000+	19,360	37.2	17.3 38.6	17.5 40.7	-0.3 1.4	-0.1 3.5	44.6 47.0	24 0 26 3	8,625 19,250	4,640	178 162	87 86
COUNTY SIZE	,	-	00.0	10.7	1	0.0	47.0	20.5	17,230	10,703	102	00
A (Metropolitan)	43,630	39.6	44.8	44.8	5.2	5.2	51.2	27.4	22,340	11,935	191	94
B (Suburban)	34,040	30.9	29.1	28.1	-1.8	-2.8	42.6	22.0	14,500	7,485	165	76
C (Small Cities) D (Rural)	16,480	15.0 14.6	12.7	13.6 13.5	-2.2 -1.1	-1.4 -1.0	38.6 41.7	21.9	6,360	3,610	179	85
CABLE STATUS	10,030	14.0	10.4	13.3	-1.1	-1.0	41./	22.5	6,700	3,610	191	91
Broadcast Only	15,620	14.2	19.4	20.1	5.2	6.0	61.9	34.3	9.670	5,360	313	121
Cable Plus/ADS	94,580	85.8	80.6	79.8	-5.2	-6.0	42.5	22.5	40,195	21,250	155	82
Cable Plus W/Pay DBS	46,820	42.5	37.2	36.0	-5.3	-6.5	39.6	2C.4	18,535	9,570	144	78
PERSONS	22,280	20.2	14.1	12.8	-6.1	-7.4	31.5	15.3	7,015	3,405	130	73
Kids 2–5	15,690	5.6	0.0	1 7	2.0	2.0	45.7		7.1.5			
Kids 6–11	24,270	8.7	8.8 6.7	1. <i>7</i> 2.3	3.2	-3.9 -6.4	45.7 22.6	4.1	7,165 5,475	645 865	230	47 46
Teens 12-17	24,710	8.8	4.2	2.8	-4.6	-6.0	13.9	4.4	3,435	1,075	97	39
Women 18-34	32,940	11.7	8.5	6.3	-3.2	-5.5	21.1	7.3	6,950	2,405	107	51
Women 35-49	32,590	11.6	11.3	11.4	-0.3	-0.2	28.4	13.4	9,255	4,365	105	58
Women 50-64 Women 65+	26,080 20,380	9.3 7.3	11.2	13.4	1.9	4.1	35.1	19.7	9,165	5,125	122	75
Men 18-34	33,100	11.8	7.2	6.4	-4.6	-5.4	46.4	3 .4	9,455	6,390	188	115
Men 35–49	31,340	11.2	11.6	12.8	0.5	1.7	1 <i>7.7</i> 30.3	7.4 15.7	5,875 9,495	2,435	93	54 59
Men 50-64	24,270	8.7	10.8	14.4	2.1	5.7	36.2	22.5	8,775	5,470	136	84
Men 65+	15,130	5.4	8.0	11.8	2.6	6.4	43.3	29.6	6,555	4,475	173	109

SOURCE NTI - Jan and Feb 2006 surveys covering 1 week per month. For 13-week total hausehold cumes and AAs, see Table 7.

 * Cume % is PTV's penetration or reach within each specific demographic group. Percentages may not sum to 100% due to rounding.

PBS National Audience Report Table 8/1 of 1

appeal to viewers of lower socioeconomic status (as well as to younger viewers). The result is underrepresentation of such viewers in certain audiences. This underrepresentation is, however, on balance, only slight and limited largely to prime time, being offset in the week's cumulative audience totals for other programs having broader appeal. Critics often overlook the fact that underrepresentation does not mean no representation. NOVA, for example, is watched each week in some 900,000 households headed by a person who never finished high school. Even operas average nearly 300,000 such downscale households in their audiences.

The kinds of audience statistics just cited serve a unique function: justification of public television. Commercial broadcasters and cable operators justify their existence when they turn a profit for their owners and investors; public broadcasters prove their worth only when survey data indicate the public valued (that is, viewed) the service provided.

Developments Ahead

Many people in the noncommercial field believe the public television station of today will become the public telecommunications center of tomorrow a place where telecommunications professionals handle the production, acquisition, reception, duplication, and delivery of all types of noncommercial educational, cultural, and informational materials and stand ready to advise and counsel people in the community. In this scenario, existing public television stations will transmit programs of broad interest and value to relatively large audiences scattered throughout their coverage areas; but they will also feed these and other programs to local cable channels and transfer programs of more specialized interest to DVDs for use in schools, colleges, libraries, hospitals, industry settings, or in use on homes. Because of its high quality, HDTV may give public broadcasters the special edge they need-if enough programming becomes available and if early adoption proves practical.

The coming years pose special challenges to those who hold public television licenses across the country. To achieve its public service potential and move beyond the limitations posed by broadcast towers into the new video distribution technologies, as well as make full use of its satellite capacity, the social value of noncommercial, educational video services must be reaffirmed by American policymakers. Public television cannot complete its transition into the new media environment of the mid-twenty-first century without such affirmation. The public service, and particularly the educational value of this institution, is founded on the principle that a certain portion of the public's airwaves should be reserved for noncommercial, educational use. Public financing was a key element of that founding assumption, and billions of dollars have been invested in making public television available to the entire nation. To continue as the national resource that it has become in broadcasting, public television must extend its mandate to additional media technologies. The educational role of public television is certain to play a key role in achieving that objective.

A renewed focus on its educational mission will guide PBS's program selection and fundraising efforts in the future. One of its successes, Arthur, targets school-age children on weekday and Sunday mornings and is the most watched children's program in all of television, among young children. PBS usually has six of the top-10 preschool programs on U.S. television, including Barney and Friends, Dragon Tales, Teletubbies, and others. On the other side, public television is seeking wide-appeal programs, much like commercial networks, that can attract underwriting. One such recent effort was Slavery and the Making of America, a four-part documentary produced by WNET in New York, which was underwritten almost entirely by the New York Life Insurance Company. These programs may signal directions for the future. As with all broadcasters, however, the operative strategy for public networks and stations is alternative means of program distribution via the internet and interactive CD- and DVD-ROM.

By 2012, PBS will still be around, but it may be a smaller force on the national scene because public television faces daunting competition for product and funds. On the hopeful side, PBS's additional digital channels and exciting program ideas, coupled with digital compression and high-definition pictures, may revitalize the noncommercial television industry.

Sources

Current. Weekly Washington DC newspaper about public broadcasting, 1981 to date. www.current.org.

Farhi, Paul. "Tomlinson Cited for Abuses at Broadcast Board: CPB Ex-Chief Puts Friend on Payroll, State Dept. Says." Washington Post, 22 January 2007, p. C1.

Witherspoon, John, and Kovitz, Roselle. *The History of Public Broadcasting*. Washington, DC: *Current*, 2000. Chapters by Robert Avery and Alan Stavitsky. *www.abtonline.org*

www.cpb.org www.pbs.org www.pbskids.org

Notes

- 1. *ITV* in this usage should not be confused with *ITV* meaning "interactive television" or "internet television."
- 2. Credit for this analogy and other portions of the chapter goes to S. Anders Yocum, Jr., who was at that time director of program production for WTTW in Chicago and an early contributor to this chapter, as published in *Broadcast Programming* (Belmont, CA: Wadsworth, 1980).
- 3. As of 2008, two people shared this title as "Co-Chief Program Executives."
- 4. www.pbs.org/om/budsman/2006/10/a fair analysis.html.
- 5. This particular expression was coined by President Charles Van Hise of the University of Wisconsin in the early 1900s, but all land-grant colleges espouse similar traditions.
- 6. Everhart, Karen, "PBS May Rely on Rating Floors to Cull Series," *Current*, 26 April 2004, retrieved at www.current.org/pbs/pbs0407ratings.shtml.
- 7. Quoted in Townsend, Bickley, "Going for the Middle: An Interview with David F. Poltrack," *American Demographics*, March 1990, p. 50.

Cable, Wireless, Satellite, and Telephone Program Distribution

Susan Tyler Eastman and Michael O. Wirth

Chapter Outline

The Multichannel Distributors

Cable Systems Wireless Cable and Wi-Fi Satellite Systems Telephone Video

Selection Strategies

Technical Parameters

Digitalization Fiber Optics Interoperability

Legal Requirements

Universal Access Corporate Policies

Economic Considerations

Revenues Expenses

Marketing Factors

Scheduling Strategies

Evaluation Strategies

Audience Size Repetition and Ratings

Promotion Strategies

Local Origination on Cable

Entertainment Channels Local-Origination News Programming

Community Access on Cable

Changing Usage Nonlocal Programming

What Lies Ahead

Sources

Notes

ultichannel programming has been caught in a whirlwind created by new communications technologies and loosened federal regulations. The period through 2015 will see still more transformations in the media industries of cable, satellite, telephone, and computing. Already, cable companies are striving to blanket homes and offices with digital television, DVRs, voice telephony, and fast internet connections. Cell phone and personal assistant companies have gotten into the game by offering Wi-Fi internet connections and wireless online video programming. Direct broadcast satellite companies counter by offering attractive alternatives to cable and DVRs. Phone companies are copying cable by marketing combos of voice. broadband data, and video services.

Mergers and buyouts—those that foster cooperation rather than head-to-head competition—seem the increasingly likely path for nearly all media companies. Comcast, one of the very big players, led the way with its purchase of AT&T's cable systems, making it the largest cable operator with over 24 million subscribers and now reaching more than one in three of the 68 million cable subscribers. By 2008, more than 90 percent of the country was subscribing to some kind of multichannel program supplier.

Because communicating via the web is consuming an increasing amount of the time once devoted to television viewing, cable operators and telephone companies are rushing to provide high-speed home access to the internet as well as a wide range of digital video and audio programming. As one Bell Atlantic (now Verizon) executive predicted, "The people who will win this game are the folks who provide depth and breadth in programming and knock-the-socks-off customer service." The underlying technologies of multichannel media are changing in ways that give viewers more options and more flexibility, and at the same time, they are forcing companies that were once competitors to join hands.

Irrespective of the kind of owner—cable, telco, wireless, or satellite—the job of multichannel programmers is to *select*, *schedule*, *evaluate*, and *promote* channels of television and audio programming from the several hundred basic and premium

video and audio subscription networks described in Chapter 9, and to provide access to online programming on the internet, described in Chapter 10. For a few local cable programmers, the job also includes *producing* one or more channels of local or regional cable programs or web offerings. To do these tasks, multichannel programmers must operate within technical and legal limits while generating profits for the parent corporation with maximally marketable services.

The Multichannel Distributors

Four kinds of program retransmitters coexist: terrestrial wired cable, terrestrial wired telephone systems, terrestrial wireless systems, and direct satellite broadcasters, although telcos often own both wired and wireless systems. Collectively, they serve over 100 million out of the 111 million U.S. television households, and millions more homes and businesses around the world. Not surprisingly, the thousands of operators of these distributing systems face common problems. Although they offer different advantages and disadvantages to consumers, the major distribution services operate according to the same principles and face many of the same limitations.

Cable Systems

The term *cable systems* refers to geographically bounded and franchised companies using fiber optic and coaxial cable to deliver hundreds of program channels to about 75 million homes and offices; most also offer broadband (high-speed) internet service, too. Each local cable operator picks up signals from several satellites and broadcast antennas and then redistributes them via wire to homes and other buildings. Subscribers pay an average of \$50 to \$60 per month for cable services, depending on how many packages of channels they want and whether they have digital or high-definition service; internet service adds another \$40 or so to the bill. Currently, 7,090 separate cable systems operate in the United States, but the number is stagnant

or declining domestically. For the industry, growth can be achieved two ways: sell more domestic services and serve more countries.

In the United States, cable operators have been buying, selling, and exchanging systems to create large local market clusters that generate economies of scale. And because cable has matured as a business, one manager with office staff can effectively serve a much larger geographic area than the small areas most cable franchises encompass. Thus, swapping systems to create large clusters of several adjacent or nearby cable systems under a single manager saves significantly in overhead costs and provides about the same level of service, according to the industry. Clustering is clearly more efficient than operating a patchwork of scattered systems in different counties and different states. Studies also show that after the 5-million-subscribers mark, significant economies of scale emerge in the national market. In cable, the five largest multiple system operators (MSOs)—Comcast, Time Warner, Charter, Cox, and Cablevision-together serve about three-quarters of all cable subscribers (see 8.1).

Historically, one of the cable industry's biggest problems was limited channel capacity. However, construction of optical fiber systems throughout the country in the 1990s and development of the ability to digitally compress video signals—so that more content networks can be transmitted through the same amount of bandwidth—have enormously increased cable's capacity. For decades, there were twice as many cable networks vying to get on cable systems as the systems could carry, but the combination of large-capacity fiber, the digitalization and compression of program network signals, and

8.1 The Top Cable Operators, 2007

Company	Total Subscribers (in millions)
Comcast	24.1
Time Warner	13.4
Charter	5.5
Cox	5.4
Cablevision	3.1

the digitalization of home TV sets changed this equation. Like satellite systems, modern cable systems offer 300 or more channels of programming (some duplicates of analog channels in digital form, some high-definition premium channels, and some audio-only music channels), as well as high-speed internet access. By 2008, nearly two-thirds of the 100 million cable, satellite, and other multichannel subscribers were taking digital services, and that percentage was expected to grow rapidly to 80 percent. The full digitalization of cable, accompanied by high-speed online access, is sometimes referred to as the "thousand-channel universe."

Wireless Cable and Wi-Fi

Operating alongside cable companies are other distributors called multichannel multipoint distribution service (MMDS) operators, more commonly called wireless cable. MMDS operators broadcast channels of local television and cable networks using microwave frequencies from an antenna located on a tower, tall building, or mountain. Homes, apartments, and hotels receive the signals by using a small microwave dish, typically about 16 to 20 inches in size. A set-top converter, identical in function to a cable TV set-top box, has to be located near each TV receiver. MMDS most successfully serves portions of large cities where tall buildings are not too numerous to block the lineof-sight microwave signal. By 2008, the number of wireless cable subscribers had dropped below 100,000, which represented less than 0.1 percent of the multichannel video distribution marketplace.

Implementing another vision of wireless cable in the late 1990s, MCI WorldCom and Sprint each purchased a significant number of MMDS operators (altogether, about 60 percent of the total MMDS licenses) with the intention of using this spectrum as the "last-mile" connection to homes for the provision of high-speed internet access to voice communication (telephones). Then sending video to cell phones captured cell phone subscribers' interest, and the spectrum was deployed for wireless video and popularly named Wi-Fi. Although still and moving video pictures are rapidly appearing on cell phones, pagers, and personal communication

assistants (PCAs, formerly PDAs, such as Black-Berrys) using this MMDS spectrum, most of the material comes as brief shorts—miniprograms or promotional bites—because of the small size of the screens. Virtual keyboards, projected onto nearby surfaces, supplement BlackBerrys to aid internet access, e-mail, and data manipulation.

Because wired networks lack mobility, WiMax (a wide area network wireless broadband technology) may eventually become the last-mile technology for virtually all terrestrial systems, while Wi-Fi (a local area network wireless data technology) will continue to be the best way to spread a network over an office, home, or small area.

Satellite Systems

Satellite systems refer to three signal distribution methods: (1) low-power C-band home satellite dishes (HSDs); (2) medium-power Ku-band direct-to-home (DTH) satellite systems, such as Asia's STAR TV and the former ALPHASTAR and PRIMESTAR services; and (3) high-power Ku-band direct broadcast satellite (DBS) systems, such as DirecTV and DISH in the United States and SKY in Europe. The oldest form of satellite program delivery, HSD requires large backyard dishes that are often banned by horrified neighborhood associations—but the business was really killed off by the scrambling of satellite signals. HSD used to allow consumers to intercept the signals of various broadcast and cable networks as programs were transmitted via satellite to affiliates and local cable operators; now they must pay for service through a cable or satellite company, and the large dishes have almost disappeared from urban and suburban backyards.

The medium-power Ku-band DTH services lasted only a short time in America, selling off to DBS because of antitrust issues, their inability to match DBS's all-digital channel capacity, competition from small-size (24 inches or less) DBS home receiving dishes, and the loss of control of the most desirable geosynchronous satellite slots to DirecTV and EchoStar (DISH). However, the term DBS is used only in the United States; in the rest of the world, *DTH* means all kinds of home satellite

delivery services. Today, DirecTV and DISH have more than 30 million subscribers and are by far the largest noncable multichannel operators. To date, HSDs, telcos, wireless, and others reach only a few million subscribers together.

Two factors changed the satellite system landscape: the passage of the Cable Television Consumer Protection and Competition Act in 1992, and the establishment of a digital video compression standard (MPEG-1) in 1993 (see 8.2). Combined, they led to the rapid expansion of DBS systems in the late 1990s. Mergers and some failures resulted in two dominating companies by the turn of the century: DirecTV and DISH (owned by

8.2 Getting to Today's Satellite TV

he first factor that changed the satellite land-scape was the 1992 Cable Act. It guaranteed satellite distribution companies access to virtually all cable program networks owned by cable MSOs. Moreover, it forbade cable television programmers owned by cable MSOs from discriminating against DBS; they had to sell their program services at terms comparable to those they gave to cable operators. This requirement gave DirecTV and DISH access to the program services they needed to compete with cable, attract investors, and entice subscribers. Cf course, DBS companies still had to pay handsomely for the programming.

The second factor was the establishment of a digital video compression standard. The engineering community solved the initial problems in coding and decoding compressed video, and in 1993 MPEG-1 was chosen as the international standard. Using MPEG-1, DBS companies could squeeze eight analog program channels into the space of one digital transmission channel, thus greatly increasing the total number of program channels they could make available to consumers. Subsequently, satellite companies adopted MPEG-2 and then MPEG-4. These and subsequent compression standards substanticlly increase the number of digital channels that can be fit into the space alloted to one uncompressed video transmission channel.

EchoStar). By 2008, about 18 million households were subscribing to DirecTV, and about 13 million were subscribing to DISH, although such startups as VOOM were trying to eat into their business. The high-power Ku band of these systems allows subscribers to use dish antennas of one to two feet in diameter. (The Japanese already broadcast video and data using an even higher frequency band, Ka, to antennas the size of half dollars.)

Like digital and premium cable, DBS programming is decoded in the subscriber's home using a digital set-top converter box. The required home equipment is often given to new subscribers as an incentive to subscribe (usually as a loss leader). When DBS companies sell set-top boxes, the cost is between \$89 and \$399 (for a high-definition unit). Like local cable operators, DirecTV and DISH must negotiate with individual program providers (and normally pay for the right) to distribute broadcast as well as cable network signals to their paying subscribers. As with cable subscribers, consumers pay a monthly fee for MMDS or DBS satellite service, paying extra for upper program tiers and premium channels. Since satellite signals were digital from the beginning, the enormous cost of conversion to digital born by broadcast stations and cable systems gives satellite companies an advantage (less debt), provided that homeowners invest quickly in digital television sets.

Long-term success in the competition among these services is likely to depend on their ability to provide consumers with a bundled set of telecommunication services—a "triple play" which consists of a large selection of video channels plus broadband access and telephone service. The video means digital television plus high-definition and on-demand programming; the broadband refers to high-speed connections to the internet via cable modem or DSL (digital subscriber line); and the telephone can mean standard phones or cell phones, but increasingly it means VoIP, which stands for Voice over Internet Protocol, telephony services that use packet-switched rather than circuit-switched networks. VoIP greatly reduces the cost of providing voice service and of entering the telephone business. Bundling is the industry trend; it usually refers to grouping these three kinds of services in a package. The long-term goal of bundling has led to many of the recent megamergers between program producers, broadcast/cable/DBS program distributors, and internet access companies.

At this point, cable's short-run advantage over DBS—of being able to deliver all services (traditional and digital video service, VoD/SVoD, highspeed internet access, VoIP, and HDTV) over a single "wire" to its subscribers—has been somewhat reduced as a result of DBS/telephone company partnerships. (In the long run, telcos may well eliminate cable's "one wire with everything" advantage by becoming successful competitors in the multichannel video portion of the national marketplace.) On the other hand, because DBS is wholly digital, satellite companies supply higher quality video and audio signals than telcos-and more HDTV service—and subscribers can easily add on other digital accessories (such as integrated digital video recorders or DVRs) right now. DBS companies also permit greater personalization of their packages, giving the consumer more flexibility. Cable companies still have a small advantage when it comes to carriage of local broadcast television stations. Cable companies retransmit virtually all local broadcast stations in all 210 U.S. television markets, while both major DBS distributors retransmit local television signals in just about 75 percent of U.S. television markets (although those cover more than 92 percent of U.S. television households). Cable does it for free (with basic service); DBS charges extra.

Telephone Video

Wireline cable companies had an early advantage over DBS because DBS technology allowed DBS entrepreneurs to offer only high-definition television and VoD (to a limited extent through use of DVRs) directly to their subscribers. To put together bundled telecommunications service packages that are more competitive with cable, DBS companies have partnered with Regional Bell Operating Companies (RBOCs) such as Verizon, AT&T (the former SBC and BellSouth), and Qwest to offer VoIP as well as local wireline telephone service, and high-speed internet access (via DSL service).

8.3 Multichannel Service Distribution, 2007

Delivery Technology Total	Household (in millions)	Percentage of Multichannel Households	Percentage of TV Households		
Cable	67.4	67.6	60.5		
DBS	29.2	29.3	26.2		
Broadband service providers (includes relcos and cable overbuilders)	1.6	1.6	1.4		
Private cable	1.1	1.1	1.0		
HSD	0.2	0.2	0.1		
Wireless cable (MMDS)	0.1	0.1	0.09		
Over-the-air-only TV	11.8	-	10.6		
Total multichannel households	99.6	100.0%	89.3%		
Total TV households	111.4	100.0%	100.0%		

In the short run, this partnership benefits both the DBS companies and the RBOCs. However, the long-term viability of DBS/RBOC partnerships will likely depend on the success of the RBOCs in upgrading their twisted pair telephone networks to broadband, fiber-optic networks.

AT&T and Verizon are operating as distributors of cable network programming and high-speed internet access in many markets. AT&T's U-verse technology offers more than 300 channels of television, including high definition, and high-speed internet access. Verizon's FiOS TV service is similarly robust. As more and more fiber is rolled out, RBOCs will become increasingly competitive in the multichannel video area. This will allow them to deliver the full bundle of telecommunication services (meaning digital video service, VoIP, HDTV, VoD/SVoD, and high-speed internet access, as well as traditional voice) over a single "wire" to compete directly with cable across the country.

Another service that these companies need to offer is in-home Wi-Fi, an increasingly desired component of both television and computer access. As the teleos successfully upgrade, they will no longer need to partner with DBS for the video portions of the telecommunications bundle. This would leave DBS once again without the ability to deliver VoIP or high-speed internet service cost-effectively to its subscribers.

Since about 90 percent of the 112 million U.S. homes with television sets are multichannel homes (a total of about 100 million homes, depending on whose numbers one likes), it follows that only 10 percent of U.S. television households are overthe-air-only homes. As 8.3 shows, back in 2007, about two-thirds of the multichannel households had cable, more than one-fourth had DBS (and a few had both cable and DBS), and about 3 percent had some other broadband service-a wireline cable overbuilder, private cable, wireless cable, telephone, or home satellite service-and these numbers have risen since the digital changeover. Also, about 70 percent of multichannel homes had either cable modems or a DSL connection to the internet (see Chapter 10).

Selection Strategies

A shortage of broadband spectrum has long restricted the kinds of programming that terrestrial and satellite multichannel video distributors could initially offer. At present, a few cable and wireless companies still remain particularly disadvantaged by having relatively small capacity compared with satellite operators, but most multichannel distributors have greatly enlarged their technical capacity. The long-term solution to bandwidth shortages has

been clear to all participants for many years, and the FCC agrees: Transition rapidly from analog to the complete digitalization of broadcast and cable program providers, distributors, and home equipment, and follow this with interoperability. Digital rollout in the industry has progressed rapidly, but consumer demand has been modest. Despite plenty of press, the February 2009 deadline for the end of analog television broadcasting has caught some of the public by surprise.

Three stages relating to spectrum availability affect the selection of cable and satellite programming. The first is completed: the conversion of terrestrial analog broadcast stations to digital signals. The second is the upgrading of cable systems to retransmit digital broadcasters and interactive on-demand as well as cable network signals. The third is the conversion of homes and offices to high-speed internet access and high-definition television.

Although some experts predict total conversion to an on-demand video and data system by 2015, several conditions create roadblocks that slow the transition. These conditions can be divided into overlapping technical, legal, economic, and marketing circumstances affecting cable, wireless, and satellite delivery and reception and thus programming strategy. Not all factors inhibit innovation and change, however; some encourage them. Successful programmers juggle all the variables of physical and legal limits, licensing and marketing costs, along with revenue potential, to select the best options for their coverage areas, and thus the mix of services necessarily varies somewhat from town to town and from one company's footprint to another. At present, the most challenging programming decisions are those arising from the changing nature of new communication technologies.

Technical Parameters

The precise number of channels (or amount of bandwidth) a system is able to carry is largely a function of its delivery, compression, and filtering technologies as well as its flexibility. Because the newest technologies (GHz) have tremendous capacity, cable and satellite companies no longer

evaluate capacity by maximum bandwidth capability or by the number of 6-megahertz (MHz) analog channels that can be handled (such as 36, 120, or 500 channels). Instead, the industry views fiber and amplifier technology in terms of platforms, or levels of potential capability. A 1-GHz platform with appropriate design architecture can be utilized for mixes of digital signals, and the number of functions it performs (and thus services it delivers) can be gradually increased over time. Indeed, the upper levels above 750 MHz are sometimes thought of as "virtual channels," the cable engineering equivalent of "virtual reality." Virtual channels are for streams of digitized information that function as return paths to the cable operator; movement of these digitized streams through a cable (or telephone) system is measured in time and distribution rather than in old-fashioned radio frequencies.

The 1-GHz platform is viewed by engineers as practically limitless, but several intervening developments in technology are necessary in order to fully utilize that capacity. This section on changing technology goes into detail about aspects of digitalization (including compression, high definition, on-demand video, and fiber optics) and the different kinds of interoperability (including addressability, multiplexing, and interactivity).

Digitalization

Digitalization of communications provides tremendous increases in usable bandwidth. It means better-quality pictures and high-definition television. It means the interactive delivery of the various kinds of on-demand television (VoD, SVoD, NVoD). In the decades ahead, it is likely that very few live broadcasts will occur. Eventually, only a few networks will deliver real-time sports and breaking news; the rest of television will be on-demand programming, operating much the same whether the consumer seeks entertainment or information, and looking the same to the consumer whether the original source was once called a broadcast, cable, satellite, telephone, wireless, or online network and whether the programs are watched on the TV set, computer, iPod, or BlackBerry. The change to all-digital cable transmission and reception demands a complex infrastructure with expensive technical characteristics, for which the public will certainly have to pay.

For cable, the high cost of upgrading systems to all-digital transmission and providing advanced settop boxes has led the industry to utilize a phased rollout strategy. Cable operators seek to retain as many of their subscribers and advertisers as possible while moving step-by-step into digitalization as the economic payback becomes visible. An overnight shift is viewed as impossible because it would require all cable subscribers to have a digital set-top box for every television set in the home. Although all broadcast stations had to end analog transmission in 2009, most homes still have some analog TV receivers. Additionally, the capital expenditure connected with a complete transition to digital would be quite high for cable companies. As a result, cable operators offer digital signals as an option at present and gradually introduce more and more capable set-top boxes. Although the theoretical capacity of most cable systems is extremely high, as a practical matter there will be too few channels for all the services that want to be carried on local systems—until full industry digitalization is completed at some point in the future. As the internet becomes a bigger part of the television system—and vice versa subscriber choice will expand dramatically.

For satellite companies, digitalization is not an issue. DirecTV and DISH Network launched their operations as fully digital systems, often touting the quality of their picture and sound in their marketing efforts to consumers. Although each system uses a different digital video compression system, both are able to deliver on their marketing promises. Each piece of DirecTV and DISH equipment, from antennas to set-top boxes, is digital (although the converter boxes go anywhere but "on top" when screens are flat). Satellite companies are, however, restricted by the number of transmission channels currently licensed to them by the FCC: 46 for DirecTV and 107 for DISH. Using present-day digital compression standards of 12 to 1, DirecTV can transmit more than 600 channels, and DISH can send almost 1.300 to subscribers—far more than most cable systems offer.

From the consumer's perspective, digitalization will eventually necessitate the replacement of all existing television sets and VCRs. Digitalization also means a higher proportion of discretionary income has to be allotted to subscriber fees. All new TV sets sold since 2007 have been digital and able to handle high definition, but most people have several sets and won't throw out old ones that work. As a result, the industry has been forced to recognize that not all TV sets will be digital even in digital households and, moreover, that many of the remaining 10 percent of noncable/nonsatellite U.S. households will continue to require analog signals for a long time to come. The FCC's solution has been to require the purchase of inexpensive cownconversion boxes for each TV set.

On the VCR front, the public's rapid adoption of digital music and DVD players signals the approaching end of VCRs and videocassettes (except maybe for the preschool children's market). By 2010, nearly all homes will have DVD players, and most homes will have at least one DVR and/or a TiVo-like system. Although DVRs can replace VCRs in off-air recording capability, they lack videotape's portability and library functions. To date, DVD has stalled, staying only a playback technology because of two warring high-definition recording systems, Blu-Ray and HD-DVD (see 8.4). The bad news is that much home equipment is unlikely to be compatible with subsequent generations of DVRs and DVD machines. Meanwhile, Hollywood is rushing to play catch-up by digitalizing its enormous libraries of old movies and television series.

Compression

Another element that has drastically changed how cable, broadcast, and online video operate is signal compression. To compress a digital signal, redundant information is removed (such as background that does not change for several seconds) and only the changing information is transmitted. Advanced compression techniques can send between 4 and 12 or more television signals in a 6-MHz band—what was once required for just one television picture. International telephone and satellite television signals have long made use of compression, and video

254

8.4 The Competing Scanning and Recording Systems

igh-definition television (HDTV) contrasts with standard-definition television (SDTV) and other lower-definition TV systems. SDTV has 525 lines of resolution and uses interlace scanning. The HDTV system called 1080i has 1,080 lines of resolution and displays images using a form of interlaced scanning that first transmits all the odd lines on the TV screen and then the even lines. This system of HDTV is supported by CBS and NBC. The competing HDTV system, called 720p, offers 720 lines of resolution and displays images using progressive scanning, which means it transmits each line from top to bottom. This system provides image quality close to that of 1080i, Moreover, when transmitted at 24 frames per second instead of the usual 60 frames per second, cable operators can squeeze more HDTV channels into their lineups. This system is, not surprisingly, supported by cable operators, as well as by ABC and FOX. Then, there is a third option, 480p, with 480 lines of resolution scanned one after another progressively on the screen. It allows for transmission of either multiple programs in the space of one channel or data services such as internet access. It is, quite logically, supported by Microsoft and various computer companies who use progressive scanning.

Making it all more complicated is the war over hi-def recording disks and devices. The giant Sony Corporation supports Blu-Ray, a blue-laser system for home and industry recording and playback of DVDs, video games, and computer games. Because Blu-Ray has substantially more capacity (50 gigabytes), gaming powerhouse Electronic Arts and a host of U.S. and Japanese equipment manufacturers are on its side. Battling Sony and friends are the HD-DVD interlace supporters, headed by Toshiba and several big Hollywood studios, including Paramount, Universal, and Time Warner. This format holds 30 gigabytes of data—substantially less than Blu-Ray but plenty for hi-def movies and present-day computer games. Both have far bigger capacity than standard DVDs that cannot even hold a single hi-def movie. A disk for either of the new systems can store 100 hours or more of standard television (plenty for all the episodes of Seinfeld or Cosby). Of course, the systems are incompatible with each other and with standard DVDs. Currently, machines that can read two or all three systems (including the present-day low-def system) have very high-end price tags.

signals on the internet also utilize digital compression, although some pictures seem jerky because too much information was not being transmitted. It is expected that compression rates as high as 20:1 may soon become common through MPEG-4 with little degradation in picture quality, making television via the internet look like television on a small TV set. To compete, TV set manufacturers push larger and larger screens.

High-Definition Television

Virtually all prime-time television and major sporting events on ABC, CBS, FOX, NBC, and PBS appear in high definition, shortened to hi-def or HDTV (or even HD in the industry). The largest cable networks, including ESPN, TNT, A&E, Showtime, HBO, USA, TLC, Spike, Discovery, and most regional sports networks, as well as

the largest television stations, offer most of their evening programs in hi-def (see Chapter 9), but many cable program suppliers have been slow to adopt HD.

Although HDTV was available to consumers on some cable channels by the turn of the century, its penetration has been slow, in part because technical and marketing emphasis went first to digitalization and high-speed internet access. HD requires special set-top converter boxes and full digitalization by the program providers and distributors, as well as in homes. As of 2008, the bulk of consumers could not access HD signals either because they did not take digital service or because cable operators did not deliver signals in HD format. Additionally, of course, homeowners have to have HDTV sets and pay extra for digital and HD service to take full advantage of the signal.

DirecTV dishes and receivers can handle the standard compressed NTSC signals (traditional non-HD signals) and HDTV signals from satellites in both progressive format (scans like computers in 720p HD) and interlace format (scans like television in 1080i ATSC). The differences between systems are described in 8.4. Indeed, a single satellite receiver can function simultaneously as a digital television receiver for over-theair signals and for high definition of both kinds and provide seamless switching among all channels, accompanied by Dolby Digital surround sound. The flexibility of present-day dishes has great appeal for consumers of high-end equipment, and cable has a ways to go to catch up. Hi-def is particularly suited to the large screens of sports bars and other public places, but its availability on cable and telco systems and the growth of live HD sports is driving home subscriptions. Movies on HD are also a big pull because on flat HD screens they look more like their theatrical counterparts. Also in 8.4 is an explanation of the competing DVD formats.

On Demand

In spite of the significant cost of doing so, cable operators have been rapidly rolling out various on-demand services because they have the potential for great profitability (their content is described in Chapter 9). If on demand proves to be successful in the market, it will eventually force a complete shift to this form of interactive transmission and reception by cable operators. Ultimately, on-demand services will mean the realization of a greatly expanded channel universe by combining the vast resources of the internet with all preproduced and recorded video and audio programs, and, less happily, with a large supply of commercial messages targeted to individual consumers.

The speed of this huge change, which is now in progress, depends on several things. These include the deployment of **smart set-top boxes** (with complex software) and the spread of greater standardization among technologies via **open** or **flexible architectures** (infrastructures that can transform any kind of signal into something the viewer can see and hear). At the other end, they also depend

on consumer willingness (that is, desire) to purchase video "by the program" in their homes.

Only for digital households, video-on-demand (VoD) is an interactive system in which programs (mostly movies) are delivered instantaneously from servers at the cable headend or downloaded to the homeowner's DVR so that they can be watched at anytime. This contrasts with pay-per-view (PPV) in which programs/movies are shown back to back on the same channel(s) to all viewers. PPV is still utilized in smaller-capacity cable systems. However, it is being replaced rapidly by NVoD and VoD. The other common technology is near-video-on-demand (NVoD). This bandwidthintensive arrangement allows local caching of multiple copies of a program so that viewers can watch any of a pool of movies at, say, 10-minute intervals. It is only offered by large cable companies and DBS companies with large channel capacities, and which have not yet rolled out VoD.

Some on-demand programs (old ones, especially for children) come at no extra cost if the subscriber has digital service (free-video-on-demand—FVoD). Other on-demand programming is provided to consumers who subscribe to premium cable networks such as HBO, Showtime and Starz. This type of on-demand programming is referred to as subscription-video-on-demand (SVoD). As viewers and the industry digitalize, pay-per-view is rapidly giving way to on demand; both may look the same to consumers, but on demand can provide hi-def and much more flexible service from the viewer's perspective.

Fiber Optics

Another element in the conversion to digital systems is fiber optics. Cable systems and telephone companies are evolving toward all-fiber communication networks because of their *much higher capacity* (as much as 1,000 times a comparable thickness of coaxial cable), *better picture quality* (because fewer and different types of amplifiers are required), and *greater reliability* (through redundancy because systems typically use only a portion of capacity and thus have plenty left over for backup channels). In most systems, however, fiber installation ends at nodes

that serve as much as a neighborhood and as little as a block or so of homes (fiber-to-the-node—FTTN) because installing fiber all the way to individual homes (fiber-to-the-home—FTTH) will not be cost-effective for the foreseeable future. The cable industry claims that most services, including high-speed internet connection and VoD, can be adequately provided with FTTN. Users of up-to-date office campuses that are equipped with fiber all the way, however, commonly notice (and complain about) a significant lessening of speed and reliability at home—compared with their all-fiber offices, dorms, and classrooms—when part of the signal travels via ordinary telephone or cable lines. If the telcos can afford to upgrade first with fiber to the home, they could give themselves a significant advantage.

Although enough miles of optical fiber have been strung to reach to the sun (and probably back again), and fiber delivers data at the rate of one billion bits per second (a gigabit), fiber has been used primarily as a long-haul medium. A shortage of high-speed, local-access connections between consumer residences and cable operators persists. As the quantity of high-speed internet connections increases, however, the number of special paid services via wire will dramatically increase, and the cost of these services may decline. Fiber seems to be potential-in-waiting. Whether cable operators or telephone companies will ultimately dominate—or split—the delivery of high-speed internet service to U.S. homes has been a big question for the communications industry. About 56 percent of television households currently have high-speed internet connections; about 33 million via cable modem and 30 million via DSL.

Interoperability

Today, broadband communication systems are being constructed, not just cable or telephone systems. To take advantage of complex information flows and to seamlessly mix signals coming from many sources, sophisticated digital switching centers that can transfer among signals from computer data, broadcast television, cable television, telephone, banking signals, shopping credit records, fax, and so on are essential for realizing the dream of the electronic superhighway. *Interoperability*,

the ability of two-way video, voice, and data to operate through the same home equipment, however, requires common standards—down to the basics of jacks and plugs—across the entire communications industry. Widespread adoption of the MPEG-4 standard (the chip language for digital video compression) has been one step on the way to interoperability.

In 1999, MPEG-4, a huge advance in distribution technology, came from the Moving Picture Experts Group (MPEG), the organization in charge of developing standards for video and audio. This compression standard for multimedia applications permits program suppliers to compress program content in standardized ways so that program distributors—whether cable, satellite, or broadcaster—can reconstitute them in viewable form.

However, the quest to bring consumers the ultimate experience in multimedia entertainment means that the boundaries between the delivery of audio (music and spoken word) and accompanying artwork (graphics), text (lyrics and printed words), video (visual), and synthetic spaces have become increasingly blurred. Thus, the members of MPEG are developing a "super-platform," MPEG-21, to encompass copyright for all digital media applications. New and complex technical solutions are required to manage the delivery of these different content types in an integrated and harmonized way that has to be entirely transparent to the consumer of the multimedia services. At the same time, different parties have intellectual property rights associated with multimedia content and understandably seek to acquire income from those who make use of their content. MPEG-21 integrates two critical technologies: one that allows consumers to search for and obtain content—either personally or through the use of intelligent agents-and another that presents content for consumption that preserves the usage rights (payment of royalties) associated with the content.

Addressability

The technical ability to send customized packages of signals to each home with or without certain pay channels or a second tier or level necessitates twoway service or addressability. The operator must be able to address (talk to) the set-top box. Without addressability, all channels pass every home (or reach all homes in the case of satellite signals), and pay channels must be scrambled (electronically jumbled, requiring a descrambler in subscribing homes) or mechanically trapped (defeated at the pole or box) to keep them from entering nonsubscribing homes. Traps can capture only about four channels on a telephone pole and must be physically installed and removed with every change in cable or phone service. The primary problems with scrambling, from a consumer perspective, is that it necessitates a converter for each TV set on which the consumer wishes to receive scrambled signals.

With addressability, headend computers can add or delete digital and hi-def services without sending a technician to the customer's home, direct different sets of channels to individual homes, and offer movies and events using impulse ordering (VoD, rather than prearrangement by telephone or office visits). Very few cable systems address all subscribers, however; fewer than half of households have addressable converters—the digital set-top boxes that let cable operators communicate to individual TV sets from the cable headend. Without rolling a truck, cable companies can carry out a variety of technical services for cable subscribers (including service upgrades and downgrades). Installing addressable converters via digital set-top boxes has big benefits (and some frustrations, see 8.5) for cable operators. Systems typically charge a monthly rent for the boxes, and their presence encourages consumer use of VoD and the premium services (HBO, Showtime, Starz).

Set-top converters have some downsides for subscribers, however. Most converters defeat the utility of the television's original remote control and interact poorly with purchased DVRs (such as TiVo), frustrating subscribers and generating complaints. Moreover, subscribers must pay monthly for *each* converter box, raising monthly bills in homes with many television sets. (The national average is three, and it is common to have as many as five or six TV sets and a mix of accompanying VCRs, DVD players, and DVR units.) Now that smart digital boxes have replaced analog boxes, cable programmers will face diffi-

8.5 Converter Piracy

or cable operators, frustrations lie in signal theft and the illegal selling of set-top converters that descramble premium and pay-per-view channels. One cable company president was quoted as saying, "Converters are becoming a cash commodity" and that his company was forced to pay armed guards to protect its warehouses of converter boxes.² Pirated converters are often advertised in consumer and electronics magazines for about \$350, and the FBI has become involved in seizing illegal converters from independent manufacturers in six states. Pirated cable signals allegedly cost the industry millions of dollars annually. In addition to grossly illegal practices such as splicing into a neighbor's cable line (thereby degracing the neighbor's picture), some subscribers install fancy electronic chips in their set-top converters, disabling the trapping function to watch unauthorized pay channels. This practice reached such extremes that one cable company "fired on electronic bullet from its headquarters" through all converter boxes in its system that caused all illegally installed chips to malfurction. The company urged subscribers with "broken converters" to bring them in for repair and then filed federal suits against severa hundred who brought in boxes containing illegal chips. Whether the next generation of intelligent settop boxes will have sufficient security to defeat piracy is more a question of cost than technology.

cult decisions about how to provide sophisticated capabilities without disrupting service to households with only elementary capability. For a long time to come, there will be households (or secondary TV sets) that will merely need simple down-converters to take digital signals back to analog (\$30 at the supermarket). Only DVRs incorporate hard drives and fancy computing functions, giving them replay, record, search, and other abilities, and they become increasingly sophisticated with each generation. Cable operators are in a transition period, moving inexorably from limited addressability toward a totally addressable digital infrastructure that should eventually eliminate one of DBS' current advantages over cable.

The newest intelligent boxes include a cable modem, advanced graphics, greater speed, and a "triple-tuner" architecture that allow customers to watch television, access blogs and vlogs on the internet, and talk on the telephone at the same time. Rollout proceeds in fits and starts because such smart boxes are very expensive, and competing units lack compatibility. Instead, set-top converters evolve and mutate, gaining abilities until they reach the full-service, intelligent two-way platform.

Once standardization of the technology is achieved—at some date in the future—such million-circuit converters (and DVRs) will probably move inside television sets, but adoption of such advanced technology will require replacement of all home electronic equipment, and thus widespread adoption will be slow in arriving. In the meantime, incorporation of high-definition signals and connections to other digital services must be worked out among industry competitors, further slowing implementation of new services. All the technological hurdles delay the implementation of this portion of the electronic highway.

Multiplexing

In the mid-1990s, several national cable network programmers began multiplexing several channels of entertainment carried by the same signal, which are subsequently split into separate channels for subscriber viewing. The premium networks were the first to implement the idea: HBO initially delivered three channels of HBO, and Showtime and Cinemax offered two each. Three factors inhibited its initial spread on wire-line cable. First, although multiplexed offerings slowed churn, they served more to improve retention than to attract new subscribers to pay channels. Second, the channelcapacity crunch, brought on by the need of cable MSOs to find space for newly acquired or created program networks, limited the possibilities for implementation of multiplexing. Third, the rapid growth of internet access turned network interest away from separate channels and toward online interactivity. In contrast, multiplexing has thrived on direct broadcast satellite services-because of their greater channel capacity—by encouraging such theme clusters as Discovery Health, Discovery

HD, and Discovery People or Encore Hits, Encore Action, Encore Mystery, and so on.

As wire-line cable systems upgraded in the last few years to a channel capacity similar to DBS, multiplexing began resurfacing on cable. Today, it is common to see six or more multiplexed channels of movies and sports from each of several networks (Encore, Starz, HBO, ESPN) and dozens of multiplexed audio services from MTV and its kin (see Chapter 9).

Interactivity

On the programming side, program guides, home shopping, and games have been pushing the cable industry toward implementation of secure interactivity. As digitalization, high-speed internet access, and Wi-Fi arrive nationwide, it is expected that all kinds of programs—from education to cooking to comedies—may eventually avail themselves of the ability to ask viewers to respond in real time.

Interactivity via the internet has already revolutionized information gathering about audiences and methods of calculating audience size, and it will spread to television, altering the revenues available to cable and satellite companies as well as the program content. For example, with some interactive setups, viewers can tune in to a live sporting event, then choose their own camera angles, select the most recent statistics, or purchase their favorite player's jerseys-all by clicking a remote. Imagine watching a television show, then instantly ordering the soundtrack or a particular star's dress or sweatshirt, without even having to dig out credit cards: The item will appear on the monthly service bill. Viewers can even play along with a popular game show or do banking and pay bills without getting up from their living-room or office chairsall by clicking a remote. Although some of these functions can be done at present on a computer, all require more than merely clicking a button.

Some interactive options are already available from a number of cable and satellite operations: DISH in the United States; SKY Broadcasting in the United Kingdom (formerly BSkyB for British Sky Broadcasting but now expanded beyond Great Britain); TPS and Cable Lyonnaise in France; PrimaCom in Germany; Via Digital in Spain; and

Galaxy Latin America, the exclusive provider of DirecTV in Latin America. Such companies as OpenTV, ICTV, Inc., Liberate, MystroTV, and Diego, Inc. continue to work with multichannel video distributors and programmers to develop viable business models for interactive television in the United States.

Although the market for interactive television services has been slow to develop, the potential for viable interactive applications has improved significantly thanks to three developments: the continued expansion of DBS subscribership, the large investment in infrastructure and upgrades by cable MSOs after passage of the Telecommunications Act of 1996, and the increased demand for interactive communication among those who have grown up with the internet.

Legal Requirements

On the legal side, like all businesses, multichannel television distributors must adhere to federal law, state law, and municipal agreements. Several long-established policies promulgated by Congress, enforced by the FCC, and upheld by the courts particularly affect programmers. These policies can be grouped as universal access (including hot topics like must carry and retransmission consent) and corporate policies (and associated legal requirements concerning franchises, syndicated exclusivity, and antennas).

Universal Access

One congressional policy is the goal of equality for rural and urban users. This goal has a century of tradition in government regulations encouraging and then demanding access to utility and telephone services for all citizens, and it drives many policy decisions regarding television and the internet. Above all, communication technologies are viewed as essential to the proper operation of a democracy—for both their informational and their educational capacities. Thus, access for all the public, irrespective of household income or geographic location, is a policy goal.

For several decades, the main method of implementing this goal was a federal mandate requiring the delivery of terrestrial radio and television broadcast signals to all homes. Historically, Congress viewed cable and satellite services as secondary to broadcast service, though the courts tended to equalize their value. Since 1996, access for all to the internet has been a goal, but implementation lags behind policy, largely because imposing regulations on the internet early in its development was widely seen as inhibiting innovation and speedy growth. Although dial-up access is now widespread, the issue has shifted to ways of encouraging high-speed access around the country, and the next concern will be differential access via handheld mobile media.

Must Carry

One of the most contentious regulatory issues of the 1990s—carrying well into the twenty-first century—is the required carriage of signals. The issue of must carry divides the program providers (networks) from the distributors (local cable systems, telcos, and DBS companies) and even more vociferously divides local broadcasters from multichannel video distributors.

Initially, the must-carry question was whether cable operators should be required to carry all local broadcast television signals. Without a legal requirement forcing cable systems to carry all local broadcast stations, cable operators could have excluded some stations from easy access to cable viewers because the installation of cable connections usually means over-the-air antennas are disconnected. Cable operators could be expected to want to carry highly watched network affiliates of the major networks—but to have less desire to carry small-audience religious, Spanish-language, educational, public, and quasi-independent stations, and shopping affiliates. Shopping channels, for example, probably compete for viewers with channels owned by the cable MSO or shopping channels with which the operator has a favorable financial arrangement. Any broadcaster excluded from cable systems would be greatly threatened financially because of decreased audience reach. Congress (eventually supported by the courts) decided cable "must carry all."

Next, the question shifted to whether satellite services had to carry local broadcast signals. Would DBS have to provide retransmission of all local stations (called local-into-local service), eating up considerable bandwidth and necessitating high scrambling costs because their footprints overlapped many markets? On the one hand, direct satellite broadcasters had long sought the lifting of prohibitions against carrying any local terrestrial broadcast television stations; on the other hand, they said that being required to carry all local stations in order to carry some local stations, irrespective of content, was difficult and not in the public interest. It was decided that although a DBS company has the option of providing localinto-local service, it is not required to do so. As a result, DirecTV and DISH rapidly began offering local broadcast television signals to DBS subscribers in most markets.

Nonetheless, DBS distributors complain that forced carriage of all broadcast stations in a local market—including low-power signals or stations that are essentially shopping services—eats up a disproportionate amount of their capacity. Even with sufficient capacity, hypothetically, satellite operators offering merely the affiliates of all nine broadcast networks plus a PBS station to all 210 markets would require the operators to catch more than 2,110 signals, scramble them, and then selectively unscramble 10 signals for each market. Of necessity, satellite operators say, they charge subscribers for local affiliate signals.

After the turn of the century, the contentious issue shifted to digital must carry. Although federal law required broadcast stations to shift from analog to digital signals by 2009, as long as a significant portion of the public could receive only analog signals before that date, broadcasters had to (for economic as well as political reasons) distribute both kinds of signals. Most cable operators however, claimed that they lacked the channel capacity to provide two signals for every broadcast station (along with a wide range of both analog and digital cable networks) and that most households could only receive analog signals. At the same time, broadcasters argued that their enormous financial investment in digitalization would

be squandered unless local cable operators were required to carry both their analog and digital signals during the transition from analog to digital. The FCC declared that cable operators were required to carry *either* the analog *or* the digital signal, not both.

Once the conversion to all digital was firmly on the horizon, the battle shifted to multicarriage, or carriage of multiple digital broadcast signals, instead of high-definition. Congress's goal is to shift the country to high-definition television. Complicating the issue, the larger stations now argue that the most viable business model for many stations may be to divide a digital channel into a hybrid HD service (less than true hi-def) along with several other SDTV (standard-definition television) multicast program services, rather than fill it with only one channel of true HDTV. In essence, many broadcasters want to copy cable networks by becoming multichannel program suppliers and delivering multiple channels of programming (perhaps all news or local sports, all old movies or non-English programs—some hybrid HDTV and some not).

However, to date, the FCC has ruled that a station is entitled to carriage of only one primary video programming stream under the current must-carry rules. At the moment, carriage of secondary digital television programming depends on successful negotiations between local TV stations and cable operators rather than on the must-carry rules. At the same time, Congress has made it very clear that it expects local TV stations to broadcast some form of HDTV, not just multiplexed SDTV.

Retransmission Consent

In 1992 Congress allowed local television stations to choose between being carried free of charge by cable systems or negotiating with the operators for some compensation for carrying their signals (retransmission consent). After some years in the courts, the law was upheld, and stations had the choice of opting for inclusion under the must-carry rules or giving permission for carriage, with the majority of stations picking the latter. In order to deliver local-into-local service, the Satellite Home Viewer Improvement Act of 1999 also required DBS companies to seek retransmission consent

agreements with those television stations that chose this option over must carry, thus essentially treating all multichannel distributors alike, including telephone companies.

However, most cable distributors have so far not agreed to actually pay direct cash for any broadcast signal. Consequently, the broadcast networks (and other major group broadcasters) initially exchanged their owned-and-operated stations' retransmission rights for cable carriage of cable channels, such as FX, MSNBC, and ESPN2, that they owned outright or in part. By the turn of the century, however, Disney and FOX were aggressively seeking leverage against such major cable MSOs as Cox and Time Warner. Their tactics included requesting more favorable channel placement (lower or "good" digital numbers, the easy-to-remember ones) on systems for Disney or FOX-owned channels; charging relatively high monthly per-subscriber fees for their existing cable networks, any new cable networks, local news, and video-on-demand; and charging for reuse of advertising. So, although most cable MSOs continue to avoid paying a direct monthly price for carriage of local over-the-air television stations, the indirect costs of doing so continue to rise. By contrast, DISH, Verizon, and AT&T decided in 2007 to pay direct cash for the rights to retransmit local TV stations, which rang loud warning bells of change in the industry.

Corporate Policies

In addition to legal carriage requirements enforced by the FCC, the policies of the parent corporation may impose restrictions on what a local system can and cannot carry. Some MSOs, for example, have policies against carriage of adult programming. Moreover, MSOs often sign agreements with program suppliers that have the net effect of compelling carriage of a particular cable network on all their systems irrespective of whether it might be the best choice for each market. A cable network naturally wants the largest possible audience and can offer discounts to an MSO to encourage wide carriage. With giant cable operators having thousands of local systems scattered across the country,

standardized channel selection is unlikely to be an ideal fit for every location but it is economical for the MSO.

Franchises

Historically, every cable system has had to win a franchise (a contract) from a local municipal government in order to operate in the local geographic area. Once cable operators have received a franchise, most are required to pay a percentage of their revenues into local government coffers. This is called the franchise fee, and cable subscribers see it listed on their monthly bills. Local government justifies charging operators a fee because they are making commercial use of local infrastructure (streets, poles, trees) that belong to the whole community. Cable operators then list the franchise fee on the bill (typically about 5 percent of the subscriber's monthly statement) to inform cable subscribers about this tax.

In addition, local franchise agreements often specify that cable operators must provide a specific number of public, educational, and government (PEG) access channels and that they must carry all local broadcast stations reaching the area. DBS companies also have public interest obligations amounting to 4 percent of their channel capacity. DirecTV, for example, carries C-SPAN, NASA TV, Worldlink TV, and others. The advent of Verizon's and AT&T's entrance into the multichannel television business led many states to eliminate the local franchising requirements for telcos in order to speed up their competitive entry into the multichannel video distribution business.

Periodic refranchising of local cable operators used to be a hurdle for each cable operator and local government every 10 years or so. Since 1992, local communities have been forbidden to grant exclusive or monopoly franchises. At the same time, local communities must legally prove that an incumbent franchisee has provided inadequate service—a very difficult thing to demonstrate to a court's satisfaction—in order to refuse to renew an existing cable provider's franchise. When coupled with the ever-changing multichannel competitive landscape, cable operators appear to have a strong renewal expectancy with respect to refranchising,

which, in theory, makes it more difficult for local authorities to negotiate for improvements.

Syndicated Exclusivity

Another area of federal concern has to do with exclusive rights to show syndicated programs. Federal regulations now enforce the syndicated exclusivity rule (often called syndex), which requires cable operators (and now satellite and telephone program carriers too) to black out syndicated programs on imported signals (distant stations or satellite-delivered cable networks) in an area when any local station possesses exclusive rights to the syndicated program. For example, if both WGN, the Chicago superstation, and a local station in Indianapolis (or Kansas City, Columbus, Fresno, or wherever) carry rerun episodes of Frasier, and the local station has stipulated exclusivity in its contract with the syndicator (usually for a stiff price), the superstation must be blacked out or covered up with another show in the franchise area when Frasier is on. Most importantly, this rule also applies to sporting events carried by satellite. Because most local cable systems lack the insertion equipment to cover up one program with another, such superstations as KTLA, WPIX, and WGN have tried to make themselves "syndex proof" by scheduling only original programming or paying for exclusive national rights to syndicated shows. DBS and telcos are also required to provide syndicated exclusivity to local TV stations. But the most valued syndicated programs are sporting events because they involve original programming, huge audiences, and big advertising revenue; in consequence, the cost for exclusive national cable or satellite rights for sports is usually very high.

Antennas

Another bone of contention has to do with regulations about antennas. The FCC's Over-the-Air Reception Devices Rule removes the ability of local governments, property owners, and covenant-controlled communities to restrict individual homeowners' ability to install outside antennas (dish or aerial) in order to receive video programming signals from television stations, wireless cable providers, and satellite/telephone systems. The rule prohibits

most restrictions that (a) unreasonably delay or prevent installation, (b) unreasonably increase the cost of installation, or (c) preclude reception of a signal of acceptable quality. The rule applies to subscribers who place video antennas on property they own, including condominiums and cooperatives that have an area for the subscriber's exclusive use (such as a balcony or patio) in which to install the antenna. The rule applies to townhomes and manufactured homes, as well as to single-family homes, and in essence greatly increases the number of potential customers for wireless cable and DBS service.

In sum, federal regulations have generally freed cable and satellite operators to program as they wish, with the exception of the must-carry and retransmission consent rules. However, local franchise agreements and cable MSO policies place some limits on which program networks get scheduled and on which channels. Once the cable operator has signed a local franchise agreement that specifies the delivery of particular types of services, the cable programmer must place those services on the system before calculating the amount of channel space (or bandwidth) and locations available for other services. For satellite and other services, regulations have been instrumental in leveling the playing field with cable by eliminating many restrictions concerning program access and service availability.

Economic Considerations

Nearly every aspect of the cable and satellite business involves cost expenditure as well as potential income. In deciding whether to carry a new channel, operators have to calculate whether the benefits (revenues) will outweigh the expenses. On the benefit side, revenues come mostly from monthly subscriber fees, advertising time purchases, and promotional support; on the outgo side, expenses include the cost of carrying and installing the program services, paying for copyrights, and paying for churn. Understanding the basic economics of cable, satellite, and other program delivery involves knowing who pays whom.

Most cable networks require each local cable, satellite, or telephone operator to pay a monthly fee for each program service supplied, calculated as a dollar amount per subscriber per month. A few cable networks come without charge to redistributors (especially brand-new or highly specialized services), and a very few actually pay the systems for carriage (mostly shopping or new services offering short-term arrangements). In the past, Univision paid cable operators a small amount per Spanish-surname subscriber (rates varied with the quarter of the year), but its great popularity ended the need for such payments. FOX paid operators for one year to add Fox Sports to their systems.

Shopping services usually pay local cable operators a small percentage of sales as a carriage incentive and may operate as a barter network on an exchange-for-time basis, similar to the barter programs discussed in Chapter 3. A distributor such as Home Shopping Network presells most advertising spots, although a few local availabilities (avails) may be included as an enticement for the cable service to carry the channel. Nonetheless, most cable operators pay out hundreds of thousands of dollars each month for the cable networks they carry.

Premium cable networks have a different licensing pattern: The local cable or satellite operator gets between 40 and 50 percent of the fee paid by subscribers (the very largest systems usually get close to 60 percent), and the remainder goes to the program network. This fee-splitting arrangement explains why operators offer so many premium channels and are so anxious for their subscribers to upgrade.

One increasingly successful method of gaining shelf space for a new program service is to offer equity holdings (partnership) to cable MSOs and DBS companies. Operators are then motivated to place an owned service advantageously on the system because they benefit from its success.

Revenues

Cable operators make money by selling both subscriptions and national and local advertising, whereas satellite television companies have

subscription revenues plus only national advertising. Fees for minimum service on cable have been kept low by federal mandate (that is, rates have been regulated), and basic service (the minimum level) usually includes only the local broadcast stations and local-access channels. Typically, additional channels are divided into tiers of programming, such as an expanded basic or "classic" tier, various other digital service tiers, and various premium and HD service tiers. Subscribers pay an additional monthly fee to receive individual tiers. The 1992 Cable Act requires cable operators to make all service tiers available to basic service subscribers—without requiring them to purchase any additional intermediate tiers—once the cable system is addressable.

Going digital in the home requires a subscriber to pay an extra fee per month (typically \$10 per month) plus the rental cost of one digital converter or DVR per in-home television set for which the subscriber wants service. Finally, virtually all cable and satellite operators provide several pay channels (HBO, Showtime, and other pay networks) for an additional monthly per-channel fee, and the larger systems also offer PPV, NVoD, or VoD, where subscribers may be charged for each program they watch (although some VoD programming is free). Currently, major cable operators average \$50 to \$60 in monthly revenue from each subscribing household.

Because there has been only modest growth in new cable subscribers for more than a decade. cable operators seek increased revenues through global expansion into other countries and through new interactive services—in particular, digital and hi-def services and high-speed access to the internet. In America, new interactive services for individuals linked to the web are expected to be the "killer applications" of the next decade. On the other hand, DBS growth was dramatic early in this century. Over the past few years, two out of every three new multichannel video subscribers have been signing up for DBS (as opposed to cable), and a significant number of cable subscribers have switched from cable to DBS. Altogether, cable holds flat at about two-thirds of multichannel households, and DBS serves almost one-third.

Advertising

On the positive side for cable operators, high programming costs can be offset in the case of the most popular cable networks because the local operator can sell up to two minutes of spot time per hour (local avails) on the most popular channels. Local advertising has become an increasing source of revenue as a result of the increased clustering of cable systems. In addition, more and more cable systems have joined with other systems in a geographic region to distribute advertising messages. As with broadcasting, there is greater interest in purchasing ads on the most highly rated cable channels—such as ESPN, CNN, MTV, TNT, Discovery, and USA. By contrast, satellite operators presently lack this option, but as spot beaming capabilities and other required technologies improve, the potential for DBS carriage of local advertising increases.

Offering spots for local sale is a major bargaining point for cable networks when renegotiating contracts with local cable systems. For the most part, these spots are deducted from program time rather than network advertising time, so they cost the network little. There is, of course, a practical limit to how much a program can be shortened to allow for advertising. Moreover, advertising spots that cannot be sold (such as spots in less popular programs or in lightly viewed time periods) offer little advantage to a local cable system.

Promotional Assistance

When cable and satellite programmers are deciding which networks to carry, they also consider how much promotional support the program network provides. On-air promotion as well as print advertising and merchandising are especially valuable for gaining new subscribers, reducing churn, and creating positive images in the minds of current and potential subscribers and advertisers. National networks can supply professional-quality consumer marketing and sales materials, including on-air spots, information kits, direct mailers, bill stuffers, program guides, and other materials that the local system lacks the resources to create. In other words, some fees paid to national cable program suppliers are, in effect, returned in the form of advertising avails, co-op advertising funds, and prepaid ads in *TV Guide* and other publications that attract audiences to cable and satellite programming (and thus to becoming subscribers or upgrading by signing up for more tiers of service). Major program suppliers also maintain elaborate websites about key programs, another factor in audience retention.

Expenses

The most powerful factor affecting carriage of most programming is cost to the local system. Operators expend between \$4,000 and \$7,000 to install a new cable channel, and marketing it adds another \$1 or so in cost per subscriber, which results in a price tag of tens of thousands of dollars in midsized and large systems. Cost is directly affected by whether the cable network is advertiser or subscriber supported, whether the MSO or satellite company owns part of the service, and which additional incentives the service offers the operator. The cable industry is consolidating very rapidly, partly because larger companies can negotiate lower per-subscriber prices for program networks. If a multichannel distributor controls a subscriber base of 10 or more million homes—whether terrestrial or satellite-it has considerable leverage with program suppliers in negotiating monthly fees. Comcast, the largest operator of all with about 24 million subscribers, has enormous clout.

Estimates are that cable operators collectively spend more than \$10 billion on programming each year, with approximately 75 percent of these payments going to advertising-supported cable networks. The fees per cable network vary from nothing to as little as a nickel per subscriber per month to almost \$4 per subscriber per month (see 8.6). ESPN, the most popular and most profitable of all channels, costs an average of nearly \$4 per subscriber per month and requires operators to also carry ESPN2, ESPN Classic, and ESPNEWS. For both cable and satellite operators, ESPN is an absolute must-have. In contrast, such smaller audience services as truTV (formerly called Court TV) charge in the neighborhood of \$.35 per sub per month (which is still \$35,000 a month in a midsized market with 100,000 subs). The fees paid

8.6 Channel-Cost Wars

Programming fees have long been a major point of friction between nonaffiliated MSOs and cable networks. Operators always attempt to hold down programming prices, although often in unconventional ways. When MTV prepared to increase its rates in 1984, a group of cable operators, led by the nation's then-largest MSO, Tele-Communications, Inc. (TCI), approached Ted Turner to start a competitive music channel, Turner launched the Cable Music Channel, which the operators used as a threat to control MTV's rate hikes. Having served its purpose, the Cable Music Channel closed within 36 days, with Turner admitting many years later it had been only a Trojan horse in the battle over fees. TCI also beat down a planned ESPN rate hike in the early 1980s by threatening to remove the network from all its systems and to support development of a competitive allsports service with the additional backing of brewery giant Anheuser-Busch. The corporate integration of distribution and programming companies has substantially reduced, although not completely eliminated, such brinksmanship. In 2003, Cox Cable threatened to turn ESPN off in all its systems—once again during negotictions over proposed rate increases.

Patrick R. Parsons, Ph.D. Pennsylvania State University

to cable networks become a sizable monthly outlay for a system that carries 50 or more advertiser-supported networks to 10,000 or 20,000 subscribers, as the following equation shows:

\$.10 × 50 services × 10,000 subs = \$50,000 monthly cost for 50 networks in a tiny franchise area

Just imagine what Comcast must pay for, say, 100 services for 24 million subs! Moreover, network contracts often specify even larger persubscriber fees if the network is placed on an upper tier—under the assumption that fewer people will subscribe to an upper tier or package of channels. To date, most cable operators have not been forced to pay directly for retransmitting local terrestrial broadcast signals, but when that day comes, it will

alter the economics of the lowest level of service offered to multichannel video subscribers.

Compulsory Copyright

In addition to network fees, all cable and satellite systems pay copyright royalty fees based on a variable fee schedule, with a base compulsory license fee and then additional fees, that ranges from about \$.15 to \$.19 per subscriber per month for each distant station or network signal. These added fees raise the cost of carrying such superstations as WGN, KTLA, WPIX, WWOR, and others. These funds are returned, proportionately in theory, to copyright holders such as the holders of rights for sporting events, music, movies, domestic and foreign television programs, and so on. From the operator's perspective, they are an additional expense. According to the U.S. Copyright Office, the cable industry paid a total of \$132.4 million in copyright royalty fees for carriage of distant signals in 2004.

Audience Churn

Another big problem is audience churn, or turnover. Subscribers who disconnect, even if they are replaced, cost the system in hookup time, administrative record changes, equipment loss, and duplicated marketing effort. Annual churn rates are typically around 30 to 36 percent for basic cable and 50 to 80 percent for premium services and digital cable. For DBS providers, typical overall annual service churn is 18 to 20 percent. The churn rate for any local system or DBS service can be calculated for a year, or for any length of time, by dividing the number of annual disconnections by the average annual number of total subscribers; all systems keep careful track of their churn rates.

 $\frac{\text{Disconnects in}}{\text{Average number of total}} \times 100 = \% \text{ chum}$ subscribers in that period

Not all cancellations can be prevented, of course, because people move, children grow up and leave home, and local economic recessions cause unemployment and cutbacks on services. College towns normally have lots of cable cancellations at the end of spring semester and lots of new connections in

the fall, but minimizing avoidable audience churn is one of the primary responsibilities that a service's programming and marketing executives share.

266

Turnover on premium channels occurs more frequently than with the basic service. Instituting hefty charges for disconnecting single channels has reduced the practice of substitution, in which subscribers casually drop one premium channel to try another. Nonetheless, several premium channels such as American Movie Classics, Galavisión, and Disney were forced to move from premium to basic services, and the challenges faced by other premium services have led to mergers and combined marketing efforts by HBO and Showtime. Economics may in the long run result in the disappearance of stand-alone premium services.

Marketing Factors

After technical limits, legal requirements, and economic considerations have been evaluated, the multichannel programmer weighs several marketing considerations in deciding whether to carry a particular network and how to position and promote it. Cable system programmers seek to attract and hold both the local audience and the local advertiser; satellite programmers must seek both national and major-market local audiences but not advertisers. To achieve these goals, both must maximize new subscriptions and minimize disconnections. The nature of the local audience determines what has particular appeal. National research has established that nowadays the multichannel audience differs not at all from the over-the-air-only audience, but in particular markets, subscribers to a system may differ dramatically from national norms. One cable system, for example, may have more middle-aged, upscale, urban subscribers with higher-than-average incomes, while another may have many more large families of mixed-age members. The upscale households might want documentaries and sporting events, while the large families might want G- and PG-rated movies and kids programs. Foreignlanguage channels are highly desired in major cities, but less so in most small towns (except in the Southwest). Program services have to be chosen so that every subscriber has several channels that are especially appealing, but the method today is to bring hundreds of digital channels to all homes, reserving only the premium, hi-def, and specialized services (such as sports and perhaps Spanishlanguage networks in the north of the United States)—in other words, the ones for which subscribers will pay additional fees.

Some services of particular appeal are considered to have lift in that they will attract subscriptions to higher tiers or premium services. The major sports channels create lift on virtually all cable and satellite systems, and high-definition sports channels draw fans to an even higher tier. Game channels have this impact for households with children aged 10 to 15 years. Lift generally diminishes as systems add more and more services, however, which leads to discounting and bundling of services that mix high and lesser appeal in upper-tier packages. Cultural channels are often marketed more for their balancing effect than for any lift they create, and similarly, public-affairs channels, classified advertising listings, and community access services are carried because they create a positive image for the cable system even though they very rarely generate any increase in subscribers.

Tiering provides cable operators with the opportunity to market customized sets of channel offerings in order to increase revenues and to provide various subscriber groups with highly targeted programming. For example, Insight Communications offers its subscribers separate tiers for its Basic and Classic lineups (analog), and then digital tiers for Entertainment, Life & Home, Family, Multicultural (Spanish language), News & Documentary, Sports, Movies, Music, HDTV, and pay-per-view. Cox Cable also carries such international premium services as TV Asia and Korean TV, depending on the market.

With the goal of gaining lift, one year HBO intensely promoted its hit series *The Sopranos* but found that its expensive marketing effort only temporarily doubled subscribers, and that after a month, most new subs had canceled the service. A further strategy, adopted by the entire industry, has been to locate adult programming only on premium or pay-per-view tiers, which makes good economic and political sense because so many

people are willing to pay extra for adult fare while households that don't want adult programming visible need not be aware of it. Having adult fare, however, definitely provides lift.

Scheduling Strategies

Up to this point, this chapter has been concerned with the technical, legal, economic, and marketing factors that impact the *selection* strategies of cable and satellite programmers—in other words, how and why cable and satellite operators pick some services to carry rather than others. In addition, operators have scheduling, evaluation, and promotional concerns.

Scheduling on cable and satellite systems has a special meaning in addition to the usual meaning of placing programs in an orderly flow on a single channel. It also refers to locating whole channels of programs in the lineups or digital displays of home television sets. The channels have to be placed so they meet federal regulations and limits on the technology while maximizing revenue and marketability (see 8.7).

As a result of the passage of the 1992 Cable Act, cable operators followed channel matching for all local VHF (and for some local UHF) television stations; in other words, they placed over-the-air stations on the same channel numbers on which they broadcast over the air (or on a mutually agreed-upon channel) as required by federal law—but the law never applied to DBS, and never applied to cable networks who have no assigned numbers.

A channel number that differs from the actual frequency of a signal is a virtual channel (also called a logical channel number). Now that broadcasters have been shifted far up in the spectrum to high frequencies, their originally assigned analog numbers have become irrelevant, but cable operators can choose to retain them as virtual channels. Alternatively, broadcasters can be repositioned, a practice that threatens station revenues when a location is far from popular channels because it reduces audience sampling.

Nonetheless, some scheduling patterns are consistent. Digital networks typically occupy segments

8.7 Uniform Lineups

ven within a single Nielsen DMA, having the most popular advertising-supported services on the same channel numbers on all cable systems makes selling advertising easier. Standardization within a market is called a common channel lineup to distinguish it from the ideal of consistent positions for services from market to market across the country (called a universal channel lineup). Nationwide standardization of channel positions has the particular advantage of making national on-air promotion more effective.

The goal of any kind of uniform channel lineup, even for the dozen most popular services, is a long way from realization. The Los Angeles DMA was the first major market in which several cable operators agreed on a common channel array (in analog), and in the late 1980s newly constructed systems (new-builds) in Philadelphia and New York adopted uniform aralog channel configurations. Those patterns may survive into the digital and ther HD eras. The pattern adopted in Los Angeles, however, did not match the one adopted in New York.

Moreover, technical considerations limit the realization of such plans in many markets that have long-established systems. As cable becomes a software-driven system, those people who use onscreen guides will find channel numbers irrelevant. Those who utilize "appointment viewing" and want to go straight to a particular show are more likely to want some log c to channel arrangements. Standardization among menus and search systems is now an unrealized goal. Uniformity makes sense for viewers, cable networks, and delivery systems.

of the lineup separated from the former analog broadcast stations, partly to simplify pricing schemes. On many systems, over-the-air broadcast stations have virtual numbers under 100, and cable networks occupy the 200s, 300s, and higher. Cable systems usually practice content clustering, placing channels on virtual tiers according to their content or appeal. Channels can be grouped according to whether they are (1) all narrowly alike in content—such as sports channels, movie channels, or audio

channels; (2) all alike in their appeal to a particular target demographic group—such as for children or Spanish-speaking viewers; or (3) all broad-appeal entertainment or all news and information.

The basic level of service typically consists of broadcast stations, access services, C-SPAN, and local weather clustered together (virtually). After that tier comes broad cable entertainment, children's, news, and some sports, priced as second level of service. Then, additional high-numbered tiers provide more sports, more movies, selected high-definition channels, adult channels, and premium, pay-per-view, and on-demand channels for added fees.

What used to defeat effective clustering concepts for nondigital cable systems was the lack of channel capacity. To be convenient (and effective) for remote control users, networks in a cluster have to seem to be adjacent on the channel numbering scheme; but without capacity, operators had to shoehorn channels into the available space, irrespective of placement logic to users. The arrival of digitalization completely changed the situation. Channels could be converted to any virtual position so that electronic guide channels could make efficient use of clusters, irrespective of the incoming frequency of a particular channel. All the sports or all the movie channels can be listed together in a virtual sequence, even if the channels carrying the sports (or movies) are actually scattered throughout the system.

Wireless and satellite systems have long employed two kinds of virtual lineups in their interactive electronic guides: the alphabetic listing of service names, and thematic clustering. Alphabetic listing makes the search for a particular channel quick—if the user knows the name or call letters; clustering suits channel-by-channel selection within the grouping. Neither one especially suits grazing.

At some point in the all-high-definition future, operators are expected to transition totally to menu- or topic-driven systems. Menu systems make channel numbers (and therefore lineup concepts) irrelevant (as was explained in 8.7). Just as all channels coming through a VCR used to be converted to Channel 3 on the TV set, so in the future digital television sets might have only a single

"channel" and receive all input from a converter (built into television sets), leading to the disappearance of the very idea of *channels*. Nonetheless, it is hard to conceive of a time when all set owners will want to subscribe to all services for all sets. For the purposes of pricing, some subdivisions will be needed. Eventually, viewers are expected to have individual web search agents capable of "knowing" our individual likes and dislikes. The size and distribution of channel arrays then become irrelevant because search agents can jump around at lightning speed. Clustering would remain only as an aspect of guide listings, providing a way to scan options onscreen, should a viewer actually care to look with his or her own eyes.

Evaluation Strategies

Multichannel services have two evaluation concerns: evaluation of audience size and evaluation of program size and thus presumed popularity. These result in very different practices, and some are unique to cable because wireless and satellite systems do not carry local advertising.

Audience Size

Evaluation of multichannel audiences has been a long-time problem. The overriding difficulty is that the audience shares for cable network channels cannot be exactly compared with over-the-air audience shares. As explained in Chapter 2 and shown in 8.3, although nowadays multichannel distributors collectively reach about 90 percent of the homes reached by broadcast television, each individual channel attracts only a portion of the people watching via cable, wireless, telephone, or DBS (and not all cable networks appear on all or even most services).

Usually, cable network ratings range from 1 to 3 percent of total TV households in prime time rather than the 7 to 8 that the top local broadcast affiliate achieves. Of course, hit programs on cable do much better: Higher-level sports programs get average ratings in the 4s and 5s. During the height of interest in huge news events like 9/11 and the Iraq War, CNN's and Fox News's ratings reached

very high levels (such as 12s and 14s). Sporadic season-opening or ending episodes of cable dramas (such as *The Closer*) rise into the teens. The only cable network to do consistently better is ESPN, and it fails to reach the level of top local affiliates most of the time. However, without disasters or extraordinary events, these and other popular cable networks usually attract fewer than 2 percent of viewers individually. However, the collective cable ratings in a market (for all the dozens of networks) often exceed those for the highest-rated station.

Advertisers had little interest in the small numbers of per-channel viewers (which are even smaller when the DBS audiences are removed) until the cable industry came up with four strategies for increasing the number of people reached simultaneously and for making them more salable to national or regional advertisers.

The first strategy has to do with geographic coverage in portions of a state. Because the geographic area covered by an individual cable franchise is far smaller than the coverage areas of a single broadcast station, the cable industry now links franchises over a wide area (like the center of a state) by microwave or cable to create large interconnects. Advertising interconnects are arrangements for the simultaneous showing of commercials on selected channels. Of course, each operator must purchase expensive insertion equipment for each channel that will have local advertising added. (The ads usually cover up promotional spots sent by the networks, and how many and which ones can be covered by local spots are specified in cable network contracts with local cable operators.) Interconnects generally occur in or near large markets, however, leaving thousands of cable systems with unsalable (too small and undefined) audience sizes. Moreover, satellite services cannot be part of local interconnects. Their subscribers add to the national ratings but not to audiences for local or regional advertising.

A related strategy is **zoning**, which refers to subdividing an interconnect into tiny geographic areas to deliver geographically targeted advertising, which permits even small local businesses to purchase low-cost ads that reach only their neighborhoods. A dry cleaner, for example, hardly wants to pay to reach the other side of town where the competition operates—but might find two or three zones on its side of town ideal for reaching potential customers.

A third strategy is roadblocking—scheduling the same ad on all cable channels at the same time so that the advertiser's message blankets the time period. This can be done nationally by buying the same minutes of time on all major cable networks, or handled locally in one market by inserting the same ad simultaneously on all channels in an interconnect. Then, no matter where a remote user looks on the lineup, the same commercial spot seems to be playing. (Some big advertisers buy all the broadcast networks also, thus airing a single ad virtually everywhere on television in the whole country at the same time.)

A fourth strategy has been to develop criteria other than ratings for wooing advertisers. Sales executives for the cable networks generally emphasize the homogeneity of viewers of a particular channel, meaning their demographic (age, gender) and psychographic (lifestyle, income) similarities. Viewers of MTV, for example, are alike in age and interests; weekday viewers of Lifetime are mostly women; viewers of the "Puppy Channel" share a common interest in pets. The clustering of similar channels on digital services also makes it possible for an advertiser to roadblock a group of channels with homogeneous viewers.

Repetition and Ratings

On the programming side, program repetition is another strategy used to increase audience size. Sales executives for cable television report how many people saw a program *in all its airings*, rather than how many saw it on, say, Tuesday night at 9 P.M., the usual way that broadcast ratings are calculated. For cable, the size of the cumulative audience is often more salable than the audience for a single time period. Reporting cumulative audience size makes programs seem more popular and more visible, thus better environments for advertising messages.

To deal with advertisers' perception that cable ratings are too low, some cable operators have 270

begun to collect their own data using set-top converters. Garden State Cable TV, a system covering a Philadelphia suburb in the state of New Jersey, uses converter boxes in more than half of its 200,000-subscriber base to collect television ratings data. Older analog set-tops from both General Instruments and Scientific-Atlanta have some capacity to monitor and take "snapshots" of what channel a TV set is tuned to, a feature typically used in relation to PPV. Newer digital boxes build in this ability. This information can be used to convince local advertisers that sufficient numbers of viewers are tuned to specific channels at some hours.

Promotion Strategies

Effective promotion of cable and DBS systems took a backseat to technical problems for several decades. Once America was fully wired, cable systems turned to marketing their services to new subscribers using such traditional advertising tools as flyers on doorknobs and ads in local newspapers. Because money was tight as a result of huge capital expenditures, most cable companies' efforts were minimal at best for more than a decade.

Competition from satellite services raised the bar, however. To capture subscribers from cable, DBS services designed clever marketing tools that carefully targeted specific groups of potential subscribers. No longer was one ad good enough to reach everybody. As thousands of its subscribers left cable for satellite service and later for telco service, the cable industry woke up and began spending the money to make more effective advertising tools.

At first, most of cable's efforts were directed toward getting basic subscribers to upgrade by taking an upper tier, especially one or more pay channels, because of their immediate boost to system profitability. Subsequently, the introduction of complex packages of digital services necessitated educating the public about the huge variety of digital programming channels that could be obtained. Direct mail and bill stuffers were the initial media of choice.

Nowadays, cable, telco, and DBS operators make use of both print promotion and on-air video insertions to get their messages across. In addition to magazine and newspaper ads, cable operators use their interconnects to run self-promotion on a variety of channels. They use spots that might otherwise have been sold, foregoing that revenue, to tout what the subscriber misses by not having digital service and what's available on VoD and PPV. As the number of HD channels increases, promoting them to consumers will be the next goal. In the long run, having large numbers of subscribers who subscribe to higher levels of services can be expected to bring in more revenue than the cost of the promotional spots and print ads to lure them to upgrade. Even more important is that such promotional spending has become critical to maintaining market share in the increasingly competitive multichannel video marketplace.

Local Origination on Cable

At the local level, cable programming means several very different things. On one hand, local cable refers to the programming activities of the 8,500 or so managers of cable systems or their MSOs. They may produce their own local/regional channels of information or entertainment, such as an all-day newscast or a high-school sports channel. On the other hand, broadcasters also make use of some cable-only channels to replay or multiplex additional channels of programming. Finally, local cable also refers to the programming activities of several thousand not-for-profit community access groups or centers. Theirs is the most local of all cable programming and has flourished in some cities for nearly four decades, although the internet is rapidly altering this kind of local cable programming. Altogether, about 1,000 public access program services exist today.

Local cable channels consist primarily of entertainment mixed with infomercials, classified advertising channels, sports, and news and community affairs. When produced and controlled by the cable operator or a contractor, such channels are called local-origination (LO) channels, although the news channels tend to cover such wide areas that they are often referred to as regional cable. When produced and controlled by a local

not-for-profit group, such channels are called **community access**. Local and regional cable-only channels have the long-term benefit of differentiating cable from competing wireless, telco, and DBS services and, in some cases, the short-term benefit of generating advertising revenue.

Entertainment Channels

Channels with original entertainment content produced (or purchased) by cable operators themselves are universally commercial and intended to supplement a system's profits. The programming is selected, scheduled, and evaluated for its suitability for carrying advertising messages. Religious broadcasters (really, cablecasters) operate about one-third of local cable channels, and they typically mix syndicated programs with local and nationally distributed religious programming, including gospel music, discussions of gospels, sermons, and religiously oriented talk, some of which is merely slightly disguised sales messages. In addition, a few foreign-language cable channels usually have a full spectrum of news, entertainment, and talk in one non-English language. Many of these channels have dropped their over-the-air channels in favor of becoming digital-only splinter networks with national distribution.

The remaining local-origination channels around the country tend to be like the regional news channels described next or are programmed like independent television stations. When entertainment oriented, they can carry nationally syndicated series or movies—very old ones because the programs are licensed cheaply as a result of the relatively small cable audiences (compared with the audiences of broadcast stations or even cable networks). Such programs may be chosen and scheduled locally but, like syndicated programs on broadcast stations, are not very local. Toledo, Ohio, for example, has a popular LO channel called WTO5 that is remarkable for its syndicated series and sports (see 8.8).

On other LO channels, high school and minor league sports are especially effective for attracting audiences of considerable appeal to local advertisers. Local talk programs also provide an ideal

8.8 Toledo's Local-Origination Channel

ecause Toledo has only five local broadcast stations, TV5 was able to become the WB affiliate (later CW) for Toledo and to license a great deal of "good" unsold syndication. Now called WTO5, this local-origination channel carries offnetwork reruns, such as Mad About You, Friends, The Nanny, and That '70s Show, and nightly sports (for example, Big Ten and Mid American Conference asketball and WWW Smackdown) or movies.

Because the local newspaper (*The Toledo Blade*) owns the local cable company (Buckeye Cablevision) that procuces WTO5, the channel receives the enormous benefit of a listing at the top of the newspaper's grid, right under the local broadcast stations, instead of burial in the Ws where *TV Guide* places it (and similar channels).

The "station" has its own website and operates with a great deal more funding than the usual local-origination channel. The combination of having a national affiliation, only a few local broadcast stations in the market, and supportive ownership by the local newspaper places WTO5 in the forefront of successful local-origination channels that compete directly with broadcast stations.

environment for both local and national infomercials. Major national companies such as Sears, Verizon, Ford, General Motors, and Procter & Gamble supply the bulk of direct-sell infomercials to cable systems, and these are supplemented by shorter infomercials from nearby car dealers, restaurants, pharmacies, home builders, and the like. Hyperlocal infomercials may be produced in the cable system's facilities (for a fee).

Classified advertising channels, often produced by local newspapers, have been another successful area for local cable, especially when operated in conjunction with a daily paper. Digital insertion equipment permits the quick updating of listings and the use of photographs (and some video), making real estate, car, and other classified ads as well as Yellow Pages viable as auxiliary revenue streams for cable. Because the internet provides much the same opportunity for reaching out to viewers, however, religious broadcasters, retail companies, and newspapers are generally operating websites with the same content they put on local cable channels and are increasingly favoring the web over cable.

Local-Origination News Programming

News is a powerful environment for advertising messages and thus popular with many commercial entities that want to reach news consumers and make money. Having hyperlocal services helps systems attract and retain subscribers and keeps them in the good graces of local franchising authorities that grant them their licenses.

One strategy has been to replay broadcast newscasts on cable channels. Pittsburgh Cable News Channel, for example, began in 1994 as a retransmission consent channel. (Federal law requires local television stations to give permission to cable systems for carriage of their signals and allows them to negotiate a fee or other compensation from cable operators in exchange for their broadcast signal.) Many stations exacted cable channels of their own in lieu of monetary payment.

Most of these are solely rebroadcast channels, but a joint effort of WPXI (TV) and cable operator Tele-Communications, Inc. (now owned by Comcast) created the Pittsburgh Cable News Channel that carries multiple repeats of WPXI's newscast accompanied by original news, special events, and a talk show. LIN Broadcasting, a group owner, has been successful with local weather channels started by the company's broadcast TV stations that reach more than 1 million subscribers. Such commercial channels are effective promotional tools for both the station and the cable operator and hold the promise of becoming significant revenue sources.

The pricing of ads is comparable to that of local ad inserts on CNN and Headline News, and cable systems carrying the channel receive two minutes of ad time per hour. In the case of the Pittsburgh Cable News Channel, all other advertising revenue is split between WPXI and Comcast. In the case of

LIN Broadcasting's weather channels, the stations get a percentage of ad revenue plus a license fee for each of the 1 million subscribers.

Modeled on CNN and its repeating counterpart, Headline News, nearly 40 cable-only local and regional cable news channels have been formed, and they attract considerable industry attention. Although they require capital investments of many millions of dollars in equipment, crew, reporters, and studios to get going and have high daily operating costs, their revenue potential is usually much greater than for entertainment channels because they attract more regular viewing. What the services share is their focus on the neighborhood level of service. Traffic reports are street by street, weather reports describe in detail what is important in small geographic areas, and "news" moves down to the level of parades, store openings, and official city activities. This kind of information also transfers very effectively to online services.

These local and regional cable-only news services differ from ratings-driven broadcast stations. The latter normally divide their newscasts into half-hour segments, devoting airtime to sensational crimes, fires, and accidents, and also include nonlocal stories if they are likely to hold audience interest. On broadcast stations, local events get only a few minutes at most, and events likely to be of interest to only a few viewers are scrapped.

In contrast, hyperlocal cable-only news channels that operate live for several hours daily—increasingly 24 hours as they become established and profitable—can focus on neighborhood events on the scene and at length if they might be of interest to a few viewers. Most model themselves on CNN rather than the broadcast network newscasts and carry live programming for hours, although New York 1 News is gaining increasing influence with its half-hour news wheel (see 8.9). With the luxury of more time to dwell on events, regional networks can spend hours on breaking events and enough time on stories about health, sports, and entertainment events to avoid the taint of sensationalism.

Cable news producers' success with audiences and owners comes from an intense focus on local interests and, especially in times of stress, lots of ongoing weather and traffic reports. The details emphasizing the problems important to neighborhood residents and businesses appeal to viewers and advertisers, and the very low cost of such reportage appeals to cable operators.

In line with keeping expenses minimal, these regional channels take advantage of the newest robotic cameras and other automation, which may result in some odd pictures at times but reduces (compared with broadcast newsrooms) the technical staff necessary for them to function. The reporters tend to be young and inexperienced, are often interns or employees working for nonunion salaries, and carry their own handheld video cameras with portable video recorders, eliminating still other staff costs. By using portable tripods, reporters can even tape themselves at the scene of events and in interviews. As one reporter for New York 1 News put it, "I do a story every day. I dream it up. I set it up. I produce it. I report it, and I even edit it. I get to do everything."3 The videojournalist who functions as correspondent, reporter, camera operator, and producer has become the model for inexpensive news gathering.

Although financial support must initially come from a parent corporation with deep pockets and patience, major national advertisers have become increasingly interested in cable-only news and its online counterparts. Local and regional cable news channels can attract advertising from businesses too small to be able to pay broadcast station rates. Rates on New England Cable News are about \$500 for a 30-second spot, compared with the \$3,000 or so on a Boston network affiliate. Although such cable channels typically average less than a 1 rating for 24 hours, local disasters drive up ratings dramatically. For example, New York 1 News had ratings of about 6 for its live coverage of a winter snowstorm.

More recently, local and regional cable news channels have added highly interactive internet sites to further enhance their viewers'/users' ability to selectively choose among news stories and to have news on demand. As a result, the same news information appears simultaneously on a cable channel and online. This serves to broaden the current audience and is a key factor in estab-

lishing a successful media convergence strategy for local and regional cable news channels. In the long term, regional cable distribution may take over the role that local broadcast stations have traditionally played because cable does not use scarce airwaves (although the broadcasters are likely to step in as owners and producers of content). Upgrading to all-digital and then hi-def will have such high price tags that wired cable distribution, in turn, is likely to be supplanted soon by wireless web services.

Community Access on Cable

In dramatic contrast to commercial cable, the access channels operated by community groups are non-commercial and driven by educational, artistic, and public service goals. They tend to operate on the neighborhood and city level, rarely reaching outside county boundaries. Federal law permits local franchising authorities to require cable systems to provide channel space and sometimes financial support for community access services.

Although by law these services divide into three kinds—public, educational, and government (PEG) channels—in practice, they usually operate out of community access centers. Such centers are non-commercial and local not just in practice but also in active philosophy, and they provide alternative programming that would never be viable on for-profit stations or local-origination cable channels. The mainstays of access content have been community-produced videos, video art, municipal meetings and hearings, and educational productions. Like commercial companies, they are finding the internet increasingly effective for reaching their audiences, and they face the same problem of having to fund the shift from analog to digital and then to HD.

Traditionally, access has meant two things to local-access centers: (1) access by community members to the means of television production through training classes, arrangements for loans of TV cameras, and the sharing of editing equipment; and (2) access by community members to an audience through the cablecasting of locally produced programs. The underlying principles guiding the staffs of access centers are the ideas of free speech

Regional Cable News Services

he first and best known of the regional all-news ventures on cable continues to be News 12 Long Island. Launched in 1986 by Cablevision, News 12 Networks is a division of Rainbow Media, the programming arm of Cablevision Systems Corp. Rainbow Media has also launched 24-hour local news operations in Connecticut, New Jersey, Westchester, and the Bronx (see www.news12.com). News 12 Networks reach 3.3 million cable households in the New York tristate area.

Each service supplies news about the local region to residents, beginning each morning with a radio-style mix of news, weather, and hyperlocal traffic reports (for example, live from key points on the Long Island Expressway on News 12 Long Island). Then the service continues at a slower pace throughout the day with reports on local community events, live interviews, local news updates, and reprises of national and international news. Stories include everything from school parades to unsolved murders to reports on issues like garbage dumping and pollution. With a staff of 150, facilities rivaling those of nearby broadcast stations, and an annual budget of more than \$10 million, News 12 Long Island, the flagship service, attracts enough advertising revenue to make a profit. Interestingly, its highest viewing comes in prime time.

Time Warner Cable established New York 1 News (NY1) in 1992 as a 24-hour news channel. NY1 and its more than 25 full-time news reporters serve New York City's five boroughs from a new all-digital (and almost tapeless) facility. NY1 also provides NY1 Noticias, a 24-hour Spanish-language news channel, and a corresponding website, www.ny1.com, to complete its thorough approach to news coverage. NY1's use of comprehensively trained journalists—who report, videotape, and edit their own stories—and broadcasts that are structured in half-hour programming wheels has become a global model for inexpensive news coverage. In addition to advertising, it attracts revenue by charging for consulting about low-budget news.

NorthWest Cable News (NWCN), now owned by Belo Corporation, came on the scene in 1995 when KING Broadcasting (that is, KING-TV in Seattle, KREM-TV in Spokane, KGW-TV in Portland, and KTVB-TV in Boise) used its retransmission consent leverage to gain shelf space on cable systems in Washington, Oregon, and Idaho to establish a 24-hour regional cable news channel. NWCN provides news programming, which is targeted to the geographic area it covers. As a result, NWCN achieves higher ratings than CNN Headline News, and it has attained an audience of approximately 2 million viewers (see www.nwcn.com).

The Texas Cable News (TXCN) was established in 1999 as Belo's fourth regional cable news effort. Although some regional news channels choose to cover a metro area or even a limited part of a metro area, TXCN followed the design of NWCN by opting for coverage of vast regions (that is, the entire state of Texas) that include multiple metro markets. In 2000, Texas Cable News established TXCN.com as its online presence. TXCN has a staff of 100 devoted to administration, operations, and sales. However, it has no reporters of its own. Its newscasts depend entirely on contributions from its television and newspaper partners, The Dallas Morning News and WFAA-TV8 in Dallas, KHOU-TV in Houston, KENS-TV in San Antonio, KVUE-TV in Austin, and The Denton Record Caronicle. TXCN is available to 1.6 million cable households throughout Texas (see www.txcn.com).

News Channel 3 Anytime (NC3A) is a service of Time Warner Communications and WREG-TV, the CBS affiliate in Memphis, Tennessee. NC3A operates as a 24-hour-a-day, 7-days-a-week news network. The overwhelming percentage of its content is devoted to repeat cablecasts of the latest WREG-TV newscast. Each new WREG-TV newscast is also carried live on NC3A (followed by repeat after repeat of that newscast until the next live WREG-TV newscast). NC3A is available to all 225,000 Mid-South Time Warner cable

for everyone, the egalitarian use of the media, the fostering and sharing of artistic expression, the accessibility of all people to affordable education and instruction, and open and participatory government decision making.

The internet is proving an even more effective vehicle for achieving these goals than cable, however, and as home video equipment falls in price and rises in sophistication, fewer members of the public are seeking the video training that access subscribers in Tennessee, Mississippi, and Arkansas (see www.wreg.com).

In Washington, DC, News-Channel 8 (NC8), owned by Allbritton Communications, was founded in 1991. NC8 is a 24-hour news channel available to approximately 1.1 million Washington, DC, metroarea cable subscribers. It uses a fiber-optic delivery system to deliver targeted local news (on a nightly basis with separate anchors and producers) and advertising (on a 24-hour basis) to suburban Maryland, Northern Virginic, and the District of Columbia. NC8 operates three local news bureaus from which it originates live coverage (see www.news channel8.net).

CN8, the Comcast Network, is a 24-hour regional cable news, talk, sports, and entertainment network. owned and operated by Comcast Cable Communications. Inc. CN8 launched in 1996 and now serves 4 million cable homes in its mid-Atlantic operation (Pennsylvania, New Jersey, Delaware, and Maryland) and 2.2 million cable homes in New England. Its programming is primarily locally produced regional news, entertainment, and sports (high school, college, and professional), with some live, interactive programming (see www.cn8.com).

Hearst Corporation and Comcast jointly own New England Cable News (NECN), a 24-hour regional cable news network, which was launched in 1992. NECN provides news, weather, entertainment, and sports to 2.7 million homes in 855 New England communities. It has won many awards, including a George Foster Peabody Award, an Alfred I. duPont/Columbia University Broadcast Journalism Award, and a National Edward R. Murrow Award. In addition to its standard programming, NECN also regularly produces documentaries focused on issues of importance to New Englanders (see www.necn.com).

Begun in 1993, Chicagoland Television News (CLTV), which is owned by the Tribune Company. carries a heavy dose of Chicago Cubs games and Chicago Tribune news coverage. CLTV is the Chicago

area's only 24-hour regional news, weather, sports, and information channel, serving 1.7 million cable households in Chicago, Chicago's suburbs, and northwest Indiana. CLTV shares content and staff with the local newspaper, the Chicago Tribune. The newspaper newsroom now has a 30 foot by 50 foot soundstage and has, in effect, become a televised stage that showccses daily journalism. Several newspaper staffers now coordinate the flow of reporters and editors onto the stage. Both the newspaper and CLTV are specifically oriented toward the suburban Chicago audience. One goal of the cable channel is to promote the value and expertise of the newspaper reporters, which should, in turn, improve newspaper circulation [see www.cltv.com].

Central Florida News 13 (CFN 13) is Orlando's only 24-hour local news channel serving the central Florida region. Originally owned by Orlando Sentinel Communications (that is, the Tribune Company) and Time Warner Communications, Bright House Networks (that is, Advance/Newhouse Communications) recently took over 100 percent ownership of CFN 13. Under the new ownership arrangement, CFN 13 continues to feature reporters and columnists from the Orlando Sentinel. WESH-TV, Orlardo's NBC affiliate, also provices significant content to CFN 13 (see www.cfn13.com).

The Dispatch Broadcast Group (which includes WBNS-TV, WBNS-AM/FM, and The Columbus Dispatch in Columbus, Ohio) launched Ohio News Network (ONN) in 1997, becoming the first statew de 24-hour cable news channel in the country. ONN can be seen in 1.4 million Ohio cable households in such cities as Columbus, Cincinnati, Dayton, Akron/Canton, Youngstown/Warren, and Zanesville. ONN speciaizes in providing highly localized news, weather, and sports along with a regionalized approach to statewide news coverage (see www onnnews.com).

For further information on local and regional cable news channels, visit www.newschannels.org, the website of the Association of Regional News Channels.

centers can provide, and their training equipment has largely become obsolete. Thus, the centers focus increasingly on digitalizing their facilities to aid in the convergence of video and computer input and output.

A few access programs have moved up to wider distribution, and the flamboyant Bobby Flay, host of several shows on The Food Network, got his start on access television. The best of public access television get Philo Awards (the name comes from television inventor Philo T. Farnsworth), and the worst are played at the Found Footage Festival for comic effect. The hilarious "Wayne's World" spoofs about access television as part of *Saturday Night Live* have raised awareness of public access television on the national level, for better or worse!

Changing Usage

The more than 1,000 access centers in America come in a bewildering variety of organizational setups, and many are finding common bonds with farseeing public libraries. As the repositories of printed books and periodicals move into DVDs, CDs, and computer storage of ideas, their non-commercial, anticensorship, free-speech, and openaccess goals come to merge into those of community access television centers.

Many access centers, including one of the oldest in America—Bloomington's Community Access Television Service (CATS)—have located themselves within a community public library and receive financial support from the city, county, library (a taxing authority in Indiana), and cable operator. This particular center operates five PEG channels: a city government channel, a county government one (mostly meetings and some interviews); an educational channel called The Library Channel; a traditional public access channel where community members supply the content; and a SCOLA channel (news from other countries in their native languages).

In many other communities, once-separate local arts centers and local television centers have come together to become community media centers and are evolving into community communications centers. They can involve institutional networks, local libraries, health centers, and schools, connecting them to each other, to community agencies, and to the internet, all of which have become central to their future survival. It is not the particular technology (television, books, or computers) that ultimately matters but serving the mission in the community—the mission of public access to the means of communication.

Many of the community members who were once clamoring to gain local-access time to televise their home videos or local performances, however, can now exhibit continuously on personal websites, bypassing one of the motivators for public cable access. One striking aspect of the internet has been the rapid shift of art video and low-budget movies from cable access to the web. Video artists now fill several sites with original film shorts, and the internet provides places for the videos of birthday parties and church fairs as well as the more serious animation and dramatic films that once characterized local public access cable.

Educators, another group that formerly sought large numbers of cable access channels, have also turned increasingly to websites to provide interaction with students and parents. Homework instructions can go online; e-mail allows personal messages from teacher to student or parent; and the cost of such sites is far less than for effective cable production. Religious groups that also clamored for more time on local-access channels now, on the internet, have more freedom to program as they wish. Nonetheless, church groups that wish to reach older, downscale constituents who tend to avoid computers still seek a significant portion of time on access television, creating problems for some managers as they see other kinds of traditional access fare fading in quantity.

In many well-wired communities, local governments are also finding websites effective for some of the kinds of information they produce. Long lists of community events, community service agencies, and government office phone numbers suit menu-driven websites better than television channels. Users can access the websites at their convenience and select only the material of particular interest, unlike cable channels that unfold programs over time. Nonetheless, live carriage of public meetings, especially those of municipal government and local school districts but also of environmental protection committees, councils, and planning approval commissions-and live carriage of other ad hoc meetings on community issues-continues to remain best suited to local-access cable until the accessibility and quality of online video improves.

Nonlocal Programming

Although it was once thought that all access channels would carry only locally produced programs, some regional and national sources are now available to supplement what can be made locally. In addition to public broadcasting, noncommercial services such as SCOLA provide unedited segments of broadcast news from other countries in their original languages. Especially popular in university towns and cities with large foreignborn populations, SCOLA offers, over the course of a week, news, weather, and cultural information from such varied sources as France, Spain, Germany, Poland, Hungary, Italy, Korea, Greece, China, Croatia, Slovenia, Lithuania, Latvia, Macedonia, the Netherlands, Moldova, the Ukraine, the Philippines, and other countries.

The oldest distributor of access programming has been the Deep Dish TV Network, available to community access centers via satellite and now the internet. (The name *Deep Dish* refers to parabolic receivers as well as apple and pizza pie!) A not-for-profit program distributor, it is supported by donations and grants, as are Free Speech TV and Democracy Now! Independent and community producers create the highly diverse programs and largely political documentaries or analyses these satellite services circulate on such topics as housing, the environment, civil liberties, racism, sexism, AIDS, the Middle East, and Central America.

Deep Dish identifies itself as "the first national grassroots satellite network" and quotes author Studs Terkel: "The idea of a democracy in this country is based on an informed citizenry, an intelligent citizenry—and you can't be intelligent without being informed." These services appear unscrambled on commercial satellite transponders; the programs are carried by 200 or so cable systems, some public television and radio stations (including NPR), and on the internet, and come directly to backyard dishes (HSD).

What Lies Ahead

VoD and SVoD represent leading-edge services for cable MSOs. On-demand television has long been considered the cable industry's "holy grail." However, only recently has the cost of providing VoD/SVoD fallen sufficiently to move it out of trials and into commercial market rollout.

Although more than half of cable and satellite subscribers have access to on-demand programming, the challenges continue to be tough. The industry has to get subscribers used to purchasing on a per-program rather than on a per-channel or per-package basis; it has to negotiate low enough rights fees with Hollywood to make VoD profitable and negotiate an earlier window for releasing VoD movies to match the window for home video sales (see Chapter 9). At the same time, the industry has to build the technical capacity to handle simultaneous consumer demand for individual household on-demand video streams.

The advertising industry's concern about DVRs has led to the elaborate tracking of viewer patterns to learn how common commercial skipping is and what factors minimize it. As DVRs proliferate in homes and offices, advertisers will need strategies for getting their products out and messages heard. Product placement within television programs is one such development, and such marketing tricks as discounts, coupons, and other kinds of fee reductions for watching commercial messages have surfaced. How far this will go and how the public will adapt is unknown.

Cable, telco, and satellite distributors have moved rapidly into the HDTV service business. DBS's ability to deliver a national HD service attracted many of its new subscribers during the early stages of the transition to the newer technology. In the short run, as HDTV set penetration increases and as cable and broadcast program offerings in hi-def continue to expand, HD service offerings from both cable and DBS can be expected to generate significant additional revenue. However, once the transition to digital is complete, separate HD service tiers are likely to fade away.

278

Although cable was long the clear market leader in the area of high-speed internet service, telcos are close to catching up, and the question is whether telcos will continue to supply service to the DBS companies as the three-way competition heats up. Cable telephony service has been slower to develop because circuit-switched telephony is a very expensive and risky business to enter and because many cable operators decided to wait until internet telephony (more formally called Voice over Internet Protocol or VoIP) was technologically ready to be deployed. Now that VoIP is here, cable telephony is growing rapidly. Of course, the telcos are responding with appealing packages of television, internet, and voice telephone to counteract cable's move into telephony. AT&T and Verizon have very deep pockets, so it will be very interesting to watch as things develop.

On the reception end, the industry awaits widespread distribution of truly intelligent converters incorporated into new television sets and computers, and it awaits improvements in search engines to personalize program viewing and searching. As the number of channels and programs proliferate, consumers need effective methods of becoming aware of entertainment programs, news stories, and other messages they would probably like to see.

At first, this meant elaborate online program guides, preview channels, and programmable (meaning complicated) menu-driven selection systems, but it is envisioned that over time mass guides will evolve into personal search engines, toward which DVRs are just the first step. People will gradually, over a lifetime, program and reprogram a personal agent with learning capability that will select—from the huge sea of entertainment, news, and commercial messages—those pieces of content that will have maximum appeal or fulfill expressed needs for the individual or group. Agents for each individual will notify him or her about specific blogs, vlogs, and RSS postings based on previously expressed preferences or current wants. The process of reprogramming an agent (by voice or perhaps merely by what is frequently chosen or requested) will eventually become transparent to users, and over decades, increasingly sophisticated agent programs may become the equivalent of the semisentient computers in science fiction. Agents will eventually mutate into avatars (virtual selves) with virtual bodies that can interact with other avatars on the internet, far beyond the static cartoon representations that exist today.

As screens on handheld devices that access the internet get bigger and become virtual like the keyboards on some present-day BlackBerrys, television programs will become truly viewable and writing and analyzing on handheld computers will become practical. Nonetheless, history will repeat itself: Mobile media will supplement—not supplant—traditional media. Consumers will still want large TV screens in their homes (and public places) and desktop computers in their workplaces, and WiMax will have to spread far beyond its present limits. But the world will be a different place when most people can access the internet—for video, audio, or text—wherever they are.

Sources

Broadcasting & Cable. Weekly trade publication. New York: Reed Business Information, 1931 to date. www.broadcastingcable.com.

Cable Strategies. Monthly trade magazine concentrating on the operations and marketing of local cable services. Denver, CO, 1986 to date.

Cable Television Business (formerly TVC). Biweekly trade magazine covering cable system management. Englewood, CO, 1963 to date.

Federal Communications Commission. Tenth Annual Report: In the Matter of Annual Assessment of Competition in the Market for the Delivery of Video Programming [MB Docket No. 03–172]. Washington, DC: 28 January 2004.

Grant, August E., and Meadows, Jennifer H. (eds.). Communication Technology Update, 10th ed. Boston: Focal Press, 2006.

Multichannel News. Weekly trade publication. New York: Reed Business Information, 1980 to date. www.multichannel.com.

Reinvesting in America: An Analysis of the Cable Industry's Impact on the U.S. Economy. Denver, CO: Bortz Media and Sports Group, July 2003.

SkyResearch. Monthly trade magazine concentrating on the satellite industry. Golden, CO, 1994 to date. www.alliancem.org (Alliance for Community Media) www.bitpipe.com

www.dsl-forum.org (an international DSL association)

www.ncta.com/content view (National Cable & Telecommunications Association)
www.newschannels.org (Association of Regional News Channels)
www.sbca.com.mediaguide.htm

Notes

- 1. Kenneth Van Meter, president of Bell Atlantic Video Services' interactive multimedia platform division, speaking before Kagan Services' Interactive Multimedia Forum, 18 August 1994, New York.
- 2. Berniker, M., quoting Barry Rosenblum, president of Time Warner Cable of New York City, "Cable Thieves Undaunted by New Technology," *Broadcasting & Cable*, 10 July 1995, p. 36.
- 3. Seligmann, J, "Covering the Neighborhood," *Newsweek*, 13 December 1993, p. 6.
- 4. From the brochure cover for Deep Dish TV Network in New York, 2000.

Basic and Premium Subscription Programming

Douglas A. Ferguson and Susan Tyler Eastman

Chapter Outline

Competing Program Services

The Nonbroadcast World

Foundation and Niche Subscription Services Types of Premium Subscription Services Video-On-Demand Competition among Program Services

Selection Strategies

Economics and Technology Program Types Genres on Advertising-Supported Channels Genres on Premium Channels Launching a Network

Scheduling Strategies

Basic Channel Scheduling Premium Channel Scheduling

Evaluation

Comparison Problems Nonbroadcast Audience Measurement

The Channels

Major Subscription Networks Premium Networks

Subscription Network Promotion

Audio Services

Basic Audio Premium Audio

Directions for the Future

Sources

Notes

281

able program services are no longer limited to cable systems. Direct-to-home (DTH) satellite services, telcos, and other broadband carriers offer a full array of program channels that surfaced originally as cable networks (see 9.1). Indeed, most of the companies that own these cable program channels first operated local cable systems in the United States.

Competing Program Services

In spite of tougher competition for viewers and subscribers, new "cable" channels are proliferating. The number of cable networks with nationwide audiences grew from 145 in 1995 to about 300 by 2007—a 135 percent increase in just over 10 years, but still not quite the 500-channel universe widely

predicted back in the early 1990s. Moreover, some of the channels are audio-only, typically 30 or 40 on a cable system or satellite service.

Today, about 170 basic cable television networks exist, and of those, about 75 reach at least a minimum of 30 million U.S. homes, making those the ones on which most advertisers will pay to place commercial spots. About 20 of those networks, such as ESPN, CNN, TNT, USA, MTV, Nickelodeon, and the others listed in 9.2, have become household words because they appear on virtually every cable system in the United States and on both satellite systems. In other words, each has around 92 million U.S. subscribers and is closing in on 200 million worldwide. Since there are only about 112 million TV households in America and of those, 102 million (91 percent) subscribe to some kind of multichannel system, reaching 92 million is not far from reaching nearly everybody.

9.1 Multichannel Reach

he cable industry organization no longer publishes the precise percentages of viewers who receive the cable networks over alternate delivery systems (ADS), perhaps because satellite and terrestrial competitors to cable are growing while cable system penetration is shrinking. Overall cable penetration of the U.S. TV households has stayed stable for a decade at two-thirds (67 percent) of multichannel households. ADS penetration from services such as DirecTV and DISH has crept up to 30 percent of multichannel homes. Other land-based systems—such as telephone, wireless cable, and SMATV—exist, as was pointed out in Chapter 8, but together account for only about 3 percent of the 102 million multichannel homes.

Satell te services—inherently digital systems—are more common around the planet than terrestrial wired systems (cable, telco), so much higher percentages of services outside of America have been all digital for many years. By the end of 2010, it is expected that nearly all homes in the United States will be digital via cable, satellite, telephone, or other means.

9.2 Top 20 Basic Cable/Satellite Channels

Services	Total Subs	
The Discovery Channel	92,500,000	
ESPN	92,300,000	
CNN	92,300,000	
TNT (Turner Network Television)	92,100,000	
Lifetime Television (LIFE)	92,100,000	
USA Network	92,100,000	
Weather Channel	92,000,000	
Nickelodeon	91,900,000	
History Channel	91,900,000	
ESPN2	91,800,000	
A&E Networks	91,800,000	
TBS	91,700,000	
The Learning Channel	91,700,000	
Spike TV	91,700,000	
CNN Headline News	91,500,000	
ABC Family Channel	91,300,000	
MTV	91,300,000	
Home & Garden Television (HGTV)	91,200,000	
Food Network	91,100,000	
Cartoon Network	91,100,000	

SOURCE: WWW.NCTA.COM (DECEMBER 2006).

In addition to all the basic cable networks, premium television channels number about 35 counting such splinter services as HBO Comedy, HBO Family, HBO Latino, HBO Plus, and HBO Signature. Of those, the five channels with the largest number of subscribers are Home Box Office, Encore, Showtime, Starz!, Cinemax, and The Movie Channel, Flix and The Sundance Channel also reach large audiences. Details on the number of premium subscribers are generally not available, especially as the absolute number of pay subscribers also began declining in 2004, but the total number of subscribers to the five largest fullpay premium cable networks (HBO, Showtime, Cinemax, The Movie Channel, and Starz) was less than 70 million in 2008. As 9.2 shows, not even HBO has quite the penetration of the top 20 basic cable networks.

The Nonbroadcast World

The terms network, channel, and program service have become interchangeable. Many of the companies that provide nationwide programming have adopted the word network in their names, trumpeting that they possess the primary characteristics of a network and likening themselves to the long-familiar broadcast networks. Others use the word channel. Such program services are saying that they occupy (at least) a full channel on television sets and that they are centralized; that they distribute simultaneous programming, advertisements, and adjacencies (if advertiser-supported); and that they are retransmitted to homes via cable and satellite services. These program services come in three general types: advertiser-supported basic cable networks (CNN, ESPN), pay-per-month without advertising (HBO, Showtime), and payper-use (PPV, VoD). The internet also has some subscription services that will probably become online variations of these types (see Chapter 10).

In this chapter, program services designed for multichannel delivery are usually called "cable networks" or "cable channels," but a new comprehensive name is needed because growing numbers of people get their "cable" from home satellite dishes or through their computers. The term *subscription services* seems a good choice to encompass all forms of delivery, with subsets of basic networks and premium networks to refer to those with and without advertising, respectively. (Ordinary viewers who subscribe to HBO may not see themselves also as subscribers to Fox News, especially if they seldom watch Fox News, but their basic subscription fee to their cable or satellite operator includes hidden subscription fees to *all* of the channels provided.)

Foundation and Niche Subscription Services

National subscription networks can be differentiated in terms of how established they are and whom they target. Foundation networks-generally the earliest, most firmly established, and most popular entries in the field—reach about 102 million U.S. subscriber homes each via cable, satellite, or other. The largest (ESPN, the Weather Channel, Fox News Channel, and TBS) reach more than 200 million homes worldwide. The second broad group are the niche or theme networks. Some of major networks began life as theme networks and grew into channels that serve more than a niche. Comedy Central is an example of a theme network that became a foundation network. If a new cable, satellite, or telephone system wants to offer potential subscribers at least one of every kind of channel, it will begin seeking to license all the foundation networks.

True niche networks usually either have a single program content type (all music, all shopping) or target a defined demographic group (just children, just Spanish speakers—groups numbering in the tens of millions) with a mix of program types. Currently, the hot type of niche network is the branded subniche network, which is the product of further specialization within a theme network by a well-known media company. They are managed as a group and owned by one parent company or network. Most notably, Discovery Communications, which operates the Discovery Channel (foundation) and the Learning Channel, launched several branded subniche services (Discovery

Health, Discovery Science, Discovery Kids, Discovery Times, Discovery Home, Discovery Wings, and so on), all using the Discovery name, and other networks, such as Nickelodeon, FOX, and CNBC, have followed its lead. And HBO now provides programming for nine subniche channels: HBO2, HBO Signature, HBO Family, HBO Comedy, HBO Zone, HBO Latino, HBO on Demand, HBO Home Satellite, and HBO HDTV.

As the spread of newer technologies permits greater proliferation of channels, the strategy of channel spinoffs (into subniches) is becoming more commonplace. For example, in 2007 FOX spun off a new branded business news channel in addition to FX, Fox News, and its multiple sports channels (Fox College Atlantic/Central/Pacific, Fox Soccer, FSN Midwest).

Microniche networks target even more specialized population subgroups (hearing-impaired viewers, foreign-language speakers), generally with a broad range of program types. Some provide programming that is a further differentiation of a niche service (women's sports, independent films) and thus are both narrow in content and targeted in audience. Currently, microniche networks include Asian American Satellite TV, the Independent Film Channel, and the Filipino Channel. As streaming video opportunities expanded via broadband internet connections (see Chapter 10), a few of these microniche channels (in particular, TRIO and Lime) shuttered their cable/satellite channels and moved onto the web.

Subniche services are made possible by cheaper satellite time resulting from digital compression. As outlined in Chapter 8, digital compression encourages a process called multiplexing, distributing several different channels simultaneously, usually twelve digital channels squeezed onto one old analog channel. In some cases, the "new" services run the same programs as the main network; they are merely scheduled at different times (most of these are pay channels). In other cases, programs are subdivided by target audience, and each channel focuses on one target audience. Because the primary competitor, satellite-delivered programming, has the advantage of being inherently digital, it had a head start over cable systems in delivering

many of these new compressed channels, but cable systems are playing catch-up, and the telcos are coming up behind.

Virtually all basic subscription networks carry advertising; the smaller ones carry as much as they can get. A very few services, notably C-SPAN, C-SPAN 2, and C-SPAN 3, are basic cable networks but without advertising. Because their content consists largely of government meetings, hearings, and discussion shows on which elected and appointed government officials appear, they are offered as a noncommercial public service on the lowest level of cable services (in hopes of forestalling government regulation of commercial programming). The C-SPANs are owned by the parent companies of several large cable networks.

Types of Premium Subscription Services

Premium services is an umbrella term for a group of specialized entertainment services that provide special or "premium" programming to about 70 million U.S. cable or satellite subscribers who pay additional fees above the cost of basic cable. These services primarily offer unedited movies and original productions in a commercial-free format. The premium television field has long had three distinct components:

- 1. Pay-cable networks, which charge viewers a monthly subscription "premium" (traditional pay)
- 2. Pay-per-view (PPV) services, which charge on a program-by-program basis
- 3. Video-on-demand (VoD) services, which usually charge per-program-viewed, similar to PPV, and are available in several subvarieties or formats, but that offer more viewer control and often DVR-like functionality

The key difference to consumers is that classic pay cable means buying a group of movies over a month (pay-per-month), whereas PPV and VoD mean purchasing just one program at a time (payper-use). This chapter sometimes differentiates the services by payment method (by month or by use), but at the time of this writing, the distinctions among them are becoming very fluid. Many premium services of the pay-per-month variety are being relabeled subscription-video-on-demand (SVoD), and pay-per-view services are switching to VoD as systems digitize.

Video-On-Demand

PPV was once thought to be the "killer application" of cable, but the industry had turned to VoD by 2003. VoD households have grown along with digitalization, but only 10 percent of households order VoD movies once per week, although other households make use of the free VoD channels. Letting customers try VoD service before they commit is one strategy cable operators are using to increase the VoD subscriber base. Cable operators are anxious to recover their \$70 billion investment in building out their digital plant during the late 1990s and early 2000s. Cable operators hope that VoD is the kind of service to which viewers are strongly attracted, once they try it.

One programming problem is that many network executives fear that feeding strong product to VoD will cannibalize their main networks and give them little in return. At the same time, cable operators are working hard to persuade networks to move hit series to the VoD menus. Paying twice for the same program is a key source of resistance because basic subscribers already pay for all channels in their monthly bills. For example, the cable operator charges about \$.50 per month for MTV (hidden in the total bill), which includes The Real World, so why would viewers want to pay again for that show on VoD? Convenience is the real selling factor because VoD comes whenever the subscriber wants it. However, the video-on-demand name is currently applied to five somewhat different formats:

- 1. VoD, the true digital kind, which delivers movies or programs as the consumer asks for them
- 2. FVoD, free-VoD, where some content is available without charge to entice subscribers to become more comfortable with the idea of ondemand programming
- 3. SVoD, subscription-VoD, where a separate monthly fee is charged (for example, Showtime on

Demand and HBO on Demand) but the movies come as requested

- 4. NVoD, near-VoD, a hybrid service on analog systems, soon to be ended
- 5. Download-to-own, a internet venue that relies on broadband connections but offers the same programming as basic and premium cable channels

True video-on-demand is a system of pay-peruse movies and other programs without a defined program schedule, delivered via broadband. From the standpoint of the end-user's experience, true VoD operates largely the same as recorded programs stored in DVRs, with play, pause, stop, fastforward, and rewind capabilities. Usually viewers can watch all or part of any movies as often as they wish during a 24-hour period. One of the major reasons for implementing VoD is to cut down on churn (subscribers who start and stop their premium subscriptions faster than the network would prefer, a process that adds to the business costs). The industry's assumption is that if more options and more conveniences are available to consumers, they will be more likely to continue paying for a service.

New internet services have surfaced to compete with cable: CinemaNow and Movielink offer internet-based VoD services (see Chapter 10). Not to be outdone, over-the-air broadcast television has its own version of VoD called MovieBeam, a service that uses the analog spectrum to deliver movies from major Hollywood studios to 160-GB set-top boxes equipped with a small antenna. The days when VoD meant only "cable" are long gone.

Free-VoD means the cable or satellite operator charges neither a separate monthly fee for some on-demand program nor a fee for each time the free selection is used. Free-VoD is the name commonly given to on-demand programs when the cable operator includes the DVR in advanced cable boxes and charges inclusively for "digital service." Of course, viewers still pay extra for watching true VoD the movies and specials, but they get some programming without an extra charge. Comcast has been able to leverage its full or part ownership of such niche networks as Home & Garden Television, Food Network, Cartoon Network, the History Channel, and E! Entertainment Television to create demand for FVoD that requires subscribers to upgrade to digital cable.

Even sports networks associated with the NBA and the NFL have expressed an interest in experimenting with FVoD using older game replays and highlights. Multicultural programming is particularly popular on FVoD, especially Hispanic programs on Comcast (see Time Warner's FVoD in 9.3). FVoD is now viewed enough that Nielsen already measures aggregate linear cable networks separately from VoD viewership of individual programs. VoD revenue in 2006 reached \$1.45 billion.¹

With SVoD, subscribers may get the best of both worlds for the same subscription price. They get (1) a packaged "live" service for watching highly promoted first telecasts of premium programming and (2) using a different distribution system, a video-on-demand version of the same programs. The packaged service is like a conventional real-time linear network where scheduling is important. The VoD version has two methods of delivery, depending on the cable operator. The first method warehouses the programs on a central video server located at the headend building of the cable provider and makes the content available whenever the viewer requests it. Niche or "lightly

9.3 Time Warner Cable's "Start Over"

ime Warner Cable has its own FVoD feature called Start Over, an on-demand application that allows customers to jump to the beginning of a program in progress without any preplanning or in-home recording devices. When tuning to a Start Over–enabled show in progress, customers are alerted to the feature through an on-screen prompt. By pressing "Select" on the remote control, the program is immediately restarted from the beginning (but without the ability to skip commercials). About 70 percent of Time-Warner's digital subscribers use Start Over, and the idea was awarded at Engineering Emmy at the 2007 Consumer Electronics Show.

viewed" networks are considered the best for early implementations of switched digital video, a relatively new technology that directs channels only to customers that want to view them at that time.² The second system relies on decentralized storage, housed in set-top boxes equipped with high-capacity disk storage, if viewers have DVR equipment. The operator downloads the material, where it can be retrieved on demand. Either way, viewers can watch what they want, when they want it, for only a monthly fee. They can choose to watch the first-available "live" version or choose another time to view a replay.

If all these kinds of VoD sound complicated, it is because this decade is the shakeout period in which new delivery and reception technologies are battling to win. Because cable subscribers are more accustomed to paying monthly for tiers of services than paying for each use, SVoD successfully bridges the two models. Anyone who has had the option of paying a single price for entry to all amusement rides at a county fair versus a per-ride cost understands the appeal of SVoD over VoD, even when it is called "free."

Services such as HBO that cling to the premium pay-per-month model use SVoD as a way to enhance the value of their programming. Disney (which owns ABC Family, ESPN, the Disney Channel, and other services) is reluctant to give away the added value of its programs by making them available on demand, so it has resisted SVoD. At the other end of the spectrum, World Wrestling Entertainment launched WWE 24/7 as an SVoD service to leverage its 75,000 hours of professional wrestling. As long as subscribers are willing to pay an additional \$4.95 or so a month for SVoD access to basic channels, such channels will resist the trend toward pay-per-use, the true VoD. Having unpredictable amounts of revenue is what understandably scares content suppliers.

Some analog PPV providers—such as InDemand—provide NVoD, in which the same program is offered on a predetermined schedule (in contrast to pay-per-month channels like HBO that offer different programs within a time grid, or true VoD services that have enormous, more-orless-permanent selection lists). InDemand uses its

two analog channels (iN1 and iN2) and 28 additional digital channels to spotlight feature films, events, and adult-oriented programs.³ Analog PPV continues to be popular on cable systems that cannot yet offer digital services, but the number of such providers is shrinking fast. InDemand also offers true VoD on digital systems whereby the viewer can stop, pause, rewind, and play again hours later. Although its analog programming leans toward boxing, wrestling, and soft-core adult programming, InDemand content also includes first-run movies, soccer, concerts, and professional sports packages from the NBA, NHL, MLB, and NASCAR.

Furthermore, VoD and NVoD are not limited to cable and satellite television. Any multichannel provider (for example, the phone companies) can offer menu-based services. Indeed, even conventional broadcasting stations can be part of this brave new world through online services, second channels negotiated from cable operators in return for retransmission consent, or multiplexed digital channels using a spectrum set aside for HDTV. In 2005, CBS-owned stations began offering a new CBS on Demand service to compete with HBO on Demand and TBS on Demand.

Increasing the comfort level for subscribers ordering VoD is a major concern for operators. Some people are confused by the menus or frightened away by the seeming complexity. As a result, different ways to access on-demand programming have evolved on many major systems: through menus, through the channel lineup, through a flip bar that can be called up when a user is watching a particular channel, and through banner ads.

The internet variety, download-to-own VoD, is more suited to the type of distribution described in Chapter 10 but offers programming identical to that offered on basic and pay services. Showtime has begun selling digital downloads of its shows through Amazon.com's Unbox. Episodes of The L Word, Weeds, Penn & Teller: BS!, and Free for All, for example, are available through Unbox for \$1.99 an episode. Similar download-to-own opportunities exist for other programs and companies via Apple's iTunes store, where programs are sold for the same \$1.99 price if one has the appropriate Apple TV equipment.

Competition among Program Services

When considering advertiser-supported services, what is the real difference between CBS and USA networks? Both target a broad audience, both carry a mix of rerun and original shows, both carry live sports, both have theatrical and first-run movies, and both have sitcoms and game shows. The main difference is the presence or absence of news programming, but another difference lies in the better than 98 percent reach of a broadcast network versus the barely 91 percent reach of the biggest cable and satellite networks (and much smaller reaches for smaller ones). Also, broadcast networks still outspend the cable networks, with each of the Big Four networks spending far more on content than any subscription program services.

One way to understand the multichannel programming business is to consider the wholesaler-retailer analogy: National cable networks are like coast-to-coast wholesalers in that they sell their product—programming—to regional and local outlets, the wired (or wireless) cable system program operators, satellite services, and others. Multichannel providers are like retailers because they sell their product—television programming services—to consumers, home by home and subscriber by subscriber. The wholesalers have four functions:

- 1. Licensing existing shows or financing original programming created by Hollywood's studios or independent producers, or in conjunction with international joint-venture partners
- 2. Packaging programming in a form acceptable to consumers (by providing interstitial promotions such as wraparounds, titles, on-air hosts, and graphics)
- 3. Delivering programming by satellite to cable or other multichannel provider operators
- 4. Supporting their products with national advertising and promotion and by supplying advertising materials and co-op dollars at the local system level

As Chapter 8 explains, shelf space varies greatly among the more than 7,000 U.S. cable systems.

Basic and premium networks compete with one another (and with broadcasters) for a share of the best shelf space on delivery systems (local cable, DirecTV, DISH) by offering such financial incentives as splitting revenue promotion and advertising support.

Moreover, competition occurs for content as well as distribution. The licensing of many American television programs and movies follows a pattern beginning with the most profitable U.S. markets and ending with international distribution. Basic cable networks bid directly against local broadcast stations (and each other) for the rights to movie packages and hit off-network television series. Because of the way original contracts for most series are written, most basic cable networks pay much lower residuals than broadcast stations do. Residuals, as discussed in Chapters 3 and 4, are payments to the cast and creators every time the program is reshown. Licensing fees for cable networks can be as much as \$200,000 per episode (which may seem expensive but is far lower than for big broadcast stations). As a result, basic cable television has become a key aftermarket in the progression of sales of movies and serial programs, generating hundreds of millions of dollars in profits for U.S. and foreign program distributors.

In addition, the largest cable networks have consistently outbid broadcasters to get first rerun rights to newly available hour-long adventure and drama series and even some half-hour situation comedies. (As discussed in Chapter 3, hour-long series are less useful in rerun to broadcasters, and even such a hugely successful action series as CSI has underperformed many half-hour sitcoms in station reruns.) A few theatrical films have gone straight from theaters to basic cable, and many European television series go directly to cable. Spike TV imports Japanese shows dubbed in English or cloned. Basic cable also has become a foremarket for some programs that later appeared on U.S. broadcast stations. For example, Politically Incorrect migrated from Comedy Central to ABC in 1996 (although Bill Maher eventually took his show to HBO to escape censors and controversy).

The battle for movies after their theatrical appearance rages on. The established premium

channels get access to theatrical moves long before they are offered to most basic cable networks (and broadcasters), but the window for the hottest movies doesn't come soon enough to suit HBO and Showtime. Because video sales and rentals are a cash cow for the major studios, the popular movies must exhaust the DVD market before the premium networks are given access to them. The pay-per-use services, being the newest guys on the block, would be low on the totem pole in the bidding for Hollywood's movie output except for the fact that most are owned by the same parent companies as the established pay channels, so most deals are packages for all channels owned by one company.

Of all the problems associated with VoD, the delayed release windows (for movies) and lack of content are perhaps the most frustrating for programmers because they have no cortrol over them. Delayed windows helped prevent pay-per-view from taking off a decade ago, and they are hampering VoD growth now. Most movies currently have VoD release windows about 45 days after a film goes to DVD (and the video stores). Many movies that are highly popular in rental and sales are completely withheld from premium networks, sometimes for decades. One estimate puts the difference in potential revenue at \$4.1 billion without windows versus \$1 billion with the usual window.4 The entire size of home video rental revenue is about \$8 billion per year.

As media conglomerates grow larger, competition favors the giants. Vertical integration in combination with digitalization of cable systems has eliminated much of the shelf space shortage. The clout that comes with enormous size has improved the owned channels' ability to license top programs and produce original shows, but movies are the lifeblood of the premium services, and rapic access to them continues to be a barrier to growth.

Selection Strategies

To fully understand programming strategies, it is first necessary to grasp the economic fundamentals of multichannel service as described in Chapter 8 and expanded here. *Unlike the broadcast model*

9.4 Ted Turner And CNN

aunched in 1980, the Cable News Network was critical in helping bring viewers to cable television and, before the advent of competitors such as Fox News, was an influential and well-respected monopoly in the field. Ted Turner, who created CNN, is often credited with having a great vision of around-the-clock television news, but in fact, Turner's vision had a great deal more to do with revenue than with public service. Turner, ironically, never really liked television news. He built his early success in broadcast television in Atlanta by counterprogramming local news, offering viewers reruns of old network sitcoms like Gilligan's Island, and he was once quoted as saying, "I hate news. News is evil. It makes people feel bad."

But Turner was an exceptionally astute businessman. He surveyed the available niche markets in cable programming at the time and concluded that all the lucrative genres had already been tapped by others. According to his memoirs, he told his new CNN President, Reese Schonfeld, "There are only four things that television does, Reese. It does movies, and HBO has beaten me to that. It does sports, and now ESPN's got that. There's the regular kind of stuff, and the three networks have beaten me to that. All that's left is news! And I've got to get there before anybody else does, or I'm gonna be shut out." In later years Turner would also create the Cartoon Network and subsequently comment that while CNN received most of the accolades, the Cartoon Network was always more profitable.

Patrick R. Parsons, Ph.D. Pennsylvania State University

of maximizing the audience size, the multichannel model seeks to maximize subscriber revenue. On one hand, VoD programmers need not choose their content carefully because there's room for so much programming. On the other hand, selection of programs for most basic cable networks is far more constrained (see 9.4). And in both cases, only so many programs can be actively promoted.

Economics and Technology

The programming side of the business has matured to the point that selection decisions related to the subscription networks have become secondary to many multiple system operators (MSOs). Their primary concern is expanding their media dominance via high-speed internet service and Voice-over-Internet (VoIP) phone service. Although this programming textbook focuses on the traditional two revenue streams (subscriptions and advertising), it must be noted that cable network programmers, as well as system operators, are distracted by the prospect of bundled services (phone, internet, and pay TV). Nevertheless, for multichannel network programmers, the key to maximizing revenue in the programming realm is to generate the greatest

value for the bread-and-butter subscriber who probably wants choice and convenience (but who may not need phone or broadband services).

Advertising is one of the two main revenue streams for nearly all basic cable networks. Agencies base their buying decisions on reach, frequency, selectivity, and efficiency. Subscription channels are slowly approaching universal reach, and they offer tremendous format selectivity. It is ironic that cable and satellite networks have stolen away much of the broadcast audience by offering a proliferation of choices because the huge constellation of channels now works against the kind of mass audience viewing that supports big-dollar advertising. Targeting specific audiences is great, but the efficiency lost in smaller and smaller groups of viewers produces diminishing returns in selectivity. As more nonbroadcast networks launch, find distribution, and ultimately, acquire broader household penetration, subscription program services have begun to feast on themselves in the same way they consumed broadcast network share.

Carriage fees are the other main support of subscription networks. In most arrangements, the cable operator pays a monthly license fee to the program supplier, and these fees normally expand

in each contract renegotiation. In order for large systems with more potential viewers to pay more than small systems, cable network license fees are usually structured as per-subscriber, per-month charges to the cable operator. The typical fees range from about \$.15 per subscriber for services such as Country Music TV to about \$1.00 per subscriber for more popular services such as CNN. For advertising-supported networks, a tension exists between getting the national penetration necessary to attract advertisers and keeping the carriage fees high enough to pay the bills. At \$.40, A&E's license fee is about on par with that of Lifetime Television, which is way below that of TNT. The high price of sports contracts has driven up the cost of all channels that bid high for telecast rights, driving TNT's carriage fee above \$1.00 per subscriber. Fox Sports Network 1 carries a rate of \$2.25 per subscriber, per month, while its second regional network charged about \$1.00 in 2005. ESPN charged an average \$3.80 per month in late 2005.

Many new channels pay one-time-only launch fees and offer free carriage to appeal to potential cable operators. For example, E! Entertainment paid operators \$7 per subscriber and gave free carriage when it launched the Style Network. Originally, the Fox News Channel paid \$10 per subscriber to be added to DirecTV's lineup. By the late 1990s, paying launch fees was such an established inducement system that DBS providers were charging new networks an average of \$6 per subscriber.

On the premium channels, feature films are licensed to networks in one of two ways: persubscriber charges or flat fees. *Per subscriber* means that the film's producer or distributor negotiates a fee per customer for a specific number of runs within a fixed period, the number varying with the presumed popularity of the film. Such a fee is based on the number of subscribers who had access to the film (though not necessarily the number who actually saw it). In a *flat-fee* arrangement, the parties negotiate a fixed payment regardless of the number of subscribers who have access to the film.

Once the premium cable networks grew large enough that the amounts for movies were substantial, they usually abandoned the per-subscriber formulas and negotiated flat-fee arrangements with the program suppliers. The flat-fee method is also used for acquiring original programming. In PPV and VoD, however, the cable operator pays a per-subscriber fee to either the studio or service provider, necessitating large enough fees to users to cover their costs.

Program Types

Although the subscription services license many off-network shows and air movies already shown on the broadcast networks, there are also unique kinds of multichannel programs. Signature programs and vignettes characterize the cable and satellite universe. In addition, subscription services increasingly choose to license first-run series and produce their own programs.

Signature Programs

Tough competition for viewers drives most subscription networks to strive for signature programs, unique programs or a pattern of programs that distinguish a network from its competitors. Signature programs create a well-defined image for the network and breed a set of expectations for both audiences and advertisers. These expectations, whether positive or negative, help viewers select which channels to watch and lead advertisers and their agencies to expect that advertisements on some channels will or won't be effective. A lack of program definition, or an absence of signature programs, killed off several early cable services.

Four major types of signature programs appear on cable program services. The first consists of original movies or series not shown elsewhere, also called made-for-cable movies and programs. Although they are expensive to produce, they are highly promotable and attract new viewers more than repeat programming does. A second type of signature programming consists of narrow theme genres, such as all live nightclub comedy or all shop-at-home or all instructional programs. BET's Comic View is an example of the comedy nightclub genre. A third type consists of programs for a niche audience, or viewers with a narrowly defined set of interests or within a targeted demographic

9.5

Larry King

or more than two decades, Larry King Live has remained CNN's top-rated and most-visible program. Airing in the peak viewing hour (9:00 P.M.), King is known for his high-profile guests (including the last six U.S. presidents) and his "soft" questioning style. Some argue that Larry King's ability to book big names is directly a result of his one-sentence questions and jovial nature. King contends his show is not journalism but "infotainment," pointing to his wide range of guests (ranging from Marlon Brando to Pete Rose to J. K. Rowling), encompassing a considerable swath of American interests. Critics maintain that the rise of King's program represents a notable shift from hard news to soft news stories on television. Many of his recent programs have had animal guests or explored such nonissues as the paranormal.

Initially trained in radio broadcasting, King's CNN program premiered in 1985, with peak interest occurring in 1993, when a debate on free trade between Ross Perot and Al Gore reached the largest cable TV audience in history, a record that held for more than a decade (until ESPN's Monday Night Football surpassed it in 2006). King's show is also different from most other television talk programs in that it allows for live call-ins from viewers at home, encouraging a conversational and easygoing format. Larry King's work has been richly rewarded; he is one of the few people to receive Peabody Awards for his work in both radio and television.

Andrew C. Billings, Ph.D. Clemson University

group. For example, Spike TV sought a young male audience with *Maximum Exposure*. The fourth and least common type of signature programming consists of the *cable exclusive*, programs shown once or twice on the broadcast networks but not shown before on cable. A fifth type are long-running popular programs whose hosts or personalities have become household names. See 9.5, which discusses CNN's Larry King.

Sometimes signature genres cut across various networks. For example, such channels as the Travel Channel, ESPN2, and Bravo all caught the wave of popularity for poker after 2004 with such shows as Celebrity Poker Challenge and World Poker Tour. In the case of poker, the Travel Channel and Bravo temporarily diverged from their central programming mission to boost short-term ratings because of pressure from advertisers to attract larger audiences, and the result was far greater than anticipated. A similar fad surfaced in the same period for house-remodeling and room-makeover programs, followed by such person-makeover programs as Extreme Makeover and What Not to Wear.

Less temporary overhauls in signature programming occasionally occur, too. American Movie Classics switched from pre-1980 classic movies to modern-day classics, to the consternation of some

system operators who wanted the movie content to stay different from mainstream movie channels (but, doubtless, to the joy of Turner Classic Movies). Another major change took place in 2004, when the Game Show Network condensed its name to GSN and got rid of classic and neoclassic game shows in favor of interactive gaming and reality-based content. Probably the most dramatic makeover for a cable channel was in 2003 when the National Network (TNN, formerly the Nashville Network) rebranded itself a second time as Spike TV, the first network for men (or so it claims).

Vignettes

Another common cable genre consists of vignettes, also called interstitials, meaning the programming bits between the regular programs. Traditionally a staple of premium services, this type of short-form filler programming appears between movies that end at odd times, and vignettes have also found their way onto basic program services. The Hallmark Channel offered a Tell Us Your Story campaign in association with Valentine's Day 2006, featuring the best viewer-submitted stories of romance and love for its network and online platform as part of a new interactive programming initiative. Although the primary purpose of vignettes is to promote

branding, they also serve as backdoor pilots or ways to push viewers to online programs and websites.

Many basic networks use interstitials even though the airtime could be sold to advertisers. For example, *Perspectives on Lifetime*, a series of editorials and interviews tied to issues such as breast cancer awareness or events such as Black History Month, contributes to the overall mosaic of the channel. Lifetime has even experimented with live hosting between programs to achieve a seamless look with no commercials on the hour or half hour, thus keeping viewers away from their remote controls. Turner Classic Movies shows vintage filler called *One Reel Wonders* between featured movies.

Movie studios have also begun using interstitials to promote theatrical films by showing the first several minutes of the film to tease the audience into going to the box office. Universal Pictures paid USA to show the first 10 minutes of the movie *Dawn of the Dead*. In a similar move on the internet, Warner Brothers showed the first nine minutes of *Taking Lives* online at Yahoo! Movies to whet potential moviegoers' appetites.

The growing popularity of the clip culture (see Chapter 10) on websites like YouTube and Revver may add to the importance of vignettes. As online videos further shorten the attention spans of many viewers, cable networks can be expected to expand the use of interstitials for content or promotional purposes.

Originals

Despite the continued use of off-network programming, the dominant trend for subscription networks (and superstations) is toward more commissioned, coproduced, or solely produced original programming (*Monk* and *The Closer* are two broadly popular examples). Only original programs successfully brand a network by defining and distinguishing it from competing services. In the last decade, such networks as Lifetime Television, FX, the Learning Channel, Bravo, the Sci Fi Channel, Comedy Central, USA, MTV, Court TV, and even ESPN have dramatically increased their budgets for original programming, especially creating programs for Friday and Saturday nights when the broadcast networks offer weaker shows

than usual. Collectively, the subscription networks spent about \$15 billion for original programming in 2006, and that amount is expected to grow past \$20 billion by 2010, according to Kagan World Media.⁵ With the exception of signature reruns like *Law & Order: SVU* on USA, *Without a Trace* on TNT, *CSI* on Spike TV, *CSI: Miami* and *The Sopranos* on A&E, and *Everybody Loves Raymond* on TBS, off-network programming has largely migrated from prime time to other dayparts. It appears especially in daytime and access.

In the summer of 2008, NBC heavily crosspromoted live Olympic coverage on Bravo, CNBC, MSNBC, Telemundo, and USA. Although the segments of the Games appearing on the basic cable networks were noncompetitive with NBC because they occurred outside prime time, carrying such a high potency mega-event live improved the channels' international visibility as well as their domestic viewing (and advertising sales), and the original nature of the content contributed to their positive branding.

Genres on Advertising-Supported Channels

Some basic services such as USA, TBS, TNT. and ABC Family consist of a broadly appealing mix of program forms (full service) similar to those of broadcast television, scheduled by daypart. Along with the superstations WGN and WWOR, they are among the most popular networks. Nearly every genre of program seen on a broadcast network has been tried by these full-service cable networks, although not all have proved equally successful. Despite the shift to more original programming, hit off-network syndicated hours such as Law & Order remain very popular with audiences of broad-appeal networks. Because these networks generate most of their income from the sale of commercial time, they must select programs that will appeal to the same mass audience sought by the broadcast networks. Most basic networks, however, especially the newer services, are niche (or theme) and subniche services. They must select programs that have a particular type of content or that target a specific psychographic group.

9.6 The Sports Fan's Program: SportsCenter

elebrating its 30,000th unique episode in 2007 (along with thousands of reruns), ESPN's venerable SportsCenter has aired continuously since the sports channel's inception in 1979. The program currently appears in high definition between 6 and 12 times daily, providing a mix of game highlights, recaps, top stories, commentary, analysis, and predictions. At its start, many television experts claimed that an entire program devoted to sports was too narrowly defined and doomed to cancellation, but the joke was on them. SportsCenter evolved into a national and international phenomenon, part of not just one but several television channels of all-sports news, talk, and events from ESPN, FOX, and other networks.

When fresh game news is scarce, SportsCenter fills slow days with such attention-grabbers as Chris Berman's "2-Minute Drill," which looks forward to the weekend's NFL games with analysis and predictions. Other examples of SportsCenter-specific formats include the "Budweiser Hot Seat," in which a guest is asked some particularly probing/interesting questions; "Contender or Pretender" where analysts determine whether a currently successful team or player can continue to excel; and "Top 10 Plays," which can range from the best plays of a particular day to the worst plays of the week, to the 10 best catches by a centerfielder.

SportsCenter not only analyzes games but has influenced the way games are played in small ways. For example, the number of slam dunks has increased in professional basketball because they are more likely to make ESPN's highlight reel. The same can be claimed for spectacular dives to catch baseballs. The program has also had an impact on vocabularies ranging beyond sports. Most fans know that "going

yard" is a home run and that "boo yah" is host Stuart Scott's catchphrase when describing the action. SportsCenter's Chris Berman gave a twist to the long tradition of nicknaming athletes, as with his Bruce "Eggs" Benedict and Jose "can you see" Cruz.

Sports Center has become the broadest brand of sports news and is sometimes referred to as "The Big Show"—handling the most important sports, with niche sports interests being served by complementary ESPN news shows, such as Baseball Tonight and College Football Gameday. Starting first on SportsCenter, these shows all now include a scrolling "Bottom Line" ticker to supply ongoing and just-past game scores for several sports. SportsCenter integrates other ESPN programming into the show by having commentary from Tony Kornheiser and Michael Wilbon from Pardon the Interruption and integrates itself into ongoing games with a "SportsCenter 30 at 30 update," in which fans get 30 seconds of the top headlines within a college basketball telecast, for instance.

SportsCenter has had dozens of anchors, ranging from its earliest days with George Grande—to smooth Bob Ley and chatty Chris Berman—to roughly 30 anchors today, supported by a large team of reporters. Some notables, such as former Late, Late Show host Craig Kilborn, have moved into nonsports television, and others, such as MSNBC Countdown host Keith Olbermann, have moved to competing programs. No single sports program wields the international influence that SportsCenter does. With its clever animated graphics, it is now offered in multiple versions ranging from a Canadian-oriented show to Spanish-language offerings on ESPN Desportes.

Andrew C. Billings, Ph.D. Clemson University

For example, ESPN's signature program, *Sports-Center*, is a flexible sports-talk program that can appear live a dozen times a day or be cut back or rerun when live sporting events take up center stage (see 9.6). After obtaining live NFL games, ESPN became a major network competing (alongside ABC) for such megasports events as NBA, NHL, and MLB games; soccer; boxing; and NCAA college

football. The network has had limited success with such series as *Playmakers* and *SportsCentury*.

Once the home of all-day, all-night music videos, MTV now combines signature programs (for example, *Punk'd*, *Laguna Beach*) with music-based favorites (*TRL*). Writing about signature programs on MTV is difficult because the trend has been for its shows to move very quickly, often

within a year, from being a phenomenal success to being yesterday's news (for example, Jackass). A similar situation exists on Comedy Central, another favorite of fickle youth, where only South Park and The Daily Show with Jon Stewart have much staying power.

On Lifetime, romantic made-for-cable movies predominate, mostly about relationships and the "woman-in-danger." Its prime-time schedule has reruns of Reba. USA wins awards for Monk and The Closer but mostly schedules reruns of shows like JAG and Law & Order. The History Channel is characterized by older documentaries about battles, airplanes, and ships in past wars, as well as by colorful hosted documentaries that investigate the warfare, art, and other remnants of ancient Roman, Greek, or other civilizations. One recent two-hour original special surveyed the entire 600 years of the Dark Ages. The Sci Fi Channel has filled its early-evening schedule with episodes of Stargate SG1, which eventually spawned Stargate Atlantis, as well as new episodes of Battlestar Galactica and reruns and new episodes of Andromeda. Later in prime time, Sci Fi airs a plethora of horror films, full of monsters and death in scary varieties.

The Travel Channel now goes beyond travelogues, having hit it big with World Poker Tour. Food Network has a winner in Emeril Live. Home & Garden Television has found hits in home redecorating and fix-up shows. Spike TV features police videos and movies about men doing dangerous (but heroic) things. The Discovery Channel has drifted away from stories about pivotal inventions (for example, Industrial Wonders) into motorcycle shows (American Chopper and Gut Busters). Its sister service, the Learning Channel, has its own signature shows entitled Trading Spaces and Moving Up. Bravo has captured the reality contest genre with its signature competitions in Project Runway, Top Chef, and Top Design.

Genres on Premium Channels

Every cable system in the United States offers at least one premium service. And if a system has only one pay channel, the odds are very high that it is HBO (formerly, Home Box Office). HBO achieved

its leading position through its early entry into pay television in 1972 and early adoption of satellite delivery in 1975. (Showtime began in 1976 and moved on the bird in 1978, but never quite caught up.) HBO then consolidated these early leads through aggressive national marketing campaigns in the 1980s that competitors could not afford because of their smaller audience bases. Relatively few systems carry just Showtime, Flix, Encore, or one of the other pay services.

With HBO in the primary role for many years, the competition among the others focused on securing shelf space as the second or third (or even fourth) service provider on the local cable system's menu of premium offerings. And then cable became alldigital like the satellite services, with room for all, especially in various kinds of VoD. Today, HBO's main competition comes from co-owned Cinemax, The Movie Channel, Showtime, Flix, Starz, and Encore, and all of these services, including HBO, have taken advantage of compressed video delivery and spun off handfuls of additional channels.

Selection strategies for premium networks differ from those for basic networks. Because viewers pay extra per channel (or per sets of channels, such as 8 Encores), they have higher expectations of the programming on premium channels, which leads to enormous investments in such original series as Entourage and the award-winning The Sopranos, along with large quantities of more or less successful entertainment specials. Those networks competing with HBO-particularly Showtime-target their movies to more carefully defined audiences and directly counterprogram HBO's lineup, at least on the main channels. Differentiating themselves through acquisition of exclusive rights to hit movies and developing appealing and promotable original shows has become key to the premium services' competitive strategies. Besides spinoff channels, differentiation via promotion, and original content strategies, some premium networks have adopted time-shifting as a strategy by using staggered start times (see the discussion of bridging in Chapter 4).

Movies

The staple of premium cable networks, including PPV and VoD, remains the Hollywood feature film, aired soon after theatrical release. The rapidity with which a film can be offered to subscribers is central to establishing a premium service's viability and value. While the pay-per-use services generally present top movie titles a few months after their initial domestic theater distribution—which is still usually about 30 to 60 days later than home video—by contrast, the usual exhibition window for the monthly premium channels is 6 months after theatrical release (with the broadcast networks following at 18 months). VoD distributors are very eager to get their window earlier than home video, but Hollywood worries about piracy and lost DVD revenue (\$24 billion for home video versus only \$10 billion in box-office revenues). Comcast, a top-three cable provider, has floated the idea of showing high-definition VoD movies during the theatrical window for \$40, aired and priced like a pay-per-view boxing match.6

None of the national premium services as yet carry commercials. With rare exceptions, films are shown unedited and uninterrupted, including those rated PG-13 and R (containing strong language and behavior normally censored on broadcast television). The pay-per-view services and at least Cinemax on the pay side also run films in the NC-17 category (formerly X-rated).

Entertainment Specials

Selecting performers to star in original specials for the pay-per-month channels and choosing properties to adapt to the television medium requires an in-depth examination of subscribers' expectations. Because the major broadcast networks can offer opportunities to see leading entertainers, either on specials or daily talk/variety shows, premium programmers are forced to seek fresher, more unusual entertainers and material. They have several options, especially the following:

- 1. Using performers who are well known but who appear infrequently on broadcast network television
- Using performers often seen on broadcast television but who rarely headline their own programs

6. Developing programs and artists unavailable on broadcast television

Unlike the typical broadcast network special, every effort is made by premium producers to preserve the integrity of a complete performance without the guest stars, dance numbers, and other window dressing used to widen the audience base of most broadcast network variety shows. At their best, these shows are vivid reproductions of live performances. Premium cable's time flexibility also permits nightclub acts and concerts to run their natural lengths, whether they are one hour and 11 minutes or one hour and 53 minutes. The private nature of pay viewing also allows for telecasting "edgy" adult-oriented comedy (for example, Dennis Miller, Chris Rock) and dramatic material unsuitable for airing on broadcast television (The Sopranos).

Sports

The third major component in pay programming is sports. ESPN offers six ESPN-PPV channels on most cable and satellite systems, along with five other channels, with competition from four FOX sports channels, and another ten or so specialized sports channels (Tennis Channel, Speed Channel, NFL Network, The Golf Channel, and suchlike). HBO and Showtime have traditionally scheduled major, big-ticket, national sporting events in prime time, especially on their HD channels. Sports programming creates a divergence of opinion, however, in the pay-television community, with some programmers arguing that sports blur a movie network's image. In consequence, neither The Movie Channel nor Cinemax carries sports. Because of the broadcast networks' financial strength and audience reach (and a general consensus that certain events like the Super Bowl should stay on overthe-air television), ABC/ESPN, FOX, CBS, and NBC still manage to acquire the rights to most major sporting events. Thus the pay-per-month premium networks often have to settle for secondary rights or events of lesser national interest. Nevertheless, an audience can be found for some sports that broadcast television does not adequately cover, such as middle- and heavyweight boxing, regional college sports, track and field, swimming, diving, soccer, and equestrian competitions.

Big-ticket boxing and wrestling have been programming staples for pay-per-view packagers for many, many years. For over a decade, the relatively small number of headline events and the relatively small universe of pay-per-view-equipped homes took PPV out of contention for major events. But by 2005, PPV and VoD carried major boxing matches (generating over \$100 million for a single high-profile match), and DirecTV was carrying live NFL or NHL games. These sporting events continue to achieve record buy rates and revenues. and they fuel subscriptions to PPV and VoD, causing ESPN to enter the PPV competition in a big way. The key to success in sports apparently lies in having strong branding, along with extensive local and national marketing efforts.

PPV Specialties

Interactivity is one way to enhance original PPV offerings. For example, Playboy TV has had much success with its call-in show *Night Calls*, which generates significant revenue (and thousands of phone calls). Cable operators get 70 to 80 percent of the \$8 to \$10 per-program-viewed cost of adult PPV programming (compared with 50 percent of the \$4 cost of typical movies), so adult programming is their most bankable asset.

Launching a Network

As the digital tiers have filled, cable and DTH providers are no longer eager to bring on new services unless they can be bundled with existing services from the subscription networks with big muscle, such as Disney, Viacom, or Comcast. By 2003, observers had declared the end of the era of new network launches. Still, some new channels have emerged since that year: Fuel (a FOX-owned sports action channel), G4 (a Comcast-owned video gaming network), NBATV, the Tennis Channel, TV One (targeting African-Americans), and a few others. But compared with the 25 channels that launched between 2000 and 2005, only one network (Sleuth) launched in 2006 and only one in 2007 (Chiller, dedicated to

the horror genre), so maybe the declaration was only a little early.

The first element in strategy for a start-up network is to pay launch fees to cable MSOs or DBS providers, typically \$10 to \$12 per subscriber. A related approach allows such large MSOs as Comcast and Viacom to become partners in the venture. With the periodic megamergers of media industries, fewer players are controlling larger pieces of the multichannel universe. Another way to facilitate distribution of a new channel is not to charge cable systems for carriage for a few years. As was pointed out in Chapter 8, some cable networks have launched by reversing the traditional model of carriage; in other words, by paying MSOs a monthly per-subscriber fee for carrying them. Because of excessive start-up costs in the range of \$40 million to more than \$100 million, there have always been difficulties launching a new cable network.

Nonetheless, certain incubation strategies have become traditional for gaining shelf space for new cable networks. One is sheltering launches to help new networks establish themselves before moving full speed ahead. Americana Television, a 24-hour country lifestyle channel, got its start as a part-time service on Nostalgia Television. Viewers could watch a BET on Jazz program on BET before Jazz Central launched. Turner Classic Movies showed up on TNT, and Cable Health Club was initially part of the Family Channel. NewsTalk Television launched with 4 million part-time homes as well as 3 million full-time homes. To gain sampling, newer networks have also turned to DBS for distribution, because DISH and DirecTV offer many more channels than most cable systems. One final strategy, and a solution to the low distribution problem for new networks, is piggybacking or sharing a channel with another service. American Movie Classics gave Romance Network a slot on Sunday afternoons and incubated American Pop on Saturday nights.

Regardless of shelf space, a high mortality rate will continue among new services. No matter what a network's programming entails, limited distribution into America's subscription households will make it difficult to cover operating costs. Thus, three basic ingredients are needed in order for a network to survive: a good programming idea,

smart people behind the idea, and money. In addition, new program services need to be flexible with regard to tiering, pricing, and packaging.

Overcrowding in the subscription cable environment will inevitably have two outcomes. First, cable operators will remove (or displace to less desirable locations) older foundation services that have become stale in favor of new services; and second (and more common), start-up services will sell out to other (larger) networks, thus merging their top content or serving as a splinter version of the key network. In addition, because of the high cost of maintaining a single network's infrastructure and purchasing or producing programming, a service that is comarketed (and usually co-branded) simultaneously with several other networks reduces sales, marketing, and engineering/ production costs. Further, it helps to be able to lose money through sister companies.

Scheduling Strategies

Basic and premium cable networks need to follow the same general practices outlined in Chapter 1: conserve resources, form habits, control audience flow, schedule shows to be compatible with viewer lifestyles, and maximize breadth of appeal. Until the day when viewers truly can choose anything, anytime—when VoD and DVRs make scheduling irrelevant—the linear scheduling aspect of the programmer's job will be crucial to the success of a program service.

Basic Channel Scheduling

The advertiser-supported networks have adopted several program scheduling ideas that have appeared for a short time on broadcast services but better suit the special needs of subscription program suppliers. These include program marathons, blocking, zoning, and other alternatives to ratings that build the networks' appeal to advertisers.

Marathons

Subscription networks often use marathons—all-day, all-night, continuous program scheduling

of the same series-to counterprogram major broadcast events like the Super Bowl. Marathons are also scheduled during holidays, protracted bad weather periods, or any time viewers are likely to turn into "couch potatoes." There have been plenty of examples: Leading up to and on Mothers' Day, TBS gave viewers a Leave It to Beaver marathon with Barbara Billingsley, the actress who played Beaver's mother, as the host; Nick at Night provided a Coach marathon starting after the end of the Super Bowl in hopes of snaring football fans who liked the old ABC sitcom about a college athletic director. During the 2007 Super Bowl, TNT ran 13 hours of The Closer, which performed well during the actual game. Marathons can generate exposure for a newly acquired show as well as remind viewers that a popular show appears on the network.

Because the networks promote marathons heavily, they usually perform well—even better than the average programming—which can lead to increased advertising sales. In one case, a marathon briefly generated a signature program for VH1 when I Love the 70s devoted an hour to each year of the decade; this resulted in the nostalgia sequels I Love the 80s and I Love the 90s. VH1 previously enjoyed marathon success with its Behind the Music series on defunct or controversial music groups.

Blocking

Some networks have adopted blocking strategies to lure mainstream audiences away from network affiliates. TNT's daytime programming is called "Primetime in Daytime" and features reruns of such off-network programs as Charmed, ER, Judging Amy, and Law & Order. At one time, these shows were syndicated only to broadcast stations. Now such scripted dramas go to subscription networks, while broadcast stations concentrate on first-run syndication and off-network sitcoms.

In another variation, several basic cable networks have scheduled multiple episodes of a single series in one block starting in early evening and going on for several hours. Spike TV has blocked as many as three or four episodes of *CSI* on some evenings, and USA has put several episodes of *Law* & Order: Special Victims Unit in sequence on an

evening. The Sci Fi Channel schedules blocks of *Stargate SG1* on Mondays. And interestingly, Sci Fi varies the season of shows in such blocks, mixing up first-season to sixth-season episodes (so the characters' hair is first long and then inexplicably short and then long again, and costumes change without rationale).

Homogeneity, Zoning, and Roadblocking

Cable has developed criteria other than ratings for selecting and scheduling national and local services and for attracting advertisers. Cable executives generally emphasize the demographic or psychographic homogeneity of viewers of a particular service. MTV viewers, for example, are alike in age and interests; Lifetime viewers are mostly women. A second and related strategy is zoning, dividing an interconnect into tiny geographic areas to deliver advertising, which permits local businesses to purchase low-cost ads that reach only their neighborhoods.

Another strategy is roadblocking, scheduling the same ad (or promotional message) on all cable networks at the same time so the advertiser's message blankets most cable channels (and sometimes broadcast networks, too). This practice occurs at the national level (so all viewers might see the same spot at the same time) and at the regional level (using inserts on a single cable interconnect) (see Chapter 8). Roadblocking, in theory, keeps grazers from using their remote controls to avoid commercials because many viewers quickly give up surfing when the same commercial message appears on channel after channel. But the strategy works for program promotion, too. For example, on one June day in 2005 at 9 P.M., all nine of NBC Universal's broadcast and cable networks ran the same the two-minute 30-second teaser trailer for the movie King Kong.

Cable networks are analogous to radio stations in a single market—both numerous and fragmented. No one can deny their collective media reach, but few can figure a way for each individual program service to compete with any of the individual broadcast networks. Only the biggest MSOs can buy up very large numbers of cable networks and market them as a group to advertisers

but individually to viewers. Most cable programmers must focus their strategies on hard-to-reach audiences, just as radio programmers do.

Premium Channel Scheduling

The need to schedule movies is likely to be the first aspect of traditional programming to succumb to the advent of the widespread availability of VoD. Nevertheless, some viewers would rather choose a channel than pick from a menu, so some pay channels will stay with a schedule for the foreseeable future.

Rotation

Preplanned multiple reuse of content used to be a major difference between traditional premium and broadcast television; now both broadcasters and large cable networks lay out a multiplatform design before a new show goes on the air. As pointed out in other chapters, only when shows a hit or develop a cult following are such plans actually implemented.

Most pay services offer a range of 20 to 100 movies per month, some first-run and new to the schedule (premieres), some repeated from the preceding month (carryovers), and some returning from even earlier (encores). In the course of a month, movies are typically scheduled from three to eight times on different days and at various hours during the daily schedule. Different movie services offer varying numbers of monthly attractions, but all services schedule most of their programs more than once. (Programs containing nudity or profanity, however, rotate only within prime time and late night on most networks.) The viewer, therefore, has several opportunities to watch each film, special, or series episode. These repeat showings maximize the potential audience for each program. The programmer's scheduling goal is to find the various complementary time slots that deliver the greatest possible audience for each attraction during the course of a month—not necessarily in one showing.

Unlike the monthly pay-cable networks, payper-view services rotate *rapidly* through a short list of top-name Hollywood hit films. The same movie may air as few as 4 or as many as 10 times in a day. This occurs because pay-per-view programmers market "convenience viewing." Pay-per-view networks either rotate two to four major movie titles a day, some across multiple channels, or run the same movie continuously all day. As the number of channels available to pay-per-view increases, the trend is to assign one movie per channel, thus emulating the "multiplex" theater environment.

Title Availability

Balancing the number of major films and lesser-known but promotable titles every month, then adding a handful of encore presentations, is one of the key challenges a premium movie programmer faces. A crucial factor in preparing the lineup is title availability. Most films with good track records at the box office are obtained from major film distributors, but an increasing number can be purchased from a wide variety of independent distributors and producers.

Usually it does not make economic sense for studios to hold a film in theatrical release for more than a year, but video sales have disrupted this pattern and delayed film availability as already explained. The home video sell-through is a film priced to be bought rather than rented by consumers. (For rentals, the studios receive revenues only from the initial purchase of each tape by the retailer.) Successful sell-throughs of extremely popular films, even at much lower wholesale prices, are a distributor's dream—and the studios maximize revenues by delaying premium television release until the first stage of video sales has passed.

Time constraints on the use of films also affect steady product flow, including *how long* and *when* a film is available to pay services. Commercial broadcast television buyers, for example, traditionally had the financial clout to place time limitations on distributors' sales of films to premium services. The broadcasters would seek early telecast of key films to bolster their ratings during Nielsen ratings sweeps, shortening the period of time during which the films were available to premium networks. The number of such key films of interest to the broadcast networks has been dropping, however, as their ratings deteriorate because of increased home video and premium penetration.

Some desirable films are unsuitable for broad-cast sale altogether, increasing their pay-television staying power. Films such as the *Emmanuelle* series, although not recent, crop up again and again because they never enter broadcast windows. Therefore, distributors allow premium networks to schedule them as many times as they like for as long as they like.

Occasionally, the major pay-per-month services disagree about whether to schedule a movie *after* it has already had a commercial broadcast network run. HBO and Showtime have found a following for these movies when they are shown unedited and without commercials. Some survey research even demonstrates viewer support for reshowing films that have been badly cut for commercial television presentation or that have exceptionally strong appeal for repeat viewing. Almost all premium services also show selected off-network movies, often drawing sizable audiences.

Exhibition Windows

As explained earlier, distributors create a distribution window for a film's release when offering it to the premium services. The programmers negotiate for a certain number of first-run and second-run plays during a specific time period, generally 12 months. For example, a given film may be made available to a pay-cable service from April to March. It might premiere in April, encore in August, and then play again the following March to complete the run. Programmers must project ahead to see that the scheduled play periods for similar films from different distributors do not expire at exactly the same time. Generally, premium services don't want to waste their scarce resources by running five blockbusters, four westerns, or three Kevin Costner films in the same month. Such clustering can be advantageous, however, when the films can be packaged and promoted as special "festivals."

Broadcast television's scheduling practices, organized around the delivery of commercial messages, differ broadly, resulting in the weekly series, the daily soap opera, and the nightly newscast. In most cases, in broadcasting, an episode is shown only twice in one year, and the largest possible audience is sought. Some premium networks have adopted

the short-length formats of broadcast television, such as episodes of Weeds on Showtime and Six Feet Under on HBO. The shorter lengths (not to mention the sometimes provocative content) help these first-run shows get sold internationally and to move later into domestic syndication. Most pay programs, however, run to their natural lengths, ending when and where the material dictates rather than running in fixed segments to accommodate commercials. Even with series programs, frequent repetition and rotation throughout the various dayparts set premium program scheduling apart from broadcast scheduling. Also, broadcasters set their schedules for an entire seasonpay-per-month and pay-per-view set them one month at a time.

Monthly Audience Appeal

Another major contrast between broadcast and premium programming services lies in their revenue-generating strategies. As already noted, to maximize ad revenues, commercial networks and broadcast stations program to attract the largest possible audiences every minute of the programming day. Premium cable networks, in contrast, try to attract the largest possible cumulative audiences over the period of a month.

The lifeblood (read daily operating revenues) of a pay service is its direct subscriptions. Payper-use services must satisfy their customers movie by movie, event by event, or night by night. Payper-month services must satisfy their subscribers month to month, throughout the year, forestalling disconnections. A premium service's success is not determined by the audience ratings of its individual programs but by the general appeal and "satisfaction levels" of its overall schedule. Insofar as quantitative measures such as ratings reflect that appeal (especially for one-shots like boxing matches or a live Sheryl Crow concert), they are useful in gauging response. In cable and satellite service, however, where subscribers must be persuaded to pony up month after month, qualitative measures take on greater importance.

One important qualitative measure is subscriber turnover. Because both schedules and subscriber billings are arranged by the month, viewers tend to evaluate programming in month-long blocks. Subscribers will most likely continue the premium service for another month if:

- They use their pay service two or three times a week.
- They see benefits in its varied viewing times or on-demand availability.
- The service runs commercial-free, uninterrupted program content.
- The service runs unique entertainment programs and theatrical feature films.

The pulse of pay-per-use and VoD success is measured by buy rates. Careful matching of buy rates and titles offers both the pay-per-view or VoD distributor and the system operator a tool for finetuning scheduling and promotion plans. Providing viewers have plenty of PPV or VoD choices, they can always find something to watch. In contrast, month-to-month services have different problems. While discontinuing a month-to-month pay service seldom reflects dissatisfaction with one or two individual shows, viewers disconnect when they feel that the service as a whole is lacking. Customers repelled by violence, for example, may disconnect a movie service if a large number of a particular month's films contain a great deal of violence. A family may determine that its desire for wholesome, G-rated fare is not being filled by the programming mix of one particular movie service and so will cancel after a trial month or two.

Movie Balancing Strategies

Selecting programs that will appeal to different target audiences through the course of a month becomes the challenge for most pay-per-month programmers. For example, if a particular month's feature films have strong appeal to teenagers and men 18 to 49, the obvious choice for an entertainment special is a show that appeals to women. Premium programmers break down their audiences as follows:

- 1. Urban-rural classifications
- 2. Age groups of 18 to 24, 25 to 49, and 50+
- 3. Gender

By scheduling programs each month that will appeal to all these groups, the premium programmer theoretically creates a "balanced" schedule.

Films subdivide into several groups with overlapping appeals and are usually scheduled by considering either their timeliness or their appeals. The major audience attractions for monthly schedules are the premieres-that is, the films that were recent box-office hits and are being offered for the first time on that premium service. These films may be rated G, PG, or R by the movie industry. The second sets of films placed in a pay-per-month channel's schedule are the major G- and PG-rated films. This establishes a strong pattern of family and children's appeal in the schedule. The third group of films has varied adult audience appeals. Films without notable box-office success usually fall into this category. They are repeated slightly less frequently than premieres and G-rated hits.

Other films that were not major theatrical hits may still rate as important acquisitions for premium services. Viewers may value seeing a film on television that they might not be willing to pay \$8 to \$10 to see in a movie theater. Foreign films fall into this group. Also, if a premium network feels that a particular film has appeal to a segment of its audience, it doesn't matter whether it was originally made for home video or made for broadcast television; films in both categories increasingly show up on premium schedules. Another growth category is film classics.

Film Placement

On the pay-per-month channels, the general rules of thumb for film scheduling include beginning weeknight programming at 7 or 8 P.M. and starting final showings (of major offerings) as late as 11:30 P.M. to 12:30 A.M. Those networks concentrating on the overnight daypart employ still later final showing schedules. For most of the premium movie services, an evening consists of three to five programs, depending on individual running lengths. Entertaining short subjects, elaborate animated titles, and promotional spots for other attractions fill the time between shows. All-movie networks especially favor movie-oriented shorts, such as interviews with directors or location tours. Using 16 or more

new films each month (not counting carryovers of the previous month's late premieres) usually means scheduling *four premieres each week*, gradually integrating first-, second-, third-, and up to sixthrun presentations week by week. This pattern gives viewers a constantly changing lineup of material from which to choose—and new movies appear every week on the pay-per-month channels.

Counterprogramming broadcast network schedules is another strategic consideration. For example, on Tuesday nights when CBS schedules a string of male-appeal dramas (NCIS, The Unit, and Without a Trace) and NBC carries Dateline NBC and two Law & Order shows, premium networks tend to schedule films with female appeal. Taking another tack, preceding or following a popular broadcast network show with a program of the same genre on pay cable creates a unified programming block for viewers (requiring channel switching, an easy move with remote controls). Beginning programs on the hour as often as possible-especially during prime time from 8 to 11 P.M.—makes it convenient for viewers to switch to and from pay cable.

Films and specials containing mature themes are usually scheduled at later hours than G-rated films, even though pay television is not bound by broadcasting's traditions. PG features are offered throughout premium schedules. Monthly program guides have encouraged parents to prescreen all films rated PG, PG-13, or R early in the week to decide which are appropriate for their children to watch on subsequent airdates. Ironically, all rules with regard to mature themes can vanish during free preview promotional periods. Some parents who manually delete unsubscribed pay channels from the electronic tuner on their television sets have discovered that enterprising youngsters can learn to key in the channel number to watch R-rated movies during the free showings of premium channels.

Evaluation

Audience evaluation remains a problem in the cable industry. Inadequate viewing data hampers many national advertiser-supported networks in selling time—especially the newer niche services. Although the total number of a system's subscribers is always known more or less accurately, and the most popular services are rated by Nielsen, determining how many subscribers view the less popular nonpay channels has traditionally been a problem on most systems.

Comparison Problems

Cable penetration stands at about 61 percent of U.S. homes. In addition, another 30 percent or so of homes are connected to the subscription networks via direct satellite service, and 3 percent get the same channels from telcos, wireless cable, or some other small business. Individually, however, audience ratings for most cable/satellite networks (excluding the top-10 services) have only occasionally exceeded 1 or 2 million television households at a time. In fact, the very top services garner 3 to 4 million households each in prime time (about the same as a 3 or 4 rating among all 112 million television households). Although the combined audience for ad-supported subscription networks regularly exceeds that of the 10 commercial broadcast networks, the broadcast business is still very healthy. Because many advertisers continue to buy spots one channel at a time, the combined cable network ratings are not much comfort to them.

Nonbroadcast Audience Measurement

As discussed in Chapter 2, ratings for subscription networks really represent three audience measurements. One measure is the audience watching a particular program at a given time, measured by average quarter hour (AQH) ratings and shares as in national broadcast ratings. A second measure is the cumulative audience that watches a given program in all of its showings because some program services repeat shows. When all viewers of repeat showings of a program (such as a movie) are summed, the audience for that one program may exceed a competing broadcast station's audience. The third and perhaps most important

measure to subscription networks is the *cumulative audience for a channel*. Although people meters have benefited the established cable networks by increasing their reported share of prime-time viewership, they reveal little about the viewing of less popular advertiser-supported services. Subscription networks must commission their own research to understand viewing by such demographic subgroups as children, teens, and ethnic minorities.

Measuring Cable/Satellite Viewing

The overriding problem in evaluating cable program audiences is that local audience shares cannot be compared directly with local over-the-air audience shares. As 9.7 shows, cable franchise areas differ in size and shape from markets defined according to broadcast station coverage patterns (DMAs). This type of map prevents advertisers from comparing cable's effectiveness with that of broadcasting and other media in one market.

To be measured on a national level, Nielsen currently requires a subscription network to be available in about 3.3 percent of U.S. TV households (about 3.7 million homes) to qualify for its national cable TV ratings report, the *Nielsen Cable Activity Report (NCAR)*. Further, to show up in the report, the network has to generate at least a 0.1 rating in its coverage area (the number of households a channel reaches).

Although in total the programs on all subscription networks have averaged more than a 25 Nielsen prime-time rating in the last several years, most viewers apparently watch the established broadcast services. The weekly cames still favor the broadcast channels despite gains in subscription network viewing (see 9.8). Further growth in the number of channels will make increases in individual network ratings difficult. Programmers and consultants are divided over how to best increase audience size: Some believe that heavy series production is necessary (USA); others argue for original movie production, heavy promotion, and more effective scheduling (TNT).

Courtesy of Cable Media, Inc. Used with permission.

9.8 Nielsen Television Activity Report

Broadcast Affiliates	Average Weekly Cume %
NBC	75.7
CBS	74.9
ABC	74.6
FOX	70.1
WB	44.7
UPN	37.2
Cable Networks	Average Weekly Cume %
TBS	39.0
USA	38.3
TNT	38.2
FX	29.6
A&E	28.3
DISC	27.6
SPIKE TV	27.5
ESPN	27.2
NICK	26.8
LIFE	26.5
COMEDY	26.5
AMC	26.4

Nielsen Media Research Television Activity Report, NHI, first quarter, 2COć. www.tvb.org/rcentral/MediaTrendsTrack/tvbasics/10_Reach_BdcstvsCable.asp.

The cable industry reports its own ranking of top shows, which are based on multichannel homes, not all television homes. The *rankings* in 9.9 come from these so-called cable ratings, but the *ratings* shown in the table are based on household ratings. In 2004 Nielsen changed the way it measures multiplexed premium channels, no longer aggregating the different channels showing the same program (for example, *Entourage*) on cable and satellite systems. Instead, Nielsen began reporting ratings for each "plex" separately.⁷

The goal for basic and premium programmers is to count the number of people who make a return visit to their channels on a regular basis. Perhaps because of the influence of measuring the enduring appeal of web pages, the cable industry has borrowed an internet term to describe the viability of a channel: stickiness. A website that holds its viewers is said to be sticky, like a real spider web, and now programmers discuss the stickiness of

their channels. It's a new word for an old concept: giving the target audience what it wants so it will come back for more.

Measuring VoD Use

Surveys and audience sampling are unnecessary for gauging on-demand programming. Two-way capabilities in most cable systems allow accurate tracking of buy rates, and the satellite services have their own usage records. However, this is proprietary information, compiled by each separate cable or satellite system. No combined measures exist, and estimates of all VoD and PPV use are not wholly reliable. In 2005, Comcast and research firm Rentrak (known for compiling data about revenue from movie box-office sales and home video rentals) celebrated a successful one-year trial by establishing a new OnDemand Essentials system for measuring and reporting anonymous video-on-demand usage. They established a multiyear agreement about gathering the ratings data that ad-supported networks want as leverage for moving into the PPV and VoD markets. What secrets it tells all parties are keeping to themselves.

The Channels

This section looks at content of the various kinds of subscription services widely available in the late 2000s by dividing them into 13 general types (and listing unclassifiables in "other").

Major Subscription Networks

Foundation

As already described in 9.2, these channels are found on nearly every multichannel service in the United States, so most people are probably quite familiar with their content. These are the long-established channels: CNN, ESPN, USA, MTV, VH1, TBS, Lifetime, Nickelodeon, Comedy Central, the Discovery Channel, E! Entertainment Television, Food Network, GSN, TNT, the Travel Channel, the Weather Channel, and others. These networks capture the largest audiences, spend the most money, and have the most visibility in the United States and abroad.

9.9 Top Cable Shows, February 2007 Top 10 Cable TV Programs (Total Day)

Rank	Program	Network	Total U.S. Household Rating	Total Viewers
1	WWE Raw	USA	3.4	5,975,000
2	WWE Raw	USA	3.3	5,706,000
2	Prime Movie (Montana Sky)	LIF	3.3	4,767,000
4	SpongeBob	NICK	3.1	4,809,000
4	Monk	FX	3.1	4,856,000
6	Fairly Odd Parents	NICK	2.9	4,431,000
7	SpongeBob	NICK	2.7	3,916,000
8	SpongeBob	NICK	2.6	3,838,000
8	Fairly Odd Parents	NICK	2.6	3,871,000
10	Jump In	DSNY	2.5	3,731,000
10	Fairly Odd Parents	NICK	2.5	3,404,000
10	Fairly Odd Parents	NICK	2.5	3,459,000
10	Drake & Josh	DSNY	2.5	3,432,000
10	Hannah Montana	DSNY	2.5	3,695,000

Nielsen, www.nielsenmedia.com (retrieved for February 2007).

Children's

For a while, only one or two channels targeted to children found their way onto the cable/satellite lineups. Nowadays, several choices are available. Noggin is Nickelodeon's answer to PBS programming, right down to the use of Sesame Workshop as a supplier. After Nickelodeon, the best known of the dozen or so are Cartoon Network, Discovery Kids, the Disney Channel, PBS Kids, and Toon Disney (see 9.10).

Foreign

Until the availability of digital channels, the only way to receive foreign channels was to live in a very large city or stay at a Disney hotel. Dozens of options have found their way onto the lineups of both satellite services and some cable MSOs in very large metropolitan areas. Many of these networks have high production values and provide Americans a chance to learn about other cultures. The best-known channels include ART (Arab Radio & Television), Asian American Satellite TV, BBC America, TV Asia, and TV Japan.

Lifestyle

Lifestyle channels are the niche and subniche channels that instantly remind viewers they are not watching regular broadcast television. The content is very specialized, but so are the advertising and viewers. A few examples are DIY (Do It Yourself), the Outdoor Channel, and the Military Channel.

Movies

There are a handful of movie channels on basic or extended basic cable and satellite services, especially American Movie Classics, the Fox Movie Channel, the Sundance Channel, and Turner Classic Movies. As already mentioned, in 2003 American Movie Classics abandoned its classic movie format and began to show movies from the 1980s and 1990s in heavy rotation.

Music

Channels that offer different music formats have grown beyond the limited MTV/VH1/CMTV options of the early 1990s. Now five different variations of the trailblazing MTV service coexist.

9.10 Are Kids (Still) Watching TV?

ith MySpace, Neopets, Gaia, YouTube, and blogging, it's not surprising if one wonders whether kids have time to watch plain old television, whatever service it comes from. A recent study by the Kaiser Family Foundation found that "new" media such as computers and video games have not displaced the use of "old" media such as television and music. In fact, for better or worse, the amount of time spent viewing TV per day was three times greater than the time spent with any other medium. So, yes, kids are still watching TV, and they are watching cable, Nickelodeon and Disney in particular. Despite the broadcast network's efforts, these two networks garner the lian's share of kids and tweens. With kids 2-11, Nick gers top ratings with SpongeBob SquarePants; Disney captures tweens 9-14 with popular live action series, especially Cory in the House, Suite Life of Zack & Cody, and Hannah Montana, although Nick's Naked Brothers Band, Ned's Declassified, and Drake & Josh are also often among the top 10 for this age group. But television for kids is not all escapades and cartoons.

Concerns about children's health and wellness have not gone unnoticed by cable programmers. Nickelcdeon's 2006 "Let's Jus- Play" campaign centered on a five-month miniseries that documented real kids' efforts to make their lives healthier, and the "Let's lust Play" website encourages kids to join the challenge and implement an action plan for living a healthier lifestyle. In honor of the Worldwide Day of Play, Nickelodean goes dark for three hours to encourage kids to "get up, go out, and go play." "Rescuing Recess" is part of Cartoon Network's "Get Animated" initiative to get <ids active, healthy, and involved. The network introduced the first annual National Recess Week in 2006, concluding with a new "Operation R.E.C.E.S.S" episode of the network's series, Codename: Kids! Next Door The "Get Animated" website features information on how to eat like a superhero and games that kids can play both inside and outside. Whatever the broadcast networks are doing has so far not made much of a dent in the distribution of ratings.

> Nancy C. Schwartz, Ph.D. The Academic Edge, Inc.

Some of the best-known newer services are BET on Jazz, CMT (Country Music Television), and Z Music Television. TNN has morphed out of music into Spike TV.

News

What were once just CNN and CNN Headline News have now expanded to several options. Newer channels include Bloomberg Television, a specialized business news service, and CNBC, Fox News Channel, and MSNBC, all covering news of all kinds. Fox News had actually surpassed CNN in viewing popularity by 2005. Foreign-owned news channels have also expanded over the years (see 9.11, which discusses the controversial Al Jazeera channel).

Religion

The number and variety of religion channels has increased greatly in the past decade because of digital shelf space. Some of these channels sign leases to pay for their space on cable and satellite services. Current examples are Eternal Word Network (EWTN), Gospel Music Television, the Inspirational Network, TBN (Trinity Broadcasting Network), the Worship Network, and a newcomer, Jewish TV. Sometimes cable services group a few religious channels with such channels as TV Land, ABC Family, and the Hallmark Channel, creating a "Family" section of service. This is probably an unhappy linking for Hallmark and ABC as well as for the more formally religious networks.

Sex

Soft-core pornography still abounds on multichannel services. Social norms that used to discourage the proliferation of such services are eroding, especially with reformers' attention focused on hard-core internet pornography. Another key to the popularity of soft-core porn is a very relaxed view of "porn" by twenty-somethings, who no

9.11 The Phenomenon of Al Jazeera

ince its beginning in 1996, Al Jazeera has had difficulty in shaking the public perception that it sympathizes with Al Qaeda and provides favorable treatment to Islamic terrorist groups. Started in Qatar by emir Sheik Hamad bin Khalifa al-Thani, Al Jazeera was touted as an attempt to bring democracy to the region through the introduction of a 24-hour television news service independently run within the Arab world. Despite its pledge to bring objective news reporting and a freer news media, the public perceives Al Jazeera as a propaganda vehicle for Al Qaeda and similar extremist groups. This view has stigmatized the network, ultimately forcing temporary shutdowns of its field offices in many major Arab countries. Indeed, two of its offices were bombed by American troops.

Over time, Al Jazeera expanded beyond Arabic news reporting to include Al Jazeera Sports 1 and 2, Al Jazeera Children's Channel, Al Jazeera Documentary Channel, Al Jazeera Mobasher (a channel similar to C-SPAN), and a pan-Arab newspaper. It even spawned several Arabic-language television competitors: Al Arabiya out of Saudia Arabia, Al Kawthar from Iran, and German and French Arabic-language

news and entertainment satellite channels, along with BBC programming in Arabic. CNN sponsors an Arabic-language website in the near east, with others in Russian and Spainish, and has plans for a Danish radio channel, but other American efforts to compete in Arabic via Al Hurra have been unsuccessful.

In order to fight back, Al lazeera in 2006 also added Al Jazeera International, an English-language news channel made available around the world This channel provides international news coverage, drawing on news offices in Qatar, Washington DC, London, and Kuala Lumpur. By hiring experienced journalists away from established world news providers such as the BBC and CNN, Al Jazeera International hopes to give a credible voice to underrepresented parts of the world. Its stated goal is to cover controversial stories not always fully reported on by the Western news media. Unfortunately, because of its negative profile, many cable and satellite providers around the world do not retransmit Al Jazeera International's broadcasts.

> James Angelini, Ph.D. Indiana University

longer see social stigma associated with viewing pornography. The widely available choices include Hot Choice, Playboy TV, Pleasure, Spice, and TeN (The Erotic Network). In some locations these are restricted to PPV.

Shopping

Home shopping channels continue to attract viewers, but the number of services has leveled off since 1990, largely because competition from the internet has drawn away some customers. Options include HSN (Home Shopping Network), Home Shopping Spree (Spree!), Product Information Network (PIN), QVC, Shop at Home, and Value-Vision.

Spanish

Unlike the "foreign" category, this programming reflects the mainstream of Hispanic and Latino viewers in the United States. Advertisers are keenly interested in this growing population segment. Latino or Hispanic programming is found on Galavisión and three hybrid broadcast/cable networks, Univision, Telemundo, and TeleFutura. Univision regularly often outdraws the Englishlanguage broadcast networks in many markets. There are also Spanish-language versions of several foundation services.

Sports

ESPN, ESPN2, ESPNU, and ESPN Classic are still the main purveyors of cable sports, but as has been pointed out, they get plenty of competition from Fox Sports and its many regional sports channels, plus about a dozen other sports channels, ranging from all-horse racing to all-outdoors. The most recent trend is to differentiate each channel by the sport itself, rather than solely by league or channel owner, although branding from NFL or FOX always helps. Because men are a difficult-to-reach advertising target, the revenue potential is very high. On the other hand, rights fees continue to skyrocket (see Chapter 5). Besides the ESPN and FOX groups, the dominant channels include CNN/Sports Illustrated (CNNSI), the Golf Channel, MSG (Madison Square Garden), NBA.com TV, NFL Sunday Ticket, NHL Center Ice, and the Speed Channel.

Superstations

Local stations with sports and movies can get national attention when distributed by satellite to distant cities. Most of these stations originate in very large cities and bring urban news and sports. The Big Five are KWGN, WGN, WPIX, WSBK, and WWOR. WTBS is considered a local station, and its sister network, TBS (once a superstation), is now considered a foundation network.

Others

Several channels do not fit any of these categories but strive to find shelf space, advertisers, and audiences. Trio, for example, a critically-praised cable channel owned by NBC Universal, promoted its offbeat series as "Brilliant But Canceled." Mostly resurrected series with high quality writing and original storylines, the content appeals to discriminating upscale viewers but not to advertisers because the channel lacks an easily identifiable niche. Trio faded fast in 2005 after being dropped by DirecTV. Now Trio is available as an online video channel (see Chapter 10). Another almost singular channel, MTV's Logo, debuted in 2005 after several delays. Devoted to gay and lesbian programming, Logo carries mostly series and films that previously aired on other broadcast and cable networks or appeared only in movie theaters (see 9.12).

Premium Networks

The number of pay-per-month channels has leveled off as such competing forms of distribution as VoD and PPV have rolled out. The signature programs on each premium channel have created well-known brand images for subscribers.

HBO/Cinemax

Owned by Time Warner, HBO encompasses nine pay channels already described as its subniche services, plus Cinemax, MoreMAX, ActionMAX, ThrillerMAX, HBO en Español, HBO Ole and Brasil, HBO Asia, and HBO Central Europe. (The sole focus of Cinemax is movies.) The company also owns 50 percent of Comedy Central. HBO is no longer the movies-only channel that began in the 1970s. It differentiates itself from other "movie" channels by scheduling critically acclaimed original programming. HBO has won dozens of Emmys for such programs as *Entourage*, stealing the limelight from the Big Four broadcast networks.

The Movie Channel/Showtime/Flix

CBS Corporation owns Showtime and its moviesonly channels Flix, The Movie Channel, and the Sundance Channel. Showtime's strategy is to make major studio deals, having learned a tough lesson in the 1990s when other premium channels kept it from getting new, big-draw theatrical movies. The channel's other strategy is to compete with HBO for the top-boxing draws. Showtime won several Golden Globe Awards for its original series Weeds.

Showtime's subniche channels are Showtime Too, Showtime Showcase, Showtime Extreme, Showtime Beyond, Showtime Next, Showtime Women, Showtime FamilyZone, along with The Movie Channel and TMC Extra. In addition, two high-definition channels (Showtime HD and The Movie Channel HD) and three on-demand/PPV channels (Showtime on Demand, The Movie Channel on Demand, and Showtime PPV) appear on cable and satellite systems. In 2007 Showtime introduced Showtime Interactive 2.0 on the DISH Network.

Starz and Encore

Comcast owns Starz Encore, which comprises 13 channels of cable- and satellite-delivered premium movie channels. The cornerstone of Starz Encore's programming strategy is to lock in studio releases of theatrical movies for several years, although the associated costs of this strategy had put the company in financial jeopardy by 2005, causing a rebranding effort that year to gather more subscriptions. Encore's

9.12 Narrowcasting to the Gay Community

he 8-year run of NBC's hit Will & Grace brought a successful gay title character to the prime-time landscape for the first time. This Emmy-winning show in turn spawned other programs on cable featuring gay or lesbian characters. Showtime followed up with an adaptation of the British hit Queer as Folk, which ran for the five years in the early 2000s and brought the premium network some of its highest Nielsen ratings. Bravo found similar rating success with its makeover show Queer Eye for the Straight Guy.

These popular programs were convincing evidence that a niche audience existed for gay, lesbian-, bisexual-, and transgender-themed (GLBT-themed) programming, and cable networks with programming targeted to gay and lesbian viewers appeared. The first network, Here!, began in 2002 as a video-on-demand service or a premium subscription channel on most cable and satellite systems. The most popular program in Here!'s history is Dante's Cove, a drama series that mixes the soap opera and horror genres. Movies and documentaries are other staples of Here! programming.

Q Television Network (QTN) was the second cable network to target a GLBT audience. Begun in 2004, the short-lived QTN aired primarily in such urban markets as New York, San Francisco, and Seattle, carrying a range of variety, talk, and music programs.

The most popular of the network's original shows, *The Queer Edge with Jack E. Jett*, was a variety show that mixed music and comedy. QTN was unable to gain carriage outside the largest urban markets, and after being plagued by rumors of financial problems and impropriety by its executives, went dark in 2005.

Launched in 2005, the Logo channel became the third channel targeting GLBT (or LGBT) audiences. Owned by media giant Viacom in its MTV Networks division, Logo found a secure place with most cable providers across the country. Carriage came easily because it was swapped for Viacom's fading VH1 Mega Hits, a digital channel already slotted on hundreds of cable systems. Logo airs both original and syndicated programming, including the popular reality series Coming Out Stories, the stand-up comedy series Wisecrack, and the African-Americanthemed drama Noah's Arc. In addition, Logo partners with CBS News to bring coverage of gay-themed news coverage to the cable network. Logo has also become an internet presence by providing three LBGTthemed websites and by having its programming downloadable from iTunes. Logo programming is also available via video-on-demand, and it provides a wireless platform for Sprint.

> James Angelini, Ph.D. University of Delaware

rebrand involved a slightly modified logo and the addition of the Encore name to all of its channels. Starz's makeover was more dramatic, opting a completely redesigned logo and cohesive graphics package across all channels. Starz Theater, a channel that showed four Starz films at fixed times all week, changed its name and format, respectively, to Starz Edge, a movie channel for young men (also known as "The New Generation"). Starz Kids and Starz Family were merged into one channel (Starz Kids and Family) to make room for a new channel called Starz Comedy. And to fit in with the new look, Black Starz was renamed Starz InBlack. Starz Cinema is the only Starz channel to keep its original name.

Pay-Per-View Services

InDemand (formerly Viewer's Choice and Request Television) is the main nationally distributed PPV service. In addition, a number of adult-oriented services, such as Spice and Playboy, exist. In addition to cable, telco, and wireless cable distribution, U.S. distributors are DirecTV and DISH, but they have many counterparts in other parts of the world, such as SKY, Asianet, and others, who also carry PPV channels. Satellite distributors have pushed PPV so hard, in fact, that cable operators have turned their attention to two-way digital services that lend themselves more to VoD than to PPV.

For example, Showtime PPV has become overshadowed by its VoD service, Showtime on Demand. In the past, Showtime PPV, formerly Showtime Event Television, produced and distributed 7 of the top-10 pay-per-view events of all time, including the top 4: Holyfield vs. Tyson II, Lewis vs. Tyson (with HBO PPV), Holyfield vs. Tyson I, and Tyson vs. McNeelev. Showtime PPV also has produced numerous music concerts, including The Last KISS, Spice Girls in Concert— Wild!, the Backstreet Boys, Tina Turner, the Rolling Stones, Prince's Trust Party in the Park, Pink Floyd, Phil Collins, Music for Montserrat: An All-Star Charity Concert Featuring Paul McCartney, Elton John, and Eric Clapton, and the Moscow Music Peace Festival. Most of these took place in (or were holdovers from) the 1990s, when PPV was king.

It is clear that PPV will not remain a separate category for much longer. Since 2002, the number of special events scheduled for pay-per-view has declined (primarily because Mike Tyson was in jail, reducing the number of major boxing events). and wrestling events have migrated to basic cable (where WWE Raw captures the big cable ratings). More important, the rise of VoD has drawn attention away from live events. In particular, sports franchises have decided to "go it alone," opting to market their own events in VoD. Finally, many cable operators see more revenue from nonevent programming, such as adult content, which may help explain the renaming of Showtime PPV (from Showtime Event Television). In 2006, wireless mobile users gained access to content from Showtime PPV programs, making mobile a hot competitor to the more established distributors.

Subscription Network Promotion

Like the broadcast networks, basic and premium networks try to achieve economies of scale that can support sophisticated marketing. Although some newer networks naturally focus on acquiring new viewers, the usual strategy is to retain existing viewers while developing new services. Above all, promoting brand identity is the key marketing goal, as in such phrases as "Lifetime—Television for Women" and "Spike TV! The First Network for Men."

All subscription services use on-air tune-in and cross-channel promotion. Tune-in promotion encourages viewers to stay with the channel for upcoming programs. Cross-channel promotion allows regular viewers of one cable or satellite channel (or website) to learn about the shows on another program service. Most of these efforts are accomplished using automated equipment with insert capability that can introduce one channel's promos into another channel's program lineup in predetermined time slots. In addition, automated flow-titling has been adopted by several channels. This form of on-air promotion places an overlay on one side at the bottom of the screen naming the next program coming up. To the annoyance of viewers, such overlays sometimes obscure a crucial part of the story content and certainly draw the viewers' attention away from the ongoing drama. Nonetheless, like network identification bugs logos in the corner on live programming), automated advance titling is probably here to stay.

Over the years, the premium channels have developed especially sophisticated, big-budget campaigns for marketing their programs year-round using slogans, giveaways, and special package rates. The actual promotion vehicles include mass media advertising, reminders in monthly bills (statement stuffers), and coupons left at homes in plastic bags (door hangers). When trying to expand subscriptions in a local area, they may temporarily unscramble their signals to give cable viewers a taste of what they are missing. Premium channels seek greater buy rates by promoting specific events or signature programs (such as The Sopranos on HBO) through all available promotional vehicles. They also send special mailers to those who have discontinued their pay channels. When successful, anticipating and meeting customer expectations creates brand loyalty that is difficult to dislodge. Just how this principle will apply in some future all-VoD age is an interesting question.

Regardless of the method, subscription network programmers must get closely involved with the promotional and marketing efforts on the air, in print advertising, and on related websites. These days, the job of acquiring and scheduling content is tied to making sure that an audience will be there when the program is shown. Launching a new program sometimes calls for innovative methods. One event that backfired on Turner was its promotion of an "Adult Swim" program called *Aqua Teen Hunger Force*. A few fake devices that looked a lot like bombs were placed under bridges in Boston, causing a mild panic. The promotion chief lost his job over that stunt.

Audio Services

In addition to video programming, cable and satellite systems provide subscribers with audio and radio services. Like video services, audio and radio come in both basic and pay forms and are both locally and nationally distributed. In local cable radio, nearby stations are distributed to cable subscribers, usually free. In national digital audio, basic nonpay services exist; some carry advertising, and some do not. There are also pay services that charge subscribers a monthly fee for a series of specialized music channels, which are collected by the local cable or satellite operator and shared between the two entities. If people want to hear the king of shock jocks on satellite radio, for example, they'll have to pay (see Chapter 12).

Cable operators are skeptical about the size of pay audio's potential as a revenue stream for wired distribution (see 9.13). The buy rate for all digital audio services is about 15 percent of basic cable television subscribers, and marketing plans generally target the 40 percent of cable subscribers who have CD units. On the positive side, CDs have become common, and newer surround-sound and other receiver advances have much improved reception, making consumers more sensitive to audio quality. This new awareness and appreciation of audio has spurred the digital audio business. Cable audio has plenty of competition from internet downloading, however (see Chapter 10), and satellite radio has secured the car market (see Chapter 11).

9.13 Major Audio Services in 2007

Subscribers	
32,000,000	
11,000,000	
10,000,000	
3,800,000	
1,300,000	
29,100	

www.ncta.com

Basic Audio

Several national services provide audio programming. The Cable Radio Network provides six channels of adult contemporary music, talk, and specialized shows. This service is used as an audio component for character-generated channels, cable FM, and telephone "hold" music. C-SPAN supplies international news and public affairs programming in English from Japan, Canada, China, Germany, and many other nations.

Yesterday USA is the national radio voice of the National Museum of Communication, Inc. of Irving, Texas. Its old-time radio shows and vintage music are free of charge and without commercials. Yesterday USA is free to cable television networks and satellite dish owners, and it broadcasts on the audio subcarriers of WGN. The service is also available free of charge to AM and FM, full- and low-power stations.

WFMT-FM from Chicago is considered a radio superstation that airs fine arts and arts talk 24 hours a day. The station is sold as a premium service by some systems and allows nonlocal advertising. Moody Bible Institute provides religious programming in a variety of Christian formats, including music, drama, education, and national call-in programs.

Premium Audio

The two leading premium services are Digital Music Express (DMX) and Music Choice, formerly Digital Cable Radio. DMX (owned by Liberty

Media) reaches 10 million homes with 100 satellite-delivered (and digital cable) music channels that include classical, country, light rock, light jazz, current hits, and easy listening instrumentals. DMX is also the leading service in foreground music for businesses, including the music provided on airplane flights. Music Choice, like DMX, is a commercial-free service of CD-quality music. Music Choice offers more than 50 channels of music through cable and satellite delivery and is enjoyed in more than 32 million households.

One innovation by Music Choice uses technology advances that allow it to put album facts, album art, and artist information onscreen on receivers, making the service more compelling. To economize on that technology, the company began to offer screen ads during a given hour or over a playlist without interrupting the audio. This introduced another revenue stream and made possible a feature some audiences desired.

The future of cable audio has been negatively influenced by the rising popularity of satellite radio. Because most radio listening takes place in cars, which are not accessible by either cable or video satellite reception, the advent of XM/SIRIUS satellite radio has dramatically limited the appeal of cable audio. Once a satellite radio receiver is purchased for the automobile, it can easily be used inside the house on the stereo system. At that point, the cable subscriber may wonder why it is desirable to listen to the radio through TV speakers.

Directions for the Future

The last 25 years have seen dramatic changes in basic and premium services. The advertiser-supported networks have proliferated into chains of niche program services, many of which are intended to reach subscribers beyond the U.S. borders. Expanded international distribution has become the primary means of growth for cable and satellite programmers. Hundreds of millions of potential subscribers in such countries as India and China have become a powerful lure for U.S. cable program suppliers, who can clearly see the pie at home being split into smaller and smaller

portions by increasing numbers of hungry new services. Increasing access to potential viewers in the once-inaccessible countries, however, is fueling experimentation with new types of niche services and providing hope to wannabes who envision a world market of sufficient size to support their programming.

Nearly all newer and proposed program services fit into the niche, subniche, and microniche categories. Very few seek broad appeal. These newer services function like radio station formats, targeting a specific audience segment with demographicallytied programming, talent, and promotion. More niche program services mean greater competition, however, and in almost every category or genre, the dominant service now has many challengers.

Why do people subscribe? For the abundance of basic choices—and usually without much attention to the other businesses that have come along: cable modems, cable telephony, and so on. John Malone, chairman of TCI before the AT&T merger (see 9.14), used to refer to basic service as "plain vanilla cable," which has been overshadowed by the huge number of channels that digital service brings. The number of basic-only subscribers has declined rapidly in the post-analog age, and cable providers have turned their attention to VoD, broadband internet service, and VoIP phone service.

On the premium front, while HBO has continued to dominate the marketplace, the number two service, Showtime, wrestles with strategies for building its market share. When pay-perview and VoD networks entered the picture in 2004 and offered movies and entertainment on an a la carte basis, many pay services began to lose ground quickly. The wider availability of top-name movies on pay-per-view, DVDs, and both sell-through and rental videocassettes has reduced the overall attractiveness of theatrically released film titles, pressing the movie-based pay networks into producing even more exclusive and original products. HBO's competitors are likely to pursue stronger creative and financial links, perhaps even partnerships, with program suppliers and cable operators. Carrying advertising is another option for marginal pay services. Premium services have come under increasing

9.14 Cable Titan John Malone

ohn Malone's enormous impact on the cable industry began in 1973 when he became the President and CEO of Tele-Communications, Inc. (TCI) and rapidly transformed it into the largest U.S. cable MSO. Malone's powerful effect came not just from making TCI big but also from the way he used that size as economic clout to improve the company's financial position. Referred to as "Darth Vader," Malone negotiated lower carriage charges for many channels by threatening to remove them from millions of cable homes. And his methods tended to be heavy handed: For example, when the tiny cable system in Vail, Colorado, refused to allow a rate increase, TCI replaced the programming on all channels with a screen providing the name and phone number of the town manager.

TCI was acquired by AT&T in 1999, which was in turn acquired by Comcast in 2002, but by then Malone's emphasis had shifted from cable operations to the programming side. Continuing to exert a powerful influence on the cable industry, he runs Liberty Media Corporation, which now owns all or part of Discovery, QVC, Starz!, and Game Show Network. In 2004, Liberty became the second-largest shareholder after Rupert Murdoch himself in Murdoch's News Corp. That position makes Malone a major player in news, sports, movies, and broadcast television, in addition to cable.

Dom Caristi, Ph.D. Ball State University

pressure to reduce their retail prices to bring them better in line with customer expectations and spending patterns. A *low-price*, *high-volume* strategy seems likely to replace the retail pricing strategy that has been endemic to pay television since its beginning.

As pay-per-view services increase their market penetration and offer the early release pattern for movies that was once the exclusive province of pay cable, more pay-cable services may evolve into "super basic" channels on many cable systems, providing lift for a second or higher programming tier. Such has already been the case to a large extent with former pay channels American Movie Classics, Bravo, and the Disney Channel. Encore is intended for such a tier. The practice of discounting to operators to gain more subscribers encourages such new packaging strategies.

As compression allows for greatly increased channel capacity—and impulse technology becomes standard for cable converters—a wide range of possibilities opens up for cable operators and programmers alike. Increasing numbers of cable subscribers can now order a pay-per-view movie, concert, or sporting event in an instant, and, increasingly, they will avail themselves of the opportunity. Projections of 60 million VoD homes in just a few years may entice Hollywood's studios to release movies to pay-per-view services closer to their theatrical release date, truly creating a "home box office" bonanza for movie makers and event organizers. The key obstacle is that Hollywood receives over half of its revenue from home video rentals and sales and is reluctant to gamble with anything that threatens that honey pot.

One caveat lies in the rapid spread of online programs that allow viewers with high-speed online connections to watch pirated movies. Hollywood studios that invest \$150 million for a feature film have more to lose from pilfered content than a music company whose product costs a fraction to make. A digital copy is a perfect replica of the original. The sheer size of the file for each film makes movies more difficult to steal (or "share") than music files, but faster connections and larger hard drives will likely encourage pirates to defeat the copy-protection schemes designed by the content providers.

Because of efficiencies in cross-promotion and the reuse of original programming in multiple media, the clearest direction for the future is that—joint ventures, mergers, and buyouts will increasingly integrate cable program suppliers with both the companies that distribute their wares and with broadcast services. The trend toward building media conglomerates that reach across media technologies and once-rigid legal boundaries, as well as across international borders in distribution, is undeniably accelerating.

Sources

- Broadcasting & Cable. Weekly trade magazine. New York: Reed Business Information, 1931 to date. www.broadcastingcable.com.
- Cable Television Developments. Annual publication. Washington, DC: National Cable Television Association.
- Cablevision. Monthly trade magazine covering the cable industry. Denver, CO, 1975 to date.
- Cable World. Weekly trade articles on national cable programming. Denver, CO, 1988 to date.
- Miles, Hugh. Al Jazeera: The Inside Story of the Arab News Channel That is Challenging the West. New York: Grove Press, 2005.
- Multichannel News. Weekly trade publication. New York: Reed Business Information, 1980 to date. www.multichannel.com.
- The Pay TV Newsletter. Weekly trade analyses of the pay and pay-per-view market from Paul Kagan Associates. Carmel, California, 1983 to date.
- Trout, Jack, with Steve Rifkin. Differentiate or Die: Survival in Our Era of Killer Competition. New York: John Wiley, 2000.
- TV Week. Weekly trade publication covering electronic media news. Chicago: Crane Communications.

www.ctam.com www.ncta.com. www.onetvworld.org

Notes

- 1. Downey, Kevin, "The More They Know," Broadcasting & Cable, 17 July 2006. www.broadcastingcable.com/article/CA6353584.html.
- 2. Gibbons, Kent, "SVoD: Following Dollars, Sense," *Multichannel News*, 5 February 2007. www .multichannel.com/article/CA6413136.html.
- 3. For further information, see www.indemand.com, also known as www.ppv.com.
- 4. Farrell, Mike, "Cleaning Up on Closing DVD Window, Multichannel News, 29 January 2007. www.multichannel.com/article/CA6410561.html.
- 5. "Top Basic Nets Bask in 'Must Have' Status with Fat Carriage Fees, Broad Penetration," 17 November 2005. www.kagan.com/ContentDetail.aspx?group=5&id=113.
- 6. Winslow, George, "Multichannel Industry Indicators: A Look at the State of Pay Television and Related Businesses," *Multichannel News*, 10 April 2006. www.multichannel.com/article/CA6322713.html.
- 7. Lowry, Tom, and Grover, Ronald, "Cable Fights for Its Movie Rights," *Business Week Online*, 27 October 2003. www.businessweek.com/magazine/content/03_04/b3855133.htm.
- 8. Mandese, Joe, "Nielsen Plan Would Whack 'Sopranos,' Other Pay Cable Ratings," MediaDailyNews, 23 December 2003. www.mediapost.com/dtls_dsp_news.cfm?newsID=230415&newsdate=12/23/2003.

Online Video and Audio Programming

Douglas A. Ferguson

Chapter Outline

Convergence

The Online World

User-Generated Content (UGC) The Online Formats Gaming and Virtual Worlds

A Conceptual Framework

Geography Economics

The Content Providers

Strategic Considerations

Daypart Compatibility
Habit Formation
Audience Flow
Conservation of Program
Resources
Breadth of Appeal

Specific Approaches

Selecting Content Scheduling Content Promoting Content

Online Measurement

Impact on Mainstream Media

What Lies Ahead

Sources

Notes

nline video and audio programming, also known as interactive media, officially arrived in the early part of this century. In a programming book, one expects to learn what an online "program" is, but its definition continues to be fuzzy and evolving. As in all media, entertainment and information are the major content types, but in the online world, it is more useful to distinguish among video programs, music, enhancing information, and interactive games as the key kinds of online program content.

Just as in conventional television and radio, most online entertainment content is storytelling, and telling stories—real or fictional, in video or in music or in games—is the primary task of what can be called **online programs**. Thus, on the internet, the term includes short and long video programs akin to television series, specials, documentaries, theatrical and made-for-TV movies, newscasts, and hosted entertainment/talk. At the same time, the associated promotional information (called **enhancement**) appears on websites supplied by all broadcast and cable networks, the Hollywood studios, most stations, most music producers, and other key groups in the entertainment industry.

While the internet certainly contains mountains of "information," much of it is related to retail sales and other businesses, or it consists of reference material (current and archived data) or personal/political content (such as individual websites and chat on a wealth of topics), and is thus outside the parameters of this book. What is unique about the internet is its game function, but most games involve entertainment and storytelling, too, with an added dimension of interactivity. This chapter focuses on online content that is similar or at least related to what appears on television or radio.

Online media rely heavily on high-speed internet connections, collectively known as **broadband**, which was described in Chapter 8. As more people acquire broadband connections via **cable modems** or **DSL** (**digital subscriber loops**) from cable providers and telephone companies, the potential for new forms of online programming grows with each passing year. At the time of this writing, more than two-thirds of homes in the United States are connected to the internet, and more than 80 percent

of those internet-active homes have high-speed broadband connections of one kind or another.

Parts of the internet can also be distributed directly to cell phones—the so-called "third screen" (TV sets and computer monitors are the first and second screens). The conventional settings for enjoying video entertainment have now moved well beyond the home. MobiTV, for example, offers its 2 million subscribers more than 50 channels of streamed live television that show up as large as the phone screen, including broadcast networks and such cable nets such MSNBC, CNBC, Discovery, and the Learning Channel, along with several web-only networks. For \$9.99 per month (no extra charge for cellular airtime) MobiTV offers its service via AT&T, Sprint, Cingular, and Alltel phones. Sprint offers ABC prime-time shows on its cell phones. Verizon Wireless has its own V CAST Mobile TV and music service, which costs \$15 per month. Amazing many experts, video-enabled cell phones have diffused almost overnight as consumers have upgraded their phones.

Handheld audio and video players also supplement media content received by computers. Apple's video iPod, Microsoft's Zune player, and Sony's PSP are the most common of the portable media players, and they are capable of storing hours of video which can be displayed on a tiny screen. Despite concerns that most people would not choose to watch a tiny screen, media analysts have observed that viewers seem willing to adapt to the largest or smallest screen that suits their situation at a particular moment. In other words, if 2-inch screens are all people have when riding on subways, then they will use them until they get home to their 42-inch plasma display.

Of course, most viewers still prefer their video to appear on their home television receivers (see 10.1). Microsoft's Xbox 360 was the first device to offer PC-to-TV downloads, and soon other companies, such as Movielink and Amazon.com's Unbox, began providing their customers with wiring instructions for connecting their PC downloads to their TV sets or TiVo DVRs. This was followed by Apple TV, which moves broadband content wirelessly to digital television sets. Apple TV, however, streams mostly television programs and movies downloaded

10.1 Watching Channels Online

efore the internet, it was not likely you'd try to watch TV on your computer. Although add-on tuner cards have been available for years, most people keep the computer and the TV experience separate. If you want to watch TV at the office, for example, you're out of luck unless you bring in a small portable TV.

Thanks to online video, nowadays you can watch standard TV anywhere. The most common way is to purchase a Slingbox. Hook your home cable or satellite to the Slingbox and then tune in all of your channels with a broadband connection from any remote location. Copyright is not a problem because you are already paying your multichannel provider for the right to watch. You are merely extending the reach of the cable coming into your home. With a Slingbox, you can extend it around the world.

Without adding equipment, you can still watch regular channels (as opposed to clips on websites such as YouTube and Rewer) with NeepTV. A Miami-based service, it offers access to hundreds of worldwide TV and radio channels through your computer. Add a device such as Apple TV, and you can even transmit the

programs to your television set. NeepTV is a subscription service, charging \$10 per month (or \$5 if you sign for a year) to receive live programming from over 2,800 TV stations and over 13,000 radio stations. How NeepTV shares revenue with the copyright holders is not at all clear. Furthermore, NeepTV does not offer a trial service for free.

If you want to try a similar service at no cost, you can download a **TVUPlayer** from TVUNetworks, head-quartered in Shanghai, China. Unlike NeepTV, users themselves can upload live TV channels, analogous to the way standalone clips are uploaded to YouTube. Or you can watch channels uploaded by others. At this point, the service seems to cater to foreign-born residents who want to watch television from back home. In effect, one person shares satellite access with internet users who don't have such access. Many of the TVUPlayer channels are copyrighted, so this service may not survive if the more popular channel owners successfully remove them from non-pay circulation or if the Digital Millennium Copyright Act is rewritten to close the loopholes that protect YouTube and others.

from its Music Store partners (and YouTube videos using the Quicktime Format). Apple TV competes with cable providers by offering VoD movies. Even without additional hardware, media companies have begun to anticipate the viewers' desire to watch online video. Sony offers Bravia HDTVs that allow viewers to watch internet video on their TV sets via their own wireless internet connection (meaning that no computer needs to be in the same room of the house as the TV set).

Convergence

For a long time, some observers were reluctant to foresee any merger between the two broadcast and computer worlds, not just because of the disparity in picture quality, but because of the inherent distinction between the activities of watching television (passive) and using a computer (active). These predictions have proved

unfounded, however. As wireless home-computer networking has increased, computers have found their way into the traditional media room, and television-like content now appears on computer screens. Journalist Penelope Patsuris has posed a shocking (to the cable/satellite industry) question: "Consumers may start wondering why they should pay \$100 a month to DirecTV or Comcast for a bunch of channels they never watch, when they can just maintain their broadband connection at \$40 a pop and only watch exactly what they want to watch."²

Broadband video began exploding in 2007. "There will be an infinite number of internet channels," said Will Richmond, president of Broadband Directions, a consulting firm specializing in broadband video. "And just like cable networks have put the squeeze on broadcast networks, broadband content will put the squeeze on cable." Still, traditional television has a big advantage over video streaming: It can deliver HDTV-quality

pictures, while video streaming via the internet remains comparatively limited in picture quality.

In many ways, digitalization changed the media world. Convergence, the word used to describe what is gradually happening, refers to the merger of old media (radio, TV, film) and new media (internet, MP3 audio). But author Joseph Dominick takes note of three different kinds of convergence: Corporate convergence is the trend toward the acquisition of other distribution channels by content providers; operational convergence occurs when media owners combine their properties into one operation; and device convergence combines the function of two or more devices in one mechanism (e.g., fancy cell phones). Content convergence, defined as new ways of distributing old-style content, should be added to this list. The internet was designed for digital information (text or data) at a time when most music and pictures were still analog. Now that media are almost exclusively digital and the internet's speed and capacity has greatly increased, the web can transmit video and audio with relative ease.

Viewsers is a recently created word that designates viewers who have become video users. Viewsers are empowered by continuous choice among huge numbers of options that allows them to create their own video environment. They are still passive viewers once the selection has been made, but their active participation in the searching process suggests an unprecedented amount of control. Digital cable and satellite channels may have vastly improved the ability of viewers to choose among hundreds of programs, but the sheer volume of millions of archival and recent video clips on the internet has turned viewers into viewsers.

The Online World

Streaming is the digital distribution of audio or video in near-real time, the closest thing to conventional television programs. Also known as IP video and webcasting, streaming differs from broadcasting because the viewer receives a single transmission not intended to be seen at the same time that other viewers might watch. Just like with a television set, anyone with a computer and a connection to

the web (World Wide Web, or www) can receive streamed pictures and sound, and the faster the connection, the better those pictures are. The number of web users who are willing to watch streamed video grows as connection speeds increase. The competition between cable modems and DSL, like the competition between cable and satellite, has stabilized (but not yet driven down) the cost of broadband connections.

Broadband is the high-speed delivery of digital information, video, music, text, data, and so forth—over wires, cables, and through the air. It is broadband connections that have made video downloads practical. Companies like Movielink and Akimbo offer movies and other video programming to be downloaded. Slingbox is a device that also takes advantage of high-speed delivery by allowing travelers to watch channels from their home receivers over an internet connection to their hotel rooms or other television sets.

User-Generated Content (UGC)

Many websites provide streamed audio content and video content to home computers. YouTube, owned by Google, is by far the most popular such site, providing user-generated content (UGC) and sometimes-copyrighted materials uploaded by users (see 10.2). YouTube has proliferated into dozens of channels and has become video-on-demand: what people want and when they want it, in almost real time.

YouTube has plenty of other competition. Revver is a similar UGC site that was purchased by Microsoft, a close competitor of Google's. Another extremely high-quality video site called Joost (from the creators of KaZaa and Skype) offers full TV shows and movies from commercial content owners, rather than mostly short clips. Veoh TV gathers video from across the web and creates one customizable, controllable site where viewers can search for (and then subscribe to) streamed shows or download them for later viewing. And there are sites willing to pick up the clips that YouTube discards. *DailyMotion.com* is a French website that contains hundred of copyrighted TV shows and clips that have been banned from YouTube,

10.2 The YouTube Phenomenon

n 2007 Viacom demanded that more than 100,000 video clips, originally produced by MTV, Comedy Central or Nickelodeon, be removed from the YouTube site. The same month the BBC demanded that another 100,000 clips from its shows be removed. In both cases, YouTube complied. Meanwhile, the Japanese Society for Rights of Authors, Composers, and Publishers demanded that thousand of its producers' videos be removed, and NBC and CBS both filed complaints about their material appearing. Amusingly, Iran banned the site as "culturally undermining." The U.S. government also got in the act when it objected to rebuttals of the "public service" announcements they were uploading. After discovering fight and gang attack videos on YouTube, ITV in the UK claimed it was encouraging violence and bullying. Of course, these attack videos have since become big hits on news services, which shake their collective heads in disgust even as they run the cuts for the 100th time. Given such complaints, one might think that the existing media would keep its distance from this web upstart. One might also assume YouTube was on the verge of failure. One would be entirely wrong in both cases.

YouTube was founded in 2005 by three former PayPal employees using \$3.5 million dollars in venture funding. In 2006, YouTube was named Time magazine's Invention of the Year and sold to Google for \$1.65 billion. Today, the public, to whom the service is free, adds about 65,000 new videos daily to the more than 100 million that YouTube already has on its servers. Members of the public can upload whatever they want so long as it meets the 10-minute time limit (although there are special categories without time limits, but which require original production).

By making it free, YouTube succeeded in avoiding the problems that had plagued Napster. While it hasn't ruled on the web as such, the Supreme Court has traditionally said members of the public can do whatever they want with materials sent into their homes or which they have purchased, so long as no money changes hands. YouTube gets its revenue from conventional banner ads and from an innovation: Commercial customers can also upload videos, but

for a price. Even as Viacom was demanding removal it was buying in. NBC negotiated its own channel, and Time Warner touts YouTube as a great outlet for its music videos. The big entertainment companies don't hate YouTube; they would just like to control it. Indeed, most of the material they demanded be removed is back on-just with official sanction.

YouTube is without doubt one of the great success stories of the web. It has added new channels, special groupings of videos, and even special categories (such as for comedians and amateur producers). The NHL agreed to provide brief highlights of hockey games to the online service. In fact, many YouTube producers and entertainers have developed their own followings, becoming stars in their own right with their works featured on late-night television shows. Although critics once claimed that YouTube would find it impossibly expensive to maintain the required bandwidth and storage capacity, they have suddenly grown quiet. The public has welcomed the ability to participate in this one area of video freedom, and the revenue from advertisers has appeared.

While there are certainly many who would like to see it fail, it was probably already too late after its first two years of operation. The public rapidly embraced this new outlet. Even as Brazilian model Daniela Cicarelli was demanding YouTube be shut down until all copies of an unauthorized video (of her having sex with her boyfriend on a Spanish beach) be removed, the video had already spread through hundreds of other websites. While YouTube makes no provision for downloading, the needed software can be found in a few minutes of surfing the web. As Sean McManus, president of CBS News and Sports, noted: "Our inclination now is, the more exposure we get from clips . . . the better it is for CBS News and the CBS television network; so in retrospect we probably should have embraced the exposure, and embraced the attention it was bringing CBS, instead of being parochial and saying 'let's pull it down'."6

> William J. Adams, Ph.D. Kansas State University

at least until someone forces *DailyMotion.com* to stop. But getting videos removed that continuously pop up on multiple websites has been likened to smoothing out bubbles under wallpaper: The forbidden videos reappear somewhere else on the internet.

The wide availability and frequent viewing of short online videos has led to the phrase clip culture, which refers to the presumption that viewsers have acquired shorter attention spans. If a person is only interested in the highlights or the most important moment, then clips on the internet easily meet that demand. Internet technology has led to a rise in a kind of promotion that goes beyond word-of-mouth advertising. Viewsers who forward to other users interesting videos or segments of information about programs or sites are inclulging in a form of active publicity called viral communication. Viral video refers to images or programs that often get shared this way-for example, when the latest hit on YouTube is forwarded to groups of friends.

The Online Formats

Online video content comes in a variety of forms. In less than a half-dozen years, online programming has multiplied and diversified so greatly that seven distinct types can be identified:

- 1. User-generated content (UGC)
- 2. Podcasts
- 3. Enhanced viewing
- 4. Repurposed video downloads
- 5. Games with tie-ins to mainstream content
- 6. Virtual worlds
- 7. Social networking

At its most basic, users sit at their keyboards and talk or perform UGC for their web-enabled cameras. In an effort to entertain or inform viewers, they might also shoot digital video in other places and later upload it to sites like YouTube. A more elaborate effort is called a mashup, defined as a new video edited out of other videos from multiple (often copyrighted) sources. To date, many video mashups have been parodies, sometimes

accompanied by elaborate music mashups. Occasionally, as a gimmick, a network and an advertiser will encourage ordinary users to create content for distribution on mainstream channels, such as the homemade Doritos commercial that appeared in the 2007 Super Bowl telecast.

Beyond user-generated video and viral communication, an explosion of professionally produced content appears daily on an equally impressive number of broadband video channels. Sites like Ruckus and ManiaTV offer vast amounts of video from professional independent producers, somewhere between the two extremes of conglomerate producers and silly amateurs. Ripe TV offers sports, music, and women, perfect for reaching the 18-34 male demographic (see 10.3). LX.TV covers food, nightlife, style, health, and other topics targeting upscale audiences in Las Vegas, New York, and Los Angeles, while Boston.TV does the same for Boston. How-to sites, like ExpoTV, VideoJug, and ExpertVillage, carry videos offering helpful tips on nearly everything.

Podcasts are another source of audio and video content. They differ from other online content because they are intended for download to iPods or other MP3 players (see Chapter 11). The key difference between a podcast and streaming video is that the former has the ability to be downloaded automatically. The user is normally expected to subscribe to programming at websites such as iTunes) which "push" the video to the media player, similar to the way new issues of a magazine periodically arrive at a subscriber's home. Of course, subscriptions can be easily started and stopped online, unlike with some mailed magazines. In contrast, streaming video uses "pull" technology. Users have to watch or download individual items on an ad hoc basis. Although the audience for podcasts has been small to date and more people have heard of them than listened to them, at least one observer expects podcasting to change in the coming decade: "Gone will be the 30-minute long weekly shows in favor of 5- to 10-minute segments which can be better monetized, and better distributed. People have ADD [attention deficit disorder] as a collective whole, and don't want to listen to poorly edited talk radio."7

10.3 Does Anyone Watch UGC and Other Streaming Video?

ccording to a 2007 study of 500 consumers by Advertising.com, 66 percent of consumers said they viewed streaming content at least once per week. News clips were the most popular type of content, with 49 percent of those surveyed saying they were likely to stream it. News clips were followed by music videos at 47 percent, movie trailers at 33 percent, TV shows at 26 percent, and user-generated videos at 21 percent. Respondents aged 18 to 34 tended to prefer TV shows, movie trailers, music videos, and user-generated videos, while viewers 35 and older favored news and sports clips.*

Another study found that **displacement** occurred. With adults at least, but maybe not kids (see Chapter 9), using online video normally displaces the amount of time spent on the kinds of media

programming described in other chapters of this book. About a third of Americans report spending less time with traditional media because of the amount of time they are spending online. ** In particular, online consumers say they are spending less time reading printed newspapers and magazines. Many say they spend less time watching television or listening to AM/FM radio because of their online activities. Whether extended use of the internet for entertainment and information (as opposed to work) is a fad because it is so new—or a phase that rootless teens and young adults pass through—is unknown. Two key factors are how deeply internet-access technology has penetrated family living rooms, and to what degree video-enabled mobile devices have proliferated—but one thing is certain: The future is beginning to look more and more like science fiction.

Nowadays, virtually every TV station has streaming versions of its newscasts featured prominently on its web page. In addition to program webcasts, several broadcast networks have created synchronized interactive links between their evening news broadcast and websites. Moreover, nearly every sports event has an enhanced viewing online feature, with a logo in the screen's corner to remind viewers that they can access game statistics or enter contests online. Even syndicated game shows offer play-at-home online enhancements.

Webcasts are excellent for repurposing broadcast television and cable network content, and typically are accompanied by commercial messages. Most web users who watch streamed prime-time shows on such sites as NBC.com do so after missing an episode on its original air date, but the interesting things is that many viewers also also go online to watch episodes a second and third time. Many users of NBC Rewind—the network's full-length online video

player—watch episodes they have already seen on the air and also watch programs they have never before seen. Unlike the network's own site, NBC Rewind is an advertiser-supported venue in which each video is preceded by a pre-roll, which is a commercial that must be played before the selected clip begins to roll. In June 2007, CBS began streaming full daily episodes of the popular dramas. The Young and the Restless, As the World Turns, and Guiding Light on CBS.com (after completion of the over-the-air showings on the West Coast).

Another way to distribute mainstream content as downloaded video or audio is to charge a fee for each copy of a program that is then transferred to a computer hard disk or portable player. The iTunes store is the best known source of downloadable music, TV shows, and podcasts. Some networks and studios distribute their programs on a pay-per-download model, typically at \$1.99 per television program and \$14.99 for feature-length movies.

^{*}Gupta, Shankar, "Study: Two-Thirds of Web Users View Streaming Video Weekly," MediaPost, 7 February 2007. http://publications. mediapost.com/index.cfm?fuseaction-Articles.showArticleHomePage&art_aid=55157.

^{**}Rose, Bill, and Lenski, Joe, "Internet and Multimedia 2006: On-Demand Media Explodes," Arbitron. www.arbitron.com/study_h/internet2006.asp

10.4 What Home Networking Does

n the last decade, an explosion of home networking has occurred in which household electronics devices, such as computers, TV sets, stereos, phones, and video games, are interconnected around the entire house without the need for wiring. Operating on the Wi-Fi standard allows users to transmit streams of data (from computer keyboards, graphic cameras, photo printers, and home video cameras) within a small geographic radius via radic waves. The central unit is typically a desktop computer with immense storage capacity that acts as a server for the rest of the home. The computer links to any number of cable boxes, alarm systems, stereo audio systems, video game consoles, and video displays.

Typically, internet content can come to the main (biggest) television set, a device that has enjoyed a privileged location in the home for the past 60 years but where computers do not normally reside. The "smart" home imagined decades ago by futurists is finally beginning to appear, and this includes new video and online abilities for those ubiquitous cell phones.

Gaming and Virtual Worlds

Traditional media networks also hope to use online gaming opportunities to promote offline programs. ABC hosts a web game for fans of the series *Lost* in which they try to find their way off the island, and NBC lets visitors play blackjack and poker with cards featuring the cast of its show *Las Vegas*. Contrary to stereotypes about video game players, according to Boston-based Forrester Research, nearly half the people playing online games are aged between 30 and 59, and they play everything from mahjong to Sudoku, word games, and solitaire. Moreover, such games appeal to men and women almost equally, and they increasingly play them at home (see 10.4).

Another trend is the growth of virtual worlds. These are computer-based simulated environments intended for users to inhabit and interact with via avatars, as illustrated in Chapter 5.

Defined as the web user's representations of his or her individual self, avatars occur in three forms: three-dimensional models, two-dimensional icons, or text constructs. Very shortly after such sites first appeared, big commercial interests latched onto the branding and profit opportunities. For younger children, CBS's Neopets.com has been especially successful. Nickelodeon's Nicktropolis.com targets children's desire to play games, watch videos, design personalized 3-D areas, and interact with other kids in real time—and also targets parents' desire for a 'safe' online environment.¹⁰

Middle-school children are attracted to such semi-educational sites as *Gaiaonline.com* on which they use anime-type avatars (cartoons, manga) to interact in real time and earn rewards that "buy" virtual toys. Such sites earn their revenue from the purchases of clothing, hair clips, posters, stickers, games, etc. Such virtual-world models are moving into regular classrooms for more directly academic learning. For the adult population, the most popular virtual world site is *SecondLife.com*, a 3-dimensional UGC where participants buy and trade virtual land and virtual dollars (using more spooky avatars).

A related trend is social networking via online communities, where participants engage in computer-media communication. Sometimes accompanied by widgets (downloadable software programs that feature media content), these sites provide the opportunity to interact, but the largest such site, MySpace.com, encourages its users to post videos (vlogs, which are video versions of blogs) that can be watched for information and entertainment value. By late in the decade, MySpace had more than 200 million members, so its potential impact on online video and audio programming is immense. Another popular social networking site is Facebook.com, which has a membership made up largely of college students. Comcast (which has an interactive media site called Ziddio) formed a partnership with Facebook to invite students to upload videos to Ziddio, in hopes that Comcast could also promote its cable-based VoD offerings in addition to its online video site. Mature media 322

companies are eager to protect their core business by following their users onto the internet in order to stay close to their current and potential customers.

A Conceptual Framework

When an innovation comes along that fundamentally changes the way people view the world, the term discontinuous change is used. At first glance, the use of online technology to distribute radio and television programming appears merely an extension of broadcasting-another way to receive the content—as with cable and satellite. The key difference, however, is the degree of interactivity between the user and the programmer, a factor which has created a sea change from the past. The seemingly infinite number of choices is another important difference: By 2008, there were more than 500 million internet hosts (which are comparable to channels). 11 Another change is that the formerly dominant media are now forced to compete with unconventional forms of electronic entertainment, such as digital photo albums, visual encyclopedia, vlogs, virtual worlds, and amateur podcasts.

Previous chapters in this book have been structured around strategies for selecting, scheduling, and promoting programs and evaluating audience response. The "a la carte" nature of program offerings on the internet, however, has transformed many of the programmer's tasks. Instead of schedules of limited choices, the online audience has an abundant menu of near-limitless choices. Every listener and every viewer can construct his or her own media landscape using internet-

based digital video recorders (iDVRs), such as MythTV, or program-seeking robots or other kinds of rapidly evolving avatars. In this contenton-demand world, fewer people spend the same time enjoying the same program that other people are watching. Yet, many viewers continue to expect that someone else will assemble offerings into a schedule, or at least a highly simplified тепи.

Although it is safe to define online programming as media content available through a computer screen or speaker that displaces or substantially supplements the use of noncomputer media content, it is only possible to sketch out some segments, not boundaries. While it includes live and taped shows, described previously as streamed or video content, online content can encompass virtual events, including chat rooms and group event simulations (Gaia, SecondLife) such as those just discussed. Online programming particularly includes but is not limited to web pages that promote programming delivered over conventional channels, but for the purposes of this book, the archived sound bites and video clips found on journalism sites are set aside.

Conceptually, online programming compares with other programming as shown in 10.5. The list of differences is not exhaustive but is nevertheless helpful for framing the relative position of online distribution. Although these distinctions may seem peripheral to how programming is strategically scheduled, these conceptual differences are crucial for programmers' understanding of why new media are fundamentally unlike more traditional media.

What is unique about the online world is its interactivity. Applications that are interactive

10.5 Strengths and Weaknesses of Media Delivery Systems					
System	Reach Limited by	Revenue Streams	Bandwidth	Interactivity	
Broadcast Cable/Satellite Online	Geography Channel capacity Bandwidth	 Advertising Ads, plus subscriptions Ads, subs, plus merchandise 	High High Medium	One-way Mostly one-way Two-way	

account for only a tiny slice of spending on the media. Although early projections for revenue have proved to be overly ambitious, many still expect that the arrival of interactive media has merely been delayed by the rollout of new media devices, not by a lack of interest on the part of consumers. Perhaps cell phones, portable media players, or some new multichannel television platform will lead to realizing the potential of new media systems.

Geography

Because they are distributed by middlemen-the broadcast stations and cable systems-ordinary over-the-air radio and television are limited by geography. Back in the mid-twentieth century, networks were developed to link together stations and cable systems to create national services. In the 1980s and 1990s, multichannel media (cable and satellite) became collections of networks. limited by shelf space to about 600 digitally compressed channels (see Chapter 8).

Online, in contrast, is free of inherent geography and fixed channel capacity, but limited by the small pipe (bandwidth) through which programming must flow. Bundled fiber cables, however, are now replacing old-style coaxial cable and telephone lines, thereby increasing bandwidth, and internet cable modems and DSL have pushed delivery speeds to 5,000 kilobits (5 megabits) per second, with speeds up to 8 megabits for additional monthly fees. When internet access comes through such connections, high-quality video and audio are possible. Nonetheless, to match real television quality, distributors must provide several megabits per second over shared access lines, and HDTV requires even higher speeds than are now available. It is a rule of science that faster speeds produce better video and audio quality.

Bandwidth capacity is not entirely based on speed. Until fiber-optic cables are connected to the home, video services can slow down the global network. The internet was not designed for television; and Google, in conjunction with cable operators, is devoting major resources to combining its search technology and its tailored advertising with the cable networks' high-quality del-very of shows.12

Economics

The very essence of programming strategy is linked to how revenue flows from consumer to program producer, with the distributor (qua programmer) as middleman. All three forms of media programming shown in 10.5 have offsetting benefits and drawbacks. The key distinction between broadcasting and multichannel distribution has been the number of revenue streams: Over-the-air radio and TV stations rely almost entirely on advertising, whereas cable/satellite services have dual income from advertising and subscriptions. Although the broadcast industry has only a single revenue stream to date (NBC has taken the first baby steps toward a second stream from cable operators), the "free" element of broadcasting allows nearly complete audience penetration: 98 percent of U.S. homes receive broadcast radio and TV stations, meaning nearly all 300 million Americans can see and hear them.

Thus, broadcast advertising is much more efficient for reaching enormous numbers of people than cable or internet advertising, which means that broadcasters can charge more for the time in which commercials air. Online programming has a third revenue stream from merchandising because its technology allows point-and-click purchasing of items related to media content. Once, such products and services could be sold only in the commercial breaks within TV shows.

Except for content not readily available elsewhere, like pornography-on-demand, the ability to attract subscribers to internet programming was negatively affected by the "free" nature of the internet, because, at the start, most content was reused broadcast material or a sorry sort of amateur sm (UGC) lacking the production quality that viewers are used to. Nowadays, those who supply highquality programs made-for-online must charge (like cable) and compete with those that seem free because they are advertiser-supported (i.e., broadcasters—and the pirate services that share

their content with everyone for free). To date, web users have been reluctant to pay because they have become accustomed to getting most things free on the internet, even copyrighted music (!).

Convincing advertisers to evolve away from the long-established system of cost-per-thousand and gross ratings points has been a challenge for the online world. On the positive side, unlike conventional television's delivery of spot messages to an unknown audience, broadband video delivers a targeted message to actual users. A survey of members of the American Advertising Federation found that more than half expected 20 percent or more of their TV advertising budgets to shift into online video by 2010.13

In traditional broadcasting, programs that under-deliver (have fewer than the predicted and thus paid-for number of viewers) necessitate the giving up of precious airtime in future programs for "make-good" commercials. In the online system, content providers cannot so readily hedge potential audience size. As a result, the traditional advertiser-supported model is slowly transforming into a "pay-per-viewer" model for advertisers. However, internet media analysts and executives predict that demand for subscription video or audio services will ultimately eclipse the current pay-per-use models because of the greater convenience to consumers.

At this writing, it is unclear whether pay-perdownload or advertising-supported models will continue to coexist, or whether one will win the battle over the other. At least one British company, Adams Media Research, predicted that by 2011 the commercial-free digital video distribution model will be the most lucrative one, but others feel the future in the United States may favor the pre-roll advertisement.14

Despite broadcast and cable's continuing importance, there are some highly positive features to being an online program supplier. No licenses and franchises are required, as with broadcast stations and cable systems, and very little FCC regulation applies. Moreover, at present, the distinction between distribution and content is tenuous. Because there are very few distributors, content really is king. There are no bricks and mortar. Very few barriers exist to consumption immediately after the creation step. Programmers online are better known as content providers, and the sizes of staffs required to maintain a website are much smaller than for broadcast stations or cable operations.

Most crucial to this book about media programmers, the job of the online programmer has uniquely become the job of librarian. Selection and evaluation remain valid functions, but the importance of scheduling is greatly diminished. There is not much "scheduling" because everything is potentially available all the time. At this early stage, promotion tends to be supplanted by research to find out who to promote to. The key job is helping users find what they want (before their patience runs out). Whether listeners and viewers prefer to create their own media landscapes or choose among packaged ones remains to be seen, but the online world is not a particularly friendly place to middlemen.

The Content Providers

Who is behind media convergence? Google is one entity, perhaps the most influential, and Microsoft is another. Bill Gates has foreseen a big future in video and has been following up with enormous investments, such as \$5 billion in AT&T Broadband. Although his WebTV service didn't work out, he continues to try to invade the traditional video marketplace. AOL is another giant company that took a risk-in the form of a merger with Time Warner in 2000—to exploit the interactive future. AOL/Time Warner wound up losing \$99 billion in a single year but has since recovered.

AOL is one of the four giant portals, also known as walled gardens, where content is kept somewhat separate from the rest of the internet (which brings solace to parents of young children). Google, Microsoft's MSN, and Yahoo! are the other major portals. Ironically, the two major television networks (ABC and NBC) that tried to become major portals were unsuccessful, and after investing heavily in 1999, they withdrew in 2001, leaving AOL, MSN, and Yahoo! as the dominant entry points. These sites combine start pages with browsers, navigation tools, and search engines. But portals fell on hard times by 2008, because most users began associating major search sites (Google and Yahoo!) with more convenient jumping-off locations for finding what they need to know or want to see. AOL has fought back with a separate video search site of its own called Truveo (www.truveo.com).

Industry observers have declared the portals "dead," and attention now focuses on content aggregators like YouTube and hyperaggregators like VodPod. Thus, content providers choose to place their "shows" on aggregator sites or to remain off-portal as independent websites, not unlike the old independent television stations. However, the programmer must rely on the second kind of major site—search engines such as Google and Yahoo!-in order to be located by most users. Programmers must decide whether to offer their content via major sites or to go it alone, hoping to be found by the search engines. In the days of text-only search engines, this was a real decision, but video search has been integrated into all the major search engines, making it difficult not to be found. On the other hand, the numbers of entries turned up by Google and others sometimes run into the hundreds of thousands, and being buried on such long lists brings few hits. The solution for players with deep pockets has been to purchase placement at the start of a related search as a form of advertising. Google .com and others charge advertisers for favorable placement during an online search.

If the online world were already a mature medium, there would be little need to explore the growth of companies vying to become major players. For radio and television, and even cable and satellite, the major players are already known, with occasional reconfigurations from mergers and buyouts. But after years marked by startups and collapses, the precise array of major players in online at the end of the first decade is still unclear.

The choice between free and subscription internet content exists for those who have broadband, and is no different than the choice between broadcast and cable. Nowadays, the best content comes at a premium, but advertiser-supported free content is still pretty good. Those who decide to pay

10.6 Good Ideas

ctually, anyone can get into the online video business if they have a good idea. Missy DePew of Denver, a mother of two, decided to reach out to other moms by launching her own network on the internet. Her MomMe TV microchannel, at www.mommetv.com, is a profitable advertiser-supported video-distribution destination. Another example is GolfSpan network, launched by a group of professional golf instructors. The network is supported by both advertising and paid downloads of instructional videos, many of which are filmed with just one stationary, inexpensive digital video camera. Both successful web video startups avoided the complicated, costly world of TV licensing and distribution by reaching out to Brightcove .com, which charges them nothing for distribution and promotion, and splits advertising revenues with the grassroots producers.*

*Quain, John R, "Online Video Gets Real," PC Magazin∋, 10 January 2007. www.pcmag.com/article2/0,1895,2086595,00,asp.

extra for content—that is, beyond the considerable monthly expense for high-speed access (which has other benefits such as fast e-mail and instant messaging)—can save money by subscribing to a content provider that packages several services. AOL Broadband, RealNetworks, Yahoo! P.atinum, and other providers cost less than the sum of their parts. Such services combine content from a wide range of sources, charging a lower fee than what it would cost to buy the content separately.

At the time of this writing, the most popular free site is *ESPN.com*, featuring ESPN Motion and ESPN360. Free short films, television highlights, and entertaining commercials, such as those that ran during recent Super Bowls, can be obtained on *iFilm.com*. The British Broadcasting Corporation's *www.bbc.co.uk* offers free news video. Another good place to look for free content is on the websites developed by cable networks (see 10.6).

Until the income from broadband advertising and paid search placement (as on Google) finally grows large enough to support free content, much of the really desirable content is paid download. The prices for packaged content are not cheap—without even counting all the pornographic websites that offer "adult" content for very large fees. Users can also buy pay-per-view content. For example, *Movielink.com* offers movies for \$1.99 to \$4.99, with prices at the higher end for the more recent titles. The quality is amazingly good, but the opportunity to view only lasts 24 hours. Download times vary depending on one's broadband connection.

Broadband users also can download music free of charge, although they risk prosecution by the Recording Industry Association of America (RIAA). A wide range of free radio and music-video services exist on the web that do not allow downloading, like Yahoo! Inc.'s Launch (www .launch.yahoo.com), but one can listen. Broadband users can enjoy several legal music-downloading services like Apple Computer's iTunes Music Store (www.apple.com/itunes), which charges 99 cents per download, and Rhapsody on RealNetworks' Listen.com site (www.listen.com), which charges \$9.95 a month for unlimited listening (and offers CD burning for an additional 79 cents a song).

Strategic Considerations

If program strategists are middlemen, and the internet has no middle, then what is the role of program strategy? Considering the strategic themes outlined in Chapter 1 might lead to the conclusion that *selecting* online programs is different from selecting in the old media environment—but there are, however, enough similarities that programmers can make the transition from a time-bound broadcast world to an a-la-carte online world.

Daypart Compatibility

The utility of dayparting as a strategic theme was considerably weakened for broadcasters with the advent of themed cable channels in the 1980s and 1990s (for example, CNN, Game Show Channel, Cartoon Network). However, the true goal of dayparting is to target groups of people, and the use of a time segment is only one means to the goal.

Online programmers who select programs for a given website certainly can match their content to a *compatible* audience. For example, ESPN Motion and other sports sites take advantage of knowing what fans like to see and delivering it to them.

In the earliest days of streaming video, the distribution of materials was a novelty, so targeting was minimal. Streaming was done because it was possible, not because there was any market demand. For example, in the early days, programs from mainstream television took so long they would not warrant the users' effort because it was easier just to watch TV.

The typical early online user was a young male. Programmers consequently needed "edgy" content that met the sensibilities of pleasure-seeking youth. The most successful early programs became iconoclastic cartoons like *The God and Devil Show*, which was reminiscent of *South Park* humor. By 2007, however, the audience had changed. A larger female audience on the internet made traditional-type online sitcoms possible; for example, *Illeanarama* (available by search on *YouTube.com*).

But despite the fact that teens and college students account for a big chunk of the online video audience, the average age of U.S. viewers is an ancient 39 or so. Over and over, data compiled by such online research companies as Nielsen// NetRatings, comScore, and Ouantcast show that web surfers over 35 years old make up anywhere from half to two-thirds of YouTube's audience.15 Nowadays, the typical online user is no different than the typical television viewer. Thus, the strategies used by the cable theme channels will find new homes online, with the key difference being the user's ability to select from a list of options (online menu), as in digital cable. The programmer, as always, must construct an online menu that is compatible with the desired visitor to the website.

Habit Formation

Freed from time constraints, the web can show anything, anytime. Programmers must count on first-time visitors being so impressed with their sites' contents they will find it rewarding and may even bookmark it (save the site's address). Present

studies of website repertoire already note that users have a limited number of favorite sites (so much so that the idea of "web surfing" has become outdated except as a way to find specialized information). Entrance portals like Yahoo!, MSN, and AOL function like networks, connecting groups of content (rather than outlets like local broadcast stations). A main screen menu presents different categories of content (called links) that are sorted by interest area: news, sports, weather, travel, shopping, and so on. As mentioned above, portals do not hold the power they once did, because people have become accustomed to searching via Google, Yahoo!, AskJeeves, AOL Search, HotBot, Teoma, AltaVista, and similar search engines.

The job of habit formation becomes making a favorable first impression and having the most user-friendly appearance and content—to the extent that that users think of certain sites as "the best weather radar site" or "the best online auction site," an evaluation that may also appeal to the "programmers" of search engines and get them top listing. Nonetheless, paid search placement is increasingly the deciding factor. With paid placement, the search engine grants preferential positioning to the client who pays them for the favor.

Another financial scheme is for the video aggregators to share revenue with the creators of short videos, especially when short roll-in advertisements precede the videos. In the case of YouTube (the aggregator), Google (the search engine) maintained the upper hand by acquiring it (YouTube) for \$1.65 billion (which may sound like a lot of money until one recalls that Yahoo! paid \$5.7 billion for Marc Cuban's broadcast .com website in the late 1990s during the dotcom heyday).

Audience Flow

When it comes to the notion of audience flow, most online sites, once again, follow the cable television model for specialized theme channels. As discussed in Chapter 1, the main strategy is to invite audience flow in and discourage flow out. On the other hand, much as multichannel programmers promote other channels, online programmers can cross-

promote content by including new offerings (other programs) on the same screen page as those containing established programs (or other content). For such branded content providers as Cartoon Network and ESPN, cross-promoting among cable channels, online video games, and pay-per-view videos is effective. The audience can be encouraged to watch the scheduled cable content, as usual, but is given the option to sample other forms of branded entertainment (or information) without tuning away from the brand. The internet and on-demand digital services strive to give loyal users alternate ways to remain with a program brand.

Because *surfing* (the online world's answer to *grazing*) is less common nowadays than in the beginning, new services need a developed programming strategy, beyond promotional support, to attract an audience. The spinoff approach and the tie-in approaches used by broadcasters can work well for online content providers. Some examples of these approaches are discussed toward the end of this chapter.

Conservation of Program Resources

Just as broadcast and cable programmers recycle material to optimize its value, online programmers put as much material onto their online menus as possible. *Unlike time-bound broadcast and cable programmers, the online content providers are not forced to rotate or rerun offerings because nearly everything is continuously available.*

One consideration influences some providers to limit the availability of their material: Many programmers believe that *perceived scarcity* makes content appear more valuable to the public. For example, Disney carefully limits accessibility to its old classic films on videocassette and DVD to make them seem more special when they briefly become available in stores. If online content becomes too common or too readily available, the perceived worth of the contents (as compared with premium materials) may be diminished. One reason why cable viewers spend so much of their time watching HBO is because they pay extra for it, and the extra use justifies the cost. The lessons for website program services seeking subscription

fees are to keep content original and promote the content as "special."

Breadth of Appeal

Online content is not immune to being categorized as broadcasting or narrowcasting, even though the term webcasting encompasses both. Most online programmers have a choice between two tactics: to narrowcast unique content (such as sports highlights) and to broadcast mainstream content (weather, news, commerce). Eventually, it is likely that subscriptions models will proliferate on the web, and result in some kinds of "basic" and "premium" content. Those who toil in the programming business should take heart that, regardless of the technology and distribution, content remains the most important factor in influencing users. Programs have to have broad (or narrow) appeal to meet the consumers' needs and wants.

Specific Approaches

Experts know as little about what strategies work and do not work in this new medium, just as "experts" were ignorant during television's inception or radio's early days. Many honestly thought radio would be used for education! In the present day, repurposing television and radio content has become an automatic process for news directors and station managers. Many television stations now offer access to their recent news broadcasts via web page. It has become is a competitive necessity. Even the Associated Press, the premier wire service for print newspapers, has begun to offer video news in television markets via the internet. Whether the strategy of repurposing applies equally well to all content and all situations is an open question.

Selecting Content

Shelly Palmer has described a media world of linear (scheduling in real time) and nonlinear (on demand with viewer control) television, where the value of content is best realized where that content is best viewed. ¹⁶ For linear viewing (plain old broadcast and cable television), he designates emergent

content, meaning news, sports, and live events. For nonlinear viewing (internet TV), he suggests evergreen content, meaning sitcoms, movies, dramatic hours and documentaries. The third type of content he calls disposable content, meaning talk shows, service shows (whose subjects have been rendered irrelevant because of technology), and infomercials. Disposable content is suited to either linear or nonlinear viewing.

Games have the best online growth potential. Games, contests, gambling, and other kinds of online competition are probably the "next big thing" in terms of interactive program content. Because they are free online and the brand names are known to parents, Disney and Toon games have gained enormous popularity with children as spinoffs, and many others are available for adults. Some efforts have been made to distribute computer games for a fee over the internet, a successful strategy for capturing the person who has tried the free version and become hooked.

Running mini-lottery programs online has considerable (but unrealized) potential for the major media companies because the public is familiar with reports of lottery numbers and talk about winners as elements of television content, and the content could be tied together. However, the FCC would probably frown on close ties between gambling and media businesses. It has regulations in place that specify that any contesting that is lottery-like can only be incidental to the main programming service. Whether this applies to the internet is unknown. It is clear that the unregulated online world could run lotteries more readily than any other medium could.

Scheduling Content

Cross-referencing is the primary strategy for displaying content as a substitute for "scheduling" it. YouTube, for example, cross-references its clips so that the viewer sees suggestions related to the video just viewed. If the viewser watches a video featuring a particular politician, then all other videos featuring the same official will appear as choices. Sometimes general themes (humor or news) will trigger a menu of choices. Content providers have

control over these suggestions and can choose to suggest videos for its paying video clients, which is somewhat akin to a paid search placement.

As discussed earlier, dayparting is a minor consideration for online channels because, as with cable and satellite channels, the choices for users are so plentiful. Radio and television stations normally have one channel, so it makes sense to target the one demographic group most likely to be watching at a particular time of the day or day of the week-by age, gender, or lifestyle. Online programs exist in nearly limitless cyberspace—where shelf space is endless and digital media can be ordered without regard to time or space. Similarly, flow is not very controllable for online programmers; users are as likely to travel horizontally as vertically, or even jump to distant sites, although ideally sites keep themselves constantly appealing and guide flow to other spots within the site.

At the same time, storytelling seems to be an inherently linear process, unfolding over time. Efforts to create innovative multiple paths for stories tend to evolve either into games or educational activities: both effort-full, not effortless entertainment. When full convergence comes, internet programming may have to distinguish carefully between users' personal goals, and target those users who want either relatively passive or active content.

Tiering is one scheduling strategy that successfully makes the transition from the analog to the digital world. It is likely that consumers will purchase more higher-tiered programming more often than not, just as cable and satellite subscribers purchase premium multichannel programming (see Chapters 8 and 9). Indeed, much of premium programming from HBO, Showtime, and Encore has moved to random-access schedules in homes with digital set-top boxes and DVRs, and such program services will move smoothly online as new home technology spreads.

Promoting Content

The practice of online program promotion is still very young, but it is already clear that content providers need to promote their products and services using a mix of mass marketing and an abundance of online spot messages (the equivalent of "onair" in broadcasting and cable) and on-screen invitations (comparable to print ads). The traditional media's interest in all things internet also provides many opportunities for publicity (unpaid promotion).

One avenue for the promotion of videos is the viral nature of the internet. Most online video sites encourage viewsers to "share this video with a friend" or to "leave a comment" (which creates more involvement and increases the chance that an ordinary video will rise to the status of viral

Wikis are sometimes associated with hit televisions shows (ABC's Lost, CBS's Survivor). A wiki is a website that allows internet visitors themselves to easily add, remove, or otherwise edit and change available content, typically without the need for registration. In the case of Lost, fans can contribute their own explanations and interpretations of the complex storylines; meanwhile, the episode creators get feedback and generate excitement for future shows. Such collaborative processes allow mainstream content providers to be more closely connected to the eventual audience. A dedicated website further serves to promote the program, whether the show appears online or on the air.

Moreover, interactive media frequently generate e-mail lists and sophisticated demographic databases of potential audiences for specific services. Nearly all websites that offer such content already require the user to sign up for the service, even when it is free. That user's e-mail address then becomes available (most sites ask permission) for updates. Instead of reaching merely potential users (as radio does with outdoor advertising), online services reach actual users, past and present, with their messages. Present users can also be encouraged to provide names of others who might be interested in the site, sometimes with a reward for the referral. In this way, online content providers can send messages directly to their subscriber base, without postage costs (although it may be spam to many people).

The standard online medium of banner ads reaches small targeted groups of online users, but getting promotional messages out to a wider audience will draw new users. After all, many people can be persuaded to try out something new at least once, especially if it is free. Such offers usually have a time limit, after which fees kick in. Because computers can tell when a given household has used up all free plays (of a program or a game), they can flood that household with "time to subscribe" messages on multiple channels. In consequence, online promotion planners should budget money for paid advertising. Although some adults still avoid online content, the traditional media of print, radio, and television supply enormous potential audiences for online entertainment and information. Despite the greater efficiency of online advertising, the reach of older media is important for building a base of users. It needs to be combined with a targeted online approach.

Interactive media of several types can follow the promotional guidelines for the cable networks discussed in Chapter 9. For example, motion pictures will someday be released to PPV immediately following their theatrical runs, assuming that video stores become less effective in distributing movies and that studios are willing to take risks. Mass marketing ads that once said, "Now on VCR and DVD," will shortly say, "Now on PPV and On Demand." Other pay events carried online will require the same kind of promotion currently used by cable operators and DBS satellite companies. Viewers won't care which way a movie comes to them.

Online Measurement

As outlined in Chapter 2, Nielsen//NetRatings and Media Metrix measure the size of online audiences using two different methods: online panels and server-side audits. Both methods report mostly cumes. Measuring total reach is a good tactic when a "channel" has not yet attracted a substantial audience. As convergence of the media takes place over the next dozen years, conventional percentages of the estimated total audience (ratings) and percentages of those actually using any service at a time (shares) will prove useful tools for measur-

ing the kinds of online programming that garner a large core of regular users.

Like the national/local ratings for broadcast, cable, and radio, internet audience measurement has proven to be a very difficult and complex process. Companies are refining the process and constantly testing to find new and better ways to measure web audiences; the task is daunting. Nielsen's Home Technology Report describes some major complications that make accurate measurement very difficult. For example, because of the increasing interactions happening with users on their PCs, information collected at the website level tells little about how content is actually being consumed. In some cases, PC users may access a website and then perform other totally unrelated operations while still keeping the original website online. Such uses may be widespread and varied but would be considerably different from the kind of use taking place when a visitor goes to a site, looks at it, and then closes it. Thus, measurements of "time-spentviewing" a particular web page may be misleading.

Who are the users of website content? There were more than 126 million unique video streamers in the United States in March of 2007. Moreover, viewing is quite splintered; only one service (NBC. com) had as many as 5 million unique visitors. Although less than 15 percent of adults in the United States watch video online at once a week, men aged 18 to 34—that elusive group that advertisers so desire-account for nearly half of daily viewers of online video. By comparison, 93 percent of adults spend at least one hour a day, on average, watching television.¹⁷ A study by Frank N. Magid Associates revealed that viewing online video has become a routine practice for many internet users and an addiction for some. Daily viewers account for about 5 percent of consumers, with heavy viewers comprised of the usual early adopters: males, young adults, singles, broadband users, and those with high socioeconomic status.¹⁸ The box shown in 10.7 describes one group of online users as of 2006 (keep in mind that this group is likely to change).

According to The Media Audit, the percentage of adults who spend at least an hour a day on the internet is significantly greater than the percentage

10.7 Who Uses Media Companies' Online Sites?

Sychographic studies for the Online Publishers Association suggest that four distinct groups of consumers make use of highly branded online media; they have been called on-liners, multi-channelers. dabblers, and off-liners. In the most recent published study, the on-liners, who comprise 29 percent of the survey respondents, used the internet as much as several times a week.* They were 70 percent male, 40 percent were between the ages of 18 and 34, and 50 percent were between 35 and 54. These frequent users reportedly enjoy their time spent on the web. More than half say they rely on websites, and two-thirds say the sites are easier to use than their offline counterparts. Moreover, when both a website and comparable offline properties are available, more than 8C percent would rather use the website.

Multi-channelers are more loyal to brand names.

Although about half rely on websites, when both a website and offline channel have the same content and

are available, about half prefer offline services (such as ESPN's cable channel or *ESPN The Magazine*). Only a third of multi-channelers consider websites easier to use.

Dabblers are merely occasional internet users. They go online several times a month or less, and 65 percent of them are aged 35 to 54. Only a fifth of dabblers feel they rely on a site, but when both the website and offline property are available, two-thirds say they prefer to use the website. Dabblers are more purposeful in their attention to a story.

Off-liners are predominantly female, and nearly three-quarters have ages between 35 and 54. While the perception may be that off-liners are not sophisticated web users, they actually spend an average of 17 hours per week on the internet, and more than half report enjoying looking at websites. Thus, this category may be a matter of user self-perception and specialized kinds of use (such as household and clothing purchases) rather than quantity of use.

*Elkin, Tobi, "Study Paints Portraits of the Multimedia Consumer," MediaDailyNews, 9 February 2004. http://tinurl.com/3894u4.

of adults who spend an hour a day with the print edition of a daily newspaper. Research has shown that about a quarter of adults spend seven or more hours per week on the internet, and heavy use (however defined) has been growing faster among internet users than among users of other media. The percentage of affluent users is also higher for the internet than for other media.

In this interim age before full convergence arrives, some crucial things are known about consumers' media choices that may apply to cable and broadcast channels in the current online media environment. According to Nielsen, the number of TV/cable channels available to the average U.S. household increased from 41 channels in 1995 to 89 by 2004 (an increase of 117 percent), but the number of TV/cable channels actually viewed only increased from 10.4 to 14.8 (an increase of just 42 percent). Thus, over a four-year period, the number of channels had increased nearly three times as fast as

the number of channels actually viewed or used by viewers. This pattern suggests that online usage will not grow in tandem with increases in the number of available channels. Just as the increase in available channels brought about by cable had a major impact on the existing broadcast channels, the internet is now having an even greater impact on how viewers use their cable/satellite/broadcast channels.

Although the number of websites has shown enormous growth, the number actually used by internet customers has increased only marginally. Web users seem to have begun to reach a comfort level where they usually access the same sites each time they go online. Perhaps an occasional new site is added or even accessed regularly (for example, YouTube), but the core number has remained rather small and consistent. Whatever lure that "surfing" held in the first few years of the World Wide Web, the most recent research indicates that habit formation is at work.

Impact on the Mainstream Media

For a programmer operating from within the established media, staying informed about trends in online programming is important to maintaining audience share. Even more important, programmers of mainstream media can spot new opportunities by following the new developments in the online world. The flipside of opportunity is threat, so it also pays to know what looms over the horizon. This section recounts some of the threats to (and opportunities for) the status quo.

Video and Advertising

The internet arena in which the biggest money has been spent is that of video. Online video represents different levels of threat to the more established media. The delivery of television commercials themselves may be more suited to web pages than ordinary television. Viewpoint's Unicast service provides broadband versions of television commercials to such sites as ABCNews.com, About.com, Accuweather, CBS Sportsline, ESPN, FoxSports, iVillage, Lycos, MSN, and Tribune Properties. These streaming video ads require no download time and are of high quality. Because the total advertising pie is more-or-less fixed over a short period of time, the growth of online advertising is coming at the expense of traditional media's revenues. The saving thing, for the status quo, is the present low cost of online advertising.

Network Television

The major networks all experimented with made-foronline programming in 2001 and 2002, but results were disappointing. As connection speeds improve, however, future attempts may meet greater audience acceptance. Sports is one area where streaming video is taking root. Major League Baseball began offering on its website, www.mlb.com, live streaming video pregame shows before every postseason game (including the World Series). The shows run one hour before the first game of the day and a half hour before the subsequent games each day. Initially, visitors to the website can listen for free and interact with the show via e-mail and live call-ins.

Enhancing existing series is another way that broadcasters use online content at present. Survivor and Big Brother feature online video that gives their networks a chance to hold the audience's attention even after each episode had ended. Another advantage of enhanced television is that it encourages the audience to watch live television instead of watching competing stored programs using a DVR.

Political coverage of the summer 2004 conventions was scaled back for the traditional network news operations and vastly expanded on their online counterparts, a pattern that was followed in 2008. Several websites covered the proceedings and transmitted parts of them live. One even used a skybox camera for 24 hours a day. The viewer also had the capability of communicating directly with floor correspondents through dozens of e-journalism websites. Although this proved less popular with television and web users than hoped when it was first tried in 2000, it grew in popularity with the 2008 convention.

Network Imitators

Some websites emulate network programming of the low-budget variety, especially animation and video compilation shows. Although most early online animation sites died around 2001, the arrival of better video compression and faster connection speeds provided some original production of online-only animation. Surviving sites, such as www.atomfilms.com, produce their content as flash animation using Shockwave, which is relatively easy to create and capture. Another popular site is www.stupidvideos.com, where web visitors can choose from a menu of video clips that celebrate embarrassing mistakes, an imitation of ABC's America's Funniest Home Videos.

Local Television

Local broadcasters are always looking for ways to use their spectrum to create new revenue streams beyond advertising. One idea is for companies to help local stations provide content to personal computers using the unused portion of their new digital channel allocation. At the turn of the century, it was common to read about t-commerce (which markets online products via over-the-air TV commercial links) and the rosy future of interactive broadcast television. Since then, however, companies like Geocast and iBlast have been unsuccessful at getting the effort off the ground.

T-commerce may eventually succeed, if the experience of European broadcasters is a sign. T-commerce is integrated into the well-developed interactive television systems overseas. Similar to e-commerce, which exists solely online, t-commerce may be on the back burner for most television broadcasters, but the idea remains sound. It may have to wait until the dust settles around the transition from analog to digital (HDTV) television over the next few years.

Cable/Satellite

Cable operators already have a two-pronged approach to online programming. First, they sell high-speed connections via cable modem. A list of cable modem services shows that the number of subscribers in early 2007 had risen to 29 million, doubling nearly overnight (or as fast as installations could be managed). Second, cable operators and DBS companies provide programming content that competes with (or complements) online viewing. As described in Chapter 8, the satellite services can only offer high-speed internet access via DSL (a telephone line return loop) because DTH is one-way, and now the telcos are getting serious about competing for high-speed subscribers.

The primary advantage of internet VoD over conventional PPV/VoD is that the former can be completely automated. Subscribers get their content played as if they had put a dollar into a jukebox. For a movie to download in five minutes or so, however even at the high compression rates used in most software, the end-user must be equipped with access lines supporting throughput of at least 3 megabits per second.

Online Program Guides

TV Guide and other companies (e.g., www.zap2it .com) have online guides to track broadcast and

10.8 Internet Broadcasters (June 2006)

Rank	Company	Cume Listeners (6 a.m7 p.m.)	
1	Yahoo! LAUNCHcast	1,505,200	
2	AOL Radio Network	1,106,100	
3	Clear Channel Online	783,500	
4	MSN Radio	617,700	
5	Live 365	515,800	
6	ESPN Radio	124,000	

Source: www.audiographics.com/agd/092106-1.htm.

multichannel offerings (radio listings are available at www.allinternetradio.com). Television receivers with online capability lend themselves to userspecific methods of searching for content. Unlike printed program guides and their online counterparts, which are designed by the publishers in "one size fits all" fashion, web-based television puts the user in control of the flow of information. Webbased television typically provides on screen access to very detailed websites, for example, www.imdb .com, a searchable compendium of information on television and movies. As described in Chapter 8, some observers predict that smart television receivers will use artificial intelligence to anticipate audience desires, based on past viewing habits. This author predicted a decade ago the need for a "something else" button on remote controls that would allow viewers to change broadcast and web channels without ever going back to a previous choice (during a single sitting). Nowadays, such a forecast should be revised to a "give me what I like" button that would be the viewer's last resort after giving up on finding anything good without the set-top box's help.

Audio

Streaming audio content has become commonplace on the web, and the internet radio audience has been estimated at more than 50 million listeners per month. The most popular services come from such large media conglomerates as AOL and Yahoo!. Cumulative listenership to the top six internet broadcasters was 4,415,135 in 2006 (see 10.8), so

the total number of streaming radio websites has to be considerably greater to account for all 50+ million listeners.

Music Recording Industry

File sharing has changed greatly since the early 2000s, especially with the transformation of Napster to a pay-per-song website and the huge success of Apple's iPod music player. Rather than risk legal action from the Recording Industry Association of America (RIAA), many users buy their music online for less than a dollar per song, which still beats buying a CD that is mostly filler. In the mid-2000s, pricing at a dozen major services, from Apple to Dell, was identical at 99 cents a song and \$9.99 an album. Although Wal-Mart was undercutting with 88-cent downloads, its tactic did not pressure rivals to trim their prices for mainstream songs.

If Napster started the first generation of file sharing, and services like Kazaa and Gnutella represented the second, then BitTorrent may well be leading the third. BitTorrent cuts up files into many little pieces, and as soon as a user has a piece, they immediately start uploading that piece to other users. The practical result is that the faster users upload, the faster they are allowed to download. Almost all of the people who are sharing a given file are simultaneously uploading and downloading pieces of the same file (until their downloading is complete). The implication is that the BitTorrent system makes it easy to distribute very large files to large numbers of people while placing minimal bandwidth requirements on the original "seeder." That is because everyone who wants the file is sharing with others, rather than downloading from a central source. A separate file-sharing network known as eDonkey used a similar system until it was shut down in 2006 under a copyright infringement settlement.

One ray of hope for the music recording industry is getting existing customers to use social networking to promote content to potential buyers. Users can join iLike (available at www.ilike.com) to obtain a downloadable sidebar (widget) for their iTunes page, which allows them to receive new music and connect with friends. Ordinary listeners

Movie Streaming/Download Services Amazon.com (UnboxTM) AOL Video Apple iTunes® CinemaNow ClickStar, Inc. EZTakes Guba MovieFlix, Inc. Movielink LLC Starz Ticket VongoSM (Starz Entertainment Group-SEG)

get to rank and talk about music, which helps encourage more paid downloading.

Film

Each of the major Hollywood studios has its own *dot.com* and is exploring the streaming video world—and wondering where it is leading them. They fear, with some justification from the Napster imbroglio, that some little application program written by a teenager in a college dorm room could steal their intellectual property and eliminate copyright royalties. Even encryption schemes may fail, if someone is clever enough to remove the digital fingerprint from a purchased copy.

Nevertheless, *Movielink.com* and others are offering a list of film titles that rivals the video rental store. About a dozen of these services compete nationally; these are listed in 10.9.

Major competition to video stores comes from Netflix and similar services that package video rentals that are delivered by postpaid mail and incur no late charges. The user can possess up to three DVDs at any time for a flat monthly fee. The sooner the movie is returned, with no postage cost to the user, the sooner another movie can be sent. Blockbuster saw Netflix and such new internet film technologies as a very real threat to its video rental business, so it began offering a competing service that improved on Netflix by letting renters choose

between mailing back the DVD or trading them at a brick-and-mortar store.

What Lies Ahead

A good strategy for the major film studios, big broadcasters, and the other impacted "old" media. is to adapt to the new environment. An adaptive strategy has to be viewed from the standpoint of the established media and their "old" business models. As digital viewing technologies wrest control away from conventional television programmers, they too will have to change. Even so, the old way of packaging shows in arranged schedules will not vanish completely. Many businesses adapt by changing their business model or product. When the telephone industry saturated its growth potential by the 1980s, it looked to other information entities, like cell and cable. When Kodak saw the impending doom of its film business in the 1990s, it got into the digital photography business.

In response to the question—Can streaming video sites with entertainment actually make money?—the answer is "soon." Revenue is beginning to flow in many streams: advertising, sponsorships, transactions, and commerce. The pay-per-view model works well, as long as others are no longer giving away content. As for advertising, it may work best when it is personalized—something called one-toone marketing, where share of customer is more important than share of market. Privacy is also an issue, and a sufficient base of potential consumers must exist to make the extra marketing effort worthwhile. Bandwidth considerations of the past are being solved. Faster connections and better video compression are making the online platform a practical way to distribute content. The new Blu-Ray DVD standard promises to deliver HDTV movies on a single disc, but it remains to be seen if high-definition images will find their way to the internet anytime soon.

Faced with the announcement of big changes in store for old media in a new media world, some people wonder aloud whether people really want to interact with their TV sets. One should consider that the same question was asked about the personal computer, which was originally designed

for doing such office work as spreadsheets, word processing, and databases. The answer proved to be *yes*. Will people be just as enamored with interactivity from their TV as from their computer? The answer, again, seems to be *yes*.

Do people want to watch video over the web on their computers? Yes, if the added control and convenience are there. People want conveniences that make their lives easier. Way back in 2000, Gary Lieberman, analyst for Morgan Stanley Dean Witter, made the following pithy predictions about the future of online that have proven accurate. 19

- 1. Once the tools and applications are in place, the revenue potential is huge.
- 2. Watching [home shopping channel] QVC, if you have a "buy" button on your remote, will be hard to resist.
- 3. Set-top boxes will not succeed unless they cost \$300 or less.
- 4. Obsolescence will become the same problem for set-top boxes that it is now for computers.
- 5. Thin applications will be more successful than fat ones.
- 6. DVRs are like power windows on your car: Once you have them, you can never go back.
- 7. The first step will be video-on-demand.
- 8. The "killer application" will be a surprise, likely dreamed up in a dorm room.
- 9. Interactive TV will land in the middle of the PC and TV experience: You won't lean back as much as you once did, but you won't lean forward as much as you do with your computer.
- 10. Brand names will continue to be important.
- 11. Compatibility is a must.

A forecast from Strategy Analytics for the sixth edition of this book put U.S. household penetration for the internet at 91 percent by 2005. That was overly optimistic at the time, but we can be certain that 2010 is a realistic target. When nearly all of America is finally online, and most have high-speed service, then the ubiquity of the broadcast world will no longer be so wonderful. It might be hard to imagine that consumers might download their

favorite shows while channel-surfing through thousands of channels or letting a DVR robot download programs for them while they are away, but such change seems likely in the coming years. Whoever designs the kind of remote control Americans will use will have a tough job. Will a trackball replace the mouse? Will voice-recognition do away with the lap keyboard? Can the public afford to pay individually for each show? Will product placement within sitcoms and dramas be enough to pay the stars' salaries? If the economics are wrong, the old mass audience ways will last much longer. If the new media demassify the audience, however, there may be no turning back. You will live in interesting times.

Sources

- Broadcasting & Cable. Weekly trade magazine. New York: Reed Business Information, 1931 to date. www.broadcastingcable.com.
- Ferguson, Douglas A., and Perse, Elizabeth M. "The World Wide Web as a Functional Alternative to Television." Journal of Broadcasting & Electronic Media 44 (Spring 2000), pp. 155-174.

Ha, Louisa (ed.). Webcasting Worldwide. Mahwah, NJ: Erlbaum, 2006.

Multichannel News. Weekly trade publication. New York: Reed Business Information, 1980 to date. www.multichannel.com.

Noam, Eli, Groebel, Jo, and Darcy Gerbarg (eds.). Internet Television. Mahwah, NJ: Erlbaum, 2004.

Online Publishers Association. "From Early Adoption to Common Practice: A Primer on Online Video Viewing." March 2006. www .onlinepublishers.org/pdf/opa_online_video_ study_mar06.pdf.

Palmer, Shelley. Television Disrupted Boston: Focal Press, 2006.

Revolution: Business and Marketing in the Digital Economy. Monthly magazine. New York: Haymarket Management Publications. www .revolutionmagazine.com.

Schonfeld, Erick. "Web TV's Top-Rated Acts." Business 2.0 Magazine, 27 Feb 2007. http://money.cnn.com/ magazines/business2/business2_archive/2007/03/01/ 8401044/index.htm?postversion=2007022309.

www.atomfilms.com www.movielink.com www.streamingmedia.com www.video.aol.com www.vodpod.com www.warnerbros.com/web/wboriginals/ www.voutube.com

Notes

- 1. Edwards, Cliff, "Internet TV Is Finally a Reality Show," Business Week, 29 January 2007. www .businessweek.com/technology/content/jan2007/ tc20070129_246549_page_2.htm.
- 2. Patsuris, Penelope, "Will Pay TV Soon Be Imperiled?" Forbes.com, 8 April 2004. www.forbes .com/2004/04/08/cx_pp_0407patsuris_print.html.
- 3. Spangler, Todd, "Broadband Video Girds for Growth," Broadcasting & Cable, 8 January 2007. www.broadcastingcable.com/article/CA6405148 .html?display=Special Report.
- 4. Dominick, Joseph R. The Dynamics of Mass Communication, 9th ed. New York: McGraw-Hill, 2007, pp. 22-23.
- 5. Delaney, Kevin J, "Duo Envisions Merging Best of TV, Web," Wall Street Journal, 15 January 2007, p. A5.
- 6. Montopoli, Brian, "ACBS to YouTube: Who Loves You Baby?," 17 July 2006. www.cbsnews.com/ blogs/2006/07/17/publiceye/entry1809404.shtml.
- 7. Cashmore, Pete, "2007 Predictions, Round Two," 29 December 2006. http://mashable.com/?p=1560.
- 8. Davis, Wendy, "NBC: Viewers Catch Up Online," Mediapost, 1 February 2007. http://publications .mediapost.com/index.cfm?fuseaction=Articles .showArticleHomePage&art_aid=54874.
- 9. Steel, Emily, "Media Firms Learn New Game Online," Wall Street Journal (eastern edition), 16 February 2007, p. B3.
- 10. Goetzl, David, "Nicktropolis Ramps Up Nick's Digital Initiatives," Mediapost, 30 January 2007. http://publications.mediapost.com/index .cfm?fuseaction=Articles.showArticleHomePage&art_ aid=54715.
- 11. Internet Systems Consortium, "ISC Domain Survey: Number of Internet Hosts, "Redwood City, CA (n.d.). www.isc.org/index.pl?/ops/ds/host-count-history.php.
- 12. Van Grinsven, Lucas, "Google and Cable Firms Warn of Risks from Web TV," USA Today, 7 February 2007. www.usatoday.com/tech/news/2007-02-07 $google-web-tv_x.htm?csp=34.$
- 13. Mandese, Joe, "Ad Execs See TV Budgets Moving into Online Video," Mediapost, 14 November 2006. http://publications.mediapost.com/index.cfm? fuseaction=Articles.showArticleHomePage&art_ aid=51103.
- 14. Zouhali-Worrall, Malika, "Ad-Supported Online Video 'Losing Ground'," Financial Times, 21 February 2007. www.ft.com/cms/s/8963c644-c1f5-11db-ae23-000b5df10621.html.

- 15. Hau, Louis, "Old People Like Web Video!," Forbes, 14 November 2006. www.forbes.com/2006/11/14/youtube-video-demographics-tech-media-cx_lh_113webvideo.html.
- 16. Palmer, Shelly. *Television Disrupted*. Boston: Focal Press, 2006, pp. 77–79.
- 17. Media Post Communications, "Men 18 to 34 Years Old Are Key Online Video Viewers," New York (n.d.). www.centerformediaresearch.com/cfmr_brief.cfm?fnl=070227.
- 18. Online Publishers Association, "From Early Adoption to Common Practice: A Primer on Online Video Viewing," March 2006. www.online-publishers.org/pdf/opa_online_video_study_mar06.pdf.
- 19. Kerschbaumer, Ken, "For Lieberman, It's All About Perspective," *Broadcasting & Cable*, 10 July 2000, pp. 52–56.

Music Radio Programming

Gregory D. Newton

Chapter Outline

A Little History

Terrestrial Radio
Developments
Cable Radio
Satellite Radio
Online Audio
Broadcast Radio and the
Internet

Choosing a Format

Comparing Technical Facilities
Defining the Competitive
Market
Identifying Target Audiences
Knowing the Available Budget
Estimating Potential Revenue

Step-by-Step Selection Process

Implementation

The Music

A Music Model Music Research Controlling Rotation The Hot Clock Commercial Load

Marketing and Promotion

News and Other Nonentertainment Programming

The Big News Question Journalistic Content

Station Personalities

Network and Syndicated Programming

Concerts and Specials Feature Syndicators

What's Coming for Radio?

Sources

Notes

t's hard to overstate the impact of consolidation in the radio industry that resulted from the 1996 Telecommunications Act, and consolidation certainly affected radio programming. For the large groups, competition has changed. Before 1996, a program director (PD) was responsible for one or maybe two stations, and the competition was all the other stations in the same *market* that were broadcasting in the same format or targeting the same demographics. But a group can now own five, six, or even eight stations in a market. The most direct "competition" may be across the hall rather than across town.

PDs working with station clusters need to understand the company's vision of the radio market and the roles of their stations in their company's overall strategy. In other words, programmers are increasingly brand managers—responsible for all of the elements that position each co-owned station and with the strategic goal of dominating listening within a demographic category or a set of formats. Most of the major group owners have developed specialties in one or more formats. For example, Clear Channel dominates the contemporary hit radio market, whereas Citadel is a country music leader, and Radio One is the country's largest operator of urban stations. Yet very little in radio is really new. Most programming remains a variation of the tried-andtrue formulas that have worked in the past. Thus, programmers need to understand the history of the industry—what worked, what didn't, and why.

A Little History

In the beginning, there was broadcasting, and broadcasting consisted of AM radio stations. There were fewer stations (and fewer competing media) than now, and it was possible to appeal to an extremely broad audience using some of everything. Stations typically programmed not only some live music but also comedies and dramas, news and talk programs, farm information, game shows, soap operas, and a great variety of other programs for people of all ages.

Then came television. Television took many of radio's entertainment programs, and much of

radio's audience followed favorite radio stars to television. "Radio is dead," said some. "It is old-fashioned. Who wants just sound wher you can also have pictures?" But radio was not dead. Instead, a new style of programming emerged. The radio station no longer tried to supply all types of programming to all people some of the time but instead offered the most important programming to some of the people all of the time. The format approach created a new golden age for radio.

The first format was top-40 radio. From pop to country, a top-40 station played a little bit of everything, as long as it was a hit, and adjusted the music rotation by times of day (dayparting) to cater to the available audience. Music fans now had a place to hear the most popular songs of the day, any time they wanted to tune in.

Over time, the number of stations and the competition for listeners increased. A new part of the spectrum, called FM, appeared after World War II and offered better audio quality. And some programmers asked whether it wasn't a bit strange to have a country song alongside a rock song followed by a jazzy ballad. Radio stations soon found it necessary to fine-tune their top-40 formats to target a specific audience (segmentation). Thus, top-40 radio begat the niche formats. At first, there were four: country, album-oriented rock (AOR), urban, and adult contemporary (AC). Now, fans of particular broad types of music could find what they wanted on the radio any time they wanted to listen. Those with wide-ranging tastes still had top-40 stations.

Radio continued to thrive, and because it looked like a good business, still more stations came on the air through the 1970s and '80s. As more and more stations competed for listeners, they needed to find new ways to attract audiences. Thus, the four niche formats produced offspring, alone or sometimes in tandem, while the "mainstream" parents also continued to thrive. From country came traditional country and "young country." AOR begat classic rock, active rock, and alternative. AC begat o dies, soft rock, beautiful music/easy listening, and adult standards (the old middle-of-the-road, or MOR). Urban and top-40 (now known as contemporary hit radio, CHR) begat a format originally referred to as "churban" but that is now known simply as

rhythmic CHR. Urban and AC begat urban AC, smooth jazz/new age, and urban oldies formats. AC and CHR begat hot AC and adult CHR.

Stations and formats continued to multiply through the 1990s, fragmenting the audience even further. Rock and AC begat adult album alternative (AAA). In turn, alternative and hot AC begat modern AC. Alternative and classic rock begat classic alternative (or modern gold). Classic rock and AC begat classic hits. Oldies multiplied into '50s, '60s, '70s, and '80s (and '50s/'60s and '70s/'80s). Gospel and CHR begat contemporary Christian, and then gospel plus AC begat Christian AC and Inspo (a mix of Christian lite, AC/new age, and easy listening).

American radio's family tree also became more global as various Hispanic formats appeared, similar in their structure to CHR, AC, and country. Latin music formats (including regional Mexican and Caribbean music as well as contemporary and gold-based Spanish-language), appeared in niche variants, and Spanish-language news/talk formats grew rapidly—leading the market in some areas. Formats have exploded in the past few years. Radio & Records now lists four separate Spanishlanguage charts (consult the Latin charts section in any issue or at www.radioandrecords.com for a current list and typical artists), reflecting the diversity of cultures and music often lumped under the umbrella terms Hispanic and Latin. And as with Anglo formats, there is frequently some crossover between particular formats (see 11.1).

The past couple of decades also brought additional competitors to the audio marketplace, including cable radio, satellite radio, HD radio, and on the internet, streaming audio. The major differences between these media and what have been traditionally called radio stations are that broadcast radio and HD radio retain a *local* focus, even if they incorporate some national news networks and syndicated music and information, and they are available to the audience at no additional cost beyond a receiver. Cable radio and satellite radio, on the other hand, require a subscription fee and are essentially *national* services available all over the country.

Along with many of the formats offered by terrestrial radio broadcasters, these services provide other music not widely available—traditional jazz, blues,

11.1 Spanish-Language Radio Formats

panish-language radio formats are found in large regions of the United States, especially the West, Southwest, and Southeast, as well as in most major cities. Four of the most common formats are the following:

- **Tejano.** The term itself refers to Texans of Mexican descent; the music is native to South Texas. The music and the instruments reflect not only traditional Spanish and Mexican influences but also the presence in South Texas of other European immigrants in the nineteenth century, particularly Germans, Czechs, and Poles. Thus, Tejano music draws on Mexican folk, polkas, and waltzes, as well as on contemporary Latin and rhythm and blues influences.
- Regional Mexican. This format features the traditional music of Mexico from the past 100 years. It embraces several specific styles, including ranchero, banda, and Norteña (a musical cousin of Tejano historically rooted in northern Mexico).
- **Tropical.** The music is primarily from (or influenced by) Spanish-speaking cultures in the Caribbean. It also has influences from some northern countries in South America as well as Central America. Music styles include salsa, cumbia, and merengue, among others.
- Latin pop and Latin rhythmic. These are the Spanish-language versions of the standard CHR formats, drawing on the most popular music in many Latin styles.

world beat, reggae, show tunes, bluegrass, folk, classical, kids. There is even a channel dedicated to unsigned bands. Streaming audio content is best conceived as "all of the above." The thousands of audio services available online run the gamut from simply repeating the programming of local radio stations to offering web-only broadcasts of every imaginable sort, all with a potentially global audience. To get some idea of the musical artists that are characteristic of each (or that cross over format boundaries), consult the charts in trade magazines

such as Radio & Records (www.radioandrecords .com), Billboard (www.billboard.com), or Friday Morning Quarterback (www.fmqb.com).

Tastes vary greatly from region to region and among markets in a region. For example, the top station in New York City has an adult contemporary format—but the next two are Hispanic, and four of the top ten are urban or urban AC. In San Francisco, news/talk has led the market for years (with two of the top three stations). Two rhythmic CHRs and an AC are the top music stations, but a classical station consistently has a larger share of the audience than any rocker does. In Milwaukee, on the other hand, the top five stations are news/talk, country, urban, CHR/pop, and Hot AC. If one heads south to Memphis, Tennessee, gospel appears among the top five along with urban, urban AC, and urban oldies. In Portland, Oregon, two country stations compete with an AC station for the market lead. Such strong differences mean that a smart program director always tailors a station's programming to the target audience within the market it serves. The advertising value of different audiences, the station or service's technical facilities, and the existing competition in the market also affect programming choices.

Terrestrial Radio Developments

Since the turn of the century, digital audio broadcasting (DAB) has been supplementing both terrestrial AM and FM analog broadcasting, improving the sound quality of each. Although most other countries have adopted a digital radio system that uses a different portion of the spectrum—and that therefore makes digital broadcasting incompatible with existing radio (such as the Eureka 147 system used in much of Europe) in those countries—the United States has chosen to create an in-band-onchannel (IBOC) system that operates within the current AM and FM spectrum allocations and is totally compatible with existing AM and FM systems. Thus, unlike with broadcast television, no date for ending analog AM and FM broadcasting in the United States has been established.

The U.S. IBOC technology is licensed to equipment manufacturers and stations by iBiquity Digital

(www.ibiquity.com), and stations have to pay annual royalties to iBiquity. Referred to as HD radio (note the parallel to high-definition television in the name—something already familiar-sounding to consumers), it is multiplexed along with the primary analog FM or AM signal and requires a special HD receiver. HD allows for inexpensive simulcasting (repeating the main signal, ads and all) at startup; this is followed by the creation of specialty signals for local news, sports, and other content for narrow niches—and allows for advertising that can be multicast on secondary (HD2) channels.

As of 2007, approximately 1,100 radio stations had been approved by the FCC to activate their HD service, but few consumers had purchased receivers because of the high unit cost and limited choices in the marketplace. The early entrants were mostly FM stations (AM stations can transmit digital signals only during daylight hours) and were likely to be owned by Clear Channel, Infinity Broadcasting, Cumulus Media, Bonneville International, Emmis Communications, Entercom Communications or Greater Media—the members of the "HD Radio Alliance" formed in 2005.

One concern limiting adoption of HD Radio for both AM and FM broadcasters is the ability to maintaining their existing coverage area (the geographic area where listeners can receive an adequate signal). With analog broadcasting, a station's signal gradually fades in quality farther away from the transmitter, creating a fringe area at the outer reaches where some listening is still possible. However, a digital signal is subject to a cliff effect—the signal is either of sufficient quality for the receiver to reproduce or it is not. In addition, technical bugs still have to be worked out for AM service. And stations wait for the price of receivers to fall.

Cable Radio

The larger cable systems and the satellite television services in the United States offer dozens of digital audio channels alongside digital television. These are large packages of nationally syndicated channels from such companies as DMX Music (formerly Digital Music Express) and Music

Choice. In addition, DirecTV and DISH offer satellite radio programming on some of their programming tiers. Cable audio thus comes in dizzying array of formats, ranging from bluegrass to rap to salsa to gospel to pop Latino, just as satellite and internet audio do. Comcast, the largest of the cable operators, offers a pay subscription service from DMX Music, a lineup of over 100 channels. Other cable operators, such as Insight and Cox Communications, offer between 45 and 50 channels of commercial-free audio channels without extra charge to subscribers who take an upper tier of television services.

The disadvantage of cable radio for most people is that reception requires a wireline in a house or office. The advantages are that these audio services come automatically along with cable television service and are available all the time, although some, such as DMX, are pay services. MusicChoice also provides many of the same channels both on cable and online. The online availability of the service thus makes music available to subscribers not only at home but also anywhere they can access a wireless broadband connection.

Satellite Radio

DARS (digital audio radio service) refers to high-powered national satellite signals that require only a small receiving antenna that is especially suited to cars and mobile media. At the start of the 2000s, Sirius and XM were two competing satellite-radio providers licensed by the FCC. Each provided more than 100 channels of audio service nation-wide to a combined total of nearly 14 million paying subscribers (for \$12.95 a month). Like most large radio companies today, both were publicly traded corporations and eventually were forced by economics to merge in 2008.

Although their individual subscriber bases had grown rapidly by 2007, a great deal of churn had also occurred. The two services had tried to distinguish their programming by introducing original live talk and sports, and had marketed themselves as different not only from terrestrial radio but from each other. Each had signed deals with substantial rosters of cable networks that supplied

news, sports, music, and other content, and each had various exclusive agreements with consumer electronics manufacturers and retailers and with specific car manufacturers. In addition, XM provided Major League Baseball games, and Sirius had the infamous Howard Stern (see Chapter 12).

But by 2007 it had become clear that the national market could support only one service. Because their receiving equipment was not compatible, the two combined companies quickly developed receivers that could pick up either signal, making more than 200 channels potentially available to subscribers. As with cable television, tiers of service were created and made available for a monthly charge of \$12.95 to \$25.95. Over half of the channels are dedicated to various music formats, most of which are commercial-free; the rest offer news, information, sports, foreign language channels, and other special programming.

Online Audio

Widespread adoption of broadband internet service has opened several opportunities for online distribution of audio content. These can generally be grouped into two categories. The first, *streaming* or *webcasting*, is akin to traditional radio programming because content is delivered in real-time over the network to a computer. Some of the streams available are the programming of terrestrial radio stations, but there are also many, many online-only services. Those providers have the advantage of not needing a license from the FCC and are happily without content oversight by the government other than that imposed by defamation or obscenity statutes.

However, as with all digital audio services (including satellite radio), online services pay music performance royalty fees to the record labels and recording artists beyond those that apply to analog terrestrial radio, making the economic structure of this market more difficult.

Most online listening occurs in offices or homes. Compared to broadcast or satellite coverage, wireless broadband internet connections are not yet widely available. However, wireless providers continue to expand the networks, and Wi-Fi has become one of the greatest competitive threats looming over both traditional broadcast and satellite radio. When wireless broadband is generally available to subscribers (or available for free as a municipal service)—to the point where mobile listening is possible—the "radio" marketplace will expand from a few dozen or scores of choices within a local market to tens or hundreds of thousands.

The second type of online audio service, colloquially known as podcasting (the result of the Apple iPod's early dominance of the audio player market), is archival in nature. Prerecorded content is downloaded from a provider's website to a computer and can then be transferred to another listening device. Podcasts are therefore more mobile at this time than streaming services. However, because of licensing problems, podcasts seldom include popular music and are primarily filled with the spoken word.

Broadcast Radio and the Internet

Radio was slow to warm to the online world. However, by 2000 radio stations and associated companies like Arbitron and Nielsen were racing each other in a furious game of catch-up, fearing that the window of opportunity for attracting and profiting from the new media audience might close before they could develop a serious presence in that environment.

At first, even those stations that were online did little more than put up rudimentary websites or perhaps offer the listeners the ability to e-mail requests to the station. The majority of these sites were the product of one poorly equipped staff member at the station or done as a tradeout (a service or goods provided in return for advertising time on the station) by the station's internet service provider (ISP). The results generally gave listeners little reason to visit once, let alone return. Moreover, stations and listeners were often frustrated by the technological problems (primarily insufficient bandwidth) that made it difficult for the stations to deliver high-quality content. Stations that delivered programming online often found that it was an expensive way to reach only a few listeners. Yet, as the online world accounted for a rapidly increasing portion of the public's media consumption, it became clear that radio would have to adapt to that environment to survive. In order to not only survive but also flourish, radio would have to offer compelling content online and be able to sell the audiences attracted to that content to advertisers.

Broadcasters have developed several strategies for online radio programming. The simplest approach, taken by many stations and networks, is to merely repurpose their broadcast programming by streaming it online, commercials and all. Although further fragmentation of the audience continues to be a fact of life for radio as new, competing services develop, several conditions can lead to improved online revenues. For stations that merely stream their existing broadcast programming, ad insertion technology offers stations twice as much inventory to sell. Stations using the technology from RealNetworks (www.real.com) and other companies that provide broadband services have the ability to insert either the same ads or different ones simultaneously into the streamed content and the broadcast signal.

The best stations, however, go well beyond rudimentary websites and develop very aggressive and elaborate online strategies. Content-rich websites include numerous features of use or interest to the audience. For example, online playlists give answers to some of the most common listener questions ("What was that song I just heard?" or its more frustrating variation, "What was the song you played last Thursday right after the weather forecast?"). In addition, websites can showcase local community information, coupons from local merchants, and online-only promotions. Moreover, stations not content to merely stream existing programming can offer internet-exclusive programming options. These online sister-stations can take several forms, including subniche formats (designed to superserve one or more fragments of the broadcast station's audience) or even listenercustomizable audio streams. However, it is important to remember that there are additional royalty costs when pursuing these options. Indeed, in 2007, proposals for vastly increased royalties threatened to kill off online radio as well as broadcast stations on the internet, but years of court tests have delayed that outcome.

Taking a page from the publishing industry, stations have begun to carry online classified advertising, which is one of several forms of e-commerce. Stations that aggressively reach out to the online audience can also become affiliates of ISPs or local retailers, thereby netting yet another stream of revenue. Providing a virtual mall for local retailers, for example, supplies an additional incentive for visiting the station's website and can be a valued service for both listeners and advertisers.

Radio stations have repeatedly adapted to technological changes and increases in competition for the audience and advertisers. The internet is merely the latest in a long line of challenges facing programmers searching for a big enough piece of the audience pie. In the 1990s, radio still enjoyed several advantages (particularly portability) over early attempts to distribute programming online. The development of wireless internet services (Wi-Fi) and small portable audio players (some of which also receive traditional radio signals as well as serve as a means to play podcasts and other audio) are removing the portability advantage of traditional broadcasting. To maximize their audience and the value of their programming, smart programmers leverage their existing audience goodwill and brand recognition in order to aggressively court the online and mobile audiences while not forgetting the traditional (and larger) broadcast audience.

Broadcasters streaming on the internet have the potential advantage of global reach but have been limited by the scarcity of wireless broadband service, and by the absence of the kind of audience research that advertisers expect. However, wireless internet access is expanding rapidly around the world, and the number of consumer devices capable of accessing the services is also multiplying. The streaming audience is particularly fastgrowing among at-work listeners. As more people began accessing audio through their computers, cell phones, and music players, streaming audio became a viable competitor to broadcast radio; when a station streams itself, that can be jointly marketed as a sister-service to advertisers. For more information on the streaming audio market, consult Radio and Internet Newsletter (updated five days a week at www.kurthanson.com).

As more stations stream programming (and internet-only stations emerged), the appearance of content aggregators became inevitable, given the inherently decentralized nature of the World Wide Web and the attendant difficulties in promoting programming to such a geographically dispersed audience. Aggregators provide a centralized location for a variety of online programming services, thus making it easier for programmers and target audiences to connect in the vast universe of cyberspace. Broadcast.com, one of the earliest aggregators, developed a sizable roster of radio stations from around the world as well as internet-only audio services and other specialized content before it was sold to Yahoo!. As Chapter 10 points out, Google and other internet service providers, particularly AOL, have entered the radio aggregator field as well.

This is the competitive landscape for radio programmers. The question facing all of them, from the smallest local markets to large national groups, is how to best compete effectively?

More than 13,000 radio stations exist in the United States, with countless more in other countries. The buying and selling of radio stations in the U.S. and around the world continues to be one of the most active areas of media, and the process illustrates the principals of effective media decision making. Therefore, the remainder of this chapter tightens its focus to traditional broadcast radio—and consists of a proposed decision to buy/not buy and then program a station in a hypothetical market. The problems and solutions discussed here also affect programming in today's cable, satellite, and online audio.

Choosing a Format

The heart of most radio stations continues to be their music, however it is distributed, and the principles guiding on-air have counterparts for cable, satellite, and online-only radio. In all cases, the program director's job is essentially a continuous cycle of *analysis*, *design*, and *implementation*. The first step in analyzing a market is a thorough evaluation of all stations (or competing services)

and their current programming. This information can then be used to modify or replace existing program formats or to decide which property to buy and what to do with it after purchase. Such an evaluation, in the context of the company's overall strategy, takes into account the following factors: (1) the technical facilities of each station or service, (2) the character of the local or national market, (3) the delineation of a target audience, (4) the available budget, and (5) the potential revenue. Once completed, this evaluation will determine which music format is commercially viable and which can best help the station or service succeed in a given market.

Comparing Technical Facilities

Unlike television, radio isn't going fully digital anytime soon. Industry deals still focus on traditional AM and FM analog technology. Therefore, the old rule holds for now: The best over-the-air facility has the best chance to succeed. Going head-to-head with a similarly formatted competitor that has better facilities is almost always a big mistake. For AM stations, power (strength of signal), frequency (lower in the band is better), and any license limitations (reduced power or eliminated night service and directional requirements) are the key factors. For FM stations, power and antenna height are the crucial considerations. Generally, these elements determine signal quality.

A clear, undistorted signal is less tiring to the listener than one that is distorted, faint, or accompanied by natural or artificial interference. All other qualities of similar formats being equal, the station or service with the best signal will be the listener's choice. Emotional fatigue unconsciously sets in after a period of straining to hear a program with a noisy, uncomfortable signal.

An FM station with 100,000 watts of effective radiated power (ERP) and that has its antenna assembly mounted on a 1,000-foot tower is a much better facility than a station with the same power but with the antenna mounted on a 500-foot tower. An AM station with a power of 50,000 watts on a clear channel (820 kHz) is a much better technical facility than a station with 5,000 watts of power at 570 kHz.

Usually the low-power station is at the mercy of the higher-power station. A 5,000-watt facility with a talk or news format may be very vulnerable to a same-format station broadcasting at 10,000 or 50,000 watts because the more powerful station will provide a listenable signal over a larger area.

This rule of thumb does not hold in all cases. For example, a 5,000-watt facility at 1600 kHz might easily fall victim to a 1,000-watt station at 710 kHz. In AM, both power and dial position are important. The lower the frequency, the greater the range of the AM signal. A 1,000-watt AM station at 710 kHz might easily reach a bigger population than a 10,000-watt station at 1600 kHz.¹

In FM, tower height and power are the principal considerations, and antenna height is generally the most important (a station with a higher antenna using lower power will generally cover more area than a station with more power but a much lower antenna). However, the terrain is also an important factor. Hills can block FM signals, so three classes of FM have been developed (see 11.2).

11.2 Classes of FM Stations

here are three broad classes of FM stations. although there are also subclasses, and not all stations use the class maximums. Class A stations are permitted a maximum of 6,000 wattsor 6 kilowatts (kw) - ERP with a maximum antenna height-above-average-terrain (HAAT) of 100 meters, which provides a signal radius of approximately 18 miles. Class B stations (located in the more densely populated eastern United States) have a maximum ERP of 50 kw and a HAAT of 150 meters. Class C stations are located primarily in the flat parts of the western United States and are permitted up to 100 kw and a maximum HAAT of 600 meters. These stations may have a signal radius of 60 miles or more. Dial position is much less technically important in FM, although stations at the center of the dial get more sampling. An FM station at the upper fringe of the band the lower portion from 83 to 92 MHz is reserved for noncommercial stations) needs an advertising and promotional blitz when altering its format.

For many years, AM was the king of radio. AM stations were tops in ratings, regardless of format. Beginning in the 1970s, FM replaced AM as the music format champion. Music simply sounded better on FM because of the technical differences between the two bands. Furthermore, FM doesn't fade under bridges or inside urban skyscrapers and doesn't suffer from weather interference the way AM does. To survive, AM turned toward full-service programming, including elements of news, talk, sports, satellite or syndicated programming, ethnic (non-English-language), and religious (preaching and gospel music) content. The station's technical facility plays an important part in the initial decision about whether to enter the music programming competition. It would be aesthetically foolish and economically disastrous to pit, say, an AM station against a full-power FM station in the contemporary rock field. Always—having the best or one of the best facilities in the market is crucial to beating the competition.

Defining the Competitive Market

In order to decide on the potential of various radio formats on competing stations, the first step is to analyze the competition thoroughly. A demographic profile of each station and each ownership group in a set of bar graphs will show what percentage each group has of each of the six standard demographic groups. The bars in such graphs display the age "leaning" of a station's audiences, suggesting the industry name of skew graphs. Arbitron (www.arbitron.com) is the principal source of these data. The 6 A.M. to midnight, Monday through Sunday page of a ratings book breaks out the individual demographic groups. Any audience analysis service that provides demographic separation, however, has the necessary information. Skew graphs for two stations in the hypothetical market that is considered in this chapter are shown in 11.3.

With skew graphs of all stations laid out, program strategists can quickly analyze which demographic groups are best served by which stations and groups, and therefore which stations represent major competition. Compare the examples from the hypothetical market in 11.3. KAAA, a rock station,

is skewed male (nearly 70 percent) and young (more than half the audience is younger than 35 years of age). KIII, a soft AC, is nearly the opposite. Their audience is nearly all female and older (almost 60 percent between 35 and 64 years of age).

Graphs for the Big Sky and RadioEast station clusters appear in 11.4. Although the individual stations vary, group patterns emerge here. Both groups skew male overall, but Big Sky more so. There are also significant differences in the age breakouts. RadioEast is strongest for ages 35 to 54, while Big Sky's stations appeal to younger listeners. These differences reflect the existing formats of the stations in each group, but more important, they provide important strategic information about the marketplace for a potential new entrant (including any reformatted station within one of these groups). In order to maximize the advantages of group ownership, it is essential not only to look at the formats of individual stations but also to consider how the programming and audiences for each station fit together in the group. Different groups try to leverage different audience segments. One may focus on capturing the female audience across several age categories; another may try to dominate a specific age demographic for both men and women.

Identifying Target Audiences

It is not enough to study population graphs and other research data about a market's radio listeners. Radio is essentially a lifestyle medium. Listeners choose stations, at least in part, because the station's image reflects their self-image: their tastes, their values, and their interests. It is important to go into the community to find out specifically what people are doing, thinking, and listening to. It is helpful to observe lifestyles by visiting restaurants, shopping centers, gas stations, nightclubs, bars, parks, sports arenas, and other places where people go to have a good time. Don't think of this as a task reserved for times of change, however. Being active in the community, and especially in the areas of most importance to the audience, is not a onetime or occasional effort but an ongoing process to keep programmers in touch with listeners and

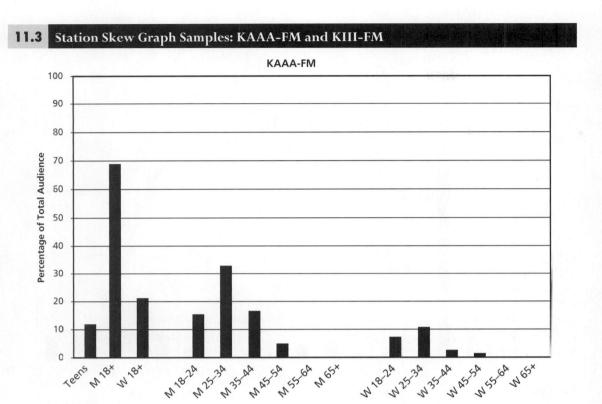

all aspects of their lives. Street presence, as both a promotional exercise and a research tool, is critical to the success of most music stations.

Personal interaction with the members of the audience and community is important and can provide valuable insights, but programmers should be careful not to generalize too much from that kind of anecdotal evidence (and should never assume that their personal tastes reflect the target audience's taste). Therefore, formal research using careful sampling procedures should supplement personal investigation. Most cities have research firms that can be hired to make special studies, and many national firms specialize in broadcast station research (see the directory published by Radio & Records at www.radioandrecords .com for a substantial list of research firms and consultants). Psychographic profiles (listener lifestyles and values) can provide additional invaluable information for programmers about target audiences.

A study assessing current formats in the market using lengthy, in-depth interviews might get interesting responses: too many commercials, bad commercial production, too much unfamiliar or repetitive music, obnoxious contests, can't-win contests, or DJs who talk too much. A station getting answers like these is ready for a major overhaul (or is vulnerable to new competition). However, research is merely one tool in the programmer's arsenal. Any study should be carefully weighed before being used to make important decisions.

As an example of the kind of findings that prove useful, a broadcast station may identify its typical over-the-air listener as a male, 30 to 35 years old, who earns \$50,000 to \$75,000 a year, drives a Lexus or other upscale car, drinks imported beer, goes out at least twice a week to a good restaurant, and plays golf. The station can sell this audience to advertisers that have the same target. Station promotional efforts, from contests to events, would tie

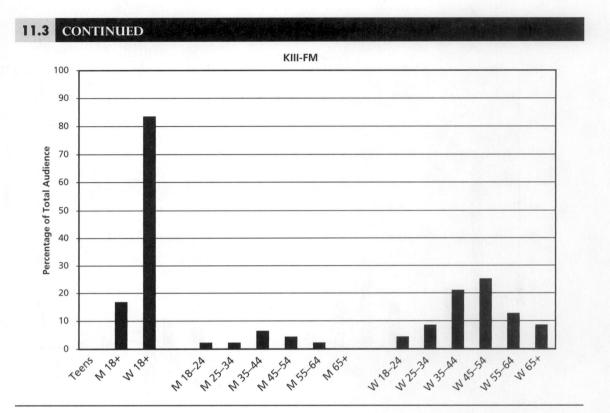

in elements of lifestyle with the programming on this particular station.

Knowing the Available Budget

In addition to a program director, the usual hit music operation requires one or more air talents along with a production director and, perhaps, a music director. Salaries vary widely, even within market classes, and are a function of the station's results (ratings and ad revenue), the individual's job history, and the individual's negotiating skills. In a medium market of 500,000, the program director may earn as much as \$50,000 a year—more if she or he also handles an air shift. The morning DJ probably gets \$50,000 to \$80,000, and a popular afternoon drivetime DJ may get up to \$40,000. The production director's salary is probably between \$30,000 and \$50,000 per year, and the other five or six jocks fall in a somewhat lower range.

In the top-10 markets, stations would likely have to double or triple these salary figures to

get the required talent. Top morning show talent for a large market can easily run well into six figures, with superstars earning a million dollars or more annually. Successful PDs can likewise command six-figure salaries in a major market. But talent is often expected to do more for that money than they used to have to do. The afternoon drive jock is probably also recording midday, afternoon, or evening shows (voice tracking) for as many as five or six other stations in addition to making a promotional appearance or two for the station each weekend.

In addition to staff salaries, management must expect substantial ongoing costs for promoting and advertising. Moreover, a station often employs various consultants to help with specific areas of the operation—legal, technical, management, personnel, marketing, and sales as well as programming—and all of these consultants are useful or even essential at one time or another. Some consultants are practically required on an ongoing basis—for example, a communications law firm in Washington, DC, should handle proceedings with the FCC

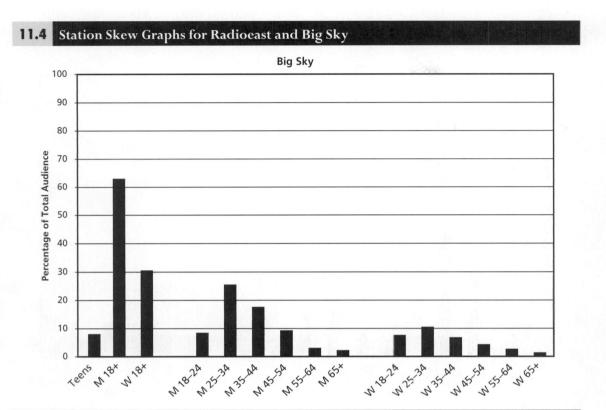

and keep the station advised of changes in the requirements for operation.

Engineering consultants with experience in going before the Commission are necessary when the station is applying for a new license or at any subsequent time when the station makes a change to its facilities that requires FCC approval. Programming consultants can provide important insights on a regular or occasional basis by finding market voids and spotting competitors' weaknesses (or your own). They may even assemble a staff to work up a specific format. Consultation is expensive, however. An engineer may charge \$700 a day plus expenses; a programmer may charge \$3,000 a month on a three-to-six-month contract. For a complete station overhaul, consultants range from \$400 to \$1,000 a day. A neophyte licensee may be literally unable to start up without using one or more consultants, and even experienced operators will frequently rely on the expertise consultants provide. A great deal of highly specialized knowledge and experience must be brought to bear immediately once the FCC has given the licensee authority to operate the station following construction or, more commonly, a license transfer.

Estimating Potential Revenue

It's a cold, hard reality, but programming decisions are based primarily on their revenue potential. Maximizing advertising revenue is normally the goal of the station's owners, and the value of a station and its programming is found in the value of the audience to advertisers. Program directors need some understanding of basic business principles in order to be effective. Good programming (along with good promotion and a few other factors) should deliver a good, salable audience. That is what determines the success (or failure) of a station (unlike commercial-free services).

In addition to cable, satellite, and online radio competing for audiences, television, outdoor, direct mail, and newspapers compete with radio for many of the same advertising dollars. The increasing number of stations and audio services has fragmented

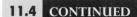

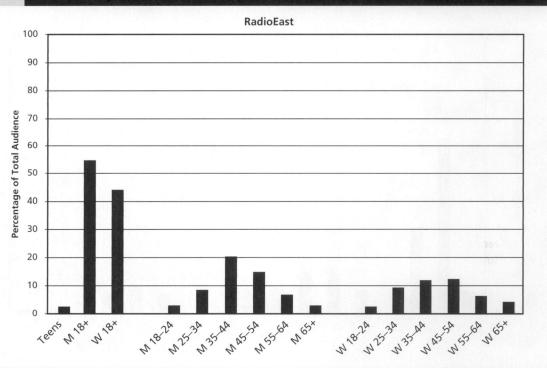

the available audience more than ever, making survival even more difficult. Terrestrial radio is generally viewed as a mature medium, demonstrating little revenue growth. Although total revenues for the industry have gone up in recent years as a result of larger total advertising expenditures within the whole economy, this factor is quickly affected by dips and rises in the overall economy. Radio's percentage of total advertising dollars has been around 7 to 8 percent for decades, and consolidation has not improved that figure as many had hoped it would. On the other hand, the new competition hasn't particularly hurt it, as yet-largely because most services are supported by subscriptions rather than by advertising or have limited availability compared with radio.

Radio station selling prices are generally based on multiples of cash flow. A station or cluster with a strong history and good facilities in a large market might sell for as much as 12 to 14 times cash flow (even more in rare circumstances). Weaker or unprofitable stations, smaller market stations, or other less desirable properties have lower multiples. The extent of consolidation in a market, station facilities and condition, current ratings, retail sales, and advertising expenditures in the market all contribute to the determination of a station's value. Largemarket stations can be worth tens of millions of dollars, while stations in the smallest markets may sell for only a few hundred thousand unless land or other considerations drive up the price.

It is important to keep in mind that commercial media compete intensely for local advertising revenues. In any area, advertisers most desire the 18- to 49- or 25- to 54-year-old audience (although as the baby boomer generation ages past 60, some advertisers and programmers are beginning to target those older demos). In radio, the audience subdivides into 10- to 15-year segments that specific formats target. Following Arbitron's pattern, most radio audience segments end in a 4. If particular advertisers are not seeking all listeners 25 to 54,

then they want a subset of that market; some seek subgroups of 25 to 34, 25 to 44, or 35 to 54. For example, many nightclubs and other entertainment venues target audiences aged 18 to 24 or 18 to 34. Selected advertisers, such as banking and financial institutions and packaged vacations, may seek listeners aged 55 to 64. For the most part, though, older people are seen as set in their buying habits, and regarded as saving money rather than spending it; it is presumed that they have probably bought just about everything they are ever going to buy. This perception is not necessarily accurate, however, because people are living longer, healthier, more active lives.

Many advertisers are most interested in the large population bulge represented by the baby boomers. They see that market as having money, responding to advertising, and receptive to buying, even if it means going into debt. Stations have tended to track the boomer generation and adjust their music formats to continue to appeal to this group as it ages. This has resulted in continued heavy play of late '50s, '60s, and '70s music (oldies or classic rock, as well as AC formats that feature plenty of songs from that era), which capitalizes on the hit songs of the baby boomers' teens-through-20s years.

Step-by-Step Selection Process

Format strategy can be examined by working through a hypothetical market—say, a metropolitan area of slightly more than 1 million people, with 19 commercial stations licensed to the city or to nearby suburbs. The market also includes four noncommercial stations: three public radio stations affiliated with colleges and a contemporary Christian station. (The different nature of noncommercial operations was discussed in Chapter 7.) See 11.5 for a list of commercial stations in the hypothetical market. Boldfacing shows the leading station in each demographic group.

The market is typical of many medium and large markets, with three significant group-owned station clusters. The remaining commercial stations in the market are owned by small groups, with additional properties located in other markets. Of the three groups, HugeCo controls the most stations in the market and is one of the biggest national station groups, with several hundred stations covering all market sizes. Big Sky is also a major group with around 200 stations nationally, primarily in medium and a few large markets. RadioEast is a relatively small company, family controlled with fewer than 20 stations, most in medium and small markets. This is their largest cluster and second-largest market.

After a period of rapid consolidation, programming and station rankings in the hypothetical market have been fairly stable for the past couple of years. The last station acquisition took place two years ago when RadioEast bought into the market. The last format change (KIII's move to soft AC from alternative) took place at about the same time. There is relatively little competition within formats; KDDD-FM, KAAA-FM, KOOC-FM, and KKKK-AM have generally been the ratings leaders for quite some time.

Station facilities are remarkably equivalent. Of the AMs, only one station is a daytimer (KNNN), although KHHH does have a restricted nighttime pattern. In the FM band, all are high-powered class Cs with the exception of Big Sky's KBBB and KSSS, both of which are class A stations licensed to nearby suburbs of the metro city. Most of KSSS's programming is simulcast on KSSS-AM as well as on four other AM stations around the state (billed as the Sports Monster Radio Network). Big Sky recently added a translator for KBBB on the cpposite side of the metro area to improve coverage.

Even taking into account the relatively poor nature of its facility, Big Sky believes KBBB is underperforming in its present/smooth jazz format and is considering a format change. Given the makeup of the market, what are the best options? Is there a format that could improve Big Sky's overall competitive situation? What groups are unserved in the population? See 11.6 for a description of the population distribution in the hypothetical market.

First, let's look at the competitive structure of the market. Big Sky's existing primary strength is in the male demos; it has the number-one station (KAAA) among men aged 18 to 34 and 25 to 54. Between the rock and sports stations, it has nearly

List of Stations, Formats, Facilities, Owners, and Ratings in the Hypothetical Market (6 A.M.–Midnight, Monday–Sunday)

Station Format	ERP/HAAT Frequency	Owner	Share 12+ Cume (00)	M 18-34	W 18-34	M 25-54	W 25-54
KAAA-FM	97 kw kW/375m	Big Sky	8.2	24.6	8.4	12.6	3.9
Rock	100.7	97	1475	559	329	558	309
KBBB-FM	6 kw kW/100m	Big Sky	2.3	0.8	0.8	2.7	2.7
Smooth jazz	98.1	3 /	446	41	39	147	156
KPPP-FM	100 kw/325m	Big Sky	5.6	7.6	10.7	5.6	6.7
Hot AC	99.1	0 /	1423	329	409	379	465
KSSS-AM*	1 kwD/1 kwN	Big Sky	1.5	2.9	0.1	3.2	0.4
Sports	620		386	89	9	217	39
KSSS-FM*	6 kw/90 m	Big Sky	1.7	3.8	0.4	4.0	0.4
Sports	105.1		401	120	31	263	52
KCCC-AM	1 kwD/1 kwN	HugeCo	1.3	1.4	2.0	1.1	1.2
Variety	1320		309	63	79	70	97
KDDD-FM	100 kw/300 m	HugeCo	10.9	10.5	18.5	5.4	11.5
CHR	102.9		2268	443	575	434	692
KIII-FM	100 kw/425 m	HugeCo	3.9	1.3	3.8	2.6	7.1
Soft AC	94.9		918	97	174	219	389
KKKK-AM	5 kwD/5 kwN	HugeCo	6.5	2.0	1.4	5.3	3.5
News/talk	1010		1207	77	65	329	254
KLLL-FM	100 kw/425 m	HugeCo	6.1	6.6	11.1	4.6	7.9
Hot country	102.1		1249	223	334	301	412
KOOO-FM	98 kw/350 m	HugeCo	7.6	5.0	6.6	6.8	8.1
Country	96.3		1401	162	256	326	441
KRRR-AM	5 kwD/5 kwN	HugeCo	1.1	0.1	0.1	1.3	0.5
Talk	910		359	10	11	90	43
KFFF-FM	100 kw/400 m	RadioEast	5.4	3.4	7.9	4.0	9.2
AC	104.3		1201	149	268	285	500
KGGG-AM#	50 kwD/50 kwN	RadioEast	1.4	0.2	0.1	1.4	0.6
Oldies	1490		392	21	14	92	67
KGGG-FM#	100 kw/275 m	RadioEast	5.8	1.4	2.4	6.2	6.9
Oldies	92.7		1156	86	82	351	387
KJJJ-FM	100 kw/300 m	RadioEast	6.5	7.7	4.3	12.4	6.1
Classic rock	107.7		1199	258	180	584	359
KNNN-AM	1 kwD	Hometown	3.7	4.1	5.5	2.5	4.5
Urban	1110		513	90	129	104	166
KHHH-AM	2.5 kwD / .5 kwN	Faith	0.9	0.2	0.5	0.8	0.8
Religious	780		252	21	11	69	63
KEEE-FM	100 kw/250 m	OK Ltd.	4.4	3.3	1.7	4.1	2.9
Classic country	93.5		730	86	78	186	174

^{*}Simulcast approximately 75%.

[#]Simulcast approximately 90%.

11.6 Selected Population and Demographic Estimates

Total metro population: 861,000 Total DMA population: 1,300,000

DMA Racial/Ethnic Population Estimates

White	77.0%	
Black	10.0%	
Hispanic	5.0%	
Asian	3.0%	
Native American	5.0%	
Women	51.4%	
Men	48.6%	
Teens 12-17	10.5%	
18-24	11.3%	
24-34	16.5%	
35-44	18.7%	
45-54	16.4%	
55-64	10.6%	
65+	16.0%	

35 percent of the 18 to 34 male demographic and a 20 percent share of men aged 25 to 54. With classic rock and oldies formats, RadioEast is also strong in the male demographics, but has primarily an older audience (remember the skew graphs?). Meanwhile, because of its size, HugeCo has effectively covered the full age range on the female side. Big Sky has only one female skewing station, hot AC KPPP, which is a distant third among women aged 18 to 34 behind HugeCo's CHR KDDD and hot country KLLL. Among women aged 25 to 54, KPPP is seventh, also trailing HugeCo's mainstream country KOOO, RadioEast's AC KFFF, and oldies KGGG.

Given that overview, let's look at potential format holes in the market. We can eliminate the news and talk formats right away. They're expensive to program, requiring large staffs, and with two stations covering that territory, there are already enough stations in the market providing that programming. Plus, an FM station seems more suited to a music format.

We can also eliminate country off the top. Although this is a strong market for county music, there are already three stations in the format, with a combined 18 share of persons 12+. Each station has carved out its own audience niche, and no single station seems to have a segment large enough to further subdivide. Moreover, the two most successful country stations are owned by HugeCo, and their combined promotional and programming strength would represent a substantial barrier for any new competitor to overcome. Big Sky should look elsewhere.

The situation in AC is similar, except that no owner has more than a single station in the format. KFFF, KIII, and KPPP represent a combined 15 share (and a whopping 23 share among the primary target audience, women aged 25 to 54), and their formats are spread across the range of AC programming. A fourth station would be competing head-to-head with one—and, to some extent, with all three plus CHR KDDD (which, like many CHR stations, sounds more like an AC format during weekdays in order to better capture atwork adult listeners). There could be some small niche available but the competition in this segment, although indirect, is most likely a significant factor in KBBB's current low ratings. Moreover, we certainly want to avoid potentially cannibalizing our existing female audience on KPPP.

In the rock category, Big Sky is dominant (KAAA). Oldies and classic rock belong to competitors, but those are generally one-to-a-market formats (although an oldies hybrid might be a possibility). Combining the sports stations (KSSS-AM and FM) with KAAA, Big Sky has very strong male numbers. Perhaps it would be possible to further increase our younger male demographic power with an alternative format or add some older listeners with a AAA format? The rock audience will generally accept alternative music on their station, although the reverse is often not true, and KAAA plays some alternative music. Most likely, moving KBBB to alternative would simply take audience from KAAA, leaving little or no net gain.

There are several possibilities, however. One option would be an older-skewing music format like adult standard. This audience is not well served by existing programming, but that is because an older audience (55+) is often difficult to sell to advertisers. Another possibility is urban or urban oldies,

currently available only on an AM daytimer with poor facilities. According to the U.S. census data, the market has a substantial minority population (approximately 10 percent black and 5 percent Hispanic), and the urban format can also have substantial appeal for white ethnic audiences. One of the Hispanic formats might succeed if it had that market all to itself, although implementation is difficult for a company without previous experience in that marketplace because of language and cultural barriers.

Finally, there's CHR, currently represented by the 12+ market leader KDDD with a share of 10.9. That big share of the audience is a tempting target, and the opportunity for Big Sky to strike at the market's biggest group is a battle many program directors would relish. Moreover, the CHR (or the urban) audience would be a good fit for KPPP if there were some minor tweaking of its format, and this could potentially strengthen Big Sky's relatively weak overall female numbers without Big Sky having to simply steal from KPPP's existing audience (although there would undoubtedly be some audience sharing).

Thus, an urban hybrid (rhythmic CHR or urban AC) looks to be the best opportunity in the market. Census data indicates a substantial younger population—57 percent—within the target age range for contemporary music (28 percent in the core demographic between 18 and 34 years of age, plus 11 percent aged 12 to 17, and another 18 percent aged 35 to 44; slightly more women than men in all ages). Most of this audience is currently served by relatively few stations because the majority of stations chase the mid-adult demos. The existing urban station would not be a significant competitor because of its facility. In addition, picking rhythmic CHR rather than true urban would allow the new KBBB to attract listeners from the large KDDD audience and potentially turn them into listeners whose first preference is KBBB (P1s in rating terminology—the core listeners of a station).

Implementation

A format change will necessitate a new station identity (new call letters, which would require an FCC application, and a slogan), new music, and probably new air talent. Moreover, the work will

have to happen quietly, behind the scenes, in order to avoid tipping off the other stations (and media reporters) in the market. That means some (or even all) of the work must be done away from the station or at times when few, if any, other staff are around. The program director's first step is to settle on the station's target audience and identity. Branding and positioning are complicated matters, but in simplest terms, the station needs to create an image in the audience's minds that matches the audience's self-image. In other words, the station should fit into the listeners' desired lifestyle in all regards, from the music to the logo and slogan to the DI patter between songs. Who is the typical listener, the highly valued P1? In this case, imagine a young (20- to 30-year-old) adult, most likely female, who works in a professional or technical field; she enjoys music (with a danceable beat), clubs, movies, and sports; drives a small, sporty car; is interested in fashion; dines out several times a week; exercises regularly; and enjoys traveling.

Next, we'll need to consider, in consultation with the general manager and other corporate executives, whether current Big Sky personnel (at KBBB or perhaps KPPP, or at another station outside the market) are suited to the new format. If so, those people may be quietly brought into the process as needed. If not, there will be that much more work for the PD and the one or two other managers who are aware at this point of the impending change. The air staff can be hired prior to the debut but doesn't have to be. Some stations change format, then gradually add air talent as they can be located and hired. In the interim, the station operates either without DJs or by utilizing voice tracking. Some stations have used the initial launch period to make a splash in the market by offering extended commercial-free stretches or other special programming that lasts a few hours to a few days. But beware of setting up inappropriate audience expectations with this strategy. Whatever management does needs to both encourage the target audience to sample the station and begin the process of building an affinity with that audience.

Building the station's music library is another task to be accomplished before the format goes on the air. Developing rapport with record company promoters is one way to receive music (see

355

11.7 Paying-for-Play

espite the elaborate systems discussed in this chapter, station programmers do not get to choose all the music that is played. Dozens of songs are released weekly, but stations add only a few new tunes to playlists. New songs require spin time before they become recognizable, and too many unfamiliar songs annoy top-40 listeners. Individuals representing record companies try to persuade station programmers to include on local playlists the songs they are promoting.

Their method of persuasion is money. Because the IRS accepts that pay-for-play money is spent on song promotion, the dangerous problem of payola is sidestepped. The station's task is merely to add to its playlist the songs recommended by the indie.

The Record Companies

The system works this way because the record companies rely on radio stations to sell records. Until recently, independent promoters, called "indies," were the sole negotiators of pay-for-play deals between the large labels and about a thousand stations. These indies became the middlemen because music companies were reluctant to pay radio stations directly for music promotions. Direct pay smelled too strongly of payola.

Nonetheless, recent controversies about possible payola occurring in combination with an industry-wide economic downturn have prompted some big music companies to end their relationships with the indies. These music producers have begun to use their own promoters to deal with the big station groups at the management level. The initial fees they pay are considered "sponsorships" when songs are "previewed" by corporate programmers or "showcases" when new talent performs. Stations must acknowledge on the air whenever music is being sponsored or showcased. Although their role as middlemen for the major labels has declined, indies remain a force for promoting smaller labels, especially in minor markets.

Pay-for-play strategies have unprecedented influence over what music listeners hear. Promotions occur

in various ways. Some legitimate indies are still employed by some labels to get songs on radic playlists, and payments vary based on the station's market size. Bonuses are paid when (a) songs are added during a desired week, (b) a song's rotation increases, cr (c) a song reaches certain heights on the playlist. But the negative outcome of this system is that local artist and small labels have been virtually excluded from most commercial radio playlists.

The Radio Stations

Payola is defined as D_s or radio stations accepting cash or other consideration from record companies in exchange for airplay. During the 1950s, it was widely known that many disc jockeys accepted gifts (drugs, money, TV sets, and so on) for playing specific rock 'n' roll songs. Finally, after much scandal in the industry, in the 1960s federal laws made exchanging money for airplay illegal unless the payments were acknowledged on the air.

More recently, stations and record labels have also been accused of unethical and illegal tactics that limit opportunities for musicians and smaller labels. A 2007 consent agreement between the FCC and Clear Channel, CBS Radio, Entercom, and Citadel Broadcasting cleared several payola allegations. Each of these broadcasters agreed to provide airtime for independent labels and artists and to subscribe to certain rules, including not selling or bartering "access" to its music programmers and not working with independent promoters whose compensation is based on increased spins or plcylist additions.

The FCC's crackdown has diminished pay-for-play promotions because stations are unwilling to risk losing their licenses. Legitimate independent promoters continue to be in demand, however, especially by independent artists and smaller labels that seek higher profiles and greater airplay.

Frank Chorba, Ph D. Washburn University

11.7 to get a sense of the risks). When the music director or program director makes contacts with friends in the music business, the station gets on their call schedules and mailing lists. This ensures that the station will receive all the current material

promptly, in many cases prior to the actual release date. Most important, however, is becoming a reporting station for trade journals (see 11.8). Getting current CDs is fairly easy for stations in larger markets and others that report their airplay

11.8 Measuring Airplay

isagreements about airplay decisions and how the quantities of spins are reported have been a consistent problem for both radio and the music industry. Because of flagrant abuses in the past when stations and local retailers individually reported figures, nowadays sales figures and airplay (spins) are monitored by independent tracking organizations such as Nielsen Broadcast Data Systems and Mediabase Research. Such outside monitoring prevents unscrupulous programmers from reporting that they played certain songs more or less frequently than they really did. Subsequently, station play figures are compiled into charts for various formats, and reported in trade magazines like Billboard and Radio & Records.

Frank J. Chorba, Ph.D. Washburn University

to Radio & Records because the record labels will happily provide them. There are also more specialized trade journals, such as CMJ (www.cmj.com), and reporting airplay to those magazines can also be a way to ensure music service.

To prepare a new contemporary format, the station needs the previous 6 to 12 months of releases. Performance licenses (requiring annual royalty fees) should be obtained from each of the three traditional performance rights organizations (PROs): ASCAP (www.ascap.org), BMI (www.bmi.com), and SESAC (www.sesac.com). The licenses grant the station the right to play nearly all popular music, a necessary expense for music stations. The PROs then distribute most of the money to the music's copyright holders (music publishers and songwriters), based on surveys reporting the amount of airplay.

If the station plans to stream its signal online, separate licenses are required from ASCAP, BMI, and SESAC. More significantly, streaming requires paperwork to be filed with the U.S. Copyright Office (www.copyright.gov) along with a small fee, and additional performance royalties are due to the record labels and musicians. That separate performance right is acquired from SoundExchange (www.soundexchange.com), an organization formed to

manage those digital copyrights for the record labels much as the traditional PROs track airplay and collect and distribute money for songwriters.

Someone will have to dig for the recurrents and the gold—especially the latter. Because of their age, many of these recordings are scarce. Promoters and distributors are often out of stock and in some cases discs are no longer being made. It may take months to build the gold library, and these recordings should be kept under lock and key to forestall avid collectors among staff members. Many stations use "gold services" such as Jones TM's Gold DiscTM Library (a complete oldies library on compact disc). Although it is an additional programming cost to the station, a purchased library offers savings in time and convenience. Each disc may have as many as 20 songs on it. Furthermore, many companies offer CD jukeboxes that contain an entire library kept under lock and key. Only the music director and the program director have access to the discs.

Another option is to purchase a complete (or nearly complete) library as part of a digital automation system. Such companies as dMarc, now a division of Google (www.dmarc.net/index.html) and RCS (www.rcsworks.com), provide programming software and hardware systems that deliver the music for most popular formats and can include the music itself (for an additional charge, of course) either already on the hard drive of a new system or as separate audio files for existing systems.

Digital automation systems that use hard-drive audio storage and playback for songs as well as commercials and other spots are becoming standard (and more affordable as the cost of technology drops). However, some stations still play compact discs on the air. A few may still use carts (audio cartridges) or even, on special occasions, old-style vinyl records. The program director needs to temporarily act as the music director in order to structure the music, and later one of the jocks can take over the music duties. In a typical setup, the music director works for the program director, overseeing music research, taking calls from record company promotion reps, and preparing proposed additions and deletions to the playlist. The program director has the right to make the final call, but the music director does the background work.

To recruit experienced air talent, Big Sky will place ads in trade publications and on the websites of state and national broadcast associations of which it is a member. Management will also look for referrals within the company. Small-market stations, or others offering entry-level jobs, also send announcements of openings to nearby colleges and universities. In hiring an air staff, the program director will look for men and women who can relate to the target audience. They should be capable of conveying the station's attitude, be knowledgeable about music and other lifestyle elements that are important to the audience, and—because street promotion is important—they should look the part in most cases.

After the air staff is hired, ongoing training and development are important parts of the program director's job. Regularly scheduled aircheck critiques (listening to recorded shows and discussing the on-air performance with the talent) are important opportunities for the PD to keep the station focused and the sound consistent. For young and relatively inexperienced talent, the PD may want to have weekly aircheck sessions. More mature talent may only need (and want) monthly critiques from the program director. The best talents regularly listen to their own work and conduct self-critiques, keeping the elements of the station's format in mind.

It is essential that the air personalities bring the proper attitude to an aircheck session. They have to want to improve their work and help the team. Getting defensive when the PD points out a problem or makes a suggestion is counterproductive and will likely lead to a short career. Similarly, program directors need to offer praise for good work as well as suggestions for subsequent improvement. Each session should end with one or two specific areas for the talent to work on for the next aircheck meeting.

The Music

No one "right way" to program a radio station exists. Moreover, what works in one format or market may not work in another. Good research is one key to success, and it encompasses all formats.

A Music Model

To show how the basic process works, this chapter presents a model that combines aspects of systems used by radio stations across the country. This system represents one plan for programming a rhythmic CHR station that is designed to achieve maximum attractiveness to the 18 to 34 demographic target. The station will use five major music categories: power, current, recurrent, power gold, and gold. Other stations or formats might have additional categories. Some programmers might further divide the categories by tempo, style, or genre, or-in the case of formats with substantial gold libraries—by era. Any contemporary popular music station can use this basic formula, whether it is CHR, rock, AC, country, or urban. It would require significant modification, however, to work for an oldies or classical format.

- 1. Power. This category contains approximately 10 top songs, played at the rate of four to eight each hour. (The rotation would be slower, one to three each hour, in most non-CHR formats.) Rotation is controlled so that the same song is not played at the same time of day on consecutive days. Rotation time—the time that elapses before the cycle of 10 songs begins again-often varies by daypart. It can go from as little as 75 to 90 minutes in the late afternoon and evening in our rhythmic CHR format to as much as s_x or eight hours in some AC or rock formats. The exact rotation is decided by the program director. The songs in this category are the most popular of the day and receive the most airplay. They are selected weekly based on the following:
- How they test during call-out research with the station's audience
- Their rankings and audience test scores in national trade magazines such as Radio & Records
- Local sales (to a lesser degree)

Area record stores can be contacted weekly for sales information, which they record by bar code. In smaller markets, rankings of sales and airplay in trade magazines often play the biggest part in determining playlists (see the "Music Research"

section of this chapter). In bigger markets, telephone testing was traditionally used to measure popularity, but the popularity of cell phones among young listeners and restrictions on calling out have diminished the use of this option. In a call-out, a sample audience hears part of a song (the hook) and is asked to evaluate it. Many stations also now use online panels of listeners to evaluate songs.

- 2. Current. This category contains the remaining 20 or so currently popular songs. They are played at the rate of three or four per hour (in an hour with no commercials, five might be played). Some stations subdivide this category by tempo or mood, placing slow songs in one group and fast, upbeat ones in another; other programmers subdivide by popularity, grouping those moving up in the charts separately from those that have already peaked and are moving down in the charts. The same research methods used to determine the power songs determine those in the current category. Together, the powers and currents form the station's current playlist of about 30 songs.
- 3. Recurrent. This category contains songs that are no longer powers or currents but have been big hits within the last two years. (Some rock and AC stations may keep songs for up to three years in the recurrent section.) These songs get played at the rate of two to four per hour, depending on commercial load and desired rotation time in the first two categories. Some stations limit this category to 30 records played at the rate of one an hour; others may have as many as 100 songs, playing them twice an hour. Songs usually move into this category after being powers or currents, but a few would be dropped from the music list: novelty records that are burned out (listeners have tired of them) and records that stiffed (failed to become really big hits). These songs should be tested periodically for audience burnout by telephone call-out or web-based research.
- 4. Power Gold. This category contains records that were very big hits in the past 3 to 10 years. There may be from 100 to 300 of these classics, and they are played at the rate of one to three per hour, depending on commercial load and format.

The songs are recycled every few days. These are the "never-die" songs, often by core artists in the format, that will always be recognized by the target audience and immediately identified by it as classics. They greatly enhance the format because listeners get the impression that the station airs a broad range of music. Because there are so many of them, auditorium research is the best way to test these songs for desirability, recognizability, and burnout, but they may occasionally also be rotated through call-out or web tests.

5. Gold. The gold category contains the rest of the songs from the past 10 to 15 years that are not in the recurrent or power gold categories. This group of 200 or so titles is played at the rate of maybe one an hour, depending on format and commercial load. In some formats, they may disappear entirely for certain dayparts (in the case of our hypothetical rhythmic CHR, we probably would not schedule many, if any, in PM drivetime and evening periods). Songs in this group are carefully researched, usually with auditorium tests, to make sure they appeal to the station's target demographic group and are not suffering from burnout. Stations can extend their gold categories by not including in the active library every song that meets their criteria for airplay. Rotating songs in and out of the active gold library every few weeks-or creating subcategories that rotate at different speeds—can increase the audience's sense of musical variety on the station—while maintaining a consistent sound.

A final category, oldies, may complete the record library for some formats (although CHR stations omit it entirely). Oldies comprise the largest group because it covers the greatest span of time—all the hit songs from the 1950s up to 10 or 15 years ago. As many as 600 songs may be in the group, and they are played at the rate of one to two per hour in some formats. The commercial load and the number of older listeners the station wants to attract will determine how many oldies get played. Songs in this group had to be hits at the time they were released and must continue to be popular. Programmers for AC and oldies stations subdivide songs in this category according to the dates the songs were originally hits. The year categories

listed here roughly parallel major historical shifts in the style of popular music:

- Mid-1950s to 1964
- 1965 to 1972
- 1973 to 1980
- 1980 to the early 1990s

A song that is a huge hit in one market can be a dismal flop in another. These songs will be auditorium tested for signs of burnout in the specific market and could also occasionally be part of web testing.

Music Research

The key ingredients in designing a successful format are careful planning, ongoing local research, and a willingness to adapt to changing audience tastes and competition. Although music tastes within a format tend to be more homogenized nationally today than in the past, because of video music channels on cable, the mobility of the population, and consolidation in the music and radio industries, successful programmers are always aware of-and take advantage ofmarket-specific variations. Music stations may employ one or more people to handle call-out or web-based research and to assemble statistics, or the music director may work with specialized consulting services. The more objective information that the researcher gathers, the easier it is for the programmer to evaluate the record companies' advertising and sales. Record promoters naturally emphasize their products' victories, neglecting to mention that a record died in Los Angeles or Kansas City. The station must depend on its own research findings to rate a piece of music reliably.

As explained in Chapter 2, call-out and web-based research gets reactions directly from radio listeners. Two versions of the technique are used—active and passive. In active call-out research, the names of active listeners are obtained from lists of contest entrants or regular listeners who volunteer to be part of a web panel. The passive version selects names at random from the telephone directory (see 11.9).

Another method of radio research, primarily for the gold and recurrent parts of the library, is auditorium testing. Several companies specialize in this kind of audience research. Typically, they bring

a test group to a large room and ask them to evaluate music as excerpts are played. As many as 300 songs may be tested, with the audience writing their responses on special forms or punching in responses electronically. The tabulated results will be broken down demographically and usually provide valuable information to programmers about which songs to play in which dayparts and which songs may be wearing out for the target audience. Additional questions can be asked; for example, "What stat on do you listen to most?" "Second most?" "Who has the best news/the best sports/the best personalities?" "What is the most irritating?" and so on.

Web-based systems have made research more accessible to small- and medium-market stations than traditional telephone or auditorium testing because web testing is less expensive. The process begins similarly to that of active call-out telephone testing. A station recruits a sample of audience members willing to participate in testing (in this case, via on-air announcements or the station's website). Once the panel is assembled, the program director uploads the song hooks to the website weekly for even more frequently if needed) and then sends out an e-mail to the sample group announcing that the music is ready for their assessment. The listeners then complete the testing at their convenience, and the results are made available immediately to the program director and music director.

Controlling Rotation

Regardless of format, music stations must control rotation (the frequency of play of different kinds of songs). For many years, stations used a flip card system. Each song was placed on a 3 × 5 card in a file box (perhaps separated into different categories of music). DJs were instructed to play the next available and appropriate song and place the flip card at the back of the stack.

The basic system has not really changed much, but computers allow much more sophisticated means of tracking what song is played where and what kind of restrictions apply, allowing the music director and program director to create exactly the flow they want. By combining airplay data with ratings information, programmers can track how the music flow impacts audience flow as well as

11.9 Call-Out Research

hen calling randomly selected people out of the telephone book, the first step in an interview is to qualify the person—that is, to make sure the person is in the target demographic and listens to, or prefers, the kind of music the station plays. In either case, respondents are asked to listen to excerpts (hooks) from the songs being researched and to rate them on a scale from 1 to 5 as follows:

- 1 = "Hate it."
- 2 = "Dislike it."
- 3 = "Don't care."
- 4 = "Like it."
- 5 = "My favorite record."

Research will also assess the extent to which a record might be burned out by asking listeners whether they are "tired" of hearing the song. (A high burnout percentage tells a PD that the song might need to be retired from the active library, either temporarily or permanently.) When a sample is completed (100 calls is typical), the votes for each number on the scale are tabulated. The various totals are then manipulated to obtain interpretations in terms of ratios or percentages. (See the weekly *Callout America* report in the CHR

section of any issue of *Radio & Records* for an example of this research on a national scale.)

For example, assume 100 listeners are called within a week, and 30 records are discussed. Twenty-four listeners say they like song number five, and 36 say it is their favorite record; 11 said they didn't like it, 6 didn't care, and 9 hated it. Fourteen had never heard it before (a very high recognition rate of 86 percent). Song number five thus has a total score of 325 and an average response of 3.78—this song is scoring very well with that core audience. It should definitely be high in the playlist, and depending on its age, trend, and the scores of other current songs, it might qualify for the power category.

When doing call-based research of any kind, it is crucial that the questions be asked in the right manner. It is important to make the respondents understand that they are being asked to help determine the station's music selection. Because the station is their favorite, they should be pleased to have the opportunity to shape its programming even more to their liking. During a music interview, respondents can also be asked to comment on other things they like or dislike about the programming. This requires a sympathetic ear on the part of the researcher.

how frequently the audience is really hearing a song. Computers can be used to do the following:

- Follow a category rotation
- Restrict some songs to particular dayparts
- Balance up-tempo and down-tempo songs
- Avoid the scheduling of two songs by the same artist too closely together
- Prevent songs from playing too close to the same time every day
- Prevent adjacent songs of the same type (such as two "old school" songs or two rhythm and blues songs)

Adherence to such restrictions leaves most of the control in the hands of the program director rather

than in the hands of the on-air personality—whose focus should be on his or her performance between songs rather than on selecting music. DJs as well as the program and music directors can get printed lists of all the songs to be played, although it is more common to display the log on a computer monitor in the studio. Experienced talent with a good understanding of the format may sometimes be given the flexibility to make alterations to the schedule, but not all PDs are comfortable giving up that control. Broadcast software can integrate the music log with the traffic log to present the air talent with a single seamless schedule, and the screen may even include scrollable live copy or other performance notes for the air talent.

When setting up the rules for the format, the PD must balance concerns about the sound of the

station with the ability to schedule music. The more rules that are in place, the more difficult it becomes to schedule each day without breaking one or more rules. In setting up the rotations for various music categories, it is especially important to watch the relationship between the number of songs in the category, the rotation speed, and the clock structure. The program director must make sure the categories are not cycling in time frames that are multiples of each other, which would lead to categories synchronizing and the same songs playing together in a pattern. In the example of our hypothetical station, the power category is set to turn over every 90 minutes. Thus, the current category should be rotated at a pace to avoid turning over at 3 or 4.5 hours (which would synchronize to the second or third power rotation at 90 minutes). Good choices would be 3.5 or 5.5 hours, keeping given songs in the categories out of sync for substantial lengths of time. Gold and recurrent categories generally have enough titles and slow enough rotation that synchronization is not a major issue, but programmers should still be aware of unintended patterns.

The Hot Clock

One of the program director's major responsibilities is to construct hot clocks. A hot clock is a design (it looks like the face of a clock or a wheel), and it visualizes the formula for producing the planned station "sound." It divides an hour into portions for music (by category), weather, news, promos, and commercials. Hot clocks place the elements that make up the programming for a given hour. The PD devises as many hot clocks as are needed: one for an hour with no news, another for an hour with two newscasts, another for an hour with one newscast, another for an hour with 10 commercial minutes (or 12 or 16 or however many the station allows and could sell). Hot clocks are a way to effectively manage dayparting-that is, estimating who is listening at a particular time of day and what their activities are, and then programming directly to them.

Stations that use computers to program their music embed the hot clocks in the computer software. The computer "knows" that at six minutes

after the hour it should play the next power song. Because the computer plans ahead, it will adhere to the usual restrictions, making sure, for example, that another song by the same artist has not played recently and is not scheduled too closely in the future.

Typically, morning clocks include news and heavy doses of information (traffic and weather in particular). Clocks for the remainder of the day do not include news in most music formats but may offer traffic and weather in the afternoon. In all, there may be as many clocks as hours in the day, with a completely different set for weekends (where weather is the key information element).

Besides structuring information (news, weather, traffic), promos, and commercials, the hot clock also structures the music for a given hour. The music portion of an hour depends on the number of commercials to be aired. A commercialfree hour, for example, requires many more songs than an hour with 14 spots. A hot clock for a basic morning-drive hour designed to handle one newscast and 16 minutes of commercials appears in 11.10. This leaves room for up to 10 or 11 songs, depending on how much the DJ talks. If the station has a star morning personality (a Tom Jovner or Howard Stern, for example), there may actually be a clock with little or no music scheduled. The music for this morning hour might consist of four powers, two currents, two or three recurrents, one power gold, and one gold. The service elements—news, weather, traffic—are spaced more or less evenly throughout the hour. As is typical of a contemporary music

11.10 Morning-Drive Hot Clock

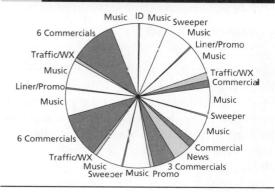

11.11 Evening Hot Clock

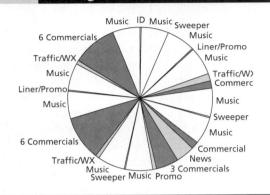

station, news has been placed in the middle of a quarter-hour. Station imaging, promotion, and identification elements, either recorded or voiced live by the air talent, occur between every song.

The hot clock in 11.11 is intended for an earlyevening show. The music selection contains 12 songs made up of six powers, two currents, two recurrents, one power gold, and one gold. Note the long music sweep from before the top of the hour until approximately 20 or 22 minutes past. This selection fits a CHR or urban contemporary station but would be different on a rock or mainstream country station (where the rotation of currents would be slower and more golds would be played). A midday clock might look similar to this one but with more golds and recurrents scheduled to slow down the current rotation a bit so at-work listeners aren't hearing the same song four or five times. The rotation pace of the currents would then pick up again during afternoon drivetime and evening.

Commercial Load

No single set of clock formulas will drive a station to the top of the market. Remember that a change in one area will also change other aspects of the clock, and there are many factors to balance. The program director has to negotiate with the general manager and the sales manager about the number of commercial availabilities (the number of spots, commonly referred to as avails) in an hour as well as the maximum number of avails in an individual break. Spot

loads vary considerably by format. News and talk operations carry the heaviest spot loads, as many as 18 or 20 minutes per hour. Music stations generally do best running about 12 minutes per hour—perhaps slightly more during morning drivetime—scattered in breaks between songs. Demands by station owners for higher earnings are forcing stations to look at ways to cut costs, and one way they can increase revenues is to increase the number of avails in an hour.

As stations struggle to make consolidation work financially, reports show many music stations running up to 16 or 18 minutes of ads in an hour. But having long music sweeps requires long commercial clusters, which may damage advertising sales and drive away listeners once they figure out the pattern. Stations running "10 in a row" leave room for only two very long breaks, sometimes with as many as seven or eight spots each, lasting between 35 and 50 seconds per avail. The strategy may work, at least in the short run, if everybody in the market follows along. The risk is that a heavier-than-normal spot load opens a station up to attack by a "more music" competitor. More importantly, this creates dissatisfaction among advertisers who feel their message gets lost in long commercial breaks because few listeners stick it out. This concern has been blamed by some in the industry for radio's inability to increase its share of the overall ad dollars, and a few groups have started to cut back on the number of avails in an hour (hoping, obviously, that the remaining spots will be worth more money). And most recent reports have operators reducing the spot loads to more manageable levels. Some station groups, most notably Clear Channel, have tried moving advertisers to 30-second or shorter spots (rather than the traditional 60-second units) in order to cut the number of commercial minutes without cutting the number of units—a strategy which can then be used in imaging for the station ("more music").

One key to understanding radio programming strategy is to compare stations with regard to the number of commercial spots per break (load) and the number of breaks or interruptions per hour (stopsets). Too many spots in a row create clutter, reduce advertising impact, and encourage listeners to push buttons. Too many interruptions destroy

11.12 Quality in Commercials

pot production quality is critical. Too many radio spots (promos and public service announcements as well as commercials) are full of clichéd copy and fail to grab the audience's attention. Listeners don't so much hate commercials as they hate poorly executed, pointless commercials that don't address a recognizable need of the audience. Commercials should sell the audience on the product or service (by explaining how that product or service fills some need or desire), and they must complement the format rather than clash with it. Stations that will take any spot, so long as it's paid for, and that rely on poorly trained (or untrained) salespeople as copywriters and producers risk alienating their audiences and failing in the long run. Stations can best serve their audiences and their advert sers by making sure that the commercials they run fit the format and the target audience, and are creative, effective selling tools aired in a (relatively) uncluttered environment.

programming flow and also encourage listeners to migrate to other stations or to CDs. Because advertising is necessary, management must establish a policy that is reflected in hot clocks and stick to it (see 11.12).

In the past, stations have kicked off new formats with no commercial load whatever. In 2004 Nine-FM (WRZA, 99.9) launched in Chicago with 9,999 songs in a row (and a promise to restrict the commercial load to just nine units per hour afterward). Another popular audience-holder is the 5-, 6-, 8-, or 10-in-a-row concept ("We've got 10 in a row coming up without commercial interruption"). The longer the listener stays with the station, the more the station's quarter-hour shares are improved. A listener staying through a 10-song sweep will have been tuned in for 35 to 45 minutes, or three quarter hours. The tradeoff is the six- or eight-minute commercial break that follows and the second long stopset that will come up after just one or two more songs.

The station still needs to sell a certain number of commercials at a given price in order to be profitable. Longer music sweeps and fewer stopsets mean longer stopsets with more commercial units in each. Nevertheless, this programming technique remains commonplace in many markets, formats, and dayparts and will likely continue until advertisers or the audience reject it. A risk-filled tension always exists between the number of commercials and the number of interruptions that can be tolerated.

Marketing and Promotion

The modern radio station pays almost as much attention to marketing as to programming. Indeed, one station group in Chicago has retitled its program directors as "brand managers." Marketing is essential for keeping a station from simply disappearing in the crowd. Nowadays, stations use television, newspapers, billboards, bumper stickers, bus cards, cab tops, and other graphic media. Promotional stunts are the special province of pop radio, and involve the cooperation of programming personnel. If this chapter's hypothetical station were trying to break into a large market, the station might need as much as \$2.5 million the first year for promotion.

Station promotion takes two forms: on-air and off-air. On-air promotion is suited for retaining current listeners through reinforcing their positive image of the station or extending the amount of time they listen through contesting or other incentives. Attracting new listeners requires a significant investment in off-air promotion, often in conjunction with on-air promotion events. Off-air alternatives include billboards, television, direct mail, and telemarketing. In a medium-sized market (500,000), television and billboard advertising might run \$25,000 a month for good exposure. It may cost five times that in a Dallas- or Chicagosized market. Not only are unit prices higher in large markets but more territory must usually be covered. A set of painted billboards reaching the whole population in one market may require 35 billboards, for example, although a similar showing in Dallas would require 125 billboards at an average cost of several thousand dollars each per month. Television advertising, which is even more expensive but often necessary for launching a new format, can help generate the kind of top-of-mind awareness among the audience that drives ratings.

Station promotion can have three possible goals: to build audience share (by extending the listening of the current audience), to build cume (by attracting new listeners), or to simply enhance the audience's expectations of the station without having to meet an immediate ratings goal (positioning). In any case, it is essential that the promotional effort be focused on the listener and the specific goal if it is to succeed. Too often, promotions happen because of advertisers' or a station's own economic concerns rather than through a focused attempt to achieve one or more of these three goals (see 11.7,

which discusses the way the industry pays to get songs on the air).

Contests can build the station's share of audience if they are constructed to extend a listener's time spent with the station (see 11.13). Thus, their elements need to stretch over multiple quarter hours (but be careful not to overdo it). To build the cumulative audience, a sufficient budget is needed for reaching and enticing potential listeners with billboards, print or television, or direct mail. In addition, stations should concentrate their efforts on one promotion at a time. Multiple concurrent

11.13 Contesting

he traditional promotional stunt is the contest, but the industry favors the term "word game." Many people think they cannot win contests, but they like to play games. For many stations, a contest approach emphasizes a superprize of \$25,000 or more. Such amounts can be offered only a few times each year (during the Arbitron survey sweeps). And because a station cannot afford to risk losing the big prize on the first day of the game, winning has to be made difficult.

Traditional promotion theory holds that people are more likely to think they can win a small prize than succeed in a \$25,000 treasure hunt or win a safe containing \$50,000. With a superprize, one person is made happy, but thousands are disappointed. Thus, it would be better to break up the \$25,000 prize into \$250 prizes and scatter them through a more extended period. But the growth of huge national station groups has added an interesting twist. Those stations regularly pool resources and jointly run a contest with larger daily or weekly prizes than would be possible for a single station or single market cluster. Thus, instead of giving away \$102 (or whatever number corresponds to a station's dial position) in the birthday game, a station may award several thousand dollars to the one hundredth caller. The catch is that the same prize is being offered simultaneously by the morning jocks on dozens or hundreds of stations across the country, making the odds of winning infinitesimal, although many in the local audience may not realize it unless they listen very carefully to the contest rules.

There are three steps to properly promoting a contest: (1) Tell 'em you're gonna do it: "It's coming—your chance to win a zillion dollars!" (2) Do it: "Listen every morning at 7:20 for the song of the day. When you hear it played later in the day, be the first caller at 555-0000 and win the money!" (3) Tell 'em you did it: "KPPP congratulates Mary Jones of your town, winner of a zillion dollars in the KPPP song-of-the-day game!" (and preferably include Mary's hyperexcited response to winning as part of the message). It is important to avoid giving exact addresses on the air. The station might be legally culpable if a robbery or other crime occurs. Also, in order to discourage possible unpleasantness for their listeners, many DJs do not use the last names of callers on the air.

Exercise caution when recording and airing telephone conversations. It is illegal to record and play back a phone call unless the person being recorded is informed of the recording and consents before recording starts or could reasonably assume from circumstances that the call might be recorded and aired. Thus, most stations avoid call-outs because the phone-call target does not respond spontaneously after going through the consent process. Listeners who call in to the studio phone line, however, are assumed to be aware that their voice may go out on the air. Management should seek legal counsel on call-out questions and should write specific instructions for programming personnel on how call-out calls are to be handled.

promotions simply dilute the impact of each and may confuse and frustrate listeners. At the same time, plenty of FCC rules and regulations apply to contests and other station promotion (see 11.14).

Community involvement projects are as important as contests for programming and promoting a successful radio station. The station must be highly visible at local events to gain a strong, positive, local image. The event should be one that is of significant interest for the station's target audience and that fits their lifestyle and the station's image. The following are community promotions that, depending on the format and market, might benefit both the station and the community:

- The station's van (customized to look like a boom box, complete with disc jockey, albums, bumper stickers, and T-shirts) shows up at the entrance to a hall that features a concert that night.
- Two or three jocks take the van and sound equipment to the beach (or public park) on the Fourth of July to provide music and "freebies" to listeners and friends.
- The station runs announcements and then helps collect clothing and other items to benefit the victims of a recent tornado by letting people drop off goods at the station van parked at different collection points in the community.

Many station groups now expect promotional efforts to directly generate nontraditional revenue (NTR) for the station. These events are similar to traditional promotion in the ways they try to connect the station to the audience's lifestyle. But nowadays, the station's sales staff (or a single, dedicated NTR account executive) works with the promotion director and PD to put together a package that will involve several large advertisers in an event. The projects can take many forms, but a typical one for many is the "Taste of . . ." The stations sell sponsorships to food and beverage distributors, which gain the sponsors plenty of visibility on all promotional literature and often exclusive rights in their product category to sell at the event (a single beer distributor, for example). At the same time, the parent station group can use

the event to promote several of its adult formats (AC, news/talk, country, some variants of rock and urban) on its other stations. Local restaurants can purchase booth space to offer their products. Live music or other entertainment can be involved, creating an additional potential revenue stream in the form of tickets for attendance (but be sure the station can at least cover the cost!).

Gordon McLendon, early innovator of the top-40 format, was one of the first broadcasters to recognize the value of sayable call letters. His first big station was KLIF, Dallas, originally named for Oak Cliff, a western section of the city. The station call was pronounced "Cliff" on the air. Then there is KABL ("Cable") in San Francisco, KOST ("Coast") in Los Angeles, and KEGL ("Eagle Radio") in Fort Worth. These call letters are memorable and distinctive brand identities and get daily usage. Today, nearly every city has a "Magic," a "Kiss," and a "Mix." More recent variants include names like "Alice" (KALC, a Hot AC station in Denver) or the Jack and Bob "antiradio" formats that originated in Canada and are now spread ng to other countries.

Stations often combine their call letters and dial position in on-air identifiers—especially if they are rock stations. In Indianapolis, rocker WFBQ calls itself Q95, and rhythmic CHR WBBM in Chicago is B96. This practice generally involves rounding off a frequency to the nearest whole number (102.7 as 103, or 96.9 as 97). The increase in the numbers of stereo receivers with digital dial displays, however, has discouraged the use of rounding off. Most stations now give their actual dial location on the a.r., such as Rock 100.5 ("Rock One Hundred Point Five"), KATT in Oklahoma City.

Other aspects of station promotion are the sweepers, liners, and jingles. Most stations use sweepers between songs during music sweeps (hence the name). These short, highly produced imaging elements include the call letters, an identifying slogan, or air talent identifier. They move the audience from one song to the next while reminding them of the station they're listening to (for diary purposes) and reinforcing the station's image, often by making aural connections between other elements of popular culture and the station.

11.14 Programming, Promotion, and Regulatory Constraints

adio broadcasters have to be aware of myriad rules, regulations, and guidelines. To keep up with them, radio programmers read trade journals, retain legal counsel specializing in communication law, and join the National Association of Broadcasters (NAB) as well as state broadcast organizations. Programmers have to be aware of legal constraints that may limit their ingenuity. Illegal or unethical practices such as fraud, lotteries, plugola, and the like can cost a fine, a job, or even a license.

Contests and Games

The principal point to remember about on-air contests and games is to keep them open and honest, fully disclosing the rules of the game to listeners. Conniving to make a contest run longer or to produce a certain type of winner means trouble.

The perennial problem with many brilliant contest ideas is that, by the FCC's definition, they are lotteries—and advertising of lotteries is explicitly prohibited by federal law (although there are many exemptions for things like legal commercial casinos and Indian gaming, charity bingo nights, and state lotteries). If your contest includes a prize, requires some form of consideration, and is a game of chance, it is a lottery and probably illegal. (Consideration here refers to payment of some kind—which could be money or extraordinary effort—that needs to be made in order for someone to be allowed to participate in a contest.) Consult the station's lawyers or the NAB legal staff if there is the slightest question.

Because of the way it conducts national contests across multiple stations in the group, at least one large group has also run afoul of the Federal Trade Commission (FTC) rules regarding deceptive advertising practices. The stations were accused of misleading listeners about the nature of the contest and their chances of winning by failing to make the multimarket, multistation nature of the contest sufficiently clear in the rules (which must be broadcast several times each day during the run of the promotion) and by broadcasting the winners' comments without identifying them as residents of other markets (thus implying they were local residents).

Sounds That Mislead

Similarly, opening promos or commercials with sirens or other attention-getting gimmicks (such as "Bulletin!")

cause listeners to believe unjustifiably that they are about to receive vital information. Listener attention can be gained in other more responsible ways that do not offend FCC rules or deceive listeners. Monitoring locally produced commercials or promos for misleading production techniques is especially important. Similarly, hoaxes perpetrated by air talent, even in the name of entertainment, can result in FCC penalties. For example, a station in St. Louis was cited for airing a phony emergency alert (on April Fool's Day) that claimed that the United States was under attack. Particularly offensive in the Commission's view was the DJ's use of the actual emergency alert tone at the beginning of the bit to heighten the realism.

Plugola and Payola

Fifty years ago, the radio industry was rocked by a series of payola scandals involving some of the industry's biggest names and stations, in which bribes were paid by record promoters to DJs in return for playing certain songs on the air. The bribes could be in the form of cash but just as often involved drugs, sex, trips, or other inducements. Although a number of reforms were implemented in the 1960s, record promotion (the attempt to influence airplay) remains a high-stakes, high-pressure part of the music and radio businesses. Similarly, announcers who "plug" their favorite bar, restaurant, or theater (in return for goods or services) are asking for trouble for themse ves and the licensees (plugola). Certainly, any tainted jock is likely to be fired instantly. Most responsible licensees require air personnel to sign statements once every six months confirming that they have not been engaging in any form of payola or plugola; some require drug tests for their employees.

Program Logs

Any announcement associated with a commercial venture should be logged as commercial matter (CM), even though the FCC has done away with requirements for program logs per se. Logs have many practical applications aside from the former legal requirement, including advertising billing, record keeping, format maintenance, and format organization.

Companies like Jones TM Century (www.jonestm.com) can provide produced imaging spots or just the production elements (music, sound effects, drop-ins from popular movies or TV shows) for local producers to use in creating these important pieces. Production directors with Musical Instrument Digital Interface (MIDI) and music skills as well as creative audio production abilities are valuable commodities in this regard.

Liners serve a similar imaging and transitional purpose but are simple scripted voice tracks or live reads without music or effects. They can be used to promote upcoming station events, music coming up after the break, or a general image for the station. To be effective, however, liners must be kept fresh, constantly rewritten, and replaced.

Singing jingles, sometimes as long as 30 or 60 seconds, were frequently the centerpiece of station imaging in most formats other than AOR prior to the mid-1980s. Companies like JAM Creative Productions (www.jingles.com) still produce short, custom radio IDs and jingles that consist of a few bars of music with the station call letters and identifying slogan sung over them. Producers create several versions for use between songs of different tempos and in different dayparts. Stations that purchase a jingle package generally receive not only complete jingles but also the individual components (music tracks, vocal elements, and so on) that they can remix themselves. Although available for nearly any format, they are seldom used today except on oldies, AC, and country stations (as well as some news and talk outlets). Historicallyminded listeners can find examples of older jingles at both the IAM website and at www.pams.com (PAMS Productions was one of the original jingle producers in the 1950s).

News and Other Nonentertainment Programming

The FCC has no formal requirements for nonentertainment programming, although licensees are required to ascertain the problems, needs, and

interests of their communities (by whatever means they deem appropriate) and to provide programming that addresses those issues. Each station's public file must contain a quarterly list of programming that the licensee has broadcast to meet those needs.

Stations targeting younger listeners often do not want to carry news, believing that their listeners are bored by it. However, adult-oriented stations must provide information to their audiences, especially during morning drivetime. News, public affairs, and "other" nonentertainment programming create a flow or continuity problem for the format. The complaint is, "We have to shut down the radio station to air that junk." Junk, of course, is any programming not directly related to the music format. However, that assumes that all nonentertainment content must be long form. The programmer's trick is weaving into the format an appropriate kind and amount of nonentertainment material, which can be effectively woven into any format. Much important information, from traffic and weather reports to upcoming events in the community, can be dished out in 60, 30, or 10 seconds, for example. Public service announcements (PSAs) are both nonentertainment and community-oriented programming, and a station can make significant contributions to the community welfare with an aggressive PSA policy. The key for programmers is to be as careful and deliberate about the choices they make with this material as they are with their music. These nonentertainment elements should be as timely and relevant to the lives of the target audience as the music. The morning jock shouldn't be wasting several minutes rehashing the weekend on Monday morning-he or she should be letting listeners know whether to grab their umbrellas or their sunglasses as they struggle to get out their doors and off to work. On Thursday and Friday, the afternoon-drive talent should be focused on events coming up that weekend as well as on helping the audience avoid the overturned semi at the airport freeway exit.

Radio will probably always be a service medium, and broadcasters will always differ on what constitutes community service. In a competitive major market served by a number of communications

media such as newspaper, cable, television, radio, MMDS, LPTV, and DTH satellite, the FM radio station that plays wall-to-wall rock music is doubtlessly providing a service, even though it is solely a music service. When the audience has so many options for music, from CDs to satellite radio, a programmer must ask just what it is that the station provides that will convince the audience to listen. In information-poor markets, owners may elect to mix talk shows with music, air editorial comments on community affairs, and in general provide useful information to the community. The services and information provided should be based on competitive market factors, the owners' and managers' personal choices, and a realistic understanding of the role a radio station can play in the particular market situation.

The Big News Question

Do listeners want news on music stations? Early studies by consultants concluded that a large percentage of rock listeners were "turned off" by news. These same listeners also hated commercials, PSAs, and anything else not related to music and fun. Some studies found, however, that everybody wanted lots of news on their music stations. More contemporary views hold that the task for programmers is to find news and information that is relevant to the target audience because it will provide an important component in the overall station identity. Listeners do value information—but only if they understand how it is relevant to their lives right now.

Some thinking on news scheduling hinges on the habits of listeners and Arbitron's diary method of surveying listeners: The idea is to hold a listener for at least five minutes in any quarter hour by playing some music so that the station will get credit in a listener diary even if the listener tunes away at news time. News is therefore often placed in the middle of one or two 15-minute periods each hour. This strategy assumes that a significant number of listeners are turned away by news. Music stations, especially those targeting younger listeners, have generally eliminated newscasts except in morning drivetime.

Journalistic Content

Having decided where to put news, the programmer must then decide how to handle it. For some stations, it is enough to have jocks (or sidekicks) rip and read newswire copy as it comes out of the machine. Some have been tempted to satisfy the need for local news by simply stealing from the local newspaper or *USA Today*. Programmers tempted to go this route should be aware, however, that stations have been successfully sued under copyright law for engaging in this practice. Although the facts of the news cannot be copyrighted, the specific expression of those facts can be.

On a slightly more elevated level, there are now local news services available that will provide local and regional news (including traffic and weather) for any station willing to pay for the service. The best known of these is Metro, a service of Westwood One. The advantage to the station is the ability to deliver timely and valuable local information at less than what it would cost to hire its own news staff. The disadvantage is the loss of any exclusivity. The same reporter filing the story for your station on the downtown fire and resulting traffic jam at 8:05 A.M. is likely to be on your competition at 8:08 (or 8:03).

Another option is to enter into a joint agreement with one of the local television stations or the local newspaper. The local evening television news anchor or a sports reporter may be a valuable addition to the radio station's morning show, and the teaming has promotional advantages for each company. Some clustered stations have adopted a variation of this cross-promotional approach if the cluster includes a news or news/talk AM station-the FM music stations get their morning news from the AM station news staff. Opinions are divided about the advisability of identifying the anchor as from the FM or the AM station during an FM newscast; some stations believe that maintaining a single brand identity is crucial to the station's image and success, while others trade on the legitimacy associated with the news station by identifying the anchor as being from that station. The lack of exclusivity is still an issue.

Programmers who set the highest goals for themselves do well to hire at least two persons to staff the news operation who trade anchoring and reporting duties during the day. This news operation would be extremely luxurious for a music station, however. The typical full-time news staff in radio stations throughout the country—if they have one—is one person, perhaps supplemented by part-time stringers or a service. And even at stations that have a news staff, the news staff is most likely serving multiple stations in a market.

Station Personalities

Dayparting is one of the major strategies of the music station programmer. The programmer's challenge is to make each daypart distinct and appropriate to the audience's characteristic activities and at the same time keep the station's sound consistent. The most important ingredient in making daypart distinctions is the personality of the jock assigned to each time period, followed by appropriate adjustments to the music rotation and other programming elements. Nevertheless, neither the PD nor the air talent should lose sight of the fact that consistency is the primary goal. Under a strong program director, a kind of "sameness" can develop among all the jocks in a specified format without the drabness or dullness normally associated with sameness. Sameness here means consistency, not predictability. Listeners tuning in to the station at odd hours hear the same "sound" they heard while driving to work in the morning or home in the afternoon. They should know what kind of programming to expect. The best talent offers enough of herself or himself to the audience that a relationship develops, and that kind of familiarity contributes to more regular listening (see 11.15).

Voice tracking is another issue at stations. As investors, and therefore corporate executives, continue to demand ever-greater earnings from each station in a group, the pressure mounts to cut costs in order to pass those savings to the bottom line. One obvious method is to eliminate some, most,

or all local air talent, but a successful station can't play just music and commercials. Radio needs personality to succeed—otherwise, the listener is more likely to play a CD so as to skip the commercials altogether.

Technology has provided one partial solution to this dilemma for broadcast managers: automated systems allow talent to voice track (prerecord) their segments, which are then played back at the appropriate time between songs. One or two people can voice track an entire day's programming on a station before going off to do production or engineering or sales; or one air staffer can provide voice tracks for many stations in a local or regional group, perhaps in addition to a live shift on one station. Using the internet, it is technologically easy for the air talent to be in Dallas and upload voice tracks to stations in Michigan, Florida, and Oregon. Not only can this provide budgetary savings for the local station, but it also offers the opportunity to use better-quality air talent than would otherwise be affordable in many small and medium markets. Large-market talent may be available via voice track for as little as \$100 per week.

The downside is the potential for losing what radio is best at—being local and immediate. If a station is voice tracked from a distant source and has competition that is well programmed, live, and local, history says unequivocally that the nonlocal station will lose. If management decides to use voice tracking, it would be best to limit it to offpeak hours (overnights, weekend mornings, and nights) to the extent possible and to make every effort to ensure the talent localizes the content. Ideally, the voice tracks should be recorded as close to the actual airtime as possible in order to provide the most up-to-date information.

Network and Syndicated Programming

For economic reasons or other factors, stations may not wish to locally program 24 hours a day, 7 days a week. Thanks to CDs and satellite technology,

11.15 **On-Air Personalities and Dayparting**

nce there was the big-voice boss who told the listener this was a Big Announcer, but this style faded in the early 1970s. Now there are SCREAM-ERS!!! (sometimes derogatorily referred to as pukers) who try to wake the very young, and shock jocks, the adult-male-oriented personalities who court FCC retribution daily (see 12.5 in Chapter 12, which discusses indecency in radio programming). But most contemporary stations rely on conversational jocks who just talk normally, as they would with any friend, when they open the microphone switch. What they talk about, and the attitude with which they convey the information, is what makes each talent and format distinctive.

MORNING: Most morning jocks are friendly, funny, and entertaining. They relate to the target audience. Morning jocks generally talk more than air talent in other dayparts because their shows are especially serviceoriented. Morning-drive air talent are more than mere jokesters—they provide the day's survival information to the audience: how cold (or hot) it will be, whether it will rain (or snow), what time it is, frequent updates on traffic problems that will keep them from dropping the kids at daycare and getting to work on time, and so on. Reports of a pile-up on one expressway give listeners a chance to switch their commuter routes—and the station a chance to earn a brownie point.

Traditionally, morning drive lasted from 6 to 10 A.M., and it is still defined that way by Arbitron. For PDs and morning jocks, however, the reality is different. People are spending more and more time in their cars as the suburbs surrounding many large urban areas continue to sprawl outward. Commutes take new forms (suburb to suburb rather than suburb to city), and people's work schedules have changed to incorporate flex time or earlier (or later) shifts. As a result, the real "drivetime" has extended. In many markets, traffic builds to significant volume by 5:30 or even 5 A.M. Therefore, most largemarket stations and some midmarket stations begin their morning shows at those earlier times. Some also end earlier, getting to their midday programming by 9 A.M.

Morning jocks are often paired in teams of a lead DI and a sidekick—someone to bounce jokes off of-or a coanchor who can add to the actcommonly a male plus a female. On most stations, the morning jock is the only performer permitted to violate format to any appreciable extent (the "morning zoo" approach). Indeed, morning can be almost music-free on some music stations. Normally, morning drivetime personalities are also the most highly paid, but with that pay comes greater pressure. They have a greater

responsibility than other jocks because the audience is bigger in the time period than at any other time of day, and stations earn a substantial part (if not a majority) of their revenue during that daypart. For most stations, "If you don't make it in the morning drive, you don't make it at all." But how far are you willing to go to make it?

In many major markets, shock jocks rule the morning airwaves, at least among the male audience aged 18 to 49. These hosts (almost all are men) target that group with a mix of crude sexual humor and innuendo, risqué audience phone calls, and titillating interviews with pop culture icons from athletes to porn stars. Howard Stern is probably the best-known personality tagged as a shock jock (although most of Stern's material is generally tame by comparison with other practitioners such as Bubba the Love Sponge or Mancow Muller). The format has worked not only on the radio—cable network Comedy Central has spun many of the same elements into its successful Man Show franchise. And the shock format is not confined entirely to mornings. Although many stations downplay personality in favor of heavy doses of music after 9 A.M., some practitioners of crude humor have found success (at least for limited times) in afternoon drivetime or evenings. Most large or medium markets probably have at least one performer, locally or via syndication, that might be described in this vein. Some of the more well-known names often associated with this style (or who have at least attracted regular attention from the FCC for on-air antics) besides those listed above include Doug "Greaseman" Tracht, Opie & Anthony (unemployed at the time of publication, following an ill-considered stunt in which two listeners had sex in a church), Steve Dahl, and Neil Rogers.

In early 2004, pressure from Congress and the FCC caused many station owners to reevaluate their programming. The Commission announced a more conservative interpretation of the indecency statute (because this area can change rapidly, readers are advised to consult the FCC website, www.fcc.gov, for current policy information) and leveled substantial fines for viclations of the indecency rules against a number of major owners including Clear Channel and Infinity. The possibility existed that the FCC would issue a forfeiture notice that would top the record \$1.7 million payment from Infinity (see 12.5). Several stations fired hosts, and others dropped syndicated programs that they felt potentially put them at risk for FCC enforcement action. Bubba was the most prominent of several formerly successful morning jocks

put out of work, and several of them moved to satellite radio where the broadcast indecency rules don't apply. Stern's program was dropped by six of his affiliates (all owned by Clear Channel) but soon was picked up by a satellite service.

The question for programmers is always, "What is best for the station in my situation?" A number of factors affect the decision as to whether the station should go the shock route-including the target audience and the market's taste for the material, the talent's track record (in terms of ratings and FCC enforcement), and the station owner's content policies and expectations for revenue. These performers can be consistent moneymakers, but the price can be steep. Some advertisers will shy away, no matter how big the ratings get. And as mentioned above, the station is open to potential legal and financial penalties when the talent strays over the line. There is no easy answer, nor one that is correct for all stations in all markets. Programmers need to carefully juggle competing needs when selecting morning talent. If you were programming a low- or mid-rated rock station with a so-so morning show and Stern was available in your market, what would you do?

MIDDAY: The midday jock is frequently conversational in style, warm, and friendly. Incidental services (requiring talk) during this daypart normally are curtailed although not eliminated—in favor of longer music sweeps. Most of the audience is at work or school. Music rotations may be slowed and more recurrents, golds, and oldies added so as not to seem too repetitious to the all-day, at-work audience. Although there is still out-of-home listening during the 10 A.M. to 3 P.M. period, Arbitron data show that the majority of listeners are at home or at work. Many midday jocks capitalize on the dominantly female audience by using liners (brief continuity between songs) that have special appeal to women and by talking about what the listener might be doing at home or after work. At-work listeners may also be targeted through daytime-specific promotions (giving away lunch to everybody in the office after entrants have mailed in business cards or faxed in requests, for example). Noontime may lend itself to special programming as people leave the office or take a break from work; for example, the all-request "dinner" hours popular on many country, AC, oldies, and rock stations.

AFTERNOON: The afternoon jock (3 to 7 P.M.) is more up-tempo, as is the music rotation during this period if the station is dayparting.² Teens are out of school, and

adults are driving home from work. In small markets, this necessitates a delicate balance between teenoriented music and music suiting the moods and atttudes of the going-home audience. Again, weather and traffic are important in this period (especially traffic) although not guite as much as in the morning. Information is more likely to take the form of the afternoon jock alluding frequently to evening activities—about how good it is to finish work and to look forward to whatever events people in your audience will be a part of that evening—a concert, a ball game, a movie sneak preview, and so on. By Thursday, and certainly on Friday, weekend plans usually become a focus

EVENING: More teens and young adults are available to listen at night, making this daypart especially strong for CHR and urban stations, as well as younger-skewing rock or country stations. The ability to use listener phone calls on the air, juggling the phones along with music and everything else, is an essential ingredient of many CHR evening jocks' shows. They may open the request lines and play specific records for specific people, get listeners to introduce songs or play along with pranks, or engage in short funny bits (with the calls always edited before playback).

Because the majority of adults over 25 are doing something other than listening to the radio (most often watching television, renting videos, and so on), AC stations, older rock outlets, and other adult formats may try slightly altering their programming in the evening to attract an audience. Syndicated programs such as Delilah or Rockline offer programming that is different yet similar enough to have broad appeal for the AC or rock audience.

ALL-NIGHT: Only large-market stations typically still have live air talent during the all-night period, from midnight to 6 A.M. But regardless of whether the shift is live or voice tracked, the jock's attitude is usually one of camaraderie. "We're all up late tonight, aren t we? We have to work nights and sleep days." This jock must commune with the audience: the taxi crivers, revelers, police officers, all-night restaurant and arocery store workers, insomniacs, parents up giving babies two o'clock feedings, shift workers at factories, bakers, and the many others active between the hours of midnight and 6 A.M. The commercial locd is almost nil during this period, so the jock can provide listeners with a lot of uninterrupted music. If they're not voice tracking it, many stations will run network or synaicated material here to save on costs or use some of this time period to offer public-affairs programming.

national or regional programming is easily available from either a radio network or a radio syndicator. Both offer similar types of programming, but they can be distinguished by the nature of the relationship between the program supplier and the local station. Networks provide an integrated, full-service product (music, news, air talent, national spots, other features) that airs simultaneously on all affiliated stations, while syndicators provide one element (a single program, a music service, and so on) to individual stations that may air the material at different times.

National and regional programming can be divided into three categories: short form, long form, and continuous music formats. A program of sufficiently broad appeal can run in more than one format (thus increasing the odds that the supplier will be able to sell the program in most markets). Stations use short-form programs as spice in the schedule, airing most longer syndicated fare on weekends or at night (some network material may air in other dayparts). Short-form offerings include individual network newscasts as well as syndicated programs and series (for example, the weekly 60-minute King Biscuit Flower Hour, in distribution for over 30 years, or Saturday Night All-Request 80's). Familiar long-form programming includes shows that run several hours on a daily or weekly basis, for example, ABC's American Country Countdown with Bob Kingsley or American Top 40 with Ryan Seacrest from Premiere Radio Networks (a Clear Channel subsidiary). See 11.16 for other examples of short- and long-form programming available from major syndicators.

Continuous music formats are just what the name suggests-24-hour, 7-day-a-week music selections. Until the late 1970s, stations programmed their own music or purchased long-form all-music programming tapes from such syndicators as Drake-Chenault. As indicated in 11.17, syndicated formats are available from a number of companies. The increased availability of satellite delivery in the 1980s brought a new type of national music programming service—the fulltime, live network radio format. Modern satellitedelivered networks supply the combined services of a traditional network (news and advertising) and a formatted program service (music and entertainment programs). Satellite Music Network (SMN) was the first provider of real-time satellite radio in 10 different music formats, including two versions of country, two rock formats, two formats targeted toward adult African-Americans, two adult contemporary formats, one version of nostalgia, and one version of oldies. That service was eventually consolidated with ABC Radio (www.abcradio.com). Other major fulltime network providers include Westwood One (www.westwoodone.com) and Jones Radio Networks (www.jonesradio.com), part of the JonesTM company.

The decision to go with one of these services instead of locally generated programming can reduce operating costs by one-half. About half of all commercial stations use at least some national or regional radio programming, from overnight filler to 24-hour turnkey operations (in turnkey arrangements, management is turned over to

11.16 Syndicators

Selected Major Syndicators Selected Programs Tom Joyner, Doug Banks, ESPN Radio, American Gold with Dick Bartley Jones Marie and Friends, Bill Cody Classic Country Weekend Premiere Delilah, Rick Dees, Bob & Tom, American Top 40 United Stations Nina Blackwood's Absolutely 80s, House of Blues Radio Hour, Dick Clark's U.S. Music Survey, Sonrise, JazzTrax Westwood One Late Show with David Letterman Top-Ten List, MTV's TRL Weekend Countdown, Beatle Brunch, Superstar Concert Series, Country Countdown USA

AC	Country	Oldies	Urban	Rock	Other
ABC:	ABC:	ABC:	ABC:	ABC:	ABC:
ABC AC	Country	Scott	The Touch	Classic Rock	Timeless
ABC Hot AC	Coast-to-Coast	Shannon's True Oldies			
ABC JackFM	Real Country	Oldies Radio			
Jones:	Jones:	Jones:	Jones:	Jones:	Jones:
Hot AC	CD Country	Classic Hits		Rock Classics	Music of Your Life
AC Smooth	Classic Hit	Good Time Oldies			
lass	Country True 24-Hour	Oldles			
Jazz					
	Country US Country				

another entity). Although local programming is desirable, nationally programmed song selections are based on the kinds of professional research that smaller local stations find difficult to afford. Using a network or syndicated format package, a small-market station can achieve a consistent "bigmarket" sound with a recognized appeal to audiences and advertisers.

Network formats offer a complete package that includes practically everything but local commercials. Syndicated formats at their most basic provide only music that is intended for use on fully automated stations. A station running a syndicated format may choose to run without air talent or may use local air talent, or for an additional fee the syndicator may also provide voice-tracking service. Unlike networks, format syndicators traditionally do not sell commercial time or produce newscasts.

Network formats are generally available on a barter basis (two minutes per hour is the norm), although stations in unrated markets or brandnew stations may be required to take the service on a cash-plus-barter contract. Full-time satellite programming eliminates the need for large staffs, large facilities, and large equipment budgets. In the most extreme form, current digital automation systems

allow stations to replace a complex of air studios, production studios, and a programming/production staff of several people with a small production studio (for local commercials, weather forecasts, and so on), an on-air computer, and a staff of one or two. In smaller markets, going with such a service may allow a reformatted station to break even in less than a year.

Like a locally produced format, the network or syndicated service operates from a hot clock, each hour following a set pattern of music sweeps, some combination of mandatory and optional stopsets, and perhaps other material (jingles, sweepers, and so on). The typical network clock shown in 11.18 might be used in the daytime for an oldies or AC format. There are 11 minutes of avails in three stopsets: 2 minutes for the network (the first minute in each mandatory break) and 9 for the local station. Also note the long music sweep (or two long sweeps if the local station doesn't take the optional break at about 35 minutes after the hour), and note the opportunities for localization (liners to be recorded by the network air talent as well as things that can be done within the station breaks). Local stopsets and other content are triggered at the local station by a network command using subaudible tones (different tones can be used

374

11.18 Sample Network Hot Clock

to trigger different local elements). After the threeor four-minute break, the station's automation system then seamlessly rejoins the network at the appropriate point. For liners, the network channel is kept open, so the liner plays over the music as a song fades or the intro begins.

In the late 1990s, many of the networks and syndicators settled on a single technological standard for satellite receivers provided by StarGuide Digital Networks (www.starguidedigital.com). At each mandatory break, the local station must fill the time with local content, such as commercials, promos, PSAs, weather, and traffic. The network then uses this time to send important information (last-minute changes in the network's lineup of air talent or the network's spot log, for example) or other material (such as copies of the network commercials for use in hours where local stations are not using the full network feed) to the affiliated stations using their regular channel. In an optional break, the network will program a precisely timed song so stations that don't have local spots scheduled there can continue with music.

It's a system that can be a bit awkward at times for the network PD—after all, how many songs in a particular format remain popular and run exactly 3:30? The timed song is generally a secondary gold or oldies because the programmer

wouldn't want to miss playing a top current hit in its regular rotation.

The key to successfully operating with a satellite-delivered format is effective localization—making the station sound like a part of the community even though the programming isn't locally produced. Networks offer major-market-quality personalities, thoroughly tested and carefully scheduled music, and (sometimes) network news.

Another part of their service is aimed at helping stations localize the product, but it is always up to the local station to direct the effort. At the request of the local station, network talent will record local station IDs, liners, and other voice tracks (intros to weather or news, contest wraps so that the 10th caller sounds like she's talking to the network DJ, and so on). These are then sent to the local station for insertion in the programming. Most stations have their call letters or slogans voice tracked by the appropriate network talent. Placed at the start of every break, song intro, or backsell (telling the audience what music is coming up or what just played), the slogan sounds to the listener like the network DJ is at the station. Most of this process is really common sense and involves little more than the kinds of things a programmer would do if the air talent were indeed at the station (for example, having the air talent repeat the call letters or slogan when coming out of music, so the station and music are associated in the listener's mind).

But it's surprising how many stations fail to follow through and wind up sounding like a satellite station because they create localizing material too infrequently or irregularly. Others make the mistake of completely eliminating local programming and production personnel, leaving account executives to write and produce commercials and the receptionist to voice track a weather forecast a couple of times a day—employees who are often without the training or talent to effectively execute those tasks.

Local information remains important: regardless of the market, people still want the weather forecast; they want survive-the-day information like traffic during the morning and afternoon drivetimes, and they expect the local radio station to provide it. Many network-affiliated stations adopt a middle-ground approach, running local information in morning drivetime and perhaps during one or two additional shifts during the day while using the satellite primarily at night and on weekends. Most networks require the affiliated stations to air the scheduled network spots, however, even during hours when the station is not airing the network programming.

One downside to running full-service satellitedelivered music programming is the lack of control at the local station. Sometimes the network personality talks too much or makes inappropriate comments. One station became upset when the network DJ (in Dallas) told Christmas listeners to "avoid the crowds and stay in today," which was then followed by local commercials asking people to do exactly the opposite! By choosing a format syndicator, a station may exert more control because the music and all other program elements (especially DI tracks) can be located (and therefore altered or eliminated as needed) at the station. The price of such control, however, is paying someone to mind the format, to handle voice tracking, and so on. For locally controlled stations, this is not a huge concern, and format syndication works well. For an automated station with a distant owner and a skeleton staff, however, the network format is a better option.

Concerts and Specials

Special music programs have long been popular with both stations and advertisers. Concerts command premium prices because they provide exclusive access to top-ranked music in a live setting. Some acts are particularly valuable because they cross over a variety of station formats (for example, from country to AC, like Shania Twain, or Alternative to CHR, like Green Day), making it fairly easy for some music shows to air on at least one station in most markets. Since the mid-1990s, however, only a few musical megastars have been able to attract audiences on the scale necessary for both meeting the costs associated with national production and distribution and justifying local stations' preemption of regular programming. (Access to these rare concerts and major performers remains beyond the financial reach of most local stations on an individual basis.)

Syndicators capable of recording such shows generally offer them to stations on a barter or cash-plus-barter basis at prices ranging from \$25 to \$50 per hour in small markets to several hundred dollars per hour in large markets. Networks may include these music specials as part of the full-service network programming of music, news, and sports. Networks can also go into the syndication business, offering music specials on a station-by-station basis.

As with any other type of network program, the key to revenue for a music special or concert series is the size of its cleared audience. Fitting a particular concert or series of concerts to a demographic category that matches a salable number of affiliates is very difficult. Most of these programs target either the youth demographic, aged roughly 18 to 34 (it may include teens), or the adult demographic, aged 25 to 54. Each group presents programming problems, and local stations can be understandably reluctant to preempt traditional programming that they know will deliver a given audience and amount of revenue for an unknown. Stations will expect a careful fit between special programs and their regular formats. Contemporary radio listeners have many choices and are ready to push a button if the sound or voices are too staid, too serious, or otherwise perceived as "not for them."

For a network that seeks musical concerts and specials, three alternative strategies exist:

- Produce many shows of varied appeal to capture fragments of the youth or adult audiences.
- Concentrate on the relatively small number of stars that appeal across the broadest format spectrum.
- Buy or produce programs that have unique, broad appeal.

The third strategy is often the most economically efficient, although many national programmers also follow the first strategy to at least some extent. For example, countdown shows target specific groups who will listen to a wide variety of music over the course of the show. Countdown shows

succeed best as regularly scheduled weekend features, and audiences tend to seek them out. These unique music programs usually clear the broadest range of affiliates, which makes them potentially the most profitable syndicated programs and competitive with top-rated radio sports.

Feature Syndicators

Radio broadcasters may use features to attract a specific target audience during mornings, evenings, or weekends. Most popular syndicated feature programs are brief inserts such as the ET Radio Minute, Late Show with David Letterman Top-Ten List, and CBS Health Watch. Stations producing their own programming include short features to add spice and variety to programming and use the longer programming to fill unsold or low-audience time periods.

Syndicated features are as varied as their producers, which include many of the companies previously mentioned in this chapter:—ABC, Jones, Premiere Radio Networks (www.premiereradio.com), United Stations (www.unitedstations.com), and Westwood One (www.westwoodone.com) are among the biggest. A few major-market stations also syndicate their talent (for example, KLOS in Los Angeles offers morning duo Mark & Brian to stations in other markets).

One of the most important types of feature programming today is the syndicated morning show. Several successful major-market morning shows have made the transition to national syndication, including Tom Joyner (Dallas), Rick Dees (Los Angeles), Mancow Muller (Chicago), and Bob & Tom (Indianapolis). As with the other programming discussed in this section, a syndicated morning show can offer small- and medium-market stations talent that would otherwise be far beyond their reach, albeit at a still significant cost in cash and avails. A wide range of styles are available, from Bob & Tom's Midwestern, occasionally risqué, humor to the outrageous and frequently offensive style of Mancow Muller. As with all choices, programmers should be aware of the tastes and interests of their audience and market when selecting a syndicated morning show. All of the shows can point to significant ratings successes; most have also failed in some markets where they were on the wrong station or the show was just not appropriate for the market.

Many companies that syndicate long-form format packages also supply short features that fit within their long formats and provide other prep services for local air talent (entertainment news, joke services, other short items that can be used on the air). The short features are also made available to other stations in the same market on a formatexclusive basis. If a feature is format-exclusive, that same short feature can be sold to more than one station in a market if their formats differ, but only one rock or one country or one talk station can license the program. This arrangement assumes nonduplicated listeners.

What's Coming for Radio?

Taking out the crystal ball in this environment, where even the most experienced industry veterans are uncomfortable making prognostications about what the industry will look like three to five years down the road, is risky business. It is probably safe to say that music will remain the main course in radio with 70 to 75 percent of the total audience share, although news/talk is now the largest single format and growing in terms of total listening thanks to its strong appeal among the baby boom generation and older adults. Stations targeting the baby boom generation with AC, rock, and country formats will remain the dominant players overall in most markets, although various Hispanic formats will continue to grow exponentially, attracting substantial listening in many markets.

The oldest boomers, however, have already aged beyond the primary 25 to 54 demo. As more of that audience continues to age beyond the point where they are of interest to the biggest advertisers, station groups will have a couple of choices. They will have to either (1) spread the formats of their stations in a market to cover a wider demographic range in order to maximize their appeal to a range of advertisers or (2) continue to chase the

boomer generation and convince most advertisers that there is more value in the older audience than was previously assigned. Some indications suggest that the primary target demo for many television advertisers is shifting upward to track the demographic bulge; perhaps radio will follow.

When iBiquity rolled out licenses for its HD Radio system for FM stations, the switch to digital transmission for terrestrial broadcasters began, although it is too soon to tell what impact HD Radio technology will really have. Some stations have begun multicasting operations (HD2 service) by offering programming that extends their brand in some fashion, which may eventually provide additional competitive leverage in a complex marketplace. However, until there is widespread access to the programming-when digital HD receivers become standard in most new cars, for example—HD remains a small factor in the overall radio market. In-band-on-channel (IBOC) for AM remains a technological problem as AM stations still have no nighttime digital service. Lacking the improved digital signal quality that IBOC offers, spoken-word formats remain the present and short-term future of AM radio. News, talk, sports, and business will be the primary alternatives. Time-brokered programming, most commonly targeting specific ethnic or religious groups not served by other stations in the market, is another possibility for AM.

The effects of industry consolidation since 1996 can hardly be overstated. Multistation clusters within a market have fundamentally altered the strategies and economics of radio programming along with the day-to-day nature of the work the employees of those groups perform. Owners are no longer looking to hold a slice of a market segment but rather to dominate one or more market demographics with multiple-content formats and to leverage that dominance into ever-greater percentages of the market's ad dollars. Although all ad-supported media saw revenues drop early in this decade following the bursting of the dot.com economy bubble, the ad market has rebounded but so far radio's share of all ad dollars remains stagnant. Two or three group owners now control most local markets. Those few markets that aren't

yet fully consolidated eventually will be, and additional mergers and acquisitions among existing groups are likely. Having six, seven, or eight stations in a market allows a cluster to reach nearly all of the listeners in one or more demographic or psychographic segments.

Although revenues will continue to grow, owners will also be looking to trim costs—thus greatly increasing earnings and pleasing the Wal. Street investment community-by extending the productivity of programming and production staffs. Although some stations will continue with live air talent in the local studio, more groups will take advantage of available technologies to use a single, centralized air staff to provide voice tracks in many or all dayparts for stations throughout a market cluster, a multimarket group of stations, or stations in a multistate region.

Although it may be a few years (or even several years) away from happening, wireless broadband services present perhaps the greatest threat of audience fragmentation to traditional radio. Terrestrial broadcasters still retain one significant competitive advantage over many of the competing services: localism. Local service has always been the soul of successful radio, and radio stations will best be able to fend off the challenge from satellite and broadband audio by emphasizing their local commitment, the cost differential to the aucience, and (eventually) similar digital quality. However, they'll have to do it with limited local staffs and tight budgets.

Sources

Billboard. Weekly trade magazine for the record industry, 1894 to date.

Journal of Radio Studies. Broadcast Education Association, 1991 to date.

Keith, Michael C. The Radio Station, 7th ed. Boston, MA: Focal Press, 2007.

Radio & Records. Weekly newspaper covering the radio and recording industries, 1973 to date. www.radioandrecords.com.

Radio and Internet Newsletter (RAIN). Free, daily web-based commentary on issues, published by Kurt Hanson, 1999 to date. www.kurthanson.com.

Radio Ink. Biweekly magazine for radio managers, 1998 to date.

Notes

1. In the United States, the AM band runs from 520 to 1710 kilohertz (kHz), with station allocations spaced at 10-kHz intervals. The FM band runs from 88 to 108 megahertz (MHz), with allocations spaced every .2 MHz beginning with 88.1 (then 88.3, 88.5, and so on through 107.9), although the lower 4 MHz (88.1 through 91.9) are reserved for noncommercial educational (NCE) stations only. Note that interference concerns will prevent assignments of stations on adjacent frequencies within a market.

2. Thirty or forty years ago, some top-40 stations sped up their turntables (so that 45-rpm records played at 47 or 48 rpm), thereby increasing the tempo and energy level and gaining enough time to squeeze in another commercial or two each hour. Digital technology now allows talk stations to speed up audio material without altering the pitch in order to create more avails in an hour.

12

Information Radio Programming

Robert F. Potter

Chapter Outline

Information Versus Entertainment Radio

Identifiable Personalities Arbitron's Influence

The Rise of Information Radio

Cost Decline in Distribution
Technology
The Abandonment of the
Fairness Doctrine
Embracing Formerly Taboo
Topics
Migration to FM
Mobile Phones
Synergistic Advertising
Environment

Information Programming Formats

All-News Formats

Network-Delivered Newscasts News Scheduling Priorities

Talk Formats

Heritage Talk Politics/Issues Talk Sports Talk
Success Talk
Hot Talk
Urban Talk
Faith Talk
Spanish/Foreign-Language Talk
Health and Help Talk
Technology Talk

The Content Infrastructure

Hosts Callers and Listeners Commercial Interests

On-Air Talk Techniques

Telephone Screeners Controversy, Balance, and Pressure

Information Formats on Public Radio

What Lies Ahead

Sources

Notes

ust what is meant by *information radio?* It is traditionally viewed by broadcasters as a fairly expansive term encompassing various formats where the spoken word—rather than music—makes up the main content feature. These formats occur on satellite radio channels and the internet as well as on analog and digital terrestrial broadcasting, and are known individually by such names as talk, news, news/talk, and sports talk. All fall under the larger umbrella of information radio but raise the following question for programmers: What is the overall goal of information radio—is it to educate or to entertain its audience?¹

Information Versus Entertainment Radio

The quick first answer may be that with a name like information radio, the format must be designed to educate. However, some broadcast industry analysts believe all radio formats—not just those designed to deliver the news or talk about issues are designed to educate and therefore are a form of information radio. If this sounds extreme, consider that about 10 percent of the broadcast stations in the United States are officially programmed as what we've called information radio, that is, fulltime talk, news, or sports. Add to that another 10 percent that are programmed as religious stations offering a focused type of information (in the form of sermons, religion-themed talk shows, callin prayer shows, and so on) to an audience with a specific psychographic profile. Of the remaining 80 percent of stations, most schedule some talk, news, or sports, typically during drivetimes, at night, and on the weekends, even though their "official" formats are some sort of music programming. In addition, more than 30 channels on the two Sirius and XM satellite services focus on information rather than music. Even noncommercial radio stations—those that we may initially associate with classical music, opera, and jazz devote substantial portions of their programming to delivering information in the form of large news blocks (Morning Edition and All Things Considered), interview shows (Talk of the Nation, Fresh Air with Terry Gross, and The Tavis Smiley Show), comedy (A Prairie Home Companion and Wait, Wait . . . Don't Tell Me!), and call-in talk shows such as the hilarious Car Talk.

Even the most highly targeted "all music" stations provide generous amounts of information to their audiences in the form of pop psychology, humorous stories, and discussions of "what's hot," all presented in the latest lingo of the target audience. These stations know that, even though they tie their brand images closely to their music mix, to succeed in the ratings they still must offer substantial amounts of useful information to their listeners—such as traffic, weather, and lifestyle news—especially during drivetime dayparts.

If you are still having trouble thinking of *all* radio as information radio, consider that more than one-fifth of the average commercial radio station's airtime is set aside for advertising and promotion—almost all forms of which contain spoken information about products, services, or the station itself. Even commercial-free public radio uses enhanced underwriting announcements between programs.

Furthermore, the on-air signal is only part of a modern radio station's or satellite service's business strategy. Most offer extensive websites packed with information about station events, biographies of station DIs and personalities, and details on movies, concerts, and other happenings in the station's city of license. Some stations and many syndicated talk programs deliver information to their listeners through periodic newsletters. Often this is a source of revenue for the host and/or syndicator. Rush Limbaugh, for example, offers yearly subscriptions to his monthly newsletter The Limbaugh Letter for purchase on his website (www.rushlimbaugh.com). Some stations or personalities, on the other hand, send out newsletters free of charge in an attempt to make more personal connections with their listeners while also developing databases of contact information for future direct marketing campaigns. Chicago music station WXRT, for example, invites listeners to become "WXRT VIPs" and receive free weekly e-mail newsletters. Kim Komando, host of a weekly syndicated talk show, also sends out daily

computer tips and weekly newsletters via e-mail to over 1 million people who have signed up for the free service on her website (*www.komando.com*).

Other hosts have authored books, for example, Howard Stern's *Private Parts*, Limbaugh's *The Way Things Ought to Be*, Michael Savage's *The Savage Nation*, and Dr. Laura Schlessinger's *The Proper Care and Feeding of Husbands*. Not only does writing books give hosts different outlets for their views, but the publicity the books receive is expected to direct new listeners to the radio programs. And the publicity surrounding books can be substantial. For example, talk-show host Mitch Albom's *Tuesdays with Morrie*, a memoir of his time spent with one of his former college professors, spent over five years on *The New York Times* best-seller list! Every copy sold mentions his daily syndicated radio show originating on WJR-AM in Detroit.

So, a lot of information is being disseminated by radio stations and their personalities, regardless of format, both on and off the air. However, some industry analysts and consultants believe that it is more important for all stations—even those that can be officially referred to as programming information radio-to focus on being a source of entertainment for listeners. These analysts suggest that a station can dominate in ratings and revenue only when it is programmed as a form of audio entertainment. The most successful news/talk/ sports programmers require their air talents to remain focused on the entertainment value of their presentations. According to consultant Holland Cooke, both information stations and popular music stations "play the hits," but in information radio that means discussing the hot topics and news that the audience really wants to hear.2

Just as Chapter 11 discussed how hot songs are tracked by music station programmers in trade magazines like Radio & Records, information station programmers refer to publications like Talkers Magazine (www.talkers.com), which offers a Week in Review feature listing the top-10 people, issues, and topics being discussed on information stations across the country. Only programmers and hosts who recognize the importance of the issues and the entertaining way in which they must be presented are likely to succeed.

There are plenty of examples in radio history of talk-radio personalities who took themselves too seriously, abandoned their focus on the *entertainment* value of their presentations, and suffered irreversible revenue and ratings decline. One personality who suffered from this lack of focus on the entertainment value of her show is Dr. Laura Schlessinger. Her increasingly strident antihomosexual rhetoric in the late 1990s resulted in censure by the Canadian Broadcast Standards Council, a loss of several key U.S. affiliates, and the loss of several national advertisers, including Procter & Gamble, which withdrew support from her proposed television show.

At a recent radio industry conference, a panel of news/talk programmers clearly explained the entertainment value of their programs. One programmer summed it up this way: "All highly rated radio is, first, entertaining, and in radio there're only two ways to entertain an ear—with spoken words [as in] news/talk or with music. When we got our staff to realize their spoken words had to be as entertaining as the music down the street, or the movie on HBO, we started to have success."³

To a certain extent, then, all radio formats have information as a key ingredient. For some formats. the most engaging way to deliver information is to present it between musical segments the audience will find appealing. In the information format, of course, the majority of the broadcast day is filled not with music but with the spoken word. There is ample evidence that the information format is growing in popularity among programmers and listeners-in the form of all-news, all-talk, or the combination of the two known as news/talk. Consider that in 1980, only 75 radio stations in the United States offered full-time information programming. By 1985, that number had grown to only 100 stations. Then, during the next two decades, the number of stations officially programming the information format skyrocketed! The 2006 Radio Advertising Bureau Marketing Guide & Fact Book listed more than 1300 full-time news/ talk stations—second only to stations with country music formats. The number of stations is not the only sign of the format's popularity. Information radio also had the highest 12+ share of any

12.1 Popular Nationally Syndicated Talk Hosts

Talk Personality	Description	Website
Jim Bohannon	"The industry's most experienced late-night talk host"	www.jimbotalk.net
Neal Boortz	"Thirty-seven-year talk radio pro"	www.boortz.com
Dr. Joy Browne	"America's leading nationally syndicated relationship doctor"	www.drjoy.com
Sean Hannity	"A multimedia superstar in the issues news/talk genre"	www.hannity.com
Clark Howard	"The industry's top consumer-issues talk host"	www.clarkhoward.com
Don Imus	"Legendary radio morning host. 'A' list guests from all walks of life"	http://wfan.com/pages/123165.php
Rush Limbaugh	"The most listened-to issues talk host in the business"	www.rushlimbaugh.com
Dave Ramsey	"Daily life and financial advice show"	www.daveramsey.com
Randi Rhodes	"Smart entertaining progressive talk"	www.therandirhodesshow.com
Jim Rome	"Sports talk's most listened-to nationally syndicated host"	www.jimrome.com
Michael Savage	"The industry's leading firebrand conservative"	www.michaelsavage.com
Dr.Laura Schlessinger	"The most listened-to female radio talk show host"	www.drlaura.com
Bev Smith	"A high-profile leader in urban issues talk radio"	www.aurn.com
Howard Stern	"Original hot talk superstar. The face of satellite talk entertainment"	www.howardstern.com

format in 2006, with an average 17.2 percent of those listening to the radio at any time tuning to an information station. Perhaps even more important, a large portion of those listening to information programming is in the demographic segments desirable to many advertisers.

Information radio has become popular with programmers because it is a format that really engages listeners. One reason for its persistent popularity is the presentation of timely "hit" topics. However, much of the driving force behind the format undoubtedly comes from the on-air personalities who present the topics in compelling, interesting, and often controversial ways.

Identifiable Personalities

Among dominant information formats, *talk is almost always live and delivered by identifiable personalities*. Having recognizable individuals is extremely important. Research has repeatedly shown that the most loyal radio listeners seek feelings of pseudofriendship or imagined personal relationships with media personalities. These relationships are evidenced

by unexpectedly intense love/hate reactions to national talk hosts such as Howard Stern, Rush Limbaugh, Dr. Laura Schlessinger, Tom Joyner, Jim Rome, G. Gordon Liddy, Dr. Joy Browne, Bob & Tom, and Phil Hendrie. An emotional connection, whether positive or negative, has been shown to be absolutely necessary for sustained listener involvement and long-term ratings and revenue success. A list of selected nationally syndicated talk hosts from Talkers Magazine's "Heavy Hundred," along with their web addresses, appears in 12.1.

Often even local personalities can develop sizable loyal followings. These hosts tend to be long-time residents of the broadcast city. They know the history of the area, and long-time local listeners develop a sense of having "grown up" with them. Even those new to the area become attracted by how tuned in to the happenings of the city such local personalities are—they know about everything from family activities happening in the coming week to the hot-button local political issues.

Sometimes information stations that have a comparatively small share of the listening audience can still be successful because of the connections

New York	WABC "Curtis & Kuby in the Morning" (Curtis Sliwa and R	www.wabcradio.ccm
Los Angeles	KFI Bill Handel	www.kfi640.com
	KABC Larry Elder	www.kabc.com
Chicago	WVON Cliff Kelley	www.wvon.com
	WCKG Steve Dahl	www.wckg.com
	WLS Roe Conn	www.wlsam.com
San Francisco	KGO Ron Owens, Bernie Ward	www.kgoam810.ccm
Dallas	WBAP Mark Davis	www.wbap.com

they make with their niche audiences and the loyalty that follows. For example, consider WVON-AM (Chicago). Rarely does the talk station register more than 1 percent of the available listening audience. However, the station has remained successful by developing close ties between its local personalities and its primarily African-American audience. According to communication scholar Catherine Squires, who spent time observing WVON talents and listeners, the station sustains a loyal audience that counts on the station to "talk their talk" when it comes to issues of concern and interest to the African-American audience in the third largest market in the United States. So loyal is the WVON audience, in fact, that Squires reported listeners were willing to make financial contributions to the station when its advertising revenues were lower than anticipated.4 Although some of those listed in 12.2 have begun to branch out to national audiences via syndication, their reputations initially developed by establishing long-term relationships with listeners in their local markets.

Arbitron's Influence

Carrying a syndicated show with an identifiable national personality and developing local talents

who become local household names should be the goals of every information radio programmer for two reasons. The first relates to the way ratings information has traditionally been collected in Arbitron's paper diary system. Because the call letters, formats, and even the total number of available stations change constantly in most metropolitan areas, radio listeners may be unaware of the precise call letters or slogans being used currently by stations—even stations they listen to regularly. However, if listeners write cown that they were listening to The Jim Rome Show without referring to a specific station by name, Arbitron will give time-spent-listening (TSL) credit to the station in the listener's market that broadcasts the show.

A recent change to Arbitron's diary analysis procedures, in fact, has made it even easier for information programmers to take credit for the amount of time that listeners report listening to personalities programmed on their stations. Before 2003, programmers had to register all their personalities' names with Arbitron prior to each ratings period if they wanted to receive TSL credit for personalities reported by diarykeepers without any, or with incorrect, station affiliations. Arbitron found, however, that only about half of programmers updated their personality information. As

hosts shifted from station to station because of changes in syndication agreements for national personalities and new contracts for local ones, Arbitron's concern was misattribution of listening credit.

To address this problem, Arbitron now uses a system whereby all mentions of each personality written in ratings diaries from a particular city are grouped together prior to attributing TSL. If there is no disagreement among diarykeepers who did attribute that personality to a specific station, then every time that personality is listed in a diary, the station of unanimous agreement receives credit even if the diarykeeper listed only the host's name and not the station. If there is disagreement among diaries about which station in a market is the home for a certain personality, Arbitron investigates that particular market—checking station websites and calling stations directly-to determine who currently airs the personality's show. Although research suggests that more than 75 percent of listeners to talk shows report correct call letters when they make diary entries, it's good to know that if programmers make the effort to obtain strong personalities, the right station will receive credit for any listening a host generates in the market. (While the deployment of portable people meters may eventually make paper diaries obsolete, that will occur only at some far distant time for most markets.)

Arbitron's research revealed another *important* fact about strong personalities: Listeners will find them on the dial even if they change stations in the market. In other words, listeners are often more loyal to the personality than they are to any individual station. For that reason, it is important for information programmers to keep aware of the status of current syndication agreements with national hosts. Beginning the next round of negotiations with the syndicator at the proper time is critical. To continue a station's association with the personality, locking the agreement up early is an important strategic move.

However, if a programmer, sales manager, and general manager determine that a new agreement with the syndicator is not cost-effective because of increases in the contract costs or decreases in projected sales revenue (see Chapter 3 for a related discussion of television syndication), it is better to know sooner rather than later that the station will be losing that personality from its programming lineup. It is also not a bad idea to estimate when competitors' national syndication contracts will be renegotiated. It could be that a favorite personality might unexpectedly become available as a result of failed negotiations with a competing station, and a wise information programmer would be ready to act quickly to sign that big-name personality, knowing that his or her loval audience will follow.

The strong loyalty between listeners and personalities also impacts the information programmer's relationship with local hosts. Often, management insists on noncompete clauses in contracts with the most popular "franchise" personalities. These clauses prevent local personalities from leaving one station and going to another in the same market without a lot of time (sometimes a year or more) passing. The logic behind these clauses is that having noncompetes in place will prevent the personalities from bringing their stations' strategic secrets—along with their loyal listeners—to competitors. This approach is not without its critics, many of whom argue that noncompete clauses have a negative effect on station morale that does far more harm than any "strategic secrets" that may get into the competition's hands. Furthermore, in 2002 the State of Arizona passed a law prohibiting noncompete clauses in media contracts; in 2003 the District of Columbia followed suit. Still, the motivation that led programmers to consider noncompete clauses in the first place should not be lost amid the controversy: Once a station has a successful local personality on its airwayes, the programmer needs to try to do everything possible to keep that person there!

The rise in the number of recognizable personalities and the greater loyalty they command are, indeed, important reasons behind the increase in the number of information stations and their ratings successes over recent years. However, other important factors also led to the popularity of the format among programmers and the listening public.

The Rise of Information Radio

Aside from social and cultural influences contributing to an interest in information radio, several technological, economic, and policy changes have also played a role, especially affecting terrestrial broadcast radio. The six key factors are summarized in 12.3.

Cost Decline in Distribution Technology

It is doubtful that the shows of Rush Limbaugh, Dr. Laura Schlessinger, Bruce Williams, or others would be available today without the dramatic drop in the cost of distributing broadcast-quality audio over long distances that occurred in the early 1980s. Prior to that time, radio network operators were forced to pay premium fees to the telephone monopoly for land-based distribution. This created the "chicken and egg" question common to most new technologies: Which will come first, the nationally-distributed radio personalities or the expensive distribution system? By the mid-1980s, thanks to the much lower cost of satellite distribution, national syndication of unproven programming became economically feasible for the first time. One of the earliest of these shows was Limbaugh's talk show, and in an interview, Limbaugh noted that his popular show airs during the midday daypart, as opposed to perhaps the more strategically

Factors in the Rise of Talk Radio

- 1. Decline in distribution costs due to satellite technology
- 2. Repeal of the Fairness Doctrine in 1987
- 3. Acceptance of formerly taboo topics
- 4. Migration of music-oriented audiences to FM
- 5. Proliferation of cellular phones
- 6. Attraction of format for advertisers

advantageous slot of morning or afternoon drivetime. This occurred because satellite time was only available during the midday hours when his syndicated show was first developed.⁵

The Abandonment of the Fairness Doctrine

Prior to 1987, the FCC's Fairness Doctrine required radio stations to cover all sides of controversial public issues equally. In application, this severely limited the topics aired on talk radio because station owners feared lawsuits or complaints at lizense renewal time by those who felt they were treated "unequally." Indeed, both sides of a controversial issue would often claim less than equal treatment. Because of this, few station owners were willing to take the risk of programming anything more than the blandest kinds of talk. Rather than risk complaints at renewal time, it was easier to avoid all controversy.

The Fairness Doctrine was merely an FCC policy that had not been made law, so the FCC could decide to drop it at any time, and that time arrived at the height of deregulation under the Reagan administration. Although many members of Congress and some lobbyists fought to write the Fairness Doctrine into law, each of three attempts ended in failure. After several years, it became clear that the Fairness Doctrine was not likely to return, and broadcasters subsequently felt increasingly free to engage in even the most slanted forms of talk programming.

By the early 1990s, radio talk hosts had more freedom than ever before to advocate one view of a controversial issue and ridicule opposing points of view. Show hosts could take—or even distort—one side of an issue and demean opposing perspectives, often with tremendous success in audience ratings. Such talk was apparently much more interesting than talk that tried to be fair or equal to both sides (see 12.4). Despite complaints of extremism, the FCC decided to rely on the marketplace to provide fairness. In theory, if one station took one side of an issue, other stations in the market would program opposing views to attract the disaffected audience. Overall fairness would be found across the dial, rather than forced on each individual station as had

12.4 Blogs 'n Talk Radio

or listeners eager to have their say on radio, the surest way is through the web. Recognizing that a daily smorgasbord of opinions and ideas flow freely online, talk radio programs like Open Source and Air America are turning to bloggers to provide content for their shows.

Open Source, distributed by Public Radio International, draws on comments and information posted by bloggers on its website, www.radioopensource.org. Bloggers suggest ideas for the program, recommend guest speakers and questions, and even appear as guest speakers. According to its site, Open Source sees itself not as "a public radio show with a web community" but "a web community that produces a daily hour of radio." To date, about 40 stations carry the program, whose topics range from global warming to national service in America to Groundhog Day to what to do in outer space.

Bloggers are also playing bigger roles in balancing and policing the air waves. For an independent talk radio show like Air America, which was created during the 2004 presidential elections to counter conservative talk radio shows like The Rush Limbaugh Show and The Sean Hannity Show, bloggers' input is critical because the show doesn't employ its own reporters. In 2007, hundreds of blogs demanded that advertisers pull their ads from San Francisco-based radio station KSFO-AM after several of its talk show hosts allegedly made racist and violence-inciting remarks. Audio clips of the shows were posted on blogs—and some were sent to advertisers, causing companies like Bank of America and Mastercard to stop advertising with the station

> Debbie Goh. Ph.D. Indiana University

been the case before. By 2000, journalists, media scholars, and even politicians were commenting that talk radio—particularly at the national level had become primarily a haven for politically conservative hosts such as Rush Limbaugh, G. Gordon Liddy, Ken Hamblin, and Sean Hannity. Although this was no problem for the conservatives in the audience, polls showed that almost three-quarters of liberals felt that the information radio format did not provide balanced programming. Many conservatives pointed to failed programs hosted by such liberal icons as Mario Cuomo and Alan Dershowitz as evidence of the marketplace at work.

However, in 2004, Air America Radio debuted on stations in New York, Los Angeles, Chicago, and San Francisco and was touted by some as the beginning of syndicated "liberal radio." Relying on easily identifiable personalities, Air America Radio signed on with dayparts hosted by comedians Al Franken, Janeane Garofalo, and Public Enemy rapper Chuck D. With the Fairness Doctrine now a distant memory, such "one-sided" left-leaning programming content became just as fair as the conservative radio that had been around for decades.

The question for local programmers seeking contracts is whether Air America has long-term viability. Despite reaching 2.1 million listeners on 75 affiliates, in 2006 the company filed for bankruptcy claiming it had lost more than \$40 million in the two years since signing on. On top of that, the network also lost Franken-by far its highestprofile host—who resigned to run for the U.S. Senate in Minnesota. Still, in early 2007 Air America was purchased by Stephen Green, a real-estate entrepreneur who guaranteed to bring what he called an "underperforming asset with unrealized potential" to profitability.6

Embracing Formerly Taboo Topics

Although the elimination of the Fairness Doctrine removed most government-imposed restrictions on the nature of talk programming, several social and cultural events in the 1990s appeared to give broadcasters the public's permission to stretch the limits of what is considered acceptable on radio. What had once been confined to the seamier sections of porn magazines, internet chat rooms, and X-rated movies was by the late 1990s suddenly fair game.

Media frenzies such as the O. J. Simpson trial, the Jon Benet Ramsey murder, and the Clinton impeachment hearings encouraged on-air listeners to vent their reactions to topics as intense as murder, child sexual abuse, and oral sex. Many programmers heard from citizen action groups outraged by the sordid and often sexual details being broadcast during morning drivetime—not coincidentally the times when parents drive their kids to school with the radio on! Most of these programmers held their ground against such groups, claiming First Amendment protection of the "information" being broadcast. The truth for many, however, was that regardless of the programmers' opinions about the Bill of Rights, many of the personalities who caused such an outcry with their titillation were also generating huge ratings numbers and advertiser revenue. Talk topics considered taboo in even the most prurient venues a few years ago are now considered mainstream radio programming.

In early 2004, however, things began to change. Some content aired on broadcast stations seemed to go too far. One was a radio stunt created by Opie & Anthony (former talkers on WNEW in New York) in which listeners were encouraged to have sex in public places. At first, this seems no more shocking than other stunts hosted by syndicated personalities on hundreds of stations across the country. Still, when the Opie & Anthony bit resulted in a broadcast "play-by-play" of copulation—at New York City's St. Patrick's Cathedral during a mass—the ever-elusive line of public acceptability was crossed.

Then, Janet Jackson and Justin Timberlake had a "wardrobe malfunction" that led to Jackson's breast being exposed to 800 million people during NBC's 2003 Super Bowl halftime broadcast. Shortly thereafter, the FCC began to strengthen its public stance against indecency. Congress, too, began to give the FCC a bigger club to swing at station owners who allowed their personalities to be overly prurient: The legislators increased indecency fines from a measly \$27,500 to as much as \$500,000. This greatly increased the motivation of station owners to keep their personalities on a shorter leash. In the past, many had decided that the small fines were a

price they were willing to pay for ratings success (see 12.5).

Increased reaction against vulgar conversation led radio ownership giant Clear Channel Communications to drop *The Howard Stern Show* from several markets and to fire long-time morning host Bubba the Love Sponge in early 2004. These moves have forced even the milder talkers who rely on innuendo rather than blatantly sexual topics to rein in their content. For example, Tom Griswold, one-half of Clear Channel's *Bob & Tom Show*, which is syndicated to over 130 stations, has said that the show is "not going to take the chance of being anywhere near the line. We've pulled way, way back." The current goal, according to Griswold, is to produce a show "that a soccer mom can listen to with her kids in the car."

The pendulum may have swung back to caution when it comes to bad taste on information stations. However, public taste is fickle, and daring programmers have made names for themselves and their stations by pushing the envelope. That may be the reason why Stern's show was immediately picked up by competitors in four of the markets where Clear Channel removed him from the airwaves. Eventually, however, the three bigmouths—Stern, Bubba the Love Sponge, and Opie & Anthony—moved to satellite radio, safe from all FCC restrictions.

Migration to FM

Another important factor in the rise of the information format was the drastic migration of listerers from the AM to FM bands. In the largest markets, audiences began abandoning AM stations for FM stations in the early 1970s. By the late 1980s, it was clear no all-music format could survive on the AM band. Those music formats that had proved successful on an AM station were rapidly duplicated by FM stations and then got higher ratings. As Chapter 11 points out, program directors of AM music stations were quick to find that when AM and FM stations offer similar music programming, the bulk of the audience will choose to listen to the FM stations, leaving the AM stations struggling for advertisers and revenue.

12.5

388

Indecency *Eventually* Costs Infinity

hen does programming result in a broad-caster making a million-dollar "voluntary contribution" to the United States Treasury? When it's indecent. Since the late 1980s, the FCC had been frequently issuing notices of apparent liability (fines) against Infinity Broadcasting for Howard Stern's allegedly indecent broadcasts. Infinity's president, Mel Karmazin, first reacted by saying the company would refuse to pay the fines, claiming that Stern's program content was protected by the First Amendment. But in 1995, Infinity Broadcasting finally agreed to pay (and as a reward, got its record of indecent broadcasts expunged).

Two developments brought about the Infinity settlement. First, in 1995 the U.S. Court of Appeals in Washington, DC, upheld the FCC's ban on indecent broadcasts in the daytime and evening (between 6 A.M. and 10 P.M.). Second, and much more important, Infinity was trying to buy 9 radio stations (in addition to the 22 it already owned). Unfortunately

(or fortunately, depending on your point of view), the purchase would require the FCC's approval.

After Karmazin failed to persuade the Commissioners to lighten Infinity's penalty, he then agreed to the \$1.7 million "contribution" while claiming his intention was to "conserve the time, expenses and human resources of the parties" involved. Howard Stern called the settlement "extortion" and the "biggest shakedown in history."

The actual amount paid, negotiated down to \$1,175,000, was the largest fine ever paid by a broadcaster. Of course, it pales when compared with the value of the stations Infinity acquired as a result of the settlement (\$375 million) or Infinity's \$3 billion value. If you won't laugh, I'll tell you that Infinity also agreed to establish a program to educate its on-air personnel about the FCC's indecency actions. Educate Howard Stern?

And Infinity has morphed into CBS Radio to clean up its name.

Lindsy E. Pack, Ph.D. Frostburg State University

At roughly the same time as the Fairness Doctrine was abandoned by the FCC, many AM stations faced financial pressures unseen since the advent of television, leading radio personalities to start supplying strong, one-sided political opinions or sexual innuendo rarely before heard. By the mid-1980s, with a nothing-left-to-lose philosophy, AM stations, even in large markets, were willing to gamble on unknown syndicated talk personalities. Visionary talk syndicators initially offered the programming for free (in exchange for clearance of the commercials), and local AM station owners were thus able to cut the expense of paying a local personality. Although almost no one in the industry believed daytime talk programming on AM could succeed, much less draw audiences back from FM, there really were no other viable programming options. Today, of course, the information format has proven to be so popular that it has also migrated to the FM band—sometimes with sustained successful results, as on KLSX (97.1 FM in Los Angeles) and WTKS (104.1 FM in Orlando).

Mobile Phones

Perhaps one reason fewer than 100 information/ talk stations were programmed in the mid-1980s is that the highest levels of radio listening occur during the morning and afternoon drivetimes. Although this may not seem like such a hindrance to the readers who have always owned a cellular telephone—and there are probably many of you keep in mind that mobile phone technology is still very new! Luckily for the format, just as the content of talk on radio was becoming more interesting, the new cell technology emerged to allow easier participation by listeners. By the 1990s, the ability of broadcasters to offer free cell-phone calls to the station's phone numbers (in return for running advertising for the cellular service) made it easier for listeners call in any time of day—but especially during their morning and afternoon commutes.

Moreover, it quickly became standard procedure for the hosts of many talk shows to move callers on cell phones to "the top of the list," thereby giving the impression that the opinions of cell-phone callers had a greater chance of being aired; thus, more and more commuters began chiming in. With the advent of "hands-free" mobile phones, even the rare commuter who feared the multitasking inherent in calling a talk-radio show with a handheld phone while driving can now safely phone in. The proliferation of cell phones has been a boon for information programmers because research shows listeners are more likely to tune in when they can call in, even if most are unlikely to actually call.

Synergistic Advertising Environment

Information radio provides an environment uniquely attractive to radio advertisers. For one thing, the audiences tend to be more loyal to the format than audiences of other formats. This, coupled with the fact that in many smaller markets only one information station exists, means that listeners are less likely to tune out during commercial breaks. Music stations, on the other hand, often have many competitors both within and between their formats. Even more detrimental to advertisers are those music stations that promote a "more music, less talk" format. This, in effect, equates talk (that is, the information that happens between music, such as commercials!) with negative emotions and invites listeners to tune out once a commercial set starts.

On information stations, however, commercials seem less of an interruption and are merely more information that the station wants to impart to its audience. Thus, given equally-sized audiences on both a talk station and a music station, advertisers are willing to pay a higher price to place their commercials on the news/talk/sports station—because more of the listeners will stay tuned during the commercial breaks.

Although the synergies between programming and commercial content have undoubtedly contributed to the talk format's rise in popularity, recent changes in the media environment mean that information programmers in the near future may need to reevaluate their strategies on commercial spot loads. First, more minutes of commercials are broadcast per hour on information stations than on any other format. While originally viewed as a benefit to

station owners, commercial clutter has reached an all-time high: Marketing messages appear in more and more places all the time, and consumer fatigue may not be far behind. Information listeners may eventually become less forgiving of an overload of commerce.

Furthermore, the popularity of the format has brought competition from other sources hoping to capitalize on the public's desire for information. Listeners can now find information programming in the form of news, talk, or sports talk from multiple radio stations in a single market, not to mention web-based talk networks, satellite-delivered radio, cable television networks, and podcasts. Loyalty to a particular source is likely to go down in this competitive environment. The wise information programmer will try to convince upper management that ultimate station success may be as much a factor of keeping listener loyalty as maximizing the number of commercials played per hour.

Information Programming Formats

Before discussing individual formats specifically, a reminder of how syndication delivery works in the media industries may be helpful. (For a more in-depth discussion, see Chapter 3.) Although many programmers initially think of television when they hear the word *syndication*, a vast number of highly rated syndicated radio shows exist as well. Any of the formats described in the following sections could either originate in the local station's studio hosted by local personalities or, instead, be delivered by a national personality via satellite by such companies as Premiere Radio Networks, Westwood One, and ABC Radio Networks.

Many syndicated shows that once relied on terrestrial broadcast signals for distribution struck deals with satellite radio services. For example, Dr. Laura Schlessinger, G. Gordon Liddy, and Michael Reagan have their shows replayed as part of the America Right channel on XM/Sirius. (The latter two conservative hosts *also* appeared as part of the Patriot channel on Sirius radio before the

two merged.) ESPN radio has also appeared on both services.

This satellite radio presence, along with webbased delivery, podcasting, and the growth of syndicated radio in the 1990s, has all but obliterated a clear line of distinction between traditional network radio and syndicators. Premiere and Westwood One are syndication companies, while ABC is a traditional network. According to some, there is no difference between such entities, especially in radio. When a single personality (such as Rush Limbaugh, Jim Bohannon, or Dr. Joy Browne) appears on hundreds of stations via syndication, the impact for advertisers on a show is the same as the impact of Paul Harvey, whose news and commentary is available only to ABC Radio affiliates. Few of the tens of thousands of people listening across the nation care whether a show is coming from a network or a syndicator. The distinction may continue to remain important to some programmers, however, because of the prestige and branding associated with being a member of a highly regarded and widely recognized broadcast network such as ABC.

As a result of the vastness of the national audience, radio remains a gold mine for talented syndicated entertainers. In 1997, Dr. Laura Schlessinger sold her daytime show to the Premiere Radio Networks (a syndicator, despite its name) for more than \$71 million. In 2001, Premiere signed Limbaugh to an eight-year, \$285 million contract. The reason for paying such enormous fees to syndicated personalities is that they generate huge advertising revenue. Although Limbaugh is certainly at the top of the heap (see 12.6), it is staggering to learn that he has generated more than \$1 billion for his distributor and affiliated stations since first being syndicated in 1988. Today, on an annual basis, The Rush Limbaugh Show brings in close to 20 percent of all revenue for Premiere.

One worry is that paying such big bucks for superstars in national syndication deals will leave talented newcomers no place to develop their skills on local radio. Michael Harrison, publisher of *Talkers Magazine*, said, "It's really sad that so much money will go to the superstars and so little to the

new talent."8 Although some program directors leave the weekends free from syndicated fare in order to groom local talent, many are concerned that their local talents may be hurting the format by expecting syndication to be their career trajectory. According to ABC Radio's John McConnell, for entertainers, "Syndication has become the automatic 'must-have,' instead of just embracing a notable person in a community."9

All-News Formats

Amid the earlier discussion of personalities and commentary, it is easy to forget that some radio programs do not comment on the news but simply deliver it. Radio did not become a primary source for news coverage until World War II, when radio technology, although still new to many, became the source of the memorable voices of Edward R. Murrow, William Shirer, and the other great war correspondents who offered listeners the sounds of battle and bombing. Today, the use of radio to keep in touch with what is happening in the world and in local communities remains popular. In such major markets as Chicago (WBBM-AM), San Francisco (WCBS-AM), and Philadelphia (KYW-AM), all-news stations are consistently among the most highly rated.

The all-news format consists of continuous newscasts, usually in 20- or 30-minute segments, for 24 hours each day. One example is WINS-AM (New York), whose slogan for a long time was, "At 10-10 WINS, give us 22 minutes and we'll give you the world." Because stations following this format repeat news cycles over and over, they tend to attract listeners for short periods of time—only long enough to hear one or two of the cycles. By then most listeners recognize that the content is nearly identical to what they heard only minutes before. This means the all-news format is a high-cume, low-TSL format: in other words, it depends on high cumulative ratings to counteract low time-spent-listening numbers. Because cume ratings are based on the number of unduplicated listeners that tune in, locally produced all-news stations are normally found just in larger markets

12.6 Rush Stumbles But Doesn't Fall

ush Limbaugh started his radio career at the young age of 16, working as an afternoon drivetime disc jockey in his hometown of Cape Girardeau Missouri. After a relatively nondescript career in music radio and a short stint in the advertising office of the Kansas City Royals' baseball team, he found his voice as the host of a political talk show in Sacramento, where he tripled the ratings for his time slot. Eventually, The Rush Limbauch Show, with its decidedly conservative political stance, found an audience at stations across the nation. Today more than 20 million listeners tune in each day to hear Limbaugh pontificate on his self-proclaimed E.I.B. (Excellence in Broadcasting) Network. Limbaugh's success in the 1990s spread to other media, too; he was the author of two bestselling books and hosted a syndicated television

Although his politically focused TV show was eventually canceled, in 2003, he had another shot at TV stardom—this time as a commentator for ESPN's Sunday NFL Countdown. Limbaugh said he wanted his role to be providing the "fan's perspective" on what long-time ESPN sportscasters Chris Berman and Chris Mortensen said during the show. It was understood among cable programming insiders, however, that ESPN had hired the talk host to do what he did best: generate controversy.

After orly five appearances, Limbaugh did just that. During a preview of a Philadelphia Eagles game, L mbaugh commented that Eagles quarterback Donovan McNabb's abilities had been overrated by the med a pecause he was an African-American. In hindsight, what may have been more shocking than the claim itself was that none of the other hosts (two of

whom were African-Americans) challenged Limbaugh on it. Nor were they instructed to do so by the ESPN producers, either during that segment or after the subsequent commercial break. Although Berman and other sportscasters on the show later made public statements dencuncing Limbaugh's comment, ESPN executives did not. Less than one week later, Limbaugh resigned.

Personal troubles continued that year for the man who often says his "talent is on loan from God." In October the newspaper tabloid The National Enquirer published a story claiming Limbaugh's former housekeeper had provided his employer with thousands of prescription pills over the course of four years. A short time later, Limbaugh announced on his radio program that he was addicted to prescription painkillers and was checking himself into a rehabilitation program. According to Limbaugh, the drugs had first been prescribed to him by his doctor following spinal surgery six years earlier. This prompted a state investigation and attempts to unseal his medical records to determine whether he used his public personality to "shop" for physicians who would provide him with the drugs.

After 30 days in rehab, though, Limbaugh was back and as bombastic as ever. What is remarkable is the extent to which Limbaugh's audience remained loyal. Survey research found that more than 90 percent of his regular listeners said they listened to him as much now as they had before the scandal. According to the researcher who conducted the study, there was "no increase in defections or negative comments even at the neight of the most negative publicity. The majority of his regular listeners are still rock-solid behind him." 10

with big enough population bases to generate the needed audience flow.

Given that listeners are constantly tuning in and out of all-news stations, commercials, program elements, and promos must be scheduled much more frequently than in other formats in order to obtain an effective frequency among the constantly changing audience. While station managers and air talent will get "sick of hearing the same thing over

and over and over," the program director must look out for the typical listener, who tunes in for perhaps 20 minutes a day and relies on the heavy frequency in order to be sufficiently exposed to the information.

Another important philosophical decision for an all-news programmer is to decide on an optimal ratio of different types of news: hard news, entertainment news, economic news, human-interest stories, and so on. Some all-news programmers insist that as many stories as possible should contain a local angle. In other words, even if the story focuses on something taking place overseas, such as the 2004 tsunami, in order to get on the air the story must be written in such as way as to have a simple, clear answer to the question, "How does this affect our local audience?" This is often accomplished by the presence of an "exemplar," a local resident or expert either affected by or offering their opinions on the story.

Other programmers make sure their content contains an ample supply of news about motion picture celebrities, television stars, famous athletes, and sex scandals. To them, "news" is the type of information that can be talked about in the break room at work or with a friend you meet for lunch. For these reasons, stories about international relations, macroeconomic policy, scientific discoverynews that cannot easily be put directly into a human context—is seldom covered. This trend toward human-interest/entertainment coverage in radio news can be seen as early as 1953 in the Programming Policy book of the Trinity Broadcasting Company (see 12.7).

Network-Delivered Newscasts

Most large-market stations are now so tightly formatted that they want newscasts more tailored to their format than any network can provide. In response, the traditional radio networks have shifted from delivering newscasts to becoming sources of original sound bites. Stations then use the network sound bites to craft their own custom newscasts.

Increasingly, network news material is delivered not by a local anchor or as part of a traditional newscast but by a sidekick to the station's drivetime personality. One model for the newscaster as sidekick is Robin Quivers, who began as a newscaster but who now is, in effect, one of the team of cohosts of The Howard Stern Show on satellite radio. Using members of the wacky "morning zoo" team as newscasters may make traditional journalists shudder, but the practice has increased program consistency, reduced audience turnover, 12.7

1953 Guidelines on Doing the News Interestingly

lot of stories . . . just disinterest, bore, and/ or confuse listeners. These stories are in the following categories, by and large:

Repatriation commission hearings Central European political developments The day's activity . . . at the UN Localized Korean fighting . . .

These are, roughly, the type of stories that will in short order kill any newscast . . . (Instead) find stories of human interest like this . . .

Marilyn Monroe denies she is marrying Christine lorgensen . . .

Play down all confusing or uninteresting stories stories without human interest.

Trinity Programming Policy Book, as reproduced in David R. MacFarland, The Development of the Top 40 Radio Format, New York: Arno Press, 1970.

and resulted in increased ratings. As local stations increasingly model their formats after Stern/Quivers or Imus/McCord, entertainment environments become the primary sources of local and national news on radio.

Ironically, what were once the great radio network news departments have assisted in killing themselves off by passing along sound bites of everything from presidential addresses to Hollywood stars pushing their latest productions. In 2004, however, Fox News surfaced as radio power on the nightly Clear Channel stations, reviving network-delivered newscasts in about 400 markets. Bringing its uniquely conservative slant, Fox builds radio interview shows around such cable news hosts as Alan Colmes and Spencer Hughes.

In smaller markets and on less successful stations in larger markets, network newscasts can still be heard in their entirety. Because these stations have much smaller audience sizes, the radio networks could not survive financially if these were the only audiences their national advertisers could reach. Network affiliation contracts require stations that choose not to carry the newscasts in full (mostly major-market affiliates) to at least broadcast the commercials that were included within the newscast. Stations receive private feeds of the commercials from the networks for local recording and insertion into local programs. They also receive schedule information from the network. They must then schedule the network's commercials in time periods equivalent to when they would have aired in the newscasts. After these replacement commercials air, station personnel produce affidavits for the networks affirming the times and dates the network spots ran.

News Scheduling Priorities

Because the programming of all-news stations is based on repeating cycles, scheduling considerations tend to be tighter than for talk stations. On the average, news occupies about 75 percent of airtime on an all-news station. The basic elements at an all-news station include the following:

- Hard news copy
- Recapitulations (recaps) of major stories
- Question-and-answer material from outside reporters
- Results of public opinion polls
- Telephone actualities from exemplars

Earthshaking news developments on a global or national scale are not necessarily uppermost in the audience's notion of what is news. During morning drivetime, weather and traffic reports should be emphasized as they will determine how listeners start their day. A typical urban schedule runs in this way: time announcements at least every 2 minutes; weather information (current and forecast) no more than 10 minutes apart; traffic information every 10 minutes; plus, interspersed, related information such as school closings, major area sports events, and so on. In other words, the top priority in any all-news format is local, personal, service programming. Item repetition slows during midday as average listener TSL increases, and is stepped up again during afternoon drivetime (4 to 6 P.M.).

Predictability is important in news programming because the audience will get used to coming

to the station at specific times for program elements such as weather, traffic, and sports. During drivetimes, in fact, many all-news stations develop on-air slogans that emphasize when listeners can count on hearing what matters to them most during their commute to work. For example, WWJ-AM (Detroit) gives its listeners "traffic and weather together on the 8s," meaning listeners know that they can tune into the station at 8, 18, 28, 38, 48, and 58 minutes past each hour and be sure to get the information they need.

Talk Formats

Just as there is format fragmentation in music radio (discussed in Chapter 11), traditional talk has fragmented to include hot talk, advice talk, business talk, sports talk, success talk, and other niche formats. Such variations of talk radio differ in approach, sound, and "attitude" and appeal to quite different audiences. Most consultants now identify at least 10 major talk formats, shown in 12.8 and described in more detail in this section.

Heritage Talk

Heritage talk stations typically are 50,000-watt clear channel stations that have included at least some talk programming for forty years or more (see 12.9). Twenty years ago, these were classified as full-service stations with a mix of news, talk, sports, and midday music. Increasingly, these stations have moved to all-information formats with emphasis on local news, weather, traffic, sports, and local talk. They are also able to attract the highest rated of the nationally syndicated talk programming, primarily because of the wide signal coverage they have at night. These stations typically carry heavy commercial loads, often up to 20 minutes an hour.

Politics/Issues Talk

Political talk occupies a formidable spot on any list of information radio formats. Rush Limbaugh is certainly the king of the genre, but there are many other well-known syndicated personalities

Ten Top Talk-Radio Formats

- 1. Heritage talk: Traditional news/talk formats, mostly on the AM band. Broad appeal with mix of news, sports, talk, health, and financial features.
- 2. Politics/issues talk: Discussion of the latest issues coming from Washington, DC, around the world, or from the local city and state.
- 3. Sports talk: Discussion of the issues surrounding major team sports of interest to men: football, baseball, and basketball. Often also supplemented with play-by-play and "guy talk."
- 4. Success talk: Formerly, money talk or business radio. A mix of investment and personal advice for financial success. May include talk about upscale travel, recreation, and relaxation.
- 5. Hot talk: Younger demographic appeal with sexually oriented content. Usually found on FM stations.

- 6. Urban talk: Similar to heritage talk but with African-American appeal. Tends to be in urban areas.
- 7. Faith talk: Also called "religious radio." Used to be exclusively Christian, but now characterized by a growing multitude of faiths.
- 8. Spanish/foreign-language talk: Similar to heritage talk but appealing to the needs of the demographic audience that speaks the programmed language. One of the fastest-growing formats.
- 9. Health and help talk: Advice given to callers about anything from health to finances to home improvement. Includes many syndicated weekend programs.
- 10. Technology talk: Initially limited to discussion of web-based issues, but is likely to broaden.

out there, such as Sean Hannity, Michael Savage, Glenn Beck, and Ed Schultz. Politics/issues talk is sometimes described as programming hosted and listened to by "angry white men"-leaning to either the left or the right politically. However, that characterization is not altogether accurate. There are examples of successful hosts of color in this format, such as Lincoln Ware on WDBZ in Cincinnati and Jo Madision, "The Black Eagle," on WOL-AM in Washington, DC, who has long been syndicating his conservative political talk show from Denver. At the local market level, Ray Taliaferro was the first black talk-show host in a major market when he joined KGO-AM (San Francisco) in 1977, and he has been talking politics in the Bay Area ever since.

Many programmers find success by scheduling female hosts who can intelligently communicate a political viewpoint to an audience. Progressive talker Randi Rhodes has been solidly holding down afternoon drivetime on Air America since its inception. Diane Rehm of National Public Radio (NPR) and WAMU-FM (Washington, DC) has been effectively discussing political issues on the air for thirty years. The Laura Ingram Show is syndicated by Westwood One, and its host was described by Talkers Magazine as the "leading nationally syndicated female political talker [with a] razor wit."11

Scholars have recognized that political talk radio is more effective than many other forms of mass media at generating a sense of solidarity and community among its audience members. Many believe the format provides "a venue for a public that feels ignored, isolated, alienated, and powerless to channel their anger concerning . . . actions by political elites. . . . "12 Politics/issues talk stations can also take the lead in affecting political attitudes and social change. Some believe that the impeachment hearings of President Clinton would never have come about had it not been for hosts of political talk radio keeping listeners focused on the Clinton/Monica Lewinsky scandal. Others believe the historic recall election of California governor Gray Davis would not have occurred had it not been for the efforts of such political talk stations such as KSFO (San Francisco), KTZK (Sacramento), and KFI (Los Angeles). These stations not only consistently raised the topic of public dissatisfaction

12.9 Heritage News and Talk

n the m d-1960s, the foundation for all-news radic was laid by two major broadcasting groups. The first was Group W, the Westinghouse Broadcasting Company, which converted three AM stations—WINS (New York) and KYW (Philadelphia) in 1965, and KFWB (Los Angeles) in 1968—to an all-news format. CBS followed suit with several of its owned-and-operated AM stations, first at WCBS (New York), KCBS (San Francisco), and KNX (Los Angeles), and later at WBBM (Chicago), WEEI (Boston), and finally WCAU (Philadelphia).

By the mid-1990s, hundreds of stations, mostly AM, were identifying themselves as all-news or news/talk stations, and the format was spreading beyond major cities into smaller markets. Although the all-news format is dependent on local programming, network affiliation provides coverage most local stations cannot supply. In addition, a growing number of syndicators supply both affiliated and

nonaffiliated stations with news services and programs.

The term talk station was generally adopted when KABC in Los Angeles and c few other major-market stations discarded their music formats around 1960 and began airing information programming featuring the human voice. KABC started with a key four-hour news and conversation program, News/Talk, from 5 to 9 A.M. KGO in San Francisco later adopted the name of that program to describe its overall format. KGO used news blocks in both morning and evening drivetime and conversation programs throughout the balance of the day. KABC focused on live call-in programs, interviews, and feature material combined with informal and formal news coverage. KABC first promoted itself as "The Conversation Station." bunews/talk stuck as the generic industry term for stations that program conversation leavened with news during drivetimes.

with Davis but also actively collected listener signatures on petitions that led to the eventual recall.

Sports Talk

Sports talk radio is a rising star in information radio. Just a few years ago, only a handful of stations dedicated their formats to sports programming. Today, hundreds of commercial sports talk stations are on the air, with some major markets supporting two sports talk stations. The vast majority of these stations are AM, but a few FM sports talk stations exist as well. Some of the leading stations in this genre include WFAN-AM (New York), WMVP-AM (Chicago), and WIP-AM (Philadelphia).

The growth of sports talk has been fueled not only by the overall success of information radio but also by the sports format's appeal to men in the 25 to 54 or 18 to 34 age groups, two elusive demographic groups much sought by advertisers. Another huge factor in sports talk's success was the development of a syndicated radio network as a brand extension of the cable television network

ESPN. ESPN Radio is carried on more than 700 affiliates in the United States, with about 300 of them airing the feed around the clock. Beyond getting the allure of the ESPN brand, affiliate programmers acquire some of the hot personalities that viewers are familiar with, such as Dan Patrick, Mel Kiper, Jr., and Mike Golic. ESPN Radio is not the only full-time syndicated sports talk source: Sporting News Radio and Fox Sports Radio also reach millions of listeners each on hundreds of affiliates in North America.

Often, programmers who affiliate with these networks choose not to schedule all of the available programming, electing instead to schedule local hosts to discuss professional, minor league, collegiate, and even high school sports of interest to the local market. Of course, play-by-play coverage of games is an important element, but other popular sports talk staples include scoreboard shows, interview shows, and talk programs with a sports slant. Ultimately, decisions in this format, just like any other, must be made according to the desired target market of the programmer. For example,

some ESPN Radio affiliates felt that the network's *The Tony Kornheiser Show* skewed too old for their programming strategies and opted instead to go after *The Jim Rome Show*, a stand-alone talk show syndicated by Premiere Radio Networks. Rome's in-your-face style as he "gives his take to the clones" (translation for those unfamiliar with the show: "states his opinion to his listeners") is viewed as more attractive to the 18 to 34 male demographic. Similarly, *The Herd with Colin Cowherd* was picked up, because it is a faster-paced show skewing to younger males.

Sports programmers agree that a successful sports talk station is more than just discussion of sports. In fact, some consultants prefer to call the format "guy talk" because what makes the format work is a combination of the games themselves and a celebration of the lifestyle that goes with them. The fun surrounding a football game is far more than just going to the game. The game becomes an excuse for a day-long or weekend-long party with tailgating, road trips, and barbecuing. In sports radio, capturing on the air the lifestyle of the sports fans is what really makes this format work. Sports talk personalities commonly discuss movies, celebrities, politics, music, and much more—as well as sports. In fact, ESPN Radio's morning drivetime show-Mike & Mike in the Morning-even has a daily stock report because the programmers at the network recognize that many of the males in their target market are interested not only in sports but also in business and investing.

Success Talk

This format, also known as money talk or business radio, offers listeners a mix of investment and personal advice for financial success. Segments include discussion of stock trading, retirement planning, insurance issues, and taxes. Some programmers of success talk also include programs that focus on health and recreation, chic travel and vacations, and upscale entertainment. Just like the sports talk format, some stations choose to sign on to a 24-hour syndicated network such as Bloomberg Radio. Others, however, use a mixture of nationally syndicated personalities (Clark Howard, the

Dolans, Lou Dobbs, and Dave Ramsey) and locally known financial gurus. Although stations in this format rarely deliver large ratings, those that succeed do so because they convince advertisers that the listeners are very loyal and upwardly mobile. One of the best known of these shows appears only on the weekends: *Bob Brinker's Moneytalk*, which focuses on financial advice. Examples of stations that program the success format include WBIX-AM (Boston) and KBNP-AM (Portland, Oregon).

Hot Talk

This format focuses on discussions of sexual issues that are presented in a titillating way to appeal to the male audience. Most hot talk formats can be found on FM stations, where many programmers are trying to develop a sound that expresses a "rock and roll" attitude without the music. One general manager described the ideal FM information listener as "male, professional, 33, two kids, political, growing out of rock 'n' roll." According to Tom Leykis, a legendary name in the hot talk format, for a program to attract this ideal listener, it must focus more on personal relationships than on conventional talk topics like politics or the economy. And that approach leads to a voyeuristic prodding into listeners' sex lives.

Whether the content is a male listener describing his sexual conquest of the night before or a female relating her conflicted feelings about sharing a sexual affair with her husband, such talk tends to repel older people while attracting those who thought they were "music-only" listeners. It will come as no surprise that Howard Stern is one of the most successful hosts of talk radio with a "rock and roll" attitude. His move to satellite radio has left opportunities for others to grow even larger in their broadcast popularity. As mentioned, Leykis is another big-name hot talker in national syndication. Local markets also have their hot talkers, such as Steve Dahl of WCKG-FM (Chicago) and the Monsters in the Morning, a seven-person hot talk circus on WTKS-FM (Orlando).

Aside from the increased audience size that bawdy talk attracts, it also allows for an additional six or seven minutes of commercials over what could be successfully programmed on allmusic formats. Programmers who may be allured into trying hot talk should consider, however, that the ultimate future of the format is unclear due to the increased scrutiny over obscenity and indecency that radio has recently received (see 12.5 earlier in this chapter).

Urban Talk

Stations programming this format tend to be in metro areas where the available listening audience includes a large number of middle- to uppermiddle-class African-Americans. The approach usually follows that of heritage or political talk, but the issues are those with a strong appeal to black listeners. A syndicated leader is The Tom Iovner Morning Show, which is delivered by ABC networks to over 8 million listeners on more than 115 affiliates (see 12.10). Although music takes up a substantial portion of Joyner's show, the key programming element is the information he and his cohosts provide to their audience. Local stations programmed to focus on the urban issues of their communities are also highly popular in major urban areas. In addition to WVON-AM (Chicago), others in this format include WOL-AM (Washington, DC) and satellite radio's "The Power."

Faith Talk

This format has long consisted primarily of talk programming that focuses on Christian topics. Stations typically have a combination of syndicated program elements from such nationally known clergy as Billy Graham, Max Lucado, T. D. Jakes, and Joyce Meyer; they are accompanied by national and local political talk hosts offering their positions on topics from a Christian worldview. The faith talk format is expanding, however, with many more beliefs now represented. Some broadcast stations program exclusively Jewish talk and Catholic talk, supported by national Jewish and Catholic network programming. Jewish Moments in the Morning has been on New York/ New Jersey's community radio WFMU since 1977 (www.jmintheam.org), and online sources include www.jewishradio.com. Those of the Muslim faith

12.10 African-American Talk on Radio

he Tom Joyner Morning Show has made a big place for itself in the radio syndication history books. Begun in 1994, the show is one of the first nationally syndicated radio programs hosted and produced by an African-American and distributed by a nonblack network. It reaches about 8 million listeners on some 115 stations. Moreover, in 2003, Joyner (majority shareholder and chairman of Reach Media) assumed control and syndication of his own show, making this a rarity in syndication—a black-owned program.

Distributed as a four-hour morning-drive radio program, The Tom Joyner Morning Show appeals to an urban contemporary audience of affluent adults. It schedules a mix of oldies urban music, guests from politics and entertainment, and multiple local tags or promos to give the show a "hometown feel."

Tom Joyner, the self-proclaimed "hardest working man in radio," made his name a household word with African-Americans while raising money for black colleges and other political causes. A daily segment called "It's Your World" is one of the few present-day radio soap operas. Listeners say following the on-again, off-again relationships of various characters keeps them on the edge of their seats, and the rating books show that the segment certainly keeps them tuned in.

George L. Daniels, Ph.C. University of Alabama

can also find a talk-radio outlet on the web at www.radioislam.com. Baha'is can listen to www.bahairadio.org, and Hindus can access www.hinduradio.com. Moreover, podcasting provides for listeners a wealth of information across a wide range of religious and spiritual topics.

Spanish/Foreign-Language Talk

This format, similar to the urban talk format, is one where the information being provided focuses on the needs of those whose native language is not English. Although the largest markets may have low-powered AM stations programming

information in almost any native tongue, by far the dominant and fastest-growing foreignlanguage talk format is Spanish. In fact, each of the five largest radio markets has at least one Spanish news/talk station. The popularity of this format has grown rapidly along with the number of Spanish-speaking people in the United States, and has been recognized by national networks. CNN now distributes CNN en Español Radio—a service of hourly five-minute original newscasts to over 70 affiliate stations. Of course, regardless of the language, many information stations now stream their signals over the World Wide Web, giving non-English speakers easy access to foreign-language talk stations from around the globe with the click of a mouse.

Health and Help Talk

Although it is rare to find a station that programs this format exclusively, many programmers find that a regular offering of some type of advice to listeners is a good addition to their broadcast schedule. The type of advice varies widely and is usually limited only by the host's expertise. Advice programming contains information on nutrition, health, relationships, household remodeling, sexuality, the law—the list is almost endless. Some syndicated weekday leaders in this area include Dr. Dean Edell and Duke and the Doctor (for health-related concerns) and Drs. Joy Browne and Laura Schlessinger (for relationship issues). Also in this category falls the network devoted to superserving the nation's truckers who are often on the road during the overnight hours. The Midnight Trucking Radio Network reaches all of the United States and over 75 percent of Canada and Mexico, thanks to overnight broadcasts on many 50,000watt stations in the United States (see 12.11).

Often, shows falling in the health/help talk category air only once a week—usually on the weekend. Well-known nationally syndicated examples include *The Money Pit*, a show about home improvement, and *On the Garden Line*. Many such weekend shows also produce "daily minutes" offering tidbits of advice to listeners while also promoting their long-form weekend programming.

12.11 Midnight Trucking Radio Network

alling itself the "national clearinghouse of information, thoughts, and opinions of the American Truck Driver," the Midnight Trucking Radio Network (MTRN) airs nightly from midnight until 5 A.M. With only 23 affiliates, the MTRN may seem miniscule compared to the hundreds carrying The Rush Limbaugh Show. However, the network can actually be heard in almost every market of the country because eight of its affiliates broadcast on 50,000-watt clear channel transmitters that have tremendous geographic reach during the overnight hours. This national reach is also expanded by MTRN's presence on satellite radio.

MTRN hosts Eric Harley and Gary McNamara take calls from truckers and deliver information precisely targeted toward their specific audience, including hourly reports of weather along the nation's highways, announcements of road closings and construction delays, news about legislation affecting the trucking industry, and daily maintenance tips. They also take calls from truckers behind the wheel during segments focusing on everything from semi-truck insurance issues to the latest in truck technologies. So, as the network's website (www.midnighttrucking.com) says, "Whether you're behind the wheel or just can't sleep, you're never alone . . . when you've got The Midnight Trucking Radio Network."

Technology Talk

Originally referred to as "internet talk," this format has now expanded to include discussions of anything to do with computers and technology. Although it is unlikely that a programmer will choose to focus on this topic 24 hours a day, weekly programs focusing on computers have been highly successful. *The Kim Komando Show* is a weekly syndicated show remarkable not only for explaining technical issues about computers in very simple terms to callers but also for being hosted by a very knowledgeable female personality in a stereotypically male-dominated genre. As computers and technology play an increasing part

in our society, expect the number of syndicated programs in this format to continue to expand.

The Content Infrastructure

Most information radio formats are constructed to showcase different types of content during different dayparts. Heritage talk stations, for example, schedule a heavy load of news during morning drivetime (from 5 to 9 A.M. or 6 to 10 A.M.) and again during afternoon drivetime (from about 4 to 6 P.M. depending on the market). The rest of their program days are devoted to various kinds of talk programs and often include some type of sports programming.

Although news and talk stations are often seen as similar because their spoken-word formats are so distinct from music stations, they are in fact very different from one another. The all-news programmer oversees the equivalent of a single program that recycles for 24 hours throughout each day, whereas talk programmers fill most of their days with diverse shows lasting from one to six hours. The talk programmer must also consider the gratifications desired by various kinds of talk listeners. Some are attracted by the personality of such hosts as Schlessinger or Limbaugh. Others use talk radio primarily as a way to gather information. Still others listen to hear viewpoints that differ from their own.

The programming infrastructures for both news and talk formats, however, are usually created on computers and form the skeletons on which hang the sections of hard news, features, talk programs, game coverage, sports commentaries, editorials, and so on. At all-news stations, newscasts are repeated in 20-, 30-, 45-, or 60-minute sequences, although most stations prefer the shorter 20-minute cycles. Cycle length affects spot and headline placement; time, traffic, weather, and sports scheduling; major news story development; and feature scheduling. Advantages and disadvantages are inherent in all lengths; which cycle pattern a programmer chooses depends on local market conditions, staff capability, editorial supervision, program content, and commercial load.

As mentioned earlier, information formats usually program a larger commercial load than music

stations because the spots seem less intrusive. Typically, each hour on an information station contains 12 to 18 minutes of spot announcements. Talk stations tend to have fewer breaks per hour, and often the number and location are dictated by the programs' syndicators. All-news stations, especially those with frequent news and traffic updates, may run as few as one or two spots in breaks coming every five minutes or less.

Hosts

In the all-news format, many of the on-air talent are experienced journalists. Some have spent years in television or print news prior to joining a radio staff. Sometimes, radio hosts have many information careers going at once. Mitch Albom hosts a syndicated talk show and writes for the Detroit Free Press. Dan Patrick hosts a three-hour sports talk show on ESPN Radio and is also a regular anchor on the ESPN cable network. Talk hosts are sometimes experts in their particular field (for example, the doctors or scientists in the health/help talk format) but usually could best be described as generalists. They have developed the ability to grasp a subject's essence. The host of a generalinterest issues talk program will discuss world and local affairs, politics, medicine, economics, science, history, literature, music, art, sports, and entertainment trivia-often on a single show. It thus becomes a vital part of the host's daily preparation to keep abreast of current events and to have at least some familiarity with a wide range of torics.

Callers and Listeners

It is important for an information programmer (any radio programmer, really) to remember that people who are motivated enough to call the station and try to get on the air represent only a small fraction of the audience. According to surveys by the Times Mirror Center for the People and the Press, only 11 percent of Americans say they have attempted to call a talk-radio program; of these, only 6 percent report that they made it on the air. It is common for show producers and screeners to choose callers to put on the air according to their likelihood of offering an interesting perspective on

12.12 Demographic Profile of News/ Talk/Sports/Radio Listeners

- 1. Almost 60 percent of the audience is male.
- 2. Three-fourths are above the age of 45.
- 3. Three-fourths have attended college, with 30 percent holding college degrees.
- 4. Almost half live in households with incomes between \$50,000 and \$100,000.
- 5. More than two-thirds own their homes.

Radio & Records Directory, Los Angeles: Radio & Records, Inc. 2004.

the topic being discussed or saying something that may hit a nerve with the host or other listeners. Programmers should keep in mind that, although the audience may like listening to this controversy, most people will not hold such extreme viewpoints. Callers do not provide an accurate profile of listeners, but station personnel frequently become so focused on calls that they forget about the larger audience—which should be their prime concern. Switching the emphasis to the listening audience usually makes ratings go up. What is known about the talk-radio listener appears in 12.12.

Commercial Interests

Of all radio formats, talk is the most vulnerable to the appearance of what is really unscheduled commercial matter. Payola and plugola have long been associated with the music industry, but the talk format offers greater opportunities for such abuses. An hour of friendly conversation presents frequent chances for the on-air host to mention a favorite resort or restaurant or to comment on a newly acquired automobile. Moreover, the program host is often in the position of booking favored business acquaintances as guests. The onair personality receives many offers from potential guests and local businesses, ranging from free dinners to discounts on major purchases. Policies aimed at preventing regulatory violations must emphasize that management will severely penalize culprits. Stations often require their on-air talent and producers to sign affidavits showing that they understand the law on these points, and some hire independent agencies to monitor their talk programs for abuses. More than one station has reinforced this message by billing on-air performers for the time when their casual conversations became "commercials."

However, guests representing commercial enterprises may certainly appear on the station. It is appropriate, for instance, for a local travel agent to discuss travel in mainland China or for the proprietor of a health food store to present opinions on nutrition. And, obviously, many personalities on the talk-show circuit have something to sell-a book, a movie, a sporting event, a philosophy, and so on. Some mention of the individual's reason for appearing is appropriate because it establishes the guest's credentials. An apt reference might be, "Our subject today is the popularity of computer games, and our guest is Dr. Ted Castronova, author of a new book entitled Synthetic Worlds." A gray area arises on those occasions when the host seems to be strongly encouraging listeners to buy the book. If the host has no financial interest in the publication, however, a claim of violating FCC regulations is unlikely.

On-Air Talk Techniques

Call-in programs are the backbone of talk radio. They can also be complicated to produce, especially if a program has a dozen phone lines to deal with. To help the on-air personality run a smooth show, the call screener or producer has become a vital part of the talk-radio staff. The screener is partly a "warm-up artist" for the host-building up the caller's enthusiasm and excitement so that it comes through in the caller's interaction with the host—and partly serves as a traffic cop.

Telephone Screeners

Screeners add substantially to station budgets, but a station can control its programming only through careful screening. Many hosts and programmers view airing "cold" or unscreened calls as a dangerous practice. Jim Bohannon of Westwood One, on the other hand, prefers the spontaneity of unscreened calls, saying to his listeners, "If you get in, you get on."

The screener for a talk program functions as a gatekeeper, exercising significant control over the information that reaches the air. Screeners constantly manipulate the lineup of incoming calls, giving priority to more appropriate callers and delaying or eliminating callers of presumably lesser interest. The screener asks each caller a series of questions to determine whether the call will be used: "What topic do you want to talk about? How do you feel about it? Why do you want to speak on the air?" At the same time, the screener determines whether callers are articulate, whether their comments are likely to promote the flow of the program, and whether they possess some unique quality that the host and audience will find appealing. In the case of The Dr. Laura Show, for example, the screener prompts callers to begin by thanking the host and tries to get each one focused on a specific question to ask.

The screener also asks for the caller's name. Most stations prohibit the use of full names to forestall imposters from identifying themselves as prominent people in a community and then airing false statements to embarrass the individuals they claim to be. Another job for the screener is to filter out the "regulars" who call the station too frequently as well as those unable or unlikely to make a coherent contribution. When screeners must dump a caller, they say something like, "Thank you for calling, but I don't think we'll be able to get you on the air today." Callers thus dismissed and those asked to hold for long periods often complain of unfair treatment, but the screener must prevail, insisting on the right to structure the best possible conversational sequence. The most effective screeners perform their jobs with tact and graciousness, but a few callers always go away mad.

Various systems are used for the screener to signal to the on-air host which incoming call is to be aired next. Most talk stations now utilize computer software they have developed themselves

or a commercial product. Using computers shifts greater program control to the on-air host. The computer display indicates the number and nature of the calls prepared for airing as well as the first name, gender, and approximate age of each caller, and it may specify the point the caller wishes to discuss. The host can then alter the complexion of the program by orchestrating call order. The display also frequently includes material of practical conversational value, such as the current weather forecast and news headlines. Hosts often use a timer to monitor call length. and many hosts cut a caller off, as politely as possible, after 90 seconds to two minutes to keep the pace of the program moving. Listeners will tune out a poor phone call on a talk station just as they would a weak song on a music stat on. Thus, hosts must control the on-air subject matter and the flow of program material rather than let callers dictate the programming. The point is to move the show along rather than get bogged down making sure each caller gets his or her "full" say.

Almost all talk stations use an electronic unit that delays the programming about seven seconds to allow the host or audio board operator to censor profanity, personal attacks, and other questionable utterances. The on-air host generally controls a "cut button" that diverts offensive program material, although the engineer should have a backup switch. Because the program is delayed, the screener instructs all callers to turn off their radios before talking on the air. If they fail to do this, callers hear their voices coming back at them on a delayed basis and cannot carry on a conversation, causing the host to exclaim, "Turn your radio down!" Listening only on the telephone, callers hear the real-time program material and can talk normally with the host.

When a program depends on callers, what happens in those nightmare moments when there are none? For just this emergency, most talk-show hosts maintain a clipping file containing newspaper and magazine articles saved from their general reading to provide a background for monologues when no calls come in. Another strategy is the expert phone list, a list of 10 or 20 professionals

with expertise in subjects of broad appeal. Resorting to the list should yield at least one or two able to speak by phone when the host needs to fill time in order to sustain a program.

Controversy, Balance, and Pressure

Although information radio programmers get many opportunities for creative expression, they also must devote considerable time to administration. Because the station deals almost constantly with public-affairs issues, its programmers spot-monitor the station's programs for compliance with FCC rules, and to avoid legal problems such as slander. A programmer, however, having many other duties as well, rarely knows as much about the minute-by-minute program as heavy listeners do. Therefore, backup systems must be established. Many stations keep archived recordings of previous broadcasts in order to respond to complaints made by the public. This task has been made much easier by digital recording. In the past, stations often had engineers rig reel-to-reel tape machines to record at ultra slow speeds in order to backup weeks of programs on a single tape. Otherwise, the number of tape reels would overwhelm the station!

Talk stations frequently find themselves the targets of pressure groups, activist organizations, and political parties trying to gain free access to the station's airtime. Although most partisans deserve some airtime in the interest of fairness and balance, management must turn away those seeking inordinate amounts of airtime. Because of this, and the fact that an effective talk station frequently deals with controversial issues, management can expect threats of all kinds from irate audience members. A provoked listener will demand anything from a retraction to equal time, and on occasion, someone will threaten legal action.

Potential lawsuits usually vanish, however, when management explains the relevant broadcast law to the complainant. Review of the archived program proves very handy in these situations. When the station is even slightly in the wrong, it is good policy to provide rebuttal time for an overlooked point of view.

A primary ingredient in the recipe for success in any talk format is commitment at the top—at the station management level. A timely and innovative music format can catapult a station from obscurity to the number-one ranking during a single rating period. Talk stations and all-news stations, on the other hand, generally take years to reach their potential. Once success is achieved, however, the talk station enjoys a listener loyalty that endures long after the more fickle music audience shifts from station to station in search of the hits. High figures for time-spent-listening and long-term stability in cumulative ratings demonstrate audience loyalty in the information format.

Information Formats on Public Radio

Until now this chapter has focused on programming commercial information stations—a task that is ultimately guided by the specific goal of gathering either a large audience or one with an extremely desirable demographic and psychographic profile that can then be sold to advertisers. The discussion now turns toward a type of information radio guided more by delivering what the programmers believe is important information than by attempting to gain high ratings.

Information programming is among the most popular formats on public radio stations—at least during large blocks of the day. Talk shows such as Car Talk and A Prairie Home Companion attract large, loyal audiences (see 12.13). Similarly, news programs such as All Things Considered and Morning Edition are popular and trusted sources for millions of Americans. Because of their popularity, the potential for earning commercial revenue from these shows is tempting to many public radio managers. However, public stations are explicitly committed to serving as an alternative to commercial broadcasting by providing programs for specialized, smallaudience needs. Instead of selling commercial spots, the major public radio networks sell their programs to affiliates (the member stations), who must in turn find funds from local underwriting by businesses

12.13 A Companion to Prairie Home Companion

Tt's been a quiet week in Lake Wobegon, Minnesota, my home town." For almost 30 years, those words have introduced listeners to the lives of the most famous nonexistent residents of Minnesota's most famous nonexistent town. Those are also the words associated with Garrison Keillor, one of the world's greatest living storytellers. But few could have seen his genius in the beginning.

The name A Prairie Home Companion was borrowed from the Prairie Home Cemetery in Moorhead. Minnesota. It goes back to 1969 when Keillor was doing a morning show on Minnesota Public Radio. While researching the Grand Ole Opry for an article, Keillor had one of those incredibly brilliant moments that most others would have considered insane. His idea was to produce an old-fashioned radio variety show. Never mind that live radio plays had been declared dead for more than 20 years. NPR wasn't interested, but about five years later, with the help of the more adventurous Minnesota Public Radio, Garrison Keiller's first variety broadcast occurred on the campus of Macalester College in St. Paul. There were 12 people in the audience. As they say, the rest is history.

News of the seemingly innovative program quickly spread by word of mouth, audiences grew, and a decade later the show moved into a larger St. Paul theater (later renamed the Fitzgerald Theater) where it has been—with brief interruptions—ever since. Those interruptions included renovations in 1986, Keillor's retirement from radio in 1987 to marry and move to Europe, and the period from 1989 to 1993 when the show was broadcast from New York under the name Garrisan Keillor's American Radio Company.

Today, alongside Garrison Keillor, a small group of people keep the show going. These include

Pat Donohue, Andy Stein, Richard Dworsky, Arnie Kinsella, and Gary Raynor (making up Guy's All-Star Shoe Band), and Tom Keith and Fred Newman handling sound effects. Tim Russell, Sue Scott, and Erica Rhodes contribute as actors. These people. along with a seemingly endless list of guest stars (the show is considered one of the most significant outlets for all genres of folk music) keep the only regularly scheduled live radio variety show in the United States fresh and innovative every week.

People everywhere now know about "The Catchup Advisory Board" (a compromise between the two spellings of catsup and ketchup and "natural mellowing agents," The Professional Organization of English Majors, Be-Bop-A-Re-Bop Rhubarb Pie, the Café Boeuf, and Ralph's Pretty Good Grocery (where "if you can't find it, you can probably get along without it"). Guy Noir and Dusty and Lefty have become household names; Dusty and Lefty even have their own sponsor (Prairie Dog Granola Bars-"healthier than chewing tobacco and you don't have to spit"). Perhaps the reason the program seems to speak to so many people, and has lasted so long, are its regular looks into the ordinary lives of the citizens of the fictional Lake Wobegon.

Carried by about 50C radio stations and listenec to by nearly 4 million people in the United States, A Prairie Home Companion has become a worldwide broadcasting phenomenon, aired in different versions by New Zealand's National Radio, WRN in Europe. BBC 7 in England, and RTE in Ireland, among other places. It has also become the flagship program for its distributor, American Public Media, which challenges NPR for the public broadcasting crown.

> William J. Adams, Ph.D. Kansas State University

and from listener donations during periodic pledge drives. The two major networks, National Public Radio (NPR) and Public Radio International (PRI), also look for underwriting from national companies and foundations in order to fund their production operations and keep the program acquisition fees charged to affiliates as low as possible.

Sometimes, donations to these national networks can create a catch-22 situation. This was experienced in a grand way in 2003. In January of that year, NPR received a \$14 million grant from the John D. and Catherine T. MacArthur Foundation. At the time it was the largest grant the public radio network had ever received. Only a few months later, it was announced that Joan B. Kroc—late millionaire widow of the founder of the McDonald's restaurant chain—had bequeathed more than \$200 million to NPR; it was one of the largest individual gifts to any cultural organization in history and far overshadowed the extraordinary MacArthur gift. Referring to Kroc's gift, NPR's President Kevin Klose said, "This remarkable act of generosity will help secure the future of NPR as a trusted and independent source of news," but he also worried that news of the gift would keep listeners of local stations from making individual contributions, something that would severely hurt the local affiliates because none of the gift would go directly to the local level.¹⁴

Unlike affiliates of traditional commercial networks, public radio stations are free to choose programs from any source, including from the three major national competitors, PRI, NPR, and American Public Media (APM). Individual public radio programmers often decide that their local audiences are best served by airing NPR's Morning Edition followed immediately by PRI's business news program The Marketplace Morning Report. More important than allegiance to one network are a station's philosophy toward its audience and its fund-raising capability, degree of localism, and integrity.

As in public television, the nature of the licensee determines many of the station's goals. About 60 percent of public radio stations have colleges and universities as their licensees, while about one-third are licensed to independent community organizations, 6 percent to local school districts or local governments, and 4 percent to state governments. Because most public stations rely on NPR, PRI, and APM for much of their information programming, a brief look at each appears in 12.14, 12.15, and

12.14 National Public Radio

private, nonprofit corporation, NPR contributes programming to more than 800 nonprofit radio stations that broadcast to communities in all 50 states, Puerto Rico, the District of Columbia, and even the Virgin Islands. In 2006, NPR FM 104.1 began broadcasting in Berlin, Germany, adding to the considerable international reach of NPR's information programming that is already accessible through webcasting and satellite delivery.

In the United States, each NPR station is itself a production center, capable of producing and distributing programming to the entire system. Each station mixes locally produced programs with those transmitted from the national production center. Satellite distribution of the NPR program service has meant better-quality transmission of existing programs and has allowed the distribution of up to a dozen stereo programs simultaneously. The high quality of national programs frequently entices stations to use NPR's offerings.

NPR schedules news, public affairs, art, music, and drama to fit into whatever formats member stations choose. The news programs Morning Edition, All Things Considered, and Weekend Edition are its most

distinguished trademarks and the core of its program service. NPR also successfully programs talk about politics and social issues with shows such *Talk of the Nation* and *Fresh Air*. NPR also has provided leadership in music and arts programming for the public radio system with such shows as *Performance Today*, *Jazz Alive*, *NPR Playhouse* (featuring new radio dramas), and live broadcasts of musical events from Europe and around the United States. It has provided stations with in-depth reporting on education, bilingual Spanish news features, and live coverage of Senate and House committee hearings.

During the terrorist attacks on the World Trade Center, NPR provided extensive round-the-clock coverage of the events and the aftermath. The coverage included not only news but also broadcasts of live "town-hall meetings" that allowed listeners from around the country to call in and voice their opinions and their grief. The same nonstop news coverage occurred during such world-changing events as the start of U.S. invasion of Iraq in 2003 and during the unfolding disaster following the 2004 South Asia tsunami.

12.15 Public Radio International

n 1983 a group of five stations formed a second public national radio network called American Public Radio (APR). Minnesota Public Radio, KJSC-FM in Los Angeles, KQED-FM in San Francisco, WNYC AM/FM in New York, and WGUC in Cincinnati initially joined together to marker and distribute programs they produced and to acquire other programming to distribute to affiliates. The name was changed to Public Radio International (PRI) in 1994 to help end confusion between APR and NPR and also to underline the network's interest in importing and exporting radio programs in the international marketplace.

Today, PRI programming is carried by over 700 affi lated stations in the United States and Guam. Its stated mission is "to serve audiences with distinctive programming that provides information, insights, and cultural experiences to understanding a diverse, interdependent world." Although well known for its music programs, it is telling that the first goal PRI claims is to provide information. PRI distributes news programs such as BBC World Service, Capital News Connection, and America Abroad. It also has the urban-talk program The Tavis Smiley Show, the popular storytelling program This American Life, and health informat on shows such as Zorba Paster on Your Health.

12.16. Pacifica, one of the most influential of public station groups, is described in 12.17.

A myriad of other sources for programming—informational and otherwise—are available to non-commercial radio programmers. WFMT's Beethoven Satellite Network, the Association of Independents in Radio (AIR), and a variety of station programming consortia have emerged to provide program elements. The appetite is strong for more information programming than NPR, PRI, APM, or any commercial outlet, for that matter, can supply.

That was certainly part of the logic behind the 1999 FCC rules that introduced noncommercial low-power FM (LPFM) radio service. LPFM consists of stations with either maximum power levels

12.16 American Public Media

merican Public Media (APM) is the second-largest producer of public radio programming, following NPR. APM produces about 20 international programs, and is essentially the interstate distribution arm of Minnesota Public Radio and Southern California Public Radio. It is home to the immensely popular variety show A Prairie Home Companion, as well as the weekday business show Marketplace. Other talk/nformation programs produced and distributed by APM include American RadioWorks, Sound Opinions, and Speaking of Faith.

12.17 The Pacific Group

he Pacifica stations—WBAI-FM (New York), WPFW-FM (Washington, DC), KPFT-FM (Houston), KPFA-FM [Berkeley], and KPFK-FM (Los Angeles) - pioneered the news and public-affairs format for noncommercial public radio. The Pacifica Foundation, licensee of the stations in this group, has a specific social and political purpose that influences its approach to news and public affairs. Listeners have little difficulty recognizing the far left-wing political predisposition, and Pacifica is open about its philosophy. These stations were especially successful during the late 1960s and early 1970s when the nation was highly politicized over Vietnam and Watergate. In their reporting of that war and the surrounding issues they demonstrated the vital role played by broadcasting that is free from commercial restraints. Pacifica stations played a similar role during the brief Persian Gulf War and continue with vocal criticism of the United States' ongoing "war against terrorism" and the invasion and occupation of Iraq and Afghanistan.

of just 10 watts (reaching areas with a radius of 1 to 2 miles) or 100 watts (reaching areas with a radius of approximately 3.5 miles). Despite vigorous lobbying against the idea by National Association of Broadcasters (NAB)—who were concerned that the presence of even low-power transmission towers

would interfere with existing commercial broadcast station signals—today hundreds of LPFM stations broadcast information programming to local communities. Most are programmed by educational facilities, local church groups, or city governments.

Finally, the government is, itself, in the noncommercial information radio business. The National Oceanic and Atmospheric Administration (NOAA) broadcasts local weather information over 900 NOAA stations in the 160-megahertz band, and state governments operate numerous Highway Advisory Radio (HAR) stations within the AM broadcast band (see 12.18 and 12.19).

12.18 NOAA Weather Radio

OAA Weather Radio is a nationwide network of radio stations broadcasting continuous weather information direct from a nearby National Weather Service office. NOAA Weather Radio broadcasts National Weather Service warnings, watches, forecasts, and other hazard information 24 hours a day. Under the FCC's new Emergency Alert System, NOAA Weather Radio has become an "all hazards" radio network, making it the single source for the most comprehensive weather and emergency information available to the public. NOAA Weather Radio broadcasts warning and post-event information for both natural (such as earthquakes and volcano activity) and technological (such as chemical releases or oil spills) hazards.

Known as the "Voice of the National Weather Service," NOAA Weather Radio is provided as a public service by the Department of Commerce's National Oceanic and Atmospheric Administration. The NOAA Weather Radio network has more than 900 transmitters that cover the 50 states, adjacent coastal waters, Puerto Rico, the U.S. Virgin Islands, and the U.S. Pacific Territories. NOAA Weather Radio requires a special radio receiver or scanner capable of picking up the signal. Broadcasts are found in the public service band at these seven frequencies (MHz): 162.400, 162.425, 162.450, 162.475, 162.500, 162.525, and 162.550.

12.19 Highway Advisory Radio

long highways people see bright orange signs with flashing lights along the side of the road. Such signs read, "Motorist Advisory When Flashing: Tune Radio to 1610 AM" (or some similar frequency). This is an invitation to listen to Highway Advisory Radio (HAR) stations. HARs give motorists a wide variety of information, such as details about the latest highway construction and maintenance projects, details on local traffic and weather conditions that may impede travel, locations of upcoming rest stops, and descriptions of local points of interest.

These broadcasts are possible as the result of an FCC stipulation for "Travelers' Information Stations." According to the Code of Federal Regulations, radio frequencies 530 through 1700 kHz may be used by individual states to inform the public about traveler safety information. There are some limitations, however, such as that the output power of HARs cannot exceed 50 watts, and transmissions may not interfere with any existing commercial stations (which is why HARs are usually at the very far ends of the AM band). In addition, identifying the commercial names of businesses is prohibited.

What Lies Ahead

When it comes to the future of information radio, perhaps the most obvious statement is that the format is not going to disappear any time soon. Our society has developed a high level of urgency about obtaining relevant news and information. However, what is *relevant* depends on the individual. A major challenge for information programmers, therefore, is determining which type of information is going to lead the way as "the next big thing." Recently, formats such as liberal political talk, Spanish-language talk, and technology talk have emerged as those most likely to reach underserved (or completely ignored) listeners. As with any programming task, those who are most successful will be those who can find a need waiting to be filled.

Another situation that information radio will continue to wrestle with in the future is the fine line between popular talk content and indecency. The FCC is signaling its intent to keep hosts of broadcast shows on a much shorter leash when it comes to sexual content, although satellite and internet radio lack such restrictions. The drastically higher amounts the FCC can now fine stations for indecency has forced many programmers into rethinking the cost/benefit analysis for broadcasting blatant sexual references. But the audience for controversial hot talkers like Howard Stern is undoubtedly very large, and satellite radio snapped him up, as it did Opie & Anthony.

Although Stern remains as a sat-caster exclusive, an interesting caveat to the Opie & Anthony saga points out an issue for information programmers to address in the future: namely, developing the next generation of new talent. After just over a year on XM, Opie & Anthony inked a deal with CBS Radio to return the show to terrestrial radio by simulcasting an "FCC-friendly" version on that network's FM hot-talk stations in major markets. After about 18 months of affiliates' unsuccessful attempts to find a suitable replacement, the move was recognized as an admission by CBS and its affiliates that there are too few suitable programs. The focus of programmers needs to return to working with local talent to improve their craft rather than exclusively contracting and scheduling nationally syndicated shows.

A final issue that information radio programmers must wrestle with in the future is that of optimizing new forms of program distribution. What used to be the novelty of streaming programs over the web on the station's home page has evolved into on-demand radio devices (e.g., radiotime.com) that not only allow for real-time listening but also allow listeners to purchase software which records a station's web stream for later playback. Essentially, the practice of timeshifting—long an easy option for TV viewers thanks to VCRs and DVRs—is now just as simple for radio listeners.

Podcasting, of course, works similarly but even allows the listener to remove the shackles of a desktop computer. Listeners can select individual

programs from iTunes or one of a number of podcast directories and download them for listening at a time and place of their choice! The challenge, of course, is that these web services and podcast directories act as portals for stations worldwide. No longer are information programmers contending with the station across town: content must be competitive with stations across the globe!

Moreover, because the commercial content is usually stripped from podcasts and web-delivered content, listening may go up, but advertisers are likely to be less than pleased. Broadcast programmers need to work closely with sales managers and general managers to develop business plans that maximize both audiences and revenue Web radio programmers can, of course, happily promote the noncommercial nature of their programming.

Sources

Barker, David E. Rushed to Judgment: Talk Radio, Persuasion, and American Political Behavior. New York: Columbia University Press, 2002.

Brooks, Dwight E., and Daniels, George L. "The Tom Joyner Morning Show: Activist Radio in an Age of Consolidation." Journal of Radio Studies 9 (Winter 2002), pp. 8-32.

Chambers, Todd. "The State of Spanish-Language Radio." Journal of Radio Studies 13 (Winter 2006), pp. 34-50.

Cohen, Noam. "Bloggers Take On Talk Radio Hosts." The New York Times, 15 January 2007, p. C3.

Davis, Michael P. Talk Show Yearbook 2000: A Guide to the Nation's Most Influential Television and Radio Talk Shows. Washington, DC: Broadcast Interview Source, 2000.

Directory of Talk Radio 2004. Springfield, MA: Talkers Magazine, 2004.

Goehler, Richard. NAB Media Law Handbook for Talk Radio. Washington, DC: National Association of Broadcasters, April 2000.

Hoffstetter, C. Richard. "The Skills and Motivations of Interactive Media Participants: The Case of Political Talk Radio." In E. P. Bucy and J. E. Newhagen (eds.), Media Access: Social and Psychological Dimensions of New Technology Use. Mahwah, NJ: Erlbaum, 2004, pp. 207-231.

Keith, Michael C. Dirty Discourse: Sex and Indecency in American Radio. Ames, IA: Blackwell Press. 2003.

- ——. Sounds in the Dark: All-Night Radio in American Life. Ames, IA: Blackwell Press, 2001.
- Oravec, Jo Ann. "How the Left Does Talk: A Fair and Balanced Examination of Air America Radio." *Journal of Radio Studies* 12 (2), 2005, pp. 190–203.
- Perse, Elizabeth M., & Butler, Jessica S. "Call-In Talk Radio: Compensation or Enrichment." *Journal of Radio Studies* 12 (Spring 2005), pp. 204–222.
- Potter, Robert F. "Give the People What They Want: A Content Analysis of Radio Station Home Pages." Journal of Broadcasting & Electronic Media 46 (Fall 2002), pp. 369–384.
- Radio Marketing Guide and Fact Book for Advertisers. New York: Radio Advertising Bureau, 2003.
- Tremblay, Susan, and Tremblay, Wilfred. "The Jim Rome Show." *Journal of Radio Studies* 8 (Spring 2001), pp. 271–291.

Notes

- 1. Credit goes to former author Joseph G. Buchman for much of this discussion of information's multiple meanings and other portions of this chapter.
- 2. Smith, Andy, "A Whole New Wavelength," Providence Journal-Bulletin, 13 July 2003, p. E-1.
- 3. Personal communication from Rollye james, talk-show host and radio consultant, to Joseph G. Buchman, Philadelphia, PA, May 2000. Quoted from Buchman's chapter, "Information Radio Programming," in the sixth edition of this book.
- 4. Squires, C. R., "Black Talk Radio: Defining Community Needs and Identity," *Harvard International Journal of Press/Politics* 5(2), 2000, pp. 73–95.
- 5. Marcucci, Carl, "Numero Uno: Rush!" Retrieved 25 July 2004 from www.rbr.com/interviews/ rushrlimbaugh.asp.

- 6. "Green Brothers Close Deal to Buy Liberal Talk Radio Network Air America," Associated Press Worldstream, 6 March 2007. Retrieved from Lexis-Nexis.
- 7. As quoted in "'Bob & Tom Show' Pulls Back from Edgy Content," Associated Press wire story, 26 February 2004. Retrieved from Lexis-Nexis.
- 8. Personal communication from Michael Harrison to Joseph G. Buchman, 27 April 2000. Quoted from Buchman's chapter, "Information Radio Programming," in the sixth edition of this book.
- 9. "Syndication Isn't Talk Radio's Best Friend," Radio & Records Online, 1 March 2004. www. radioandrecordsonline.com.
- 10. The quote is from Dr. Rob Balon, CEO of The Benchmark Company, in "Study: Rush Limbaugh's Audience Remains Solid," *Radio & Records Online*, 3 February 2004. www.radioandrecordsonline.com.
- 11. "The 100 Most Important Radio Talk Show Hosts in America—Class of 2004." Retrieved 26 July 2004 from www.talkers.com. heavy.html.
- 12. Hoffstetter, C. Richard, "The Skills and Motivations of Interactive Media Participants: The Case of Political Talk Radio." In Erik P. Bucy and John E. Newhagen (eds.), Media Access: Social and Psychological Dimensions of New Technology Use. Mahawah, NJ: Erlbaum, 2004, p. 211.
- 13. Mark Kiester, general manager of KJFK-FM (Austin, Texas), quoted by John Lippman in "FM Stations Dump Rock for Risqué Talk," *Wall Street Journal*, 29 October 1998, p. B1.
- 14. Kaltenbach, C., and McCauley, M. C., "Public Radio Gets Request of More Than \$200 Million; Donation Is from Widow of McDonald's Founder," *The Baltimore Sun*, 7 November 2003, p. 1A.
- 15. Quoted from the Public Radio International (PRI) mission statement. Retrieved 16 March 2007 from www.pri.org.

Abbreviations and Acronyms

Boldfaced terms are explained further in the Glossary.		C-SPAN	Cable-Satellite Public Affairs Network
AAA	Association of Advertising Agencies; also, adult album alternative	CSRs CTAM	customer service representatives Cable & Television Association
ABC	Audit Bureau of Circulation		for Marketing
AC		DAB	digital audio broadcasting (digital radio)
ACE	adult contemporary awards for excellence in cable programming	DARS	digital audio radio service
ACT	Action for Children's Television	DBS	direct broadcast satellite (also direct sate lite
ADI	Area of Dominant Influence		services)
ADS	Alternate Delivery Systems	DJ	disc jockey
AFTRA	American Federation of Television	DMA	Designated Market Area
AFIKA	and Radio Artists	DMR	Digital Media Report
AID	Arbitron Information on Demand	DSL	digital subscriber line (high speed)
AIT	Agency for Instructional Technology	DSS	Direct Satellite System (RCA trademark
ALTV	Association of Local Television Stations		for DBS)
ALIV	(formerly INTV)	DTH	direct-to-home (from satellite)
AMC	American Movie Classics	DVD	digital video disk
AOR	album-oriented rock	DVR	digital video recorder
A/P	active/passive (people meters)	EEN	Eastern Educational Television Network
AP	Associated Press	EEO	equal employment opportunity
APR	American Public Media	ENG	electronic newsgathering
AQH	average quarter hour	EPG	electronic program guide
ARB	Arbitron Research Bureau	ERP	effective radiated power
ASCAP	American Society of Composers, Authors,	ESF	expanded sample frame
110 0111	and Publishers	FCC	Federal Communications Commission
ASI	market research company	FOT	frequency of time
ATSC	Advanced Television Standards Committee	FTC	Federal Trade Commission
BEA	Broadcast Education Association	FTTH	fiber-to-the-home
BM	beautiful music	FTTN	fiber-to-the-node
BMI	Broadcast Music, Inc.	FVoD	free-video-on-demand
CAB	Cable-Television Advertising Bureau	GLBT	gay, lesbian, bisexual, transgendered
CAT	keystroke animation technology	GPN	Great Plains National Instructional
CATI	computer-assisted telephone interviewing		Television Library
CATV	community antenna television	GSN	new name for the former Game Show Network
Cband	low-power communications satellites	HAAT	height-above-average-terrain
CBC	Canadian Broadcasting Company	HBO	Home Box Office
CD	compact disc		one high-capacity format for HD recording
CEN	Central Educational Network	TID-DVL	and playback
CHR	contemporary hit radio	HDTV	high-definition television
CM	commercial matter	HHs	households having sets
CNN	Cable News Network	HP	homes passed
CPB	Corporation for Public Broadcasting	HSD	home satellite dish
CPI	cost per involvement	HSI	(Nielsen's) Hispanic Station Index
CPM		HUTs	households using television
	cost per thousand (used in advertising)	IBOC	in-band-on-channel
CRQ	See Our Cue	ID	station identification
CRT	Copyright Royalty Tribunal	ID	station identification 409

iDVR	Internet-based digital video recorder	NTI	Nielsen Television Index
IFC	Independent Film Channel	NTR	nontraditional revenue
IOC	International Olympic Committee	NTSC	National Television Systems Committee
ION	name of television network, formerly PAX		(U.S. TV standard)
ITNA	Independent Television News Association	NVoD	near-video-on-demand
ITV	instructional or interactive television	080	owned-and-operated
LIFO	last in, first out	OOH	out-of-home viewing or listening
LMA	local marketing agreement	P1	an individual in a station's core listening
LO	local origination		audience
LOP	least objectionable program	PAF	Program Assessment Fund
LOT	length of time	PBS	Public Broadcasting Service
LPTV	low-power television	PCN	personal communication network
LULAC	League of United Latin American Citizens	PD	program director
MFTV	made-for-TV	PDA	personal data assistant
MMDS	multichannel multipoint distribution service	PDG	Program Development Group
MNA	Multi-Network Area Report (Nielsen report)	PEG	public, educational, and government
MNTV	MyNetworkTV, a second FOX television	DC.	(access channels)
	network	PG POCS	movie code: parental guidance suggested
MOR MOW	middle-of-the-road movie-of-the-week	POCS	plain-old-cable service (parallel to plain-old-telephone service [POTS])
MPEG	Moving Picture Experts Group	PPM	Portable People Meter
MRA	Metro Rating Area	PPV	pay-per-view
MSA	Metro Survey Area	PRI	Public Radio International
MSO	multiple system operator	PRIZM	Potential Rating in Zipped Markets
MTV	Music Television		(Claritas report)
NAACP		PRO	Performance Rights Organization
14711101	of Colored People	PRSS	Public Radio Satellite System
NAB	National Association of Broadcasters	PSA	public service announcement
NAD	National Audience Demographics Report	PTAR	Prime-Time Access Rule
	(Nielsen report)	PTR	Persons Tracking Report (Nielsen report)
NARB	National Association of Radio Broadcasters	PTV	public television
NATPE	National Association of Television Program	PURs	persons using radio
	Executives	PUTs	persons using television
NCAR	Nielsen Cable Activity Report	R	movie code: restricted
NCTA	National Cable Television Association	RAB	Radio Advertising Bureau
NET	National Educational Television	RADAR	Radio's All Dimension Audience Research
NFLCP	National Federation of Local Cable	RDBS	Radio Broadcast Data Systems
	Programmers	RCD	remote control device
NHTI	Nielsen Hispanic Television Index	RIAA	Recording Industry Association of America
NISS	National ITV Satellite Service	ROSP	Report on Syndicated Programs (Nielsen)
NOW	National Organization of Women	RPC	Radio Programming Conference
NPM	Nielsen PeopleMeter	RSS	Really Simple Syndication
NPPAG	National Program Production	RTNDA	Radio Television News Directors Association
NIDD	and Acquisition Grants	SDTV	standard-definition television
NPR	National Public Radio	SECA	Southern Educational Communication
NPS	National Program Service Nielsen Station Index		Association
NSI		SESAC	Society of European Songwriters, Artists,
NSS	National Syndication Service (Nielsen report)		and Composers

Glossary

This list includes **boldfaced terminology** that appears in the text as well as other vocabulary but excludes phrases boldfaced in the text for emphasis only. Acronyms usually appear under their spelled-out definitions (see also **Abbreviations and Acronyms**.) *Italicized words* in the definitions indicate other glossary entries.

- **absolute ratings** Nielsen's total estimated number in an audience.
- AC Adult contemporary, a *soft rock* music *format* targeting the 25 to 54 age category.
- access Public availability of broadcast time. In cable, one or more channels reserved for noncommercial use by the community, educators, or local government. See also access time, community access channels, and Prime-Time Access Rule.
- access time The hour preceding *prime time* (usually between 7 and 8 P.M. EST), during which the broadcast *network affiliates* once could not air *off-network* programs. See also *Prime-Time Access Rule*.
- ACE Awards sponsored by the National Cable Television Association for local and national original cable programs.
- actuality An on-the-spot news report or voice of a news maker (frequently taped over the telephone) used to create a sense of reality or to enliven news stories.
- adaptation A film or video treatment of a novel, short story, or play.
- addressability Remote equipment that permits the cable operator to activate, disconnect, or unscramble signals to each household from the cable *headend*. This technology provides maximum security and is usually associated with *pay-per-view* channels.
- ad hoc networks Temporary national or regional hookups among radio or television stations for the purpose of program distribution; this is especially common in radio sports.
- adjacencies A commercial spot next to a program that can be sold locally, especially spots for station sales appearing within (or next to) *network* prime-time programs.
- advertising availability Unsold time for a commercial spot; see *availability*.
- affiliate A commercial radio or television station that receives more than 10 hours per week of *network* programming but is not owned by one of the nine commercial networks. This term also applies to cable system operators contracting with *basic* or

- premium subscription networks; applied loosely to public stations that are members of Public Broadcasting Service, National Public Radio, or Public Radio International.
- **affiliation agreements** Contracts between a *network* and its individual *affiliates* specifying the rights and responsibilities of both parties.
- **aftermarket** Syndicated sales of programs to a different industry than the one for which they were originally produced, as in sales of broadcast programs to cable, sales of original cable programs to U.S. or foreign broadcasters, or video rental or sales.
- agent A representative, either a person or software, that acts for someone else.
- aggregators Computer programs (built into some portals) that retrieve syndicated web content from such sources as blogs, vlogs, podcasts, and mainstream media websites.
- aging an audience A strategy for targeting slightly older viewers in the *early-fringe daypart*, starting with children in the after-school time period and moving toward adult male viewers for the early-evening newscast. Colloquially called "aging your demos." Also used during *prime time*.
- aided recall In survey research, supplying respondents with a list of items to stimulate their memory.
- air-lease rights Permission to broadcast a program.
- air talent On-air or online performers, including newscasters, hosts, and personalities.
- à la carte Programs chosen separately by viewers, as items on a menu. See also *video-on-demand*.
- American Society of Composers, Authors, and Publishers (ASCAP) An organization licensing musical performance rights. See also *Broadcast Music*, *Inc*.
- amortization The allocation of syndicated program series costs over the period of use in order to spread out total tax or inventory and to determine how much each program costs the purchaser per airing; a station may use straight-line or declining-value methods.
- amplifier Electronic device that boosts the strength of a signal along cable wires between telephone poles.
- anchor show A long-running hit series that influences the ratings of an entire evening or daypart (for example, CSI or syndicated Friends).
- ancillary markets Secondary sales targets for a program that has completed its first run on its initial delivery medium. Also called backend markets or aftermarkets.

- ancillary services Revenue-producing services other than the main broadcast or cable programming, as in data.
- anthology A weekly series consisting of discrete, unrelated programs under an umbrella title; these may be a playhouse series consisting of dramas by different authors or a sports program consisting of varied sporting events (often in short segments) and related sports talk. This technique is used by over-the-air networks for packaging unused program pilots.
- AOR Album-oriented rock, a rock music format appealing to a strongly male audience aged 18 to 34, consisting of less well-known songs by avant-garde rock artists and groups as well as their most popular works.
- appeals Elements in program content that attract audiences, such as conflict, comedy, nostalgia, suspense, and so on.
- appointment viewing Pattern of planning one's television viewing in order to tune in at the time of a specific program—as opposed to inherited viewing from flow-through or grazing.
- Arbitron Information on Demand (AID) A computerized service that identifies the best times for airing station promotional spots after factoring in program sequence, network promo content, target audience, and so on.
- architecture In communications, the design of a channel or technical platform.
- Area of Dominant Influence (ADI) One of more than 200 geographical market designations defining each radio market exclusive of all others. It indicates the area in which a single station can effectively deliver an advertiser's message to the majority of homes. ADI is Arbitron's term; Nielsen's comparable term is Designated Market Area (DMA).
- ascertainment Determining a community's needs, interests, and problems so as to be able file a report with the FCC showing how a station responded to these needs with programming. The method of collecting information is determined by the station.
- ASI Market Research Los Angeles-based company specializing in program and commercial testing using invited theater audiences.
- Association of Local Television Stations (ALTV) Professional trade association of stations not affiliated with ABC, CBS, or NBC, formerly the Association of Independent Television Stations (INTV).
- audience flow The movement of audiences from one program or time period to another, either on the same station or from one station to another; this includes turning sets on and off. Applied to positive

- flow encouraged by similarity between contiguous programs.
- audimeter Nielsen's in-home television rating meter, used until 1987. See also people meter.
- audition tape A demonstration of an anchor, host, disc jockey, or other personality's on-air abilities and appearance or sound; in radio, this may include short clips of interviewing or song announcing. Also called a demo tape.
- auditorium research In radio, mass testing of song hooks to measure their popularity.
- automation Use of equipment, usually computerized, that reproduces material in a predesignated sequence, including both music and commercials. This produces a log of airings acceptable to advertising agencies. Also used for traffic and billing and in some television production processes.
- avail Short for a sales availability.
- availability Commercial spot advertising position (avail) offered for sale by a station or a network; also, syndicated television show or movie ready for station licensing. See also inventory and program availabilities.
- avatar In computers, a virtual self in humanlike form that carries out its person's wishes.
- average quarter hour (AQH) Rating showing the average percentage of an audience that tuned in a radio or television station.
- backfeed line A line from the production site or studios to the cable headend for the purpose of delivering programs.
- backsell On radio, telling the audience what songs just
- backstory The previous history of characters in a series, or a reprise of the last episode.
- bandwidth Section of the electromagnetic spectrum, generally used to refer to amounts of the kilohertz, megahertz, and gigahertz bands used for radio, television, and astronomy.
- bannertracking Tracking the amount of viewing and clicking of banner ads.
- barker channel A cable television channel devoted to program listings; includes video as well as text listings.
- barter Licensing syndicated programs in exchange for commercial time (inventory) to eliminate the exchange of cash.
- barter spot Time in a syndicated program sold by the distributor.
- barter syndication The method of program distribution in which the syndicator retains and sells a portion

- of a syndicated program's advertising time. In cashplus-barter deals, the syndicator also receives fees from the station licensing the program.
- basic cable Those cable program channels supplied for the minimum subscriber rate, including most local broadcast stations, some noncommercial channels, and assorted advertiser-supported cable networks. See also basic cable networks.
- basic cable households The number or percentage of total television homes subscribing to cable service.
- basic cable networks Those cable program services for which subscribers do not pay extra on their monthly bills; they are usually supported by advertising and small per-subscriber fees paid by the cable operator. Contrast with pay-cable networks.
- beautiful music (BM) A radio format emphasizing lowkey, mellow, popular music, generally with extensive orchestration and many classic popular songs (not rock or jazz).
- Big Four ABC, CBS, FOX, NBC.
- Big Seven studios The major Hollywood studios: Columbia TriStar, Walt Disney Studios, MGM-UA, Paramount, 20th Century Fox, Universal, and Warner Brothers.
- Big Three ABC, CBS, NBC.
- billboard In radio promotion, either an outdoor sign or an on-air list of advertisers; in television promotion, either an outdoor sign or an onscreen list of upcoming programs in text-only form.
- bird A satellite.
- blackout A ban on airing an event, program, or station's signal; this is often used for football games that have not sold out all stadium seats. Also, FCC rules for blocking imported signals on cable that duplicate local stations' programs for which syndicated exclusivity has been purchased.
- blanket licenses Unlimited rights to plays of all music in a company's catalog by contract; this applies especially to music used by radio and television stations.
- block booking Licensing several programs or movies as a package deal.
- blockbusters Special programs or big-name films that attract a lot of attention and interrupt normal scheduling; these programs are used especially during sweeps weeks to draw unusually large audiences. They normally exceed 60 minutes in length.
- blocking Placing several similar programs together to create a unit that has audience flow.
- block programming Several hours of similar programming placed together in the same daypart to create audience flow. See also stacking.

- blogs Web logs, which can be personal journals, commentary on programs or news events, or statements of opinion.
- blogger A person who writes a blog; may be professional or amateur.
- blunting The strategy of airing a program of the same type that another competition carries in order to share the audience.
- Blu-Ray Sony's high-capacity format for HD recording and playback (competitor to HD-DVD).
- bookmarking A process for saving URLs.
- branding Marketing a program channel as a targeted product separate from the changing shows carried; also, defining and reinforcing a network or service's identity so that it becomes widely recognized as synonymous with a product or service.
- break averages Ratings for the breaks between programs; usually calculated by averaging the ratings for the programs before and after the break.
- breaks Brief interruptions within or between programs to permit station identification and other messages; usually two or two-and-a-half minutes long.
- breathe, letting a series Taking time (months) to let a series find its audience (or the audience find it).
- bridging Beginning a program a half hour earlier than competing programs to draw off their potential audiences and hold them past the start time of competing programs; also applied to five-minute delayed starts and ends of progress.
- broadband Having a wide bandwidth capable of carrying several simultaneous television signals; used for coaxial cable and optical fiber delivery.
- broadcasting Fundamentally, spreading a modulated electromagnetic signal over a large area by means of a transmitting antenna; more precisely, the industry consisting of unlicensed networks and licensed radio and television stations regulated by the Federal Communications Commission. These are over-the-air stations and networks, which distinguishes them from wired, cable-only or online networks, and from direct-to-home satellite transmissions.
- Broadcast Music, Inc. (BMI) A music-licensing organization created by the broadcast music industry to collect and pay fees for musical performance rights; it competes with the American Society of Composers, Authors, and Publishers (ASCAP).
- broadcast window The length of time in which a program, generally a feature film that was made-forpay cable, is made available to broadcast stations in syndication. See also pay window and window.

- broken network series Canceled network series revived for syndication, mixing off-network and first-run episodes of the series; usually a situation comedy.
- buffering A time-delay technique, using temporary local digital storage, that prevents interruptions in the flow of a streamed program.
- bumping Canceling a showing.
- bundling Grouping several cable services on a pay *tier* for a single lump monthly fee; also, grouping radio programs on a network for a single fee. See also *unbundling*.
- burning off Using up episodes of a syndicated *series*; "now burning off" means airing currently.
- **buying** Renting programs from *syndicators*. See also *license fee* and *prebuying*.
- buy rate Sales per show, or the rate at which subscribers purchase *pay-per-view* programs, calculated by dividing the total number of available *pay-per-view* homes by purchases. For example, if 50 of 100 *pay-per-view* households ordered one movie, the buy rate would be 50 percent; if 50 of 100 *pay-per-view* households ordered two movies, the buy rate would be 100 percent.
- cable audio FM radio signals delivered to homes along with cable television, usually for a separate monthly fee; same as cable radio or cable FM.
- cablecasting The distribution of programming by coaxial cable as opposed to broadcast or satellite microwave distribution; also, cablecast refers to all programming (except over-the-air signals) a cable system delivers, including local cable, access, and cable networks.
- cable franchises Agreements between local franchising authorities (city or county government) and cable operators to install cable wires and supply programs to a specific geographic area; usually involves payment of a franchise fee to the local government.
- cable modem Computer device that makes high-speed internet delivery possible; supplied by cable operators.
- cable network National service that distributes a channel of programming to satellite and cable systems.
- cable-only Programming or services available only to cable subscribers; also, *basic cable* and *pay-cable networks* that supply programming to cable systems but not to noncable households.
- cable operator The person or company managing and owning cable facilities under a franchise. See *multiple system operator* (MSO).
- cable penetration The percentage of households subscribing to *basic cable* service.

- cable service Same as *cable network* or *cable system* or both; also including local offerings such as an *access* or *local origination* channel and alarm or security signals.
- cable subscriber A household hooked up to a cable system and paying the monthly fee for basic cable service.
- cable system One of nearly 12,000 franchised, non-broadcast distributors of both broadcast and cable-cast programming that distributes to groups of 50 or more subscribers not living in dwellings under common ownership. Contrast with *SMATV* and *DTH*.
- cachetrack Measurement system for tracking page views stored by browser programs.
- caching The storing of digital program information. call-ins Members of the listening audience who telephone the station.
- call letters FCC-assigned three or four letters beginning with W or K that uniquely identify all U.S. broadcast stations. (Stations in other countries are assigned calls beginning with a different letter, such as X for Mexico and C for Canada.)
- call-out research Telephone surveying of audiences initiated by a station or research consultant; used extensively in radio research, especially to determine song preferences in rock music. Contrast with *call-ins*, which refers to questioning listeners who telephone the station.
- **call screener** Person sorting and selecting incoming calls on telephone call-in shows and who performs other minor production functions as assistant to a program *host*.
- camcorder A portable video camera and videotape recorder in one unit.
- captive audience Television programming for viewers who have few options other than viewing, for example, people standing in supermarket checkcut lines, waiting in airports, or viewing in classrooms as part of school lessons.
- carriage charges Fees paid to a cable network or, hypothetically, to a television station for the right to carry specific programming.
- carryovers Programs repeated from the preceding month.
- cart machine Automated radio station equipment that plays cartridges of music, commercials, *promos*, jingles, and *sweepers*.
- cash call Radio giveaways requiring listeners merely to answer the phone or call in.
- **cash flow** Operating revenues minus expenses and taxes, or cash in minus cash out.

- cash-plus-barter A syndication deal in which the station pays the distributor a fee for program rights and gives the syndicator one or two minutes per half hour for national advertising sales; the station retains the remaining advertising time.
- casting tape A videotape showing prospective actors in various roles; used especially for proposed soap operas and live-action children's programs.
- CATV The original name for the cable industry, standing for "community antenna television" and referring to retransmission of broadcast television signals to homes without adequate quantity or quality of reception.
- C band The frequencies used by some communications satellites, specifically from 4 to 6 gigahertz (billions of cycles per second). See also Ku band.
- channel balance Carrying several cable services that have varying appeal.
- channel capacity The maximum number of channels a cable system can deliver.
- channel matching Locating over-the-air stations on the same cable channel number as their broadcast channel.
- channel piggybacking Two cable networks time-sharing a single channel.
- channel repertoire The array of television channels a viewer usually watches; on average, 13.
- charts Music rankings as listed in trade publications. checkerboarding Scheduling five daily programs alternately, one each day in the same time period; that is, rotating two, three, or five different shows five days
- cherrypicking In cable, selecting individual programs from several cable networks to assemble into a single channel (as opposed to carrying a full schedule from one cable network).

of the week in the same time period.

- CHR Contemporary hit radio, a format that plays the top songs but uses a larger playlist than the top 40.
- churn Turnover; in cable, the addition and subtraction of subscribers or the substitution of one pay-cable service for another. In broadcast network television, shifting of the prime-time schedule. In public broadcasting, changes in membership.
- churn rate A cable industry formula that accounts for when a subscriber connects, disconnects, upgrades, and downgrades.
- cliff effect Precipitous falloff in signal reception.
- classic rock Radio music format consisting of older ('50s, '60s, '70s, '80s, even '90s) songs.
- clearance Acceptance of a network program by affiliates for airing; the total number of clearances governs a network program's potential audience size.

- clear channel An AM radio station the FCC allows to dominate its frequency with up to 50 kilowatts of power; usually protected for up to 750 miles at night.
- click-through An e-commerce measurement of the use of a link to assist another website.
- clip culture Sociological reference to people having short attention spans and thus seeking abbreviated entertainment and information such as headlines, summaries, best shots, and other short forms.
- clipping Illegally cutting off the beginning or end of programs or commercials, often for the purpose of substituting additional commercials.
- clipping file A collection of newspaper and magazine articles saved for some purpose, such as background and fill-in material for talk-show hosts.
- clocks Hourly program schedules, visually realized as parts of a circular clock. See also wheel.
- clone A close copy of a prime-time show; usually appears on another network. Contrast with spinoff.
- closed captioning Textual information for the hearing impaired—transmitted in the vertical blanking interval—that appears superimposed over television pictures.
- clustering Grouping. On cable systems, grouping subscription networks for marketing and pricing as a tier. In cable management, operating multiple cable systems in adjacent geographic areas to achieve economies of scale.
- clutter Excessive amounts of nonprogram material during commercial breaks; includes credits, IDs, promos, audio tags, and commercial spots.
- coding In radio, classifying songs by type or age of music and play frequency.
- commentary Background and event interpretation by radio or television on-air analysts.
- commercetracking Measurement of e-commerce activity; Nielsen//NetRatings' term.
- commercial load The number of commercial minutes aired per hour.
- common carriage Airing prime-time PBS programs simultaneously on many public stations.
- common carriers Organizations that lease transmission facilities to all applicants; in cable, firms that provide superstation signal distribution by microwave and satellite. They are federally regulated.
- common channel lineup Identical service arrays on cable channel dials/tuners/converters on most cable systems within a market.
- community access channels Local cable television channels programmed by community members; required by some franchise agreements.

- community service grants Financial grants from the Corporation for Public Broadcasting to public television and radio stations for operating costs and the purchase of programs.
- compact disc (CD) A small digital recording read optically by a laser; it may be used for computer data, visuals, or sound.
- compensation A broadcast network payment to an affiliate for carrying network commercials that appear usually within programs (but sometimes radio affiliates carry only the commercials embedded in a local program).
- compensation incentive Usually a cash payment by a network or *syndicator* to encourage program clearance.
- composite week An arbitrarily designated seven days of program logs from different weeks; reviewed by the FCC when checking on licensee program performance versus promise (until 1982 for radio).
- compression Technical process for reducing the necessary bandwidth of a television signal so that two, four, or more signals can fit in the same width of frequencies. Used for satellite and cable channel distribution.
- compulsory licensing Federal requirement that cable operators pay mandatory fees for the right to retransmit copyrighted material (such as broadcast station and *superstation* signals); the amounts are set by government rather than through private negotiations. See also *copyright*.
- concept testing Research practices asking audiences whether they like the ideas for a proposed program.
- consideration Payment of some kind (usually money or extraordinary effort) to be allowed to participate in a contest. The combination of consideration, chance, and prize is considered to be a *lottery* by the *Federal Communications Commission*.
- contemporary FCC radio format term covering popular music; generally refers to rock and is broken out into the subcategories of adult contemporary (AC), contemporary hit radio (CHR), and urban contemporary (UC).
- content aggregators Companies, such as Yahoo!, that centralize many online programming services.
- content providers Term commonly used for companies and individuals supplying programming for the internet.
- continuity acceptance Station, network, or system policies regarding the technical quality and content claims in broadcast advertising messages.

- continuous season Network television scheduling pattern spreading new program starts across the September to May year rather than concentrating them in September/October and January/February. In other words, having program starts scattered from September through April, and perhaps even in the summer.
- **Conus** A nationwide news service for licensing television stations using satellite delivery of timely news stories from all over the country.
- **convergence** Technological melding of old and new communication devices (TVs, computers, internet, telephones) into one system.
- converter An electronic device that shifts channels transmitted by a cable system to other channels on a subscriber's television set.
- **cookies** Software that attaches to the user's hard drive and provides evidence of websites accessed.
- co-op Shared costs for advertising.
- cooperation rate In ratings, the percentage of contacted individuals or households agreeing to participate in program or station/network audience evaluation, such as by filling out a diary or agreeing to have an electronic people meter installed in the home and attached to TV sets.
- coproduction An agreement to produce a program in which costs are shared between two or more companies (studios), stations, or networks.
- **copyright** Registration of television or radio programs or movies (or other media) with the federal Copyright Office, restricting permission for use.
- copyright fee In general, a fee paid for permission to use or reproduce copyrighted material; in cable, a mandatory fee paid by cable operators for reuse of broadcast programs; in online, fees paid for reuse of any printed and video content.
- copyright royalty fee Money paid for permission to use copyrighted material.
- core In public television, programs that are intended to be aired simultaneously on all stations. See *samenight carriage*. In commercial television, FCC designation for programs for children that have some "educational purpose" and are regularly scheduled on weekdays.
- corporate underwriters National or local companies that pay all or part of the cost of producing, purchasing, or distributing a noncommercial television or radio program; they may fund programs on PBS, NPR, or local public broadcast stations. See also *underwriter*.
- Corporation for Public Broadcasting (CPB) A government-funded financial and administrative unit of national public broadcasting since 1968.

- **cost per episode** The price of licensing each individual program in a syndicated *series*.
- cost per point The amount an advertising agency will pay for each ratings point.
- cost per thousand (CPM) How much it costs an advertiser to reach 1,000 viewers, listeners, users, or subscribers.
- counterprogramming Scheduling programs with contrasting appeal in order to target unserved or underserved demographic groups.
- counterscheduling Scheduling programs that differ by type (genre) rather than targeted age bracket. See counterprogramming.
- **co-venture** Shared program financing and production among two or more stations, networks, cable systems, or other programming entities.
- CPB-qualified stations *Public radio* stations receiving *community service grants* from the *Corporation for Public Broadcasting (CPB)*. The prerequisites for qualification include a large budget, paid staff, strong signal, and so on.
- crawl Electronically generated words that move horizontally across the television screen.
- crime dramas Hour-long television *series* with main characters who are detectives, police officers, district attorneys, lawyers, and so on; these series are usually aired first in *prime time*.
- critical information pile A quantity of important news breaking simultaneously that causes massive alterations in planned news coverage.
- crossmedia ownership Owning two or more broadcast stations, cable systems, newspapers, or other media in the same market. This was prohibited by the FCC unless an exception was granted (temporary or grandfathered) until ownership rules loosened somewhat in 1992 and again in 1996.
- **crossover** Temporarily using characters from one program *series* in episodes of another series. Contrast with *spinoff* and *clone*.
- crossover points Times when one network's programs end and another's begin, usually on the hour and half hour, permitting viewers to change channels easily (although a long program such as a movie may bridge some hour and half-hour points).
- crossover songs Music that fits within two or more radio *formats* (for example, songs played by country and AC *disc jockeys*); also applied to performers whose recordings are used by stations with more than one music format.
- cross-ownership rules FCC rules limiting control of broadcast, newspaper, or cable interests in the same market.

- cross-platform A business model that incorporates running shows on both broadcast and cable channels (for example, on FOX and FX) and potentially on the internet and mobile media.
- cross-promote Displaying the name and content of another program service, either co-owned or as paid advertising, on a cable channel, in a menu listing, or within an individual program.
- cume A cumulative rating; the total number of different households that tune to a station at different times, generally over a one-week period; used especially in commercial and *public radio*, public television, and commercial sales.
- cybercasting Using the internet and other online services to transmit live audio and video.
- cycle Span of news flow between repeat points in allnews radio.
- daypart A period of two or more hours that are considered to be a strategic unit in program schedules (for example, morning *drivetime* in radio, 6 to 10 A.M., and *prime time* in television, 8 to 11 P.M.).
- dayparting Altering programming to fit with the audience's changing activities during different times of the day (such as shifting from music to news during *drivetime*).
- daytimer An AM radio station licensed to broadcast only from dawn to dusk.
- **deficit financing** Licensing television programs to the broadcast networks at an initial loss, counting on later profits from *syndication* rights to cover production costs. This practice is employed by the major Hollywood studios.
- delayed carriage Airing a network program later on tape.
- demographics Descriptive information about an audience, usually the vital statistics of age and sex, possibly including education and income.
- **demo tape** Demonstration tape of a program; used for preview without the expense of producing a *pilot*.
- Designated Market Area (DMA) Nielsen's term for a local viewing area. See also Arbitron's *Area of Dominant Influence (ADI)*.
- diary A paper instrument for recording the hours in which the listening or viewing of a station or cable service occurred. Used by Arbitron, Nielsen, and other research firms; it is filled out by audience members.
- differentiation The separation between networks, stations, or services that is perceived by the audience and advertisers; generally based on programming differences and promotional images.

- digital Technology that uses the binary code (on/off) of computers as opposed to continuous signals (analog).
- digital audio broadcasting (DAB) A system for *over-the-air* broadcasting that uses digital encoding and decoding. See *IBOC*.
- digital audio radio service (DARS) Satellite-delivered multichannel digital radio.
- digital compression A technology that eliminates redundant information in a television picture or radio sound to reduce the bandwidth needed for transmission; missing information is recreated at the receiving end.
- digital delay unit An electronic device used to delay programs for a few seconds between studio and transmitter to permit dumping of profanity, personal attacks, and other unairable material. This is commonly used with *call-in* programs.
- Digital Media Report (DMR) A web-tracking service. digital subscriber line (DSL) Telephone lines capable of handling the high-speed internet signals needed for video streaming.
- digital video disk (DVD) Rented and purchased disks carrying video of whole movies or other programs to be replayed on special DVD players.
- digital video recorder (DVR) Playback and recording machine for DVDs and off-air television; TiVo is the best-known brand name.
- direct broadcast satellite (DBS) Special satellite intended for the redistribution of high-powered television signals to individual subscribers' receiving dishes; requires only small home or office receiving dishes; recently called direct-to-home transmission.
- direct-to-home (DTH) Television signals distributed by satellite to receivers on individual homes and office buildings; bypasses *over-the-air* stations and cable systems.
- disc jockey (DJ) A radio announcer who introduces music.
- disconnects Cable subscribers who have canceled their service.
- dish Receiving or sending antenna with a bowl shape, intended for transmitting satellite signals; also called earth station.
- distant signals Broadcast station signals imported from another market and retransmitted to cabled homes; usually independents. See also *superstation*.
- distribution window A period of time in which a movie or television program is available to another medium. See also window, pay window, and broadcast window.

- **docudrama** A fictionalized drama of real events and people.
- **documentary** A program that records actual events and real people.
- double jeopardy When shows with small audiences attract less committed viewers—which in turn lowers the chance of improving the ratings.
- double-running The practice of showing additional episodes of a successful show on the same day.
- downgrading Reducing the number or value of pay services by a subscriber (reverse of *upgrading*).
- **downlink** Satellite-to-ground transmission path, the reverse of *uplink*; refers also to the receiving antenna (*dish*).
- download Transmission and decoding signals at the receiving end; used for satellite program (and computer) signals.
- **download-to-own** *VoD* over the internet, meaning programs (mostly movies) that can be stored on a home computer or CDs.
- downscale Audience or subscribers with lower-thanaverage socioeconomic demographics, especially low income. See also *upscale*.
- **downtrending** A pattern of declining *ratings/shares* over time (reverse of *uptrending*).
- drama A prime-time series program format, usually one hour long (contrast with situation comedy). It includes action-adventure, crime, and doctor shows; adult soaps; and other dramatic forms.
- drivetime In radio, 6 to 10 A.M. (morning drive) and 4 to 7 P.M. (afternoon drive).
- drops Individual household hookups to cable wires, running from the street to the house or apartment.
- dual format A *public radio format* consisting of two unrelated formats, usually news and jazz or news and classical, attracting different audiences.
- duopoly rule An obsolete FCC rule that limited ownership of stations with overlapping coverage areas.
- duplicator dilemma The problem of having the same NPR programs on more than one public station in a market because affiliations and program rights are not exclusive.
- early debut Showing a first episode a week or two before the official start of the new fall season.
- early fringe In television, the locally programmed period preceding the early news, usually 4 to 6 P.M. See also *fringe*.
- earth station Ground receiver/transmitter of satellite signals; when transmitting it's called an *uplink*; when receiving it is a *downlink*. In television or radio, its purpose is to redirect satellite signals to

- a broadcast station or to cable *headend* equipment. Small Earth stations, commonly called antenna **dishes**, receive signals directly in homes or offices without a broadcast or cable intermediary.
- eclectic A mixed radio *format* applied to varied programming in radio that incorporates several types of programs; a recognized format in *public radio*.
- e-commerce Online sales of products and services.
- editorials In broadcasting, statements of management's point of view on issues.
- educational programs Television programs for schools, at-home children, or at-home adults that have instructional value. See also *telecourses*.
- effective radiated power (ERP) Watts of power measured at receiving antennas on average; it is used to measure the strength of signals.
- electromagnetic spectrum The airwaves, including AM, FM, UHF, VHF, and microwave, used by radio and television, as well as ultraviolet, X-rays, gamma rays, and so on.
- electronic newsgathering (ENG) Refers to portable television equipment used to shoot and tape news stories on location.
- electronic program guide (EPG) Onscreen program listings that promote more viewing and aid subscribers in choosing programs.
- encore In *pay cable*, repeat scheduling of a movie or special in a month subsequent to the month of its first cable network appearance.
- endbreaks Commercial breaks following a program's closing credits.
- end-to-end Refers to the entire commercial digital communication process from source to receiver, including hardware, software, programming, and billing.
- enhanced viewing Logos and other onscreen methods of linking websites to broadcast programs.
- enhancements Content related to televised programs that appears on websites; intended to supplement and enrich the viewing experience of conventional television.
- episode One show out of a series.
- episode testing Studies of audience reactions to plot changes, characters, settings, and so on while the show is in production.
- equal employment opportunity (EEO) Federal law prohibiting discrimination in employment on the basis of age, race, or sex.
- equal time An FCC rule incorporated in the Communications Act of 1934 requiring equivalent airtime for candidates running for public office.

- equity holdings A financial interest from part ownership of a business; it is the same as "equity interest" or equity shares.
- equity shares Ownership shares offered as compensation or incentive to cable operators for making shelf space for a cable network, especially newly introduced networks such as shopping and subniche services.
- **ethnic** Programming by or for minority groups (for example, Spanish speakers, Native Americans, or African-Americans).
- **exclusive cume** Total audience of individuals listening only to a certain radio station.
- exclusive rights The sole contractual right to exhibit a program within a given period of time in a given market. See also *syndicated exclusivity rule*.
- expanded basic tier A level of cable service beyond the most basic *tier* that is offered for an additional charge and comprises a package (or *bundle*) of several cable networks—usually advertiser-supported services.
- **expanded sample frame** (ESF) The base unit for a sampling technique that includes new and unlisted telephone numbers.
- extraneous wraps Reusable closings for radio news, prerecorded by an announcer or reporter for later on-air use; often used around wire service stories.
- Fairness Doctrine A former FCC policy requiring that stations provide airtime for opposing views on controversial issues of public importance. This requirement ended in 1987.
- feature Radio program material other than hard news, sports, weather, stock market reports, or music; also called *short-form* programs. In television and cable, this is generally short for theatrical *feature films*.
- feature film A theatrical motion picture, usually made for theater distribution, that is followed by *home video* sales and *on-demand* and *pay-cable* play; some are aired by the *over-the-air* networks. Feature films occupy about one-fifth of the total *syndication* market.
- **feature syndicator** Distributor of short, stand-alone programs or *series*, as contrasted with *long-form* (continuous) programming; used mostly in radio, less in television and cable.
- Federal Communications Commission (FCC) Government agency that regulates communications.
- fiber optics Very thin and pliable glass cylinders capable of carrying wide bands of frequencies. See also *optical fiber*.
- financial interest and network syndication rules FCC regulations prohibiting broadcast networks from

- owning an interest in the domestic *syndication* rights of most television and radio programs they carry. Modified in 1991 to increase the number of hours a network can produce for its own schedule; eliminated in 1995.
- fin-syn Industry shorthand for financial interest and network syndication rules.
- firewire An *HD* audio and video technology for highspeed, high-quality transfer of programs from syndicators to broadcast stations and cable networks; also called IEEE 1394.
- first refusal rights The legal right to consider a program proposal until deciding whether to produce it; this can stymie a program idea for years.
- first-run The first airing of a television program (not counting the theatrical exhibit of *feature films*).
- first-run syndication Distribution of programs produced for initial release on stations, as opposed to the broadcast networks. Contrast with *off-network syndication*.
- flash animation A low frame-rate technique for compressed video using slow speeds.
- flat fee A method of payment involving a fixed lump price; contrast with a sliding scale (which is usually based on number of viewers).
- flip card A filing system for record rotation at radio stations.
- flipping Changing channels frequently during programs. See *grazing*.
- **focus group** A research method in which people participate in a joint interview on a predetermined topic.
- footprint Coverage area of a satellite signal.
- **foremarket** The migration of a cable-originated program to a broadcast network. See *aftermarket*.
- format The overall programming design of a station, cable service, or specific program; especially used for radio and cable program packages.
- format-exclusive In radio, the syndication of programming to only one station with each *format* in a market.
- format programming Program ideas sold to other countries to be implemented in local languages with local actors.
- **formula** The set of elements that define a program *format*.
- foundation cable networks In cable, the earliest established and most widely carried *cable networks*; those networks most cable operators think are essential to carry.
- franchise area A license granted by local government to provide cable service that is based on the local government's right to regulate public rights of way.

- The franchise agreement delineates a geographic area to be wired.
- franchise show *Spinoff* of a hit into more than one *series*; a cloned program idea from the same producers that is usually aired on the same network (for example, *CSI* and *CSI*: *Miami*, *Law & Order* and *Law & Order*: *SVU*).
- franchising authority The local governmental body awarding a franchise to build and operate a cable system involving wires that cross city streets and rights of way. A fee is charged to cable operators—based on the principle that the public should be reimbursed for use of its property in a commercial business.
- free carriage When cable systems and satellite operators are not required to pay monthly fees to place a *subscription* network on their systems.
- free-form A talk-radio format in which callers' interests set the program's agenda; also called "open-line" talk.
- free-form community stations A public-access radio format begun in the 1960s (most notably by Lorenzo Milam).
- Free-video-on-demand (FVoD) VoD available without a monthly charge, although fees are incurred for viewing movies.
- frequency In advertising, the number of times the audience was exposed to a message. Also, the portions of the electromagnetic spectrum used for AM, FM, and television broadcasting, cable distribution, and satellite *uplinks* and *downlinks*; a channel number is shorthand for an assigned frequency. See also *C band* and *Ku band*.
- fringe The television time periods adjacent to *prime* time—from 4 to 7 P.M. and 11 P.M. to midnight or later (EST). Early fringe means the time preceding the early local newscast; late fringe starts after the end of late local news, usually at 11:30 P.M.
- front- and backend deal A program licensing agreement in which the *station* pays a portion of the fees at the time of the contract and the remainder when the program becomes available; see *futures*.
- frontload In pay television, to schedule all main attractions at the beginning of the month.
- futures Projected episodes in a *series* that have not yet been produced; typically, network series programming intended for *syndication* that may be purchased while the series is still on the network for a negotiated price that accounts for the purchaser's risk.
- **genre** Type of program, as in sitcom, drama, news, and reality.

- **geodemographic** A segment of the population identified by lifestyle.
- **global brands** Brand names recognized around the world, such as Disney, Coca-Cola, and Microsoft.
- gold A hit song or record generally with lasting appeal; in sales, a song selling a million copies or an album selling 500,000 copies.
- Gold Book A list of *gold* (classic) records for use in radio programming.
- **grandfathering** Exempting situations already in effect at the time a new law is passed.
- graphics Titles and other artwork used in programs, newscasts, *promos*, or commercial spots.
- grazing Checking out many television channels by using a *remote control*.
- gross rating points In advertising and promotion, a system for calculating the size of the delivered or anticipated audience by summing the rating points for all airings of a *spot*.
- **group** The parent corporation—owners of several broadcast stations or cable systems.
- group-owned station A radio or television station licensed to a corporation owning two or more stations; a cable system owned in common with many other cable systems. See also *multiple system operator (MSO)*.
- **group owner** An individual or company having the license for more than two broadcast facilities. Contrast with *multiple system operator (MSO)*.
- guides Program listings that are presented in printed or electronic form.
- halo effect The aftereffect of extensive promotion on subsequent episodes.
- hammocking Positioning a weak program between two successful programs to support a new or less successful program by lending their audiences to it.
- hard news Daily factual reporting of national, international, or local events; especially focused on fast-breaking events. Contrast with *soft news*.
- HD-DVD Format for recording and playback of high-definition television; competitor to Blu-Ray.
- HD Radio Trademarked radio reception technology licensed by iBiquity.
- headend Technical headquarters for receiving and transmitting equipment for a cable system where signals are placed on outgoing channels.
- heterogeneity Audiences consisting of demographically or psychographically mixed viewers or listeners. Contrast with *homogeneity*.
- hiatus A period of weeks or months in which a program is pulled off the air (usually to revamp it

- to improve its ratings when it returns to the air), although many *series* never return.
- high-definition television (HDTV) Various technical systems for distributing video of higher quality and with a wider aspect ratio than standard television broadcasting; generally uses a greater *bandwidth* in the spectrum and more scanning lines.
- hit list Names of controversial programs avoided by an advertiser.
- homemade programming Amateur video.
- home networking In-home Wi-Fi (wireless connections between household devices); used to link laptops and television sets to the internet and to cable/satellite television service.
- home satellite dish (HSD) Low-power *C-band* dish antenna serving a house or apartment building.
- homes passed (HP) The total number of buildings cable wires pass, irrespective of whether the occupants are or are not cable subscribers.
- home video The movie and television program sales and rental business.
- homogeneity Audiences composed of demographically or psychographically similar viewers or listeners.
- hook A plot or character element at the start of a program that grabs audience attention; also, in radio research, a brief song segment characterizing a whole song.
- horizontal documentaries A multipart treatment of a news subject spread over several successive days or weeks. Contrast with *vertical documentaries*.
- horizontal scheduling *Stripping* programs or episodes across the week. Contrast with *vertical stacking*.
- host A personality who moderates a program or conducts interviews on radio, television, or cable.
- hot clock See wheel or clocks.
- households having sets (HHs) A ratings industry term for the total number of homes with receiving sets (AM or FM radio, UHF or VHF television, or cable hookups); that is, the total potential audience.
- households using television (HUTs) A ratings industry term for the total number of sets turned on during an *average quarter hour*; that is, the actual viewing audience to be divided among all stations and cable services in a market.
- hyping or hypoing Extended promotion of a program; stunting or airing of special programs to increase audience size during a *ratings period*.
- IBOC In-band-on-channel, high-quality *digital audio* broadcasting carried on the analog frequency.
- ideal demographics The theory that a particular age and sex group should be the target of prime-time network television programs.

- impulse ordering Technology that permits a cable viewer to punch up and purchase a pay-per-view program or merchandise using a handheld remote control.
- incentive An enticement to make a deal or sign a contract. Examples include additional local *avails* offered to stations or cable systems by a *syndicator* or network, or payments for clearing a program; also, discounts and prizes offered to lure potential cable subscribers.
- incubation strategy Launching a new network by sheltering the new service under an existing network (a.k.a., sheltered launch).
- indecency A subcategory of the legal definition of obscenity, enforced by the FCC. Generally it refers to prohibited sexual and excretory language and depictions of such behavior.
- independent A commercial television broadcast station not affiliated with one of the national networks (by one FCC definition, carries fewer than 15 hours of network programming per week in *prime time*).
- independent producers Makers of television series, movies, or specials that are legally separate entities from the Hollywood movie studios.
- infomercial A long sales pitch disguised as a program, called a *program-length commercial*, usually lasting from 15 to 30 minutes or more and presented on cable channels or stations in less popular time periods.
- infotainment A mix of information and entertainment. inheritance effect A research term for viewers who carryover into a subsequent program's audience. See also *lead-in*.
- in-house Programs produced in the station's own facilities—as opposed to network or syndicated shows; also shows such as *soap operas*, newscasts, and public affairs that the broadcast networks produce themselves. Also called house shows.
- insertion news In local cable, short commercial newscasts provided by broadcasters for inclusion on local cable channels.
- **Inspo** Originally an abbreviation for "inspirational and other" music that has come to mean a radio *format* that mixes Christian lite, *AC*, new age, and easy listening.
- instant messaging Live e-mail.
- instructional television (ITV) Programs transmitted to schools for classroom use by public television or radio stations.
- instructional television fixed service (ITFS) A television distribution system delivering programs by line-

- of-sight microwave to specific noncommercial and commercial users within a fixed geographic area; the usual means for delivering instructional programming to schools by public television stations.
- in-tab Diaries actually returned to the ratings service in usable form and counted in the sample.
- intelligent boxes Television converters that give access to multiple media activities at one time on a shared channel, as in watching television, accessing the web, and telephoning simultaneously.
- interactive Media that permit users to send signals to the program source as well as receive signals from that source, for example, the internet; also refers to online video and audio.
- interactive cable Two-way cable that permits each household to receive one stream of programming and also to communicate with the cable *headend* computer.
- interconnection grants Funds from the Corporation for Public Broadcasting for public television stations to cover satellite transmission costs.
- interconnects Transmission links among nearby cable systems permitting shared sales and carriage of advertising spots.
- interdiction In cable, a recently developed technology for interrupting unwanted (not paid for) television signals outside the household, such as on a pole or the side of a building.
- internet hosts Originators/producers of video programming intended for internet delivery.
- interoperability The ability for two-way video, voice, and data to operate through the same home equipment; compatibility.
- interstitial programming Short programs intended to fill the time after an odd-length program is completed. Also called *shorts*.
- inventory The amount of time a station has for sale (or the commercials, records, or programs that fill that time).
- IP video Internet protocol webcasting.
- Iris Awards for outstanding local programming given by the *National Association of Television Program Executives (NATPE)*.
- jock See disc jockey and video jockey.
- joint venture A cooperative effort to produce, distribute, or market programs.
- kiddult Television programs appealing to both children and adults.
- kidvid Television programs for children.
- **Ku band** Frequencies used for transmitting some highpowered satellite signals, for example, the band

- between 11 and 14 gigahertz (billions of cycles per second), which require smaller receiving *dishes* than *C band*. Contrast with *C band*.
- large-market stations Broadcast stations in markets 1 to 25, as defined by the ratings companies. Contrast with *midmarket stations*, *small-market stations*, and *major market*.
- late fringe Television daypart starting after prime time, usually at 11:00 p.m.
- late night Television *daypart* from 11:30 P.M. to 2 A.M. launch fees Inducements paid to cable MSOs and satellite operators to acquire *shelf space* on their systems for a new *subscription* network.
- lead-in A program preceding others, usually intended to increase audience flow to the later programs. Called lead-off at the start of prime time.
- lead-off First program in an evening's schedule. See *lead-in*.
- lead-out Following program
- leased access Channels available for commercial lease; occasionally required by a cable franchise agreement; sometimes voluntarily offered by large-capacity cable systems.
- least objectionable program (LOP) A theory holding that viewers select not the most appealing program among those available at one time but the one that offends fewest viewers watching together; it presumes that channel switching requires an active effort occurring only when the channel currently being viewed presents something new and objectionable.
- legs Trade slang meaning that a program will provide dependably high ratings, as with *blockbuster off-network* television *series*.
- licensees Entities legally holding broadcast licenses. license fee The charge for the use of a syndicated program, feature film, or network service.
- **lifespan** In television, the number of years a *series* stays on network television.
- lift Added audience gained by combining popular with less popular cable services in marketing.
- **limited series** A television *series* that has only a few episodes for airing, usually 4 to 6 episodes.
- linchpin A centerpiece series that holds an evening together. See also anchor show.
- liners Brief scripted comments on music radio made by disc jockeys between records (without using music or effects).
- links Navigational connections to other parts of a website or to other sites.
- live Not prerecorded (or in the record industry, recorded as performed—not edited).

- **live assist** Programming that combines *disc jockey* chatter and automated music programming on tape.
- live feed A program or insert coming from a network or other interconnected source without being prerecorded and that is aired simultaneously with the source.
- **local-into-local** An engineering technique by which satellite operators retransmit only the appropriate dozen or so television stations into each market of the satellite's footprint (instead of all 1,400 stations in every market).
- **localism** An FCC policy encouraging local ownership of broadcasting and community-oriented programming.
- local marketing agreements (LMAs) Contracts for sharing the functions of programming, staffing, and commercial time sales; largely entered into by economically weak AM stations; much like newspaper joint operating agreements within a market.
- **local origination** (LO) Programs the cable system produces or licenses from syndicators to show locally, including access programs. Contrast with programs from *basic cable networks* or *pay-cable networks*.
- log The official record of a broadcast day, kept by hand or automatic means such as tape, which notes opening and closing times of all programs, commercials, and other nonprogram material and facts. Once mandated by the FCC, it is now used as proof of commercial performance.
- long-form In television, longer than the usual length of 30 minutes for *sitcoms* and 60 minutes for *dramas* or *specials* (for example, a 90-minute fall season introduction to a new prime-time *series*); also, the playing of the entire two or three hours of a *feature film* in one evening. It also refers to a *miniseries* of 10 hours or more. In radio, it is nationally distributed programming using a single musical *format*, as in automated *beautiful music* or rock. Contrast with syndicated *features* or *short-form* news.
- **long-form nights** Evenings on which a two-hour movie or *special* is scheduled by a network.
- loss leader A program (or *format*) broadcast because management thinks it is ethically, promotionally, culturally, or aesthetically worthwhile rather than directly rewarding financially; in cable, carrying cultural channels used as image builders.
- **lotteries** Contests involving the three elements of prize, *consideration*, and chance. Prohibited by the FCC for broadcast stations except occasionally, and prohibited on broadcast stations by law in some states.

- low-power television (LPTV) A class of broadcast television stations with limited transmitter strength (usually covering less than 10 miles), generally assigned in areas where a full-power signal would interfere with another station using the same channel.
- made-for-cable Movies produced specifically for cable airing; when financed by the *premium networks*, they're called *made-for-pay*.
- made-for-online Programs, usually short films, made specifically for video streaming on the web.
- made-for-pay Programs, usually *feature films*, produced for *pay-cable* distribution; they may later be syndicated to broadcast stations.
- made-for-TV (MFTV) A movie feature produced especially for the broadcast television networks, usually fitting a 90-minute or two-hour format with breaks for commercials.
- magazine format A television or radio program composed of varied segments within a common framework that structurally resembles a printed magazine.
- major market By FCC definition, one of the 100 largest metropolitan areas in number of television households.
- mandatory licensing A nonvoluntary arrangement requiring cable operators to pay fees for the right to reuse copyrighted broadcast programming; the fees are returned by CRT to rights holders; also called *compulsory licensing*. See also *copyright*.
- market report An Arbitron or Nielsen ratings book for a single market.
- mashups New videos made out of other videos (parallel to collages in art).
- matching In cable, assigning the same cable channel number as a station's *over-the-air* channel number. See also *repositioning*.
- merchandising Selling products over the air or online; generally related to programs or media company brands.
- metered cities The largest markets in which the stations pay Nielsen to provide overnight ratings from metered households.
- Metro Area The most densely populated center of a metropolitan area; defined by Arbitron and Nielsen for rating a geographic subset of a market; also, MRA and MSA in ratings books.
- microniche services *Theme networks* that target a population subgroup such as the hearing impaired or foreign-language speakers. This is not to be confused with multiplexed *subniche networks*.
- midband Channels on a coaxial cable falling between broadcast channels 6 and 7, requiring a converter, cable-ready TV set, or VCR to tune.

- midmarket stations Broadcast stations in markets 26 to 100, as determined by the ratings companies. See also *large-market stations* and *small-market stations*.
- minicam A small, portable television camera. See also *electronic newsgathering* and *camcorder*.
- minidoc A short news documentary.
- mininetworks Regional, special-purpose, or parttime networks formed to carry a limited program schedule, such as news reports, a holiday *special*, or sporting events. See also *ad hoc networks*.
- minipay service A *basic cable network* that charges cable systems a small amount per subscriber per month for its programming.
- miniseries Prime-time network television *series* shorter than the traditional eleven episodes.
- mixed format Radio formats that use a common name but differ from station to station in the song lists they play (AC, soft rock). Contrast with pure format.
- mobisode Brief videos intended for handheld mobile media.
- movie libraries Those *feature films* under contract to a *station* or cable network with *plays* still available.
- movie licenses Contracts for the right to play a movie a fixed number of times; currently, contract lengths average five years.
- movie repetition Repeating movies on a cable network.
 movie rotation Scheduling movies at different times of the day and on different days of the week on a cable network.
- MPEG A series of digital video standards created by the Moving Picture Experts Group and used for compression.
- multichannel multipoint distribution service (MMDS)
 A form of pay television also called *wireless cable* that distributes up to 33 channels (and more with compression) in a market using microwave to rooftop antennas.
- multimedia Programs, presentations, or facilities that combine computerized video, audio, and data and that possess technical interoperability. Originally used largely in educational and business training applications; now includes e-mail, video games, instant messaging, and group discussions (chat).
- multinetwork synergy Benefits from owning many television outlets for programming that reaches different and/or similar audiences; a kind of horizontal rather than vertical integration.
- multipay A cable environment with many competing *premium* services; also, cable subscribers taking more than one pay channel.

- multiple franchising Licensing more than one cable company to wire the same geographic area and compete for subscribers; this occurs very infrequently. See also *overbuild*.
- multiple networks In radio, several co-owned services, such as ABC's six radio networks or Westwood's five networks.
- multiple system operator (MSO) Owner of more than one cable system. See also *group owner*.
- multiplexing Simultaneously transmitting (via subcarriers) one or more television (or radio) signals in addition to the main channel; utilizes *digital compression* to fit a 6-megahertz *NTSC* signal into a narrower band; in radio, carries data (RBDS) signals.
- music sweep An uninterrupted period of music on music radio.
- must-carry rule An FCC requirement that cable systems have to carry certain qualified local broadcast television stations.
- narrowcasting Targeting programming, usually of a restricted type, to a nonmass audience (usually a defined demographic or ethnic group). This is used when either the programming or the audience is of a narrow type.
- National Association of Broadcasters (NAB) Primary trade association of the radio and television industry.
- National Association of Television Program Executives (NATPE) Main trade association of broadcast programmers.
- National Public Radio (NPR) The noncommercial radio network service financed primarily by the *Corporation for Public Broadcasting (CPB)*; serves affiliated *public radio* stations.
- national representative See station rep(resentative).
 National Television Systems Committee (NTSC) The system of television (named after the group that developed the standard) prevalent in the Western Hemisphere until the introduction of high-definition television.
- **near-video-on-demand** (NVoD) Meaning that the viewer gets almost any program requested from a video library but is limited to the most-requested titles. See *video-on-demand*.
- net net The final revenue figure for a syndicated (or local) program after all program costs, commissions, and unsold time estimates are subtracted.
- network An interconnected chain of broadcast stations or cable systems that receive programming simultaneously. This also refers to the administrative and technical unit that distributes (and may originate) preplanned schedules of programs (for example,

- ABC, CBS, NBC, Mutual, Westwood One, Univision, PBS, NPR, HBO, ESPN, Bravo, Showtime).
- network compensation Payments by broadcast networks to affiliated stations for airing network programs and commercials.
- network-owned series Series owned all or in part by one of the major television networks and aired on that network (for example, Will & Grace on NBC).
- **network parity** Equality in network audience sizes, usually calculated by comparing the number of affiliated stations in large, middle, and small markets. See also *parity*.
- **new-build** A recently constructed residential area in which cable wires pass all houses.
- new connects Newly built homes with cable hookups. news block Extended news programming. In radio, the time immediately before and after the hour when stations program news; in television, the period between 5:30 and 7:30 P.M. (varies with market).
- news cooperatives Joint arrangements between radio and television stations and cable systems for coproducing news.
- niche networks Cable networks carrying a single type of programming; usually targets a defined audience; also called a *theme network*.
- **nonclearance** An *affiliate's* written refusal to carry a particular network program.
- noncommercial educational broadcasting The system of not-for-profit television and radio stations, and the networks that serve them and operate under educational licenses. These include public broadcasting, public-access stations, and many religious and state- or city-operated stations.
- noncompete clauses Portions of contracts preventing local personalities and newscasters from working at another station in the same market for a year or more.
- nonduplication An FCC policy that prohibits airing the same program material on two co-owned radio stations (such as one AM and one FM) in the same market. Exceptions are granted in some very small markets, in grandfathered cases, and in cases of financial need.
- nonentertainment programming News and service information such as weather and traffic reports.
- non-prime-time In network television, the hours outside of *prime time*, especially morning, day, and late night; non-prime-time programming sometimes includes news and sports because they are handled by separate network departments even if programs appear within *prime time*.

- nontraditional revenue (NTR) Income from sources other than traditional advertising sales.
- nontraditional scheduling Putting news or other programs in time blocks other than the ones normally used by network-affiliated stations.
- novelas Spanish-language serials resembling soap operas but concluding in six months or in one to two years. They generally have specific educational goals but are presented in the guise of entertainment.
- offline Use of program elements as they are fed from a network or other source; also, being not connected to a web server.
- off-network series Former broadcast television network show that is now syndicated.
- off-network syndication Selling programming (usually a series) that has appeared at least once on the national networks directly to stations or cable services.
- off-premises equipment In cable, traps and converters installed on telephone poles or the sides of buildings outside the subscriber's home.
- off-season For the broadcast networks, the 12 weeks of summer.
- online Transmitted from an internet company, originally by telephone wire; connected to a web portal.
- online networks or services Usually a web portal or a broadcast or cable network operating multiple websites.
- online promotion Marketing programs on the internet; usually refers to program advertisements on broadcast or cable network sites.
- open architecture A flexible technical infrastructure that transforms a variety of signals into viewable or listenable content.
- operating income A company's profits before taxes and interest payments are deducted.
- optical fiber Very thin strands of glass capable of carrying hundreds of video signals and thousands of audio or data signals; used in cable television to replace coaxial cable trunk and feeder lines, and in telephone to replace telephone trunk wires.
- output deals Preselling of not-vet-produced programs by producers, usually to other countries.
- overbuild A second cable system built where another firm already has one. See also multiple franchising.
- overmarketing Persuading people to subscribe to more cable services than they can readily afford.
- overnight Radio airtime from midnight to 6 A.M.; television programming from 1 or 2 a.m. to 4 or 6 a.m.
- overnights National television ratings from metered homes in major cities; available the following day to network programmers.

- over-the-air Broadcast, as opposed to delivered by a wired service such as cable television.
- owned-and-operated (O&O) station Broadcasting station owned and operated by one of the major broadcast networks.
- page views Screens requested by online users; also called page impressions.
- paid search placement Monetary inducement to place links to a particular program service among or near the main headings on menus carried by portals and/or search engines.
- parity Audience equivalence; in network television, having equal numbers of affiliates with equal reach so that each network has a fair chance to compete for ratings/shares that are based on programming popularity. Also used when comparing VHF and UHF stations and broadcast stations with and without cable carriage. See also network parity.
- passive meter An electronic meter for recording viewing (or listening) and channel tuning that requires no action by viewers (for example, no pushing of buttons). Contrast with people meter and passive people meter.
- passive people meter A new generation of passive television meters incorporating an automatic camera with a computer recognition system (which matches viewer silhouettes with stored demographic information) to record viewer demographics. See also passive meter.
- passive viewing Watching relevision without actively consulting all the competing program options.
- patching Fixing a program schedule with a temporary solution.
- pay cable Cable television programming services for which the subscriber pays an optional extra fee over and above the normal monthly cable fee. See also bay television, premium networks, and pay-per-view.
- pay-cable households Number or percentage of total television households subscribing to a premium cable service.
- pay-cable networks National satellite-distributed cable programming for which subscribers pay an extra monthly fee over and above the monthly fee for basic cable service. See also premium networks.
- pay channel Pay-cable and on-demand channels that supply mostly movies, sports, and specials to cable subscribers for an optional extra monthly or perprogram fee.
- payola Illegal payment for promoting a recording or song on the air.
- pay-per-download System of online pay-per-view, applied to full programs or movies available from their distributors (network, studios, syndicators).

- pay-per-view (PPV) Cable or *subscription television* programming in which subscribers pay to watch individual programs; purchased per program viewed rather than monthly; now mostly *video-on-demand* (VoD).
- pay radio Premium cable FM; cable networks available to subscribers for a monthly fee.
- pay run Length of a movie's license (rights) on a cable network.
- pay television An umbrella term for any programming for which viewers pay a fee; includes *pay cable*, *subscription television*, *pay-per-view*, MMDS, DBS/DTH, and VoD packages.
- pay window A period of time in which a program, usually a *feature film*, is made available to *pay cable*, generally ranging from 6 to 12 months. See also *broadcast window* and *window*.
- penetration Reach; in a given population, the percentage of households using a product or receiving a service.
- people meter An electronic meter attached to TV sets that measure both tuning and audience demographics; it requires viewers to push buttons to identify themselves. See also *passive people meter*.
- personal data assistants (PDAs) Handheld communication devices, such as BlackBerrys and Palm Pilots, that serve as appointment books, logs, and internet and e-mail connectors operating on Wi-Fi; also called personal communication assistants (PCAs).
- personal video recorders (PVRs) Home digital equipment that can record automatically and while being viewed, and that have instant content access; later called *DVRs*.
- persons using television/persons using radio (PUTs/PURs) Measurements that use an individual audience member's viewing and listening habits instead of household data; especially important to radio and sports programs, where much listening and viewing take place away from homes.
- piggybacking In *Wi-Fi*, using someone else's wireless network. In cable, formerly, sharing a channel between two program services.
- pilot A sample first program of a proposed television *series*. Often longer than regular episodes, it introduces characters, sets, situations, and program style and is generally accompanied by heavy on-air promotion.
- pilot testing Comparing audience reactions to a new television program under controlled conditions prior to the program's appearance in a network schedule.
- **platform** A computer operating system with a certain level of technical capability.

- play A showing or *run* of a program. Also, one to two showings of each episode of a program until all rights are exhausted as specified in a licensing agreement.
- playlist Strategically planned list of recordings to be played on music radio.
- plugola Inclusion of material in a program for the purpose of covertly promoting or advertising a product without disclosing that payment of any kind was made.
- pocketpiece An abbreviated version of weekly national ratings that is available to network executives and that covers prime-time broadcast and larger cable network programs.
- podcaster The audio equivalent of a web blogger; a person who records his or her spoken thoughts for anyone to download into an iPod, MP3 player, or computer.
- podcasting Distributing audio on the internet that is intended for downloading.
- **population** All homes with television sets or radios; cable population is all the homes with cable service. See also *universe*.
- portal Company providing comprehensive access to the internet, as in Yahoo! or AOL.
- **positioning** Making the audience believe one *station* or cable service is really different from its competitors; especially important for *premium* channels, television stations, rock music radio stations, and cable shopping services.
- **prebuying** Financing a movie or television *series* before production starts to obtain exclusive future telecast rights.
- preemption An *affiliate's* cancellation of a program after having an agreement to carry the program, or a *network's* cancellation of an episode in order to air a news or entertainment *special*. This term also applies to cancellation of a commercial sold at a special preemptible price to accommodate another commercial sold at full rate.
- premiere week Start of the new fall prime-time season. premium networks In television and radio, pay services costing subscribers an extra monthly fee over and above *basic cable*; in cable, called *pay cable* and *on demand*. It also includes STV, SMATV, MMDS, and DBS/DTH services. In radio, called *pay radio* or premium cable FM.
- **prep services** Brief content items supplied by radio *syndicators* for on-the-air use by DJs.
- **pre-roll** Commercial spots that must be played before online video content can be watched.

- **prerun** Showing before the network television airdate (usually on pay television).
- presold Series episodes or film idea sold before being produced (generally related to the high reputation of the producer). See also *buying* and *prebuying*.
- primary affiliate A station that carries more than 50 percent of a network's schedule.
- prime time Television *daypart*; in practice, 8 to 11 P.M. (EST) six days a week and 7 to 11 P.M. Sundays. Technically, any three consecutive hours between 7 P.M. and midnight.
- Prime-Time Access Rule (PTAR) FCC rule forbidding network *affiliates* from carrying more than three hours of network programs and *off-network* reruns (with some exceptions) in the four hours starting at 7 P.M. (EST). The rule was eliminated in 1995.
- production fee License fee that the broadcast networks pay for new programs.
- program availabilities Syndicated programs not yet under contract in a market; therefore, available to stations for license.
- program intensive A medium that uses up a lot of programs.
- program-length commercial An advertising message on radio or television of a longer length than the traditional 30 or 60 seconds that appears to be a program, which must be logged as commercial matter. See also infomercial.
- **program log** A station's record of all programs, commercials, *public service announcements*, and *non-entertainment programs* aired.
- Program Practices Department Network department that clears all programs, *promos*, and commercials before airing and is responsible for administration of network guidelines on such subjects as nudity, sex, race, profanity, and appropriateness for children. Also called "Standards and Practices" or "continuity acceptance department."
- **promo** A broadcast advertising spot announcing a new program or episode or encouraging viewing of a station's or network's entire schedule.
- **promotion** Informational and persuasive advertising of programs, stations, or networks.
- promotional support Network or syndicator assistance with promotion in the local market, consisting of coop funds, newspaper advertisements, or other aids to increase viewing of a specific program.
- protection In radio, a form of *exclusivity* in which the network supplies a program to only one station in a market, even if the network has affiliates whose signals overlap.

- psychographics Descriptive information about the lifestyles of audience members; includes attitudes on religion, family, social issues, interests, hobbies, and political opinions.
- Public Broadcasting Service (PBS) The noncommercial, federally supported interconnection service that distributes programming nationally to member *public television* stations. It also serves as a representative of the public television industry.
- public, educational, and government (PEG) Access channels on cable television.
- public radio The noncommercial radio stations in the United States qualifying for grants from the Corporation for Public Broadcasting; mostly FM licensees.
- Public Radio International (PRI) A not-for-profit radio network serving *public radio* stations.
- public service announcement (PSA) Noncommercial spot advocating a community event, a not-for-profit charity, or a public service activity.
- public station Television or radio station receiving a grant from the Corporation for Public Broadcasting; prior to 1967 they were called "educational stations." These stations are licensed by the FCC as noncommercial educational broadcast stations.
- public television (PTV) Overall term replacing "educational television" to describe federally funded noncommercial television.
- pure format A radio format appealing to an easily definable demographic group of people who like the same music and announcing style (AOR, country). Contrast with mixed format.
- qualitative research Systematically gathered information on broadcast and cable audiences and program viewing other than *ratings* collected by the industry; also used in sociological research to contrast with quantitative research methods.
- Radio Broadcast Data Systems (RBDS) A recently developed radio technology using FM subcarriers to *multiplex* a visual display (such as an automatic station ID) and limit electronic scanning of stations to those with a prespecified format.
- rankers Jargon for lists of stations in a market that are ordered by some criterion, for example, *daypart* audience, cume audience, and so on.
- rankings In radio, lists of songs and albums from most to least popular and commonly published in trade magazines. In television, share rankings are lists of television shows showing highest to lowest percentages of homes watching (out of homes using television).

- rate structure Arrangements between cable operators and cable program suppliers for revenue paybacks or licensing rights.
- rating An audience measurement unit representing the percentage of the total potential audience tuned to a specific program or for a time period.
- ratings period Usually four sequential weeks during which local television station *ratings* are collected, reported week by week, and averaged for the four weeks; called a *sweep*. Four sweeps are conducted annually—in November, February, May, and July. In radio, this may refer to as many as 48 continuous weeks for larger markets, and to fewer weeks for smaller markets. In network television, it may refer to only one week in a *pocketpiece*.
- reach Cumulative audience or total circulation of a station or service.
- reality shows Low-budget television *series* using edited tapes of real people in contrived situations or at their jobs (supplemented by on-camera interviews and reenactments), especially police officers, fire crews, and emergency workers, or games.
- Really Simple Syndication (RSS) Headline and summary content from links to newspaper articles, TV stories, and other news sources (websites and blogs), signaling articles of interest and accessed via a content *aggregator* that provides the links.
- real-time Live, as broadcast, cablecast, or webcast.
 rebroadcasts Repeats of newscasts or programs, commonly used for broadcast station newscasts reshown on local cable channels.
- **rebuilding** Redesigning and reconstructing a local cable system.
- recaps Recapitulation of news events or news stories.
 recurrents Songs that have been number one on *play-lists* in the recent past; used in scheduling songs on popular music stations.
- regional Mexican Radio *format* of traditional Mexican music, including ranchero, banda, and northern *Tejano* (Nortena) (contrast with *Spanish contemporary*).
- relay communications satellite A satellite that retransmits cable, telephone, and other signals to *earth stations* (for example, the Galaxy and Satcom cable satellites).
- release cycles Pattern of availability of new *feature films*. remote Live production from locations other than a studio (for example, football games and live news events).
- remote control device (RCD) A handheld, infraredoperated device for tuning television channels, turning sets on and off, muting sound, controlling VCR and DVD player operations, and other functions.

- **repackaging** Grouping sets of television shows or movies to run as a tribute to a performer or to create a theme.
- **repertoire** The number of channels or sites regularly accessed.
- repositioning Moving stations and networks to different positions on a cable channel array; this generally refers to moving broadcast stations away from channel numbers corresponding to their over-the-air channel numbers. Contrast with matching.
- repurposing Using content originally produced for one medium in another medium; also, finding multiple ways to sell or air a program.
- recently made movie.
- **rerun** Repeat showing of a program first aired earlier in the season or in some previous season. Commonly applied to *series* episodes.
- resale rights Permission from the wholesaler to offer copyrighted material for retail sale, republication, or retelecasting.
- reselling Offering a program to the public for purchase, as in the videocassette and DVD rental and sales business. See also *resale rights*.
- reserve price The minimum acceptable bid for a syndicated television program.
- residual rights Royalty payments for reuse of shows or, in the case of radio, voiced announcements, news features, and other content.
- response rate The number of persons who order an
- rest The length of time a feature film or other program is withheld from cable or broadcast syndication (or local station airing) to avoid overexposure.
- resting Shelving a movie or series for a period of time to make it seem fresh when revived.
- retransmission consent Control by originating station of the right to retransmit that station's signals for use by cable systems. Also, a proposal to require agreement from copyright holders (probably for a fee) before programs can be picked up by resale carriers (cable systems, common carriers). This issue particularly affects superstations, cable operators, satellite carriers, and writers/producers. It cannot be implemented without giving up mandatory licensing.
- reuse fees Royalties for replay of recorded material.
- revenue split Division of pay revenues (from subscribers) between cable operator and cable network (usually 60/40 or 50/50).
- revenue streams Sources of income, as in advertising, subscriptions, and merchandise sales.

- rights Legal authority or permission to do something, especially with copyrighted material.
- rip-and-read The simplest form of newscasting; the announcer rips copy from the wire service and reads it on the air.
- roadblocking Simultaneously airing a program or commercial on most networks to gain maximum exposure for the content (for example, presidential addresses, political campaign spots, and commercial spots).
- rocker Colloquial term for a radio station with a rock music format.
- rollout The period for developing, producing, and scheduling new programs. Also applied to a new network's multistage plans for filling prime time.
- rotation In radio, the frequency with which different types of songs are played.
- rotation scheduling In television, repeating programs (usually movies) four to six times during a month on different days and often in different dayparts to encourage viewing, thereby creating a cumulatively large audience. This technique is used by *pay-cable* and *public television* services. In radio, it is the pattern of song play.
- royalty Compensation paid to the copyright holder for the right to use copyrighted material. See also *copyright* and *compulsory licensing*.
- run The play of all episodes of a series one time or the play of a movie.
- run-through Staging a proposed show for preview by program executives; this often replaces a script for game shows.
- safe harbor Late-night time period in which children are not likely to form a large part of the viewing audience.
- same-night carriage An agreement between PBS and public television stations to air tagged programs on the day and time they are delivered by PBS.
- sample size The number of people surveyed (in radio or television, those asked to fill out a diary or have a meter installed). See *in-tab*.
- sampling frame The population from which a ratings sample is drawn.
- sandwich For *affiliate* news, splitting the local news into two sections placed before and after the network newscast. In promotion, standardized opening and closing segments of a *promo*.
- satellite master antenna television (SMATV) Also called master antenna television (MATV); this is satellite-fed television serving multiunit dwellings (such as a condo or apartment building) through a

- single satellite *earth station*. The service is distributed within a restricted geographic area (private property) and therefore does not require a *franchise* for crossing city streets or public rights-of-way. Otherwise, SMATV is similar to cable service, charging a monthly fee and usually delivering a mix of satellite-distributed pay and basic networks.
- scatter Advertising time purchased on an as-needed basis.
- schedule The arrangement of programs in a sequence. scrambling Altering a television transmission so that a proper picture requires a special decoder to prevent unauthorized reception.
- screener An assistant who preinterviews incoming callers or guests on participatory programs; also called a *call screener*.
- screening In research, locating individuals who fit specific age or gender criteria; in radio, see *call screener*.
- seamless transition An audience flow scheduling strategy that cuts all interrupting elements at the break between two programs to move viewers smoothly from one program into the next. This is difficult to achieve because most contracts with producers require playing closing and opening credits, and the advertising time at breaks between programs is especially valuable.
- search engines Software that classifies and makes accessible portions of databases.
- second season Traditionally the 11 to 13 weeks of episodes (of new or continuing programs) beginning in January.
- segmentation Subdividing *formats* to appeal to narrow target audiences.
- **sellout rate** The percentage of advertising *inventory* sold.
- sell-through The potential of a movie on videocassette or DVD to attract purchase rather than solely rental in video stores.
- semipilot A sample videotape version of a proposed game show that has audience and production devices (such as music) but no finished set.
- series A program that has multiple *episodes* sharing a common cast, plot line, and situation.
- **servers** Hard drives, especially very large ones used by *portals* and *search engines*.
- service information Hourly reports (in some dayparts) on weather, traffic, school closings, sports scores, and other matters of practical value to local listeners.
- share A measurement unit for comparing audiences; it represents the percentage of total listening or viewing audience (with sets on) tuned to a given stat.on.

- The total shares in a designated area in a given time period equal 100 percent.
- shared time slot A time period for which two or more short series are scheduled sequentially—first one complete series, then another complete series.
- shelf space Vacancies on the channel array of a cable system.
- shock jocks Talk-show hosts and disc jockeys who attract attention with controversial material and generally target adult males through the use of offcolor patter and jokes, usually in major markets or via satellite.
- shopping services Cable networks supplying merchandise for purchase as *long-form* programming.
- short-form Program material in less than 30-minute lengths on television; typically 1 to 5 minutes long for radio. This also refers to *miniseries* that are 4 to 6 hours long. Contrast with *long-form*.
- **shorts** Very brief programs, usually five minutes or less in length. See also *interstitial programming*.
- show runner The executive directly responsible for an program; also called a line producer.
- signal-to-noise ratio The relationship between the amount of transmission noise in a signal and the intended sounds or data.
- signature programs Key programs that give identity to a network or station; often *franchise shows*.
- simulcast Airing simultaneously on two or more channels. sitcom See *situation comedy*.
- situation comedy (sitcom) A program (usually a half hour in length) in which characters react to new plots or altered situations.
- skew graphs Bar graphs showing the percentage of each of six demographic groups a station reaches; they are used to compare all stations in a market.
- **skewing** Tending to emphasize one demographic group.
- **SlingBox** Broadband device with which to connect cable television to a computer.
- **slow-builders** Programs acquiring a loyal audience only after many months on the air.
- small-market stations Broadcast stations in markets 101 to 211, as defined by the ratings companies. See also *large-market stations*, *midmarket stations*, and *major market*.
- small sweeps July ratings period. See sweeps.
- soap opera A serial drama generally scheduled on broadcast networks during weekday afternoons. Advertisers (such as laundry detergent manufacturers) that target homemakers dominate advertising time.

- soft news Opposite of hard, fast-breaking news; consists of features and reports that do not depend on timely airing (for example, medical reports, entertainment industry stories, leisure, health, and hobby material).
- soft rock A radio music format consisting of current hits but without heavy metal and other hard rock songs.
- source/loss report Measurements of the flow in and out of a website.
- spam Unwanted e-mail solicitations.
- Spanish contemporary Hit song format combining various rock, rap, hip-hop, and other current Latin songs in Spanish-language versions.
- special One-time entertainment or news program of unusual interest; applied to network programs that interrupt regular schedules.
- spin In *pay cable*, the migration of subscribers from one pay service to another; also called *substitution*. See also *spin research*.
- spinoff A series using a secondary character from another series as the lead in a new prime-time series, usually on the same network. Contrast with *clone*.
- spin research SRI's method of testing what station time periods work well for a particular show.
- spot A commercial advertisement usually 15 or 30 seconds in length, or a period of time in which an advertisement, a promo, or a public service announcement can be scheduled.
- **stacking** Sequential airing of several hours of the same kind of programs; similar to *block programming*.
- standard-definition television (SDTV) Characterized by a 6-megahertz bandwidth and 2:1 interlace, used by traditional UHF and VHF stations.
- standard error A statistical term that accounts for unavoidable measurement differences between any sample and the population from which it was drawn.
- Standards and Practices Department See Program Practices Department.
- station A facility operated by the licensee to broadcast radio or television signals on an assigned frequency; it may be affiliated by contract with a *network* (for example, ABC, NPR) or an *independent* (unaffiliated), and may be commercial or noncommercial.
- station rep(resentative) A firm acting as the sales agent for a client station's advertising time in the national market.
- staying power A series idea's ability to remain popular year after year.
- step deal An agreement to supply funds to develop a program idea in stages from expanded concept statement to scripts to pilot to four or more episodes.

- stickiness The measure of time spent at a website or with a program, comparable to time-spent-listening in radio.
- stockpiling Preemptive *buying* of syndicated programs for future use that also keeps them off the market and unavailable to competitors. See also *warehousing*.
- stop set Interruption of music on radio to air commercials or other nonmusic material.
- streaming Digital distribution of audio or video in near real time; also called webcasting.
- stringer A freelance reporter paid per story rather than by the hour or the month.
- stripping Across-the-board scheduling; putting successive episodes of a program into the same time period every day, five days per week (for example, placing *Star Trek* every evening at 7 P.M.).

strip run/strip slot See stripping.

- stunting Frequently adding *specials* and shifting programs in the schedule; also using *long-form* for a program's introduction or character *crossovers*. The goal is to attract audience attention and consequent viewership. This technique is frequently used in the week preceding the kickoff of a new fall season in combination with heavy *promotion*; also used in *sweeps*.
- stunt scheduling Moving a hit show from its regular position to another to counter the debut of another network's new show or a special episode of a series.
- subniche networks Second and third television program services (networks) *multiplexed* with the established signal to capture more of the viewing audience; many subniche networks reschedule an established network's movies or programs (*time-shifting*) to gain large cumulative audiences for the same programming; others carry only selected programs from the main service.
- subscription channel A program channel, normally delivered via cable or satellite, carrying audio or video pay programming.
- subscription television (STV) Formerly, scrambled overthe-air pay television; can be used to refer collectively to all basic and premium cable and satellite television.
- substitution Cable subscribers replacing one cable pay service with another. See also *spin*.
- success rate The percentage or number of programs renewed for a second year.
- summer schedules A recently introduced network practice of scheduling original series in the summer. Contrast with *second season* and *continuous season*.
- superband Channels on a coaxial cable between the broadcast frequencies of channels 13 and 14 (above

- VHF and below UHF); they require a converter or VCR tuner.
- supersizing Padding a hit series with an extra 10 or 15 minutes to dilute the impact of a weak lead-out show (has been done with *Friends* and *Will & Grace*); alternatively, expanding a successful reality series, such as *American Idol*, to include more or longer episodes.
- superstation A television *station* that has its signal retransmitted by satellite to distant cable companies for redistribution to subscribers (for example, WGN-TV from Chicago); may be affiliated with a network.
- sweepers Short, highly produced imaging pieces that include call letters and identifying slogans and sounds, used as recurring radio station identification.
- sweeps The periods each year when Arbitron and Nielsen gather audience data for the entire country; the ratings base from a sweep determines station rates for advertising time until the next sweep. For television, the four times are November (fall season ratings are most important because they become the ratings base for the rest of the year); February (rates the fall season again plus replacements); May (end-of-year ratings); and July, when a small sweep takes place (summer replacements). Radio sweeps occur at different times and vary from 48 weeks to two to six periods annually depending on market size.
- switched video A digital process permitting consumers to select from libraries of program or movie titles for instantaneous viewing, rather like dialing a telephone number switches the caller to another telephone. See also *video-on-demand* (VoD).
- switch-in Adding a new cable service to an established lineup (usually involves canceling one existing service).
- switch-out Dropping one cable service from an established lineup, generally to replace it with another service.
- syndex Syndicated exclusivity rule governing syndication of television programs.
- syndicated exclusivity rule Called *syndex*, an FCC rule (reinstated in 1989) requiring cable systems bringing in *distant signals* to block out syndicated programming (usually on *superstations*) for which a local broadcaster owns *exclusive rights*.
- syndication Marketing programs directly to stations or cable (rather than through a broadcast network) for a specified number of *plays*; *syndicators* are companies that hold the rights to distribute programs nationally or internationally. See also *firs*-run* and *off-network syndication*.

- syndication barter The practice in which syndicates sell spots to advertisers in a syndicated program and barters the remaining spots to stations in exchange for airing the spots in the program. Same as *barter syndication*.
- syndication window The length of time a program, usually a feature film, is made available to broadcast stations; generally ranging from three to six years, but it may be as short as two months for pay television. See also pay window.
- syndicator A company marketing television or radio programs to stations and cable systems within the United States and in other countries.
- tabloid program Sensationalistic news or entertainment shows resembling supermarket tabloid newspapers (for example, *Hard Copy, Inside Edition*).
- tagged Shows identified by PBS for same-night carriage. talk A radio format characterized by conversation between program hosts and callers, interviews, and monologues by personalities.
- tampering Unlawfully influencing the outcome of the ratings; see also *hyping* or *hypoing*.
- targeting Aiming programs (generally by selecting appropriate appeals) at a demographically or psychographically defined audience.
- t-commerce Over-the-air television sale of online products and services.
- teaser A very brief news item or program spot intended to lure a potential audience into watching or listening to the succeeding program or news story; referred to as the "teaser" when used as a program introduction.
- Tejano Music of southern Texas that combines Mexican folk, R&B, Latin, polkas, and waltzes, reflecting Mexican and European immigrant influences.
- telcos Shorthand for telephone companies, especially ones entering the television and internet delivery field.
- telecourses Instructional courses viewed on *public television* or a *cable network*, offered for credit in conjunction with local colleges and universities.
- telenovelas Long soap opera-like series in Spanish that have definite endings.
- television quotient data (TvQs) Program and personality popularity ratings, typically measuring familiarity and liking, characterized by viewer surveys asking respondents to tell whether a program or a personality is "one of their favorites."
- television receive-only (TVRO) Referring to owners of backyard satellite *dishes* and the home satellite market. See also *direct broadcast satellite*, *downlink*, and *home satellite dish*.

- **tentpoling** Placing a highly rated program between two *series* with lower ratings (often new programs); intended to prop up the ratings of the preceding and following programs.
- theme networks Cable networks that program a single type of content, such as all weather, all news, or all sports. Also called *niche networks*.
- theme weeks Daily movies grouped by genre or star on television stations and cable networks across several days.
- third-party processors Companies that sell reports summarizing, reanalyzing, or redisplaying Nielsen data.
- tier In cable, having multiple levels of cable service, each including some channels and excluding others, offered for a single package price. In syndication, having different price levels for different *dayparts*; pricing goes up when stations place a syndicated program in a small-audience time period.
- tiering Combining cable channels to sell at a package price; may be only basic cable services or a combination of pay and basic networks.
- time-buyers Advertising agency executives who purchase station time on behalf of client advertisers.
- time-shifting Scheduling programs or movies at alternate hours for the convenience of viewers (as on *multiplexed* channels); also, playing back a home recording of a broadcast or cable network program for viewing at a time other than when it was originally scheduled.
- time-spent-listening (TSL) Measure of the minutes radio listeners stay with a particular station.
- time-spent-online (TSO) Measure of the average connect time for users of an internet service. See also *stickiness*.
- titles Text portion of a program showing the name of the program or stars, credits, or source.
- TiVo Brand name of the first digital video recorder (DVR).
- tonnage Raw audience size (as opposed to demographic subgroups); used in advertising.
- **top-40** Radio music format consisting of continuous replay of the 40 highest-rated popular songs; generally superseded by *CHR* and *AC* except in the largest markets.
- tracking Monitoring a syndicated or local program's *ratings* over time, often in several different markets if syndicated.
- track record Performance history, as in how a program rated in previous *plays* on a network or on other stations when syndicated; also, how a writer/producer worked out on past productions.

- tradeout Exchange of airtime for a good or service, such as giving spots to a travel agent in exchange for airline tickets to use as a contest prize.
- transparency The appearance of simplicity to users despite very complex technical processes.
- transponder One of several units on a communications satellite that both receives *uplinked* signals and retransmits them as *downlinked* signals (amplified on another frequency). Some users lease the right from satellite operators to use the entire transponder (40 megahertz *bandwidth*); others lease only a part of a transponder's capacity. Currently, most satellites have 24 transponders, and *digital compression* of video signals greatly increases transponder capacity.
- traps Mechanical or electronic devices on telephone poles or ground-level pedestals for diverting *premium* services away from nonsubscribing households.
- treatment Outline of a new program (applied especially to *soap operas*); describes the characters and setting of the program (before a script is prepared).
- trending Graphing ratings/shares over a period of time or on a series of stations to anticipate future ratings/ shares, especially of syndicated series; same as tracking.
- tropical Radio music format drawing on Caribbean cultures in the Spanish language; includes salsa, cumbia, and merengue.
- tuning inertia A theory that viewers tend to view the next program on a channel without switching until unacceptable programs motivate them to actively switch.
- turnkey system An arrangement for turning over a responsibility to a second party. In *pay-per-view* cable, ordering and billing may be handled by a special company or the telephone company. Also, arrangements whereby local and regional cable advertising is sold and inserted within programs by a specialized advertising company rather than by the cable operator. In radio, arrangements whereby an automated radio station is programmed by satellite by another entity.
- turnover Changes in the number of subscribers, listeners, or vewers; in cable, the ratio of disconnecting to newly connecting subscribers. See also *churn*.
- **TVUPlayer** A system for importing television channels from other countries to U.S. computers.
- UHF channels Ultra-high-frequency television signals having less advantageous positions on the broadcast band than VHF and requiring separate receiving antennas in the home. Most public and many smaller commercial television stations are UHF.
- umbrella series An anthology television (or radio) program of only broadly related content under

- an all-encompassing title (for example, *Great Performances*).
- unbundling Breaking apart previously grouped programs, services, or channels for separate licensing or member purchase; used especially in cable and public radio.
- underwriter Foundation or private corporation giving grant money to cover the costs of producing or airing a program or series on *public television* or *public racio*.
- unduplicated Said of programming that is not available on any other local or imported station signal in a market; said of people counted only once in *curnes*.
- uniform channel lineups In cable, having the largest cable networks on the same channel numbers on most cable systems nationwide. Contrast with *common channel lineup*.
- universal lifeline service A minimal cable service available for a low monthly fee to all subscribers. Also called "economy basic" and other names.
- universe In cable, the total population of cable subscribers within all franchises.
- upfront Advertising time sold in advance of the new program season.
- **upgrading** Adding pay channels at the request of cable subscribers (reverse of *downgrading*).
- uplink Ground-to-satellite path; also the sending antenna itself (reverse of downlink).
- upscale Audiences or subscribers with higher-thanaverage socioeconomic demographics, especially income. Contrast with downscale.
- **uptrending** A pattern of increasing *ratings/shares* over time (reverse of *downtrending*).
- URL Universal resource locator, an internet address. user-generated content (UGC) Video and audio for the internet produced by nonprofessionals.
- value-added promotion Contests, games, and other promotions on radio, television, or cable offering more publicity to the advertiser than just spot advertising.
- V-chip An electronic system requiring the broadcast networks to add a code to each television show that indicates the amount of violence, sex, strong language, or mature situations in each individual show. Using TV sets equipped with V-chips, parents can program the set to exclude those programs deemed inappropriate for the family.
- vertical documentaries In-depth factual treatment of a subject in many segments broadcast on the same day. See also *horizontal documentaries*.
- vertical integration An industry in which the owners of the means of production also own the means of distribution; in media, a concentration of companies

- owning *cable networks* (producers) and broadcast *stations*, *cable systems* (distributors), and web *portals*.
- vertical ownership Owning both the program supply and the means of distribution.
- vertical scheduling Placing program segments sequentially on one day; also called *vertical stacking*. Used by stations and cable networks in scheduling movies of one type; also used in radio to scatter portions of a taped interview or minidocumentary throughout the day. Contrast with *theme weeks*.
- vertical stacking See vertical scheduling.
- VHF stations Very-high-frequency stations; the segment of the electromagnetic spectrum in which television channels 2 through 13 fall; the most desirable broadcast television stations.
- vid blog Written blog accompanied by video.
- videocasters People who put videos online to be downloaded; usually applied to employees of commercial companies.
- videodisc Prerecorded digitalized video information on disc for playback only; usually read by laser.
- video jockey (VJ) The announcer/host on rock music television programs; corresponds to a radio *disc jockey*.
- video-on-demand (VoD) Systems for instantaneously delivering to the home only those programs a consumer wants to see.
- video programming Term for television-like programs carried on the internet.
- videos Taped musical performance shorts used for promotion and programming (on MTV and others).
- viewsers Television viewers who also use the internet. viral video Programs that generate talk and promotional buzz.
- virtual advertising Advertising on television by superimposing product images on programs; seen only by viewers.
- vlogs Shorthand for vid blogs or vidcasts
- voicers Stories prerecorded by someone other than the announcer or disc jockey currently on the air.
- voice tracking Prerecording the filler between records, including introductions and backfill as well as chatter and perhaps news and commercial plugs.
- VoIP Technology for telephone calling over the internet. warehousing Purchasing and storing series and movies primarily to keep them from competitors. See also *stockpiling*.
- web blogger Users who maintained personal logs on their own websites.

- webcasting Digitally distributing programming only via the web.
- webisodes Episodes of a web-only program series.
- weighting Statistically matching a sample to the population by increasing the numerical weight given to responses from one or more subgroups.
- wheel Visualization of the contents of an hour as a pie divided into wedges representing different content elements; used in radio to visualize a program format and show designated sequences and lengths of all program elements such as musical numbers, news, sports, weather, features, promos, public service announcements, commercials, IDs, and time checks. Also called *hot clock*.
- Wi-Fi The standard for wireless networking over short distances (a few hundred feet); carries internet and television signals; may cover a public (park, campus) or private (a home or office building) area.
- wikis Interactive websites where users can add, remove, or otherwise edit the content, for example, the online encyclopedia *Wikipedia*.
- WiMAX A new wireless technology that passes internet users from tower to tower (like cell phones), offering high-speed transmissions comparable to in-home broadband from cable companies.
- window The period of time within which a network or distributor has the *rights* to show a *feature film* or other program (generally after the first theatrical distribution if the program was not *made-for-pay*); windows vary from a few months to many years. See also *pay window*, *syndication window*, and *broadcast window*.
- wireless cable See multichannel multipoint distribution service.
- World Wide Web (WWW) The most widely accessed portion of the internet.
- wraparound shows Talk shows scheduled just before and immediately after an event (usually a game, election, or other special programming).
- zapping Erasing commercials on home-taped videocassettes. Sometimes used synonymously with *flipping* changing channels by remote control to avoid commercials.
- **zipping** Fast-forwarding through commercials on home-taped videocassettes.
- **zoning** Dividing a cable advertising *interconnect* into tiny geographic areas to allow small businesses to purchase ads reaching only specific areas.

Annotated Bibliography

This is a selective, annotated listing of books, articles, guides, reports, and trade magazines on broadcast and cable programs and programming published since 2000. See also Internet Media Sites. Additional citations of books, articles, and websites appear at each chapter's end under Sources and Notes. For publications relevant to programming prior to 2000, consult the bibliographies to the previous editions of this book.

- Albarran, Alan B. *Management of Electronic Media*, 3rd ed. Belmont, CA: Wadsworth, 2006. Textbook for teaching management of new and mature media businesses.
- Albarran, Alan B., and Arrese, A. (eds.). *Time and Media Markets*. Mahwah, NJ: Erlbaum, 2003. Explorations of the constraints and pressures on business decisions in various media industries, especially in light of consolidation and competition.
- Albarran, Alan B., Chan-Olmstead, Sylvia M., and Wirth, Michael O. (eds.). *Handbook of Media Management and Economics*. Mahwah, NJ: Erlbaum, 2006. A synthesis of current research and industry practice relating to media management.
- Albarran, Alan B., and Pitts, Gregory G. *The Radio Broadcasting Industry*. Boston, MA: Allyn & Bacon, 2001. Overview of radio operations, financing, technology, and programming.
- Alexander, Allison, Owers, James, Carveth, Rod, Hollifield, C. Ann, and Greco, Albert N. *Media Economics: Theory and Practice*, 3rd ed. Mahwah, NJ: Erlbaum, 2003. Media industry economic practices and the processes of decision making in all the major media industries, along with comparisons of economic factors across media industries.
- Alten, Stanley. Audio in Media, 8th ed. Belmont, CA: Wadsworth, 2008. Techniques and principles of audio production from planning to post-production.
- Arbitron Cable Television Study: Exploring the Consumer's Relationship with Cable TV. Columbia, MD: Arbitron, Inc., 2006. Report of a telephone survey taken in 2006 describing use and distribution of new media and cable in subscribers' homes.
- Artwick, Claudetter Guzan. Reporting and Producing for Digital Media. Ames, IA: Blackwell Publishing, 2004. Fundamentals of digital storytelling, especially for the internet.

- Attenborough, David. *Life on Air: Memoirs of a Broad-caster*. Princeton, NJ: Princeton University Press, 2002. Autobiographical story of the professional career of one of the BBC's best-known wildlife documentary makers, who later became the BBC's Head of Programmes.
- Balnaves, M., O'Regan, T. O., and Sternberg, J. Mobilizing the Audience. Queensland, Australia: University of Queensland Press, 2002. Synthesis of industry and academic research about Generation X, computer gaming, and children's, Aboriginal, and Asian media in Australia.
- Barker, David C. Rushed to Judgment: Talk Radio, Persuasion, and American Political Behavior. New York: Columbia University Press, 2002. Analysis of the political nature of American talk radio, focusing on Rush Limbaugh's influence.
- Beaty, Bart, and Sullivan, Rebecca. Canadian Television Today. Alberta, Canada: University of Calgary Press, 2006. Discussion of challenges facing the Canadian television industry and government in the face of cable importation, high-speed internet access, and mobile media.
- Berman, Margo. Street-Smart Advertising: How to Win the Battle of the Buzz. New York: Rowman. & Littlefield, 2006. Advice on the creative side of marketing strategy.
- Bielby, Wiliam T., and Bielby, Denise D. "Controlling Prime Time: Organizational Concentration and Network Television Programming Strategies." *Journal of Broadcasting & Electronic Media* 47 (4), 2003, pp. 573–596. Analysis of networks' changing reliance on outside program suppliers.
- Billboard: The International Newsweekly of Music and Home Entertainment. New York, 1894 to date, weekly. Trade magazine of the radio industry. www.billboard.com.
- Blakeman, Robyn. Integrated Marketing Communication: Creative Strategy from Idea to Implementation.

 New York: Rowman & Littlefield, 2007. Textbook on building brand equity.
- Book, Constance Ledoux. *Digital Television: DTV* and the Consumer. Ames, IA: Blackwell Publishing, 2004. Goes beyond the technology to address how consumers use digital television and what this means for the future; includes Innovator Essays by several digital pioneers.

- Broadcaster Magazine. Toronto, Canada, 1942 to date. Canadian trade magazine covering the radio, television, and cable industries, with special emphasis on current news.
- Broadcasting & Cable Market Place (replaced Broadcasting Yearbook in 1992). Washington, DC: Broadcasting Publications, 1935 to date, annually. Basic trade directory of radio and television stations and support industries; added cable in 1980.
- Broadcasting & Cable: The Business of Television. New York: Reed Business Information, 1931 to date, weekly (Cable added in 1972; radio and Washington politics dropped in 1992.) Major trade magazine of the broadcasting industry; see especially Special Reports on cable, children's television, digitalization, high-definition TV, internet technology, journalism, media corporations, radio, reps, satellites, sports, syndication, and television programming.
- Broadcasting and the Law. Knoxville, TN: Perry Publications, 1972 to date, twice monthly. Newsletter and supplements explaining findings of the Federal Communications Commission, courts, and Congress affecting broadcast operations.
- Brook, Vincent. Something Ain't Kosher Here: The Rise of the Jewish Sitcom. New Brunswick, NJ: Rutgers University Press, 2003. Cultural analysis of selected programs on American network television that feature ethnically Jewish characters.
- Brooks, Dwight E., and Daniels, George L. "The Tom Joyner Morning Show: Activist Radio in an Age of Consolidation." *Journal of Radio Studies*, 9 (Winter 2002), pp. 8–32. Abbreviated version of Daniels's dissertation on radio host Tom Joyner, showing Joyner's rise and fall from popularity as the radio talk audience's expectations changed.
- Brown, Allan, and Picard, Robert G. *Digital Terrestrial Television in Europe*. Mahwah, NJ: Erlbaum, 2004. Economic analysis of the digital roll-out and its country-by-country situation in Europe compared with other parts of the world.
- Bryant, Jennings, and Bryant, J. Alison (eds.). *Television* and the American Family, 2nd ed. Mahwah, NJ: Erlbaum, 2001. Comprehensive treatment of research into families and media use, attitudes, and effects.
- Bucy, Erik P., and Newhagen, John E. (eds.). *Media Access: Social and Psychological Dimensions of New Technology Use.* Mahwah, NJ: Erlbaum, 2003. Cross-disciplinary approach to the motivation, characteristics, and abilities affecting the actual use of the content of the new media technologies, including the socioeconomic digital divide and access to news.

- Butler, Jeremy G. *Television: Critical Methods and Applications*, 3rd ed. Mahwah, NJ: Erlbaum, 2007. Introductory textbook about the production of television programs and commercials from a critical and cultural media perspective.
- Cable Services Directory. Washington, DC: National Cable Television Association, 1978 to date, annually (title varies). Directory of information on individual cable systems, including amounts and types of local origination.
- Cable World. Denver, CO: Cable World Associates, 1988 to date, weekly. Trade articles on national cable programming and other topics from a managerial perspective.
- Chan-Olmstead, Sylvia M. Competitive Strategy for Media Firms: Strategic and Brand Management in Changing Media Markets. Mahwah, NJ: Erlbaum, 2006. Review of the analytic frameworks behind current industry practices with application to the products of the electronic media.
- Comm/Ent: A Journal of Communications and Entertainment Law. San Francisco: Hastings College of the Law, 1978 to date, quarterly. Law journal containing articles summarizing the law on specific issues, including broadcasting and new technologies.
- Community Television Review. Washington, DC: National Federation of Local Cable Programmers, 1979 to date, bimonthly. Newsletter of the NFLCP for local cable programmers. Covers public, educational, and government access television on cable and local cable origination.
- Compaine, Benjamin M., and Gomery, Douglas. Who Owns the Media? Competition and Concentration in the Mass Media Industry, 3rd ed. Mahwah, NJ: Erlbaum, 2000. Authoritative analysis of the structure of ownership in the major media and the conditions leading to changes in market competition and concentration. Covers television, movies, radio, and the internet, as well as print media.
- Cooper-Chen, Anne (ed.). Global Entertainment Media: Content, Audiences, Issues. Mahwah, NJ: Erlbaum, 2005. Analysis of cultural and legal aspects of media in scholars' home markets. Covers psychology, gratifications, and effects of media entertainment.
- Craft, John E., Leigh, Frederic A., and Godfrey, Donald G. *Electronic Media*. Belmont, CA: Wadsworth, 2000. Introductory text available online as well as in print; integrates the newest media with traditional media history and law, economics and programming, and technology and society, using an applied orientation.

- C-SPAN Update. Washington, DC: C-SPAN Network. 1982 to date, weekly. Newspaper of program content and issues affecting the broadcasting of public affairs on radio and television.
- Current, Washington, DC: Public Broadcasting Service. 1981 to date, weekly. Washington newspaper focusing on public broadcasting.
- Currie, Tony. A Concise History of British Television, 2nd ed. Tiverton, England: Kelly Publications, 2004. Reference book on the history of programs, events, and key people from the 1940s through the late 1990s.
- Daily Variety. Hollywood/New York: Variety, 1905 to date, daily. Trade newspaper of the film and television industries. Daily version of Variety magazine that is oriented toward film and television production and programming.
- Darnell, Simon C., and Wilson, Brian. "Macho Media: Unapologetic Hypermasculinity in Vancouver's 'Talk Radio for Guys.'" Journal of Broadcasting & Electronic Media, 50 (Fall 2006), pp. 444-466. Contextual analysis of on-air programming of MOJO Radio.
- David, Nina. TV Season. Phoenix, AZ: Oryx, 1976 to date, annually. Annotated guide to the previous season's commercial and public network and major syndicated television programs.
- Davis, Michael P. Talk Show Yearbook 2000: A Guide to the Nation's Most Influential Television and Radio Talk Shows, Washington, DC: Broadcast Interview Source, 2000. Annotated listing of major talk programs, alphabetically by station.
- DBS News. Washington, DC: Phillips Publishing, 1983 to date, monthly. Newsletter covering international regulatory, technical, and programming developments in direct broadcasting.
- Dimmick, John W. Media Competition and Coexistence: The Theory of the Niche. Mahwah, NJ: Erlbaum, 2003. Application of bioecological theory of the niche to competition and coexistence among the broadcasting, cable, and internet industries.
- Dintrone. Charles V. Television Program Master Index: Access to Critical and Historical Information on 1,927 Shows in 925 Books, Dissertations, and Journal Articles, 2nd ed. Jefferson, NC: McFarland, 2003. Updated annotated reference to resources on programs, genres, and people on television.
- Directory of Talk Radio. Springfield, MA: Talkers Magazine, 2004. Annual annotated listing of current talk programs.
- Dodd, Annabel Z. The Essential Guide to Telecommunications, 3rd ed. Upper Saddle River, NJ: Prentice

- Hall, 2002. A comprehensive introduction to the hundreds of technologies and laws that govern the telecommunications industry, including trade names, jargon terms, marketing programs, and legal definitions.
- Dominick, Joseph R., Sherman, Barry L., and Messere, Fritz. Broadcasting, Cable, the Internet, and Beyond: An Introduction to Modern Electronic Media, 5th ed. New York: McGraw-Hill, 2007. Up-to-date edition of this basic text, with several chapters on programming and the internet.
- Duncan, James H., (ed.). American Radio Ouarterly Ratings Reports. Cincinnati, OH: Duncan's American Radio, Inc., 1976 to date, quarterly plus supplements. Industry sourcebook for radio ratings and programming information for all markets, with extensive tables and charts.
- . Duncan's Radio Market Guide, Cincinnati. OH: Duncan's American Radio, 1976 to date, annually. Companion reference volume on the revenue ratings histories and projections for 173 markets, including market descriptions and many charts and tables.
- Eastman, Susan Tyler (ed.). Research in Media Promotion. Mahwah, NJ: Erlbaum, 2000. Synthesis of current research on promoting programs in the areas of television, radio, and the web including sports, news, movies, children's programs, and the media branding process.
- Eastman, Susan Tyler, Ferguson, Douglas A., and Klein, Robert A. (eds.). Media Promotion and Marketing, 5th ed. (formerly Promotion of Marketing for Broadband, Cable, and the Web). Boston, MA: Focal Press, 2006. Text on strategic planning for marketing networks, stations, cable systems, and websites to audiences and advertisers, with a chapter on promotion and marketing research methods.
- Elasmar, Michael G. The Impact of International Television: A Paradigm Shift. Mahwah, NJ: Erlbaum, 2003. Meta-analyses of 40 years of research about crossborder media influence challenging the assumptions of cultural imperialism.
- Etter, Jonathan, Ouinn Martin, Producer: A Behindthe-Scenes History of OM Productions and Its Founder. Jefferson, NC: McFarland, 2003. Review of television program series produced by Quinn Martin, based on interviews.
- Fentuck, Mike, and Varney, Mike. Media Regulation, Public Interest, and the Law, 2nd ed. Edinburgh, UK: Edinburgh University Press, 2006. British perspective on law and the media.

- Ferguson, Douglas A., and Perse, Elizabeth M. "The World Wide Web as a Functional Alternative to Television." *Journal of Broadcasting & Electronic Media*, 44 (Spring 2000), pp. 155–174.
- Fisch, Shalom M. Children's Learning from Educational Television: Sesame Street and Beyond.

 Mahwah, NJ: Erlbaum, 2004. Centralized resource on findings about the impact of educational media, updating previous volumes of this sort, including S. M. Fisch and R. T. Truglio's (2001) G Is for Growing: Thirty Years of Research on Children and Sesame Street (Mahwah: NJ: Erlbaum, 2001).
- Fortunato, John A. Making Media Content: The Influence of Constituency Groups on Mass Media. Mahwah, NJ: Erlbaum, 2005. Overview of the ways corporate interests, owners, and advocacy groups affect the decisionmaking of mass media organizations.
- Fowles, Jib. *The Case for Television Violence*. Thousand Oaks, CA: Sage, 2000. A provocative argument that television violence has been misinterpreted, and that rather than undermining the social order, television supports order by providing a safe outlet for aggressive impulses.
- Gershon, Richard A. *Telecommunications Management: Industry Structures and Planning Strategies*. Mahwah, NJ: Erlbaum, 2001. Text on management practices and business strategies influencing the delivery of entertainment and information to consumers via broadcasting, cable, telephony, and the internet.
- Goehler, Richard. *NAB Media Law Handbook for Talk Radio*. Washington, DC: National Association of Broadcasters, April 2000. Guide to FCC regulations and history of decisions regarding controversial talk and other laws pertinent to radio, such as payola, plugola, and commercial time.
- Gomery, Douglas. *The Studio System*. Berkeley, CA: University of California Press, 2005. Overview of the history of the Hollywood Studios and the movies they made.
- Grant, August E., and Meadows, Jennifer H. (eds.). Communication Technology Update, 10th ed. Boston, MA: Focal Press, 2006. Latest in a quickly updated series on the newest media technologies, written by academics and media experts in their specialties.
- Groebel, Jo, Noam, Eli M., and Feldmann, Valerie. (eds.). *Mobile Media: Content and Services for Wireless Communications*. Mahwah, NJ: Erlbaum, 2006. Scholarly chapters discussing the likely content, policies, economics, and business models of the new mobile media in international markets.

- Gunter, Barrie, Oates, Caroline, and Blades, Mark. Advertising to Children on TV: Content, Impact, and Regulation. Mahwah, NJ: Erlbaum, 2005. Summary of current issues and scholarly research on children and advertising.
- Ha, Louisa S., and Ganahi, III, Richard J. Webcasting Worldwide: Business Models of an Emerging Global Medium. Mahwah, NJ: Erlbaum, 2006. Examination of the business practices of webcasters around the world.
- Hausman, Carl, Benoit, Philip, Messere, Frank, and O'Donnell, Lewis B. *Modern Radio Production: Production, Programming, and Performance*, 7th ed. Belmont, CA: Wadsworth, 2007. Handbook for introducing students to producing and performing on radio, including programming aspects.
- Head, Sydney W., Spann, Thomas, and McGregor, Michael A. *Broadcasting in America: A Survey of Electronic Media*, 9th ed. Boston, MA: Houghton Mifflin, 2001. Basic reference text on American broadcasting. Covers technology, economics, regulation, history, social effects, and programming; has three chapters on program strategies and network and nonnetwork programs in the newest edition of this classic.
- Heil, Alan L. Voice of America: A History. New York: Columbia University Press, 2003. Insider overview of a half-century of Voice of America, including developments in technology, stories of reporters, histories of programs, and discussions of external pressures and other international radio services such as Radio Free Asia.
- Hilt, Michael L., and Lipschultz, Jeremy H. Mass Media, An Aging Population, and the Baby Boomers. Mahwah, NJ: Erlbaum, 2005. Exploration of the relationship between media and aging issues.
- Hoffstetter, C. Richard. "The Skills and Motivations of Interactive Media Participants: The Case of Political Talk Radio." In Erik P. Bucy and John. E. Newhagen (eds.), Media Access: Social and Psychological Dimensions of New Technology Use. Mahwah, NJ: Erlbaum, 2004, pp. 207–231. Case study of callers and hosts of talk radio shows that discuss political issues and politicians.
- Howard, Herbert H. Ownership Trends in Cable Television. Washington, DC: National Association of Broadcasters, 1987 to date, annually. Continuing comparative series on the 50 largest cable multiple-system operations; tables and charts.
- International Journal on Media Management. Mahwah, NJ: Erlbaum and the University of St. Gallen,

- Switzerland (Institute for Media and Communications Management), 1999 to date. Scholarly articles on management and economics of media in many countries, especially focusing on the transition from old to new media.
- Jones, Steve (ed.). Encyclopedia of New Media: An Essential Reference to Communication and Technology. Thousand Oaks, CA: Sage, 2003. Collection of 250 entries from 50 academic contributors relating to the vocabulary of networking, hypermedia, cyberculture, hacking, and various software and social issues. Journal of Broadcasting & Electronic Media.

Washington, DC: Broadcast Education Association, 1955 to date. Scholarly journal covering research in all aspects of television and radio broadcasting, especially emphasizing those topics with industry impact.

Journal of Consumer Research. Chicago, IL: University of Chicago Press, 1974 to date. Interdisciplinary journal reporting empirical studies and humanistic analyses that describe and explain consumer behavior.

- Journal of Mass Media Ethics: Exploring Questions of Media Morality. Mahwah, NJ: Erlbaum, 1986 to date, quarterly. Essays, reports, and literature reviews about ethical issues of interest to professionals and scholars.
- Journal of Radio Studies. Washington, DC: Broadcast Education Association, 1991 to date. Scholarly articles on historical and contemporary radio, including programming.
- Keith, Michael C. *Dirty Discourse: Sex and Indecency in American Radio*. Ames, IA: Blackwell Press, 2003. Analysis of the development of sexual content on radio from the 1920s to present-day shock jocks and cybersex on internet radio, including changing regulations and social standards.
- The Radio Station: Broadcast, Satellite, and Internet, 7th ed. Boston, MA: Focal Press, 2007.

 Newest edition of this classic guide to the business of running radio stations. Emphasizes station operations and marketing, satellite radio, web radio, and podcasting.
- Sounds in the Dark: All-Night Radio in American Life. Ames, IA: Blackwell Press, 2001. Chronicle of nighttime radio from the 1920s to the present.
- Kelly, Tom. *Music Research: The Silver Bullet to Eternal Success*. Washington, DC: National Association of Broadcasters, 2000. Insider's guide to music research by radio stations.
- Kilborn, Richard. Staging the Real: Factual TV Programming in the Age of "Big Brother." Manchester, UK: Manchester University Press, 2003. Explora-

- tions from economic, political, technical, and cultural perspectives of the many new kinds of factual and documentary programming.
- Killebrew, Kenneth. Maraging Media Convergence.
 Pathways to Journalistic Ccoperation. Ames, IA:
 Blackwell Publishing, 2004. Investigates ways to
 manage creative people in the rapidly changing work
 environment.
- Klein, Alec. Stealing Time: Steve Case, Jerry Levin, and the Collapse of AOL Time Warner. New York: Simon and Schuster, 2003. Story of the initially unsuccessful merger of Time Warner with AOL.
- Krueger, Richard A., and Casey, Mary Anne. Focus Groups: A Practice Guide for Applied Research. Thousand Oaks, CA: Sage, 2000. Revision of the standard handbook for conducting focus-group research, including a step-by-step procedure for collecting and analyzing the data.
- Kubey, Robert. Creating Television: Conversations with the People Behind 50 Years of American TV. Mahwah, NJ: Erlbaum, 2004. Personal interviews with 40 leading creators of television showing how ideas and programs are assembled.
- Lochte, Bob. Christian Radio: The Growth of a Mainstream Broadcasting Force. Jefferson, NC: McFarland & Cc., 2006. Brief history and analysis of the surge in Christian-oriented radio talk.
- The LPTV Report. Butler, WI: Kompas/Biel & Associates, 1985 to date, monthly. Trade magazine that is the official information channel of the Community Broadcasters Association, an organization of low-power television broadcasters.
- Lynch, Joanna R., and Gillespie, Greg. *Process and Practice of Radio Programming*. New York: University Press of America, 2000. Text consisting of examples and practices current in the radio industry; contains student exercises.
- McDowell, Walter. Troubleshooting Audience
 Research. Washington, DC: National Association of
 Broadcasters, 2000. A managerial decision-making
 approach to audience research covering the topics
 of ratings, projecting sales, evaluating news anchors,
 and conducting music preference studies.
- McDowell, Walter, and Batten, Alan. *Branding TV: Principles and Practices*, 2nd ed. Boston, MA: Focal Press, 2005. Handy booklet for television broaccasters on the guiding concepts of branding local television stations and their newscasts; also covers methods of implementation.
- McDowell, Walter S., and Dick, S. J. "Has Lead-In Lost its Punch? An Analysis of Prime Time Inheritance

- Effects: Comparing 1992 and 2002." *International Journal on Media Management*, 5 (2003), pp. 285–293. Discussion and analysis of the impact of audience flow between back-to-back programs from the perspective of broadcast managers.
- "MediaPost's TV Board: Big Thoughts on the Future of the Small Screen." *MediaPost Publications*, www.tvboard@mediapost.com. Near daily blogs from Jack Myers and others about advances and problems in media, advertising, and technology.
- Miles, Hugh. Al-Jazeera: *The Inside Story of the Arab News Channel That Is Challenging the West.* New York: Grove Press, 2005. Discussion of the effects of the Al-Jazeera network's goal of speaking to the West as well as to Arabs and Muslims.
- Miller, Philip. Media Law for Producers, 4th ed. Boston, MA: Focal Press, 2004. Practical examination of types of production contracts for television and the internet.
- Mullen, Megan. The Rise of Cable Programming in the United States: Revolution or Evolution? Austin, TX: University of Texas Press, 2003. History of cable programming from about 1968 to 1995; covers cable programming's role as both imitator of broadcast television and industry innovator.
- Multichannel News: The Newspaper for the New Electronic Media. New York: Reed Business Information, 1980 to date, weekly. Trade newspaper of regulatory, programming, financial, and technical events affecting electronic media.
- NAB Legal Guide to Broadcast Law & Regulation.

 Washington, DC: National Association of Broadcasting, regularly updated (most recent, 1998). Loose-leaf, one-volume compilation of selected FCC broadcasting regulations (many on programming) with analysis and commentary designed for station managers.
- NAB News. Washington, DC: National Association of Broadcasters, 1989 to date, monthly. Reports during the 1989 to 1990 period on developments in federal regulation, ratings research, and other matters affecting broadcasters, later becoming a report on the NAB convention.
- NATOA News. 1980 to date, bimonthly. Newsletter of the National Association of Telecommunications Officers and Advisors and the National League of Cities. Short reports on current events affecting local cable franchise regulation and technology, including legislative updates.
- NATPE International Newsletter (formerly NATPE Programmer). Washington, DC: National Association of Television Program Executives, 1990 to date,

- monthly. Trade newsletter of the national programmers' association.
- el-Nawawy, Mohammed, and Iskander, Adel.

 Al-Jazeera: How the Free Arab News Network

 Scooped the World and Changed the Middle East.

 Cambridge, MA: Westview Press, 2002. Account
 of the background, programs, and influence of
 Al-Jazeera, the Qatar-based network, presented
 with an anti-Israeli bias.
- Nevaer, Louis E. V. The Rise of the Hispanic Market in the United States: Challenges, Dilemmas, and Opportunities for Corporate Management. Armonk, NY: M. E. Sharpe, 2004. Examination of the markets for Hispanic goods in North America and U.S. goods in Spanish-speaking countries, but with little mention of media beyond its function in the advertising of products.
- Newcomb, Horace (ed.). Television: The Critical View, 6th ed. New York: Oxford University Press, 2000. Latest edition of the popular critical/cultural text for students.
- The New York Times. 1850 to date, daily. National newspaper covering business and entertainment aspects of broadcasting, cable television, and the internet.
- Noam, Eli M., Groebel, Jo, and Gerbarg, Darcy (eds.). *Internet Television*. Mahwah, NJ: Erlbaum, 2004. Seminal analyses of the convergence of television, telecommunications, computers, and the internet, spotlighting the availability of network infrastructure, business models, policy issues, and available content.
- NRB Magazine. Manassas, VA: National Religious Broadcasters Association, 1968 to date, nine times per year. Magazine emphasizing evangelical broadcasting on radio and television, with informal style.
- Palmer, Shelly. *Television Disrupted: The Transition* from Network to Networked Television. Boston, MA: Focal Press, 2006. Examines the changing technologies, business rules, and legal issues of television, Directed toward professionals and business executives.
- The Pay TV Newsletter. Carmel, CA: Paul Kagan Associates, 1983 to date, weekly. Trade summaries of analyses and events affecting premium cable television.
- Potter, Robert F. "Give the People What They Want: A Content Analysis of Radio Station Home Pages." Journal of Broadcasting & Electronic Media, 46 (Fall 2002), pp. 369–384. Scholarly analysis of websites for radio stations showing a mismatch between what listeners desire and stations provide.
- Producers Quarterly. Port Washington, NY: Producers Quarterly Publications, 1991 to date. Trade magazine

- for executives in the movie and television production business. Covers developments in production technology and animation, production problems and success stories, and interviews with producers.
- Radio & Records: The Industry's Newspaper. Los Angeles, 1974 to date, weekly. Trade magazine of the record industry, ranking songs and albums. Available online at wwwradioandrecords.com.
- R&R Ratings Report. Los Angeles: Radio & Records, Inc., semiannually. Special reports on the state of radio programming.
- Radio Marketing Guide and Fact Book for Advertisers. New York: Radio Advertising Bureau, 2003–2004. Trade listing of data on radio, organized by audiences, advertising expenditures, and formats.
- Radio Week. Washington, DC: National Association of Broadcasters, 1960 to date, weekly. Newsletter on matters affecting radio broadcasters, including proposed changes in federal regulations and standards.
- Robinson, Tom, and Anderson, Caitlin. "Older Characters in Children's Animated Television Programs: A Content Analysis of Their Portrayal." Journal of Broadcasting & Electronic Media, 50 (Spring 2006), pp. 287–304. Descriptive analysis of portrayals of older characters in cartoons, revealing negative mental and physical characteristics that feed into harmful stereotyping by children.
- Rockwell, Rick, and Janus, Noreene. *Media Power in Central America*. Champaign, IL: University of Illinois Press, 2003. Assessment of media developments over the last two decades in Honduras, El Salvador, Costa Rica, Panama, Guatemala, and Nicaragua, based on interviews and focusing on journalism.
- RTNDA Communicator. 1946 to date, monthly.

 Newsletter of the Radio-Television News Directors
 Association.
- Sadler, Roger J. Electronic Media Law. Newbury Park, CA: Sage, 2005. Up-to-date text on laws, regulations, and court rulings related to broadcasting, cable, satellite, and the internet. Emphasizes First Amendment law.
- Stafford, Marla R., and Faber, Ronald J. (eds.). Advertising, Promotion, and New Media. Armonk, NY:
 M. E. Sharpe, 2005. Advanced scholarly text reporting more than a dozen analyses and sets of research findings focusing on internet and mobile media usage and measurement.
- Street, Sean. A Concise History of British Radio. Tiverton, UK: Kelly Publications, 2003. History from 1920s to 2002, covering events, key people, and programs.

- Sterling, Christopher H., Bernt, Phyllis W., and Weiss, Martin B. H. Shaping American Telecommunications: A History of Technology, Policy, and Economics. Mahwah, NJ: Erlbaum, 2006. An authoritative explanation of the stages of telecommunications development. Covers policy decisions, innovations, and regulations.
- Sterling, Christopher H., and Kittross, John Michael. Stay Tuned: A History of American Broadcasting, 3rd ed. Mahwah, NJ: Erlbaum, 2002. Most recent update of this classic one-volume review of the history of the electronic media industry.
- Stolarz, Damien, and Felix, Lionel. *Hands-On Guide* to Video Blogging and Podcasting. Boston, MA: Focal Press, 2006. Covers technology, production techniques, licensing, and launch instructions for podcasts and video blogs, including uses in business, education, and entertainment.
- Swann, Phillip. TV dot Com: The Future of Interactive Television. New York: TV Books, 2000. An introduction to developments in interactive TV that illustrates how viewers will live, work, and shop in the future.
- The Television Audience. Northbrook, IL: A. C. Nielsen Company, 1959 to date, annually. Trends in television programming and audience viewing patterns.
- Television Digest. Washington, DC: Warren Publishing, Inc., 1945 to date, weekly. Trade summary of events affecting the television business.
- Television Week (formerly Electronic Media). Chicago: Crain Communications, 1982 to date, weekly. Trade periodical covering topical news in broadcasting, cable, and new media technologies. Available online at www.tvweek.com.
- Tolson, Andrew. *Television Talk Shows: Discourse, Performance, Spectacle.* Mahwah, NJ: Erlbaum.
 2001. Analysis of broadcast talk on major American and British television shows.
- Tremblay, Susan, and Tremblay, Wilfred. "The Jim Rome Show." *Journal of Radio Studies*, 8 (Spring 2001), pp. 271–291. Case study of a popular nationally-syndicated show focusing on sports talk.
- TVI: Television International Magazine. Universal City, CA: TVI Publishing Company, 1956 to date. Daily media news on the internet derived from the major international news service. Print and online at www.tviNews.net.
- TV Today. Washington, DC: National Association of Broadcasters, 1970 to date, weekly. Newsletter addressing matters of interest to broadcast station members, including developments in technology, regulation, and member services.

- Valkenburg, Patti M. Children's Responses to the Screen: A Media Psychological Approach. Mahwah, NJ: Erlbaum, 2004. Examines selectively the theories and research about major concerns in the field of media violence, advertising, unintended effects, and computer games, and presents the author's own findings.
- Variety. New York and Hollywood, 1925 to date, weekly. Trade newspaper covering the stage and the film, television, and recording industries.
- Vise, David A., and Malseed, Mark. *The Google Story: Inside the Hottest Business, Media, and Technology Success of Our Time.* New York: Random House, 2005. Details Google's growth from its creation to its battles with Microsoft and the challenges ahead.
- Vorderer, Peter, and Bryant, Jennings. *Playing Video Games: Motives, Responses, and Consequences.*Mahwah, NJ: Erlbaum, 2006. Psychology of mediated game playing as entertainment; includes simulations, gambling, and role-playing games.
- Waisbord, Silvio. MCTV: "Understanding the Global Popularity of Television Formats." *Television & New Media*, 5 (Fall 2004), pp. 359–383. Analysis suggesting that television formats are simultaneously global and national and affected by global cultures.
- Webster, James G. "Audience Flow Past and Present: Television Inheritance Effects Reconsidered." *Journal of Broadcasting & Electronic Media*, 50 (Spring 2006), pp. 323–337. Scholarly replication of an earlier study of audience flow between back-to-back programs; finds the same predictors and strength of influence 20 years later.
- ——. "Beneath the Veneer of Fragmentation: Television Audience Polarization in a Multichannel World." *Journal of Communication*, 55 (2005), pp. 366–382. Scholarly analysis of audience behavior in the cable and internet era; reveals more similarities than differences.
- Webster, James G., Phalen, Patricia F., and Lichty, Lawrence W. Ratings Analysis: The Theory and Practice of Audience Research, 3rd ed. Mahwah, NJ: Erlbaum, 2006. Authoritative description and analysis of audience ratings data for industry and scholarly users of ratings. Covering applications, collection methods, and models for data analysis—especially for electronic media.
- Weinstein, Stephen B. *The Multimedia Internet*. New York: Springer, 2005. Covers the principles,

- protocols, and encoding of the internet, from an engineering perspective.
- Wicks, Jan LeBlanc, Sylvie, George, Hollifield, C. Ann, Lacy, Stephen, and Sohn, Ardyth Broadrick. *Media Management: A Casebook Approach*, 3rd ed. Mahwah, NJ: Erlbaum, 2004. Media-based cases exploring leadership, motivation, planning, marketing, and strategic management.
- Wimmer, Roger D., and Dominick, Joseph R. *Mass Media Research: An Introduction*, 8th ed. Belmont, CA: Wadsworth, 2006. Updated version of this classic text on applied research methods in mass media, emphasizing broadcasting; includes survey methods and people meter ratings.
- Wirth, Michael O. (ed.). The Economics of the Multichannel Video Program Distribution Industry: A Special Issue of the Journal of Media Economics. Mahwah, NJ: Erlbaum, 2002. Four articles about programmer strategy groups, cable carriage decision making, decisions about early adoption of digital cable, and operators' delivery of video-on-demand.
- Witherspoon, John, Avery, Robert K., Kovitz, Roselle, and Stavitsky, Alan G. (eds.). *The History of Public Broadcasting*. Washington, DC: Educational Broadcasting Corp. 2000. Collection of chapters by scholars and insiders who analyzed the funding, technology, and programming of public broadcasting during the last four decades.
- Yuan, Elaine J., and Webster, James G. "Channel Repertoires: Using Peoplemeter Data in Beijing." *Journal of Broadcasting & Electronic Media*, 50 (Summer 2006), pp. 524–536. Report of regression analysis of minute-by-minute viewing in China, showing that total time spent with television and cable subscriptions explained 65 percent of variance.
- Zettl, Herbert. *Television Production Handbook*, 9th ed. Belmont, CA: Wadsworth, 2006. Update of the widely-used classic text that introduces students to the skills and techniques of producing television programs (including high-definition video) in the studio and field.
- Zillmann, Dolf, and Vorderer, Peter. *Media Entertainment: The Psychology of Its Appeal.* Mahwah, NJ: Erlbaum, 2000. Scholarly treatise applying psychological theories to the appeal of entertainment carried in a wide range of media.

Internet Media Sites

This list was current for January 2008. It is continually updated on the home page link for this textbook, searchable from www.wadsworth.com or http://media-programming.com. If you encounter difficulties with any of the addresses below, try entering the minimal URL address by preceding it with http:// and then deleting any material after the .com portion.

General Interest Sites

tv.zap2it.com
www.broadcastingcable.com
www.fcc.gov
www.nab.org
www.natpe.org
www.ncta.com
www.newscorp.com
www.onetvworld.org
www.sia.org (satellite industry)
www.timewarner.com
www.viacom.com
www.tvb.org

For other media organizations and associations, see the list in 1.21 on page 32 of this textbook.

Updates and News Summaries

tv.yahoo.com tv.zap2it.com www.broadcastingcable.com www.cableworld.com/cableworld www.ctam.com/smartbrief www.mediapost.com www.mediaweek.com www.multichannel.com www.soapcentral.com www.sportsbusinessjournal.com www.sportsbiznews.blogspot.com www.tvnewsday.com www.tvweek.com www.variety.com www.warnerbros.com www.zap2it.com/tv

Schedules

tvlistings.zap2it.com
www.allyourtv.com
www.clicktv.com
www.cofc.edu/~ferguson/bcp/scheds.htm (history of
prime-time grids 1946 to the present)

www.gist.com www.tvpicks.net www.tvweek.com

Ratings Research

Broadcast Networks

www.abc.com
www.cbs.com
www.fox.com
www.fox.com
www.ionline.com
www.mntv.com
www.nbc.com
www.pbs.org
www.telefutura.com
www.telemundo.com
www.univision.com

Cable

abcfamily.go.com
dsc.discovery.com
soapnet.go.com
tcm.turnerclassicmovies.com
www.aetv.com
www.amctv.com
www.bet.com
www.bravotv.com
www.cartoonnetwork.com
www.chn.org
www.cinemax.com
www.cnbc.com

www.comcentral.com www.courttv.com www.disneychannel.com www.eonline.com www.foodtv.com www.foxnews.com www.fxnetworks.com www.galavision.com www.hbo.com www.hgtv.com www.historychannel.com www.lifetimetv.com www.money.cnn.com www.msnbc.com www.mtv.com www.nationalgeographic.com/tv/channel www.onetvworld.org www.oxygen.com www.playboy.com/pbtv www.ppv.com or www.indemand.com www.scifi.com www.showtimeonline.com www.spiketv.com www.superstation.com www.tbn.org www.tnt.tv.com www.travelchannel.com www.usanetwork.com www.vh1.com www.vvtv.com www.weather.com www.wewomensentertainment.com

Public Broadcasting

www.aptonline.org
www.cpb.org

www.current.org www.npr.org www.pbskids.org www.pbs.org www.pri.org

Satellite

www.alliancem.org
www.bitpipe.com
www.directv.com
www.dishnetwork.com
www.dsl-forum.org
www.newschannels.org
www.sbca.com.mediaguide.htm

Radio

www.abcradio.com
www.allaccess.com
www.billboard.com
www.clearchannel.com
www.npr.org
www.radioandrecords.com
www.rronline.com
www.sirius.com
www.xmradio.com

Online

www.atomfilms.com
www.itvt.com
www.movielink.com
www.streamingmedia.com
www.video.aol.com
www.vodpod.com
www.warnerbros.com/web/wboriginals/
www.youtube.com

About the Contributing Authors

William J. Adams, professor of Communication in the School of Journalism & Mass Communication at Kansas State University, has a B.A. from Brigham Young University, an M.A. from Ball State University, and a Ph.D. from Indiana University. He teaches, researches, and writes about programming, and especially focuses on network television programming for prime time and on motion pictures. Professor Adams has published extensively as a journalist and scholar. His work includes chapters in the area of television and movie programming in seven editions of Media Programming: Strategies and Practices (Wadsworth, 1985 to 2009); on promotion in Promotion & Marketing for Broadcasting & Cable (Focal Press, 2006); and on movies in Research in Media Promotion (Erlbaum, 2000). He has also published articles in the Journal of Broadcasting & Electronic Media, the Journal of Communication, and the Journal of Media Economics. Professor Adams brings considerable historical expertise in television programming to his analysis of present-day prime-time strategies at the major networks. He can be reached at wadams@ksu.edu.

Robert B. Affe, senior lecturer in Telecommunications and International Studies at Indiana University, also directs the Telecommunications Management Institute. His teaching and research center on advertising, management, and international media issues. A former television executive and attorney, he was educated at Georgetown University (A.B.) and the New York University School of Law (I.D.). After admission to practice before the New York State Supreme Court and the District of Columbia Court of Appeals, he practiced communications law in Washington, DC. Drawn to the business of television, he subsequently helped to launch or rebrand stations in several major markets. While in Florida, Professor Affe taught courses in communications law and media management at the University of South Florida and recently lectured at several leading Chinese universities, including Peking University. He has published chapters in several telecommunications texts, including five editions of Media Programming: Strategies and Practices (Wadsworth 1993 to 2009). He can be reached at raffe@inaiana.edu.

Robert V. Bellamy, Jr., associate professor in the Department of Journalism & Multimedia Arts at Duquesne University in Pittsburgh, has his B.A. from Morehead State University, his M.A. from the University of Kentucky,

and his Ph.D. from the University of Iowa. His teaching and research interests include television programming and promotion, media globalization, media and sports, and the impact of technological change on media industries. He has professional experience as a NATPE Fellow and program consultant to KLRT in Little Rock, Arkansas, and as a newscast producer, air talent, and engineer for stations in Lexington and Morehead, Kentucky. Professor Bellamy has published numerous chapters about sports and television, network branding, U.S. media economics and institutions, and international media communication in such books as the Handbook of Media and Sports (Erlbaum, 2005), Artificial Ice (Garamond, 2006), Promotion & Marketing for Broadcasting & Cable (Focal Press, 2006), Research in Media Promotion (Erlbaum, 2000), Television and the American Family (Erlbaum, 2000), Media-Sport (Routledge, 1998), and the last three editions of Media Programming: Strategies and Practices (Wadsworth, 2002 to 2009). His research appears in such publications as the Journal of Broadcasting & Electronic Media, the Journal of Communication, the Journal of Sport & Social Issues, and Journalism Quarterly. Professor Bellamy is coauthor of Centerfield Shot: A History of Baseball and Television (University of Nebraska Press, 2008) and Television and the Remote Control: Grazing on a Vast Wasteland (Guilford, 1996), and coeditor of The Remote Control in the New Age of Television (Praeger, 1993). He is a member of the Editorial Board of NINE: A Journal of Baseball History and Culture. He can be reached at bellamy@duq.edu.

Susan Tyler Eastman, professor emerita of Telecommunications at Indiana University in Bloomington, has her B.A. from the University of California at Berkeley, her M.A. from San Francisco State University, and her Ph.D. from Bowling Green State University. She is senior author/editor of eight editions of Media Programming: Strategies and Practices (Wadsworth, 1981 to 2009). five editions of Promotion & Marketing for Broadcasting & Cable (Focal Press, 1982 to 2006), and Research in Media Promotion (Erlbaum, 2000). Professor Eastman has published over a hundred book chapters and articles, most of which focus on the structural, content, and industry factors affecting programming and promotion in television, radio, and cable. She serves on several editorial boards, and her articles have appeared in such journals as the Journal of Broadcasting & Electronic Media, Critical Studies in Mass Communication, the

Journal of Communication, the Journal of Applied Communication Research, the Howard Journal of Communication, the Sociology of Sport Journal, the Journal of Sport & Social Issues, and Communication Yearbook. She can be reached at eastman@indiana.edu.

Douglas A. Ferguson is a professor in the Department of Communication at the College of Charleston, South Carolina, where he served as the inaugural chair. His B.A. and M.A. are from the Ohio State University and his Ph.D. from Bowling Green State University. Early in his career, he was program director of NBC-affiliated WLIO (TV) and a station manager. In addition, he was program director for a local origination cable channel in Bay City, Michigan, that carried local game shows, children's shows, sporting events, movies, and offnetwork syndication. He teaches, researches, and writes about programming and promotion on the internet and other new media technologies and has authored several chapters on aspects of information technology, economics, and media programming. He coauthored The Broadcast Television Industry (Allyn & Bacon, 1998) and coedited three editions of Promotion & Marketing for Broadcasting & Cable (Focal Press, 1999 to 2006) and four editions of Media Programming: Strategies and Practices (Wadsworth, 1997 to 2009). Professor Ferguson's scholarly work has been published in the Journal of Broadcasting & Electronic Media, Communication Research, Journalism Quarterly, and Communication Research Reports. He can be reached at fergusond@cofc.edu.

John W. Fuller, former senior director of research at the Public Broadcasting Service, came to the national public network in 1980 and soon became director of the research department in Alexandria, Virginia. His B.A. is in Radio-Television from Florida State University, and his M.A. is in Communication Research from the University of Florida. In 1966 he started in television as studio director of WJKS-TV in Jacksonville, Florida, moving to promotion manager and then research director and program director for WTLV-TV as well until 1976. From there he went to Arbitron as research project manager, moving to PBS four years later. Before retiring in 2007, Mr. Fuller oversaw a nine-person department responsible for collection of national carriage data and daily tracking of prime-time audiences, management of market research projects, and program content and performance. He also provides research consultation and support for both the network and its member stations. Mr. Fuller has contributed to the eight editions of Media Programming:

Strategies and Practices (Wadsworth, 1985 to 2009). He can be reached at *jfuller@pbs.org*.

Timothy P. Meyer, professor, holds the John P. Blair Endowed Chair in Communication and is Chair of the Communication Program at the University of Wisconsin-Green Bay. He received his B.A. from the University of Wisconsin and his M.A. and Ph.D. from Ohio University. Before joining the University of Wisconsin-Green Bay, he taught at the University of Texas at Austin and the University of Massachusetts, Amherst. He actively consults in marketing and advertising research and works in organizational and management communications. Professor Meyer is coauthor of Advertising & the Internet (Kendall-Hunt, 2007) and Mediated Communications: A Social Action Perspective (Sage, 1988). He has published numerous chapters and articles on programming and marketing in edited books and such major scholarly journals as the Journal of Communication, the Journal of Broadcasting & Electronic Media, the Journal of Marketing, and the Journal of Advertising. He has contributed to six editions of Media Programming: Strategies and Practices (Wadsworth, 1989 to 2009). He can be reached at meyert@uwgb.edu.

Gregory D. Newton joined the School of Telecommunications at Ohio University as an assistant professor in 2002 after several years at the University of Oklahoma. In addition to conducting research in programming and television law, he teaches courses in programming and audience research, media and financial management, and law and regulation, and is the faculty advisor for the Ohio University student radio station. He has many years of radio station experience, serving as operations manager, program director, and production director as well as air talent for several stations with AC, CHR, oldies, country, big band, jazz, and news/talk formats. He holds a B.A. from Northern Illinois University, an M.A. from Northwestern University, and a Ph.D. from Indiana University. Professor Newton has been associate editor of the Federal Communications Law Journal and has published in the Journal of Broadcasting & Electronic Media, the Journal of Communication, the Journal of Radio Studies, and the Journal of Applied Communication Research. He has contributed to three editions of Media Programming: Strategies and Practices (Wadsworth, 2002 to 2009). He can be reached at newtong@ohio.edu.

Robert F. Potter is an assistant professor in the Department of Telecommunications at Indiana University, following several years on the Telecommunication and Film

faculty at University of Alabama. He teaches in the area of telecommunication programming, advertising, marketing, and management. His primary research interest lies in cognitive processing of audio in media messages. He was also a radio professional for a decade, primarily in the programming and promotion departments at a CHR station in the Pacific Northwest. His B.A. and M.S. degrees are from Eastern Washington University and his Ph.D. is from Indiana University. Professor Potter has contributed to the last two editions of Media Programming: Strategies and Practices (Wadsworth, 2006, 2009). His research is published in Journal of Broadcasting & Electronic Media, the Journal of Radio Studies, Media Psychology, the Journal of Advertising, and Communication Research. He can be reached at rfpotter@indiana.edu.

John von Soosten, presently program director and onair personality of XM Satellite Radio's "On Broadway" music channel, based in New York City, was for many years the senior vice president and director of programming for Katz National Television, part of the nation's largest television representative firm, dealing with syndicated programming. Before joining Katz in 1984, Mr. von Soosten was vice president and program manager of Metromedia's WNEW-TV, New York (now WNYW-TV), and before that, he was production manager at the same station and production technician at WOR-TV, New York (now WWOR-TV). He also has consulted for program syndicators and software companies and has authored numerous magazine articles about the business of television and radio. His B.S. is from Ithaca College and his M.S. from Brooklyn College, and he taught television production for many years at the college level. He brings a wide experience with syndicated television programming from the perspective of hundreds of U.S. stations and their foreign counterparts to his chapters in six editions of Media Programming: Strategies and Practices (Wadsworth, 1989 to 2009). Mr. von Soosten has been president of the National Association of Television Program Executives (NATPE), a director of the International Radio Television Society (IRTS), a vice president of the International Radio Television Foundation (IRTF), and secretary of the NATPE Educational Foundation. He can be reached at johnvons@msn.com.

James R. Walker, professor and chair of the Department of Communication at Saint Xavier University in Chicago, has his B.A. and M.A. from Penn State University and his Ph.D. from the University of Iowa. He has many years of experience as a producer and host of a daily consumer affairs program aired on public television.

His teaching and research have focused on television programming practices, the effectiveness of television program promotion, televised sports, and the impact of remote control devices on television viewing behaviors and the television industry. His most recent book is Centerfield Shot: A History of Baseball on Television (University of Nebraska Press, 2008) with Robert V. Bellamy, Jr. Professor Walker coauthored The Broadcast Television Industry (Allyn & Bacon, 1998) and Television and the Remote Control: Grazing on a Vast Wasteland (Guilford, 1996), and coedited The Remote Control in the New Age of Television (Praeger, 1993). In addition, he has published more than 30 articles in national and regional journals, including the *Journal* of Broadcasting & Electronic Media, Journalism Ouarterly, Nine: A Journa! of Baseball History and Culture, and the Journal of Popular Culture. He has contributed to the last three editions of Media Programming: Strategies and Practices (Wadsworth, 2002 to 2009). He can be reached at walker@sxu.edu.

Michael O. Wirth is currently dean of the College of Communication and Information at the University of Tennessee, after many years as director of the School of Communication and professor and chair of the Department of Mass Communications and Journalism Studies at the University of Denver. He was also a Senior Fellow of the Magness Institute for cable telecommunications. He has been a visiting professor at Renmin University in Beijing, Zhejiang University in Hangzhou, and Curtir. University of Technology in Perth, Australia. Professor Wirth is an internationally known expert who teaches and does research in the areas of cable telecommunication and broadcast economics, management, and regulation. He has provided consulting services for a number of multichannel television distributors, television networks, and station groups. For five years, he hosted a public affairs program on Denver television for KWGN-TV. His B.S. came from the University of Nebraska-Lincoln and his M.A. and Ph.D. from Michigan State University. He is coauthor of Costs, Benefits, and Long-Term Sustainability of Municipal Cable Television Overbuilds (GSA Press, 1998), and he has published numerous research articles in such periodicals as the Journal of Broadcasting & Electronic Media, the Journal of Media Economics, Journal of Regulatory Economics, Information Economics and Policy, Quarterly Review of Economics and Business, and the Journal of Economics and Business, as well as in scholarly books. He has contributed to two editions of Media Programming: Strategies and Practices (Wadsworth, 2006, 2009). Dr. Wirth can be reached at mwirth@utk.edu.

Index to Program Titles

This is a guide to specific television, radio, cable, and online programs and movies mentioned in the text. (Television, radio, and cable networks and online services appear in the General

ABC World News, 177, 178 Academy Awards, 155 Access Hollywood, 63, 211 According to Jim, 131 Adams Chronicles, The, 236 African-American Lives, 239 Africans, The, 228 Air America, 386 Airplane, 199 Alf, 160 Alice in Wonderland, 158 All About You, 235 All My Children, 171, 173, 206 All-Star Charity Concert, 309 All Things Considered, 380, 402, 404 AM America, 176 AM Chicago, 208 Amazing Grace, 25 Amazing Race, The, 132, 140 America Abroad, 405 America This Morning, 179 America's Ballroom Challenge, 225 America's Funniest Home Videos, 2, 8, 332 America's Most Wanted, 130 American Chopper, 293 American Country Countdown, 372 American Dad, 131 American Dreams, 137, 146 American Experience, The, 225, 233, 239

American Gold with Dick Bartley, 372 American Idol, 6, 123, 125, 127, 134, 140, 141, 145, 146, 147,

156, 160

American Masters, 233 American Morning, 176 American Radio Works, 405 American Top 40, 372 Amigos, 235 Amos 'n' Andy, 15 Andromeda, 86, 146, 293

Angelina Ballerina, 227 Antiques Roadshow, 225, 233 Apprentice, The, 1231, 140 Aqua Teen Hunger Force, 310

Are You Smarter Than a Fifth-Grader?, 156 Arrested Development, 131, 141 Arsenio Hall Show, The, 188 Art of the Western World, 228 Arthur, 227, 233, 244 As the World Turns, 165, 171, 173, 206, 320 Ascent of Man, The, 236 Ask Rita, 191

Assignment: The World, 235 Avatar: The Last Airbender, 181 Barney & Friends, 227, 244 Baseball Tonight, 292 Battlestar Gallactica, 128, 293 Bay City Blues, 160 Baywatch, 87 BBC World Service, 405 Beatle Brunch, 372 Becker, 131, 136, 153 Behind the Music, 296 Ben Casey, 154 BET on Jazz, 295 Beverly Hills 90210, 118 Big Brother, 137, 141, 144, 332 Bill Cody Classic Country Weekend, 372 Bill Nye, the Science Guy, 86 Bionic Woman, 147 Blind Date, 207, 209 Blues Clues, 119 Bob & Tom, 372, 376, 387, 408 Bob Brinker's Moneytalk, 396 Bob the Builder, 227 Bob Vila's Home Again, 88 Bold and the Beautiful, The, 23, 171, 173 Bones, 137 Boston Public, 86 Brady Bunch, The, 120 Broadway Open House, 186 Brotherhood of Poland, N.H., 131

Brothers, 116 Buffy the Vampire Slayer, 127 Bugs Bunny, 86

Camel New Caravan, 165, 178 Candid Camera, 156 Capital News Connection, 405 Car Talk, 380, 402 Casa Fox 2 News, 63 Casos de Familia, 205 CBS Health Watch, 376 CBS Evening News, 165, 177, 178 CBS Morning News, 179 Celebrity Justice, 206 Celebrity Poker Challenge, 290 Charlie Rose, 233 Charmed, 137, 296 Cheers, 96, 104 Chevy Chase Show, The, 185, 186 Children of Dune, 158 Chronicle, 199 Chuck, 147 Class of 3000, 182 Clifford the Big Red Dog, 227 Closer, The, 125, 128, 269, 291, 293, 296 Coach, 115, 296 Colbert Report, 48 Codename: Kids! Next Door, 305 Cold Case, 120, 132, 137 Cold Pizza, 176

College Football Gameday, 292

Color Purple, The, 208

Comic View, 239

Coming Out Stories, 308

Complices a! Rescate ("Friends to the Rescue"), 183

Constitution: That Delicate Balance, The, 228

Cops, 131

Cory in the House, 305

Cosby (Show), 3, 86, 96, 110, 111, 115, 120, 151,

160, 254

Cosmos, 236

Coupling, 137

Countdown, 292

Country Countdown USA, 372

Country Music Awards, 155

Criminal Minds, 147

Cristina's Court, 207

Crow, The: Starway to Heaven, 115

CSI (Crime Scene Investigation), 86, 88, 120, 121, 125, 132, 133, 134, 146, 147, 153, 156, 159, 160, 287, 291, 296

CSI: Miami, 85, 291

CSI: New York, 133

Curious George, 227

Curtis & Kuby in the Morning, 383

Daily Show with Jon Steward, The, 7, 48, 186, 293

Dancing with the Stars, 6, 140, 151, 156

Dante's Cove, 308

Danny Phantom, 181

Dating Game (Hour), The, 87, 207

Dateline NBC, 140, 156, 175, 177, 300

Dawn of the Dead, 291

Dawson's Creek, 159

Days of Our Lives, 165, 171, 173, 206

Dead Zone, 128

Deal or No Deal, 6, 13, 174, 239

Delilah, 371, 372

Desperate Housewives, 132, 151, 160

Despierta America, 205

Dexter's Laboratory, 184

Dharma and Greg, 63

Dialing for Dollars, 208

Dick Clark's U.S. Music Survey, 372

Dick Van Dyke Show, The, 25

Discovering Psychology, 228

District, The, 23

Divorce Court, 207

Doc, 137

Donahue, 184, 208

Double Dare, 116

Doug Banks, 372

Dr. Kildare, 154

Dr. Laura Show, The, 401

Dr. Phil, 86, 88, 94, 167, 184, 188, 209

Dragnet, 153

Dragon Tales, 227, 244

Drake and Josh, 305

Drawn Together, 48

Drew Carey Show, The, 133

Duke and the Doctor, 398

Dumb Bunnies, The, 181

Dune, 158

Early, Show, The, 174, 175, 175, 179, 204, 205

Early Today, 179

Economics USA, 228

Ed, 86, 147

Ed Sullivan Show, The, 142

Elimidate, 61, 209

Ellen DeGeneres Show, The, 86, 184, 206, 207

Emergency, 154

Emeril Live, 293

Emmanuelle, 298

Entertainment Tonight, 11, 25, 85, 86, 143, 191, 211

Entourage, 293, 303, 307

ER, 125, 131, 133, 143, 145, 151, 154, 160, 191, 296

ET Radio Minute, 376

Everybody Loves Raymond, 86, 88, 136, 153, 201, 210, 291

Extra, 211

Extreme Dating, 63, 207, 209

Extreme Makeover, 127, 137, 290

Face the Nation, 165, 180

Fairly OddParents, 87, 181, 184

Family Guy, 135, 184

Family Law, 131, 144

Fea Mas Bella, Las, 133

Fear Factor, 6

Firefly, 135

5th Wheel, 209

Flintstones, The, 120, 183

Football Night in America, 168

48 Hours, 177

Fox News Sunday, 180

Fox NFL Sunday, 168

Franklin, 181

Frasier, 86, 134, 262

Free for All, 286

French in Action, 228

Fresh Air with Terry Gross, 380, 404

Fridays, 185

Friends, 27, 85, 86, 88, 96, 102, 103, 104, 125, 127, 131, 143, 153,

155, 156, 160, 210, 271

Frontline, 225, 233, 238

Futures with Jaime Escalante, 235

Garry Shandling's Show, Its, 116

General Hospital, 165, 171, 172, 173, 206

Geraldo, 184

Gilligan's Island, 288

God & Devil Show, The, 326

Good Morning America, 174, 175, 176, 179, 180, 204, 205

Great Performances, 225, 230, 233, 239

Green Acres, 135

Grey's Anatomy, 5, 120, 128, 133, 134, 151, 154

Guardians of the Legend, 181

Guiding Light, 165, 171, 173, 206, 320

Gunsmoke, 142

Gut Busters, 293

Hannah Montana, 87, 305

Happy Days Again, 93

Herd with Colin Cowherd, The, 396

Heridas de Amor, 133

Heroes, 137, 147

High School Extra, 63 Highlander: The Raven, 115 Hill Street Blues, 159 Holocaust, 239 Home Improvement, 95, 96, 145, 151 House, 5, 131, 132, 154 House of Blues Radio Hour, 372 How I Met Your Mother, 131, 153 Howard Stern Show, The, 387, 392 Huntley-Brinkley Report, The, 165, 178

I Love Lucy, 120 I Love the 70s, 296 I Love the 80s, 296 I Love the 90s, 296 Illeanarama, 326 In Performance at the White House, 233 Inside Edition, 86, 88, 211 Invisible Man, 116 Issues and Answers, 180 It's Elementary, 226

Jackass, 293 IAG, 136, 147, 293 JazzTrax, 372 Jazz Alive, 404 Jean-Michel Cousteau: Ocean Adventures, 239 Jenny Jones, 121 Jeopardy!, 62, 86, 88, 119, 174, 211 Jericho, 140, 159 Jerry Springer Show, The, 86, 121, 184, 207, 216 Jesse, 25 Jetsons, The, 183 Jewish Moments in the Morning, 397 Jim Rome Show, The, 383, 396, 408 Jimmy Kimmel Live, 185, 186, 187, 213 Jimmy Newtron (The Adventures of), 87, 181, 184 Johns Hopkins Science Review, The, 154 Journeyman, 147 Judge Alex, 206, 207 Judge David Young, 206 Judge Hatchett, 207 Judge Joe Brown, 206, 207 Judge Judy, 60, 61, 85, 86, 206, 207, 209 Judge Maria Lopez, 207 Judge Mathis, 207 Judging Amy, 147, 153, 296 Joe Millionaire, 156 Judas, 158

Kidsworld Sports, 227 Kim Komando Show, The, 398 King Bisquit Flower Hour, 372 King of the Hill, 86, 132 King of Queens, 131, 152, 210

L Word, The, 286 Laguna Beach, 292 Landscape of Geometry, The, 235 Larry King Live, 290 Las Vegas, 321 Last Call with Carson Daly, 185, 186 Last Comic Standing, 160 Last Kiss. The, 309 Late Late Show, The, 162-163, 181 Late Late Show with Craig Ferguson, 185, 187, 213 Late Night with Conan O'Brien, 76, 185, 186, 187, 212 Late Night with David Letterman, 175, 179, 185, 186, 187, 212-213 Late Show with David Letterman Top Ten List, 372, 376 Late Show Starring Joan Rivers, The, 185, 186 Later, 186 Laura Ingram Show, The, 395 Law & Order, 88, 121, 127, 146, 147, 153, 156, 291, 296, 300 Law & Order: Special Victims Unit, 115, 116, 132, 147, 153, 291, 293, 296 Law & Order: Criminal Intent, 147 Leave It to Beaver, 296 Leprechauns, 158 Librarian, The, 158 Life of Riley, The, 153 Life on Earth, 236 Lilo and Stitch, 184 Live 5 News, 61 Live from Lincoln Center, 233 Live with Regis and Kathie Lee, 86, 207 Live with Regis and Kelly, 207 Lord of the Rings, 125 Lost, 6, 120, 128, 131, 140, 151, 321, 329 Love Connection, The, 209

MacNeil/Lehrer Report, The, 229 Mad About You, 271 MADtv, 185, 187 Magic Library, 235 Magnum, P.I., 153 Malcolm in the Middle, 153, 160 Man Show, The, 186, 370 Mancow Muller, 376 Marie and Friends, 372 Marketplace, 405 Marketplace Morning Report, 404 Married . . . With Children, 120, 160 Martha, 206, 207 M*A*S*H, 155 Masterpiece Theatre, 158, 225, 233, 242 Mathline, 226 Mathworks, 235 Maya and Miguel, 227 ME:TV, 182 Medic, 154 Medical Horizons, 154 Medium, 133 Meet the Press, 165, 180 Member of the Band, 144 Merlin, 158 Metropolitan Opera Presents, 233 Mighty Morphin Power Rangers, 182 Mike & Mike in the Morning, 396 Moesha, 61 Mole, The, 141 Monday Night Football, 132, 155, 156, 168, 290 Money Pit, The, 398 Monk, 116, 128, 140, 147, 291, 293

Montel Williams, 86, 207

Monty Python's Flying Circus, 225

Morning Edition, 380, 402, 404 Moving Up, 293 Mr. Meaty, 181 Mundo de Fieras, 133 Murder She Wrote, 152 Music for Monserrat, 309 Mutant X, 146 My Name is Earl, 132 My Wife and Kids, 86, 209 Mystery!, 225, 233

Naked Brothers Band, 305 Nanny, The, 210, 271 Nanny 911, 141 Nash Bridges, 115 Nature, 225, 229, 233, 242 Navy NCIS, 131, 147, 300 NBA Inside Stuff, 170 NBC Nightly News, 62, 165, 177, 178, 191 Necesito una Amiga, 205 Ned's Declassified School Survival, 87, 305 New Yankee Workshop, 233 Newlywed Game, The, 87, 207 Newshour with Jim Lehrer, The, 61, 229, 233 News/Talk, 394 NFL Today, 170 Night Calls, 295 Nightline, 167, 177, 179, 185, 186, 187, 213 Nina Blackwood's Absolutely 80s, 372 Nip/Tuck, 128, 147 Noah's Arc. 308 Noticiero Univision, 195 Now with Bill Moyers, 231 NOVA, 225, 229, 233, 239, 242, 244 NPR Playbouse, 404 NYPD Blue, 143, 153, 159

O.C., The, 130
Old Christine, 131
Oliver Beene, 132
On the Garden Line, 398
One Life to Live, 171, 173
One Reel Wonders, 291
Open Source, 386
Oprah, 11, 23, 121, 167, 184, 208, 209, 212
Oprah Winfrey Show, The, 86, 88, 94, 106, 208
Original Amateur Hour, 146
Other Side, The, 166

Pardon the Interruption, 292
Parkers, The, 86
Passion of the Christ, The, 158
Passions, 172, 173
PBS Online, 226
Penn & Teller: BS!, 286
People's Court, 207, 209
Person to Person, 218
Performance Today, 404
Playmakers, 292
Pokemon, 87, 180, 183
Poker After Dark, 213
Politically Incorrect, 186, 287
Port Charles, 172

Power of Algebra, The, 235
Power Rangers, 183
Practice, The, 86, 153, 191
Prairie Home Companion, A, 380, 402, 403, 405
Price Is Right, The, 165, 171, 174, 205
Primetime (Live), 133, 156, 177
Prince's Trust Party in the Park, 309
Prison Break, 130, 131, 136, 159
Project Runway, 293
Providence, 147, 157
Punk'd, 292

Queer as Folk, 308 Queer Edge with Jack E. Jett, The, 308 Queer Eye for the Straight Guy, 127, 145

Read All About It, 235
Reading Rainbow, 235
Real World, The, 144, 284
Reba, 151, 209, 293
Remote Control, 121
Rick Dees, 372, 376
Ring of Truth, The, 239
Roar, 141
Rockline, 371
Roseanne, 115, 151, 160
Rugrats, 118, 184
Rush Limbaugh Show, The, 386, 390, 391, 398

Sabado Gigante, 9, 153, 165 Saturday Early Show, 180 Saturday Night All Request 80's, 372 Saturday Night Live (SNL), 185, 186, 187, 203, 276 Saturday Today, 18 Scooby Doo, 183 Scrubs, 131, 141, 153 Sean Hannity Show, The, 386 Secret Agent Man, 137 See It Now, 218, 229 Seinfeld, 63, 86, 88, 95, 96, 127, 134, 145, 151, 155, 210, 212, 254 Sesame Street, 227, 230, 236, 237 700 Club, The, 85 Sex in the City, 212 Shakespeare Plays, The, 236 Shark, 133 Sharon Osburn, 63 She Spies, 87 Shoah, 239 Simple Life, The, 28, 135, 151 Simpsons, The, 28, 62, 93, 86, 118, 120, 131, 203, 210, 238 Single Guy, 25 Sister Sister, 87 Six Feet Under, 147, 299 Six O'Clock News, 61 60 Minutes, 7, 123, 132, 156, 168, 177, 202, 238 Slavery and the Making of America, 244 Smallville, 127, 130, 136, 147, 153, 158 Sound Opinions, 405 Speaking of Faith, 405 Sonrise, 372

Sopranos, The, 70, 128, 140, 266, 291, 293, 294, 309

Soundstage, 225

South Park, 293, 326

SpongeBob SquarePants, 87, 181, 182, 183, 305

Sports Illustrated for Kids, 181

SportsCenter, 292

SportsCentury, 292

Spice Girls in Concert-Wild!, 309

St. Elsewhere, 154

Star Trek, 8

Star Trek: The Next Generation, 87

Star Trek: Voyager, 86

Stargate Atlantis, 293

Stargate SG1, 86, 135, 146, 293, 297

Steve Harvey, 61

Still Standing, 210

Suite Life of Zack and Cody, 305

Sunday Morning, 180

Sunday NFL Countdown, 391

Sunday Night Football, 132

Sunset Beach, 172

Superstar Concert Series, 372

 $\textit{Survivor}, \, 6, \, 8, \, 132, \, 137, \, 140, \, 141, \, 144, \, 145, \, 151, \, 156, \, 160, \, 175, \,$

329, 332

Survivor: Vanuatu, 156

Taken, 158

Taking Lives, 291

Talk of the Nation, 380, 404

Talkshow with Spike Feresten, 187

Tavis Smiley Show, The, 380, 405

Teenage Mutant Ninja Turtles, 183

Teletubbies, 227, 244

Temptation Island, 141

Texas Justice, 206

Texas Ranch House, 239

That 70's Show, 62, 63, 131, 153, 210, 271

That's So Raven, 87

This American Life, 405

This Old House, 225, 233, 242

This Week with David Brinkley, 180

This Week with George Stephanopolos, 180

Three Tenors, 227

Til Death, 141

Titans, 147

Today, 171, 174, 175, 176, 178, 179, 180, 204, 205

Today Show, The, 7, 176, 178

Tom and Jerry, 87

Tom Joyner (Morning Show, The), 373, 376,

397, 407

Tombs and Talismans, 235

Tomorrow Show, The, 186

Tonight Show, The, 186

Tonight Show with Jay Leno, The, 179, 185, 186, 187, 212

Tony Kornheiser Show, The, 396

Top Chef, 293

Top Design, 293

Totally Outrageous Behavior, 28

Touched by an Angel, 152

Trading Spaces, 293

Tripping the Rift, 160

TRL Weekend Countdown, 292, 372

Truly American, 235

Tu Desayuno Alegre, 205

Two and a Half Men, 131, 153

24, 6, 120, 140, 159

20/20, 146, 156, 175, 177

21 Hottest Stars Under 21, 139

Tyra Banks, 207

Ugly Betty, 120, 132

Unit, The, 131, 300

Up Close and Natural, 235

Up to the Minute, 179, 213

View, The, 171, 184, 205 Voyage of the Mimi, The, 235

Wait, Wait . . . Don't Tell Me!, 380

Walker, Texas Ranger, 157

Wall Street Week, 230, 239

War, The, 239

War and Peace in the Nuclear Age, 228

War at Home, 131

Washington Week in Review, 225, 233

Weeds, 286, 299, 307

Weekend Edition, 404

West Wing, The, 86, 135, 137, 152, 159

What Not to Wear, 290

What's My Line, 142

Wheel of Fortune, 11, 86, 88, 118, 119, 174, 211

Wheel of Fortune 2000, 181

Who Wants to Be a Millionaire?, 6, 8, 118, 119, 137, 140-141, 160,

174, 191

Who's the Boss?, 110, 111

Wide World of Sports, 169, 170, 188

Will & Grace, 86, 156, 210, 308

Wilton-North Report, The, 185, 186

Wings, 115

Wisecrack, 308

Wishbone, 227

Without a Trace, 88, 120, 131, 153, 291, 300

Whoopi, 153

WKRP in Cincinnati, 139

Wonderful World of Disney, The, 142

Woodwright Shop, The, 230

World News Now, 179, 213

World News Tonight, 176, 178 (see also ABC

World News)

World Poker Tour, 290, 293

WWE Bottom Line, 87

WWE Raw, 309

WWE (Friday Night) Smackdown!, 238, 271

Xena: Warrior Princess, 85

X Files, The, 8

Yanni, 227

Yes Dear, 210

Young and the Restless, The, 171, 172, 173, 206, 320

Yu Gi Oh, 87

Zorba Paster on Your Health, 405

Zoboomafoo, 227

General Index

Reference to topics and subjects as well as proper names of importance to programming are listed below, but some redundant references to the major broadcast networks and the Federal Communications Commission were not included. Consult the appropriate chapters and chapter content outlines.

A&E (Arts & Entertainment), 10, 15, 37, 69, 232, 241, 254, 281, 289, 291 ABC, 3, 9, 14, 20, 88, 191-194, 213. See also Chapters 4 and 5 online, 12 ABC Family Channel, 281, 295 ABC Kids, 181, 184 ABC Radio Networks, 52, 372, 389-390, 397 AC (adult contemporary), 339-340 Access, 200, 259-261, 270, 273-277 Active/passive people meters, 41, 69. See also people meters Adam Young (rep firm), 91 Adams, William J., 154, 208, 229, 318, 403 Addressability, 256-258 Adjacencies, 196 Adult programming, 266-267, 300, 323, 305-306, 309, 325, Advertisers, 6, 161, 166, 201, 301 Advertising cable, 264, 288 limits, 182 network, 125-128 online, 324, 325, 344 radio, 344, 350 television stations, 213 Affiliates, 191-192, 194-195, 213 network/affiliate agreement, 195-196 Aftermarket, 116-120, 287 Aggragators, 325, 327, 344 Air America Radio, 386 AIT (Agency for Instructional Technology), 235 Akimbo, 317 Al Jazeera, 306, 313 Allbritton Communications, 275 Alltel, 315 ALS (adult language service), 228 AMC (American Movie Classics), 266, 290, 295 America One, 192 America Right, 389 American Pop, 295 American Public Media (APM), 231, 235, 404, 405 American Public Television (APT), 223 Americana Television, 295 American Urban Radio Networks, 52 Amortization, 111-113 Anchoring strategy, 130 Angelini, James, 237, 306, 308 Animation, 183, 332 Annenberg, Walter, 228 Antennas, 252 Anthology, 239 AOL (Broadband), 36, 324-325 AOL Radio, 52, 333, 344 AOR (album oriented rock), 339-340

Appointment viewing, 134-135 AOH See Ratings Arbitron, 51, 52, 53, 343, 346, 350-351, 364, 368, 370, 371, 383-384 Arledge, Roone, 155 Armed Forces Radio, 229 ASCAP (American Society of Composers, Authors, and Publishers), 356 Ascertainment, 30, 367 ASI Entertainment, 43 Asian American Satellite Network, 283 Associated Press, 328 Association of Independents in Radio, 405 Association of Regional News Channels, 275 AT&T, 247, 250, 251, 261, 278, 311, 312, 315 Audiences, 6-8, 190. See also Demographics; Ratings aging, 209 cable penetration, 268-270. 299-300 churn, 70-71, 149-152, 253, 264-266, 340 ethnic, 77, 177, 154, 158, 171, 195, 206, 285, 306 evaluation, 300-303 flow, 16-17, 93, 166, 210, 227, 239, 309, 329, 391 homogeneity, 269 prime-time, 124-125 public television, 240-244 radio, 346-349 Audio, cable, 310-311 online, 315-316, 333-334 Auditorium research, 47 Availabilities, commercial spots. 187, 362 movies, 298 programs, 64, 249 Avatars, 278 Balancing, 233-234, 266, 299-300, 386 Bandwidth, 251, 252, 323. See also Digitalization Banner ads, 318, 329-330

Apple TV, 315, 316

Barter, 30, 90, 113-115, 121, 201, 202, 212, 263, 373, 375 Basic cable. See Cable BBC (British Broadcasting Corporation), 118, 221, 306, 318, 325 Bedwell, Timothy, 155 Beethoven Satellite Network, 405 Bell Atlantic, 247 Belo Corporation, 274 Berlesconi, Silvio, 221 Berman, Chris, 247 BET (Black Entertainment Television), 3, 289, 295 Bidding, 110-111, 121 Billings, Andrew C. 290, 292 Billboard, 341, 356 BilTorrent, 334 Blackberrys, 25, 249. See also Mobile media Blocking strategy, 131, 296-297 Blogging, 305, 386 Bloomberg Radio, 396 Bloxham, Michael, 19

Blunting strategy, 133	websites, 264, 276, 315
BMI (Broadcast Music Inc.), 356	wireless (MMDS), 248, 251
Bob & Tom, 372, 376, 382	zoning, 269
Bohannon, Jim, 382, 390, 401	Cable Act of 1992, 32, 249, 263, 267
Bonneville International, 341	Cable Health Network, 295
Branding, 13, 118, 198, 214, 216, 291, 295, 296, 309, 390	Cable networks. See Chapters 8 and 9
Bravo, 290, 292, 293, 308	Cable Radio Network, 310
Bridging strategy, 132, 293	Cable Television Consumer Protection and Competition Act
Broadband, 251, 256, 315, 317. See also Interoperability	of 1992, 249
Broadcast networks, 3-4, 9-10, 26-27, 191, 192-196. See also	Cablevision, 274
Chapters 4 and 5	Call out research, 357, 359-360. See also Radio, research
Brooks, Tim, 151	Call screeners, 400–401
Browne, Dr. Joy, 382, 390, 398	Cancellations, 144–145
Bubba the Love Sponge, 370, 387	Cannell, Stephen J., 161
Buckeye Cablevision, 271	Caristi, Dom, 312
Budgeting,	Carriage agreements, 223–226
local news, 219	Carriage incentive, 263
radio, 349-351	Carriage fees, 264–265. See also Retransmission consent
Buena Vista Television, 88, 89	Cartoon Network, 181, 182, 284, 288, 305, 326, 327
Bundling, 259, 266, 288	Cash-plus-barter. See Barter
Buy rates, 299, 303, 309	CATS (Community Access Television Service), 276
	CBS, 3, 9, 13, 20, 26–28, 88, 159, 191–194, 212, 254, 286, 308
Cable, 9-10, 246-279, 280-313	318. See Chapters 4 and 5
access, 259–261, 273–277	online, 12
advertising, 264, 288	CBS Radio Network, 218, 355, 388
audiences, 268–270	Cell phone programming, 25, 29, 315, 388–389
audio, 310–311, 341–342	Central Florida News, 13, 275
carriage fees, 288–289	Censors, 159–160. See also Ethics; Payola; Plugola
children's, 304	Channel
churn, 264	bundling, 259, 266, 288
copyright, 265. See also Copyright	capacity, 268
costs, 247	clustering, 267–268
digitalization, 248, 252–253, 256	lift, 266–267
foundation networks, 282–283, 296, 303	lineups, 267, 268
franchises, 248, 301–302	matching, 267
genres, 289–291, 291–295, 303–309	origination, 217
insertion capability, 309, 343	repertoire, 15, 327
interconnects, 269, 297	repositioning, 267
launch, 295–296	Charter Communications, 248
local origination, 270–275	Chicagoland Television News, 275
must carry, 35, 259–260	Children's Television Act of 1990, 181
MSOs (multiple system operators), 28–29, 248, 258, 261, 288	Children's programming, 116, 180–184, 242, 304
movies, 291, 293–294, 297–300, 304, 307–309	Children's Television Workshop. See Sesame Workshop
networks, 9–10, 281–313	Chiller (cable channel), 295
news, 305	Chorba, Frank, 355, 356
niche networks, 282	Chris Craft, 194
on demand, 255, 284–286, 303, 333	Churn, 70–71, 149–152, 258, 264–266, 340
original programming, 291	Cinemax, 258, 282, 293, 294, 307
penetration measures, 70–71, 251, 281, 301	Cingular, 315
premium networks, 282–284, 304, 307–309	Citadel, 339, 355
promotion, 264, 270, 297	Clear Channel, 52, 339, 341, 355, 362, 370–372, 387
radio, 340, 341–342	online, 333
ratings, 68–71, 268–270, 299, 301–303	Clearances, 166-168, 196, 204, 388, 392
revenues, 262–265, 299	Cliff effect, 341
satellite systems, 244–247	Clones, 141. See also Format programming
scheduling strategies, 267–268, 296–300	Clustering, 248, 267
signature programs, 289–290	CN8, 275
subscribers, 248, 263–266, 281, 301–303	CNN (Cable News Network), 69, 118, 213, 216, 268-269, 272
syndication, 85, 115–116, 120–121	281, 282, 288, 289, 290, 306, 326
systems, 247–279	CNN en Espanol, 398
technology, 247–248, 251, 252–259	CNN Headline News, 9, 69, 272, 274, 287
tiering 266–267 329	CNBC, 283

Cofinancing, 117. See also Coproduction Demographics 167, 209, 240, 242-244. See also Audiences Columbia TriStar, 27 breakouts, 66-67 Comcast, 16, 31, 247, 248, 264, 265, 272, 275, 284, 285, 294, 295, cable, 269, 297 303, 307, 312, 316, 321, 342 ideal, 129-130, 158-159 Comedy Central, 3, 8, 282, 287, 293, 370 radio, 346-349, 395 Commercial load, 94, 362-363, 389, 399 Development (programs), 161, 173, 183, 234 Common carriage agreements, 223-226 Diaries, 64, 241, 365, 368, 383, 384. See also Chapter 2 Common channel lineup, 267 Digital Audio Broadcasting (DAB), 341 Communications Act of 1934, 197, 221 Digital Millennium Copyr.ght Act, 316 Community access, 273-276 Digital must carry, 260 Compatibility, 13-14, 341 Digitalization, 2, 146, 190, 219, 248, 252-253, 268, 287, 317 Compensation, 31, 32, 85, 161, 195, 223 Direct broadcasting. SeeDBS, DirecTV; DISH; Sky Compression, 248, 249, 253-254, 283 DirecTV, 28, 227, 249, 253, 254, 259, 281, 295, 316, 342 Compulsory licenses, 32. See also Licenses; Royalties DISH, 28, 227, 249, 253, 258 281, 295, 342 ComScore, 52, 326 Discovery Channel, The, 33, 37, 118, 232, 241, 258, 281, 282-283, Concept testing, 42-43 Consolidation, effects of, 187-188, 215, 329, 350, 362, 377 Disney (Walt, Corp.), 13, 26, 27, 36, 123, 327 Content aggregators, 327. See also Chapter 10 Disney Channel, The, 37, 181, 266, 285, 295, 305 Content providers, 324–326 Distribution Window. See Window Contesting, 363-364. See also Games Distributors (syndicators), 85, 88-90 Contests, 34 DMX Music (formerly Digital Movie Express), 310-311, 341-342 Convergence, 24-25, 316-317, 326 Dominick, Joseph, 317 Converters, 250, 253, 254, 256, 278 Donahue, Phil, 208 Cooperation rates, 77-79 Double jeopardy, 145 Coproduction, 10, 119 Doubling strategy, 131-132 Copyright, 31-34, 265, 312, 316, 324, 334, 356, 368 Download-to-own, 284 Copyright Law of 1976, 32, 368 Drake-Chenault, 372 Corporate pressure, 234 Dramas, 6, 87, 146, 153-154, 291. See also Programming Corporation for Public Broadcasting (CPB), 231, 232 Drivetime, 380 Counterprogramming strategy, 17, 93, 132-133, 209, 210, 238, DSL (Digital Subscriber Line, 30, 315, 333 293, 300 DTH. See DBS; DirecTV; DISH; Sky Country Music Television, 289 DVDs, 24, 128, 135, 137, 149, 157-158, 215, 335, 244, 253, Court shows, 87, 206-207 287, 294 Crime dramas, 146, 153 DVR (digital video recorcer), 2, 15-16, 23-24, 37, 41-42, Crossownership rules, 85 81-82, 134, 135, 215-216, 250, 253, 257, 277 Crossplatform, 232 Crosspromotion, 153, 214, 327, 328, 368 E! Entertainment Television, 284, 289 Costs. See Program, costs E-commerce, 344 Cox Communications, 24, 261, 265, 267, 342 Echostar, 249, 250. See also DISH Cume/cumulative audience, 222, 241, 242. See also Radio, ratings; Educational programs. See Public, television Public television Electronic program guides. See Program, guides cable, 269, 301 Emmis Communications, 341 measures. 58-59 Emmy awards, 237 online, 330 Encore, 258, 282, 293, 307-308. See also Starz Encore CSPAN, 268, 283, 310 Encores, 297-298 Customization, 198 Enhancements, 315, 320 CW, The, 9, 20, 28, 36, 47, 88, 153, 191-193, 194, 210, 218. See Entercom, 341, 355 also Chapters 4 and 5 Equity, 143, 263, 295. See also MSOs; Ownership ESPN, 3, 23, 28, 47, 69, 77, 156, 168, 264, 265, 269, 281, 282, DAB (digital audio broadcasting), 341 289, 290, 292, 306-307, 327, 331 Daniels, George L., 397 ESPN Desportes, 292 DARS (digital audio radio services), 342 ESPN Radio, 52, 333, 390, 395, 399 Dayparting, 13, 175, 240, 306, 329, 339, 361, 369-371 ESPN2, 261, 281, 290 Dayparts, 164-165, 203-214 Ethics, 35-36, 98, 159-160, 195-196, 196 Daytime programming (ptv), 224. See also Chapters 4, 5, and 6 Ethnic programming, 190. See also BET; Foreign language DBS (direct broadcast satellite), 3, 249, 251, 260, 333. See also programming; Univision DirecTV; DISH Exclusivity, 193, 197, 202, 217, 262, 368 Deep Dish TV Network, 277, 279 Extensions, 19 Dees, Rick, 372, 376 Eyemark, 201 Deficit financing, 143. See also Program, costs

Facebook, 321

Fairness Doctrine, 29, 388, 385-386

Delayed carriage, 158, 166, 196

Delayed release, 287

Family Channel, 281, 295 FCC (Federal Communications Commission), 27, 29-35, 124, 182, 183, 190, 217, 260, 262, 388. See also specific regulations Feature films, 289. See also Movies Feature syndication, 376 Federal Trade Commission (FTC), 366 Fees. See Costs; Revenues Fiber optics, 255-256 Filipino Channel, The, 283 Financial interest and network syndication rules (fin-syn), 27, 120, 124, 187 Fink, Edward J., 28 First-run syndication, 11, 199-200 Flix, 282, 293, 307 Flow, 16-17. 93, 166, 210, 239, 327, 329. See also Audience, flow Flow titling, 309 Focus groups, 44-46 Food Network, 275, 281, 284, 292 Foreign language programming, 117, 271, 276, 277, 304. See also Ethnic; Hispanic formats; Spanish-language programming; SCOLA; Univision Format programming, 118-119, 141 Formats (formulas), 156. See also Franchise programs radio information, 374-375, 389-392, 393-399 radio music, 339-341, 372 television, 153-158, 254-255 Foundation cable services, 282-283, 296, 303

Foundation cable services, 282–283, 296, 303 4 Kids Entertainment, 181

FOX, 3, 9, 13 20, 27, 47, 88, 118, 191–192, 194, 205, 211, 216, 218, 254, 283. See also Chapters 4 and 5

Fox Kids, 184 Fox News, 268–269, 282, 288, 289, 392 Fox Sports, 263, 289, 392, 294, 306, 395

Franchise programs, 118–119, 141, 143, 147, 151, 156. See also Formats

Franchise areas (cable), 29, 261, 301-302

Fraud, 34

Friday Morning Quarterback, 341

Fuel TV, 28, 295 Futures, 94

FVoD, 255, 284, 285

FX. 11. 15. 28. 261

Gaia, 305, 321, 322 Galavision, 37, 69, 195, 266 GamePlay Metrics, 52 Game Show Channel, The, 326 Game Shows, 121, 171, 206, 326 Games, 52–53, 205, 321, 328, 290 radio, 364, 366. See also Contesting

Gaming, online, 266, 295, 321, 326, 328, 331

Gates, Bill, 324. See also Microsoft GE. 123 See also NBC Universal

Genres, 8, 86, 87, 167. See also Formats

Geographics, 130. See also Psychographics

G4 (game network), 295

GLBT (Gay, Lesbian, Bisexual, and Transexual) programming, 307, 308

Gnutella, 334

Goh, Debbie, 170, 231, 386

Golden Globe Awards, 307

Golf Channel, 294, 307

GolfSpan, 325

Google, 13, 36, 317, 318, 323, 325, 327, 344, 356

Grammys, 237

Group owner, 28-29, 90, 144, 161, 199. See also MSOs; Ownership

Grupo Televisa, 195

GSN (Game Show Network). See G4

Guarantees, 125

Guide channels, 268, 333. See also TV Guide

Habit Formation, 14–15, 16, 134–135, 204, 239, 326–327, 331. See also Blocking; Stripping

Hallmark Channel, 161, 290

Hammocking strategy, 131

Harvey, Paul, 390

HBO, 3, 70, 132, 255, 258, 266, 282, 283, 285, 287, 293, 294, 298, 299, 307, 327

HD Radio, 2, 340, 341, 377

HDTV (high-definition television), 2, 24, 146, 217, 244, 251, 254, 255, 260, 277, 286, 323

Head, Sydney W., xv, 7

Headline News. See CNN Headline News.

Hearst Corporation, 275

Here! (cable network), 308 Herzog, Herta, 45

HGTV (Home & Garden Television), 281, 284, 293

Hiatus. See Resting

High-definition television (HDTV), 254. See also HDTV

Highway Advisory Radio (HAR), 406

Hispanic formats, 340. See also Foreign language programming; Spanish-language programming;

Univision

Hispanic Station Index, 77

History Channel, The, 3, 281, 284, 293

Home Box Office. See HBO

Home video, 298. See also DVD

Homes passed, 70, 248, 251

Horror Channel, The, 19

Hosts, 119, 322, 399. See also Personalities

Hot clock, 361-363, 374, 399

HSD (home satellite dish), 249, 251

HSN (Home Shopping Network). 263

HUTs (homes using television), 55–58, 105–106, 108, 165, 166, 179, 188, 204, 209, 213, 214.

See also Ratings

Hypoing, 80. See also Promotion

iBiquity Digital, 341, 377

IBOC (in-band, on-channel), 341, 377

Ideal demographics, 129-30, 158-159

Independent websites, 323

Imus, Don, 382, 392

Indecency, 34, 370-371, 387, 397, 407. See also Infinity; Stern, Howard

InDemand, 285, 308-309

Independent Film Channel, 283

Independent producers, 9, 27. See also Producers

Independent stations, 191-192, 194-195

Independent websites, 323. See also Websites, television, radio

Infinity (now CBS Radio), 341, 388

Information radio, 7, 380-408

formats, 374-375

hosts, 399. See also Personalities

news, 390–393, 394, 403–405	Korean TV, 266
public, 402–406	KOST, 365
scheduling, 388–400	KPFA-FM, 405
screeners, 400–401	KPFK-FM, 405
talk, 380-384, 385-387, 393-399, 401	KPFT-FM, 405
voice tracking, 369	KPRC, 191
Infomercials, 85, 121, 203, 271	KQED, 229, 405
Insertion capability, 309, 343	KREM-TV, 274
Instructional service, 222, 235. See also Chapter 7	KSFO-AM, 386, 395
Interactivity, 258-259, 295, 315, 322-323. See also Interoperability	KTLA, 262, 265
Interconnects, 269, 297	KTVB-TV, 274
International appeal. See Foreign language programming; Spanish	KTZK, 395
language programming	KUHT, 223
International syndication, 85, 116–118, 173, 188	KUSC-FM, 405
Internet programming, 215, 315-337. See also Online; Websites	KVUE, 274
bandwidth, 251, 252, 323	KWGN, 307
high-speed connections, 256, 258, 315	KYW-AM, 390, 394
VoD, 333	11 11 1111, 570, 571
Interoperability, 256–259	T 1. 11. W/ II 44
ION, 9, 10, 20, 28, 88, 191–192, 194, 210. See also Chapters 4 and 5	Langschmidt, Wally, 41
IP video, 317	Launch
iPod, 315	audio, 326
iTunes, 286, 308, 319, 320, 326, 334, 407	cable, 295,
77 47 47 47 47 47 47 47 47 47 47 47 47 4	fees, 295. See also Costs
Jackson Janet Cas Come Poul	Late-night, 185–187
Jackson, Janet. See Super Bowl	Lead-in strategy, 130–131
JAM Creative Productions, 367	Learning Channel, The (TLC), 232, 241, 281, 282, 293, 315
Jankowski, Gene, 25	Least objectionable programming (LOP), 129, 134
Jazz Central, 295	Leno, Jay, 185–187
Jones Media (Radio), 52, 372, 373, 376	Letterman, David, 185–187
Joost, 317	Libel, 34–35
Joyner, Tom, 361, 372, 376, 382, 407	Liberty Media, 310, 312
	Licenses, 31–34, 88–90, 145–146, 286, 287
KABC, 191, 388, 394	blanket, 31
KABL, 365	cable, 248, 272, 288–289
KALC, 365	movies, 289
KATT, 365	network, 139, 142–143, 145–146
Katz Media, 91, 102–104	online, 325, 342–343, 356
KaZaa, 317, 334	radio, 349–350, 356
KBNP-AM, 396	syndication, 90, 94, 118, 201
KCBS, 394	Licencees,
KEGL, 365	public radio, 404–406
Keillor, Garrison, 403	public television, 227–231
KENS-TV, 274	Lifespan, 142–143
KFI, 383, 395	Lifestyle, 304
KFWB-AM, 394	Lifetime, 69, 269, 281, 289, 291, 293, 297
KGO, 191, 383, 394, 395	Lift, 266–267
KGW-TV, 274	Limbaugh, Rush, 380, 381, 382, 385, 386, 390, 391, 393, 399
KHOU-TV, 274	Limited runs, 140–141
Kids WB, 181, 184	Limited series, 139–141, 158, 239
King, Larry, 290	Lin Broadcasting, 272
King, Larry, 290	Linchpin strategy, 132
King Broadcasting, 274	Lineups, 267–268
King World, 88, 89, 90, 118, 188	Live 365, 333
KING-TV, 274	Living Standards Measure (LSM), 78
Klein, Lewis, xv	Local origination (LO), 270–275
Klein, Paul, 129, 162	Local programs, 11, 200, 236–238. See also News
KLIF, 365	Localism, 30, 223
KLOS, 376	Logo, 307, 308
KLSX-FM, 388	Logs, program, 366
KNX, 394	Lotteries, 34, 328, 366
Komando, Kim, 380. 398	Low-power radio (LPFM), 405
Koppel, Ted	Loyalty, 7, 152, 164, 172, 202, 241-242, 309, 331, 384, 389, 40

Made-for-cable, 86, 289	licensing, 32
Made-for-online programs, 323–324, 332	promotion, 363–366
Made-for-TV, 86, 148	news, 367–369
Magazine shows, 140, 174–176, 180	research, 46-47, 357-360
Major League Baseball, 133. See also World Series	revenue, 350, 362
Malone, John, 311, 312	rotation, 360–361
Mania TV, 319	Music videos, 292,
Marathons, 296	Must-carry, 35, 259–260
MCI WorldCom, 248	MySpace, 2, 194, 305, 321
McLendon, Gordon, 365	Myth TV, 322
Media Metrix, 71, 72, 330	
Medical shows, 154	NAB (National Association of Broadcasters), 35, 98, 366, 405
Merchandising, 323	
Mergers, 36. See also Consolidation	Napster, 318, 334 National Public Radio (NPR), 231, 403, 404
	NATPE (National Association of Television Program Executives), 8,
Microniche networks, 283	
Microsoft, 13, 317, 324	29, 33, 98, 146
Midnight Trucking Radio, 398	NBA TV, 295
Miniseries, 157, 158, 238	NBC, 3, 8, 13, 20, 27, 37, 88, 158, 191–194, 205, 212, 254, 291, 308
Minorities, 157–158. See also Ethnic, Foreign language	NBC Online, 12
programming; Spanish language	NBC Rewind, 320
programming	NBC Universal, 26, 27, 36, 160, 195, 297
MMDS (multichannel multipoint delivery system).	NCTA (National Cable Television Association), 33
See Wireless cable	Neep TV, 316
MNTV (MyNetworkTV), 9, 10, 20, 36, 88, 191–194, 210, 218	Neopets, 321
MobiTV, 315	Netflix, 17, 334
Models of programming and economics, 20–24	NetLinx, 45
cable, 262–266, 288	Networks, 9–10. See also broadcasting and cable networks by name
music, 357–359	affiliates, 191-195. See also Chapter 6
network, 161, 193, 218, 222-223, 287-288	cable networks, 281–313
online, 320, 323–324, 335	news, 174–180, 219
public television, 221–223	niche, 282–283
MomMe TV, 325	radio, 10, 374–375
Monopoly, 29	ratings, 48-52. See also Chapters 4 and 5
Moody Bible Institute, 310	websites, 320–323, 329, 332
Movie Channel, The, 282, 293, 94, 307	New England Cable News, 273, 275
Movie-of-the-week, 86	New York 1 News, 216, 272–273, 274
MovieLink, 315, 317, 334	News Corporation (FOX), 26, 36, 123, 216, 312
Movies. See also HBO; VoD	News programming,
cable/satellite, 291, 293–294, 297–300, 304, 307–309	budgets, 219 FIX INDENT
HD, 146	cable, 282, 305–306
made-for-TV, 157–158	
online, 326, 334	evening newscasts, 178 magazine news/talk, 176
premium, 307–308	
stations, 203	network news, 174–80
theatrical, 157–158	radio, 368–369, 374–375, 393–399
	station newscasts, 206, 209
MPEG (1, 4, 20), 249, 254, 256	weekend news, 180
MSN (Microsoft Internet portal), 324	News Channel 3 Anytime, 274
MSNBC, 161, 315	News 12 Long Island, 274
MSN Radio, 333	NewsChannel 8, 275
MSO (multiple system operator), 28-29, 248, 258, 261, 288	NewsTalk Television, 295
MTV, 3, 37, 118, 265, 269, 281, 284, 292, 297, 308	NFL Football, 168–171
MTV2, 192	NFL Network, 295
Mobile media, 19, 24–25, 36, 120, 187, 190, 215, 216, 309, 388	Niche networks, 282, 339–340
Muller, Mancow, 370, 376	Nick at Nite, 296
Multicarriage, 260. See also Must carry	Nickelodeon, 19, 69, 118, 119, 181, 182, 184, 281, 283, 305
Multiplatform strategies, 19, 170, 237, 297	Nicktropolis, 321
Multiplexing, 190, 258, 283, 341	Nielsen (Media Research), 47-51, 53, 82, 127, 136, 137-139, 204,
Murdoch, Rupert, 28, 193, 218, 221, 312. See also News Corp.	237, 238, 240-243, 285, 301-303. See also Diaries; People
Murrow, Edward R., 197, 218, 229, 390	meters, Chapter 2.
MusicChoice, 310-311, 341-342	Nielsen//Netratings, 50, 71, 72, 326, 330
Music programming, 338–378	Nielsen Reports, 100–102, 135–139
cable/satellite channels, 304-305. See also MTV	NOAA Weather Radio, 406

Noncommercial,	Pacifica Stations, 405
networks, 223	Pack, Lindsy E., 388
syndication, 85, 235. See also Public television	Paid placement, 325, 327, 329
Nonprime-time, 164–88	
children's, 180–184	Paid programs. See Infomercials
	Palm Pilot, 24
clearances, 166–168	Paramount, 27, 88, 89, 121, 188, 194, 254
dayparts, 164–165	Parity, 194
game shows, 171, 174	Parsons, Patrick R., 265, 288
news, 174–180, 219	Patrick, Dan, 399
ratings, 165	
	PAX, 20, 192, 194. See Chapters 1 and 4
scheduling, 166–171	Pay cable networks. See Fremium networks; VOD
sports, 168–171	Pay-for-play, 355
soaps, 171–173	Payola, 34, 355, 366, 400
syndication, 173	Pay-per-download, 320
talk, 184-187	Pay-per-use, 324
Nontraditional revenue (NTR), 365	
	Pay-per-view (PPV), 282, 283, 303, 308–309. See also VOD
NorthWest Cable News, 274	Pay-per-viewer, 324
Nostalgia Television, 295 NVoD, 255, 284, 285	PBS (Public Broadcasting Service), 4, 9, 10, 12, 37. See also Public television
	PBS HD, 227
O&Os (owned and operated), 28, 30, 31, 128, 136, 137-138, 187,	PBS Kids channels, 227
191–192, 210. See also Stations	PCAs (personal communication assistants/devices), 24-25, 249
Obscenity, 34. See also Indecency; Infinity; Stern	Peabody Awards, 290
Off-network syndication, 10, 199, 201–202 Ohio News Network, 275	PEG (public, educational, and governmental access channels), 261, 273, 276
Olympics, 133, 142, 155, 168, 169–170, 291	People meters, 40–41, 49–51, 69, 75, 81, 136, 240, 242, 301
On demand. See also VoD	Performance rights, 342, 356. See also ASCAP; BMI; SESAC;
radio, 407	Royalties
	Perse, Elizabeth, 45
television, 134, 252, 255, 277, 284, 286, 303, 333	
Online programming, 315–337. See also Internet; Websites	Personalities, radio, 357, 381–385, 388, 390, 396, 400. See also
advertising, 73, 74, 323–324, 332	Hosts
audience, 327	Petry Media, 91
audio, 333–334	Philo Award, 275
children's, 232	Piggybacking, 295
content providers, 324–326	Pilots, 42–43, 148, 157–158, 291
	Piracy, 312
film, 334	
formats, 319–322	Pittsburgh Cable NewsChannel, 272
gaming, 321	Platforms, 272. See also Multiplatform strategies
measurement, 330–331	Playboy TV, 295
movies, 326, 334	Plays, 11, 31, 234–235
page views, 73	Pledge drives, 227. See also Public television, fundraising
promotion, 12, 327, 329–330	Plugola, 34, 366, 400
[1] 이 보다 보기 있다면 있다면 하시고 있다면 보이네요. 그는 역 스	Pocketpieces, 50, 137–138
radio, 342–344, 380	
replay sites, 22	Podcasts, 319, 343, 407
research, 71–74, 330–331	Portable people meters, 51–52, 69, 384
scheduling, 323–324	Portals, 324, 327
sports, 326–327	PPV. See Pay-per-view
streaming, 332	Preemption, 142, 151, 159, 166, 196–197, 202, 205, 210, 375
television, 332–333	Premiere Radio Network, 52, 372, 376, 389, 390, 396
testing, 44	Premieres, 141–142, 297, 300
tracking, 72–73	Premium networks, 282-284, 304, 307-309. See also VoD
user-generated-content (UGC), 317-319	genres, 293–295
Opie & Anthony, 387, 407	rotation, 297–298
가 있는데 하는데 있다면 하는데	scheduling, 297–300
Oprah Winfrey, 6, 147, 199, 207, 208	
Out-of-home viewing, 76	services/networks, 283–286, 307–309
Overbuilds, 29	title availability, 298
Overnight programming, 179, 211, 213	windows, 287, 298–299
Overnight ratings, 41, 136–137, 242	Pre-roll, 320, 324
Over-the-Air Reception Devices Rule, 262	PRI (Public Radio International), 231, 386, 403, 405
Ownership, concentration of, 25–29, 188. See also Group	Prime-time access rule (PTAR), 120, 199–200, 210
[86] Charletta, 2007 (1982), 1883, 1884 (1983), 1884 (1984), 1884 (1985), 1884 (1984), 1884 (1984), 1884 (1984)	Prime-time programming, 122–162, 164, 211
owners; MSOs	
Oxygen, 15, 208	audiences, 125–135

Prime-time programming (continued)	Public 200 250 261 250 253 255
cancellations, 144-145	access, 200, 259–261, 270, 273–277
churn, 149–152	radio, 402–405
costs, 146, 148, 160–161	television, 220–245
formats, 153–158	Public Broadcasting Act of 1967, 231
licenses, 139, 142–143	Public Broadcasting Service (PBS), 4, 9–12, 37. See Chapte
ratings, 135–139	Public Radio International (PRI), 23, 386, 403, 405
renewals, 142–146	Public television (PTV), 220–245
pilots, 141, 148	ALS (Adult Learning Service), 228
premieres, 141–142	audiences, 242–244
promotion, 152–153	carriage agreements, 223–226
scheduling strategies, 130–134, 139–142	daytime programming, 224
seasons, 139, 140–141, 142	financing, 232–233
Producers, 9–11, 86–88, 191, 233	fundraising, 228, 230, 241
Product placement measurement, 127	instructional service, 222, 230, 235, 245,
Production, local, 11, 197–199	kids's, 232, 242
Program. See also Audiences; Music; Online; Radio; Syndication;	licensees, 222–223, 227–231, 240
Talk programming	local production, 236–238
cancellations, 144–145	NPS (National Program Service), 226
churn, 70–71, 149–152, 258, 264–266, 340	network models, 221–223, 227
costs, 25, 117, 119, 205	program rights, 234–235
development, 161, 173, 183, 234	producers, 232–234
directors/programmers, 3, 6, 11, 90, 339	promotion, 240
formats, 153–158, 254–255, 339–341, 372, 374–375, 389–399	ratings, 161, 240–244
flow, 16–17, 93, 166, 211, 225, 227, 239, 309, 329, 327, 391	satellite distribution, 223, 226–227, 235
franchises, 147	scheduling, 223–225, 238–240, 241
guides, 268, 333	SIP (Station Independence Program), 227
lifespan, 142–143	syndication, 235, 236
licenses, 31–34, 88–94, 118, 139, 142–146, 201, 248, 286–289,	underwriting, 226
325, 342–350, 356	
	Q Television Network (QTN), 308
off-network, 199, 201	Qualitative research, 44-47, 83, 299
scheduling, 21–22. See also Scheduling	Quanticast, 326
selection, 21, 23–24, 148–152	Quest, 250
specials, 153–155	Qubo Kids, 181
testing, 42–44	Quivers, Robin, 392
Programming, 2. See also Programs; Scheduling strategies.	
children's, 116, 180–184, 242, 304	RADAR (Radio's All Dimension Audience Research), 52
drama, 6. 87, 146, 153–154, 290–293	Radio, 339–378, 380–407
games, 52–53, 121, 205–206, 266, 290, 295, 221, 326, 328, 331,	budgets, 348, 364
364, 366	cable, 340–342
models, 20–24, 161, 193, 221–223, 262–266, 287–288,	callers/listeners, 399–400
320–324, 335, 357	commercial load, 362–363
music, 357–359	contesting, 363–364
sports, 154–156, 168–171, 285–286, 294–295, 306–309, 326,	facilities, 345–346
332, 394–399	HD, 2, 340, 341, 397
soaps, 170–173	hot clocks, 361–363, 374
Promotion, 12–13, 20, 22	informational, 380–403
cable, 264, 270, 297	internet, 343–344
model, 22	
network television, 152–153	music programming, 339–378
on-air, 214–215	music libraries, 354–356
online, 327, 329–330, 343,	networks, 10, 372, 374–375
premium cable, 309–310	news, 368–369, 390–393
public television, 240	online, 344
radio, 343, 349, 355, 363–367	personalities, 357, 369–370, 374
stations, 200, 202, 214–215	promotion, 343, 349, 355, 363–366
syndicated, 85–121	ratings, 51–52, 64–68, 385, 387
testing, 44	research, 357, 359–360
PSAs (Public service announcements), 367	revenue, 350
Psychographics, 43, 331, 347	screeners, 400–401
PTAR (Prime-time access rule), 120, 199–200, 210	syndication, 85
PTV. See Public television	talk formats, 390-399

Radio & Records, 340, 341, 357, 360, 381	Safe harbor, 34
Radio One, 339	Sales reps, 91
RAI, 221	Satellite Music Network, 372
Rainbow Media, 274	Satellite radio, 311, 340, 342, 387, 398. See also DMX; Sirius, XM
Ratings, 47–81. See also Cumes; People Meters	Satellite distribution,
cable, 68–71, 268–270, 299, 301–303	public television, 326–327
content ratings of programs, 83	radio, 385
late night, 187	Satellite Home Viewer Improvement Act of 1999, 260–261
limitations, 74–81	Savage, Michael, 381, 382
measurement, 53–59	Scarborough Research, 65
news, 179	Scheduling, 11–12, 21–22. See also Chapter 4
non-prime time, 165	appointment viewing, 134–135
online, 52	cable, 267–268, 296–300
prime time, 49–51, 125, 126, 135–139	churn, 70–71, 149–152, 258, 264–266, 340
public television, 240–244	non-prime time, 166–171
radio, 51–52, 385, 387	online, 328–329
sampling, 45, 50	prime-time, 139–142
sports, 170–171	public TV, 223–225, 238–241
stations, 138	summer, prime time, 141–142
syndication, 137	talk radio, 400–402
time slot, 145	Schlessinger, Dr. Laura, 381, 382, 385, 389, 390, 398, 399
video, 52–53	Schwartz, Nancy C., 182, 232, 305
RBOC (Regional Bell Operating Companies), 251	Sci-Fi Channel, 19, 158, 160, 293, 297
Reality shows, 6, 207–209	SCOLA, 276, 277
websites, 144	Screeners, 44, 400, 401
RealNetworks, 325, 326, 343	Scripts, 147–148
Rebroadcast channels, 272	SDTV (standard definition television), 254
Recording Industry Association of America (RIAA), 334	Seamless strategy, 134–135
Refranchising, 261–262	Search engines, 325, 327
Religious programming, 305, 397	Seasons, 139–140, 141, 142
Remote controls, 17, 23-24, 210, 257, 268, 297, 300	Second Life, 321, 322
Renewals, 142-146	Segmentation, 339
Rep programmer, 90-92. See also Chapter 3	Selection, 21, 23–24, 148–152
Repertoire, channel/website, 15, 327	SESAC (Society of European Songwriters, Artists, and Composers),
Repositioning, 267	356
Repurposing content, 18, 320, 328, 343	Sesame Workshop, 227, 233
Reruns, 18. See also Syndicated programs	Shares, 55–58, 83. See also Chapter 2.
Replay sites, 22. See also Chapter 10	Shelf space, 295
Research, 41, 44–47, 75, 80, 357, 359–360. See also Chapter 2	Sheltering, 295
Residuals, 201, 287. See also Royalties	Shock jocks, 310, 370, 387
Resting, 201	Shopping channels, 306
Retransmission consent, 32, 260–261	Showrunner, 86–88
Revenues	Showtime, 255, 258, 266, 293, 294, 298, 299, 307, 308–309
cable/satellite, 262–265, 299	Signature programs, 2, 289–290, 309
news, 175–179	Simulcast, 341
non-prime time, 164, 171–172 online, 323–324	Sirius, 34, 36, 342. See also Satellite radio
	Situation comedy (sitcom), 6, 153. See also Chapters 3 and 4;
radio, 350–351, 390	Syndicated programs
stations, 198–199	Sky, 28, 249, 258
syndicated shows, 107–110	Skype, 317
Revver, 291, 316, 317 Rhapsody, 325	Sleuth, 295
Rights, 201, 234–235. See also Licenses; Royalties	Slingbox, 316, 317
Ripe TV. 319	Soap operas, 170–173, 206, 206
Ripple effect, 19	SOAPnet, 19, 147, 173
Roadblocking, 269, 297	Sony, 27, 88, 110, 254, 316
Rollout strategy, 252, 253	SoundExchange, 356
Romance Network, The, 295	Spanish-language programming, 121, 154, 158, 171, 192, 195, 206,
Rome, Jim, 382	285, 306. See also Univision radio, 340, 397–398 Specials, 133, 153–155, 158, 293, 375
Rotation, 339, 360–361	Speed, 28, 295, 307
Royalties, 31, 265, 387, 334, 342, 343, 356	Spike, 281, 290, 291, 293, 296
Ruckus, 319	Spinoff, 142
	openions A 186

Sports, 155-156. See also Olympics; Super Bowl	tent-poling strategy, 132
cable, 285, 286, 294–295, 306–307, 309	tie-in, 327
network, 154-156. 168-171	tiering, 329
online, 326, 332	zoning, 269, 297
radio, 394–399	Streaming audio, 319, 333-334, 340
talk format, 292	Streaming video, 317, 319, 320, 332
stations, 199	Step deal, 147–149
Sporting News Radio, 395	Stripping strategy, 15, 92–93, 140, 165, 239
Sprint, 248, 308, 315	Studios, 25, 86. See also Producers
Standard definition television (SDTV or NTSC), 254	Stunting strategy, 131, 136, 142, 241
Standards and Practices Department, 159–160	Style Network, The, 289
STAR, 28, 249	Submissions, 146–149
StarGuide Digital Networks, 374	Subniche services, 282
	Subscription channels/services. See Chapter 9
Starz Encore, 255, 282, 293, 307–308	Summer schedules, 140–141
Station representative, 91, 98	Sundance Channel, The, 282, 307
Station programming, 189–219	Super Bowl, 35, 123–124, 154, 159, 169, 294, 319, 325, 387
affiliation, 191–195	Supersizing strategy, 133
cost, 197, 207	Superstations, 265, 307. See also WGN
local programming, 199, 209	SVoD (subscription video on demand), 255, 284. See VoD
online, 332–333	Sweepers, 365
parity, 194	Sweeps, 49–51, 136–137, 139, 238, 241, 298
Stern, Howard, 199, 342, 361, 370–371, 381, 382, 388, 396, 407	radio, 364
Stickiness, 303	Syndicated exclusivity (syndex), 33–34, 262
Strategies, 20–23, 128, 130–134, 238–240. See also Dayparting;	
Scheduling	Syndication, 10–11, 84–121
Anchoring, 130	barter, 113–115, 121
balancing, 233–234, 266, 299–300, 386	bidding, 110–111, 121
blocking, 131, 296–297	cable, 85, 115–116, 120–121
blunting, 133	feature, 376
bridging, 132, 293	first-run, 11, 199–200
bundling, 250, 266, 288	international, 85, 116–118, 157
cable, 267–268, 296–300	licensing, 94
clustering, 248, 267	made-fors, 86
counterprogramming, 17, 93, 132-133, 209, 210, 238, 293, 300	negotiation, 110
delaying carriage, 158, 166, 196	noncommercial, 85
delaying release, 287	off-network, 85–86, 128, 199, 201–202
doubling, 131–132	off-syndication, 85
flow, 16–17, 93, 166, 210, 239, 309, 327, 329	pitches, 92, 95–98
habit formation, 14-16, 134-135, 204, 239, 326-327, 331	radio talk, 85, 384, 389
hammocking, 131	ratings consultation, 98–104
incubation, 295-296	reports, 60–64
leading-in, 130-13129	reps, 98, 120, 121
linchpinning, 1320	Syndex (Syndicated exclusivity), 33-34, 262
marathons, 296	Syndicators, 85, 88–90
multiplatform, 19, 170, 237, 297	Syndicator/Rep Rules, 98
public television, 238–240	
repetition, 269	Talk hosts, 399. See also Personalities
repurposing, 18, 320, 328, 343	Talk programming, 212, 393–399
roadblocking, 269, 297	radio, 380–387, 393–399, 401
rollout, 252, 253	
rotating, 297–298, 339	sports, 292, 394, 395–399, 401
	talent, 357, 373
sandwich, 131 screening, 44, 400, 401	television, 184–185, 186–187
0, ,	Talkers Magazine, 381, 382, 390
seamlessness, 133–134	Targeting, 3, 346–349
sheltering, 295	Tartikoff, Brandon, 5
specials, 133, 153–155, 158, 293, 375	TBS, 11, 69, 132, 281, 282, 291, 307
spinoff, 327	T-commerce, 333
stacking, 131, 239	TCI (TeleCommunications, Inc.), 265, 272, 311, 312.
stretching, 212	See Time Warner
stripping, 15, 92–93, 140, 165, 239	Telecommunications Act of 1996, 2151, 2593, 339
stunting, 133, 136, 142, 241	TeleFutura, 9, 10, 28, 88, 123, 191-193, 195, 306. See also
supersizing, 133	Spanish-language programming

WETA, 233 WFAA-TV8, 274 WFAN-AM, 395 WFBQ, 365 WFMU, 397 WFMT, 310, 405 WGBH, 233

WGN, 69, 262, 265, 291, 307, 310

WGUC, 405 WHA, 223

Wi-Fi, 3, 6, 25, 216, 248, 251, 255, 321, 342, 344

Wikis, 329 Williams, Bruce, 385 WiMax, 249, 278

Windows, 11, 287, 298

Winfrey, Oprah, 6, 147, 199, 207, 208

WINS-AM, 390, 394 WIP-AM, 395 Wireless cable, 248, 251 WJR-AM, 382 WJZ, 208

WLAC, 208 WLS, 191, 199, 208 WMVP-AM, 395 WNEW, 387

WNET, 229, 233, 244 WNYC-AM, 405 WOL-AM, 395, 397 World Series, 133, 142, 154, 169, 332 World Wrestling Entertainment, 285 WPFW-FM, 405

WPIX, 262, 265, 307 WPVI, 191

WPVI, 191 WPXI, 272 WRZA-FM, 363 WSBK, 307

WTKS-FM, 388, 396

WTO5, 271 WUNC, 223

WVON-AM, 383, 397

WWJ-AM, 393

WWOR, 69, 199, 265, 307

WXRT, 380

X Games, 169 XM, 34, 36, 310, 342, 389, 407. *See also* Satellite radio

Yahoo!, 324–325, 344 Yahoo! Launchcast, 333 Yesterday USA, 310 YouTube, 2, 3, 36, 291, 305, 316–319, 325–328

Ziddio, 321–322 Zoning, 269, 297 Zune, 315

Telemundo, 9, 10, 28, 88, 123, 184, 191-192, 195, 306	UPN, 20, 36, 194. See also CW, The, and Chapters 4 and 5.
Telecourses, 235–236	Urban formats, radio, 339-340
Telenovelas, 6, 153, 164, 195, 206	Urban talk, 397
Telephone companies, 29, 250, 251, 261. See also Mobile media	USA (Network), 10, 15, 69, 116, 281, 286, 291, 293, 296
Televisa, 10	
Television	van Vuuren, Daan, 23, 41, 78
networks, 9-10, 14, 26-28, 36123-162, 164-188	Vcast (mobile TV), 315
public, 221–245	Verizon, 247, 250, 251, 261, 278
station, 190–219	Vertical integration, 27, 124–128, 287
TeleRep, 87	VH1, 296
Tennis Channel, The, 3, 294, 295	Viacom, 26, 90, 110, 123, 188, 194, 227
Tent-poling strategy, 132	Video streaming, 316–317
Terrestrial radio, 339-341, 350. See also Chapter 11	Viewsers, 317, 319
Texas Cable News, 274	Viral video, 319, 329
Tiering, 329. See also Clustering	VoD (video-on-demand), 257, 263, 277, 299, 303, 308, 311, 312,
Time zones, 172, 177	317, 318, 333
Time-shifting, 15, 135. See also DVRs	Virtual advertising, 127
Time-spent-listening (TSL), 66-68, 383, 390-391	Virtual channels, 10, 267, 268
Time-spent-online (TSO), 72	Virtual worlds, 321
Time-spent-viewing (TSV), 241, 242	Vlogs, 321
Time Warner, 26, 28, 36, 123, 124, 125, 128, 181, 194, 216, 218,	VodPod, 325
248, 254, 261, 274, 318, 324	Voice of America, 229
Time Warner Cable, 285, 307	Voice-tracking, 349, 369
TiVo, 253, 257, 315. See also DVRs	VoIP (Voice over Internet Protocol), 250, 251, 278, 282,
TLC (The Learning Channel), 292, 241, 281, 282, 293, 315	284–286, 288
TNT, 10, 15, 69, 118, 289, 291, 295, 296	Voom, 250
Toon Disney, 181	
Toshiba, 254	WABC, 191
Track record, 143	WAMU-FM, 395
Trade associations, 32	Warehousing, 30, 107
Travel Channel, The, 290, 293	Warner Bros. 27, 89, 90, 291. See also Time Warner
Tribune Company, 275	WB, The, 20, 36, 159, 194. See also CW, The, and Chapters 4 and 5
Trinity Broadcasting Network (TBN), 192, 392	WBAI-FM, 405
Trucking Radio Network, 398	WBBM-AM, 365, 390, 394
TruTV (formerly, Court TV), 74, 264	WBIX, 396
Trio, 283, 307	WBNS-AM/TV, 275
Truveo, 325	WCAP, 192
Turnover, 68, 299. See also Churn	WCAU-AM, 394
Turner, Ted, 221, 265, 288	WCBS-AM, 390, 394,
Turner Classic Movies (TCM), 290, 294, 295	WCKG, 396
TV Asia, 266	WCVB, 199
TV Guide, 4, 152, 228, 264, 271, 333. See also Guides; Promotion.	WDBZ, 395
TV One, 295	WEAF, 192
TvQs (television quotients), 47	Weather Channel, The, 281, 282
TVUPlayer, 316	Weather radio (NOAA), 406
20th Century Fox, 27, 235	Weaver, Sylvester, 12
Twentieth Television, 88, 89, 90	Webcasting, 317, 328
	Web-only networks, 315
UGC (user generated content), 317–320	Websites, 215. See also Chapter 10
Unbox, 315	cable, 264, 276, 315
Underwriters, 222, 223, 231, 234, 241, 244, 380, 402-403	film, 334
Underwriting guidelines, 226	independent, 323
Uniform channel lineup, 267	information, 380–408
United Stations, 372, 376	music, 338–378
Universal Pictures, 291	network, 22, 152, 320, 321, 323, 329, 332
Universal Television, 89, 90, 254	stations, 215
Univision, 9, 10, 20, 28, 33, 48, 88, 153, 191-193, 195, 205, 263,	Web testing, radio, 359
306. See also Spanish-language programming; Chapters 4	Web tracking, 72–73
and 5	WEEI-AM, 394
online, 12	Weighting, 75
Univision Radio, 195	WESH-TV, 275
Unscripted programming, 156. See also Reality	Westwood One, 368, 372, 376, 389, 390, 401